EXILED
—IN—
PARADISE

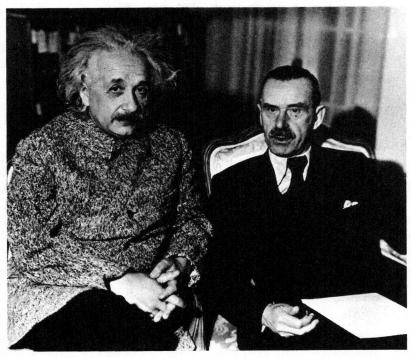

Albert Einstein and Thomas Mann, Princeton, New Jersey, 1938.
(Photograph by Lotte Jacobi)

EXILED —IN— PARADISE

German Refugee Artists and
Intellectuals in America,
from the 1930s to the Present

Anthony Heilbut

BEACON PRESS BOSTON

First published as a Beacon paperback in 1984 by arrangement with The Viking Press

Beacon Press books are published under the auspices of the Unitarian Universalist Association of Congregations in North America, 25 Beacon Street, Boston, Massachusetts 02108

Published simultaneously in Canada by Fitzhenry & Whiteside Limited, Toronto

(paperback) 9 8 7 6 5 4 3 2 1 '

Library of Congress Cataloging in Publication Data

Heilbut, Anthony.

 Exiled in paradise.

 Includes bibliographical references and index.
 1. Jews, German—United States—Intellectual life.
 2. Refugees, Jewish—United States. 3. Refugees, Political—
United States. 4. United States—Civilization— Jewish influences.
 5. United States—Ethnic relations. 6. United States—Emigration
and immigration. 7. Germany—Emigration and immigration. I. Title.
 [E184.J5H534 1984] 305.8'924'073 84-45071 ISBN 0-8070-5411-9 (pbk.)

Grateful acknowledgment is made to several individuals and publishers for permission to quote copyrighted material:

from several poems by Bertolt Brecht, from *Poems 1913–1956*, translated and edited by John Willett and Ralph Manheim, © 1976 by Eyre Methuen, Ltd., and reprinted by permission of Methuen, Inc., and Eyre Methuen, Ltd., by arrangement with Suhrkamp Verlag, Frankfurt;

from a letter from Mrs. Alfred Döblin to B. W. Huebsch, © 1983 Walter-Verlag AG, Olten, Switzerland; reprinted by courtesy of the Schweizerische Bankgesellschaft, Olten;

from a letter of Albert Einstein to Erich Kahler, © 1983 Estate of Albert Einstein; from *Einstein on Peace*, © 1960 Estate of Albert Einstein; and from *Out of My Later Years*, © 1956 Estate of Albert Einstein;

from *Childhood and Society* by Erik H. Erikson, copyright 1950 by W. W. Norton and Company Inc.;

from *Letters of Thomas Mann 1889–1955*, selected and translated from the German by Richard and Clara Winston, © 1970 by Alfred A. Knopf Inc.;

from *The Story of a Novel: The Genesis of Doctor Faustus* by Thomas Mann, translated by Richard and Clara Winston, © 1961 by Alfred A. Knopf Inc.;

from Walter Mehring's poem "The Emigrant's Song," from his *Neues Ketzerbrevier*, from the translation by E. B. Ashton, published by Hawthorn Books, New York, in *Break of Time* by Herta Pauli in 1972; reprinted by permission of the original copyright holder, Claassen Verlag, Düsseldorf;

from the song "In and Out the Garbage Pail" by Frederick S. Perls, © 1969 by Real People Press.

Frontispiece photograph by Lotte Jacobi, copyright 1938 by Lotte Jacobi

For those who didn't escape

Preface

It is only at the end that a life's shapes and shadows resemble a complete story, but even then some surprise can undo all the hard-won balances. When in 1940 the novelist Heinrich Mann arrived in America, he was almost seventy years old. In the prior decade, when he should have been enjoying the fruits of an illustrious career, he had been hounded from country to country, until finally, like some superannuated spy, he had made an escape over the Pyrenees hills. Once safe in America, Mann recalled a notion beloved of French writers, that the well-lived life was like a novel. And with his arrival, he deduced that his novel had come to an end. He was wrong. During the ten years that Mann lived in America, he was plagued by every kind of personal and professional disaster.

Hannah Arendt was another émigré enamored of the notion that a lifetime can be read as a story. She believed as well that the story is almost always beyond its subject's control. Her own life proved her theory, for although she commanded an American public far greater than Heinrich Mann's, she ended her days deeply troubled by American politics and by no means convinced that her days of emigration were over.

Everything about the German-speaking refugees from Hitler who settled here between 1933 and 1941 was special, and much of it was anomalous. The group was largely, though not exclusively, Jewish, but they had been assimilated at home to such a

degree that they considered themselves exempt from the violence that had provoked earlier diasporas. The artists and radicals among them saw themselves as vanguardists, anticipating a future that would transcend the cultural and political limits of the present, while the more typical members of the bourgeoisie were quite content to perform the functional roles of doctor and lawyer, merchant and scholar, that were required by society as currently constituted. What linked vanguardist and bourgeois was a commitment to service. Perhaps never before had any people, much less one so prominently situated and so apparently irreplaceable, been so despoiled of its confidence. Hitler reveled in the paradoxes of this destruction; he rewarded the exponents of the word with book burning and punished those who had only a historical identity by attempting to boot them out of history.

He did succeed in banishing them from Germany. They came to America knowing more about this country than other émigré groups had. From sources as varied as children's books, silent films, and political propaganda they had acquired a sense of the United States as being, alternately, a visionary landscape and a technological nightmare, populated by cowboys and Indians, gangsters and beauty queens. Uncertain about the prospects for high art in so wild a territory, they also arrived with a genuine respect for American movies and jazz. Knowing so much already—no matter how partial or artificial the knowledge—they became in short order professional interpreters of the American temperament. Bertolt Brecht once observed that émigré filmmakers—although the demand was not limited to Hollywood— were expected to decipher the Americans' hidden needs and discover for them a means of fulfilling them: this was called delivering the goods. Within a few years, while their English was still threadbare, the émigrés had achieved a remarkable success. Yet, after the political shocks of their emigration, they could not trust any form of sanctuary. True, America seemed to require their services, but a few years earlier, Germany had needed them too.

Thus, although they knew enough to take advantage of almost any situation, they also knew too much to feel completely com-

fortable or safe. By maintaining rigorous standards, they intro-
duced new forms and levels of professionalism. But these same
standards frequently led them to decry failures in America, in-
cluding their own. Their role was peculiar, in an odd way pe-
ripheral. A bit like the old court Jews, they exerted great
authority in some areas, but in other places they remained vul-
nerable: their ultimate vision was composed of alarm and be-
trayal, in both Europe and America.

Because the émigrés as a group were supremely well versed in
European high culture, there were numerous bonds uniting the
most famous artists with the anonymous Schnabels who at-
tended their concerts and the unknown Heines who purchased
their books. Additionally, all intelligent émigrés knew certain
less abstract things—there was a common wisdom that existed
long before the 1960s, when two émigré formulations, "banality
of evil" and "repressive tolerance," alternately baffled and con-
vinced the American public.

This book traces the curve of the émigrés' romance with
America, from an initial, full-throated, albeit consciously willed,
devotion (the word is not hyperbolic; President Roosevelt was
virtually canonized by refugees who usually regarded them-
selves as instinctive skeptics) all the way to the final disillusion-
ment and the attendant revision of the loving schemes and
estimations of the previous decades.

But their record, of course, is not exclusively painful. The
range of their accomplishments is staggering. From the arts to
the social and natural sciences, from the chairs we sit on to the
movies we see, to the nuclear weapons that trouble our nights—
results of their work are all around us.

This is a group that encompasses such powerful and diverse
figures as Albert Einstein, Thomas Mann, Bertolt Brecht,
Theodor Adorno, Max Ophuls, Fritz Lang, Hans Bethe, Arnold
Schoenberg, and Hannah Arendt. Yet it cannot be stressed often
enough how much these exceptionally dissimilar people saw
themselves as a group and drew from the general wisdom, pain,
and comedy of emigration. With that in mind, I have placed par-
ticular emphasis on the universal tone of emigration—witty, im-
pious, quite unlike any other, Jewish or American. Because the

émigré tone is so sharp and biting, so lacking in the sentimental consolations that other groups find warm and endearing and émigrés dismiss as sweet talk (*Schmus*) and babble (*Quatsch*), the émigré style has rendered its exponents peculiarly opaque. When they enter popular mythology, it is as comical ogres—Portnoy's therapist or Dr. Strangelove. The other qualities are either overlooked or not recognized, because they are entangled with traits that Americans find forbidding.

This book aims to be a social and cultural history of the German-speaking émigrés in America. It centers on the illustrious figures, but always presumes that their achievements were informed by and frequently indivisible from the mutual plight and, as such, their stories are best read not as local triumphs in specific disciplines but as parts of the larger émigré adaptation to American life. The assumption is that the varied histories share a basis as common as the tone and humor. Arendt once said that Einstein's exile was bad, but infinitely worse was the treatment given to poor Hans Cohen from Berlin, her apocryphal little émigré. The point is that both wound up in the same boat, in the same country, and often with the same problems. No matter how divided over method or politics—whether it was Thomas Mann, the imperial master of the German literary tradition, or Bertolt Brecht, who wanted nothing more than the demise of Mann and all his hidebound conventions—émigrés knew that each person's story acquired its full resonance only when seen as a portion of a larger history.

This history is filled with decoys and lacunae, for although the refugees were often magnificently forthright, emigration had trained them in the arts of concealment. Hence, it is only with the passage of time, and the deaths of many of the participants, that something like a complete story of the emigration is possible.

Many émigrés aided in the composition of this book. There are undoubtedly several figures who have been insufficiently examined. Often my correspondents would mention some compatriot

and scoff at my ignorance: "What! You haven't heard of Irmentraud Lautenheimer! You know nothing." That isn't merely the peremptory dismissal that comprises part of the émigré tone. There were many Irmentraud Lautenheimers—whom we can imagine as a children's photographer who had been an avant-garde filmmaker in Berlin, Prague, and Paris before she wound up in Jackson Heights, where she presided over a circle of émigrés who published self-subsidized editions of their poems—echoes of Rilke and Stefan George—which dealt with race prejudice, urban unemployment, lost loves, and the failure to find good bread. She kept the émigré tone alive, and strengthened the émigré attitude. To the extent that I neglected her and people like her, I apologize.

My parents, Bertha and Otto Heilbut, came from Berlin. Had there been no Hitler, I would have been born there. I remember on my first trip to that city discovering a familiar tone—one that I associated with New York. That discovery offered an explanation for the émigrés' comparatively easy adjustment to American urban life; it also reminded me that even as New Yorkers scarcely represent the entire range of American character types, émigrés so wary and dispassionate had a hard way to go in this country.

Of the many émigrés interviewed for this book, several have since died: Henry Pachter, Gertrude Urzidil, Yetti Kohn, Hans Reissner, Anita Daniel, Hans Staudinger, Herbert Marcuse, among others. I benefited from information and advice offered by the following people, who appear in these pages: Otto Nathan, Douglas Sirk, Paul Falkenberg, Fritz Landshoff, Wieland Herzfelde, Helen Wolff, Christiane Zimmer, Marguerite Yourcenar, Maria Ley-Piscator, Rabbi Joachim Prinz, and Herbert A. Strauss. Several colleagues of the book's principal subjects aided me, including both the associates (Lotte Kohler, Ingrid Scheib-Rothbart) and American students (Melvyn Hill, Michael Denneny) of Hannah Arendt; the secretary in America of Klaus Mann (Richard Plant), and Edith Jonas Levey, former director of public relations for the New School for Social Research. I am grateful to the Leo Baeck Institute, Goethe House,

and the Research Foundation for Jewish Immigration, Inc., for letting me use their libraries and research facilities.

The list of other émigrés interviewed—acquaintances and family friends—is extensive. Invariably they were self-effacing: "You don't want to interview me, my name means nothing." And invariably they proved to be vehicles of émigré lore, from the stockbroker who commented, "There are two German things you never lose—counting and cursing," to the social worker who wrote, "[After thirty five years of riding it] I don't love the New York subway, but we sort of understand each other—we are both survivors."

American friends also provided considerable help, reading the book in its various stages and suggesting where to dilute or dilate, as the occasion demanded. Philip Pochoda, Margo Jefferson, Leonard Lopate, Ronald Ward, Anne Middleton, Donald Wesling, Helen Merrill, and Susan Fox were all insightful readers. My extraordinary editor, Edwin Kennebeck, has been a most patient and conscientious professional. My copy editor, Linda Rosenberg, has been most diligent. They all prodded me to tell the émigrés' story as well as possible. I thank them for recognizing how much of a story there was to tell.

Contents

Part III: The Return of the Enemy Aliens

PART ONE
Europe to America

1

Berolina

"Let's be literary," they sang during the late twenties, "and go where the poets go." At the cafés that dotted Berlin's Kurfürstendamm, there was an unparalleled gathering of new talents—playwrights and actors, painters and composers, and moviemakers particularly, because the movies enchanted them all. Here a young playwright like Bertolt Brecht or a publicist like Billy Wilder or a screenwriter like Salka Viertel could share a table with Bauhaus architects and experimental novelists. This café world of 1920s Berlin attracted other intellectuals: even an Albert Einstein partied with artists. And always with the poets there were the others, friends, lovers, admirers—what Americans call "the fans"—who would later join them in exile.

It was this audience of outsiders, marginals beholding marginals, that the singers addressed. They did so with a patented Berlin irreverence, the extension in song of the famous *Berliner Schnauze* (lip), assuming that the "us" they sang to would appreciate the implicit joke, the juxtaposition of high art and public relations. The edge and comedy reflected the era's tone. For this was Berolina, where irreverence and gallows humor served to explode pomposities. Some natives might refer to their town

as "Athens on the Spree," saluting its cultural life, but another urban sense was condensed into a popular street song, "There's a Corpse Swimming in the Landwehr Canal." Even the up-to-date denizens of cafés were candidates for satire: one popular hangout, Café des Westens, was dubbed the Café Megalomania.

Part of the pleasure of Ku'damm life was the all-embracing irreverence. As early as 1919 the critic Kurt Tucholsky observed, disingenuously, "We say no to everything." The slant was fixed by idiom: Berliners tended to reply *"Nein"* (No) or *"Vielleicht"* (Maybe) to the most innocuous assertions—that tomorrow would be sunny, or that a marriage had been announced. This linguistic habit was shared by the stars of the cabaret world and the others who frequented the cafés with them. This meant, as Berlin's troubadour Bertolt Brecht knew, that nothing was ever said or taken "quite seriously." In the combine of politics and culture, intended messages might disappear; Hannah Arendt once noted that the angry tunes of Brecht and Kurt Weill were easily assimilated by middle-class audiences. Radical anthems became bouncy fox-trots. Radical politics became another Ku'damm entertainment.

There were, of course, many other cities—notably Frankfurt, Munich, Vienna, and Prague*—where future émigrés spent their youths. But Berlin's special position was due not merely to the number of important people who lived there during the 1920s. Simply, Berlin was preeminent because it set an urban tone, admittedly ironic and irreverent, that seemed singularly appropriate to a new way of living in the world. It was a city with portentous or grandiose architecture, monolithic temples of culture that mocked the armies of "little men" and the unemployed. But it was also a city of parks—the elegant Tiergarten in the west, the working-class Treptow in the east where the poor congregated for fireworks and their own satirical comedians.

* Johannes Urzidil, a Czech émigré to the United States, once distinguished his birthplace from the other German-speaking cultural centers by writing that Prague was not "easy-going" like Vienna or "sassy" like Berlin, but "serious, combative."

In the best urban style, Berlin domesticated nature. Its Land-wehr Kanal, where corpses swam, ran through the middle of the city—a waterway no wider than a boulevard on which ducks intruded their rural presence into the city's heart. The ubiquitous balconies opened apartments to the celebrated "good Berlin air." And as if to codify in social arrangements this mutual proximity to nature, Berlin apartment buildings up to 1920 enclosed courtyards where the rich families who lived in front and the poorer ones from the back buildings, the *Hinterhäuser*, would gather amid street singers and knife sharpeners to pummel their rugs, wash their clothes, and mind their children.

Berlin was distinguished by more modern institutions, especially the movie studios, as well as the theaters offering the vanguard efforts of a Brecht or a Max Reinhardt. Perhaps spurred by the movies, more likely informed by the ironic distance cultivated by people who greeted everything with a "No" or "Maybe," Berliners developed a special way of looking at the city. With the graceful eighteenth-century castles in the east, and even with the oppressive architecture of the nineteenth-century museums in the west, twentieth-century Berlin assumed the look of an urban stage set. There was so much to see and assimilate in the oddly ironic and distanced manner of cabaret Berlin that strolling through the town became a new urban pleasure for the Berliner. The supreme exponent of this exercise was the essayist Walter Benjamin, who spoke wistfully of nineteenth-century Parisian *flâneurs* (strollers), such as Baudelaire, while turning contemporary Berlin twists on the practice. As a boy accompanying his mother through the city, he had acquired a sense of "dreamy recalcitrance," which was reflected in "a gaze that appears not to see a third of what it takes in." This aimless wandering became the mark of a Berlin *flâneur* who knew at what pace and with what attention to move through a town. Benjamin even managed to achieve prose rhythms that matched the *flâneur*'s recalcitrance; his formula for great prose called for breaking up a sentence's rhythm, shifting meter in the manner of a jazz improvisation. (This was Berlin prose: Benjamin observed that the language of his French idol, Marcel Proust, repli-

cated the feelings of suffocation.) The discontinuity blessed the flow; the *flâneur* understood the value of detours.

What made Berlin so endlessly fascinating was not merely the varied architecture, the many lakes, or the nearby forests, but, above all, the variety of people. Strolling down the Ku'damm exposed one willy-nilly to unemployed soldiers and artists, fresh from a Salvation Army meal of soup with noodles and dried fruits, and to George Grosz financiers, en route to *Torten* with whipped cream at Kempinski's. Berlin was also during the twenties a city of exiles—Russians, Italians, even briefly Madame Sun Yat-sen. Their presence contributed to a pervasive sense of transience and impermanence. The homosexuals and prostitutes who cruised the streets announced that they had left their ghettos; the city was theirs as well. The menace of crime—muggers everywhere—and the calculating focus of sexual adventurers on the prowl: all this, alongside the cabarets and fancy hotels, and enlivened by the brisk Berlin climate, gave a sensual edge to the *flâneur*'s stroll.

For Benjamin, Brecht, or any of the other great Berliners of the 1920s, the walk was not merely an exercise in titillation or a spiritual antidote to Wilhelmian kitsch. If radical protest and avant-garde art combined to make Berlin the decade's most exciting city, it was because even when the protest—the urgent call for social and political change—was diverted from its main point or compromised, it was never lost. When Tucholsky admitted that his crowd said no to everything, he wasn't only defining the *Berliner Schnauze*. The fact was that the conditions evident on the Ku'damm proclaimed the need for action.

The postwar currency devaluations, with their spectacular, unbelievable rises—until wheelbarrows succeeded wallets as containers of money—provided a foretaste of even more grotesque events. While Marxism filtered down through the lyrical syncopation of Brecht's lyric "First comes the grub, then come the ethics," the truth, for many people, was that before anything else life meant poverty and hunger. Many of the artists who later congregated in the Ku'damm cafés first met at soup kitchens; Hugo von Hofmannsthal's daughter found herself waiting there on a famished Brecht—two opposing modes of lyrical expres-

sion bound together by the common condition. Poverty meant bad diets, ill health, apathy, mental depression, and, consequently, crime. Fritz Lang remembered that "Crime was rampant in Germany after the First World War." In his movies he made "the master criminal . . . a version of Nietzsche's superman," but crimes were committed by people who lacked such towering ambitions.

In memoirs of the period and in the fiction of Alfred Döblin and Leonhard Frank, Berlin is portrayed as a halfway house for soldiers transferred from army service to factory work—an exchange of capitalist confinements. In two 1929 films, the urban prison is the setting for wildly divergent experiences. In the delightful *Menschen am Sonntag* (Billy Wilder, Robert Siodmak, Fred Zinnemann), the giddy weekend pleasures of middle-class characters are contrasted with the tedium and anxiety of their workday routines. In Piel Jutzi's *Mutter Krausens Fahrt ins Glück*, the oppressive poverty of the Berlin slums, in which "an apartment can as easily kill a person as an axe," prompts a journey to happiness in the form of suicide. (In the final scene, after Krause's death, Jutzi shows her daughter racing toward a crowd of unemployed soldiers and union militants. . . . The two images sum up the options open to Berlin's poor.)

For those who knew how to look, everything they saw signaled the need for, or the arrival of, change. In one of many historical ironies, during their later emigration the people produced by cities like Berlin and Vienna would become the chroniclers and arbiters of social change in America. Their acuity dated from a time when as outsiders themselves, they had been able to register change with the immediacy of someone absorbing a visual impression. The unique Berlin skill was to take in all this intellectual and sensory information at once; that indeed was what Ernst Bloch said of Walter Benjamin's work, that it was philosophy in revue form, each side sharpening the other's cutting edge.

Although the young Berliners prided themselves on their distance from the German academy's pomp and fuss, they were

reenacting a familiar German scenario with the intersection of politics and culture. For centuries, culture had loomed larger than life for German thinkers. This may have been because culture for so long virtually took the place of politics. At the time of the Congress of Vienna, in 1814, the land that constituted modern Germany was divided into hundreds of independent units, ranging in size from Prussia and Bavaria to small duchies and city-states; Metternich had dismissed the notion of a German people as being an abstraction. In 1871 Bismarck achieved his goal of a unified German nation. This meant that in the 1920s Germany as a political reality was barely fifty years old. Its subsequent gaffes were often attributed by outsiders to late arrival on the scene, as if Germany were an overweight, overage debutante waddling through her first ball. But new and inexperienced as political Germany was, cultural Germany summoned up a tradition dating back hundreds of years, as enshrined in myth as in achievement.

This was a heterogeneous tradition that included both Catholic and Protestant elements. The Catholic preoccupation with mythical and magical uses of language was a prime source of German romanticism, while the Protestant focus, with its more stolid reworkings of Lutheran theology and Calvinist doctrine, helped to usher in nineteenth-century German commerce; both traditions accommodated xenophobia and anti-Semitism, the targeting of the outsider—i.e., the Jew—for being either not soulful enough or too mercenary. The exalted sense of art led to a celebration of the irrational; in a twentieth-century variant, Thomas Mann argued during World War I that Germany deserved to win because she alone of the Western European nations possessed a deep mystical soul.

The situation of an old culture flourishing in so new a country confused everyone; since the artist had remained faithful throughout the political changes, he became an exemplary figure. Heinrich Mann in *The Subject* (*Der Untertan*) argued that the actor had become the representative man, though his calculating succession of roles was, for Mann, a sign of a society gone mad. As if to confirm this perception, Adolf Hitler presented himself as an artist, an acolyte of Wagner and Nietzsche, the lat-

est avatar of German mythology. Other observers located him in a less hallowed tradition; upon seeing Hitler for the first time, in Munich, Richard Lindner beheld "a caricature out of Wedekind's plays." Similarly, years later German Jewish refugees would regard Himmler and Göring as buffoonlike arrivistes who seemed to have stepped out of Heinrich Mann's novels. In such a young nation, political history required excavation of a past for which culture had constituted the only political arena.

This paints a disagreeable picture of the German cultural tradition. Yet along with paeans to the mystical contemplation of isolated souls, German literature included many spirited calls to public duty; that these often issued from the same writers who celebrated solitude was, as Thomas Mann often said, a quirk of the German temperament. Schiller's great assertion was that "Art's aim is to make us free." The vehicle of this freedom would be the play, both the specific historical dramas that proclaimed Schiller's social philosophy and the very act of playing. This was another contradictory facet of the German disposition, one reflected in the style of the 1920s Berliners, despite their professed emancipation from the cultural past. German intellectuals have often married the serious and the playful, as evidenced by the Berlin-born Gershom Scholem, who after leaving Germany for Palestine became the leading scholar of Jewish mysticism. Recently an American woman sought him out for spiritual guidance. He startled her by declaring himself "a metaphysical clown" and, to complete the performing metaphor, his wife told their guest that her husband was "one hundred percent" theater. In several of the German traditions that influenced Scholem, this kind of whimsy confirmed the sobriety of his scholarly pursuits.

The German students instructed in mythology and romantic fantasies were also taught that culture and politics were partners in the same dance. Goethe's Faust or Schiller's Don Carlos (impossible to understand, argue some critics, unless one has read Kant) are exemplary figures because their most private behavior has public consequences. Such German classics—Milton's works may be the only analogue in English literature—combine didactic instruction, historical detail, and self-examination.

Apart from all the lessons instilled in them by Goethe (Thomas Mann's professed model) or Heine (the less forbidding model for the irreverent authors of *feuilleton* essays), the artists and radicals of the 1920s had learned very early that political realities impinged on private work and play. Walther Rathenau, the Jewish politician assassinated in the early twenties, once observed that sometime in the youth of every German Jew a moment comes when "he realizes he is a second-class citizen."

This horrible knowledge was usually inseparable from play; it appeared in the bullying by other schoolchildren, in class or during recess. To many sensitive children, it foreclosed the possibility of all future happiness. Walter Benjamin once said that the only solace for a melancholy temperament is allegory. There would be many ways of allegorizing the enemies of one's youth; film directors like Otto Preminger and Fritz Lang later recalled them in their portrayals of villains in American films. But since the source of melancholy was political, one means of allegory was also political. In Russia, the schoolboy Leon Trotsky divided his classroom into three groups: the sneaks on one side, the forthright on the other, with a "neutral and vacillating mass in the middle," as if history had rehearsed his own political destiny in the classroom. Similarly, the youthful Hannah Arendt acquired a political understanding in grammar school. When she heard anti-Semitic epithets directed toward her poorer, Yiddish-speaking classmates from students and teachers alike, she informed her mother, who advised her that two discrete situations obtained here: the teachers' behavior was an adult matter, and Mrs. Cohn, Hannah's mother, would look after that, but the children's insults were solely her daughter's concern. At the very least, exposure to anti-Semitism taught German Jewish children that they were marginals and outsiders, no matter how conventional their aspirations. But, as in Arendt's case, the subtle precision of a carefully rendered distinction could also provide the impetus for political action.

For Berlin's artists and radicals, the postwar period had begun most promisingly. The legacy of *Zivilcourage* and the socialist humanist aspirations of young intellectuals weaned on Goethe, Schiller, and Karl Marx combined to invest this time with ex-

traordinary possibilities. The proletariat, however, had devastated the intellectuals' hopes in the prewar years. From the parliament to the unions, many working-class leaders had either "bought in" or "sold out." Rosa Luxemburg, later a founder of the German Communist Party but then still a Social Democrat, was so astonished when the workers voted to back the German war effort that she briefly collapsed from the shock.

But by 1918 the debacle of war, the universal poverty, and the example of revolutionary activity in Russia had led radical intellectuals to assume that their hour had finally arrived. In November of that year, there was a brief sailors and soldiers' revolt in the port of Kiel. Within a week, the new political spirit had spread throughout the land; in virtually every German city, revolutionary workers' councils were established. A group of intellectuals managed to achieve a bloodless revolution in Munich by persuading the army to declare a democratic and socialist Bavarian republic. The government was headed by a distinguished lawyer, Kurt Eisner. The minister of culture was Gustav Landauer, a Shakespearean scholar, medievalist, and romantic anarchist. In his nostalgia for the past and his affection for a secular version of medieval communities, Landauer was, as George Lukács has observed, an "anti-capitalist romantic," deeply rooted in German cultural history. The choice for commander-in-chief of the army was equally improbable: Ernst Toller, later a poet and playwright before his exile and suicide in New York.

The Munich takeover had elements of operetta and tragedy. Douglas Sirk, the film director, was a student at the time, and he observed that the well-meaning political aesthetes had decreed a "revolution from above," although their manner and origins— most were non-Bavarian, all the leaders were Jewish—were different from those of the masses. In February 1919, citing a non-existent "red terror," the White Armies invaded the city, butchered partisans and innocent bystanders, and murdered Landauer and Eisner (the latter was killed by a right-wing Jew).

After the events in November, another German city, Berlin, also seemed to be poised to become a new world center of revolutionary activity, perhaps because in Rosa Luxemburg, the founder of the Spartakusbund, which was the forerunner of the

German Communist Party, Berlin could boast of having a theo-
retician who gave pause to Lenin and Trotsky. Luxemburg's
criticisms of the Social Democrats and her advocacy of mass
strikes addressed the interests of these men, but her Russian
comrades were appalled when she criticized Lenin's undemo-
cratic procedures and declared that the Left was insufficiently
concerned with workers' feelings.

In response to the Berlin revolt, the army slaughtered hun-
dreds of workers in the streets. A year later, Wolfgang Kapp's
attempt to restore the monarchy went unpunished. In January
1919 Luxemburg and her colleague Karl Liebknecht were assas-
sinated, and the authorities, as if to give justification to her re-
fusal to collaborate in any way with the nominally socialist
government of Ebert and Scheidemann, released her murderers.

But this was not the end of "Red Rosa." Her anti-Leninist
declarations made her the scourge of orthodox Communists.
Years later, justifying the party's neglect of the budding Nazi
threat, *Pravda* observed that the main German enemy had been
not Hitler but Luxemburg. In the view of the sociologist Max
Horkheimer, practical politics ended with her death. The
cryptic pronouncement of Horkheimer's colleague Theodor
Adorno that philosophy existed because its moment of realiza-
tion had passed may have referred to a moment incarnated by
Luxemburg. On the other hand, Hannah Arendt, a confirmed
anti-Marxist although both her mother and first husband were
radicals, would in emigration increasingly invoke the principles
and methods of Rosa Luxemburg.

Throughout the twenties, Luxemburg's memory cast a
shadow on the radical commitment of German intellectuals. In
the midst of dissension between Stalinists and Trotskyists, with
both sides alienated from the Social Democrats and the solidly
middle-class individuals—who constituted the vast majority of
German Jews—hewing to the German Democratic Party, poli-
tics provided the occasion for ceaseless debates. This was not the
mere chitchat of Ku'damm cafés; the Luxemburg tragedy was
too recent and troubling to make politics an amusing topic.

If Luxemburg's death seemed to put an end to radical hopes,
how could those hopes be revived? The Berlin streets provided

an answer. As the city increasingly offered a new kind of public life, forcing one to observe social change in all its manifestations, the dissolution of the barriers between public and private worlds became more of a blessing than a curse. To many children of the bourgeoisie who might otherwise have pursued conventional careers as teachers or artists, the traditional forms of scholarship and art seemed claustrophobic if not insane, given the social realities. The publisher Wieland Herzfelde felt that people like him who had served in the World War were—as Ilya Ehrenburg had first remarked—doomed forever to "stand a little in the nineteenth century." But those only slightly younger— and Brecht was Herzfelde's example—were uniquely products of the twentieth century, as demonstrated by their total lack of sentimentality or nostalgia. These young people found liberation variously, some by submerging their personal obsessions in a commitment to the working class; one legacy would be their common annoyance with psychoanalysis and autobiography. Others joined the masses in the pursuit and creation of popular culture.

The musical invitation to go where the poets go signaled the incorporation of high art into popular culture. Of course, in a city like Berlin the barriers between the two, elsewhere institutionalized, collapsed from mere proximity. If you spent time at the Romanische or the Café des Westens or the Schlichter, you were surrounded by filmmakers and nightclub singers as well as by poets. The street pulsated to "jazz" rhythms, although this American import was frequently bowdlerized into a jumping version of Viennese salon music. The pull of new cultural forms could be subliminal. Walter Benjamin, for one, saw the triumph of "advertising, American-style" in a subtle, nonverbal seduction: more insidious than the message in the red neon sign was the liquid reflection upon the asphalt.

Popular culture comprehended equally the language of ordinary Berliners, not excluding the criminals and prostitutes who drifted past the cafés. Working-class humor exhibited the characteristic Berlin disdain for authority: in one of the celebrated

Heinrich Zille cartoons, a middle-aged loafer stands at a bar and advises some youngsters nearby, "Children, don't study, otherwise you will have to work." Alongside such anarchic defiance was the expression of specific economic concerns; the working classes of Berlin were unusually sophisticated and aware of themselves as actors in a tradition that predated the Franco-Prussian war. They drew upon a legacy of wisecracks and tunes, cues and codes. For them, the lyric of a ballad, an advertising slogan, a witty tissue of obscenities, could define their lot as tersely as a Heine poem or Schiller essay or Goethe monologue invoked the sensibilities of the more educated. Berlin artists, by incorporating varieties of colloquial speech, aspired to both the resonance of high art and the visceral appeal of popular culture.

Being immersed in the culture of the masses provided these artists with another, more personal dividend. As Jews, intellectuals, and radicals, they were often regarded as outsiders. The memories of such exclusion could date from early childhood, to that time when, as Rathenau said, Jews learned they were second-class citizens. But popular culture gave one immediate access to the masses, to a world regulated by rhythms and visions that could dissolve one in fraternal bliss. The bully of your childhood might be seated right across the aisle from you, laughing as riotously at a Chaplin film.

This cultural leap had political implications. In 1932 Ernst Bloch regretted that the Left had ignored the subjective needs of the masses, leaving the realm of dream and fantasy to the Fascist manipulators. His indictment fit many radicals, but not those who were concerned with popular culture. The latter recognized, along with Marcel Proust, that "the people always have the same messengers—bad musicians." The political opportunities were evident; Erwin Piscator and Bertolt Brecht knew what they were about when they engaged in agitprop.

Interest in all the forms of popular culture was perhaps the most salient characteristic of Berlin intellectuals. It bespoke the democratic concerns of a group that was often unfairly described as elitist, or caricatured by conservatives as an early exponent of radical chic. The curiosity, if not the involvement, existed outside Berlin as well. During the late twenties, figures

like Hannah Arendt at Freiburg and Theodor Adorno at Frankfurt were absorbed in Kant and Hegel, respectively, but in exile both studied popular culture. Arendt would later see Charlie Chaplin as the Wandering Jew's newest incarnation, complete with a familiar Jewish fear of the police, while Adorno treated popular culture as a ghastly trick played by capitalism on the masses. There was far more affection and good humor in the Berlin approach, but Adorno and Arendt also understood that the people's messages had to be deciphered. They had had good teachers. Even these academic *Wunderkinder* could not escape the ubiquitous mass culture. During the 1920s the austere Adorno delighted in Kurt Weill's musical experiments. While the Olympian Arendt was "Pallas Athene" to her friends, her first husband, Günther Anders, descended to the streets; he was a brilliant early critic of movies, plays, and popular music.

There was an additional urgency to this obsession. As early as 1920 Kurt Tucholsky recognized that the paraphernalia and trappings of mass culture were already being exploited by the Right; long before Ernst Bloch, he worried that the Left was ignoring its own interests. And, indeed, throughout the twenties, Fascists were concerned with manipulating images. Berlin intellectuals, as students of the media, saw quickly that image-mongering had become political activity. Tucholsky reported the continuing use of military insignia and titles, despite the collapse of the German Army. By the decade's end, even physical carriage could indicate a right-winger's politics—for example, a confident strut could identify a National Socialist.

Similarly, the sudden infusion of media events could dull one's consciousness. Ulrich, the hero of Robert Musil's *Man Without Qualities* (1930), feels himself bereft of identity because he is so fragmented by the claims of art, scholarship, business, and tabloid journalism. A prince of Viennese society, he discovers twin spirits in a nymphomaniac housewife and a mass murderer. In Alfred Döblin's *Alexanderplatz Berlin* (1929), the lumpen characters' lives are rendered chaotic by a surfeit of language—curses and rhymes and slogans. Only those absorbed by popular culture could realize how insidious its appeals were. The easy lilt of a military anthem, the sexual glamour of uni-

forms, the evangelical fervor of a demagogue—the Berliners recognized the dangers because they had become susceptible themselves. For decades after, members of their generation, whether creators or critics, would continue to explore in exile the political implications of media imagery.

Although the right wing would ultimately win the war of cultural images, left-wing German artists made the twenties a vivid time, attempting to change the masses' consciousness through their art. Architects addressed both the physical appearance of buildings and the social arrangements they determined. With their heavy nineteenth-century edifices, cities such as Berlin were graceless, anachronistic monuments to exploitation and discomfort. As an alternative, a group of young artists associated with the Bauhaus School conceived of communities that resembled no German cities that existed up to that time. In ripping away all traces of kitsch or solemnity, they preached not merely a stark functionalism but also a new way of integrating human activities. Several Bauhaus leaders were originally allied with the Left: Ludwig Mies van der Rohe designed a monument to Luxemburg and Liebknecht, Walter Gropius collaborated with the radical theater director Erwin Piscator. In doing away with all forms of local color, they were proclaiming in architectural terms the old socialist hope of a truly nonnationalistic culture (only obliquely related to the term "international style" that would later define them). In turning their backs on architectural history, these artists were also rejecting the German political legacy. (However, Mies could recognize in Berlin's Old Museum, designed by Karl Friedrich Schinkel, a forerunner, albeit highly ornamented, of his own vision.)

There were other cultural implications. Bourgeois intellectuals had grown up in houses cluttered with furniture that was heavy, dreary, but oddly comforting: Walter Benjamin enjoyed snuggling up in his grandmother's overstuffed chairs, the "immemorial security of bourgeois furniture sealed off from death or change." A Mies Barcelona chair, by comparison, was a visual antidote to such claustrophobic comfort.

Young writers likewise were impatient with the traditional claims for aesthetic distance and moral instruction. They at-

tempted to create a freer, more flexible prose style. The Berliners among them incorporated the city's irreverent wit to cast off their cultural baggage. The Berlin sensibility was reflected as much in the difficult exegeses of Walter Benjamin as in the cabaret poems of Walter Mehring, or in the working-class fiction of Alfred Döblin. Brecht was the most eminent practitioner, a man so blithe about his sources that he almost welcomed accusations of plagiarism. But a similar attitude was found outside Berlin in, of all people, Brecht's bête noir, the emperor of German literature—Thomas Mann himself. Already by the twenties his work had begun a relentless satirizing of all the verbal forms of authority.

Looking for new models, the artists turned to America, the homeland of novelties. America had already entered the mythology of German dreams through the visionary poems of Walt Whitman and the Wild West action tales of the German novelist Karl May, the favorite writer of such disparate readers as Einstein and Hitler. (When during World War II, Hitler referred to his Soviet enemies as "the Indians," he was recalling the imagery of American Westerns, echoing their militant racism.) Now America also became a source of political instruction. Many young intellectuals were radicalized by their reading of Upton Sinclair's *The Jungle*. In awful contrast, Hitler got pointers in anti-Semitism from Henry Ford's *The International Jew*, which was doubly ironic, since *Fordismus* became a twenties expression for efficient technology, a complement to the new attitudes toward language and architecture.

In the late twenties, American jazz—in the modified version performed by Paul Whiteman's orchestra—came to Germany and caused, a Berliner remembers, "the equivalent of a rock 'n' roll explosion." (Whiteman's advance man there was a publicist named Billy Wilder.) Hollywood movies offered a delightful if cockeyed view of American life. During the twenties and even more during the next decade, Charlie Chaplin became a symbolic figure, demonstrating in pantomime that a flat-footed tramp could outwit financiers. Movies prepared the future émigrés for exile. In 1980, almost fifty years after her emigration, Lotte Lenya was asked to recall her first impressions

of New York. "But we had no first impressions," she replied, "for we had all seen the movies of Von Sternberg and Von Stroheim." The directors she cited both happened to be German-Americans, which further complicated the half-right, half-wrong vision of this country that refugees would absorb from the movies.

In Hollywood, during the twenties, Salka and Berthold Viertel joined other German filmmakers. The careers of two, Ernst Lubitsch and F. S. Murnau, prefigured the later experiences of émigré directors. Lubitsch had arrived in America in 1923 as the master of historical dramas. There, stimulated by the example of Charlie Chaplin's film *A Woman of Paris* (an Austrian converted by an Anglo-American's Hollywood version of France!), he began directing a series of light comedies. The "Lubitsch touch" became synonymous with a casual, cosmopolitan quality that exuded Old World sophistication. F. S. Murnau attempted something quite different. He brought a Continental mastery of visual effects and psychological characterization to distinctively American settings. In *Sunrise* and *City Girl*, Murnau managed to examine two sides of a familiar American myth—the countryside as both a pastoral and a provincial setting, a haven of innocence and an outpost of bigotry—while remaining true to the principles of cinematic composition he had developed in Berlin.

Such films helped to construct a new mythic image for the Berliners: an America composed of elements as disparate as comic strips, movies, and vulgar Marxist dogma. To exemplify the last, Bertolt Brecht imagined America as the apotheosis of late capitalism (typically, Brecht also wrote paeans to American energy). A coherent, if sterile, vision developed: Brecht's 1920s play, *St. Joan of the Stockyards*, is set in Chicago, Carl Sandburg's "hog butcher to the world," but the heroine might be reenacting the failure of classic liberalism anywhere in the world. In his 1932 Berlin film, *Kuhle Wampe*, Brecht again saw the breakdown of capitalism as an international phenomenon, while using American workers as symbols: an unemployed man observes that in America the out-of-work must walk, since they've all lost their cars. And that same year Brecht and Hanns Eisler composed "Ballad of Black Jim," the song of an oppressed

Negro riding the subways "in Manhattan, in Manhattan": the haunting refrain—with all the a's in "Mänhättän" umlauted—makes American bigotry conform to the rhythms and accents of Berlin cabaret. Here was a view of America as pessimistic as Sigmund Freud's had been in 1910, when he referred to the whole country as a "mistake," an "anti-paradise," a place which would both "embrace and ruin psychoanalysis."

Just as Brecht could find the prospect or at least the artifacts of American culture alluring, as demonstrated by his poetic homage to Lindbergh's flight, other Berliners allowed a tinge of hope to shade their ironic visions of the country. In 1932 Kurt Tucholsky and Walter Hasenclever wrote a comedy about Christopher Columbus that ended with shots of Times Square and Broadway flashed on the stage, as Columbus, accompanied by sounds of jazz, anticipates the phrase "Give me your tired, your poor . . ." and in an ecstatic outburst cries, "This is the earthly paradise." For writers like Tucholsky and Hasenclever, the American dream had become a mixture of technology, popular music, and political theory. But they would never learn more: both men committed suicide in exile, the first in Sweden, the second in a French war camp.

The idea of America as a technological wonderland appealed to exponents of what was known as *neue Sachlichkeit*, the "new objectivity," or "new matter-of-factness"; these included the Bauhaus artists, Brecht, Piscator, George Grosz, Igor Stravinsky, Paul Hindemith—all men who would eventually settle in the United States. These men believed that a clear-eyed, pragmatic approach to reality was infinitely preferable to the tortured probings of German idealist thought. They focused their attention on what was useful, practical, clearly spoken. Thus the German infatuation with *Fordismus* could be linked to the Bauhaus School's refusal to teach history or Brecht's concept of physical gesture, informed as it was by the experiments of American behaviorism. The advocates of such thought were usually progressive, assuming that the new objectivity would transcend the divisive effects of ideologies.

Curiously, they forgot for a moment what the study of mass media in Germany had already confirmed: that politics can in-

sinuate itself into the most apparently neutral environments. But they recognized the dangers of technological advances and tried to turn them to the working class's advantage. Berlin radicals became determined to employ the capitalist tools of advertisement for their own purposes. The Communist artist John Heartfield developed a style of photomontage that combined surrealism and satire, merging agitprop and the avant-garde. George Grosz conflated the myths of religion and militarism in an illustration of Christ on the cross wearing a gas mask and army boots. After the assassination of Walther Rathenau in 1922—his anti-Semitic enemies had finally destroyed him— Heartfield and Grosz designed a spectacular red banner that read "Hoch die Rote Republik." Setting truth against power within the framework of power's own visual terms, marching workers held the banner aloft, as if to contradict the billboards and window displays with their comparably up-to-date typography. Heartfield's aim, according to the journalist Günther Anders, was to make visible the invisible relations of power. Photomontage allowed him to present the coordinates in a manner vivid, dialectical, and entertaining (as in his 1932 photomontage for the Communist magazine *A-I-Z*, in which Hitler declared, "Millions stand behind us," convicting himself with a double pun, since floating behind him were the monies of faceless plutocrats). In such ways, the tactics of what Benjamin called "advertising, American-style," acquired a new ideological content.

More than any other European city, Berlin provided the setting for young radicals to employ art and technology as complementary tools of the revolution; a recent exhibit at the Pompidou Center, Paris-Berlin, traced the interaction between the two cities and gave abundant evidence that the work produced in Berlin had more political and social import than that created in Paris. This may have been because, at least in Berlin, the artists often shared assumptions with their patrons. They would have found little resistance, for example, from Wilfrid Israel. His family owned a large department store, Berlin's answer to B. Altman & Co. Israel was an amateur sculptor, a patron of the arts, a host to Caruso and Einstein. Foreigners such as

Christopher Isherwood thought he had a deracinated quality, the air of an uprooted Oriental prince. Yet he was no mere dilettante. He was actively involved in labor Zionism during a period when the Palestinian dream was a socialist cause. After Hitler came to power, he saw to it that all his Jewish employees safely emigrated. As a director of Youth Aliyah, he supervised the successful transport of thousands of Jewish children to Great Britain. He subsequently moved to England and died in a 1943 plane crash, shot down by Nazis en route from Portugal, where he had helped organize the migration of other Jewish children to Palestine; many friends believed that Israel himself had been the target. With supporters like Wilfrid Israel, the radical artists of Berlin were blessed with a patron who shared their convictions, their habits, and, ultimately, their fate.

For despite all their contributions to Germany, by the late thirties they had all fled the country, most of them for America. Many of these artists had grown up, as Jews or radicals, feeling like outsiders in their own homes, but they had come to see themselves as the vanguard of an internationalist spirit; paradoxically, they had found themselves more happily at home, more assimilated, as they assumed an increasingly critical stance toward all the traditions that had formerly served to exclude them. Yet the paradox was undone: Germany kicked them out as rootless internationalists, enemies of the fatherland. Those who had been the most sensitive students, on rare occasions even the architects, of change, now became its victims.

They would all leave Germany, but when they did, the best of them took with them the spirit nourished in those cafés—the social concerns, the cultivated irony, the good sense. One advantage of their increasingly isolated position as radicals and artists among the Prussian philistines and Nazi sympathizers was that it forced them to cluster together. They inhabited a small world in which "we all knew each other." These groups would prove wonderfully durable in exile. The concentric circles that gathered at the Berlin cafés—or in Frankfurt with Adorno and Horkheimer, or in Munich with the children of Thomas Mann—went almost intact to America. Along the way, even the most independent refugees knew that they had an audience of

peers who shared the same legacy, incarnated so splendidly in Berlin: the "us" such refugees referred to had very clearly defined attributes.

By insisting that their mutual aspirations and commitments were more than personal whims, refugees could maintain some form of hope during the hopeless periods. Brecht, for one, used the word "hope" with considerable irony, yet clung to it, supported by the sense of a common plight and a shared apprehension. In exile, the fantasists of America would become its shrewd and practical observers. Exile required the special alertness to culture and politics that they had initially cultivated as the German humanist tradition's last, best heirs. Walter Benjamin, who never reached America, used to fear that upon his arrival he would be wheeled through the streets, displayed as some oddity—the last European man. What he didn't foresee was that the road would have been crowded with fellow émigrés, equally uncertain whether they were superannuated figures or heralds of an internationalist dream that had been only temporarily defeated.

2

In Transit

"When I finally filled out my visa papers," a refugee writer recalls, "I could have put an exclamation point or a *'sic'* after every piece of information." No detail remained solid in exile; nationality, address, occupation, even name could change quickly. What stayed constant, however, was one's political identity. Adolf Hitler, in an ironic validation of the 1920s assumption that politics informed all activities, explicitly defined artists and intellectuals as political outlaws—as if to validate all their earlier perceptions of themselves as outsiders or second-class citizens.

In the spring of 1933 Hitler shocked the world by dismissing from their jobs the titans of German scholarship, the vast majority of whom were Jewish. On May 10, 1933, the infamous book burning occurred, this time of the works of authors both Jewish (Heine, Marx, Freud, Asch, Zweig) and radical (Heinrich Mann, Brecht, Erich Maria Remarque, even the German editions of Upton Sinclair); by October 10, it was an act of treason merely to purchase these authors' books. Hitler's actions served to define writing and thinking as political behavior. Whether or not the university professor, the free-lance critic, and the vanguard artist saw themselves as comrades, *der Führer* had no doubt that they were.

It must be stressed that Hitler's first victims were radicals and

intellectuals. Many of these—over 80 percent of the thirty thousand radicals exiled by Hitler between 1933 and 1939—were Jewish, but the monstrous treatment of the Jews as Jews lay well in the future. In 1935, the Nuremberg Laws deprived all Jews of their citizenship and their rights, but only in 1938, after the slaying in Paris of a German consular official by a crazed Jew and the subsequent *Kristallnacht* rioting (which resulted, among other things, in the destruction of Wilfrid Israel's department store), did every Jew stand in mortal danger; from that point on, being a Jew, or even a half or quarter Jewish, was sufficient grounds for extinction. But between 1933 and 1938 a Jew could continue to live in Germany. In hindsight, the Jews who remained that long may appear to have been naïve or deluded; their existences were certainly not comfortable after Hitler's accession to power. But many of them—those who were apolitical or politically moderate—simply felt that they were not Hitler's prime enemies. Others were sure that Hitler would calm down; a few shared his distaste for Marxists. It was not the first time that conservative Jews separated themselves from their more radical brothers and sisters in an attempt to escape the claims of history and politics.

Because the political reality of Hitler's Germany had been first foreshadowed in the pages of a text (*Mein Kampf*), it was appropriate that the students of literature should be counted among Hitler's first enemies. "We were all wise to Hitler," writers recalled in exile, "because we had read his book"—and, as many of them noted, been shaken by his barbarous use of language. In early 1933 Günther Anders conducted a sparsely attended seminar on *Mein Kampf;* close reading has seldom contained such political urgency. Anders believes that, whether prescient or not, all the Jews who left Germany were "political refugees," since Hitler used them for the political purpose of wiping out class consciousness; by defining Jews as the people's enemies, he obviated class struggle and solidarity. Thus even the Jews who abhorred politics or concurred with Hitler's economic views became political by default: their role had been assigned them in the book, as it were. But, again, the working out of this knowledge was first granted to intellectuals, who knew from

training and commitment how to read a book. To the extent that they would see through him quickest, Hitler was right to single out such people as his first enemies.

As Kurt Tucholsky had predicted, the Right had mastered the orchestration of imagery and symbolism. Those early actions, such as the book burning and the dismissal of academics, had succeeded in making independent thought and scholarship appear criminal. They had another, perhaps unexpected, result: though the refugees were well educated, less than 10 percent of them were professional intellectuals. Yet because the first group that left en masse was composed of university professors, and because Hitler insisted on the left-wing nature of his enemies, all the refugees were taken for radical intellectuals. Once again, it was a game played in images: throughout the thirties in the United States, the popular figure of a refugee was that of a writer or scholar, not, as in the earlier instances of immigration, a farmer or worker.

There were honorable Gentiles among them—ardent patriots who could not bear what Hitler was doing to their country*— but this was largely a Jewish emigration, an unhappy culmination of the Jews' history in Germany. Quite unlike earlier Jewish emigrants—the Germans of 1848 and the Eastern Europeans of 1896—Hitler's exiles were a largely assimilated group. Many had so transcended their ethnic identity that they welcomed Nietzsche's assessment of them as the one truly European people. German Jewish culture was more Jewish than many of them acknowledged; in fact, it was the Jewish quality that helped make the culture robust and sensible. It was certainly not characterized by excessive piety or displays of ethnic color. But, finally, it was as Jews that they left Germany.

Again, the abuse of images assumes, in retrospect, a political cast. German Jews were not numerous—in 1933 they were only five hundred thousand of Germany's sixty-five million people,

* Among the most famous were the Mann brothers, Heinrich and Thomas, and Bertolt Brecht. Although all three had written passages that could be construed as anti-Semitic, they were also all married to Jewish women.

and one-third of these lived in Berlin. Jews had infiltrated many areas of German life, particularly the media, through the newspapers they owned and edited, as well as the movies they wrote and produced. The Jew was a public figure—indeed, in Hannah Arendt's view, too often a creature of publicity—central to the confusing and largely artificial world of public relations and the commercialization of popular culture, activities that bespoke visible prominence and comparative wealth. Yet he had no real political power. Between 1919 and 1933 only five of the 640 Reichstag representatives were Jewish—a number greater than the Jews' demographic proportion, but not nearly large enough to make a difference. It was only the image they helped construct for themselves that fooled people into thinking otherwise.

The shrewdest saw themselves both as Jews—to deny that would be *idiotisch*—and as internationalists—unwilling to be bogged down in parochial distinctions. Yet in Hitler's image campaign, these internationalists were reduced to the status of ethnics. Pleading the cause of internationalism appeared to be subversive; for many conservatives, "international" was a synonym for revolutionary and demanded "Communist" to complete itself. Since most people were not interested in attending to the refugees' plight, the former masters of public relations were rendered invisible men.

Eventually, three hundred thousand Jews left Germany.* Less than half arrived in the United States. However, they were to become the most influential group of refugees in American history, again thanks largely to a series of historical ironies. Due to the demographics of German Jewish society, these refugees were more prepared for urban life than earlier groups had been. Because the U.S. government required them to prove that they were financially solvent, they tended to be richer and consequently better educated. And, because of the very nature of German Jewish life, their level of intellectual sophistication was

* Of these, 132,000 settled in the United States, 85,000 in Latin America, and 78,000 in Great Britain, to compose the main exile communities.

greater than their numbers would indicate. In Europe, "Herr Professor" was an appellation that indicated high status. Many more refugees would be considered intellectual by American standards; Vladimir Nabokov once observed that the Russian intelligentsia included doctors, lawyers, businessmen, and scientists, along with artists and writers, all conjoined in "a true spirit of international responsibility." No less could be said about those who fled Germany for the United States.

During the twenties, in Berlin or Vienna, some avant-gardists may have strutted about with the confidence that they held a passport to the future. In exile, they assumed the haunted look of people who would barter any goods for a real passport to safety. Scurrying from place to place, "changing one's nationality almost as often as one changed one's shoes," they became adept at subterfuge and chicanery. Law-abiding citizens, now no longer citizens, became cunning outlaws, smuggling currency, property, and people across the borders. Established members of the community became men on the run after that same community banished them, denied the legal protection granted to common criminals.

Some of the most daring escapes were managed by men who had made careers of creating melodrama. Fritz Lang, the director of *M* and *Dr. Mabuse,* so impressed the Nazis that in 1933 Goebbels offered him authority over the German film industry. Lang thanked him, hurried home, packed a few clothes, and left the country. Detlef Sierck (Douglas Sirk) spent a few more years in Germany. When he finally decided to leave, he happened to be in Italy on location. Stalling for time, he pretended to be sick and managed to fool his Nazi supervisors after a solicitous nun slipped him a hot-water bottle so that he could simulate a high fever. Walter Mehring, the Berlin cabaret poet, eluded some Nazis by denying who he was. Later, in a detention camp, he decided to make a left turn while his line of fellow prisoners marched to the right, and in so doing again saved himself. The Berlin novelist Leonhard Frank escaped from his detention camp by climbing over a barbed-wire fence. Melodrama also

overtook people who had no connection with the arts. Albert Einstein, for one, had become a special target of anti-Semitic terrorists in Germany. Walther Rathenau's assassination and warnings that he was next on the hit list had prompted Einstein's first trip to the United States a decade before Hitler compelled him to go into exile.

Unlike Einstein and other scholars, the majority of émigrés did not immediately head for this country after 1933. The artists and intellectuals remained in Europe, assuming—as Wieland Herzfelde recalls—that "we were not emigrating . . . we would return." They did not constitute a huge group; by 1935, there were only forty thousand refugees in Western Europe, not all of them German. They preferred life in France or Austria or Holland or the Soviet Union. The language and culture were familiar, and the cities were filled with sympathetic comrades. America was considered a fortress of reactionaries, home to Wall Street and the Ku Klux Klan. Not that European countries were particularly hospitable: conservatives shared Hitler's distaste for "all these Jews and Marxists"; workers resented having to compete with émigrés for the few remaining jobs. (In Germany the assault on academics went smoothly in part because it afforded jobs for many unemployed scholars.) Poverty was the exiles' constant companion. One woman remembers: "You can't blame the people who stayed in Germany. I saw the signs very early. I left Berlin for Paris in 1933. I was young; there wasn't any job I wouldn't take. But you simply couldn't get French working papers, and so I had to come back, feeling like a fool, and my mother grinning at the door, 'What did I tell you?' "

As they moved to other countries, refugees found no market for their specialties. So lawyers became butlers, journalists became tailors, chemists became baby nurses. Even the filmmakers had difficulty acquiring jobs. But the real pathos of the *apatrides*, the French term for people without a country, was that they were everywhere at the mercy and sufferance of hosts who had no legal or political responsibility for them. To paraphrase Günther Anders's definition, they were political people without political status. Switzerland, the logical sanctuary, closed its

borders to Jewish refugees in the late thirties—ten thousand Jews were turned back by the Swiss police—because their persecution was not considered political. Without a national home and thus without the protection of international law, they had once again become rootless drifters, in a revival of the old myth of wandering Jews.

Exile had stripped them of everything. The standard joke was that a refugee is an imported exporter, a man who has lost everything but his accent. Although Bruno Bettelheim has excoriated German Jews for their obsession with property, many were quite ready to discard useless objects. With nothing to carry, they had nothing to lose, and this made for a lighter mobility. For some, the rejection of property was a moral position: "Owning things corrupts one," says Anni Albers, Josef Albers's widow. But for others it was simply good sense. Brecht described "the standing order to refugees . . . have no things with you." Not that Brecht, like any other émigré, didn't regret the objects left behind. The exile's only portable property was his memory. "All that was home once and the bit of fatherland," sang Walter Mehring's "Emigrant." "That's what the emigrant lugs over hill and dale and bog and wave and, when his life's visa expires, to the grave." To the customary metaphor of life as a journey was affixed a new term: the visa, whose expiration could cut life short.

The master of making something out of nothing, Brecht observed, "Early on, I learned to change everything quickly, / . . . Learn to grasp things as you pass by." This assumption of impermanence endowed objects with a special, fragile charm. As condemned men, refugees could derive an inordinate pleasure from a splendid meal or a sunset or a night of love. A female colleague of Brecht's remembers: "Not all our times were terrible. We were young and adventurous and revolutionary; sometimes we even had fun." Eventually émigré communities sprang up, initially in Prague and Vienna, and after 1938 in Paris. Refugees developed their own network of newspapers and concerts and theatrical performances.

Although most of them were Jewish (and countless other Jews would later join them in exile), the émigré colonies be-

tween 1933 and 1938 defined themselves primarily in political or artistic terms; indeed, many among them, like the half-Jewish Klaus Mann, rejected a merely Jewish reading of their fates as constricted and naïve.

In terms of political allegiance, the refugees made up a most disparate group, none more so than the intellectuals. In Germany, Kurt Tucholsky noted the fragmentation of the intellectual Left; he bemoaned the lack of courtesy and friendliness. And well into the years of emigration, the various groups and subgroups would remain bitterly contentious. If the members of these assorted cliques managed to agree on facts, interpretation was another matter. Thus Hitler was obviously the common enemy, but whether he represented a unique embodiment of social evil or the culmination of decadent capitalism was question enough to inspire nights of ferocious debates in the cafés of Prague, Vienna, and Paris. Likewise the Communists and Socialists were forever accusing each other of undermining the left-wing coalition that might have prevented Hitler's rise to power.

They had enemies everywhere, and few friends. In Switzerland, the police director suggested stamping a big red "J" on Jewish passports; as with Henry Ford's anti-Semitic texts, Hitler could look abroad for inspiration in his destruction of the Jews. The Association of Swiss Authors apparently had no knowledge of the fraternity of writers, for they agitated against foreign competition. In France, political parties and journals openly preached anti-Semitism; a conservative slogan was "Better Hitler than Blum." The gifted megalomaniac Louis-Ferdinand Céline was hailed as an exemplary spirit by the likes of André Gide; Céline's scurrilous remarks about Jews were titillating respites from the general boredom. In almost every country to which the émigrés fled, Fascist parties operated. When Hitler ultimately invaded these countries, the resident Fascists often outdid the Germans in their zealous extermination of Jews; for example, Austrians constituted 80 percent of Adolf Eichmann's staff. There were no Fascists in the Soviet Union, and many émigrés—Piscator, Brecht, even, briefly, the director Max Ophuls—moved there. But in practical terms this

was a distinction without a difference. During Stalin's purges, scores of refugees were slaughtered as Trotskyists or enemies of the state; actors and actresses who had once been the toasts of Berlin cafés ended their lives in Soviet prison camps.

What embassy could they turn to? For a few years, Czechoslovakia was admirably hospitable; in gratitude, Thomas Mann never relinquished his Czech citizenship. But in 1938, following the *Kristallnacht* and transparent proof of Hitler's intentions, Western powers held a meeting at Evian at which they resolved not to increase their Jewish immigration quotas. Soon all the old allies began to capitulate. Abandoned by Great Britain and France, Czechoslovakia fell. Austria proved no test for Hitler; the people were, if anything, dying for occupation: this was clearly no national rape but a marriage in which the groom found himself overwhelmed by his bride's enthusiasm. The Soviet Union soon signed a pact with Hitler, and France yielded without much of a fight.

The United States remained. But to many refugees, America's record was not promising. This was the country that had launched exclusionary legislation in 1882 with a bill restricting Chinese immigration. A 1918 American law forbade admission to "anarchists and similar classes." This meant that left-wing refugees would have to lie themselves into the country, prolonging the masquerade of emigration. Five days after the *Kristallnacht*, President Roosevelt announced that he would not relax the American quota system. Meanwhile, refugees heard rumors about reactionary law-enforcement agencies. In 1939 the United States joined the International Police Commission, now known as Interpol, despite warnings that it was German-dominated. J. Edgar Hoover, director of the FBI, was frequently linked with such anti-Semitic demagogues as Martin Dies, John W. Rankin, and Gerald L. K. Smith. Hoover maintained contact with Nazi police officials until a week before Pearl Harbor. The émigrés believed that the FBI-Interpol connection was another sign of collaboration with the Nazis. With their heightened sense of danger, they could always smell out Hitler's potential allies among the police.

There was talk now of posthumous lives, a sense of having

lived past all possibility of rescue. Attempting to tease a meaning out of their exile, some émigrés became adherents of graphology and numerology. Seated in a Paris café, addressing a round of absinthes, the writer Joseph Roth became the unofficial arbiter of the émigré experience in France. Toying perversely with the dialectic, he would discern radical virtues in Catholic monarchists and spiritual powers in Marxists. For Roth, it was a game that had wound down somewhere, sometime. "I tell you one loses home after home. Here I sit, wandering, footsore, heart-weary, dry-eyed. Misery huddles beside me and keeps getting gentler and bigger. Pain stands still, grows vast and kindly, terror roars and can no longer terrify. And that precisely is the dismal part." Perhaps the terror had been disarmed, and perhaps the alcoholism that killed Roth was a mere reflex. But Roth's assertion signifies his refusal to give in to bathos; to remain dry-eyed is not false bravado, but the true sign of despair. He is cried out, beyond tears. The Kafkaesque image of a terror grown vast and kindly expanded to encompass a world in which danger was protean and commonplace, and evil ubiquitous to the point of banality.

In the midst of Hitler's triumphs, the émigré understood that he was of no interest to anyone. Alfred Polgar wrote of a refugee who begins to drown while swimming between two shores. The agitated onlookers utter the same prayer: "Please let him not be rescued on our side."

More than the entry visa, the transit visa, or the exit visa, the specter of the affidavit—documentary proof, required by the United States government, that the émigré would not require financial assistance—possessed a special horror for intellectuals. Who could appreciate better than they the pointlessness of a piece of paper establishing one's potential worth as a citizen? Yet such affidavits, confirming the least essential attribute (solvency) and vulgarizing the most important (character), became the supreme focus of existence. The procedure was draining and self-demeaning. Brecht beseeches his exalted vice-consul: "Deign to grant your quivering louse" some solace. After all,

you know "every hair on his tongue." Brecht was not particularly ashamed of such obsequious acts; he considered a commitment to uphold one's dignity outdated and bourgeois as well as impractical. Nor was he alone among émigrés who found themselves morally compromised in an attempt to gain a visa. The 1941 American movie *Hold Back the Dawn*, cowritten by the émigré Billy Wilder with Charles Brackett, depicts the plight of German refugees trying to enter this country from Mexico. A former gigolo marries an American spinster in order to acquire citizenship. The old roué is not even inventive in his corruption; as an immigration officer observes in a Wilderesque line, "There's an awful epidemic of marrying. . . . We have a new song: 'Is it love or is it immigration?' "

Well-off émigrés had less difficulty entering the country, though they too were dependent on condescending officials and quota restrictions. Others were forced to wait around, hoping that friends or relatives in America could raise enough money to justify the granting of an affidavit. Old grudges were rehearsed and greatly intensified. Some believed that their contacts in America had abandoned them.

Distrusting those in safety, the would-be émigrés began to argue pointlessly with those who shared their danger. By the time Leonhard Frank and Walter Mehring, in flight from the German and Vichyite forces, had reached Marseilles, the two writers were each bitterly claiming preeminence among Hitler's enemies. In the same way that Jews and leftists had argued since the time of Heine, Mehring insisted his Judaism won him pride of place, while Frank stuck by his political allegiances. Such casuistry was a sign of desperation: Hertha Pauli remembers, "We began not to trust one another."

There was a repellent fascination in listing the writers and artists whose behavior had been morally dubious. Since 1933, they had all seen decent, even amiable neighbors turn into their enemies. They knew the lures of collaboration. Not a few Jews were tempted to seek a rapprochement with the Nazis, especially when it had seemed that Hitler would countenance their existence as long as they were anti-Marxist. Many of their Gentile friends had become Nazis. In 1932 a writer in *Die*

Weltbühne accused Mies van der Rohe and Josef Albers of working too closely with the Nazis in an effort to keep the Bauhaus School open. Writers like Thomas Mann, Stefan Zweig, and Theodor Adorno were suspected of having flirted with the German authorities. It became a point of pride that one had quit Germany early instead of waiting around for Hitler to demonstrate what they had always known about him. This meant that some radicals had been sharper in their analyses and less self-serving than some liberals. But the plain fact was that they all had left—the politically prescient, the toadies, the apoliticals. Hitler had reduced them all to the status of homeless wanderers.

Although they spent too much time condemning one another, the real focus of their self-hatred was the German in them. Whether Jew or radical or simple patriot, they had all been devotees of German culture. Now that devotion inspired contempt. "They are a shitty people," Brecht declared, lamenting that "everything bad in me" had a German origin. Nevertheless, he continued to write in German. In America, Klaus Mann was more abrupt in divorcing himself from the language of his youth. "Why remain loyal to your mother tongue," he asked himself, "when the Fascists are itching to cut out your radical tongue and kill your Jewish mother?"

Humanist culture, especially as it flowered in the Weimar Republic and the Berlin cafés, appeared to have been killed. This was the most poignant of endings, going beyond the loss of language or a reading public, for it called into question an entire cultural inheritance: What could one possibly retain from this "shitty people"? Writers of dissimilar persuasions shared a sense of fatal estrangement. Perhaps the most famous statement about this was Adorno's postwar remark that to write poetry after Auschwitz was barbaric. Less peremptory statements came earlier. Stefan Zweig, shortly before his suicide, spoke of Rainer Maria Rilke as a rare bird who would not fly again. "Will such lyricism again be a possibility in this era of turbulence and universal destruction? Is it not a lost tribe that I am bemoaning . . . ?"

If the tribe wasn't lost, it was largely because another human-

ist culture sprang up in emigration, particularly in the detention camps—places that Adorno and Zweig never experienced. By 1940, following the German Occupation, those émigrés in France who had not yet received an affidavit were removed to concentration camps. While these places were not nearly as dreadful as Auschwitz and Bergen-Belsen, they were terrible enough, all of them overcrowded, wretchedly furnished, rank with the stench of inmates suffering from dysentery. One social worker remembers her stay in the women's detention camp at Gurs. On the first day, all the pregnant women aborted. Hannah Arendt arrived in the camps with her well-thumbed copies of Plato and Aristotle. Between her scholarly studies, she impressed other inmates with her absolute fearlessness in defending the rights of invalid women.

Arendt later remarked that the group consciousness cultivated in the French camps was a form of salvation. Nobody dared retire into personal considerations like suicide or collaboration, she insisted: in the moment of group imperilment, such selfishness would have been unthinkable. But not all camp inmates were model members of the besieged group. A figure of great controversy was Lion Feuchtwanger. For years his books had been best-sellers in Europe and America. They exhibited political courage if not artistic genius. In 1933 his novel *The Oppermanns*, a study of a wealthy German Jewish family, alerted foreign audiences to the dangers of Fascism. Its hero was that familiar figure—the cultured, assimilated Jew who disdains politics. He is forced into awareness, as his beloved nephew is driven to suicide and he himself is physically destroyed in a prison camp. (Feuchtwanger's description proved all too prophetic. His fiction emphasizes the camp's filth and dysentery. In 1940 he was interned in France, where, as he later wrote, he and his fellow internees were mired in "muck.") For the rest of the thirties, living in France, Feuchtwanger was one of the chief Socialist propagandists, managing to maintain his commercial success while publicly affirming a standard party line. In the late thirties he wrote an embarrassing book in defense of the Moscow trials; an editor remembers pleading with him not to publish it. Yet,

shortly after that, Klaus Mann called him a model of integrity who deeply believed his Stalinist defense (as if that justified his errors—sincerity was a disingenuous defense for radicals!).

Franz Schoenberner, who spent time in the same French camp, was less reverent than Mann. He saw Feuchtwanger as a vain hack, whose mediocre novels were "rather improved by translation." Walter Hasenclever, Schoenberner wrote later, amused him and the other inmates with a description of how Feuchtwanger had walked into an opera loge with the queens of England and France and later announced that the entire audience had risen in his honor. Schoenberner didn't deny Feuchtwanger's anti-Fascism or the accuracy of his descriptions of camp life. In fact, the two men noticed similar details: the callous *"je m'enfichisme"* (I couldn't care less) of the French guards, the improbable arrangements of limbs and torsos as bodies were packed against each other in the camp trains, the astonishing memories of old refugees quoting whole sections of classic German poetry. But Schoenberner also reported Feuchtwanger's more dubious actions—e.g., he threw away cables that contained information pertaining to the prisoners but addressed to him personally, without informing the other prisoners of the cables' contents. When they learned of his callousness, the inmates were out for blood, but Schoenberner protected Feuchtwanger with the condescending defense that "by his own dim lights" he was "quite innocent."

After his release from the camps, a loose-lipped Feuchtwanger told American journalists specific facts about the underground railroad that was moving émigrés out of Europe. As Schoenberner tells it, "This kind of brilliant publicity made it, of course, impossible for hundreds of other refugees to use the same channels of escape . . . it simply had never occurred to Mr. Feuchtwanger that the whole ingenious system was not built up exclusively for him." Other writers were more circumspect. When Franz Werfel arrived in America, he refused to tell about his escape: "I cannot speak. Most of my friends are in the camps."

While many inmates were preoccupied with such scandalous behavior, others found solace in more peaceable literary associa-

tions. Having lost his worldly goods, the refugee had become a fabulous collector, lugging around the portable property of memory and quotation. Walter Benjamin, writing of the virtues of collection, dreamed of a museumlike prose in which quote calls to quote with minimal intercession from the curator-essayist. In lieu of books, memory would suffice. Feuchtwanger himself said that in French camps the habit of quoting became "virtually epidemic."

In part, this was a legacy of Prussian education, with its rote exercises. It was also an attempt to combat the murderers of German culture. Benjamin worried that "Even the dead will not be safe from the enemy if he wins." The books were burned, the writers exiled, but memory could keep the cultural tradition alive. Thus another émigré, the Nobel Prize winner Elias Canetti, wrote, "If, despite everything, I should survive, then I owe it to Goethe." In 1944 Canetti proclaimed defiantly that he would continue to write in German precisely because he was Jewish. This Jewish insistence on German roots recalled the fact that for over a century, Goethe with his Godlike philosophical overview had been the cultural father of educated Germans. In contrast to his sustaining wisdom was the more brotherly good humor of another cultural hero, the German Jew Heinrich Heine. Carrying these poets with them out of Germany, still using them as they would have wished to be used, refugees saw themselves as the last protectors of the real humanist legacy, and they refused to yield it to the Nazis. They could quote Goethe's late tribute to America or Heine's tongue-in-cheek dissections of other nationalities as evidence of the difficulties of exile, or Brecht's more recent poems of emigration: the troubador's admirers were strengthened by his lyrics, as he had been strengthened by the prospect of their common plight. Yet others hummed snatches of German music: one émigré wrote that the melodies of Schubert or Beethoven seemed to reconstitute his dead father. So a quotation could be a curse, a valedictory, or a mark of defiance.

And such literary acts summoned up the memories of those martyred writers whose deaths had assumed representative significance: the suicides, such as those of Kurt Tucholsky and

Walter Hasenclever and Ernst Toller; the "natural" deaths, such
as that of Joseph Roth; the freakish deaths, such as that of Odön
von Horváth, a fatalistic Austrian playwright who was struck
down by a tree during a Paris storm. In the fall of 1940, two
deaths served to remind émigrés that they were doubly endan-
gered. In Germany, the amiable radical Willi Münzenberg had
virtually invented left-wing popular journalism; John Heart-
field, in one of the publications he edited, *A-I-Z*, had converted
the sleek devices of commercial advertising to proletarian use.
Münzenberg turned against the Communist Party after the Mo-
lotov–Von Ribbentrop Pact and shortly fled Paris. In October
1940, his body was found hanging from a tree; in a horribly apt
climax to his lifetime work, his death seemed drawn from tab-
loid journalism.

Barely a few days earlier, another representative figure had
died. Walter Benjamin, whose observations provided such an ac-
curate gloss on the despair and triumph of camp life, did not last
long after his release. He had remained in Paris during the thir-
ties, still engaged in his studies of that city in the nineteenth
century, and writing friends that here at least were positions to
defend. He saw no place for himself in America, but he dickered
for some time with members of the Frankfurt Institute in New
York over an affidavit; a few friends still feel the Frankfurters
were insufficiently supportive. Their efforts did, however, suc-
ceed in acquiring for him an early emergency visa.

In September 1940, after the Paris Gestapo had confiscated
his library, Benjamin joined the other émigrés in Marseilles. His
end was to assume the almost mythical aspect of an exemplary
fable, a legend of emigration. Despite a cardiac condition, Ben-
jamin and some others climbed over a hill to Spain "only to
learn that Spain had closed the border that same day and that
the border officials did not honor visas made out in Marseilles."
He committed suicide during the night. Had he traveled a day
earlier, there would have been no problem, and if it had been a
day later, the excursion would have been called off, and the fatal
combination of fatigue and frustration avoided. (Similarly, had
he lived in January 1941, he would have seen the Germans
briefly lift the embargo on exit visas.) Benjamin's vision had

been correct: he had been the wrong man at the wrong time. Brecht commemorated Benjamin's suicide in his first poem composed in America: "the future lies in darkness and the forces of right are weak. All this was plain to you."

Benjamin's fatal coincidence was the universal situation writ small. For in a reversal of the bad luck that killed him, it was the accidents of fortune that saved the others. All refugees—including those mired in internecine squabbles over camp behavior—could echo Isaiah's line: "The race is not given to the swift nor favor to the wise, but all things depend on time and chance." They would not forget those whose times had been ill-starred and whose chances had not come.

The obstacles to Jewish emigration set up by officers of the U.S. foreign service constituted a scandal that has tarnished this country's history. These civil servants were as callous as any European bureaucrats. No matter how fervent the gratitude expressed by émigrés, they all knew that their entrance was a matter of luck, not principle. Up to 1940, Breckinridge Long of the State Department went out of his way to inhibit their arrival with a series of obstacles in the form of visa regulations and affidavit requirements. To make matters worse, in June 1940 the State Department put an end to most immigration directly from Germany and the rest of Central and Eastern Europe. "The half-filled quotas," David Wyman estimates, "of mid-1940 to mid-1941, when refugee rescue remained entirely feasible, symbolize 20,000 to 25,000 lives lost because of the changed American policy."*

The émigrés had one friend in the White House: Eleanor Roosevelt. Her goodwill shone so brightly on her husband's efforts that many émigrés came close to canonizing the two, seeing them as their advocates against the anti-Semitic bumblers and bureaucrats. Their confidence in President Roosevelt was ex-

* Meanwhile, a "mercy ships" bill, facilitating the rescue of British children, easily passed in Congress; apparently WASP refugees were not a problem.

cessive. After the war, it became clear how little he had pro-
tected émigré interests: he did not publicize the existence of the
death camps and he waited until January 22, 1944, to establish
the War Refugee Board, long after it could have assisted in any
organized rescue attempt. Perhaps the émigrés' initial distrust
had not been misplaced.

There was one final rescue effort. But its very nature and its
cast of unlikely participants demonstrated that the émigrés still
had to look primarily to themselves for assistance, or to the very
few American friends willing to defy the U.S. government.

In June 1940 Hitler demanded the surrender of all German
war prisoners, a category that included denationalized citizens
residing in foreign countries. On June 4, a group of writers—
Hans Natonek, Walter Mehring, Hertha Pauli, Ernst Weiss—
sent a cable to Thomas Mann. They pleaded on behalf of
émigrés stranded in Marseilles and closed the letter with the
words "In the name of us all." In New York, the émigré writer
Hermann Kesten assumed Mann's role in organizing a rescue
committee. Karl Frank, the head of a small group of left-wing
émigrés, brought the plight of the Marseilles émigrés to the
attention of Quaker groups and labor unions. They found
their advocate not in President Roosevelt but in Varian Fry. A
young Quaker and the author of an early study of T. S. Eliot,
Fry had first been drawn to the German and Austrian socialists
after visiting their workers' projects. It was an unexpected
bonus that the political spirit of the 1920s architects should find
an affinity with a man who was now helping to rescue their
compatriots. Fry received support from Frank Kingdon, presi-
dent of the University of Newark, another sympathetic figure.
In 1939, Kingdon had offered to underwrite the distribution in
Germany of "apolitical" brochures by writers like Thomas
Mann.

From Mann to Kingdon, from Frank to Fry, the network of
associations was small but large enough. In late August of 1940
the newly formed Emergency Rescue Committee met with Mrs.
Roosevelt and its members insisted that the decision by Ameri-
can consulates not to grant visas to refugees from Hitler left
those would-be émigrés in mortal danger. The civil servants had

weakly defended their inaction as part of a general unwilling-
ness to interfere in relations between Vichy France and Ger-
many. Thanks to Mrs. Roosevelt's prodding, visas were granted
even to those without exit permits.

The government, however, still demanded political attesta-
tions and financial affidavits. Rather than decry this heartless
position, Fry sought out labor officials who would act as hosts to
the refugees. After his noble but unsuccessful attempt to rescue
two leading trade unionists, the American Federation of Labor
permitted ERC refugees to announce on their arrival that they
were the AFL's guests.

Fry realized that his services were most needed in France.
Upon reaching Marseilles, he moved into the Hôtel Splen-
dide and set up a Centre Américain de Secours (American
Relief Center). His colleagues included radicals, Catholics,
monarchists, and artists. His chief aid was Albert Hirschmann,
nicknamed "Beamish," a twenty-five-year-old Berlin-born econ-
omist and veteran of the Spanish Civil War who had never
been to America but enjoyed referring to Philadelphia as his
home base.* Franz von Hildebrand, an Austrian Catholic, af-
forded Fry access to Catholic organizations. The surrealist
André Breton seems to have been Fry's favorite among the art-
ists who volunteered assistance.

The limited funds—Fry arrived with barely three thousand
dollars—the resistance of consulates, and the proximity of
Hitler's armies forced the rescue workers to improvise a series of
activities that could rival a spy network's. To smuggle informa-
tion across the border, Fry used the "toothpaste trick": notes
were hidden in the bottoms of half-empty tubes. Cards and
papers were forged, after which Fry stomped on them until they
looked as abused as the real articles.

The hardest part was getting the émigrés out of France. Fry
developed an underground railroad. Hertha Pauli describes it:
"Since the whole frontier zone, where the foothills of the

* Hirschmann recently told a film interviewer, Laurence Jarvik, that he
has come to regret the committee's elitism: "We forgot about all the
others" who were not considered remarkable enough to be rescued.

Pyrenees meet the Mediterranean, was carefully reconnoitered, contacts with French Resistance groups were established, and, through them, with Spanish anti-Fascists, to learn how to avoid French border guards and which of the Spanish could be trusted." A hike over the Pyrenees hills would have been exhausting at any time, but it was a blazing hot summer and the climbers were sick, demoralized, often old. The most astonishing party included the novelist Franz Werfel and his wife, Alma Mahler-Werfel. Werfel was a cardiac patient. His companions were Thomas Mann's twenty-one-year-old son, Golo, and Mann's sixty-nine-year-old brother Heinrich. Out of deference to their reputations, as well as concern for their fragile conditions, Fry escorted this group himself.

In his last months in Europe, Fry met resistance everywhere. His group was attacked on the Marseilles streets by Vichyist toughs, with accompanying cries of "Filthy Gaullist." Among the French he discovered a general attitude of *se débrouiller*, which roughly translates as "look out for number one," with an undertone of beating out the other fellow. Jewish refugee agencies in Lisbon found American foreign service officials typically uncooperative and Quaker groups inefficient. The State Department devised a new and almost impossible form of visa application, but Mexico and Cuba proved more humane. After Fry left Europe, the Marseilles office managed to send out three hundred more people, rerouting them to Mexico and Cuba, before finally shutting down on June 2, 1942, nearly two years to the day after that first telegram. The last escapees included Wanda Landowska, Marcel Duchamp, and many German and Italian liberal politicians. In total, almost two thousand people were rescued through Fry's efforts.

They arrived in the United States stunned by the speed of events. Hertha Pauli, the only woman signer of the Marseilles telegram, was so exhausted that she briefly forgot her verbal *carte d'identité:* "I am a guest of the American Federation of Labor." She was almost sent to Ellis Island, where many leftist émigrés would wait for weeks before being turned away and rerouted to Mexico. For them, America would be exactly as they had dreamed it—another unfriendly country.

During her first weeks here, Pauli attended a series of reorientation services sponsored by Quaker groups and the ERC. At one dinner, both Eleanor Roosevelt and Dorothy Thompson spoke. Mrs. Roosevelt, so often the refugees' champion, encouraged the crowd, saying, "I never look back." Thompson, the refugees' best friend in the press, told the group that America could use everything they brought with them: their knowledge, their bad memories, even their nervous breakdowns. Although meant in good faith, these conflicting messages—look back, don't look back—summoned up the confusions that were part of émigré adjustment. Directed to an audience still dazed from flight, they were, if not insensitive, at least beside the point. The émigrés could not help looking back, and in most instances America would have no use for what they beheld.

The émigrés understood, with Brecht, that the refugee's "laborious job" would be "continued hoping." Upon reaching America, their hopes were sustained by something more solid than memories of Goethe and Beethoven and more immediate than radical politics. Hope is a function of youth, and the émigrés—with notable exceptions—were part of a young generation, as Wieland Herzfelde had noted, and thus were better equipped for transitions than those old enough to still see themselves as nineteenth-century men. Among those who were to make their mark in America, the following arrived while still under forty: Adorno, Arendt, Rudolf Arnheim, Marcel Breuer, Alfred Eisenstaedt, Hanns Eisler, Erik Erikson, Otto Fenichel, Kurt Gödel, Hojo Holborn, Erich Korngold, Ernst Křenek, Ernst Kris, Paul Lazarsfeld, Claude Lévi-Strauss, Klaus Mann, Herbert Marcuse, Hans Morgenthau, Otto Nathan, Erwin Panofsky, Leo Strauss, Leo Szilard, Kurt Weill. Among those who arrived while in their twenties were Billy Wilder and Otto Preminger, who would become the most American of émigré film directors, and the physicists Hans Bethe and Edward Teller, who would ultimately become twin, if polarized, leaders of the scientific establishment.

By their late twenties or thirties many émigrés had acquired a secure professional identity. Yet precisely when they should have been able to relax in their professional métiers, they were forced to prove themselves anew before audiences that did not share their background and assumptions. For some, this was a chance to begin the world again. But for others the demand for perpetual mobility was too much. In 1942, after years of exile, Stefan Zweig committed suicide in South America. In a note, he traced his action to the effects of age and fatigue: "After one's sixtieth year, unusual powers are needed in order to make wholly new beginnings. Those that I possess have been exhausted by years of travel."

Upon their arrival in America, émigrés of all ages found themselves entangled in many of the familiar political and social conflicts. Brecht observed:

> Hounded out by seven nations,
> Saw old idiocies performed,
> Those I praise whose transmutations
> Leave their persons undeformed.

Yet who could escape deformation? Not Brecht, who had squirmed before Nazi consuls and would prostitute his talents to Hollywood executives. Thomas Mann had a more generous view. "Exile creates a special form of life, and the various reasons for banishment or flight make little difference, whether the cause is leftism or the opposite—the sharing of a common fate and class solidarity are more fundamental than such nuances of opinion, and people find their way to one another." This was true up to a point, although Mann himself would be denounced by unsympathetic émigrés. For a time, his children Klaus and Erika became the leading figures presiding over émigré society; in 1940, Janet Flanner reported, "Refugees say you must be o.k.'d by Klaus and Erika."

There was a class solidarity of sorts. "We wasted two whole years on all the differences between Europe and New York," says the French author Marguerite Yourcenar. "I am filled with contrition for all this unproductive inbreeding." Yet some

émigrés seemed only too eager to break away. Arthur Koestler celebrated his move to England as being an opportunity to leave the insular world of emigration. Douglas Sirk proudly distinguished himself from the other Hollywood émigrés who stuck together and decried in German their new conditions. For every self-proclaimed "extra-territorialist," such as Ludwig Marcuse, who continued to live as if he were in Europe—writing and lecturing about German topics, never leaving the company of other émigrés—there were others who viewed their fellows with a mixture of sympathy, amusement, and contempt. They called the people who always made invidious comparisons between life here and there "bei unsers" (*bei uns* means "at our house"). It became a mark of youth and vitality to leave the group and acquire American friends. Even though many writers supported themselves by writing for émigré journals, a few assumed a slightly patronizing air toward their unassimilated colleagues. This, however, was a social, not political, categorization. Despite their vows of international cooperation, the left-wing émigrés were particularly clannish.

American Jews, the people with whom they might have had the most in common, were less than cordial in their welcome. Many émigrés still believe that American Jewish organizations were insufficiently aggressive in defending the émigrés' interests and exploited their situation for Zionist purposes with which many of them did not agree. To this day, some German Jewish refugees insist that the upper-class American Jews found them an embarrassing hindrance to assimilation while the lower-class Jews resented them for being a source of competition. In turn, American Jews, particularly those of Eastern European origin, considered the *jäckes* arrogant and condescending and were infuriated by their unfamiliarity with Yiddish culture. (They were on to something, of course: émigrés like Henry Pachter considered Jews of Eastern European origin vulgar and provincial, their much-vaunted Jewish identity a narrowing of intellectual possibilities.) On one occasion a refugee housewife entered a Kew Gardens delicatessen. When the owner addressed her in Yiddish, she said that she did not understand him. "Out!"

he screamed. "Get out! You German Jews always thought you were too good for us! Go join the *goyim;* that's where you belong! Or learn Yiddish! It's a beautiful language!"

Yet their Jewishness made adjustment to New York easier. Einstein loved a 1930s joke in which an émigré asks a friend if he is homesick for Berlin, and the other replies, "What for? I'm not a Jew." Refugees discovered a familiar urban tone, for, as Hermann Kesten has pointed out, a similar Jewish wit "stimulated" both cities. New York was not quite Berolina Rediviva, he quipped, but one could live like a Berliner there.

In largely Jewish areas, refugee communities sprang up, incorporating the artists and intellectuals among them. The same political and literary issues that aroused the cabaret customers of Berlin and Paris survived transportation to the Deauville Restaurant on East Seventy-third Street in New York or the Eclair on West Seventy-second. The refugees still worried about the old political questions. The Trotskyists despised the Stalinists, who on occasion snuck around with the Social Democrats. All three groups were dismissed in turn by the Democrats and Republicans, who viewed such European allegiances as anachronistic, not to say un-American. Meanwhile, though the little magazines might not accept the refugees' submissions, these same magazines were discovering Rilke and Kafka, two writers resurrected often in refugee conversation and variously viewed as prophetic witnesses or self-absorbed neurasthenics who had abdicated from the artist's political responsibilities.

By 1941 one observer had located 28 percent of New York refugees in Washington Heights—later known as "the Fourth Reich"—and 24 percent on Central Park West or West End Avenue, with other pockets in the West Bronx, Jackson Heights, and Forest Hills. These last areas, the most residential and tree-lined in the city, perhaps reminded the new residents of old Berlin or Vienna neighborhoods; the Berlin balconies were recalled in the terraces that graced apartment buildings in Queens and the Bronx. Like other ghettos, these areas contained their own clubs, restaurants, and stores. There was also a central journal, *Aufbau,* to which all the leading émigrés made obligatory contributions. The paper still flourishes, though now to a

very old audience that peruses the obituary pages first. Invariably the listings refer to earlier residences: *früher* (previously) is followed by one, two, sometimes several cities.

The vast majority welcomed the appearance of stability. After one has been a free-lancer, the enticements of tenure can be very alluring. Yet the sense of alarm could not diminish as long as one didn't know the fates of one's relatives. Ensconced in their suburban flats, refugees still weren't convinced of American hospitality: they heard themselves described as warmongers, radicals, foreign-born agitators. The casual remark "Why don't you go back where you came from?" could stop the heart, if one didn't dismiss it. Some were convinced that exile would be their permanent condition. In 1936 Einstein wrote in his diary, "Well then a bird of passage for the rest of my life."

Even after the United States finally began to fight the émigrés' greatest enemy, their existence remained insecure. Now, in an absurd turn of events, they were ostracized as Hitler's compatriots! For those as yet unnationalized, there were numerous restrictions; in California, a curfew kept them in after dark. As a final variant of all the terrible images of emigration, refugees from Hitler found themselves, while awaiting either citizenship or a return to Europe, registered as "enemy aliens."

3

Becoming American

In a chapter of *Joseph and His Brothers*, written in California, Thomas Mann described Joseph, the quintessential exile, as both "naïve and calculating"; from Mann's private journals, we know that he acknowledged as much about himself. His fellow voyagers also found themselves very old and very young, sophisticated and credulous, exceptionally well prepared and profoundly unequipped for life in America. Their heads reeled with so much remembered, and now so much to learn.

Or unlearn. For here was the most educated and well-traveled émigré group in American history attempting to understand America in European terms, not always sure how appropriate these terms were. Some exulted in the sea change. The Italian émigré Max Ascoli wrote that Americans were born, not made, and numbered himself among those "who can fully find themselves only when they come here." This kind of self-effacing confession was a popular means of selling refugees to the public, as if they had always been latent Americans. But few artists or intellectuals were as perfervidly eager to switch identities as Ascoli. First, it would mean giving up the internationalist perspective that had sustained them throughout their troubles at home and in exile; it would also involve rejecting out of hand a

legacy that infused their very ways of thinking and speaking. Furthermore, émigrés recognized that most Americans had not fully found themselves either. The characters in American literature are often as not rootless, restless travelers. This is a metaphorical situation, far removed from the concrete circumstance of being "hounded out by seven nations," yet, combined with the popular European image of a nation of frontiersmen, it suggested that Americans lacked a firm locus of self, while the refugees, with no space at all to maneuver, knew only too well who and what they were. Paradoxically, those committed to a group spirit saw quickly through the myths of American character, discovering the "rugged individualist" to be amorphous, fragmented, overdetermined by his society. What alert émigré would want to be like him?

For many, America had not been the first choice, as shown by the stops in France, Czechoslovakia, Holland, England, Spain, China, South Africa—seven nations and more—that went before. Many artists and intellectuals who came here were left-wingers, although the overtly Communist were rerouted to Mexico. "Big industry creates everywhere the same relations between the classes," is a Marxist tenet, and for émigré Marxists, America was everything about European capitalism, enlarged. Variations were merely local color or cultural opiate. (As an example of the wide applicability of European ideological training, Henry Pachter, the editor of the first underground paper to be printed in Berlin after the Reichstag fire, achieved a postwar success in market research by applying Marxist concepts to American business.) Likewise, Freudians arrived convinced that their theoretical axioms crossed national borders; their common denominator was a willful absence of surprise.

Jews and radicals were particularly alert to all cues. And, in fact, anti-Semitism was prevalent. Restrictions on jobs and residences were spelled out in employment ads and real estate signs: i.e., "No Jew need apply." The émigrés knew in advance that anti-Semitism was the normal concomitant of anti-Marxism. During the thirties, American demagogues like Father Charles Coughlin and Gerald L. K. Smith made anti-Communism and anti-Semitism twin banners of a neoreligious crusade. They in-

voked the old image of the Jew as Christ-killer. Racism was a central fact of American life; below the Mason-Dixon line, it was law. Indeed, it seemed so endemic that the political scientist Franz Neumann declared in 1944 that Germany was not an anti-Semitic nation, at least not so much as the United States. This was Neumann's way of asserting that the character of his homeland was essentially benign—he contended that Hitler was an aberration—but his statement also expressed the belief, widespread among émigrés, that most Americans shared the Nazis' prejudices.

There was another view of America that allowed the émigrés to adjust more easily. This perspective was found in the homeland of classic American literature. European intellectuals took it seriously and with the discernment of outsiders, separating the genuinely new from the ersatz, tolerating, even welcoming, the awkward verbal gesture as a natural attendant of vision. Henry James had his admirers, but the writers who meant the most were of another kind—Cooper, Melville, Whitman. They pointed out those qualities in American life that Europeans dreamed of. As a boy, Douglas Sirk was enthralled by Thoreau's "strangely clean language." American literature seemed a totally original response to a new landscape; in its inchoate graspings, it anticipated a new way of living. The poet of American spaces, the singer of the open road, was Walt Whitman. This self-propelled wanderer, confident that human sympathy would find him a home and friends anywhere, spoke deeply to émigrés. While some were drawn to him because he was a sexual rebel and others viewed him as a singer whose quotidian song would topple ivory towers, they all saw him as embodying the boldest qualities of American life. So much so that they made him their own; the novelist Oskar Maria Graf quoted him throughout his years in America, albeit always in German.

Other affinities of temperament were dramatized in literature. American transcendentalism was largely derived from German romanticism. As Germany in the twentieth century returned to England her eighteenth-century moral sciences recast as *Geisteswissenschaften,* so America now offered the émigrés a more high-powered version of their own romantic legacy. Yet most of

the literature, even Whitman's writing, lacked something essential, what D. H. Lawrence had called the Europeans' "easy flow of humor." Emigrés knew that humor was crucial, not merely to intelligence—after all, they were the heirs of a tradition of intellectual play—but to life itself; the *Berliner Schnauze* had carried them through emigration. The lack of humor in all but a few writers—Erik Erikson once scolded Mark Twain for abandoning in his later work his peerless comic gifts—made them less than wholly convincing. As would happen so often, emigrés found American products attractive, suggestive, and incomplete.

No matter what their intellectual bias, emigrés were bound to expand their perceptions into ideas, but before intellectual conclusions were possible, the data had to be processed. Their first impressions were, perforce, visual; the refugees' English was often an inadequate vehicle for instruction, even if the sights around them had not been so amazing. Later they would detect, in language and behavior, clues that remained invisible to the natives, but at first, noticing was something one did with one's eyes. And they were overwhelmed by the physical presence of America: the constant note in their memoirs is one of astonishment.

Since most landed in New York, the first American vision would be of America's greatest city. Many stayed there, and by the early forties some of them knew the city as well as the natives. In the memoirs of Hermann Kesten, Albert Ehrenstein, Klaus Mann, Martin Gumpert, Hans Natonek, and others, we find similar celebrations not merely of the regular tourist attractions, but also of the Museum of Modern Art, a temple enshrining the internationalist style; the picturesque charms of Greenwich Village and Gramercy Park; the momentum of crowds in banks and department stores; the noisy enthusiasm of earlier immigrant intellectuals, now living on the Lower East Side and convening at the Café Royale as the refugees had once gathered at the Romanische. They were captivated by visual novelties: elevated trains, barber poles, fire escapes. The neon advertisements had a special allure and pathos. For, as one novel

attraction was succeeded by another, as notions of the new were revised almost by the hour, émigrés perceived a general obliviousness to what was really news: the events in Europe that flashed by in the iridescent alphabet on the *New York Times* tower, history reduced to a glimmering sensation.

New York had particular appeal for former Berliners. Richard Lindner discovered in New York streets "the carnival spirit of Munich." One publisher noticed a similarity in climates: both cities benefited from their proximity to mountains, woods, and rivers. Moreover, both towns were unusually seasoned in their style and idioms by Jewish culture. One common result was a characteristically gruff, witty, know-it-all verbal style: the Berlin cabdriver met his match in Manhattan. What Berliner wouldn't respond to New York, with its spunk and bustle and contradictions? For a cosmopolitan, it was a happy move.

Yet a shift in focus modified one's pleasure. Everyone exclaimed before the colossal skyscrapers; it took a Marxist like the composer Hanns Eisler to recognize their monumental futility during an elevator operators' strike; likewise, Detroit wasn't for Eisler merely the capital of the auto industry but the home of exhausted and exploited workers. By the thirties, Eisler had already apprehended the urban anomie that would be captured by émigré directors in the great *films noirs* of a decade later.

Emigrés were excited by black people, and they gravitated to Harlem, Father Divine's gospel meetings, and the Savoy Ballroom's jitterbug contests. In the mid-thirties George Grosz did a sketch in which a well-dressed black with exaggerated Negroid features moves, conspicuous and anonymous, among the slick downtown New York crowds. Of course, some refugees could see blacks only as "jungle" or "circus" creatures. Like everyone else, they too could write of Harlem as a borough of primitives. But more of them were fascinated by the physical vigor and cultural resources of black life. By the twenties Berthold and Salka Viertel had dismissed most of Broadway except for the all-black production of the play *Porgy*. To visiting Europeans, the performance was a revelation: Klaus Mann wrote that the Negro alone "possessed a spontaneous and yet consciously developed

artistic style ... a new rhythmic experience, a new histrionic style, a new melody."

In 1934 the dancer Eugene van Groma, after visiting his Jewish father in Germany and perceiving Hitler's threat, founded the American Negro Ballet. His actions presumed a connection between two kinds of racial prejudice. Other émigrés shared this understanding, perhaps because anti-Semites had often pictured them as nonwhite: thus, the German assessment of Jew-lovers as *weisse Juden*. The American demagogues who condemned blacks invariably excoriated Jews and "foreign-born radicals" as well. Many émigrés were alarmed by the signs of racial oppression: on his first day in New York, the radical director Erwin Piscator was scheduled for an interview. Because the reporter was black and the hotel refused to allow blacks on elevators, Piscator was forced to descend to the lobby. As a first impression, the episode did not do much to suggest liberty and justice for all. Similarly, Brecht, who during the early 1940s planned to do an all-black production of *The Threepenny Opera*, commented shortly afterward that an American soldier rescuing a black man from white mobs during a Detroit riot required more courage than that needed by his compatriots on foreign battlefields.

How curiously striking were the parallels in verbal strategies and ironies between refugees and blacks. The two groups placed a premium on gallows humor, on a salutary irreverence. And other feelings linked them. Several émigrés have commented that they were deeply moved by the spirituals—"Nobody Knows the Trouble I've Seen" or "Sometimes I Feel Like a Motherless Child (A Long Ways from Home)." Once the slaves had used the Biblical narrative of Jews in captivity as an allegory of their plight; now some Jews in flight from captivity heard Negro spirituals as allegories of their own experiences.

Not everyone stayed in New York. Some received job offers elsewhere; others were directed to the hinterlands by refugee organizations who painted a bleak picture of metropolitan pros-

pects. Still others preferred a rural style. Carl Zuckmayer was famous in Germany for his good-hearted if politically muddle-headed dramas. After his arrival in 1939, he had little luck in Hollywood and acquired an active contempt for his students at New York's New School. So he spent the war years as a Vermont farmer. He found the laconic Vermonters "salt of the earth" types similar to the peasants who surrounded his Austrian home: "The pathless woods lured me; their solitude promised me protection, asylum, consolation." Sufficient unto the days, perhaps, but Zuckmayer returned to Europe shortly after the war.

Similarly, thousands of miles away, refugees in southern California had discovered another kind of protective environment. To Arnold Schoenberg, the state was a happy blend of Switzerland, the Riviera, the Vienna Woods, the desert, Salzburg, Spain, and Italy; to Thomas Mann, the California sun seemed Egyptian. Yet some were not satisfied. The usual complaint was that there was a surfeit of sensual impressions. Once settled in his Pacific Palisades home, Mann wrote a friend, "Here everything blooms in violet and grape colors that look rather made of paper. The oleander . . . blooms very beautifully. Only I have a suspicion that it may do so all year round." Similarly, Brecht observed that "in my garden are nothing but evergreens," and Ernst Křenek composed an emotional text, reflecting his sense of an exile completed in California, "where at Christmas the gentle breezes move through the palm trees." More bluntly, Hannah Arendt confided to her husband after her first trip to California that the "climate" alone was enough to turn people "meshugge." (Toughest of all was Toscanini's famous response to southern California—"Italy without soul.")

For the likes of Brecht or Mann, landscape was primarily a dramatic setting. The first thing such people noticed about the American countryside was the absence of people. (They echoed, unconsciously, D. H. Lawrence's contention that a landscape painting without a human subject was unfinished.) Some émigrés to California responded otherwise. Douglas Sirk was much more curious about American life than Brecht or Mann. His favorite area was the West: "Oregon with its dark

greens. In the desert with its yellow light . . . The North West, sheltering woods, open country. Old farms. Oldness . . ." These are a filmmaker's notations, combining an attention to the qualities of light with a visceral response to the physical objects and their history of human use. Fritz Lang shared Sirk's conviction that the West was the homeground of American mythology. Both men admired the Western as a film genre; Lang's 1941 film *Western Union* begins with unforgettable shots of buffalo herds charging before the horse of Randolph Scott, the representative of Yankee modernization.

Further mythic responses to the American landscape are contained in the unpublished writings of the Indologist Heinrich Zimmer. At first as he travels through the Midwest, Zimmer repeats a common refugee line: You can travel for days without the scenery changing. Then he hits New Mexico and Arizona, and "takes a sniff of this thin fragrance of the seventeenth-century Spanish atmosphere," delighted to have abandoned "the ascetic and repressive atmosphere of the last Puritans, the Anglo-Saxon eighteenth century and whatever efficiency it implies." What a cultural rainbow: the Puritan antithesis discovered in Spanish Catholic architecture by a German Lutheran Indologist! In the same key, Zimmer derives a political understanding from the landscape. In the desert, "you understand isolationism as an inborn reluctance, bred by the soil and the distances, to bother with what seemingly is going on in another hemisphere." Lawrence would have approved of Zimmer's means of perception: "It came to me as an initiation through the mineral realm, not through human beings nor through symbolic figures of flowers or animals," as if we can only strip back the layers of civilization "through the epic of geology."

Although Zimmer finds American nature imbued "with the divine indifference of the Hindu god and unearthly radiance of compassionate Buddhist saviors," his suggestive analogy manages to cancel out any religious content "in the calm of eternity." At last, he learns "the epic of geology" as he approaches the Grand Canyon. "You look down and down without reaching the bottom and, out of the depths, rises a series of the most magnificent apparitions, domes, pyramids, summits resembling the

enormous rock-hewn Hindu sanctuaries, shining forth with the most mellow and graceful colors." Geology becomes a visible synthesis of the present and an infinite past. "You are facing the epic of time, enwrapped in the calm of eternity. These rocks hum the music of time, the cycling melody of timeless eternity, its supreme monotony through endless variations of rise and downfall." These images of humming rocks, cycling time, and "supreme monotony" have all kinds of European origins—Hölderlin, Spengler, Jung. Hegel's influence colors the final description of "a paradoxical harmony of antagonistic principles forming one whole, balancing each other and speaking to each other in the same vision. This paradoxical union of conflicting forces and attitudes, you feel, forms the essential enigma of reality." Perhaps this "hieroglyph of majestic serenity" could be read only by a European Indologist. But the hieroglyph is American—the Grand Canyon. And Zimmer ends sounding like D. H. Lawrence celebrating Whitman on the open road: before this hieroglyph, this enigma, all overheated theories dissolve and "a wonderful coolness takes hold of your heart."

Brecht would have been unmoved by such charming variations of the pathetic fallacy. In a wartime poem written in California, he cites Gide's description of a pastoral scene and concludes that while the nations are "bleeding to death, . . . / no natural plan / Provides for a happy equilibrium." The most luminous myth disappeared in the alternately radiant and blinding light of political events.

The émigré's interest in American speech and behavior was colored by his own distance from the more familiar patterns of discourse. Like Orwell, he was preternaturally alert to the political distortions of language. But while Orwell was a master of easy, idiomatic English, the émigré felt verbally inhibited. Even the most fluent could make blunders; one says, "I'm married to an American woman, I only speak English to my children and my students, but I will never master this language of yours." For any artist or intellectual, the loss of his native tongue can be disastrous. But since so much of the refugees' very reflexes of

thought were predicated on German grammar, they now had to expand or contract even their manner of comprehending the world. Just as the sun seemed to shine a clearer light in America, the language also made events conform to another order of reality.

German possesses a grammatical structure with an imposing variety of cases and inflections and a syntax with Latinate placement of verbs at the end of sentences. This allows for complicated constructions—as well as the glib remark "So-and-so's prose reads like a translation from the German"—but it also makes possible subtle and even mischievous relationships between words: the final verb can undercut or sabotage all the lofty words that have preceded it. The possibilities are extended by the numerous portmanteau words. These multisyllabic terms appear ponderous, but they aim for precise distinctions and so actually condense discourse—for example, Marx distinguishes between *Klassengefühl*, the fellow-feeling of the working class, and *Klassenbewusstsein*, a more sophisticated sense of class interests and mutual oppression. The long words look burdensome on an English page, but they swiftly render a complex distinction. By comparison, American English lacks both the historical awareness that makes Marx's differentiation meaningful and a verbal tradition in which words and philosophical concepts can clearly modify each other. In German, where one can distinguish between the *Sinn* (sense) and the *Bedeutung* (meaning) of a word, a world of Oriental circumlocution and Talmudic complexities is possible: refugee intellectuals could argue for hours about the precise meaning of a word like *Aufheben*, grotesquely translated as "sublation," with its twin connotations of "retention" and "transcendence." If ever a language was suited to dialectical paradox, it was classical German.

Exchanging that instrument for English was for some an impossible task. Even those moderns who relished the idioms of an industrial metropolis remained bound to the expansive openness of the German sentence—it was a lot to give up. One writer speaks of losing "the language of one's dreams," though others report that after some years here, they began to dream in English. Another had prided himself on verbal pyrotechnics in

German; here he was rather relieved to have to settle for a blunter, more economical form of assertion. Yet another had been ashamed of his verbal limitations but found himself a hit on the American lecture circuit, perhaps because he didn't have the problem of unlearning the labyrinthine ways of literary German.

Not that they didn't know English. Many had lived and studied in Great Britain; others had English as a second language. Indeed, their language was at times too good, too literary, too *British* for America. The English of émigrés can be a wondrous instrument; Joseph Conrad and Vladimir Nabokov managed to discover treasures in an English that was idiosyncratic to the point of not resembling any language spoken by a native. Humbert Humbert has the characteristic émigré penchant for puns and advertising slogans; verbal play of this sort demonstrates the émigré's own pleasure in manipulating the native's idioms, as if the special attention didn't reveal his own foreignness. (With customary verbal amplitude, Nabokov also created in Pnin an émigré whose attempts at idiomatic fluency were forever doomed. The poor man commits malaprops in several tongues, expressing the confused trajectory of his exile.) More typical than Nabokov's gymnastics was another kind of verbal sport, as, for example, when Arnold Schoenberg replied to a student who had dreamed of composing a "soaring melody," that the proper word, surely, was "snoring." Such puns could be funny, cruel, and tone-deaf (in seven nations and twelve tones), comments of exasperation as often as they were attempts at endearment.

But if one wanted to participate in American society, whether by joining a club, teaching a class of undergraduates, winning over a customer, or simply reading a newspaper, one needed to know the language. So the refugees listened as carefully as they looked. In their early writings, addressed as much to one another as to native readers, they exhibited a shrewd attention to idiom and metaphor. Their guides to American speech are thus not mere dictionaries but attempts at mastering the culture. They reckoned that help was needed; paradoxically, the refugees from German considered English insufficiently straightforward!

In 1941 *Aufbau* (Reconstruction), the leading German Jewish newspaper, published an almanac for recent Americans. In among the assorted essays on politics and geography was a section on idioms. The refugee is introduced to terms of praise—"swell," "cute" (nicely compared with the German *nett*)—and terms for money—"dough," "bread," "two bits," "saw buck"—and fun—"booze," and "dope" to mean both drugs and gossip. Perhaps because he himself was often the butt of jokes, the almanac translates several terms of contempt: "dumbbell," "screwy," "nuts," "a rube," "a sucker"; much is made of the dismissive "shut up." In an amusing cultural parallel, the editors compare the skeptical response "Tell it to the marines" with *Das kannst Du deiner Oma erzählen* (Tell that to your grandmother). Implicit in all this is that American culture is like these idioms—glib, sensual, mercenary.

Certain idioms particularly impressed refugees, who took them as indicators of the distance between their new and old cultures. "Fun" was one: refugees noticed the strained, mechanized, conformist nature of American pastimes. Their Marxist training cued them to inauthentic, commodity-related obsessions; for this reason, Adorno could throw his hands up at all the forms of pleasure this society recognized. The displays of pleasure appeared hypocritical—Arnold Schoenberg advised his son-in-law to avoid debates and keep "smiling, always smiling," switching to English for "smiling" as if it were an American aberration.

They were startled too by the associated term "personality," as in "Gypsy Rose Lee has personality," commenting that in context it was either a priggish euphemism or an uninspired slogan in a language that offered many wittier phrases for sexual behavior. There was a more painful paradox associated with the word. Radical intellectuals regarded a preoccupation with the individual as being selfish and reactionary. But in transit they would discover their "colorful personality" to be a major asset. This meant that character was diminished to an assortment of tics and cadences, curious accents and funny clothes. "Personality" signified the dissolution of the concept of "individual" in a

vat of frivolous stylistic assumptions. By misapprehending everything important, the proponents of personality could make out of a bewildered refugee an "unforgettable character."

The emphasis on work was exemplified by the use of "job" as a means of self-definition: "What do you do?" meant only "What is your job?" Perhaps this bewilderment was limited to intellectuals; the few laborers among the group were used to identifying themselves as workers. A more distinctive locution was the language of finance. In Europe, money was simply not discussed in public or before children. Emigrés found the American obsession with salaries and prices vulgar. (Similarly, that American expression of satisfaction "I can't eat any more, I'm full" shocked them. Fullness required elimination: "I'm full" was heard as an announcement of intestinal discomfort. It is curious that neither filled pockets nor filled bellies were polite topics of conversation, as if the émigrés were confirming Freud's association of money and excrement.)

In the same way that "personality" denied character, the term "self-improvement" sounded like a blurring of the self. Those attending night school dared not patronize the American interest in adult education; many found their first work at places like the New School. But they saw something particularly self-abnegating about the success of best-sellers with titles like *How to Read a Book* or *How to Win Friends and Influence People.* Dale Carnegie's very title suggested an audience of social failures. "Win friends and influence people" was the language of profit making—as Brecht observed, "to convince" now meant "to sell." People were to be won over and exploited; friendship required schooling, as it was nothing but an ancillary of work. "Self-improvement" thus struck the refugees as the marriage of self-seeking and self-doubt, an almost schizoid form of false humility.

Other verbal concepts moved them deeply. The emphasis in popular biographies on "hardships" and "breaks" made the individual peculiarly passive, but the most aggressive refugee understood that his liberation was largely due to chance. The "comeback" was an optimistic American metaphor. It meant anyone could start anew, prove himself in strange circum-

stances, make up for lost time. These were the clichés of magazine prose, but they spoke exactly to the refugee's condition. Brecht's perpetual hope was that "Everything changes. You can make / A fresh start with your final breath."

Most refugees tried to adjust to the culture, adopting slang terms that would always sound funny to them or their listeners. (A few others wouldn't do this much. Johannes Urzidil lived here for almost thirty years and persisted in pronouncing "show" as if it rhymed with "now.") Some changed their names: Heinrich and Heinz called themselves Henry; Hans frequently became John; Wilhelm, Bill. Last names were changed or translated. Another American habit was perplexing. German had its terms of endearment—an umlaut and a *chen* or *lein* could improve relations wonderfully—and its hierarchy of pronouns—friends of a lifetime might never graduate from *Sie* to *Du*. But what was the justification for the arbitrary and whimsical forms of American nicknames?

The refugee was playing a game, aware that there were rules and frightened that he might be missing some crucial point. He needed the sophistication of maturity and the buoyancy of youth in order to relearn almost everything—from spatial directions to verbal idioms to social customs to political temperament—quickly enough so that he wouldn't forfeit his few opportunities for advancement. Folk wisdom says we must crawl before we walk, but the refugee had to go from crawling to running. In making the attempt, he often appeared more ridiculous than courageous; he began to see himself as a clown.

Those émigrés most burdened with linguistic problems were the actors. It was a question not merely of accent but of living in a language. Max Reinhardt's wife, Helene Thimig, bemoaned as fatal "this exile from our native tongue." It was difficult to act natural when every syllable was an effort. Otto Preminger tells of a famous refugee actor who appeared in a Broadway play; the actor understood no English and performed his part by rote, speaking words that were meaningless to him. It was even more difficult to act natural when the European acting tradition was

not naturalistic. European actors looked pompous and stagy alongside Americans. Erika Mann noted that, above all, the two acting styles were separated by "the sense of the European past." The variety of dialects and regional accents indicated more than linguistic divisions; local color provided the patina of social structure. In a sense, a European actor incarnated hundreds of years of social history in each stylized gesture or turn of phrase.

Applications of European technique to American styles often yielded ludicrous results. In the late thirties, there was a short-lived radio program called "Refugee Theater of the Air." Its eager performers included the opera diva Madame Fritzi Jokl, the accordionist Max Hamlisch (father of the songwriter Marvin Hamlisch), and the Yiddish baritone Dr. Gottfried Buschak. There was also a solo of the popular song "Ferdinand the Bull" by the emcee Joseph Bonner, who, according to *Variety*, delivered his introductions in "plain enough English, but poorly chosen wordage. He's not sufficiently straightforward, and perhaps unconsciously, plays too much for sympathy for talent which can, and should, get by on its own." The performers did not appear to have rehearsed—for encores, they could only give a reprise of the number they had already performed. It all appeared so melancholy and lugubrious that a critic wondered whether Hitler hadn't exiled any comedians.

Eventually a few refugee performers acquired a following, but those that did tended to be "types." Freakish in accent, the European actor frequently impressed audiences as being abnormal in other ways as well. A hero of German comedy, Paul Graetz (known in Berlin as "*unser Paul*"), went unnoticed, but the insidious pop-eyed intensity of Peter Lorre set off a sexual alarm. Conversely, the indubitably virile Charles Boyer was a larger-than-life Lothario. The two women to impress Hollywood most were Marlene Dietrich and Greta Garbo. Both were atypical, appearing to be exotically androgynous. Salka Viertel recalls her surprise when Irving Thalberg approved her conception of Queen Cristina, the Garbo role that defined the actress's ambivalent image. Perhaps he was amenable because Garbo was European—everyone knew that foreigners were perverse. Character

actors who hoped for commercial success had to play many games, becoming in the process masters of routines, which were often brilliant but also usually the same; some of these performers found themselves typecast as Nazis. As if to confirm Heinrich Mann's contention that the actor was the representative man, actors provided visual and, with their accents, aural images of emigration.

The object world battered one with impressions. The émigrés' memoirs exhibit a common bafflement: the simplest phenomena required a new angle of vision. Reorientation was no mere slogan, as evidenced in New York, where streets were defined by spatial direction rather than name. Looking up, the refugee beheld skyscrapers and billboards. As early as the twenties, Berthold Viertel was amazed by California signs, with their casual treatment of personal hygiene: "toilet seats shaped to conform to nature's laws," "teeth may shine like tinted pearls, still pyorrhea attacks 3 out of 4." Schoenberg quoted such slogans disapprovingly in his letters. Less censorious, Billy Wilder used them as guideposts to the American funnybone. His screenplay for *Ball of Fire* (1941) depicts the strenuous attempts of an American professor of linguistics to keep up with shifts in idioms, e.g., the head-of-a-pin distinction between "corny" and "baloney."

In his home, the refugee was sometimes surrounded by possessions. Despite Brecht's standing order not to carry property, many found ways to cart their old furniture with them. But for rich or poor, it must have been almost unbearable when the furniture crate was opened and "the past crept out . . . with its double meaning of familiarity and horror." For years Europeans had argued about phenomenology, that strenuous attempt to observe the thing in itself. But this was the cruelest application. These chairs, sofas, desks, and bureaus were truly stripped of meaning. If they could have registered the causes of their removal, they would have contained a Kafkaesque horror. Instead, they were mere objects, horrifying in their neutrality—as if nothing, neither nature nor manufactured product, had paid attention to the refugees' story. So, for a few, salvation lay in in-

vesting objects with a more recondite meaning. Marguerite
Yourcenar recalls how André Breton would entertain guests
with his newly collected objects and then proceed to discern
surreal and magical correspondences. Similarly, in a dialectical
form of phenomenology, Brecht could regard fishing tackle and
recall its former owner, a Japanese-American who was currently
being detained. The object existed to remind him of so many
"unsolved but not insoluble questions." Breton and Brecht were
not indulging in a pathetic fallacy, they merely wanted what all
owners want: for their objects to make the world coherent and
whole.

If the refugee kept a few old pieces, the new ones he bought
signified for him the machine. Some of the émigrés wrote of cars
and buses as if they'd never snaked their way through traffic,
about bathtubs as if they'd never washed. On one hand, they
welcomed the conveniences; on the other, they deplored the
standardization. Conformity was registered in appearances. One
man wrote that he knew he was nationalized when he knotted
his first American tie. A Harvard dean who had arrived as an ad-
olescent remembers feeling like an outcast in his European short
pants and long woolen stockings. But, he says, after purchasing a
lumber jacket and long pants, "I felt very much at home, even
though I knew no English." Men's shirts had shorter tails, suits
and pants were less tailored; one had no cause to own—or be—a
stuffed shirt. (Some émigrés, like Einstein and Brecht, preferred
the informality of rumpled shirts and open collars; others, like
Thomas Mann, were never seen without jacket and tie.) This
made for quick dressing and relaxation, as well as easy access for
women to inexpensive garments and cosmetics.

But the ubiquitous cosmetic proved another symbol of dehu-
manization. Cosmetics starched and mummified, disguised na-
ture and systematized artifice. The refugee who saw a made-up
woman rush to work perceived her as someone who was openly
proclaiming her servitude to a machine culture. Perhaps he
didn't overstate the case. The most prominent cosmetics ad de-
picted affectless debutantes and, in a roundabout syllogism,
trumpeted, "She's lovely! She's engaged! She uses Pond's!"

Even food was not the same, either to smell or to taste. It be-

came an obsession; after all, as Brecht was to say, one's home-land was where the bread was tastier and the air spicier. Carl Zuckmayer, seeking solace anywhere, writes, "When we ate as we had been accustomed to doing at home, we did not feel as utterly annihilated by this strange land." In Hollywood, the émigré colony gathered at the Blue Danube restaurant, operated by Joe May, a Berlin director now down on his luck; during her later difficulties with congressional investigators, Salka Viertel contemplated selling goulash from a wagon on the beach. New York's Eclair and Cambridge's Window Shoppe provided em-ployment for recent émigrés who shared the customers' tastes and languages.

The common attacks on American food—"One couldn't even find a decent piece of bread"—were not always fair. There was a lot of good food around, many varieties of bread if one knew where to shop, much richer grades of cream and milk, fresher fruit and vegetables. More typical than the snobbish dismissal of American cuisine was the astonishment at the sheer quantity. The émigrés could not believe the massive portions of vegeta-bles, the huge intake of milk. A luxury at home, milk here was either inexpensive or provided free in school lunch programs. It was not the quality of the food that struck the refugees; it was simply that food was yet another sign of the differences in com-modity distribution and social structure.

All the conditions of life seemed overrun by commerce and the machine; death itself was not immune. Schoenberg de-scribed a California ad in which a driver who had just killed a child sits racked with grief—not for his victim, but for failing to pay his insurance premiums. Californian informality invaded the funeral parlor: at the services for Max Reinhardt, Thomas Mann heard a thirteen-year-old acting student announce that he could not speak formally about Max, for "We were simply good friends." Such jargon and misappropriation of camaraderie made it difficult for the mourner to keep a straight face.

As outsiders, émigrés were particularly drawn to those areas of public life in which they couldn't participate. As would-be natu-

ralized citizens, they could only observe the workings of the po-
litical system; similarly, they stood outside the traditions of
American religion. Most refugees had been exiled for their
religious ancestry, if not for their beliefs; they were therefore
particularly attentive to American religion, especially as it ex-
hibited signs of anti-Semitism. Like everything else, American
religion was more public and flamboyant than anything in Eu-
rope outside of Lourdes or the Vatican. In the twenties Salka
Viertel had escorted Sergei Eisenstein to the gospel tabernacle
of Aimee Semple McPherson. This engaging evangelist used to
give fresh roses to new members of her congregation. Her ser-
vices would work up from seductive mumblings to an emphatic
altar call: "All right, ushers, clear the one-way street for Jesus!"
Eisenstein was fascinated; another visitor, Klaus Mann, was
horrified. He later asserted that only Adolf Hitler could match
Aimee's mastery of mike technique. In its excesses, evangelism
seemed to spill over into displays of public insanity, aisles filled
with the possessed, foaming at the mouth, their eyes glazed over.
Later émigrés in California also saw fundamentalist worship as a
clue to American mores. Douglas Sirk was struck by the mar-
riage of "sorcery and religion"; Fritz Lang, in his film *Fury*,
evokes a peculiarly native boredom by having his outlaw heroes
idling around on a dreary Sunday while the radio softly drones
the evangelical hymn "If You Love Your Mother, Meet Her in
the Sky."

The refugees from Fascism linked religious tolerance to the
democratic freedom of choice. They contrasted the "birthright"
faiths—those sacramental religions familiar to Europeans—in
which one was born Catholic or Lutheran, with Anglo-Ameri-
can sects—Baptist, Congregationalist, Methodist, Quaker—in
which conscious commitment, exemplified by adult baptism,
was a matter of doctrine. Alas, they discovered that fundamen-
talists could be as intolerant as Catholics and were in fact fre-
quently opposed to liberal emigration laws. Emigrés were struck
too by the tie-ins between piety and commerce. American reli-
gion was a pragmatic faith. Pentecostals worshiped a god who
cured ills and paid bills; Methodists and Congregationalists
lauded a god who seemed to prefer executives to widows and

orphans. The refugees noticed all this because our "old-time religion" was to them brand-new.*

The spiritual workouts, characteristic of evangelistic services, were clear examples of public therapy. Refugees noticed how often public behavior appeared more therapeutic than practical. Americans assumed that getting one's troubles off one's chest would take care of matters; political disputes were domesticated into personal disagreements. Many observers expressed surprise at the American labor unions' class collaboration with management, a reverse of the European battle between classes. Pluralism had fragmented anything resembling class solidarity. While labor in Europe was organized politically, here it seemed to have achieved the status not of a political party but of a guild or, as in the trade unions, a social club on the order of the Elks or Kiwanis. One émigré writes, "In the unions exactly as in the reactionary capitalists, one misses a political or even social sense." And this in a country which had once boasted dozens of socialist mayors (56 alone in 1912).

Instead, the majority of Americans paid homage to a common ideal, echoing Thomas Jefferson's remark "We are all republicans, we are all democrats." Political organization was not predicated on class interests; pluralism expressed a multiplicity of social, rather than economic, positions. Although many émigrés, exhausted by the political squabbles of Central Europe, welcomed this economic pluralism, others insisted that class interests still prevailed, that here they were only disguised by new forms of political rhetoric. Any alert émigré could spot the contradiction between the myths of "pluralism" and those of "rugged individualism." How could you love your neighbor, much less accede to his wishes, when your aim was to outdo him on the job or in the marketplace? In pluralist America, speaking

* Paul Tillich's widely disseminated assaults on traditional religion were read by American fundamentalists as attacks on their most cherished beliefs. The reply of one black gospel singer to Tillich's theology—"My God isn't dead. I talked to him this morning and he's doing fine"—is as American in diction and sentiment as Tillich's thought was a foreign import.

one's mind was considered reward in itself. But, despite the numerous voices, the same forces remained in power.

Despite its manifold contradictions, the U.S. Constitution offered unparalleled freedoms. The First Amendment guaranteed a liberty of expression that seemed paradisiacal to journalists and editors who had been fired because of their political positions, as well as to writers whose books had been burned. Some émigrés decided to use all the freedoms of the system in order to improve it. These ranged from academics like Leo Strauss, the conservative political scientist, to people like the photographer Lotte Jacobi, an active participant in New England town meetings.

In Europe there had been one revolutionary model: France. Its stress on universal emancipation had made Jewish freedom possible. And in Germany since Bismarck, sickness, accident, and old-age insurance had been accepted conventions. So although émigrés had acquired many new freedoms, they were bemused by the absence of an aggressive and potent revolutionary party and by the lack of a relief system for the poor. To their amazement, neither was perceived by Americans as a political failure.

Most German Jewish refugees were not radical, but they all possessed a refined historical consciousness. In Germany, politics had infiltrated all areas of life; one could even make popular comedy of it, as in the Berlin cabarets. And emigration had proved to be the universal politicization of experience. In one old joke, an immigrant grandmother's response to all news items is the same: "Is it good for the Jews?" That, in abbreviated form, is a political sensibility. Emigrés would always appear politically eccentric to Americans, despite their normally centrist positions and their fanatical devotion to the Roosevelts, by virtue of both their assumption that welfare was a citizen's right and their intense concern with public events.

In the émigrés' own lives, the country's customs forced a change of behavior. This was nowhere so clear as in the treatment of women. Refugees immediately noticed the discrimination

against women, evident in the small number of female legislators and doctors as compared with the Weimar Republic's record of employment. But there was something insidiously misogynistic about the refugee male intellectual. In Europe Karl Kraus, the mentor of many, idealized prostitutes as mindless priestesses of *amour* while referring contemptuously to the female journalists who watched as maimed soldiers died.

Refugee wives were often years younger than their husbands. This alone accounted for a certain social resilience, as did their apparent linguistic superiority: a man who taught English to refugees says the women invariably scored much higher on language exams. Refugee wives also acquired independence because they got jobs first. These, however, were often unappealing; many worked as domestics, baby-sitters, factory hands, or salesgirls. More fortunate women intellectuals found positions in schools and colleges or in social welfare agencies. But for the unmarried woman, life was not easy. In a rare such memoir, Erna Barschak expressed her resentment at being ostracized because she was single. She enjoyed the company of women; this was fortunate, since in the midwestern town where she taught, other social engagements were infrequent.

The women knew—from menial jobs, from trips to supermarkets, from PTA meetings—the requirements of American discourse. As a rule, they valued a direct and economical mode of expression, in contradiction to the often windy literary styles favored by their husbands. Even Hannah Arendt at her most discursive writes a prose of comparative simplicity when read beside that of her male mentors; indeed, a luminous prose is essential to her belief that all important issues can be discussed in terms accessible to the informed common reader. The husbands were advised of the need for a clear prose style by their students, who were quick to laugh at what they took to be Germanic muddle, and by their editors, who were merciless in their demands for simplification. But the women, with their greater exposure to American life, were always around to insist on making things plain. The editor Helen Wolff was amused recently when a colleague told her, "You really lay it on the line."

In the same way that emigration forced the male refugee to

reconsider his wife's talents, it also severely disturbed his traditional relationship with his children. Emigrés did not tend to overvalue childhood. Victims of household tyrants, they became autocrats themselves; Thomas Mann used to scold his youngest son, Michael, "Go under the table with the dog!" an insult the boy never forgot or forgave. Similarly, although they are now in their fifties, the children of an eminent scholar still feel damaged by his patronizing endearments, remembering such fond remarks as "Come here, my little *dummerchen*" (dummies). Americans, on the other hand, seemed to idealize their offspring, and exile had constructed a new myth of childbirth as liberation in exile. (The Erwin Piscator–Alfred Neumann adaptation of *War and Peace*, written in 1941, ends with Pierre, who has escaped from battle, cradling a small child: "I want to kill Napoleon and this holds me back . . . this sign and token of new life . . . worth as much as the emperor today, and more tomorrow . . .")

Becoming an American was a difficult and humiliating experience for the émigré father. Often he took his frustrations out on his wife and children. At best, he didn't always know what counsel to give. Brecht wrote of the time his daughter came home in tears after students had picked on her for being a German; while comforting her, he had to explain that their cruelty was politically correct. In another poem, he advised his son to avoid academic subjects, each one either compromised by capitalist and imperialist deployment or irrelevant to the émigré needs for food and shelter. Then, after a pause, he changed his mind: "Yes, learn mathematics . . . / Learn French, learn history."

The refugees' children were profoundly affected by the many changes in setting and direction. In their own adjustments to America, they often became ashamed of their parents' accent and appearance. Compared with their neighbors, refugee parents were often poorer, older, visibly peculiar. Or they might seem too cosmopolitan to their children, who envied the homogeneous conformity of their neighbors' homes. Many refugee children became top students, responding to the middle-class standards of their briefly impoverished parents. But as scholars

of assimilation, some virtually disowned their heritage, forgetting their childhood German or refusing to learn it; a trilingual child might become monolingual within a year of arrival. (Conversely, some children remained cocooned within the émigré community. Like little Adornos, they would forever be disappointed that the cultural standards of their parents' homes were not replicated in their schools and jobs.) A refugee father could well feel overtaken by his wife and rejected by his children.

But in all the refugees' future engagements with American culture and America—including their virtual dominance of some areas—there would remain a residual bafflement: What in the world were they doing here? There was also a perpetual self-consciousness, demonstrated in the standard question they would ask after hearing another émigré speak: "No, my accent isn't as bad as that?"

4

The Academic Welcome

Among the émigré's many unusual attributes was one of practical importance; he had marketable skills. Earlier immigrants had looked for jobs on farms and in factories, but the logical workplace for many of the émigrés was much more exalted in status: the academy. The reiteration of images, whether by Hitler or by the popular press, succeeded in establishing the émigrés as professorial figures, and for once the stereotypes aided them. Within a few years, American schoolchildren would refer casually to Einstein as the epitome of wisdom; it was from this that their playful "You're no Einstein" derived. In 1968 a compendium of scholarly articles defined the émigrés' move in its title as *The Intellectual Migration*. By then, the newcomers' conquest of the American academia appeared to be a glittering success story. But it took place in a context of unceasing disappointment and insecurity. Above all, professional advancement could hardly compensate for the knowledge that in Europe one's relatives remained in mortal danger.

Ironically, those who had first experienced Hitler's wrath benefited from their privileged position. The academics he booted out in 1933 were extended assistance and hospitality almost at once by American and British institutions; hence their

crossing was comparatively smooth. Although academic salaries were scandalously low, these professors fared better than the artists and writers—and, for that matter, the academics—who arrived later. Without institutional protection, these intellectuals often supported themselves initially with menial jobs, working as gardeners and dishwashers or, if strong enough, as stevedores and mechanics: one agency suggested to the newly arrived Hans Morgenthau that he get a job as an elevator operator; the composer Paul Dessau worked on a New Jersey chicken farm; the writer Walter Mehring became a warehouse foreman on Long Island; Heinrich Blücher shoveled chemicals in a New Jersey factory; Brecht's mistress Ruth Berlau tended bar. Others got low-paying jobs in German-language radio and journalism.

Many of the émigrés who arrived later never resumed their academic careers. Some found that their specialties did not transport well, for example, the lawyers trained in Roman law, who had to learn both the English language and the tradition of Anglo-Saxon law; many of these would never practice or teach law in the United States and wound up in fields as diverse as Egyptology and film direction. Worst off were those émigrés who had not completed their degrees in Europe and would be virtually prevented from doing so in America by the language barrier as well as lack of funds. The historian Toni Oelsner remembers, "I often ran around like a peddler [in pursuit of employment] but in most people's eyes, I was just a person with no Ph.D."

Participating in all the areas where expertise was valued, if not generously rewarded, such refugees became the epitomes of the "ach so" specialist—the pedantic pharmacist who might have been a *Privatdozent* in Freiburg, the hysterical piano teacher who almost launched a musical career in Vienna. By comparison with these foiled scholars, the most abused academic rested on a flowery bed of ease. These unfulfilled émigrés remained present in the academics' lives, as their friends, their relatives, the audiences for their lectures and publications. Hans Staudinger, the former dean of the New School, once said, "The great thing about the émigrés, the one thing they don't tell enough, is that we brought our audience with us." He didn't add

that the audience was composed of many people who were thwarted scholars and writers themselves.

One cannot make too fine a distinction between academics and nonacademic intellectuals and artists. They were products of the same generation; in some cases, they had been habitués of the same cafés. In Europe, as the best heirs of Goethe, the last universal man, they had constituted a society of polymaths. Einstein, for example, was an amateur musician. Once, at a party, he performed in a chamber group and requested Gregor Piatigorsky's assessment of his work; the cellist told the physicist, "You played *relatively* well." Arnold Schoenberg, the avatar of twelve-tone music, was also an accomplished painter and poet; after his arrival in America, he composed an English-language libretto. The painter Hans Hofmann had been a physics prodigy and was inspired in his work by Einstein's theory of the fourth dimension. The Austrian novelist Robert Musil was also an engineer and a philosopher, and another great Viennese writer, Hermann Broch, was a logician and amateur scientist.

This versatility obtained among many refugee academics; Helmuth Nathan, a professor of medicine and also a professional painter, and Hans Winterkorn, a professor of soil engineering who devoted his years of retirement to translating French symbolist poets, are representative of this group. So too are all the anonymous Heines who attended the concerts of Artur Schnabel, read the books of Thomas Mann, audited the lectures of Einstein, and on occasion contributed poems and *feuilleton* essays to the small journals that formed a part of exile literature.

It was therefore appropriate that many academics, particularly the younger ones, achieved reputations in the United States as generalists. The leapfrogging from one field to another that had compromised academic success abroad might work otherwise here. Peter Drucker believes that the ability to move among disciplines guaranteed his generation's success; this flexibility could also be practical, since if no position was open in one's chosen topic, one could teach several others. (Conversely,

Henry Pachter thought that his American career suffered because department chairmen didn't know where to place him.)

The polymaths' contribution to the American academy was evident in new disciplines, as well as in those that could incorporate new methods and procedures. In the social sciences, there was a particular welcome. It was customary for American graduate students in psychology and sociology to work abroad; after all, such influential figures as Talcott Parsons and Gordon Allport had studied or taught in Germany. If Hitler exiled nearly 43 percent of all German academics, he depleted the stock of social scientists even further—almost half, 47 percent, lost their positions and emigrated abroad. Such an extraordinary influx was bound to influence the American academy for decades: well into the 1970s, émigrés Karl Deutsch and Heinz Eulau in political science and Lewis Coser in sociology remained leaders of their disciplines, Eulau as president of the American Political Science Association and Coser as president of the American Sociological Association. Other émigrés helped import German ideas: Hans Gerth transmitted Max Weber's theories of social structure to American students.

Others acted almost as advance men for such diverse thinkers as existentialists and psychoanalysts. With eclectic grace Paul Tillich collapsed Nietzsche into theology and brought American churchmen the news that God was dead; he also cultivated a radical theology informed by his own participation in émigré politics and his friendships with the scholars of the Frankfurt school.* The fields of art history and musicology were invaded, if not invented, by émigré scholars. Musicologists joked that Arnold Schoenberg had made their discipline a viable one, the extreme difficulty of his theories having convinced American educators that anything so abstruse must be academically respectable.

Within the disciplines, new and old, there was considerable

* Finally, there were many scholars who continued their investigation of the European historical past. Among the products were Robert Kann's studies of the Hapsburg Empire, Fritz Stern's biography of the German Jewish banker Bleichröder, Peter Gay's analysis of Weimar Germany, and Henry Pachter's exegeses of the literary styles of German historians.

room for methodological disputes. Art historians instructed their American pupils in ways to understand form and symbol in Renaissance painting; Hans Hofmann's pleasure was to discover historical parallels in the procedures of artists separated by generations, if not by centuries. But the Bauhaus artists and architects abjured the study of history: a Walter Gropius and Josef Albers were simply too concerned with the requirements of the present, as embodied in whatever object was at hand.

Academics and artists alike recognized that their fierce debate over methods characterized their attitudes toward history and politics as well. Franz Neumann wrote, "The German scholar generally came under three intellectual influences: German idealism, Marxism, and historicism." He was "bred in the veneration of theory and history, and contempt for empiricism and pragmatism." Even a materialist philosophy like Marxism demanded that empirical data be broken down into the dialectical elements of thesis and antithesis; since these elements were frequently hidden, a method based on the objective treatment of reality might well also appear speculative. Clearly, refugee intellectuals were overburdened with method, and many happily discarded some of their scholarly apparatus. A professor of literature recalls, "How wonderful it was to simplify things. We Germans have this horrible trait of making green appear gold. This damnable love of paradox. It's just intellectual trickery, and you Americans cured us of it."

Maybe. Certainly there was an open reception for academics who shared the American affection for pragmatism. It was as if an old conflict between the Austrians—who considered Germans stuffy—and the Germans—who considered Austrians trifling—had been revived, with the result that some Austrian academics fared far better than their German colleagues. While the German historical economists floundered at the New School, the products of the eminently practical and procapitalist Austrian school of economics waltzed through industry and the university, notable members of this group being Joseph Schumpeter at Harvard and Ludwig von Mises at N.Y.U. The logical positivists, associated with the Vienna Circle and led by Rudolf Carnap, were quickly assimilated by American philosophers

who shared their pragmatic stance and curiosity about language. The Austrian Paul Lazarsfeld's close inspection of raw data helped make him a doyen of American sociology.

But there were naysayers. For them, pragmatism and empiricism provided the intellectual justification for the notion that "whatever is, is right." Long after his return to Germany, Theodor Adorno observed that in America "induction and deduction were the scientistic substitutes for dialectics." By definition, induction and deduction drew details toward or extracted them from conclusions, but only dialectics, by identifying the historical and economic forces that shaped the details, provided a social context. Adorno felt that American empirical sociology placed "emphases in all the wrong places." In its sleight-of-hand trickery with details, it revealed nothing but its own inadequate procedure—"a simple case of circularity." Adorno's friend Paul Tillich offered another topographical metaphor, writing, "Thinking here is horizontal not vertical"—an assertion that the American mindset was not even circular, just flat. The empirical method also was, to them, appallingly naïve: how was it possible to arrive at so-called objectivity by compiling lists of subjective responses?

All the while that the émigrés raged over procedure, they were being tempered by their students, for the American collegians were innocent of method. The contrast must have been shocking: adult debates by night, confrontations with the young by day. Academics were surprised at the switch in emphasis here. American colleges were "student-centered"; instead of required courses, students were allowed "electives." In Europe, the professor was king, but in democratic America, the students elected him. Not all émigrés liked this change. One historian, after forty years, still says, "They're so unequipped. I've never had one student from whom I learned a thing." Hannah Arendt was more approving: Hans Jonas remembers that she continually referred to her students as her "children." But friendliness could not dissolve the European formality. In one well-known story, Wolfgang Köhler is supposed to have told an American col-

league, "Why must you always address me as Professor Köhler? Why don't you just call me Dr. Köhler?" Wilhelm Reich was so correct that in his laboratory he would call his wife by her academic title.

Some émigrés became classroom scourges. One thinks of the City College (of New York) professor who opened each semester with the announcement that despite his Semitic-sounding name, "I am not a Jew." Or the celebrated tale of Bruno Bettelheim informing a student that her knitting was a symbol of masturbation and getting the reply, "You do it your way, I'll do it mine." Other émigré professors were less brittle. During his stay at Cornell, Vladimir Nabokov instructed his fascinated students to "caress the details." The émigré was offering them the gift of their own literature, distilled into "divine details." In a charming valedictory, Nabokov told his students, "The work with this group has been a particularly pleasant association between the fountain of my voice and a garden of ears—some open, others closed, many very receptive, a few merely ornamental, but all of them human and divine."

Nabokov was one of several émigrés who found themselves in isolated rural areas. In these settings, so unlike the agitated cities of their youth, they found a pleasing tranquillity; the peripatetic historian Hans Kohn loved the dignified New England atmosphere of Smith College, and his wife became celebrated for her baking. Some of these colleges subscribed to a quota sytem that limited the number of Jewish students; in other places, there were hardly any Jewish students at all. So in these schools, even more than in the Columbias or City Colleges, the émigré became the representative of European culture and, by virtue of his very presence, the embodiment of the refugee's plight. The difficult but rewarding old professor, with the charming wife who baked such beguiling cookies, knew that to his students he was a walking reminder of political realities. That he was an urbanite in rural surroundings, a Jew among Gentiles, someone whose most serious debates had occurred in forums to which his students had no access—all this was irony reserved for his private delectation. It is doubtful that the students did much to alter their professors, outside of correcting their grammar and simplifying

their discourse. But émigré scholars, merely by their presence on campus, contributed to the growing sophistication of their students. Fifty years earlier, the American upper classes had "come of age" abroad. Now, European educators came here to complete the education of young Americans.

Hitler's actions in 1933 did not faze his apologists in London or Washington, but the Assembly of the League of Nations was alarmed enough to create an Office of High Commission for the Refugees (its first director, Dr. James G. MacDonald, later became the first American ambassador to Israel). The PEN Club officially deplored Hitler's actions. In England and the United States, rescue groups sprang up, subsidized by Jewish organizations and directed by non-Jews, usually maverick intellectuals.

The earliest groups had the reasonable aim of placing émigré scholars in American institutions. But the 1930s did not provide a bullish market for Ph.D.s; thousands of American academics were unemployed and less than sympathetic to the jobless exiles. Nevertheless, the Emergency Committee in Aid of Displaced Foreign Scholars found positions in 145 schools and colleges for 288 displaced scholars; after a grant from the Rosenwald Foundation, an additional forty-seven professors acquired positions. In his memoir, the director Stephen Duggan recounted the refugees' work as archivists at the Library of Congress and New York Public Library in a happy use of their scholarly training. He cited the war efforts of physical scientists and social scientists in government programs, disproving the familiar charge that refugees made unreliable citizens. Duggan's is one of the happiest stories of emigration. As a clearing house rather than an agency of employment, the committee did not encounter the intramural difficulties of institutions with established political and philosophical identities. (Many other small groups offered assistance to refugee scholars. Among them were the Refugee Scholars' Fund and the American Council for Scholars, Artists and Writers.)

Some of the most productive work was done in academic settings specifically set up for refugee scholars. The problem was

whether such environments existed merely to rescue and employ an elite or to appropriate and exploit it. After their initial gratitude, the more suspicious émigrés were troubled by the implications of institutional employment. Except for the privately subsidized Institute of Social Research, all of the institutional settings for émigré scholars were founded by Americans (except in the case of Paul Lazarsfeld's Bureau of Applied Social Research, which was affiliated with a university).

In 1932 two eminent American educators, Abraham Flexner and Alvin Johnson, happened to be traveling in Germany. Both saw the same signs and received the same message. Back in America, they proceeded to act. At Princeton, Flexner, the first director of the Institute for Advanced Study, and an expert on universities, made plans for an ideal academy where scholars could work without pressure or administrative responsibilities. This was to be a community of Europeans and Americans, linking the sciences and the humanities. The art historian Erwin Panofsky and the archaeologist Ernst Herzfeld were early arrivals, and writers like Thomas Mann and Hermann Broch were later members of the institute. But Flexner's greatest catch was Albert Einstein, although the scientist's dealings with Flexner were not always amiable. Flexner's vaunted ideal transcended politics, but since the political climate was not neutral, the institute was not immune from inspection, and Einstein was disturbed by revelations of tie-ins with military research. His views may have been informed by Otto Nathan, a young refugee economist then lecturing at Princeton whom he met shortly after his arrival.

The institute was financially well endowed and beautifully situated. A less cloistered, more financially tenuous atmosphere was provided in New York City by Alvin Johnson at the New School for Social Research, which he had founded in 1919. Johnson was the classic *New Republic* liberal, a social activist though not a Marxist. His first action in response to the situation in Germany was to recruit Emil Lederer, an Austrian-born economist. From the hiring of one academic, Johnson leaped to the notion of establishing an entire graduate faculty of political and social science scholars. As a name, Johnson rejected both the

Faculty of Exiled Scholars and the New School Faculty of Polit-
ical Science before arriving at the inspired choice of University
in Exile. He intended to have a full faculty assembled by the
new division's first semester, which he planned for September
1933. As a one-man operation, he could circumvent the bureau-
cratic red tape that was stranding other scholars in Europe. By
hard, fast work and precisely conceived means of selection,
Johnson set out to gather a faculty that, unlike Flexner's, would
represent a specific ideology.

Johnson recruited men who shared his political and economic
concerns. In keeping with his activist but non-Marxist bent,
these colleagues tended to be Social Democrats, several of
whom—Arnold Brecht, Eduard Heimann, Hans Simons, Hans
Staudinger, Julius Hirsch—had been officials in the German
government. They were amused by the number of refugees who
had discovered themselves in transit to be fellow democrats. "In
Germany, they all condemned us; here, we heard that they had
always been democratic."

But the New Schoolers' political positions evoked suspicion
from American isolationists and those who sympathized with
Germany. In the mid-thirties, the editor of the *Jewish Daily
Forward* informed Staudinger and Johnson that German-
American Bundists and agents of the *Staatspolizei* had infil-
trated the student body and were spying on the former govern-
ment officials. Yet Johnson's plans for his school were eminently
patriotic.

Because Johnson recognized the risks to democracy posed by
unemployment, he hired labor specialists. These men were not
Marxists. Emil Lederer, before his death in 1939, published an
attack on Marxist economics, claiming that it had been super-
seded. Perhaps these scholars didn't envision a social revolution
because, as Hans Staudinger said, "We all knew about alienation
in work. After all, we'd seen the Social Democrats fail to con-
vince the workers of their class interests. We didn't expect con-
ditions to be more advanced in the U.S.!"

By the time Staudinger arrived in America, he had a history
of government activity. During the twenties he was a high offi-
cial in the economic, industrial and trade ministries of the Wei-

mar Republic. In 1932 he was elected to the Reichstag as a So-
cial Democrat. The Nazis arrested him even before Hitler as-
sumed power; his writings were included in the first book
burnings. After the intervention of Belgium's king, Staudinger
briefly moved to that country before emigrating to the United
States. In Germany, his charm and appearance—"I was *der Ro-
senkavalier*"—had been notable political assets, and they would
prove equally useful in an American academic setting. Stau-
dinger's social savvy and administrative talents were shared by
his wife, Else. For many years she directed the American Coun-
cil of Emigrés in the Professions.

Shortly after he arrived in 1934 and joined the faculty of the
New School, Staudinger was offered a good position in Turkey.
Johnson would not let him go: "If you leave, I will disband the
school. There will be *no deserters.*" Staudinger stayed, and
eventually became dean of the school. Johnson did not mind if
Hans Speier went to the Rand Corporation or Gerhard Colm to
the Bureau of the Budget; he had expected some of his faculty to
wind up in Washington. Nor was he upset when Karl Brandt
moved to Stamford, or Leo Strauss to Chicago: the New
School's loss was the American academy's gain. But to leave the
country was to sabotage the original scheme.

Johnson later wrote that he hoped to ease the refugees' assimi-
lation without forcing them to deny their cultural past. There
was little danger of this. When the Graduate Faculty (the new
name for the University in Exile) convened, its meetings would
begin in English, but as passions rose the vocabulary changed.
One time, an enraged Max Wertheimer leaped out of his seat,
addressing a colleague with *"Es ist nicht wahr"* (It is not so).
After attending a seminar, Kurt Wolff asked his wife, "Why
don't they talk in German?" Quickly reviewing their syntax and
abstract vocabulary, he said, "They're talking German any-
how." Americans associated with the New School enjoyed
helping the émigrés in their linguistic battles. When Hans Kohn
grasped at the air, seeking the correct English word, his students
would call out suggestions from around the room.

The economist Adolph Lowe and Staudinger organized the
Institute of World Affairs. Once again, know-nothings criticized

Johnson's scholars. He defended them against the right-wing Congressman Hamilton Fish; the institute would contribute "helpful research," like the earlier New School studies of labor. The institute did produce a series of books that were published by Oxford University Press, including some important studies of propaganda. Johnson was right again: the study of propaganda would join the study of unemployment as a refugee specialty, informed by earlier and more virulent experiences in Germany.

In 1940, after the fall of Dunkirk, a grant from the Rockefeller Foundation allowed Johnson to set up an extension of the New School for French émigrés. The Ecole Libre's faculty held themselves aloof from the German-speaking members of the Graduate Faculty—Staudinger remembers that "they thought of the New School as a German cabal." They awarded their own degrees, and made no secret of their wish to return to France as soon as the war ended. (This was not the case they put forth in print; French refugees wrote many articles in which they proclaimed gratitude and devotion to America.) Even those who would remain briefly in America, as Claude Lévi-Strauss did, didn't spend much time in the New School after the war.

In retrospect, Staudinger considered the New School's greatest intellectual contributions to be its studies of phenomenology and Gestalt psychology. (In fact, the opposition of American behaviorists made it difficult for Gestaltists to teach elsewhere.) He awarded equal place to the theatrical program directed by Erwin Piscator. Like that of another New School faculty member, the composer Hanns Eisler, Piscator's image was unambiguously leftist. But despite Piscator's legacy, the New School was stamped by Alvin Johnson's good-hearted, middle-of-the-road liberalism. (It was a sad but typical irony that even these politics would provoke attacks by "America First" supporters in the thirties and Cold War advocates in the fifties.) Of all the émigré academic groupings, the New School alone employed veterans of the political arena. These men, at least, could not be dismissed as marginals. But, paradoxically, the most famous school would wind up with the least solid identity. As if to reflect the pluralist style that New School academics applauded in American poli-

tics, the institution became a home base for numerous methods. It allowed a forum for such maverick academics as Hannah Arendt; her first and second husbands, Günther Anders and Heinrich Blücher; and Henry Pachter, not to mention the more traditional political scientist Hans Morgenthau and the sociologist Albert Salomon, as well as radicals like Piscator and conservatives like Leo Strauss. This variety, albeit illustrious, served to cancel out any dominant position other than that of liberal democracy. Yet, given the nature of Johnson's scheme, would it be fair or even possible to expect a more rigorous and coherent slant?

A third haven for émigrés provided just that, but—not incidentally—it had originated in Germany. This was the Institute of Social Research; it shared a nominal concern with the New School for Social Research, but in all other ways they were unalike. While the New School's faculty contained respectable veterans of the SPD and DDP, the institute's bent was Marxist, though of a special order. The members, being younger, ought to have found it easier to adjust to America, but despite the fact that the institute produced a series of important studies of American society, its members were never at ease with the life or the language; for years, they published a *Zeitschrift* (journal) in German, seeking a very fit audience though few.

The institute had been formed in Frankfurt under the direction of the sociologist Max Horkheimer. From the start, it attracted leftist scholars and writers, including Walter Benjamin and Paul Tillich, with an anomalous combination of abstruse speculation, rooted as much in the works of Marx's philosophical ancestors as in that of Marx himself, and a fascination with psychoanalysis and vanguard art. These were the concerns of many young Germans; in Berlin cafés, one spoke endlessly of the links between the arcane and the demotic. But the Frankfurt scholars alternated between scholarly argument and belles-lettristic impressionism, sometimes incorporating both in one work, or, as in the case of Theodor Adorno, one paragraph.

They also stood apart on questions of philosophy. Their Marxist heritage was evident in their scorn for logical positivism's aspiration to the precision of mathematics and abandon-

ment of metaphysical speculation. To the Frankfurt scholars, this was not a clarification, but an obfuscation; as early as 1931, Adorno noted that the new "nominalism"—concern with isolated data—of sociologists nullified the entire concept of class.

But despite their vaunted interest in class relations, the Frankfurters were maverick radicals. They managed to employ Marxist theories and methods without accepting Marxist goals and conclusions. Thus they could make lengthy and detailed analyses of the follies of capitalist production and distribution without suggesting any political alternative: the perception by many other German radicals that the Soviet Union was the incarnation of historical synthesis struck them as unwitting and vulgar Marxism—in fact, Adorno once observed that philosophy must continue its wearying course because its historical moment of realization had already passed by. One of Adorno's mentors, Siegfried Kracauer, later observed that "Teddy's" dialectical darts and turns produced "social concepts . . . too wide to be able to characterize any social reality."

This obsession with method partnered with the rejection of goals—as if an atheist had become the most wily manipulator of Christian apologetics—struck observers as variously brilliant, melancholy, impractical, and finicky. More politically active émigrés grumbled that complaints that were not grounded in practical politics were intellectual gymnastics. Such leftists referred to the institute's offices as "Café Max" in honor of its director, or, more mercilessly, as "Grand Hotel Abgrund" (Abyss).

In Germany and America, the Frankfurters benefited from investments and donations. Herbert Marcuse recalled Horkheimer himself as having been a "financial wizard," although in Germany Horkheimer had already complained to a student, "The whole world is clinging to me." The institute's members included the sons of rich fathers; the *haut bourgeois* income of a Friedrich Pollock subsidized the mandarin Marxism of an Adorno. One supporter, Dr. Felix Weil, may have been the group's most ardent Marxist. He was a longtime patron of George Grosz, and Grosz's friend and old Dadaist colleague Wieland Herzfelde still insists that Weil was the group's only

true radical. Herzfelde still recalls Weil's father, Hermann, an Argentine wheat dealer, who donated food supplies to the Soviet Union during its early days. The other Frankfurters he dismisses as "haughty dilettantes" and "inhuman wise-crackers. . . . They called themselves the Institut für Sozialforschung [Social Research]. I call them the Institut für Sozialfälschung [Social Falsehood]."

The institute had its enemies in Germany and few friends after its move to America in 1934. Yet thanks to the subsidies from people like Weil, the institute is said to have aided as many as two hundred scholars in the United States, although the members have also been accused of having played favorites and of being ungenerous to the philosopher Ernst Bloch, whose singular blend of Marxism and Judaism presaged a religious mood that was evident in their later work. Despite its isolation, the men associated with the institute became at least as illustrious as the New School's faculty; included among them were the legal scholar Otto Kirchheimer, Marcuse, Leo Lowenthal, Erich Fromm, Horkheimer, and, particularly, Adorno.

Theodor Wiesengrund Adorno (he chose to go by his mother's name, some said to hide his Jewish origins) was the most versatile scholar—a student of philosophy, sociology, literature, and music—as well as the best writer. His style signaled the breakdown of barriers between art and the academy. He could be overpoweringly theoretical, which was enough to exhaust most readers, and then pirouette whimsically around a subject he had just examined with pedantic rigor. His colleagues in Frankfurt had treated him as special, a fragile membrane of consciousness enclosing a protean intellect. Happily, he discovered in Horkheimer both a patron and a guardian. His students, however, experienced a less delicate creature. One prominent publisher says, "I am famous for not criticizing anyone. But Adorno was horrible, horrible," rolling his *h*'s and *r*'s with vehemence. "He was arrogant, affected. He was such a German; he made everything so complicated. He would translate the simplest things into this metalanguage, and sit back enjoying our confusion." Adorno later admitted his early arrogance. He combined a youthful dandyism—he is recalled as having been an

excellent dancer—with the avant-gardist's conceit that he has pride of access to the spirit of the age. Later his solace would be that he, and very few others, understood the nature of the Oppressor: he went down among those waving the flag of negation. There would seem to be no temperament less suited to America, but he became a relentless observer of its culture. (See chapters 6 and 8.)

In 1934 Nicholas Murray Butler of Columbia University offered the institute office space. Though other members had arrived earlier, Horkheimer and Adorno were the undisputed leaders. At first their American work focused on European topics. In an essay entitled "The Jews and Europe" Horkheimer argued that to understand Fascism one must understand capitalism. He later omitted the essay from his collected works. (Karl August Wittfogel claims that the institute discovered "Fascism as an object of critical rejection only in America"!) Members of the institute gave occasional classes and contributed essays to the collections put together by other refugees, but they preferred to isolate themselves, both from Americans and from their fellow émigrés. In 1936, for example, they published in German *Studien über Autorität und Familie*, which at times employed American methods of empirical research to arrive at the generalized conclusion that the bourgeois family was susceptible, within and without, to authoritarian manipulation.

Lurking beneath the philosophical disagreements were diametrically opposed conceptions of the kind of work possible in emigration. While the sociologist Karl Mannheim's intellectual presence colored the attitudes of New Schoolers, the Frankfurters defined themselves as critical theorists. (In Frankfurt, Horkheimer and Adorno had attended group discussions with Mannheim and Adolph Lowe.) Mannheim's "sociology of knowledge" took as its subjective center a "free-floating intellectual" who soared above ideology in his pursuit of knowledge; the emphasis of this method was on eclecticism and pluralism. It also happened to prefigure the gadfly circumstances of emigration. As such, it appealed to the New School's liberal democrats, with their Alvin Johnson–mandated interest in the immediately practical. But Adorno and company found Mannheim's sociol-

ogy "reflective" (meditative and quietist) where it should have been "critical" (theoretically alert). Adorno heaped scorn on Mannheim's affirmations of consensus and assimilation: "This materialism akin to that of the family head who considers it utterly impossible for his offspring to have a new thought, since everything has already been thought, and hence recommends that he concentrate on earning a respectable living."

Similarly, Adorno's recoil from American methods intersected with his discovery that in the "super-trust" of American life, "the intellectual from abroad . . . will have to erase himself." This émigré could assert himself only by not "coming to terms with the world." Resistance to power therefore meant a disdain for the empiricism that consisted in defining the world in the world's own terms. Years later, in Germany, when even Horkheimer would capitulate and employ empirical research without apology, Adorno still stood firm against "the dogged description of what is."

There were further differences. While the New School attended to practical matters like unemployment and propaganda and émigré sociologists like Paul Lazarsfeld sacrificed any concern with "quality" in "empirical analyses" of subjective responses, art had pride of place in the Frankfurter pantheon. These scholars harked back to Goethe and Schiller in their insistence on art's social relevance, but they also spoke in terms that managed to be simultaneously transcendent (art offered *une promesse de bonheur*, though not here or now) and dialectical (throughout history, art had incarnated the spirit of protest). Now more than ever, art's purpose was to "negate" or "contradict" the dominant values of capitalist society. Not overtly, however: Adorno loathed agitprop—art's revolutionary role was "to resist by its form alone the cause of the world"— and the calculated use of popular forms. Siding with the masses did not require one to assume their bad taste. Since popular art was chirpily affirmative, Adorno called for an art of supreme difficulty: by his lights, kitsch was almost fascistic, and the introduction of the pretty was tantamount to a political sellout.

Compared with the other institutes' procedure, this all sounded abstract and elitist. Adorno and Horkheimer always

disavowed such descriptions: they claimed to oppose a nostalgia for high art and attacked mass culture only because they considered it to be a vehicle of social injustice. Perhaps Adorno's contemptuous dismissal of what the people liked and his promotion of the most difficult avant-gardists, from Schoenberg to Samuel Beckett, were merely aesthetic responses. But he prefaced a late essay on his idol Schoenberg with this quote from Keats: "Heard melodies are sweet, but those unheard are sweeter." In the same way that Keats swooned to "ditties of no tone," Adorno demanded a music in which the listener had to fill the silences with an almost preternatural consciousness. This time around the ditties were atonal in a way Keats could not anticipate, but Adorno's response was firmly in the romantic tradition.

Another aid in resisting assimilation was language. The Frankfurters preferred to write in German because they found its precise grammar more suited to philosophical speculation. And even more, by nourishing the spirit of German *Kultur* as incarnated in its language, they anticipated the rebirth of the language in postwar Germany; theirs was not the behavior of men who intended to stay here. Paul Lazarsfeld, among others, attacked their hermetic approach to language, enraging the institute leaders. For them, it was precisely language that distinguished them from the New School's "consensus" prose or Lazarsfeld's commercial discourse. Horkheimer wrote, "That the German intellectuals don't need long to change to a foreign language as soon as their own bars them from a sizable readership, comes from the fact that the language already serves them more in the struggle for existence than as an expression of truth." This attack condemns refugees attempting to reach an American audience, and dismisses both English itself as a vehicle of "truth" as well as an English-speaking audience capable of perceiving that truth. Thus it is not difficult to apply to the institute's members the Frankfurt scholar Ernst Bloch's distinction between the artists who armored themselves in the émigré community's traditions and those who chose to step out and become Americans. ("They were isolated," Hans Staudinger said. "We were *not* isolated." But he admitted that the Frankfurters'

return to Germany after the war—and their subsequent considerable success there—may have been partly motivated by their sense of being isolated in America.)

After World War II, Columbia University's Bureau of Applied Social Research offered to integrate the institute into its own structure in a department founded and directed by Paul Lazarsfeld, the Frankfurters' old friend and colleague. Horkheimer refused. He spoke of the "freedom in our institute." In a subtle dig at Lazarsfeld, he declared himself "not responsible to big business or to mass-culture publicity." So philosophy, language, and commerce all prevented the Frankfurt school from joining forces with their fellow refugees.

Yet precisely this abstinence allowed them to look around with a clear-eyed focus. Perhaps they lacked peripheral vision, that awareness of cultural subtleties vouchsafed only to participants, but, seen in retrospect, the concerns of the institute can be said to have been prophetic. Their studies of religious prejudice, the decline of the family unit, and popular culture helped turn these subjects into refugee-academic specialties. Of the three institutes nominally devoted to social research, the isolated Frankfurters produced the most noteworthy work.

Thus, the greatest contributions to American education may have come from men who viewed America with continual fear and loathing. In part this was due to their Marxist suspicion of capitalist society, although in America their radicalism was guarded and literally academic. For example, the Frankfurters' *Zeitschrift* reprinted in German a revised version of "The Work of Art in the Era of Mechanical Reproduction," an article written by Adorno's mentor Walter Benjamin. In the original text, Benjamin ended with the following description: "This is the situation of politics which Fascism is rendering aesthetic. Communism responds by politicizing art." The *Zeitschrift* substituted "the totalitarian doctrine" for "Fascism" and "the constructive forces of mankind" for "Communism," a nebulous misrepresentation of Benjamin's statement. (Benjamin had other editorial problems with Adorno, who argued that in proclaiming the political uses of art, Benjamin, like Brecht, made too much of revolutionary techniques while ignoring the market forces that

would render them commercial and harmless. Perhaps so, but there was something grotesque about the metapolitical Adorno lecturing Benjamin and Brecht on procedure when at that time the latter two stood in immediate physical danger for broadcasting such "vulgar Marxism" in Hitler's Europe. Benjamin wrote that Adorno's criticism made him feel "as if the ground was giving way under my feet.")

Trotskyist, Stalinist, even liberal journals would have been more direct. The journal was published in German, and its readership was minute; so why were the editors so cautious? The tampering with Benjamin's text, which was a mere scholarly footnote, exemplifies the paranoia shared by many refugees. As late as 1944, Horkheimer was unsure whether Americans had much sympathy for radical émigrés. He worried about the responses to "a bunch of foreign-born intellectuals sticking their noses into the private affairs of American workers."

Yet, in the same year the institute discovered the advantage of speaking out. With its writings on the effects of Fascism, at home and in Europe, the institute finally began to reach an American audience. And also in 1944 it offered a series of well-attended lectures on National Socialism by Pollock, Marcuse, Kirchheimer, and Leo Lowenthal. The last, drawing on the studies of Bruno Bettelheim (which have since been greatly disputed), argued that Fascism produced something similar to a psychological collapse in the inmates of concentration camps—an analysis that paralleled the Frankfurters' bleak view of mass culture and its lobotomizing effect on the public.

That year Horkheimer and his colleagues began a series of studies on prejudice, subsidized by the American Jewish Committee. Bertolt Brecht, when he first heard of the project, predicted that his fellow émigrés would ignore the connections between anti-Semitism and capitalism; Adorno replied that Marx's class analysis was out of date. Brecht found the argument self-serving; he wondered whether the AJC sponsors would tolerate any Marxist interpretations. The impudent playwright knew a thing or two. For while the studies incorporated the latest techniques in data tabulation and psychoanalytic exegesis, they also managed to avoid the important questions of social

structure and class analysis and played down the fact that anti-Semitism and Red-baiting tended to be twin buds of the same noxious plant.* There was another, more intimate, émigré subtext to the argument. In the 1930s Brecht had suggested in a parable-play that rich Jews were disposed to making deals with the Nazis at the expense of poor workers, Jewish and Aryan alike. This would appear outrageous were it not for its partial validity: some Jewish heads of German banks had donated heavily to Hitler's political campaign.

Brecht thought that the institute's research project was fundamentally designed to reflect the values of their institutional sponsors and, by extension, the political and economic systems that provided funds for their work. Since the Frankfurters were subtle explicators of the materialist origins of all forms of expression, it is surprising that they didn't see how close in form, if not procedure, they were to other subsidized academics. The archcynic Brecht would have told them that when you're poor, there's hardly any money too dirty to touch.

The institute's studies employed notable scholars: Bruno Bettelheim (*Dynamics of Prejudice*), Marie Jahoda (*Anti-Semitism and Emotional Disorder*), and Paul Massing (*Rehearsal for Destruction*). Of these three, only Massing was part of Horkheimer's group. Jahoda was the former wife of Paul Lazarsfeld; and later, she was his colleague at Columbia's Bureau of Applied Social Research.

The most famous of the studies was *The Authoritarian Personality* (1950), written by a group of scholars headed by Adorno. This study introduced the F-scale, an ostensibly precise tool for measuring fascistic tendencies based on a series of responses that ranged from aesthetic tastes to racial prejudice and political conservatism. In recent years, the procedure has been attacked as a dubious use of statistics; ironically, it looked back to the empirical methodology of the 1936 German-language studies on authoritarianism and the family. Adorno

* Or, conversely, that anti-Semitism had also appeared in Europe as an adjunct of anti-capitalism—as what August Bebel had called "the socialism of fools."

himself later admitted that the book was overly long and at times circuitous in argument. He was also saddened to give up "the most searching and original lines" of investigation—for instance, his beloved correlation of authoritarian traits and a dislike of modern art was unverifiable, since the majority of his subjects had never been exposed to high culture. Adorno was astonished to discover that the "good," conventional youngster was freest of aggressive tendencies. Of course, the realization that they shared many attributes of rage and pessimism with authoritarian types had long been the despair of émigré intellectuals.

Perhaps the most poignant of the studies of prejudice in relation to the émigrés' history was *Prophets of Deceit* (1949), an analysis of American demagogues coauthored by Leo Lowenthal, the institute's resident critic of American literary styles, and Norbert Guterman. The work describes the rabble-rousers' assaults on Jews, radicals, émigrés—on all those, in fact, who are not native-born white Christians. The most depressing passages, in view of the émigrés' experiences, describe some Americans' perceptions of refugees as being variously "distasteful," "a subrace," and irreconcilable to the American way of life. The work itself pays more homage to the terms of European alienation than to the facts of American history. Economics is almost invisible; psychoanalysis prevails.

Curiously, the advocates of intellectual resistance had committed their energies to what amounted to bourgeois propaganda. Leo Lowenthal says the studies were planned as a "political pedagogical mass inoculation program, a 'fire brigade,' as Americans say." Whether in accord with their sponsors' wishes or in despair at the lack of sophistication of their American audience, the Frankfurters traded in their complex exegeses for blunter assertions; initially they had even planned a series of pamphlets "in a popular format." The irony, as Lowenthal admits, was that anti-Semitism had never been their primary interest. In fact, they found something distasteful about airing a "family matter" in public. When they analyzed the cause of their emigration in public, they sounded like mainstream American liberals. Rather than welcome the accusation of "irreconcilability"—for this quality was perhaps their finest and

surely their most authentic characteristic, at least in light of crit-
ical theory—the Frankfurters wrote as if all sensible readers
shared their respect for the famous bourgeois tolerance of differ-
ences, a posture that their colleague Herbert Marcuse would
eventually regard as hollow (see chapter 19). Almost predict-
ably, Lowenthal later went on to a stint as research director at
the Voice of America.

Paul Lazarsfeld, the future director of the Bureau of Applied
Social Research, arrived in America in 1933, five years earlier
than Adorno. The two men had been *Wunderkinder* together in
Europe—only three years separated them in age—and Lazars-
feld gave Adorno an early job in America. But the two were
often at odds. Lazarsfeld regarded European sociology as over-
weighted with speculative theory; he interpreted data; he fa-
vored the adjective "applied." To Adorno, that adjective defined
the difference between the kinds of social research he and La-
zarsfeld were engaged in. Applied by whom? For what? As
Walter Benjamin would say, "To whom is this technique use-
ful?" These were the questions of a critical theorist. To an ap-
plied researcher, they appeared to be distractions, introduced
from another world of discourse. Lazarsfeld quotes as an exam-
ple of Adorno's aestheticized formulations, his description of mu-
sical responses: "Sometimes music has the effect of freeing
hidden sexual desires. This seems to be the case particularly
with women, who regard music as a sort of image of their male
partner, to which they yield without ever identifying them-
selves with the music." Unfortunately, there is a tradition be-
hind this kind of sexist speculation, and Lazarsfeld was right to
object to it in sociology.

 In a private letter to Adorno, Lazarsfeld made their differ-
ences even plainer. Adorno might call other people "neurotics"
and "fetishists," but he exhibited his own fetishism by sprin-
kling his text with words in Latin, even though Lazarsfeld had
implored him to use "more responsible language." Adorno's ar-
rogance provoked Lazarsfeld's harshest remark: "You and I
agree upon the superiority of some parts of your intellectual

work, but you think because you are basically right somewhere you are right everywhere. Whereas I think that because you are right somewhere you overlook the fact that you are terrible in other respects, and the final reader will think that because you are outrageous in some part of your work where he can easily catch you, you are impossible altogether." This is an almost unanswerable criticism of the cavalier approach of writers who combine brilliant insights and "outrageous" errors with the implicit assumption that the reader must work out just where they are "right" and where they are "terrible."

Lazarsfeld had too good an eye for his audience to commit Adorno's errors. Yet he was not without Teutonic arrogance. In a memoir he quoted an early letter from an American friend, who had informed him, "People don't feel safe with you . . . you are too grand at all times and never sufficiently modest. . . ." He admitted that "in the first years, I was rather rude to assistants and students, barking at them when they fell down on assignments," but joked, "I like to think I changed my behavior at the same time as I learned to eat with the fork in the right hand." Adorno would doubtless have found such humor self-demeaning.

Lazarsfeld actively wooed an audience. He was a novelty created by emigration: a product of refined European learning who hustled himself a position in the marketplace. In Austria, he had been a disciple of Alfred Adler, the most sociological of Freud's followers. In 1930, a few years after receiving his doctorate, Lazarsfeld volunteered his services to an American group in Vienna that wished "to promote the use of applied psychology among business." From 1930 to 1931, he and his colleagues collaborated on what might have been the first survey of radio listeners. In the course of these studies he noticed a divergence in class tastes. In later years he devised three possible methods of sociological analysis: the first listed the number and characteristics of the particular study's subjects; the second noted how and when they behaved as they did; and the third explored their motivations. A synthesis of these approaches would supposedly reveal what kind of people listened to what kind of programs for what kind of reasons—the commercial applications were evi-

dent. For example, Lazarsfeld gave two dubious interpretations of why working-class consumers preferred sweet chocolates and strong perfumes while wealthy customers did not: a psychological one, suggesting that they were starved for pleasure, and a sociological (and dialectical) one, postulating that the rich did not need blatant displays to denote their "sensual wealth."

In 1935, two years after his arrival, in an article written with Arthur Kornhauser, Lazarsfeld told American businessmen that he was providing a means by which "to forecast and control consumer behavior . . . a systematic view of how people's marketing behavior is motivated." Defending his method against criticisms that the explorations necessary would be endless, he wrote, "The explorer must know far more of the country than the spot where he pitches his tent." By sorting out "special causes in the external situation," one could arrive at "natural expressions of desire." The implicit assumption was that these could then be exploited to the sponsor's benefit. The Frankfurters could not have asked for clearer confirmation that the "natural" was programmed and that, even in its desiring, the id was unfree.

Lazarsfeld was unperturbed by such criticism. He accommodated easily to American styles. Lacking an English title for an early study of applied research, he came upon the florists' ad that contained the line "Say It with Flowers"; his book, greatly expanded by his colleague Hans Zeisel, appeared as *Say It with Figures* (1947). Similarly, his fellow Austrian Oskar Morganstern named his consulting business Mathematics Inc., a craftily American locution implying that the most abstract discipline can be converted into a capitalist tool. One of Adorno's more gnomic remarks was, "Only those thoughts are true which fail to understand themselves." For Lazarsfeld and Morganstern, abstract thought had no problem making itself understood. With Viennese whimsy, they asserted that figures can talk and incorporate themselves.

After early work for the University of Newark, under the presidency of Frank Kingdon, Lazarsfeld became the first director of the Office of Radio Research, a bureau subsidized by the

Rockefellers. First established at Princeton, the office moved in 1939 to Columbia, where Lazarsfeld spent the rest of his academic career. He employed some prominent scholars: his wife, the psychologist Herta Herzog; the sociologist and comparative literature specialist Leo Lowenthal; and Adorno, among others. Addressing the National Association of Broadcasters in 1941, Lazarsfeld made it clear that "communications research" into the responses of listeners who doubled as potential consumers was now a "joint enterprise between industries and universities" from which business had little to fear. Allow us the occasional criticism by intellectuals, he said, and we will find ways of "making criticism more useful and manageable." In the name of objectivity, Lazarsfeld wanted to institutionalize his research and so remove any residual "emotionalism." The critical and positivist schools of sociology were now explicitly divorced, and Lazarsfeld did not look back. He became director of Columbia University's Bureau of Applied Social Research, an institute that had evolved from the Rockefeller radio project. There he turned his methods to marketable use by surveying listening habits for advertising agencies and sponsors.

At that time, the involvement of universities in contract work was highly controversial. Lazarsfeld acknowledged his critics. Some felt that students of market research would become "mercenaries" and abandon problems that were not adaptable to "research machinery"; on a more personal and basically irrelevant level, it was contended that nonconformists would not prosper in such institutional surroundings or would somehow be corrupted.

Lazarsfeld's impersonal criticism of his own procedure exemplified the style of what he dubbed the "institution man." In this new émigré locution, "institution" does not connote conformity. Almost like an American version of Musil's man without qualities, this fellow is "a marginal man who is part of two different cultures. . . . According to his gifts and external circumstances he may become a revolutionary, a surrealist, a criminal. In some cases his marginality may become the driving force for institutional efforts." Instead of submitting to the paradoxes of his di-

vided condition, he exploits them. The institution, so to speak, sets him free; in Lazarsfeld's case, both sponsor and donor benefited from the "institutional innovation." This is a witty, if disingenuous, apology for manipulating the needs of consumers. But it also explains why Lazarsfeld could see the deficiencies of his own "institutional system," since as a marginal figure he remained not quite part of it, ready to hop back into the other culture to join those who despised his positivist mutterings.

Lazarsfeld's sense of shifting allegiances informed all his work. In 1954 he wrote, "Occasionally the citizen forms an alliance with the industry against the government; occasionally with the government against the industry; occasionally he finds himself faced with an alliance between the government and industry." Members of the Frankfurt school, such as Herbert Marcuse, would condone only the third possibility. Lazarsfeld chose to remain the "institution man," converting his revolutionary tendencies into the reporting of cycles and voting habits. Thanks largely to his work, mechanical systems of observation could chart everything from voting preferences to tastes in mouthwash and deodorant. At the same time, his emphasis on procedure and decontextualizing of behavior came under attack from refugees of both Right—such as Leo Strauss—and Left.

Hans Zeisel worked on some of Lazarsfeld's early studies before becoming the acknowledged expert on the American judiciary system. In a recent letter to *The New York Times* attacking the proponents of capital punishment, Zeisel explicitly criticized their methods of quantification, as if to say that the games won by numbers were not worth winning. Lazarsfeld has also been attacked in some quarters for the way his American partner Bernard Berelson used the data resulting from "value-free" mathematical models to support elitist and antidemocratic statements. In both instances, saying it with figures was not applauded. At times, Lazarsfeld anticipated his critics. In 1954 the Ford Foundation Program on Economic Development and Administration funded the Lazarsfeld analysis "Some Reflections on Business: Consumer and Manager." Lazarsfeld, in his report, acknowledged that sociologists are not supposed to side with

either element, although their research tends to enrich their managerial sponsors at the consumers' expense. He is almost comically detached, granting that some may find his studies "socially dangerous," exploitative or demagogic. With an Olympian objectivity that makes him almost invisible, he wonders whether future historians will approve of the methods he has refined. He even imagines that a "politico-economic power elite" of managers and bureaucrats will destroy American democracy, armed no doubt with poll results and television ratings.

In 1957 Adorno, writing in Germany, observed that "the better-paid office-boss has replaced the scholar; the lack of intelligence is not only celebrated as the virtue of the unassuming well-adjusted team-member but is institutionalized in the structure of the research process, which recognizes individual spontaneity only as a coefficient of friction." One couldn't ask for a more total indictment of Lazarsfeld's approach—personal history colors Adorno's generalizations—or of the dangers accompanying institutional sponsorship. After over twenty years in America, the forces controlling the academic Establishment had reduced the émigré scholar to two unacceptable options: the free-floating intellectual and the institution man.

Lazarsfeld's self-presentation can be read as a document for the prosecution. It shows that measuring the links between voting preferences and consumers' tastes provides a rationale for what Adorno would call their administration; the application of research made the sociologist a bureaucrat in the service of Adorno's Oppressor. Political democracy today is widely regarded as having been cheapened, if not ruined, by its association with the strategies of mass-marketing. So the Adorno-Lazarsfeld conflict was more than a refugee dialogue. America provided the setting, the occasion, and the content; if Adorno was right, Lazarsfeld's ascendancy prefigured the decline of American democracy. Yet perhaps only a refugee would have achieved the peripheral stance of an institution man. Certainly only a refugee intellectual could have seen the market researcher as a brother to the revolutionary and the surrealist or appre-

5

Left and Right

"We had two things to do," an émigré recalls. "Start a new life and rescue those we had left behind." Mastering American customs and earning an American salary may have been difficult, but they were nothing compared with the urgency and frustration of the second task. Emigrés were not overwhelmed with support. Leading American Jews—including Bernard Baruch, the most prominent businessman, and Walter Lippmann, the most influential journalist—would have preferred that they seek asylum elsewhere, in part because they feared that the refugees' presence would inspire an outbreak of native anti-Semitism. Many Americans, educated or not, feared the professional competition represented by a battalion of multiply skilled émigrés; their versatility made them even more threatening. By January 1941 the Social Security Board reported that some employers refused to hire not only noncitizens but also the children and even the grandchildren of foreigners. Right-wingers discerned the familiar figures of political menace, Zionist conspirators and "foreign-born radicals." The Left, at least, rallied for a time to the émigrés' support, but after the Molotov–Von Ribbentrop nonaggression pact of August 1939, American Communists began to describe the refugees' vehement anti-Fascism as part of

their imperialist politics. Abandoned by the Left, and condemned by the Right, the émigrés realized that the job of rescue had been largely left to them.

Since most intellectuals had never expected much help from the America of Wall Street and the Ku Klux Klan, they rallied together for their compatriots' sake. This made for strange associations, conjoining people of widely opposed positions, although the more timid understood the dangers of "fellow-traveling," even in a common cause. The academics, with the most achieved and the most to ose, were often circumspect. In internecine squabbles during the 1930s, some scholars accused others of being insufficiently anti-Fascist: one unforgiving émigré still asserts, "They just couldn't give up those damned summer vacations in Europe." But a number of academics involved themselves in politics too, albeit on a rarefied, scholarly plane.

The Committee of 15, brough together by William Alan Nielson, the president of Smith College, was comprised of American educators like Lewis Mumford and Van Wyck Brooks, and notable émigrés like Albert Einstein, Thomas Mann, the Italian political figures Salvemini and Borgese, and the historian Hans Kohn, who taught at Smith. In 1940 they released a statement which stressed that "the outlawing of war is and remains the next step in the progress of man." Its authors knew that their "next step" was nowhere in sight. Still, this was an attempt by influential émigrés to reach their American peers, employing a modest, low-keyed style and the language of civilized scholars drinking sherry at the Faculty Club. And in an era when no political stand was uncontroversial, the committee's unexceptional position was attacked as a devious new form of warmongering. After August 1939, during the period of the Molotov–Von Ribbentrop pact, Hans Kohn had many run-ins with academic Stalinists, who opposed any verbal attacks on the Soviet Union's peace-loving ally.

Emigrés who ventured into more public circles found themselves caught in a tug-of-war between the American left and right wings that didn't involve them but, in many instances, would haunt them for years. (See chapter 17.) Several refugees

appeared on the mastheads of organizations—some of them Communist fronts—without understanding the political nature of these groups. The famous men may have felt that the fight against Fascism was larger than any sectarian squabble. In any event, there were few right-wingers, except for the Catholic monarchists,* and they were counterbalanced by the American Guild for Cultural Freedom, directed by the liberal Austrian Catholic Prince Hubertus zu Löwenstein, Thomas Mann, and the New School's Alvin Johnson.

In the thirties, a period during which reactionaries depicted President Roosevelt as being a Soviet agent, outspoken émigrés were often subjected to right-wing attacks. *The Saturday Evening Post* and *The American Magazine*, echoing the line of Ambassador William Bullitt, published articles that declared "liberal refugees" were really fifth columnists. (Bullitt's excessive fear of radicals may have had some connection with his earlier, ill-fated marriage to Louise Bryant.) *The Saturday Review of Literature*, however, offered a series defending the émigrés and anticipating with excitement their impact on the country. ("What America means to them will be important for us to know," wrote Henry Seidel Canby in 1940. As a sign of fellow-feeling, the New York *Herald Tribune* published a weekly column, "Where Are They Now?")

The Red-baiting forced Alvin Johnson and Frank Kingdon to proclaim publicly that they were opposed equally to Communism and Fascism. Yet fellow-traveling was almost unavoidable if one opposed Fascism. Up to August 1939, Marxist organizations were the most aggressively anti-Fascist groups. The Exiled Writers' Committee was one Communist-affiliated group; since more conventional institutions would not assist the politically unorthodox, it provided Mexican transit visas that enabled many radicals stranded in Europe to reach the United States. On June 5, 1939, *The New York Times* covered a conference of

* Heinrich Brüning, the former German chancellor, taught from 1937 to 1952 at Harvard, maintaining a strict silence about the Nazis. In the early forties, reporters discovered a link connecting Brüning, right-wing businessmen, and Vatican representatives.

the American Writers' Congress at the New School. The head-
line read EXILES' WOES MOVE WRITERS' CONFERENCE: MANY
LISTENERS WEEP; the subhead was AUDIENCE STANDS WITH
BOWED HEADS AS NAMES OF 45 WHO WERE KILLED ARE READ.
This list, which included the names of seven Americans who
had been killed in the Spanish Civil War, was read by Langston
Hughes; years later, Hughes would disown his participation in
all such Communist fronts. The conference passed a resolution
calling for "international solidarity" and stressing the need to
take Hitler "seriously"—harmless, if conventional, Communist
Party rhetoric.

The conference speakers lectured on liberal themes. Kenneth
Burke analyzed Hitler's appeal to crowds, a topic that had ab-
sorbed émigré students of popular culture for almost a decade;
Malcolm Cowley observed cheerfully that New York had be-
come the "cultural center of the world," thanks largely to the
émigrés' arrival. A note of cultural loss was sounded by the
working-class novelist Oskar Maria Graf when he said, "We
naïvely believed that the great work of our culture could not be
tainted and disfigured." The pathos of refugee life was evoked
by the writers Ludwig Renn ("The strangest of new profes-
sions, bringing forth both excellent possibilities and great dan-
gers") and Erich Franzen ("The worst thing an exile has to fear
is the feeling of belonging nowhere and being of no use at all. . . .
He realizes that he does not understand the functioning of a sin-
gle social or cultural unit.") Manfred George, editor of *Aufbau*,
pleaded for solidarity: "We must stand together, regardless of
our shades of belief," something that would prove impossible
two months later, after the Molotov–von Ribbentrop pact.

The conference closed after a series of resolutions had passed
supporting work-relief and art projects, calling for future associ-
ation with Negro authors, and condemning a list of celebrated
anti-Semites that included J. Edgar Hoover, Father Charles
Coughlin, Congressman Martin Dies, and Fritz Kuhn. Donald
Ogden Stewart, the doyen of Hollywood radicals, was voted
president, and the list of vice-presidents included Langston
Hughes, Ernest Hemingway, and John Steinbeck. *Natürlich*,
Thomas Mann was declared honorary president.

The political groups formed by left-wing refugees were small and isolated. Separated from American radicals by the language barrier, they were despised by German-Americans. (French-Americans welcomed their compatriots, but then, their country had already been defeated.) The émigré may have brought this on in part by lording himself over the natives, priding himself on his culture, perhaps on his economic class; but one cannot gainsay the widespread German-American support for Hitler.

The radical refugee may have differed with his more conservative fellow in politics, but, to one observer, Hannes Schmidt, they both shared an exalted sense of their own experience. "With the words *Ich bin ein Emigrant*, he sets himself above everyone else and no one contradicts him. . . . He speaks of unity and means his own party and its hangers-on." Radical politics for some did mean a rehearsal of old Weimar debates, sometimes with the same cast, always in the same language. In Weimar Germany, politics had been a full-time interest, generating summer camps and social clubs. Similar organizations began here. Once again, calisthenics do-si-doed with group discussions; as before, physical fitness became an ancillary to proper politics. Today, a few German socialist summer camps survive in communal houses, rented by old leftists. Their summer trips seem as much an homage to their youth in Germany as to their youthful radicalism.

The German groups reconstituted in this country were as disputatious as ever. The Communists dismissed the Social Democrats as "reformists," and the Social Democrats remained adamant against cooperation with "Stalinists." The Social Democrats' journal, *Neue Volks-Zeitung*, was edited by Gerhart Seger from 1936 until its demise in 1959, by which time most of the leading SPDers had returned to Germany.

Refugee Communists were required by law to disguise their allegiances, but they worked closely with native radicals and left-wing unionists. A leading group was the Deutsch-Amerikanischer-Kulturverband (DAKV), yet another organization graced by Thomas Mann as honorary chairman. After Hitler

invaded the Soviet Union, the DAKV's shift from pacifism
to interventionism was predictable. World War II was
the era of Stalin's popular front, and by 1942 the DAKV
had joined numerous other labor organizations in supporting
a German-American Emergency Committee whose journal,
German-American, published the writings of such prominent
Communists as Gerhardt Eisler.

Overanxious right-wing refugees beheld Communist agents
everywhere. Rudolf Brandl, the former editor of *Aufbau*, fired
off privately printed salvos, warning that the paper had been
corrupted by its new editor, Manfred George, and his fellow-
traveling brother-in-law, Oskar Maria Graf. (Graf was indis-
criminate; a friend recalls him as a man who would call everyone
"Comrade.") During the war years, a social worker named Ruth
Fischer distributed sheets attacking her radical brothers, Ger-
hardt and Hanns Eisler, outside refugee meeting halls; later, she
proclaimed her accusations in the Hearst press and before Con-
gress.

The humanist center and non-Marxist Left had been horri-
fied by the Molotov–Von Ribbentrop pact. Thomas and Klaus
Mann withdrew from the front-group German-American Writ-
ers' Association (presided over by Oskar Maria Graf) in re-
sponse to the group's party line that Germany and the Soviet
Union were allied in opposition to the "militarist imperialist"
powers, Great Britain and France. Some devout fellow-travelers
could not countenance what they regarded as a stab in the back:
Karl August Wittfogel remembers Hanns Eisler raging that
Stalin was as bad as Hitler, and one of Brecht's friends admits
that the playwright was bitterly unhappy in the Soviet Union
when he had to curb his statements on anti-Fascism during the
pact's duration. Klaus Mann wrote, "In our circles, the neces-
sary agreement in most political principles and goals is ... no
longer present." It would not be until Hitler's invasion of the
Soviet Union. And some émigré radicals would find it impossi-
ble ever to forgive the Soviet Union for the series of betrayals
that culminated in the pact with Hitler.

These groups achieved very little outside of nurturing hopes
during a time when émigré radicals were battered on all sides.

Certainly they had no effect on internal events in Germany. During World War II, the well-publicized Council for a Democratic Germany was based in Mexico City, chaired by Paul Tillich, but actually led by Alexander Andersch, an old Berlin Dadaist colleague of the Herzfelde brothers. Tillich's chairmanship signaled that disparate members of the German Left could still associate with one another, and Mexico's extension of hospitality to refugee Marxists, in combination with the identification by many radicals, such as Brecht, with the council, made this work easier. But for all their insistence on a still-vital opposition to Hitler,* the council members were as astonished as anyone else by the 1944 generals' conspiracy against him; obviously, they would have preferred a workers' revolt.

New Beginnings, a very small group, had an influence that far exceeded its numbers. In Germany its leader, Karl Frank, alias Paul Hagen, had advocated a united grouping of all workers' organizations, not excluding the KPD. (For such catholicity he was later accused by Ruth Fischer of "crypto-communism," and was denied an exit visa.) Frank's group had only three hundred members in Germany in 1934 and far fewer here after his arrival in 1939, despite some attention for its journal, *In Re: Germany.* New Beginnings had no clout or special access to information. But perhaps the most productive action to come out of émigré intramural politics was the final emergency rescue effort, which Frank initiated by contacting Varian Fry in June 1940 after the German invasion of France.

On the East Coast, the fear of fifth columnists predictably led to the targeting of émigré radicals. The government arrested five hundred illegal aliens on May 18, 1941. The left-wing congressman Vito Marcantonio of New York City leaped to their defense. On a June 12 broadcast, he railed against the assault on workers and noncitizens. "There shall be no Gestapo in America!" he announced, condemning the Hobbes Concentra-

* There had been an unsuccessful generals' rebellion in 1938, following the resignation of General Ludwig Beck, chief of the German general staff.

tion Camp Act, with its provisions for detention of nondeportable aliens and for denying them trial by jury. He found American precedents for such mistreatment by citing the Alien and Sedition Acts of 1798. But he also spoke the current line, attacking those agitators who would lure "freedom and peace-loving Americans" into "an imperialist war." Ten days later, after Germany's invasion of the Soviet Union, the line would change.

Meanwhile, outside New York, other émigrés organized efforts to rescue their fellow professionals. Some of the most productive activity occurred in Hollywood, where, by the late thirties, the émigré colony was large and thriving. In popular mythology, the accented film director—"Zis vay, dollink! Schmile vor ze kemmera"—had become a new symbol of exile. At first, the Hollywood émigrés clustered together, bound by a common past and present, both fraught with fears: many, like Billy Wilder, would lose their families in concentration camps. There was also a common sophistication that was matched only by the best wits in Hollywood, and crossed with a gallows humor the émigré had special claim to. And the obsession with good food—and with political satire—as they dined at Joe May's restaurant, the Blue Danube, as they partied at Friedrich Hollaender's cabaret, the Tingel-Tangel Revue, was endless. In such places, the constant topic was the condition of those stranded in Europe.

A very few gathered with the right-wingers at the home of the wealthy Lady Elsie Mendl—Otto Preminger dubbed these "the FBI group." The real salon was Salka Viertel's Maberry Road cottage, the one place in Hollywood, an émigré remembers, "with comfortable armchairs." Here Karl Kraus's old friend was joined by the same group of left-wing bohemian filmmakers and writers that had come together at the Romanische Café. Here they could vent their annoyance with a city where "winners of the Beautiful Bust contest" had a ticket to stardom, while émigré artists begged for work. And, as in Berlin, connections were easily made between a shallow popular culture and Fascism.

Through a series of probably fortuitous events, right-wing

congressmen were able to attack the works of German directors who were then actively engaged in emergency rescue efforts. In the mind-boggling summer of 1939—when the nonaggression pact had robbed the émigrés of their most vocal national defender, the Soviet Union—congressmen took after the directors William Dieterle and Fritz Lang. To Hollywood émigrés, it must have seemed a double betrayal.

Dieterle, a German Gentile, had arrived in America in 1930. Although he was not a refugee, he identified with them. His films weren't masterpieces, but, like Fred Zinnemann, he managed to merge entertainment and good intentions. His *Juarez* is regarded as the first sympathetic film portrait of Hispanic-Americans. At the end of *Blockade,* a Dieterle film about the Spanish Civil War, Henry Fonda gave a cry that appeared sentimental to cynics but rang true to all refugees: "Where is the conscience of the world?"

In his first American films, Fritz Lang attempted to examine the underside of American life without falling into the ethnocentric trap of drawing resemblances to German society. *Fury* (1936) is a study of mob violence set in a small town. The setting is captured with all its meanness of spirit: as Klaus Mann observed, "perhaps one must come from the outside to see so clearly."

In the first scene, the town barber says, "In this country, people don't land in jail without committing a crime"—a veiled reference to Europe, where they did. In later scenes, a rabble-rouser recites the familiar litany of "law and order" to justify mob violence, but there neither law nor order is to be found. The National Guard is called off by politicians. Spencer Tracy, wrongly accused of murder, is trapped in a burning prison. In a striking expressionist scene, Lang juxtaposed two women standing by the fire; one glows with maniacal pleasure, the other prays. Lang knew that both piety and sadism were representative, banal responses, equally useless to the beleaguered Tracy.

During a trial scene in the film, the district attorney attacks nativist bigotry and mob justice, saying, "the mob is the destroyer of government ... American democracy is on trial here

... be guided by your patriotism." When the sheriff blames the victimization of Tracy on "outsiders," the D.A. responds, "Aha ... *foreigners or redskins.*" As an émigré radical, Lang must have directed the scene with particular involvement. And he heaped cinematic scorn on the American mass media throughout the film. A radio announcer gleefully reports the courtroom panic, then pauses for a commercial; a movie newsreel displays the headline 22 FACE DEATH. Karl Kraus could not have mounted a more savage attack. At the end, Tracy admits that as he escaped from the jailhouse fire, "a belief in justice, ... a feeling that this country of mine was different ... was buried." The subsequent rebirth of his faith is not convincing; Tracy's decent kid brother, his lachrymose fiancée, and one straight D.A. cannot compensate for a community of know-nothings and the amoral media.

Two years later, a congressional hearing would conclude that Lang's bitter indictment of the American legal system contained "Communist propaganda."

In a political age, the Hollywood émigrés found themselves in political situations. While few were more than *salon gauchistes,* most had no qualms about working again with Marxists to combat Fascism, as they had in Europe. But Red-baiting was abroad in the studios, and the refugees found themselves forced to choose between quietism and fellow-traveling. The problem was that if one chose the first, one might be able to live in America, but one couldn't live with oneself. Prince Hubertus zu Löwenstein moved the anti-Nazi league he had formed in the East to Hollywood. As always, Salka Viertel proved a dedicated organizer for such efforts. But Ernst Lubitsch, disillusioned by an earlier journey to Moscow, told her he would have no contact with anything smacking of a Communist front. She pleaded with him: after all, the Catholic prince was no Red, and the Popular Front needed help from all quarters. Lubitsch refused. But refugees supported the prince, as did such Hollywood leftists as Donald Ogden Stewart, Dorothy Parker, Anita Loos, and S. N. Behrman.

In the summer of 1939, Congressman Martin Dies waged the first attack on Hollywood radicals. He discovered Communist propaganda in three films, Lang's *Fury* and Dieterle's *Juarez* and *Blockade*. And so it evolved that the earliest assault on the movie industry focused on émigrés. Hollywood panicked. The agent Leland Hayward forced his star client, Greta Garbo, to withdraw from a picture with a plot involving the Resistance. FBI men began checking up on suspicious refugees. Naturally, they interviewed Salka Viertel about the doings of "you people." "Whom do you mean by 'you people'?" she exploded. "The refugees? They were the first victims of the Nazi horror, the first enemies of Hitler." She could have spoken in German for the impression she made.

A few courageous people, mostly women, refused to be intimidated by such snooping. Liesl Frank, the daughter of the musical comedy star Fritzi Massary (the very name sounds defiantly Middle European) and wife of the novelist and scenarist Bruno Frank, joined forces with Charlotte Dieterle, wife of William, in founding the European Film Fund. Refugee film workers pledged 1 percent of their weekly earnings to support their unemployed brothers and sisters. Frank and Dieterle also helped bring to Hollywood the last batch of refugee writers to leave Marseilles and Lisbon in 1940 and 1941. The agent Paul Kohner was their spokesman in dealings with the studios; he approached Jack Warner and L. B. Mayer, playing on their Jewish loyalties.

As a result, the Hollywood studios took on a slew of refugee writers, salaried at a hundred dollars per week. These émigrés included Heinrich Mann, Alfred Döblin, Leonhard Frank, and Walter Mehring—men who had been traipsing over the Pyrenees hills barely days before. No wonder that they were dizzied by the leap to Hollywood, or that, given the suddenness of their move, these men—who were totally untrained in the craft of film writing—would have no impact in Hollywood. Their California years were to be miserable.

For the moment, though, they were safe. In March 1941 Heinrich Mann celebrated his seventieth birthday at Salka Viertel's home. Among the guests were several with Hollywood

contracts—Alfred Neumann, Alfred Polgar, Döblin, and Mehring—but they came that night as men of letters honoring Germany's greatest literary family. After dinner, Thomas Mann rose and in formal tones addressed a fifteen-page speech to his brother, commending him for his political foresight. The reference was not lost on that audience; almost thirty years earlier, Thomas had extolled German spirit and poetry, criticizing the soulless rhetoric of Europe, while Heinrich had been a devout Francophile. Scarcely had Thomas finished when Heinrich stood up and delivered his own lengthy essay on "Thomas's continuous fight against Fascism." Afterward, Bruno Frank informed Viertel that the same occasion occurred every ten years. With all respect to the Mann brothers, the guests were more than ready for Salka's chocolate cake.

The language, the sentiments, the history, even the comedy was European. In the same way that the events within seemed removed from their proper time and place, the house itself provided a brief oasis of safety from what was waiting without: the most American of cities, there to welcome, threaten, and disappoint its guests. And somewhere else, in a position too horrible to contemplate, were all the writers and artists who had not made the final flight to safety.

Nine months later, America found itself at war with Adolf Hitler. Emigrés responded passionately; the momentary conjunction of American interests and their own made patriots of the lot. The war effort enlisted the efforts of refugees representing many political positions. Klaus Mann and Hans Habe both served as privates in the U.S. Army, while Franz Neumann and Herbert Marcuse toiled at the OSS, where they helped train several younger scholars, foreign and native. H. Stuart Hughes, who worked under them, considers this time to have been "a second graduate education" at the government's expense. He recalls the Americans' "gentle teasing" of their elders for their old-world manners and Teutonic prose; he doesn't believe the émigré scholars had much to do with actual operational procedure.

The Office of War Information allowed other refugee writers

to work in "psychological warfare," a concept often credited to the Austro-Hungarian Hans Habe. (Habe's postwar conservatism might have been predicted from his novel, *Three Across the Frontier*, published in 1937, in which religious and German nationalist ideals counter a Marxist, internationalist ideology.) Habe's co-workers at OWI were a mixed crew; they included André Breton, the French surrealist; Walter Mehring, the Berlin Dadaist; Leo Lania, the author of a popular leftist drama of the twenties; and Joseph Wechsberg, the international gourmet.

Familiar feuds and alliances remained potent in this new setting. Henry Pachter recalled that his branch of the OSS was staffed by refugee Communists and Socialists. The Stalinists had no interest in sabotaging the war effort—in fact, they were if anything too zealous—but at least one émigré, Brecht's mistress Ruth Berlau, lost her OWI job when the government discovered her Communist ties. Only a very few émigrés did not think it fitting for radicals to serve capitalist governments in any form. A friend remembers Brecht condemning Marcuse's work for the OSS.

For many months, it was unclear whether the Allies would prevail. By 1942 Hitler commanded all of Europe from the English Channel in the west to the gates of Moscow and Stalingrad in the east, from Norway's North Cape to Sicily in the Mediterranean; North Africa and the Middle East were also under his sway. There was no guarantee that the devastated Soviet and the inexperienced American armies could defeat him. In the summer of 1942 a cable sent from Switzerland by Gerhard Riegner informed the world of Hitler's mass murders of Jews. It was months before either the Allied governments or American Jewish leaders appeared to take the news seriously. Meanwhile, as noncitizens, émigrés were officially defined as "enemy aliens." For a year in California, they were subject to nighttime curfews, and they had been threatened with mass evacuations. Even worse, the detention of Japanese-American citizens reminded them that concentration camps were an American reality. Why shouldn't they be detained next, in a California version of the French internment camp at Gurs?

Radicals had special grounds for alarm. In 1936 John Strachey, an Englishman, had been deported for teaching Marxist economics. In 1940 the American Civil Liberties Union ousted the Communist Elizabeth Gurley Flynn from its national board of directors and passed a resolution barring any advocates of a "totalitarian society" from serving on its board; the resolution proved to be a forerunner of the postwar loyalty oaths. In 1941 in the New York State Legislature, the Rapp-Coudert committee's probe into Communist Party infiltration of CCNY led to friendly witnesses identifying colleagues and the subsequent dismissal of at least fifty teachers. Emigré academics knew how to read these signs. Henry Pachter, shortly after his arrival in 1941, was asked by government investigators to identify émigré radicals. Though Pachter had been an ardent Communist in his youth, he was later disillusioned by Stalin's excesses. Still, he refused to inform: "They wanted me to betray my comrades!"

That same year, after the first of the Smith Act trials (in which people were accused of conspiring to overthrow the government by force) the United States jailed an American Trotskyist leader, James P. Cannon, largely for his principled support of the Soviet Union. Many émigrés had dallied with Trotskyism during the thirties, perhaps because they perceived a congruence of perspectives between Trotsky and Rosa Luxemburg. (Henry Pachter once joked, with considerable exaggeration, "Wasn't every Trotskyist a refugee?") The abandonment of American radicals, particularly by the powerful and unpredictable Stalinists, did not bode well for émigrés with independent opinions.

After the war began, the Stalinists themselves leapfrogged over to conventional displays of "Popular Front" patriotism. The Party opposed wartime strikes, applauded the Smith Act trials of 1941 to 1943 (aimed as they frequently were at Trotskyists), dismissed civil rights struggle in the United States and anti-imperialist efforts in the colonies as Nazi-inspired diversionary tactics, and momentarily altered the language of class warfare. Emigrés remembered how in Communist Party jargon an "imperialist war" had only turned "freedom loving" after the

German invasion of the Soviet Union. It would later become clear that the Russians had made little attempt to warn their Jewish citizens of the dangers of a Nazi invasion. Although the first massacres of Jews occurred in the Soviet Union, the Soviet government has never acknowledged the particular victimization of Jews. They were entitled to suspect that their situation remained of minimal interest to either the Right or the Left.

While in December 1942, a United Nations declaration denounced the atrocities committed against the Jewish people, several U.S. officials declared the message too strident. In February 1943 Breckinridge Long, the same government official who had helped make emigration so difficult a few years earlier, asked U.S. officials not to accept or transmit any further messages like the one from Gerhard Riegner. Men like Long contended that the Jewish question was a sideshow, incidental to the war with Hitler. (This was an argument also waged from the Left by Trotskyists, who argued that the murders of Jews, though terrible, were not sufficient justification for workers to fight an "interimperialist" war. Even the Council for a Democratic Germany maintained silence on the Jewish question; they had been kicked out of Germany as radicals, not Jews, and they continued to oppose Hitler as radicals, not Jews.)

In Great Britain and the United States, government officials warned Jews that any prolongation of the war effort simply to rescue their people would induce a virulently new form of postwar anti-Semitism, and a fair number of prominent Jews believed them. Perhaps for this reason, American Jewish leaders were not always impassioned defenders of the European martyrs. Subject to a universal indifference, refugees persisted in believing their lone advocate was Roosevelt. Yet the president's failure to set up the Wartime Refugee Board until January 1944 could be seen as ultimate evidence that a war that had claimed Jews as its first victims had rendered them politically negligible. "I never trusted their crocodile tears," says one man about the occasional Allied declarations of sympathy for the Jews. "The plain fact is that since nobody knew what to do with us, we were expendable."

Meanwhile, there were frequent reports of war profiteering in

the United States. The government sweetened industry's involvement through refundable corporate taxes. A great many Americans were getting rich off the war, while émigrés wondered whether Hitler would win, whether their families would be rescued, whether their political allegiances left them vulnerable to prosecution, whether as "enemy aliens" they had a home anywhere.

PART TWO
Europe in America

6

New Opiates of the People

The émigrés' political experiences, not to mention the cultural legacy of Berlin, Frankfurt, and Vienna, had made the refugees alert to signals and gifted at interpretation. Their irrepressible curiosity and questioning temperaments proved to be salutary, both psychologically (giving hard lives a bracing edge) and economically (providing a means of employment). For, in one of the more exorbitant occupational demands placed on immigrants, some of them were expected to comprehend a new culture and, with barely any breathing time, make sense of it for the natives. As if theirs were a generation of Tocquevilles, they found themselves employed as professional explainers. And with an exile's combination of craft, cunning, and chutzpah, they set to work.

While they were still trying to learn the language, refugees were hired to observe American society at its most idiomatic and to analyze its most inarticulate citizens. By the late thirties, a group of young people, led by Paul Lazarsfeld, was engaged in pioneer studies of radio broadcasting. A similar curiosity had been demonstrated ten years earlier in Berlin. Veterans of that era, invoking the continuum between high and low culture, recalled as representative figures Walter Benjamin and Dolly

Haas—a philosopher and a soubrette. The Berliners had been preoccupied with technology and its novelty products: movies, phonograph records, photomontages, radio, typography. Popular culture provided them with both sensual pleasures and political insight. By contrast, the émigré students of American culture came to their work as curious outsiders or salaried employees, not as enthusiasts; these were not, in the American idiom, "fans."

Yet as social research became an émigré specialty, the refugees found themselves employing methods developed in Europe to interpret uniquely American phenomena. This twist alone confirmed Brecht's witty remark: "Refugees are the keenest dialecticians. They are refugees as a result of changes, and their sole object of study is change. They are able to deduce the greatest events from the smallest sampling—that is, if they have intelligence." The spectacle of intellectuals writing about pop trivia provided a fine kind of dialectical amusement in itself, as if the BBC's first and third programs had crossed wires.

"But it's only a movie!" was the famous reply to an émigré critic's deconstruction of an American film. The point was, however, that to these émigrés the study was not merely about movies. It was, as Franz Schoenberner noted, about audiences. And émigrés were horrified about what mass culture did to the American audience: Lazarsfeld wrote that some believed that "jazz and the radio daytime serials were 'opiates of the people.' " The bebopper, the jitterbugger, the housewife listening to her soap operas might seem innocuous figures, but the émigré critics contended that their satisfactions were not innocent ones. The fans had become mindless zombies, emotionally immature and politically ignorant. Where others simply saw a bunch of deluded enthusiasts, émigrés saw an audience ripe for Fascist dictatorship.

The more objective researchers—Herta Herzog, Rudolf Arnheim, Lazarsfeld—relied on systematic testing procedures, statistics, and itemized questionnaires. The members of the Frankfurt school employed a more impressionistic vocabulary. They were defiantly European in their analyses of American culture: Adorno used Freudian terms like "sado-masochism"

and "castration" to describe jazz fans; Leo Lowenthal saw his
subject as being something between "a mutilated child" and "a
standardized man"; Horkheimer said that pop culture had
cheated man of his chance at original life. And they all shared
Benjamin's conviction that a critic's task was "to uphold the in-
terest of the public against the public itself . . ."

The émigrés' analysis exposed their own peculiar position be-
tween cultures, European and American, high and low. Brecht's
remarks could be applied two ways: the change that was the ref-
ugees' sole object of study was a permutation that embraced
them as well. Thus, years after his return to Germany, Friedrich
Pollock of the Frankfurt Institute of Social Research could
question the whole study of mass communications. His analysis
acknowledged "the significance of minority groups in the shap-
ing of majority opinion." In other words, the outsider, the Jew,
the avant-garde artist or radical was recognized as an architect of
the mass sensibility. But in a system preoccupied with sheer size
and numerical distribution, the vanguard figure would become
invisible. Pollock was really saying "There is no room for me"
in *mass* communications.

And then, too, who were the members of this mass? Oppo-
nents of the empirical approach argued that mere data revealed
very little about the mass's inner lives. The empiricists nimbly
turned the argument on its head: while the Frankfurters leaped
at objective generalizations, the Lazarsfeld disciples dismissed
their findings as uninformed fantasies. Dissolving the theoretical
apparatus revealed that the Frankfurter "subjectivity" was still
subjectivity.

Both sides agreed that whatever was commonly understood as
subjective—emotional, intuitive, extrarational—led a restricted
life in America. Despite a national mythology that exalted "rug-
ged individualism," émigrés discovered the principal focus of
psychological and emotional responses not in American males
but in "the women's world," a ghetto of cheap melodramas and
soap operas. That affairs of the heart had become "mushy love
stuff" suitable only for benighted housewives baffled Europe-
ans who had been reared on Goethe, Balzac, and Stendhal. The
sparse affective life left to the individual had been isolated for

commercial exploitation. The poor American housewife had been entrusted with the only emotional life that late capitalism would allow the public. By yet another accident of emigration, she would find her advocate in refugee critics of popular culture.

On a Sunday evening in 1938, the Mercury Theater aired Orson Welles's radio adaptation of H. G. Wells's *War of the Worlds* in the form of a simulated music program interrupted by a broadcast announcing a Martian invasion. The resulting pandemonium baffled researchers. How could people believe such nonsense? Frank Stanton, later president of CBS but then its research director, asked Lazarsfeld to investigate. Lazarsfeld's associate and second wife, Herta Herzog, wrote a memorandum, "Why Did People Believe in the 'Invasion from Mars,'" concentrating on women listeners. This is a study of psychological discontent that was manifested in social attitudes that a refugee might well have considered proto-Fascist.

Herzog asked the appropriate Lazarsfeldian questions: When did the listeners tune in? What made the radio program convincing? She alluded to radio's penchant for the "scoop," suggesting that listeners were prepared to accept anything if it was offered in this familiar form.

In analyzing the listeners' responses, she discovered that many women were reluctant to acknowledge their fantasies. Some were religious fundamentalists, convinced that they were living in the last days: for them, the invasion might be Armageddon or the rapture and the pointy-headed Martians seraphim in disguise. Others derived a sense of importance from the coming apocalypse, or felt released from internal prohibitions, though the one example of orgiastic indulgence was the consumption of leftovers. (It is truly a world of boundless tedium where a Martian invasion allows one to raid the icebox.) Some paranoids projected their personal worries on the community. A few sadists relished the vision of people "drowning like rats" and "dying like flies."

None exhibited common sense, perhaps because each woman responded to the event as the enactment of a unique, individual

fantasy, experienced, after all, in the privacy of her home. Only one-third of those whom Herzog questioned checked with the radio station to find out if this was a real newscast. The rest enjoyed a state of mindless terror. Herzog demonstrated "how great the danger is that a state of panic distorts our rational thinking"; she could as well be showing the unhappy impact of news turned into entertainment and broadcast for the listener's personal delectation.

In 1930, a Chicago schoolteacher named Irna Phillips created the first soap opera, titled appropriately "Painted Dreams." As a form of storytelling, the "soaps" seemed to combine the world of folklore—old wives' tales—and popular melodrama. Yet, no matter how puerile the genre was, its success was undeniable. By the late 30s over sixty serials were being broadcast daily on the radio; here was a new aesthetic form for which, like jazz, Americans could take credit. Paul Lazarsfeld hired other émigré scholars to make sense of the soap operas. By 1939 Herta Herzog, assisted by Theodor Adorno, was working on a study, "On Borrowed Experience," which was later published in the Frankfurt school's English-language journal. In 1941 Rudolf Arnheim produced a seminal study of the serials' content and the audience's response. (It says something about the divergence of the Lazarsfelds from their colleagues that within ten years Adorno and Arnheim had established themselves as giants of the academy, while Herta Herzog had become the director of an advertising agency.)

Listeners told Herzog of the benefits they derived from serials, but this might have been the familiar case of interviewees trying to tell researchers what they want to hear. At that time, radio actors affected a mannered diction, as if they were all graduates of an elocution school, while most of the listeners were uneducated, working-class people; thus, when the listeners commended the serials for helping them learn "grammar and English," refugees, with their own linguistic problems, must have sympathized. But when the listeners indicated that they turned to serials for advice on living, the researchers became

alarmed. Herzog concluded that serial writers should have "the awareness of a great social responsibility." Rudolf Arnheim had the bold notion that serials could emulate Schiller's *Don Carlos*, in which individuals appeared as "representatives of a common cause."

It was undoubtedly unfair for Arnheim to expect from soap operas a historical sense that nighttime radio seldom exhibited. But his comments go beyond Herzog's in his analysis of the social implications of the serials. He notes that little people in soap operas triumph over the representatives of "wealth and society," but that theirs is a pyrrhic victory, since they do not assume real power; the same forces remain, in new guises, to threaten them. "Life is not conceived from the point of view of a community"; the individual is isolated, but the enemies, as in all paranoid fantasies, have the force of thousands. Bad people "impersonate not only personal adversaries . . . but also the anonymous forces of politics and economics."

A major failing of all vulgar responses, Arnheim observes, is that they are ad hominem rather than ad hoc: the serial preoccupation with psychological detail would ultimately lead to "calling Hitler a villain and having the matter settled over that . . . overlooking the historical and political causes of the phenomenon by considering it just a case of personal badness." Here, Arnheim provides the most lucid demonstration of how serials could act as an "opiate of the people," dulling their political awareness. The other conclusions of Herzog, Adorno, Arnheim, and Lazarsfeld are now well-known facts: that in serials of the early 1940s, men cause the problems while women provide the solutions; that only bad people have extramarital sex; that the sanitized world of the daytime serial is populated almost exclusively by small-town Anglo-Saxons; that the conventional virtues of family and motherhood are stressed at the expense of career or public power. In other words, the soaps promulgated a world with which émigrés had nothing in common; Adorno later referred to "the idiotic women's serial."

But for all the merits of the studies, Herzog, Adorno, and Arnheim missed some crucial elements. In 1941 the most popu-

lar soap operas were the creations of Irna Phillips. Had the researchers concentrated on these more carefully, many of their conclusions would have required revision. Phillips's serials all took place in a big city—Chicago—and often involved ethnic types—Jews, Irish, Italians, and Germans—though immigrant parents spoke Pidgin English and their children sounded like radio announcers. Phillips's ethnic mix was startling enough, but her storylines were downright subversive, especially when considered within the context of Arnheim's finding that serials affirmed the basic family ties, or, even more, within the context of the studies of Adorno and Horkheimer, which described the family as the last redoubt of protection for the individual under late capitalism.

As if to summon émigré critics, Phillips strode a Freudian tightrope. In her "Road of Life" (its theme was a passage from Tschaikovsky's "Symphony Pathétique"—pathos announcing bathos; how Adorno must have enjoyed that!), a doctor was shot in the hand by his brother and—shades of castration—became afraid that he would never perform surgery again. Phillips's most famous creation, "The Guiding Light," was by 1941 a mess of Oedipal intrigues. Ned, a foundling raised by a minister, (who was the program's eponymous guiding light), spent years worrying about his genetic background. To confirm his paranoia, he discovered that his mother had murdered his father so that he would not learn that they were both criminals: after this drop in psychological and social status, Ned suffered a breakdown. Meanwhile, a working-class girl, Rose, had an illegitimate baby by a married man, a wealthy publisher, but gave the infant up for adoption. When she learned that the child had somehow been adopted by his own father, Rose sued for custody and won, but the child died. She then became a governess to the daughter of Edward, a man married to an insane woman, Norma, whose mother had tried to prevent an operation on Norma's diseased brain. The operation was a success, but Norma died of other causes; at which point Edward's daughter began to suspect Edward of murdering her mother. Parent-child relations remained tenuous in later years, as the serial told of Claire, a spinster who decided to leave home and her mother's domination. She

adopted a child and then unwittingly married the baby's real father. This disgruntled fellow, upon learning the truth, divorced his wife and sued her for custody of his son.

By 1949 Irna Phillips had become the doyenne of television serials. Today, her approach is the norm, subject to extensive parody, but in the early forties, in the respectable trappings of radio drama—the funereal organ accompaniment, the meticulous diction—her serials had a more insidious effect than any of the émigrés recognized. The individual was isolated, as they had discerned, but in a world where sibling rivalry and mother phobia were rampant. There was no tribal protection: any family member could be a sexual rival or physical threat.

As a form of storytelling, the soap opera related obliquely to the émigrés' lives at a time when melodrama was the norm. Arnheim noted the diffuse form: in Irna Phillips's "Right to Happiness," one group of characters would appear, suffer, and then withdraw for several episodes while at least two other groups would enact virtually discrete storylines. So existences that had been fragmented into fifteen-minute episodes were further atomized, denied the minimal continuity of linear sequence. How disturbed the émigrés must have been by the implicit assumption that personal tragedy could be so casually and passively engaged; life could not be beautiful in the dystopia of painted dreams.

Irna Phillips and Theodor Adorno make a remarkable pair, not least because they were both Jews: the American Jew was constructing a fantasy for the European Jew to decode, about a life in which neither, as Jews, figured. Adorno's criticisms, and those of other refugees, vexed her deeply; in 1947 she used *Variety* as a forum to dismiss them all: "Life is a daytime serial, escape it if you can." The obtuse woman didn't recognize that this was precisely the objection. Still, the émigrés had missed the full alienation of her painted dreams. Quality should not have been an issue; "idiotic" ought to have been, for Adorno, the least interesting of comments. For had he listened carefully—and dialectically—her serials might have shown him that even in the areas restricted for their expression, affective and familial feelings were in hopeless disrepair.

In the late thirties Paul Lazarsfeld began editing *Radio Research*, a series of annual compilations of program analyses. Adorno contributed a study of the implications of media technology for traditional music. In line with Benjamin's ambivalence about the mass production of art, he criticized radio broadcasts and recordings of concerts for their inferior sound and for separating the home audience from the communal experience of the concert hall. The superior quality of later recordings has invalidated his first criticism. The second is more challenging: when listeners and performers were separated, music became segmented into themes and snippets. Adorno warned that music, which promised the most transcendent release, also offered the quickest descent to "infantile" and "culinary" raptures. He would have relished a 1977 television commercial for an album that contained "all the classical music your family will ever need to own."

But when Adorno turned to popular music, his dialectical epigrams only exposed his ignorance. Why did so bright an émigré write so strangely about popular musicians? Some of the problem lay in the language. Adorno admitted that his distaste for jazz began with the word's sound, and it was intensified by the claims made by jazz's defenders: "Anyone who mistakes a triad studded with 'dirty notes' for atonality has already capitulated to barbarism," an attack he elaborated upon by comparing jazz fans with logical positivists—a scattershot assault on all his enemies.

One may wonder how much émigrés like Adorno knew about jazz. They first heard it in Germany, far from its Afro-American roots. George Grosz described German jazz as a demented version of Viennese salon music. What Adorno called jazz might better be called "swing" or even pop music. When he refers to Benny Goodman and Guy Lombardo in the same breath, he does himself no service.

By the end of his life, Adorno could have seen jazz accepted as a form of classical music, fulfilling all the requirements he associated with high culture. Historical development has been jazz's

norm; what other music has undergone so many changes in so little time? Jazz provides a complete, completely musical vocabulary for historical discussions, one that, like Adorno's model Schoenberg, treats even instrumental color as a compositional form. Each instrument in jazz has its own history, but Adorno blurred the distinctions: "the pseudo-vocalization of jazz corresponds to the elimination of the piano" in the bourgeois household (more likely, it would be the other way around!). So much for Teddy Wilson, Art Tatum, Earl "Fatha" Hines, Bud Powell, Thelonious Monk, or Cecil Taylor. Adorno could extrapolate a psychosexual meaning from colloquial chitchat. Sometimes the process paid off. But when it came to jazz, the musicologist proved tone-deaf.

In a spectacular irony, Adorno himself would be blamed for mass culture. In the late 1970s the U.S. Labor Party, an ultra-right-wing movement, declared that Zionists and British Imperialists (the "British Zionist Gestapo") created rock 'n' roll as a means of "zapping" the minds of American youths . . . and had employed as their trusted agent Theodor Wiesengrund Adorno.

Leo Lowenthal applied the Institute for Social Research's characteristic themes of alienation and the commercialization of culture to literary criticism. He saw himself as mediating between the antihistorical Americans and the Europeans with their exaggerated sense of historical import.

The first notable product of this self-consciousness was a study of magazine articles about celebrities that Lowenthal contributed to Lazarsfeld's *Radio Research 1942–43.* Unlike Adorno's work on jazz, Lowenthal's essay exhibits the sensitivity to data and idiom that characterizes the best refugee writing about America. As a literary critic he is struck by the false intimacy of such phrases as "especially for you" and the hectoring tone that suggests a dialogue but instead compels the reader's assent. Magazine biographies are written in a language of superlatives. It is not unamusing to see the émigré's alarm at American misuse of "high language," the application of terms like "saga," "myth," "historic," and "fabulous" to the lives of star-

lets and athletes. There are no limits in this discourse: an actress "looked a bit like a Buddha," a showman "like a priest of Osiris." In a nice use of pop culture, he sees such prose emanating from a "make-believe ballroom" (the title of a radio show on New York's WNEW).

"These biographies as a literary species are true." The truth they reveal is more important than local errors of fact: there has been a change in the conception of the individual. Lowenthal shows this by comparing the biographies published in *Collier's* in 1901 and *The Saturday Evening Post* in 1941. Though the number has almost quadrupled in those forty years, the genre's nature and implications were hugely constricted. He sees the early biographies as canonizing "idols of production." But by 1941 success was no longer the product of work and application. The vast majority of biographical subjects were involved in "consumption," service industries and entertainment. The serious people were shown to be "not so serious at all." Among the few entrepreneurial figures were a quack doctor, a business swindler, a gambler, Howard Johnson, Jinx Falkenberg, the rector of Groton.

This is a Chinese-box situation: in their leisure time, people read about the heroes of their leisure, a doubly passive form of escapism. The dominant tone is comic; success and power are nothing to worry about. At home, the rich are as much bound to the habits of consumption as those who read about them. They don't do very much; their lives reveal them as "takers" not "givers," content with wants, oblivious to needs. Discussion of their private lives skips over emotional and sexual engagements; the modes involved, both narrative and psychological, do not allow for the strenuous efforts love and friendship require.

One heading in the article, "Just Facts," is meant facetiously. Lowenthal knows too well that facts as mere facts are useless. By looking at what passes for factual explanation, he finds evidence to justify Horkheimer's statement, "Development has ceased to exist." Successful people cannot explain how they got that way. They credit luck, friends, the stars—anything but spontaneous effort. Like love or sex, success is a gratuitous blessing.

Lowenthal interprets idioms such as "hardships" and "breaks" as signs of a "repetitive freakishness," which only shows how fortuitous success has become. He dismisses even amiable American traits as mechanical; with dialectical wit, he alludes to a "rigid code of flexible qualities." In sum, the magazine biographies sanctify people who have no friends, no inner life, no ambition, no power. Their model subject is hard pressed to be easygoing while straining to be relaxed, and is equipped with two or three ways to be a man for all seasons.

This shadowy figure is an easy mark for political demagogues. Lowenthal fears that "Behind the political mask of training and adjustment lurks the concept of a human robot who without having done anything himself, moves just such parts and in just such direction as the makers wished him to do"; as postwar man would say, he is only following orders. In his later work, Lowenthal was to extend the Adornoesque perception that mass culture exposed its public to "a reign of psychic terror" that bulldozed them into submission, destroying their capacity to react and resist.

Such analyses of meretricious popular artifacts allowed for prophetic insights into American culture. If the idols of production had been replaced by the idols of consumption, if frenzied melodrama—much like revivalist hysteria—induced resignation and passivity, then a new figure had indeed emerged on the American scene. And if nothing else was clear, this emotionally impoverished weakling would be of little help to an émigré. Many refugees remarked that Americans were the kindest of people and the dullest. But analysts like Lowenthal wanted to rescue them, not least because in 1942 they provided the émigrés' only defense against Hitler. What appeared to be cultural elitism had the urgency of a military program.

The refugees at the Institute of Social Research and the Bureau of Applied Social Research agreed that popular culture incorporated a latent form of propaganda. Meanwhile, the scholars at the New School for Social Research examined the real thing— Nazi propaganda—with a similar attention to details and idioms,

though with far more confidence, since the language and customs were their own. Despite differences of method and temperament, the conclusions and aims were comparable.

During the war years, the Berlin-born historian Henry Pachter worked for the Office of Strategic Services, translating German newspapers that were imported from Lisbon. It was his job to note any signs of internal dissension. At the same time, his wife, Hedwig, worked as a typist for the Office of War Information. In 1941 the two collaborated with some friends on *Nazi Deutsch*, perhaps the first systematic study in English of the changes Nazism had wrought in the German language. Giving a curious compliment, Ernst Cassirer (briefly the Pachters' neighbor in New York) said that he found the book's deficiencies enlightening: he felt the authors had failed to translate the newer terms because they could not transmit "the emotional atmosphere which surrounds and envelops them. This atmosphere must be felt . . ." What the Pachters could do was show how the merest syllable turned normal language into propaganda.

Pachter later joined the New School, and was one of the contributors to a book sponsored by the school, *German Radio Propaganda*, which was edited by Hans Speier and Ernst Kris and published in 1944. The project relied upon the monitoring services of the BBC, with which Kris had previously been connected. In a New School version of the study of mass culture, Kris describes the kind of programs Nazi broadcasters favor: lectures on physical fitness and vitamins; popular war songs ("Balkenlied," "Afrikalied," or that syncopated favorite, "Wir fahren gen Engelland"), "blood and soil" novels; lowbrow scientific lectures by scientists like Planck. As the war draws to a close, Pachter derives a deeper meaning from a switch in program content. Light entertainment is introduced, in Goebbels's words, "to unobtrusively take the mind off the working day." The schmaltzy music, the chats with crystal-gazers, astrologers, and palmists, are all signs of despair. Hans Speier adds that the very existence of propaganda demonstrates an imperfect consensus.

The study gives characteristic attention to the political impli-

cations of shifts in tone and imagery. Kris notes that propaganda attaches epithets to the enemies: Americans are corrupt, the British hypocritical. Hitler is a god of light battling the powers of darkness, represented by international Jewry. (Historians have shown that the Nazi spy network failed largely because it relied on stereotyped fictions.) But as the war proceeds, disdain turns to fear: the latest broadcasts cite an American book, *Germany Must Perish*, and warn that "international Jewry" will never forgive the Germans. (Nazi broadcasts assumed that citizens were generally aware of Hitler's treatment of the Jews, although many postwar Germans denied any knowledge of it!)

Kris discovers that the man in the street is missing from such propaganda. He enters only as a soldier or, in the final hours, as the party responsible for German defeat. Then attention shifts from the enemy, who is winning, to "the positive equipment of the self." Always alert to dialectical possibilities, the writers discover that what the Nazis give, they also take away. Fear and guilt pervade the calls for cooperation and friendship. A spectacle worthy of Orwell is the "politeness campaign," in which people are encouraged to spy on one another's behavior. Grumblers are "nervous nellies"; bad manners weaken the military resistance; *der Führer* wants us to smile—"Smile," one might add, "if it kills you." Goebbels had previously lamented the failure of his hate campaign: "We Germans . . . are ill-suited for chauvinism." Now they were to be bullied into loving each other.

Kris, a psychoanalyst and anthropologist, is sensitive to the implications of Nazi imagery. "The Nazi radio invites the German people to a puppet show. The hero is the self, the villain is the enemy, and the rest is chorus." This is a harking back to myth and legend. But if one looks carefully, one sees that the self on display is not a representative German but *der Führer*. Pachter observes that when times were good, Hitler used the first person singular ("I decide," "I could have cut off the heads of the whole intelligentsia"), but now, declining responsibility, he employs the third person plural, "ready to put the stigma of defeat on his followers." Similarly, nouns are arbitrarily deployed—National Socialism steers the nation to victory, but it is

Germany that loses battles; verbs contradict reality—the people are "not governed but led, not indoctrinated but enlightened"; and human beings are abstracted out of existence—there is a constantly rising birthrate, but there are no references to actual parents and children. A language that overturns the rules of logic and grammar can do away with death; thanks to National Socialist scientists, disease is being wiped out: nobody dies in bed.

The New School study is itself a subtle form of propaganda. It concludes with Kris's plea that postwar Germany be spared the punishments that allowed the rise of a Fascist mythology and the consequent destruction of logic and grammar. Though homage is paid to anti-Fascist leaders—Roosevelt and Churchill become Hitler's propaganda opposites, with their fireside chats and inspirational lectures—the study is suffused with sadness. As the last heirs of the German humanities, these scholars saw their legacy disappearing in the solecisms of Nazi *Deutsch*. Here is why they may have overlistened and overreacted to American kitsch. What had already happened in Germany must not take place again.

Television would eventually elicit other severe responses from émigrés. In 1952, following a brief return to this country, Adorno condemned lightweight entertainments for the psychic damage they either reflected or induced: they were mysteries without mystery, satisfying the public's infantile need for the protection afforded by aesthetic convention; situation comedies that "insult . . . the American spirit"; romances that preach a gospel of resignation and adjustment, denying the utopian possibilities of a happy end. Adorno suspected that television existed to browbeat its audience into a "smugness, intellectual passivity and gullibility that seem to fit in with totalitarian creeds." To be fair, this was an interpretation of television's subliminal effects that pays no heed to the producers' intentions. It is shamelessly impressionistic—Adorno admits that it would be "hard to corroborate by exact data"—and, far more devastating than recent criticisms of the unfortunate links between politics and com-

mercial television, Adorno finds the enemy inherent in the very technology, the medium.

In 1978, after most of these men had died, a media event occurred that made a mockery of their findings. *Holocaust*, a television series, employed all the devices they abhorred. Its diffuse narrative reduced history to a family soap opera, replete with false melodramatics, an inappropriately lush musical score, and commercial interruptions: the very image of the fragmentation of modern life. Here was Adorno's culture industry at its dreariest. Yet, aesthetic flaws notwithstanding, *Holocaust* had an astonishing effect in the United States and a staggering one in Germany, finally conveying to the mass audiences truths they had refused to acknowledge for years. According to the émigré analysis of popular culture, *Holocaust*'s cheap tricks should have limited its impact or turned it to evil uses. Instead, the program educated its public and prompted a positive political development: the German statute of limitations against war criminals was revoked, thanks largely to the show's dramatizations of their actions. In resorting to soap opera, commercial entertainment had restored the human element neglected by highbrow commentators. As Günther Anders observed, the postwar publication of books "reduced the Holocaust to its enormity," and "only through individual cases can the innumerable be made clear and unforgettable." Irna Phillips's shade kicked up its heels as Adorno's wandered off in a slump.

7

The Line of Most Resistance

While a band of isolated academics studied the impact of popular culture, other refugees were actively changing Americans' ways of seeing and hearing. But first they had to make some adaptations themselves. The adjustments demanded of these artists, forced to switch home and language in mid-career, were not easy. As if they didn't have the normal émigré problems, they also found themselves vulnerable to criticism from all sides, especially from their fellow artists and, even more, the audiences who had migrated with them and stood ready to expose their slightest betrayal of the cultural legacy. All the praise and commercial success the marketplace could afford might not compensate for an expert dismissal by one's own. The ideal was to appear accessible without being obsequious or self-serving, to be an artist, not a toady or a whore.

All of them, the Olympians and the streetwalkers, found themselves tossed about in a society where any cultural commodity—not merely jazz, pace Adorno (see chapter 8)—is subject to "perennial fashion." The struggles for public applause resembled relay races with a greased baton; just as you were winning, it would slip out of your reach. For example, Schoenberg's American career was plagued by disappointment and in-

attention. Only after his death did his twelve-tone theory achieve predominance in the academy and among other composers. Today a rising backlash against serialism places him, together with the equally unfashionable Bauhaus architects, in the position of a superannuated avant-gardist. Like the members of their émigré public, who were underpaid, overworked, bewildered by American society, and worried about the relatives trapped in Europe, the refugee artists led lives of constant uncertainty.

Among the visual artists, one might note two separate groups—the teachers and tourists—taking both terms in a literal sense. Refugee artists were often great teachers in colleges or in their own art schools. As a result, their influence extended beyond the small art public, or even smaller audiences that remembered their work abroad. What did they teach their students? A man who studied with Josef Albers at Black Mountain College credits the artist with giving him "a pair of eyes." Albers's art pays special and, by his standards, scientific attention to color, proportion, and geometric forms that simultaneously welcome the viewer and keep him at a distance. This combination of involvement and discretion seemed to answer to the artist's own sense of personal limits.* Artists like Robert Rauschenberg (Albers's student at Black Mountain) have extended his concerns with color and shape. Similarly, Albers's assertion that "the performance—how it is done—is the content of art" has had a powerful influence on American artists. Not that they didn't relate to the earlier romantic obsessions with artistic process. But by working so rigorously, and demanding similar effort from his students, Albers brought an American audience around to seeing things his way.

* According to Martin Duberman, Albers, for all his pedagogical innovations, disliked the "capricious" and "unexpected." He felt no inclination to interfere in local politics, particularly Southern racism. In fact, Albers and several of his refugee colleagues considered native radicals suspect. He is reported to have considered folk dancing a Communist pastime.

A much less successful teacher was George Grosz, perhaps because he seemed determined to deny his own nature. The scourge of Prussian philistines tried to play Pollyanna. He was too much of a curmudgeon for the new style to take. In his youth, Grosz was part of a group of political and artistic radicals; his Dadaist comrades included the Communist brothers Wieland Herzfelde and John Heartfield. But by the early thirties Grosz was telling friends that the masses were rabble, radicalism was a delusion, the Germans deserved a Hitler. He came to America intending to disown his past. Hurling himself into the mainstream, he became an illustrator for popular magazines and taught at the Art Students League in New York City before opening his own school.

Grosz adjusted with unseemly haste to American expectations. In his autobiography he admitted that he painted for money. It would be hypocritical to deny that artists, like everyone else, need money, but Grosz almost boasted of his pecuniary worth, as if to demote himself from artist to businessman. He advocated "pragmatism," that bugbear of émigrés who believed in dialectical materialism; he understood their argument, but actually welcomed what they feared. Tacitly agreeing that a commitment to the moment and to unmediated impressions fragments human character, he declared character "overrated"; this was not a denial of the "individual" in favor of the group but an expression of simple misanthropy. The most saturnine of illustrators picked Norman Rockwell as his American idol. His heart had never belonged to Dadaism, he claimed, and in pursuit of Rockwell's clarity, he vowed to "stifle anything . . . too Teutonic, too German, too Groszian, too original."

The outcome was neither acceptance nor fame. As he admitted, "I could not succeed in attaining expression of the normal and good"; something "schizophrenic" infiltrated his work. He tried to absorb American life, even compiling a file of newspaper clippings representing "a complete morphology" of the culture, which he described, revealingly, as "an anarchistic world of form." If the society was really anarchistic, Grosz nevertheless managed to condescend toward the middle class, with its "little ugly man." Perhaps his German style would have been too sav-

age for Americans, but he could not manage a sea change from bile to plain vanilla. Trying to be "only an illustrator," he learned in a limited tenure at *Esquire* that illustrators are easily replaced. American values could be assumed but not assimilated. For example, his 1937 drawing of factory workers, "Dog Eats Dog," depicts a quartet of feral laborers with animal heads: what American public would have been amused?

In demeaning himself, Grosz canceled out any possible influence he might have exerted. His public posture became increasingly grotesque. In 1952 he attended a party given by Erich Mosse, a refugee psychoanalyst and novelist. There he confronted his fellow émigrés, the filmmakers Hans Namuth and Paul Falkenberg, and berated them for promoting "inhumanity in the arts" by filming the work of the abstract expressionist Jackson Pollock. In his last year, Grosz lectured at the annual ceremonies of the American Academy of Arts and Letters. Still condemning himself, he "denounced satire as an inferior form of art." But almost as a metaphor of his career, the microphone failed, the audience hollered, and Grosz yelled back at them, "mistaking their shouts for disagreement." In a distinguished American setting, he was still arguing with himself.

Hans Hofmann first came to this country as a visiting lecturer before 1932. He extended his visit after Hitler's rise to power because he had a Jewish wife and a record of left-wing positions. Like Grosz, he taught for a time at the Art Students League before opening his own school on East 57th Street in 1932. Naturally generous and friendly, Hofmann became perhaps the most influential art teacher of his generation—his students included Larry Rivers, Alan Kaprow, Louise Nevelson, and Helen Frankenthaler. They remember his European manner: Kaprow describes his then "foreign" notion of art as "a destiny"; Rivers writes of the "way he had of making art seem *glamorous* and meaningful." Quite properly, Hofmann called upon his European ancestors, from Goethe's correlation of color and moods to Einstein's theory of the fourth dimension. He employed a traditional romantic vocabulary, using musical terms and telling his students to "work from nature in all her glory."

Yet Hofmann loved America, and his art noticeably changed

in this country. Arriving as a figurative expressionist, he eventually became a leading member of New York's abstract expressionists; Hofmann had begun to splash pigment around freely as early as 1938, years before Jackson Pollock's similar experiments. Just as Schoenberg, in Adorno's phrase, liberated color as a compositional element in music (Schoenberg was himself a painter), so Hofmann promoted color and visual texture as the preeminent concerns of painters. In a painterly reformulation of the beloved European concept—the dialectic—he postulated a perpetual interaction of flatness and depth. This process, inherent in the very movement of paint on canvas, managed to express both scientific law and metaphysics, a double reality that merged two of Hofmann's obsessions. He called the painterly process "push and pull": "only from the varied counterplay of push and pull, and from its variation in interaction, will plastic creation result."

His theories of art reflected the habits of the New York school of "action painters," and some critics see him as a conventional painter rehabilitated by exposure to American tendencies. But "push and pull," as all processes must, comprehended the past as well as the present and future. Hofmann knew he was shifting focuses; he liked to reexamine Renaissance art with its emphasis on content and apparent disregard for what he considered art's true concerns. By diagramming the planes and canvas organization in painters separated by centuries and comparing such artists as Rembrandt and Mondrian, he was able to construct a new pantheon for old heroes: by abstracting compositional elements, he could defend the past to vanguard artists who might reject anything representational. In his most adventurous paintings, the European tradition made itself felt, even in its absence; if one compares him with a Barnett Newman or Jackson Pollock, other New York School painters, the Americans appear more antihistorically audacious; in contrast, Hofmann's innovations accompany such a fine sense of the past that his work appears almost classical. "Push and pull" of past and present, as well as canvas and paint.

Hofmann and Albers, and, to a much lesser extent, Grosz, were teachers. More isolated in achievement and hence in influ-

ence were other artists who can be defined as tourists. Among these would certainly be artists who came after 1939, including the many French painters. They were visitors stopping off in New York for a few years, and then returning without altering their painterly approach. An exception was the Dutch Piet Mondrian, who arrived in 1940: a lover of jazz, he sought to capture its mood and rhythm in his final paintings; his last is called "Broadway Boogie-Woogie." Once the master of a rigid formalism, Mondrian in his brief American period infused his compositions with a new and uncharacteristic energy. The photographer Charmion von Wiegand met Mondrian here; she credits her exposure to his work with enabling her to see and photograph New York City in "an entirely different light." Years later she visited his native country, and beheld outside her train window the gridlike formations of Mondrian's New York, traced now to their Dutch source—"it was all there." So a Dutch vision reorganized an American perception. (Similarly, when Gertrude Stein took her first airplane trip she saw landscape formations that resembled Cubist sketches.)

Mondrian was here for too short a time, and probably too late in life, to change very much. Another exception was Max Ernst, who during his stay here became fascinated with the look of America, especially the lunar landscapes of the Southwest. Ernst's paintings of massive rock walls looming in the desert are uncharacteristically placid. Like Heinrich Zimmer, who was awestruck before the Grand Canyon, Ernst realized that the timeless shapes needed no mythic enlargement: they were fantastic enough. Ernst may have been a tourist, but he stayed a long time before returning to Europe, and his work there became more purely plastic than his earlier programmatic exploitations of the bizarre and fortuitous.

Richard Lindner came earlier and younger than either Mondrian or Ernst, and his art changed totally. Lindner defined himself as a tourist. "My figures are the impressions of a tourist visiting New York. There is no one else in America who paints quite like that. I don't belong to any movement. I am not a Pop artist, nor an anything: I am a tourist on a visit to America who

has to see all the sights. In this respect Saul Steinberg and I have a lot in common, we are both tourists, both arrived at much the same time, we are friends, and of course we see New York better than anyone who was born there. I am a tourist everywhere— meaning an 'observer.' " Saul Steinberg joined the army shortly after his arrival here; he says he was determined to separate himself from the refugee community and see America with Americans. Of course, as Lindner observes, such tourists don't see what Americans see; their vision of America is unique precisely because it is not American, a hybrid form calling upon its own systems of push and pull. Thus Lindner's dubious image as the inventor of pop art must be qualified by the understanding that his use of pop devices was neither expedient—he was fifty-nine before his first painting was sold—nor facile—popular forms required great rigor of attention.

Another painter transported his European themes to an American setting. Hans Richter, a Berlin artist, was associated in Europe with Dadaists, constructivists, and filmmakers. He was one of the most serious and least anarchic of the founders of Dadaism, and quickly acquired a political image: his 1928 surrealist film, *Ghosts Before Breakfast,* earned him the Nazi label *Kultur-Bolshevik;* a year later he collaborated on a film with Sergei Eisenstein. Exiled after 1933, he directed films in several countries before arriving here in 1941. For fourteen years, Richter taught film technique at City College in New York. In 1943 he produced an extraordinary collage in the form of a scroll titled "Stalingrad (Victory in the East)," replete with geometric formations either inscribed or formed from newspaper clippings. The language was English but the procedure was European, as was the radical political intent: "By putting ... geometrical forms (the Nazi war machinery) against free-flowing forms (the people) I was able to develop the two compositional themes adequately into a kind of symphony." (One recalls the time Picasso was asked by a Nazi officer whether he was the one responsible for "Guernica." Picasso replied, "*C'était vous.*")

Richter's widow says, "He was a Don Quixote. I don't think he would have said he did the artworks because he wanted a po-

litical fight, but more like any other human being as an expression of his natural involvement in the state of affairs ... he would take a stand." And so an émigré artist produced this country's nearest equivalent to "Guernica." After the war, Richter continued his witty pastiches. He directed movies that featured émigré artists; in the late fifties he filmed men like Hans Arp and Richard Huelsenbeck, who had been Dadaist colleagues forty years earlier in Zurich. His "8 × 8" (1955–1958), was shot in an abandoned, sunlit Wall Street through which Max Ernst waltzes about. Richter was seventy at the time, Ernst sixty-seven. In the country of the young, in the very center of capitalism, the two old men clown like children taunting their uptight parents. It is a rare, breathtaking image of émigré transcendence. It is also a tourist's Dadaist gesture, making sport of the local icons.

Thanks largely to émigré academics, Americans became concerned with the sheer act of looking. The Gestalt psychologists offered one approach to visual perception; another came from psychologists of art like Rudolf Arnheim. That college graduates register design and shape the way they do probably owes as much to the training of their teachers by Erwin Panofsky as it does to the example of refugee artists producing their avant-garde paintings for a small group of collectors. Panofsky worked for years at Princeton's Institute for Advanced Study; he once credited his happy experience to the fact that he came as an invited guest, not as a refugee.

He also claimed that America had forced him to clarify his diction. Certain German terms can be used in many contexts; this is a glory of the language, perhaps, but it also obfuscates expression, even in the original, and limits translation. Panofsky noted that words like *taktisch* or *malerisch* could be used in numerous ways: to denote the "picturesque," to mean "pictorial" as opposed to "plastic," or "dissolved," "nonlinear," "loose," "impasto"—a galaxy of terms ranging from the technical to the impressionistic. "But in English, even an art historian must more or less know what he means and mean what he says."

Panofsky's prose style changed in America; his later work is more lucid and streamlined. In liberating the specific terms confused and concentrated in such German words, he also released them as objects of attention. So although his concern with iconographical patterns was totally different from Hans Hofmann's, a resemblance can be drawn. Both men made their students look more precisely; Hofmann stated and Panofsky intimated that they shared in the new precision. If to speak clearly is to see clearly, Panofsky's adjustments to the demands of the American language helped usher in a greater range and definition of visual perception that would be disseminated by the many teachers who once were his pupils.

So far the visual transformations were subtle expansions of consciousness that perforce involved most the buyers and students of art. The biggest transformation of all would be apparent to everyone, and would change the working and living patterns of millions. This was, of course, the design of a new cityscape by Bauhaus architects—Walter Gropius and Marcel Breuer in the East, Ludwig Mies van der Rohe and László Moholy-Nagy in the Midwest, and their pupils. The Bauhaus influence extended from Park Avenue to the suburbs, from the workplace to the home. Once émigrés had been amazed by the objects and furniture manufactured in America; now they themselves provided objects that became the new models of good taste. They benefited from the most up-to-date promotional medium: movies. The interiors of Paramount films of the 1930s were often the creation of Hans Dreier, who admired and collected Bauhaus furniture. His cinematic interiors expressed a new sort of glamour: such sleek lines brought into reality the viewers' imaginings of power and character by presenting the visible signs of material achievement (it was a peculiar irony of emigration that Bauhaus should incarnate capitalist success rather than socialist emancipation).

When Americans scurried to work or returned home, they were surrounded by émigré design. Even the shopping center was an émigré contribution, pioneered by the Viennese-born Victor Gruen. Since he shared the Bauhaus preoccupation with social uses, "Gruen was determined that Northland [a Detroit

shopping mall] be more than simply a collection of stores, and he filled the malls with sculpture and included an auditorium for public use, making the complex almost a civic center."

Bauhaus members were welcomed by academic institutions; Gropius achieved far more influence at Harvard as a teacher than he did through his architecture. In Chicago, Mies became the virtual inventor of industrial design. This was a confounding shift from his youthful radicalism—he had designed a Berlin memorial to Rosa Luxemburg and Karl Liebknecht—to preeminence in American commerce. Mies designed many more buildings here, as if he required a capitalist America to realize his radical European vision (although the Bauhaus architects had always admired not only American industry's infatuation with aluminum and steel but also the beauties of American technology).

The Bauhaus triumph was reinforced by the leaders' acolytes. The bible of the movement was Sigfried Giedion's *Space, Time and Architecture* (1941), but by 1932 two young Americans, Henry Russell Hitchcock and Philip Johnson, had mounted an exhibit of Bauhaus work, calling their mode of design the "International Style." Unfortunately, what had been in Germany a dream of a postcapitalist, international community was here stripped of most of its political content. Philip Johnson recalls the hatred of history: "Walter Gropius felt that every problem should be solved on its own merits." Yet apparently this meant only the immediate structural requirements, not the demands of neighborhood or community—"Mies felt you could stamp out identical buildings anywhere you liked" and ignore the *genius loci.*

The Bauhaus designers operated in reaction against the superfluous ornaments that cluttered streets and homes. In removing excesses, they took their stand against the forms of mystification engendered by late capitalism; liberating lines meant liberating lives. There were other aesthetic rewards; at their best they brought an eerie beauty to the workplace. Mies's glass-and-metal high-rises mobilized a subtle play of reflections; the ceiling-high windows exposed business to outside observers, to the very heavens themselves.

But the subliminal effects on the people working in those offices were less than gratifying. For all their humanist principles, the Bauhaus architects produced buildings that Americans found unpleasant. Worse yet, huge housing projects constructed according to the Bauhaus notion of functionalism became known as breeding centers for crime. This was a horrible irony. In Germany, radicals had recognized, as the film *Mutter Krausens Fahrt ins Glück* declared, that "an apartment can kill." The architects had envisioned a vibrant architecture, not rows of square boxes that only intensified the desperation of the working class. In recent years a new reaction has set in. Some critics now find that the severe, impersonal lines of a Barcelona chair or a Seagram Building—to name two of the glories of Bauhaus design—inhibit human response. Some feel the human presence "destroys the purity of the composition"—although the Bauhaus members found objects not consecrated to human use abominations. The European past that Bauhaus rejected now seems to many Americans to be more *gemütlich* than gushy; Beaux-Arts gingerbread has come to satisfy appetites starved by the Bauhaus diet. The shift in tastes tells more about modern politics than about the Bauhaus achievement. The cycle of public taste, the circuit of distribution and publicity, the switch from an internationalist perspective to a local, "populist" decentralization—these are matters that are more sociological than aesthetic.

In America the Bauhaus members became teachers and prophets—symbols of an outmoded fashion. It was a curious romance: they began as admirers of American design, eventually became its arbiters, and ended up as its outcasts. And who knows what new turns lie ahead? Whatever, the American market devoured the International Style as if it were yet another commercial product. But the Bauhaus members may well have had the last laugh. Because of the ubiquity of their designs and the drastic changes in the nature of American work and leisure, there may be no possible return to a world devoid of shopping malls, high-rise buildings, and functional furniture.

Music, not architecture, proved to be the most welcome import, perhaps because in the classical realm, Europeans had always set the standards. Though émigré musicians found a large and adoring public, it is debatable whether their American experience had much effect on their art. The broadcasts of Toscanini in the thirties and the telecasts of his son-in-law Vladimir Horowitz in the seventies introduced classical music to millions of new listeners. But the repertory and performing style would most likely have remained the same if such artists had merely continued the American tours they were making before Hitler and Mussolini forced them to move.

And always, along with their new public, there was the old audience of émigrés. They alone could pack a concert hall: one society, the New Friends of Music, was known in some circles as "Old Friends of Schnabel." Emigré conductors—Bruno Walter, Otto Klemperer, George Szell, William Steinberg, Erich Leinsdorf, Pierre Monteux, Efrem Kurtz—headed orchestras in many cities. Knowing that an informed émigré public sat out there made concerts bittersweet occasions for performer and audience alike. As the musicians bowed to their public, they were acknowledging a special relationship with those members who shared their accents and their fates.

The serious classical musician was confused by American mass culture but saw promise in its development. While Adorno deplored the effects of radio and records, a more tempered analysis came from the pianist Artur Schnabel. Unlike Adorno, he recognized that new audiences had been created through mass communications; he even welcomed "swing at the harpsichord" as a sign of the instrument's vitality. But he was as serious as Adorno in his belief that art was no plaything, "not occasional refuge or holiday but a perpetual mandate to our spirit." The machine was not the enemy: "the banality is not in material but in spirit."

As a professional musician then operating in the American marketplace—and, not incidentally, as a refugee exhibiting the characteristic interest in American idioms—Schnabel spoke of the risks attending the kind of flashy musicianship that won popular approval. "A virtuoso is a trashuoso"—only a foreigner

would have bothered with this wordplay—"if he hides Beethoven in Lehár." You could not disguise your intentions without betraying them. "Who presents treasures and trash cannot claim to be a champion for the treasures, for he always takes the risk that the trash might be preferred." In a nice linking of European and American slogans, he compared "The end justifies the means" to "Keep smiling"; both would be superfluous if conditions were not rotten.

His advice to the old was "Avoid 'bravura' pieces" in favor of a more intensive examination of deeper and subtler music. To young musicians, and, by extension, to all artists lured by an easy success, Schnabel advised, again in a refugee rephrasing of American idiom, "Take the line of most resistance."

Emigré composers were scattered all over America. Academic institutions offered support to many: Paul Hindemith at Yale; Darius Milhaud at Mills College; Ernst Křenek at Vassar and Hamline University; Hanns Eisler at the New School. Several composers reciprocated the American hospitality with works that paid homage to their new country. Hindemith composed a musical setting of Walt Whitman's "When Lilacs Last in the Dooryard Bloom'd," which Hindemith subtitled "An American Requiem"; in response to his students' demands, he renewed his exploration of tonality. There were token acknowledgments of jazz: Stravinsky composed "Ebony Concerto" for Woody Herman; Schoenberg and Darius Milhaud taught jazz musicians. Even Béla Bartók was indirectly affected by jazz; he spent his last years in New York, suffering his final illness with great dignity, helped financially at the end by a brief appointment at Columbia University—and by a commission from Benny Goodman, made possible through the intercession of his fellow Hungarian Josef Szigeti and of John Hammond, the premier jazz producer and Goodman's brother-in-law.

Always there was a danger of compromising too much. While some, such as Kurt Weill, Hanns Eisler, Paul Dessau, and Hindemith (all, incidentally, at one time collaborators of Bertolt Brecht), had trafficked with popular idioms, too much accom-

modation would break Schnabel's "line of most resistance." A few were actually ashamed of their versatility. In 1953, assessing his chameleon musical persona, Ernst Křenek apologized, "This presupposes a fair degree of adaptability which proves to me that I have not really the makings of either a crusader or a hermit." A good American living might mean an aesthetic sellout. In Hollywood, Erich Korngold, once the darling of Austrian opera, joined the ranks of such glorified hacks as Max Steiner, Alfred Newman, and Franz Waxman. In such hands, the clichés of European orchestral music created the aural atmosphere of American romance.

But one had to live. Even Schoenberg, canonized by Adorno for his refusal to yield to public expectations, was forced to instruct American child prodigies, jazz musicians, and movie composers. In 1935, through Salka Viertel's intercession, he conferred with Irving Thalberg at MGM. Thalberg congratulated him on his "lovely music." Schoenberg barked, "I don't write lovely music." He was willing, however, to compose the score for the MGM production of *The Good Earth*. His demands were appropriate but unacceptable. He wanted fifty thousand dollars, and complete control of the soundtrack; the actors were to speak in the same pitch and key he composed in (as if Paul Muni and Luise Rainer didn't have enough difficulty playing Chinese peasants!). He later told Viertel "to compose means to look into the future of the theme." With his ambitions, a Schoenberg score could have pointed to a whole new form of musical drama in film. In retrospect, it seems cheap at the price.

Even if American forms had little influence on their work, the exigencies of survival in America affected all the émigré musicians. At least in Europe, government assistance had been available. Erich Leinsdorf remembers, "The whole group of émigrés I came over with in 1938–39–40, every one would say '*Bei uns* . . .' and then go on to complain about the lack of subsidies here. But I would say, 'Over here, if Mr. So-and-So or Mrs. So-and-So doesn't like you, you have other people or other institutions or other foundations. There, if the minister doesn't like you, you're *licked.*" Hanns Eisler would concur that a musical career in America involved the pursuit of patrons. But for someone as

imperious as Schoenberg, the requisite tactics of seduction were intolerable.

In Europe, there were numerous orchestras to employ classical musicians. In America, limited opportunities forced some of them to swallow their pride and work for the movies. The studios hired émigré composers, conductors, and musicians. As events had rendered their actions tentative and ephemeral, now they labored by day to produce disposable music. (Hanns Eisler even suspected that movie work forced trained musicians to resist his kind of "difficult . . . modern music" as an act of "self-defense"). But night offered a chance to renew their commitment to art: both Stravinsky and Schoenberg conducted film studio musicians in orchestras that appeared in synagogues and churches, or on occasion in the famous Lovell house designed in the 1920s by Richard Neutra.

Perhaps unavoidably, a hierarchy arose of émigré musicians who felt themselves morally superior because they were redeeming their hack labor with nighttime obeisance to high culture. To the émigrés who dominated the audience as much as to those who performed, these Hollywood programs provided a resounding "Enough, no more, give us our freedom" against the fantasy and commerce of their working lives. Here, in the purity of cultural commitment, was the vaunted *promesse de bonheur*, a sign that mammon did not own its employees.

In different ways Brecht's two leading musical collaborators, Kurt Weill and Hanns Eisler, set about making sense of life in this country. Weill, the less reflective, translated his understanding of the country into music and achieved an unparalleled popular success. Eisler, on the other hand, was less visible to the general public. He provided a literary gloss of the working lives of musicians, émigré and native, from a radical perspective honed in Vienna and Berlin.

Adorno, Weill, and Eisler had all studied with Schoenberg. Of the trio, Weill had always seemed the most out of place. In Europe, Adorno had praised his music by both Marxist and Schoenbergian criteria, though the master himself despised his

pupil's facility. Weill was notably absent from Adorno's later music criticism. Eisler was much more Adorno's sort—and Brecht's: the playwright made a point of declaring publicly that he preferred Eisler's Marxist aesthetics to Weill's marketplace mentality, although he had neither knowledge of nor sympathy for Schoenberg's august musical style. Talk about playing "old games": personal animosity resonated throughout essays written as if music, the most subjective of aesthetic forms, had been elevated to the objectivity of scientific principles.

Like Fritz Lang, Douglas Sirk, and very few others, Kurt Weill prospered after emigrating. This may be because, like the film directors, he held himself aloof from the émigré colony. Legend has it that he never spoke German after his arrival here. His widow, Lotte Lenya, said he didn't want to see the old-timers, "always talking about the past . . . how marvelous it was back in Berlin . . . and Weill never did." A mastery of popular forms could already be detected in his European work. The jazz syncopations and blue-note tonality were obvious American influences. But there was also his affectionate, not merely ironic, exploitation of the plaintive appeals of Lutheran hymns and operetta melodies. American popular music had long relied on similar sources: country-and-western tunes largely derive from nineteenth-century hymns, while for years Tin Pan Alley ballads joined the sweep of operetta arias to the idioms of popular speech. Weill was disposed to appreciate the conventions of popular music; indeed, some critics find his mimicry too protean, as he evokes now Kern, now Berlin, now Porter.

Weill's most famous European work was done in collaboration with Bertolt Brecht. They shared an affection for old church hymns and catchy tunes: Brecht, something of a cabaret poet, composed the melody for "Moon of Alabama." Weill was generally perceived as an artist of the Left; his last German work, *Silverlake*, has been described by its director, Douglas Sirk, as having been "ten times more radical than anything by Brecht." Yet Weill distrusted the aesthetic theorizing that Eisler specialized in. Brecht, in a 1930 statement on *Mahagonny*, introduced his criteria for Epic Theater while condemning "culinary" opera, with its easy pandering to bourgeois tastes—a

tactless reference to Weill. Brecht continued to speak unkindly of Weill's work, though by 1943 he was again suggesting collaboration, perhaps because he was tired of a self-debasing struggle for hack writing jobs. Weill got a revenge of sorts, by insisting that he would not write "incidental music"—not quite the proper opposite of "culinary" but close enough to suggest he was replying to the earlier insult: the implication was that Brecht would not allow a full aesthetic collaboration. Weill wanted a "musical play" and the impossibility of his vision's coinciding with Brecht's had more to do with temperament and loyalty to their respective vocations than to political disagreement.

In 1943 Weill and Lenya gave a concert at Hunter College, and included some Brecht-Weill songs among the more recent American compositions. This was the kind of nostalgic indulgence allowed the famous; the very context suggested that Weill saw his German work as a mere preliminary, an "and-then-I-wrote" survey. While Brecht's impressions of America were mostly negative, Lenya says that she and Weill felt "immediately at home" in New York. Like other refugees, they were inspired by Gershwin's *Porgy and Bess.* That opera tapped roots in Afro-American folklore, thus promising a uniquely American form of musical theater. Weill's native source would be New York itself. He loved to wander about in the city, in the manner of Walter Benjamin's *flâneur*, and the great composer of Berlin adapted quickly to a new urban style. Weill admitted his addiction; in 1949, he told a *Time* reporter, "Americans seem to be ashamed to appreciate things here. I'm not." Broadway welcomed his good-natured, uncritical response; others regarded him as little less than a traitor. Academic critics joined his fellow refugees in their condemnations—both groups felt he had sold out either "modern music," as exemplified by Schoenberg, or his art. Weill prided himself on being the man who never looked back—and that was exactly what his critics held against him.

Out of either craft or instinct, he selected as his collaborators lyricists of a quintessentially American stripe. Some critics debated who mastered whom, Weill or Broadway, and denounced the absence of political content in his new show music, but his

first production, *Johnny Johnson,* an antiwar musical drama, had a libretto by the Southerner Paul Green, an early civil rights advocate. And the stolid dramaturgy of Maxwell Anderson was set to Weill music in two overtly political works: *Knickerbocker Holiday* (1938)—with one tune, "How Can You Tell an American," that evoked an American character whose rugged individualism borders on an espousal of anarchy—and *Lost in the Stars,* the dramatization of Alan Paton's *Cry the Beloved Country*—more evidence yet of the émigré's interest in blacks.

Moss Hart and Ira Gershwin collaborated with Weill in writing the lyrics for *Lady in the Dark* (1941). Though some critics disliked this musical treatment of the brittle world of cocktail parties and fashionable psychoanalysis, it was a fitting irony that a Berlin composer should satirize a Viennese specialty.

Weill's next lyricist, Ogden Nash, was the master of rapid-fire rhymes. If their *One Touch of Venus* was conventional musical comedy, it did team Weill up with the sort of native minor poet who attracts foreigners with verbal acrobatics; an affection for Nash sprang from the same source that made refugees love puns. Langston Hughes, Weill's collaborator for *Street Scene,* introduced yet another American idiom. Weill clearly aspired to an exact rendering of urban speech: thus the wittily torrid tempo of "Ain't It Awful the Heat," a tribute to the urban capacity to make something sensual out of discomfort. The opera even has as a character a Jewish socialist muttering about the upper classes.

There is no question that Weill adapted to Broadway and perhaps to its homogenization of the varied American styles, though he resisted more strenuously than almost any other popular composer. Allowing for some bondage to Broadway and a musical ventriloquism that could be called either uncanny or contemptible, Weill's work here represents a seamless blend of blues and jazz elements and the atonality of his European compositions. If the politics now appear sanitized and sentimentalized, it should be remembered that Brecht's agitprop has not all aged well either.

Weill was a devoted American citizen. During World War II he appeared frequently in factories, offering a musical encour-

agement to war work, with agitprop ditties like "Buddy on the Nightshift" and "Schickelgruber." He also composed the music for a mass rally for Jewish victims of Hitler that was held in 1943 at Madison Square Garden. He and Lenya remained the kind of popular performers who could pack a hall; however, their public, unlike that of other veterans of Berlin cabaret, was largely without an accent. As much as any non-jazz composer, Weill captured the sense of peril and pleasure of New York life. In *Street Scene*, he sought "to use different forms of musical expression, from popular songs to operatic ensembles, music of mood and dramatic music, music of young love, music of passion and death—and, over all, the music of a hot summer evening in New York." That last note vindicates the whole eclectic procedure: it comes from someone who knows how variously people live in New York. Taking a more rigorous "line of most resistance" might have prevented him from yielding to all the impressions of urban life. Most of his émigré critics would not have dreamed of attempting so much, but their reticence was itself open to question; perhaps they looked back too much.

Hanns Eisler's political credentials, unlike Weill's, were never in doubt. During the twenties, after he moved to Berlin from his native Austria, Eisler began working with left-wing lyricists like Brecht and Kurt Tucholsky. During the thirties he composed an anthem for the United Front at the suggestion of Erwin Piscator (who was then living in Moscow). Eisler's compositional skills were so advanced that, as David Drew points out, he eventually influenced Weill, who had preceded him as Schoenberg's pupil. His work is something more than the objective rendering of social conditions, as is evident in the melancholy of his "Hollywood Elegies," a musical setting of Brecht's wartime poetry. Yet Eisler brought to his music and his criticism an absolute commitment to Marxist principles. Since he could be as suave a dialectician as Adorno and much more pithy, his writings offer something special, the inside view of a professional who is able to explore the social implications of phenomena that other refugee musicians were satisfied simply to behold.

During the thirties, Eisler saw the standard astonishments in ways markedly unlike the reactions of his fellow refugees. He traveled by ship, and used the trip to criticize the working conditions of the crew. When he arrived in New York, he stood amazed before the skyscrapers, moved to a lyrical comparison with "200 Strasbourg Cathedrals." But his binoculars were Marxist. Others saw architectural form, but even as Brecht could write about skyscrapers with FOR RENT signs, Eisler discussed a recent strike by elevator operators: what good were skyscrapers if the elevators didn't run? Where others celebrated the range of cultural offerings, Eisler detected the stranglehold of the socialite dowagers who sat on boards and controlled repertoires—their Metropolitan Opera was a "luxury club for snobs," in contrast to the Composer's Collective of contemporary composers like Copland, Cowell, Riegger, Seeger, and so on.

When Eisler went to Hollywood, he described in good Marxist fashion the technological advances in microphone design, the assembly-line model of movie music composition, the secretive guise of leftist protest in a city controlled by reactionary politicians and presslords: he cited William Randolph Hearst's attacks on Chaplin's *Modern Times*. He described twenty-two thousand unemployed extras who were forced to buy automobiles because public transportation had been stymied through the collusion of car dealers and city officials. He saw these workers go hungry "in order to keep the car." Later he addressed the Choir of the International Ladies' Garment Workers Union. His strong accent might have prevented communication, but his comments exhibited a real attempt to speak to their concerns, up to and including praise for FDR and the music projects of the WPA. He talked of folk music but, contradicting the conventional left-wing infatuation with it, denied its contemporary existence; the Industrial Revolution had destroyed it by replacing rural rhythms with the tempo of factory work.

In an attempt to proletarianize the composer, Eisler showed how the Industrial Revolution had created a hierarchy of promoters and virtuosos. He analyzed those *Tendenz* songs always dear to reformist groups and satirized their ineffectual spirit, the

typical "Someday We Shall Be Free," a lyrical foreshadowing of "We Shall Overcome." Even as Walter Benjamin in *The Artist as Producer* tried to reach an audience of socialists, Eisler extended himself to address the union members. Give the progressive composer "a new chance, and he will give you a new chance"; he will even use your jazz and swing—Duke Ellington was talented—though not "in the corrupt manner of Broadway and Hollywood," a fleeting reference perhaps to Kurt Weill. (Elsewhere he was less positive. Attending Group Theater rehearsals, he joined his fellow-traveler Brecht in pronouncing the American efforts "dreck" and "shit.")

So Eisler too wooed an American audience, more sharply defined than Weill's, yet more elusive. By 1948, after ten years of disappointment, he exclaimed bitterly that the "traveling salesmen" of the culture industry were prepared to bombard the public with "overheated eccentricity." Late in his book *Composing for the Films*, written in collaboration with Theodor Adorno and published in 1947 as part of the New School's Film Music Project, he admits that "no serious composer writes for the motion pictures for any other than money reasons." This is not the socialization of the artist he had hoped for! Audiences go to movies in order to be restored for the labor process; entertainment contributes to their enslavement. With social conditions stifling and emotional life bowdlerized, the composer has little to draw upon. So movie music is kid stuff, characterized by melody and euphony: "easy intelligibility is guaranteed, tunefulness is assured by the preponderance of small diatonic intervals." Such stupid, undemanding music, he writes, constitutes "the sort of melodrama for which the German language has no specification but which the English word 'tune' expresses quite accurately," as if musical melodrama weren't a German specialty!

Eisler said that the composer has become an assembly-line worker and will soon be replaced by machines; he envisioned a synchronization of image and sound, automatized by a "rhythmogram." He mounted an old-line humanist defense on behalf of both composer and writer, against this triumph of technology. As Karl Kraus had observed two decades earlier, movie

music is "inseparably connected with the decay of spoken language." Rather than supplementing speech, movie music must come to the rescue of a deficient vocabulary, so demonstrating "the true muteness of the talking picture." This muteness buries the music as well. Eisler noted on his own that movie music vanishes so quickly that "it renounces its claim that it is there." Just as Adorno observed that movies made love sloppy and death comic, Eisler saw that music had become "funny"! He sympathized with working people who giggled at the pompous, overblown accompaniments to banal events and mediocre acting.

What an indictment! Where is there room for a "song born of struggle" when the simplest tune disappears with its last note? Eisler's alternative was his Oscar-winning score for *Hangmen Also Die* (1944), a film about the assassination of the Nazi mass-murderer Heydrich. Where other composers would attempt to engage the audience's sympathies with the hero, Eisler intensifies the score to divert the audience from "the sphere of privacy to the major social issue"—a statement of aesthetic intent that could have been written by Brecht or Hannah Arendt. In a long shot of Prague, "music acts as the representative of the collectivity." Employing a device he used with Brecht in the Berlin movie *Kuhle Wampe*, he presents first movement, then rest, as dialectical contrasts. An unheroic use of piano figures and string pizzicatos accompanies Heydrich's death. Eisler was also proud of his score for Joseph Losey's unreleased film *Children's Camp*. By employing the tunes of American nursery rhymes, he proved that the "simplest materials," even tunes, can make for "unconventional music."

No other émigré composer was so alert to sociological conditions. The movie industry often drives its employees into similar depressions. But Eisler was able to move from despair to analysis, always convinced that this move was determined by his Marxism. Increasingly, he moved alone; by the late forties, he was hounded by congressional committees. The cautious Adorno, who had cowritten *Composing for the Films*, refused to allow his name to be used in the byline for the book, fearing public connection with Eisler. Happily, other friends, émigré

and American, rallied to his defense. Nevertheless, he was deported in 1948 and routed to Czechoslovakia. In 1949 he composed the national anthem of the German Democratic Republic, and a year later he moved there. He continued to compose for the movies and theater, collaborating several times with Brecht.

This latest exile allowed Eisler to speak forthrightly about his fellow composers. He had always celebrated Schoenberg as the greatest of bourgeois composers. In 1948 he had hailed him for anticipating the horror of aerial warfare, before planes had even been invented, and called him the "lyric composer of Auschwitz and Dachau." (Adorno would later condemn any musical treatment of the Holocaust: as so often, the professional composer is more lenient than the critics.) In a word, "Schoenberg never lied." But even he, Eisler remarked, fell prey to the delusions that accompany capitalist culture. Schoenberg became a teacher without a school: twelve-tone serialism is a cul-de-sac because of its inherent contradiction between form and material: "It would require the utmost mastery to compose a strong, precise, clear work which appears to be spontaneous and not a careful exercise, under such preconditions." The consequent confusion for Schoenberg's untalented mimics made even the master observe, "Modern music is much too complicated and nervous. Why can't young composers write more simply?"

Eisler contrasted Schoenberg and Stravinsky. Where the Austrian's emigration was marked by financial and physical distress, Stravinsky moved with ease from triumph to triumph. Somehow the Russian composer's style reeks not only of religious formalism but of high finance. The "impervious . . . coldness" incarnated by Wall Street, while lacking the ceremonial qualities of Stravinsky's *Oedipus Rex*, is comparably "mundane, elegant, and falsely modern." There is no joy in either composer's music. Both succumb to mysticism; the numerology of Schoenberg's later works answers to the ritual of Stravinsky's neo-Catholicism. Schoenberg requires "pure craftsmanship and the working out of new musical material"; without a social center, his stimulations must be aesthetic and self-induced. Stravinsky is worse: he depends on "imitation of style and the security of good society." (Stravinsky was kinder. He

praised Eisler's score for Brecht's *Galileo*, and signed a petition protesting the younger man's deportation.) America was not exclusively to blame for their ideological confusion, but as a nonsocialist society it offered no alternatives.

Meanwhile, the common people were bombarded by commercial music. In 1958 Eisler sounded an Adorno-like indictment of the "jazz" blasting from his radio. This was no call to resistance, he complained, but the song of "a flat pseudo-humanity, something like 'Aren't we all?' " And no, Hanns Eisler said, we all aren't. At least, I'm not. And yet he could reverse himself. In praise of bad music, he cited Proust's matchless observations about bad music's position in the history of human emotions. "The people always have the same messengers—bad musicians. . . . A book of poor melodies, dog-eared from much use, should touch us like a town or a tomb." With such artifacts, style and appearance are irrelevant. Eisler continued to hope that Socialism and Communism would destroy the "musical illiteracy which is brought about by social conditions." But he had lived too long and traveled too far not to be moved by the bond between musical illiteracy and the most elemental human desires.

In varying configurations, Adorno, Brecht, Eisler, and Schoenberg gathered in California in the early forties. Eisler and Brecht would go to parties held by Frankfurt institute members and later devise plots of satirical novels centering on them. But Eisler also worked with Adorno, and accepted stipends from the Rockefeller Foundation. (This astonished Brecht. In his journals he contemplated a rethinking of the Tui project—his anagrammatic term for treacherous intellectuals, derived from "*t*ellekt-*u*ell-*i*n," or "intellectual" pronounced backward—then decided that Eisler had not sold out his politics in accepting a grant.) Eisler was severe enough on Brecht. He noticed when the poet was untrue to his principles of class struggle, as when he romanticized the activities of Resistance workers, although such Popular Front gush was a commonplace of wartime Stalinism.

Typically, Adorno seemed unhappy with everyone. His hero was Schoenberg, and he became an acolyte more Catholic than his pope. Thomas Mann noted that in California the two maintained a distance, as if Schoenberg realized that not even he could meet Adorno's Schoenbergian standards.

The battles over music must have been ferocious. Kurt Weill refused to write "incidental music" for Brecht, and even the ideologically compatible Eisler felt "Brecht was pursuing a chimera. Brecht said he wanted a kind of music to which lengthy epics can be narrated." He so disliked the "emotional confusions produced by symphonies, concerts and operas" that he invented an alternative, called "misuc," yet another anagrammatic send-up of convention. Brecht didn't like Beethoven because his music evoked paintings of Napoleon's battles—a "pseudo-identity" indeed! Eisler, now the guardian of music tradition, was outraged.

In 1942 Eisler finally introduced Brecht to Schoenberg. He feared that the militant poet might be tactless and that the conservative composer would respond in anger. Eisler's sensitivity before his aged mentor bespeaks his own ability to be a friend as well as a comrade. Schoenberg had never heard of Brecht, and of course Brecht disliked Schoenberg's music; he remarked rather stupidly beforehand that it was too melodic. But the meeting went well once a common interest was established. Brecht used to keep a wooden donkey in his office, and he relished Schoenberg's story of a hike up a hill, during which the composer, who suffered from a bad heart, found the mountain path too steep until a donkey wandered by and demonstrated another route. And there they were in Hollywood, talking about learning from a donkey. Kicked halfway across the world, they had become used to moving in unforeseen directions.

8

The State of Having Escaped: Theodor W. Adorno

Even for as sophisticated an émigré as Brecht, Theodor Adorno was a confounding presence, pompous and elusive, austere and sensual. Although cultural analysis provided his livelihood, Adorno's disdain for American culture bordered on the pathological, and he was barely tolerant of other émigrés' attempts to master that culture; nobody was less inclined to assimilate. While some émigrés joined Artur Schnabel in taking the line of most resistance to popular styles, others had no trouble enjoying jazz and Hollywood films. But the only lesson Adorno could derive from popular culture was that late-capitalist society was in a very bad way, and that his own position, opposed to mass culture and indisposed to venerate the "classics," would be from now on lonely in the extreme. Adorno's manner could drive émigrés like Brecht to distraction. Yet the cold glare of his gaze illuminated many conditions—theirs, his own, and, more often than not, that of what he saw as the great, bamboozled American public.

The Institute of Social Research had moved to California in

the early forties, following a decline in the health of its director, Max Horkheimer. Still appropriately melancholy, the Frank- furters found solace of sorts in a relentless pursuit of dialectics. Their nocturnal gatherings resembled graduate seminars held in a wartime bunker, or so they seemed to their most caustic wit- ness, Brecht.

Brecht was splendid at exposing refugee sophistries, the more abstruse the more ripe for satire; thus his constant battle with Thomas Mann. Adorno and Mann exhibited a similar vanity in public, and Brecht incorporated the behavior of the two writers in a late novel about Tui affectations. And yet Adorno was the one Frankfurter whom Brecht took seriously. After all, Adorno had been a close friend of Benjamin's and was a collaborator of Eisler's. Also he shared, for greatly similar reasons, both Brecht's distaste for American culture and his rage over the way it warped émigré lives. Verbally, at least, the two could demol- ish the American enemy in short order, as demonstrated by Brecht's dismissal of American theater as "dreck" and Adorno's more genteel but equally contemptuous characterization of American academics as "office bosses." While despising each other, Brecht and Adorno found similar ways of resisting an America that was, they thought, overwhelming most of their brothers and sisters.

Adorno's World War II writings are of two sorts: academic prose filled with eccentric analyses of culture under capitalism and private journals that express the deepest forms of refugee anguish. *Dialectic of Enlightenment* (1944), which he wrote with Horkheimer, was initially published in New York to mini- mal attention, perhaps because it appeared in German. It was dedicated to their colleague Friedrich Pollock; the language and dedication suggest that the émigrés were still talking to them- selves. Much of the subject matter and verbal style can be attrib- uted to Adorno. Horkheimer's own work tended to be more prosaic; a friend says, "Horkheimer was basically your good *Aufbau* reader. But Adorno was an artist." The book's very title is playful, conveying the application of a German method—dia- lectics—to a French product—the Enlightenment. It is filled with dizzying dialectical observations about many subjects: eco-

nomics, the family, religion, mass culture, each apothegm characterized by a tone of unremitting melancholy. The authors assume that their work will have neither impact nor audience, and that anyhow it is too late for change. These are not notes for anybody's revolution.

The book projects Adorno's personality at the same time that it reflects the true complexity of events. For example, in considering the term "homeland," a word of some importance to any refugee, he rejects mythological associations. Nor does he accept the materialistic "settled life and fixed property" (Hannah Arendt's bases for citizenship). No, "homeland is the state of having escaped." On the surface, this is a meaningless paradox, but what he means, of course, is that the escaped writer provides his own homeland: the state is, in fact, a state of awareness.

The authors attack the technological spirit in all its manifestations. In one of the book's first, simplest statements, they say that "Enlightenment is totalitarian." The Enlightenment belief that everything can be illuminated in order to be administered presages the errors of totalitarianism. Though the book condemns capitalism, it is also unsympathetic to socialism: "By elevating necessity to the status of the basis for all time to come, and by idealistically degrading the spirit to the very apex, socialism holds on all too surely to the legacy of bourgeois philosophy." Brecht would snort at such writing, but it finds its echo in Hannah Arendt's strictures against introducing domestic needs into political considerations. Toward the book's end, human destruction is prophesied as the goal of the quantitative, mechanistic spirit. D. H. Lawrence ended his *Women in Love* with a similar vision of destruction succeeded by "new cycles of wonder"; less lyrical, Adorno expects "the whole thing will have to be started on a much lower stage."

So much for general forces. Adorno is equally severe when he examines specific cultural data. In the tradition of the Frankfurt institute's criticism, he derives psychosocial generalizations from events in pop culture. Individual life is a self-mockery, he says, whether you exalt it—as in the religious best-sellers (he was most likely thinking of Werfel's *Song of Bernadette*) and those "idiotic" soap operas—or deride it. Adorno is no less

scathing on the German writings of Alfred Döblin, then a fellow exile in California, or Hans Fallada. Shallow personal transactions are what one might expect between "pseudo-individuals." As a refugee accustomed to a certain propriety in social forms, he is particularly offended by the easy camaraderie that allows strangers to address each other by their first names. Bourgeois family names once asserted individuality by linking the bearer to "his own past history" (Adorno must have been aware of the many refugees who had changed their names), but nicknames are "petrified formulas," like words themselves.

In Adorno's view, cultural life promises what it withholds. Where jazz offers physical release, it actually "belabors." Jazz syncopation "simultaneously derides stumbling and makes it a rule." This phony physical freedom is like the "pseudo-individuality" known as style, a peculiarly American concept. Adorno's examples are drawn from hacks: pop crooners, band musicians, a film star whose stylistic eccentricity is curls, a photographer who renders elegant a peasant's hut. And he praises the European artists Schoenberg and Picasso for their "mistrust of style" as if it were another sign of barbarism.

Only in the family is there some refuge. But if the family is a "haven in a heartless world," it also has its hellish side. On separate occasions both Horkheimer and Adorno quote Marx's descriptions of the bourgeois father who compensates for his submission at work by physically assaulting his children. There does remain "mother love," which they describe sentimentally as "the ground of all tenderness." But Adorno understands the folly of idealizing women. Precisely because of their biological functions and sexual appeal, they are bound to be subjugated by a civilization whose attitude toward the body receives its "authentic expression in the [self-loathing] language of Luther," and whose aim is the domination of nature. In one of his bolder demolitions of cultural icons, Adorno examines two female types, the Virgin Mary and the shrew. Consistent with his dialectical somersaults is his discovery that the "image of the Mother of God stricken with sorrow" is a fiction, a celebration of the institution of matriarchy which had already disappeared into the doctrine of female inferiority (implicit, perhaps, in the

very fact that the Virgin was a mother, but no mother is a virgin). Likewise, the shrew is monstrous—Adorno finds her type in a Madame Defarge or a "perversely aggressive" social worker, an unkind knock at the many refugees who chose that profession—but her actions are honest. Just as Marx spoke of the father's "revenge," Adorno diagnoses the shrew mother's "revenge," a notion anticipated in Engels's writings on the family.

Dialectic of Enlightenment contains an analysis of anti-Semitism, a subject that Adorno was to treat much less provocatively in *The Authoritarian Personality* (1950). That study, devoid of a class perspective, is almost a parody of empirical research. The earlier book is intuitive, eclectic, fully assertive. It includes a historical analysis that owes something to Marx and might have satisfied Brecht: the Jews, as the "colonizers for progress" and the missionaries of capitalist technology, became the enemies of all the "craftsmen and peasants . . . declassed by capitalism." But then comes a barrage of philosophical and psychological points that derive more perhaps from the Frankfurters' condition than from history. The Jew's unconventional behavior hopelessly isolates him from his neighbors. To the non-Jew he is "the embodiment of the negative principle." Adorno's analysis of the psychological causes of anti-Semitism leads to an irreverent exposé of the Christian ethos as tawdry and banal, eminently worthy of rejection. The Jews stress their covenant with God, but the Christians worship an idol; by confusing the absolute and the finite, God-into-man, they create in Christ a "deified sorcerer." Adorno romps through this maze: the idol is the ultimate reification, a finite life turned into an absolute object. Christianity gives "a deceptively positive meaning to self-denial": the poor *goyim* can't even get their dialectics right.

He considers one Jewish stereotype, "which they, as the first burghers, were the first to overcome. . . . Because they invented the concept of kosher meat, they were persecuted as swine." Adorno acknowledges the Jewish image is that of a defeated people and says this is precisely the negative principle the world cannot abide, for the Jew represents "happiness without power, wages without work, a home without frontiers, religion without

myth." The first three conditions apply to only some Jews, but absolutely to Theodor Adorno and his fellow refugee intellectuals. If his work is his play, he truly receives "wages without work," and has "happiness without power." And if "homeland is the state of having escaped," then the free-spirited refugee inhabits "a home without frontiers," surrounded, no doubt, by Walter Benjamin's objects emancipated from the drudgery of usefulness.

Adorno derided the self-examination in popular autobiographies. In a late philosophical work, *Negative Dialectics* (1966), he argues that individuals are merely "agents of tendencies" outside their control, what Louis Althusser calls the "practices" we enact under the misapprehension that our performances are self-willed. In an important passage in an earlier essay, Adorno argues that the "illusive importance and autonomy of private life conceals the fact that private life drops in only as an appendage of the social process." Hence the cultural critic must examine the "social physiognomy" rather than the individual. Complicating this cultural anthropology was the fact that Adorno remained enough of a Marxist to discern a gap between the latent ideology of mass culture and "the lives of its consumers," who are deluded into taking a programmed desire for the real thing. So several layers of fiction must be stripped away before the cultural critic can arrive at something resembling an accurate observation.

In the mid-sixties, having long returned to Germany, Adorno surveyed his American experiences in an essay about intellectual émigré life, which was included in a collection of essays published by Harvard University Press. His title alone, "Scientific Experiences of a European Scholar in America," prepares the reader for a modest, straightforward discourse.

Adorno varies his manner of approaching the social through the individual—his language and perceptions change with the nature of his audience. This essay is in Adorno's public style. His manner is self-effacing: "I hope I went completely free from nationalism and cultural arrogance"—a superhuman require-

ment for one of his training. He recalls the refugee's need for "adjustment," and translates this "magic word" as a demand that he stop acting so "haughty" and cease invoking his former status. He seems sincerely grateful that Americans were helpful, more so than his democratic fellow émigrés scratching for the crumb of an academic position, and more than the postwar Germans, for whom democracy was a new game. Americans displayed none of the Germanic "silence in the presence of everything intellectual," though we wonder if Adorno welcomed the noise.

He allows that he found things wrong in America. From his study of astrology he developed conclusions about "reified minds," and though such minds were not "limited to America," he discovered their existence here. Adorno's later observations that his friend Siegfried Kracauer, the film scholar, had been forced to identify with the "aggressor" during his American exile does not convey much affection for the country, though Adorno could understand why friendless emigrants like Kracauer had to "capitulate."

In an unconsciously funny recollection, he describes his run-in with a Mennonite jazz musician (a collocation to amaze any refugee). The two worked together on one of Paul Lazarsfeld's early studies of mass culture. The Mennonite found him "arrogant," and, when Adorno made an educated guess that jazz fans would be more numerous in cities than small towns, regarded him as "a medicine-man." One is willing to guess that Adorno was indeed arrogant and that the American had a right to be offended, although Adorno was merely exhibiting "horse sense," a trait he conceded was central to the American character.

Perhaps Adorno's most honest remark comes at the close of the essay, when he confesses that he has negative attitudes about this country but says that "reflections of this sort are hardly conceivable without American experiences. It is scarcely an exaggeration to say that a contemporary consciousness that has not appreciated the American experience, even in opposition, has something reactionary about it." This country may have ex-

panded Adorno's vocabulary—H. Stuart Hughes has collected the Americanisms in Adorno's postwar writing—but its greatest gift, paradoxically, was to present itself as an awful example. In truth, Adorno is thankful to America for helping him define a truly independent "contemporary consciousness," one that would enable him to be in active, informed resistance against America itself.

Nowhere was Adorno more relentless or more wrongheaded in this resistance than in his attack on America's greatest cultural product, jazz. He first wrote about jazz in the early thirties and in the late fifties was still railing against "jazz, perennial fashion." Adorno dismisses jazz as a commodity, the tool of advertising—commerce, not art. Its function is merely physical, he says—he often cites "jitterbuggers"—and as dance or background music it never compels the listener's intellectual participation or "praxis." The vaunted stylists of jazz are really pseudo-individualists. Rebellion in jazz is accompanied by a "tendency to blind obeisance," and its so-called freedom is more like sadomasochism. Early and late, Adorno ignored polyrhythms and heard only the "crude unity of the basic rhythm," a rhythm derived from marching bands and thus explicitly military (he had no interest in the other social uses of band music in New Orleans). Improvisations are "mere frills," so carefully calculated that "any precocious American teenager knows that what appears as spontaneity is in fact carefully planned out with machine-like measures. . . ." For Adorno, there is no historical development in jazz; its devices remain the same, and as a perennial fashion it lacks the sole dignity of fashion, its transience. Tell Adorno that he has no understanding of "soul" and he would agree, while accusing you of bathetic fallacies.

Adorno's most vicious criticisms of jazz are sociopsychological. He finds jazz fans a terrified rabble, relaxing to the same rhythms that set them to work or to fight. Their sensual release is self-denying; his dialectical reflex is to consider it castration! He can sound like a member of the Legion of Decency: "Jazz's general implications are better understood by its shocked opponents than by its apologists. . . ." Jazz tends to effeminacy and

impotence: it demands that its adherents "give up [their] mas-
culinity" (so much for women in jazz). As proof, Adorno cites
Virgil Thomson's comparison of Louis Armstrong's trumpet
trills to the cadenzas of eighteenth-century castrati.

Equally outrageous is Adorno's interpretation of the split be-
tween "short-hairs" and "long-hairs." But at least here there is a
personal animus. He identifies himself with the "starving art-
ists" of the world, and defends them against smears on their in-
telligence and virility. You may call "long-hairs" sissies, he says,
but it is really the "short-hairs" who are castrated: "what the
shorn hair represents barely needs elaboration."

For a more appealing sense of Adorno's discomfort with
Americans, one must turn to his more introspective essays, with
their curious combination of intellectual generalization and per-
sonal pique. Early in *Dialectic of Enlightenment*, Adorno
stresses the value of thinking, its "superiority to reality by virtue
of distance." But thinking, in the capitalist world, has acquired
"an aspect of manic foolishness"; and its distance from reality
induces "anguish." In a society that will not allow a refugee the
dignity of memory, "History is eliminated in oneself and others
out of a fear that it may remind the individual of the degenera-
tion of his own existence." The emigrant's history has no thera-
peutic function and no market value; psychoanalysis and
capitalism have expropriated his past.

In a society that esteems only business success, the refugee's
nonconformity, his "manic foolishness"—a term answering to
Walter Benjamin's "dreamy recalcitrance"—renders him pow-
erless. He becomes "self-employed," that is to say, he has no
supporting institution behind him. Toward the end of *Dialectic*
is "A Personal Observation." Adorno notes that men of forty or
fifty, his own generation, exhibit a premature senility. They
have abandoned their youthful hopes and "adjusted," "come to
terms with the world." Better to appear childish or foolish than
to give over one's best self to the Aggressor.

To be childlike is to be tentative, provisional, and so there is a
late-Romantic air to Adorno's distrust of the fully achieved style
or product. Just as Valéry observed that "great art has some-

thing of the quality of finger exercises, of studies for works that were never created," so Adorno finds in his beloved Schoenberg's late music "paradigms of a possible music." Transcendence comes when the fully mature composer acts like a novice.

Adorno agrees with Benjamin that the cultural critic must retain the sensual apparatus of childhood. His essay on Kafka reads like a dialogue between a sophisticated scholar and a precocious, neurasthenic schoolboy. He discloses Kafka's literary models, a surprising number of them American: Edgar Allan Poe, detective novels, comics, American films, even a German fantasy of American life. But the essay's ambience is less the library than a child's bedroom. He describes Kafka's prose images rushing at the reader "like a locomotive in a 3-dimensional film" (a rare indication that he is not immune to the appeal of vulgar pop devices). The reader should move as in a dream, and ask no questions. Kafka saw himself as a deprived child, and his reader must be "like the youngest boy in the fairy tale . . . completely unobtrusive, small, a defenseless victim," instead of shielding himself in adult fashion. This is how to read Kafka—also how to decode the "cryptogram of capitalism" that is present without Kafka's having to name it.

Oscar Wilde said that criticism is the most civilized form of autobiography. Adorno's essay on Kafka conveys the range of his own personality: the magisterial critic and "the youngest boy in the fairy tale." He reads Kafka so well because he finds illuminations in the most opaque passages. He could be defining his own style: "Every sentence has been snatched from the zone of insanity," as is evident by the subsequent defense, "into which all knowledge must venture." To risk childishness and madness is to achieve knowledge; the anguish of Kafka and Adorno is that the adult world of "common sense" and "enlightenment" that condemns them is itself insane.

During World War II, Adorno compiled *Minima Moralia: Reflections from Damaged Life,* a journal he dedicated to Horkheimer. This was surely one of the most depressing products of

emigration, redeemed only slightly by an allegorizing process that makes the unhappy émigré an acute observer of disasters invisible to everyone else.

In the American society that he beholds, all positive elements have been corrupted by market mechanisms. "Commodity forms" dominate all relations. So on the first page, he presents divorce and alimony as the reduction of romance to accounting, the accumulation of property. Adorno demonstrates the nouveau riche nature of American culture, perhaps too much in the manner of an elitist émigré. He laments that the most subversive material can be neutered by large-scale distribution: "Even Kafka is becoming a fixture in the sub-let studio." If Adorno appears insufferably arrogant in his contempt for inexpensive reprints, he is also harking back to his objection to phonograph recordings. In the forties he visited the typical flat of an urban intellectual. He found cheap van Gogh reproductions, even a Random House edition of Proust—mocking Proust's intentions by its very "omnibus" shape—a phonograph and a record collection of political cantatas, Broadway musicals, and "noisy jazz." Listening to the *Oklahoma!* album or jazz would make the listener feel at once "collective, audacious and comfortable." Adorno may be sympathizing here with these listeners, but they do appear foolish. Yet, as usual, he is on to something. In recent years the inexhaustible appetite of the mass media for anything the traffic will allow has been shown too often, turning class confrontations into "psychodrama" and "situation comedy." As a result, political events are now regarded with the same nostalgia as canceled television series and oldies-but-goodies, all manifestations of the desire to "bring back the sixties."

Mass distribution devalues high culture while low culture vulgarizes every human response: Adorno goes to the movies and finds audiences laughing at death. Prepackaged movie music makes individual responses superfluous: "Music does the listening for the listener." The bourgeois contempt for the body makes love uncomfortable, sloppy, "sticky." Perhaps sentimentally, Adorno hails sexual bliss as a reminder of a "forgotten life." But in America remembered life is embittered and unprof-

itable, death is comic, and love is messy. No wonder Adorno's outburst: "Anyone who knows freedom finds all the amusements tolerated by this society unbearable."

These are general conditions impinging on the émigré's life. *Minima Moralia* also focuses on the individual. Its first entry—dedicated, appropriately, to Marcel Proust—describes the intellectual son of well-to-do parents. Much like Adorno or his friends, such a man will appear to be a "dilettante," not "professional" to his fellow scholars. For this fellow "repudiates the division of labor" and recognizes no distinction between work and recreation. Ian Watt remembers a morning talk with Adorno; after describing his own workaday routine, he asked about Adorno's, and was informed, "I have been meditating on erotic and musicological problems." Adorno shows little sympathy for the "competing supplicants" scuffling in the academic marketplace, exhibiting their worst qualities to their fellow émigrés. In selling out, they exchange their play for work. As the academic becomes the businessman's twin, he loses his "joy," his youthful spirit, his critical distance, his capacity for real experience.

In another somersault of dialectics, Adorno argues that the infatuation with private life proves its absence. He admonishes his fellow refugees not to overvalue their privacy. Because the ownership of goods falsifies our relationship with them, and with our neighbors, "it is part of morality, not to be at home in one's home" (remember "Homeland is the state of having escaped")—yet if we remain too aloof from things, we abandon people as well. This is a dialectical imagination mired in despair: each about-face signals a refugee who believes he must stay poised for flight. Goods will disarm him into believing he has a life when he doesn't even have a history.

Without divulging many intimate details, Adorno allegorizes his posture until the book becomes a treatise on how to live "in an incomprehensible environment." You are called critical? There is "no remedy but steadfast diagnosis." Haughty? The "esoteric gesture" of "austerity" may have been affectation in Europe, but it is fundamental now. They call you biased? "The splinter in your eye is the best magnifying glass." He quotes

Hegel: "To think one's limit is to cross it," a whimsical summation of the intellectual play that is the refugee's only freedom.

He accepts the risks of unpopularity: you will stand apart if you criticize both capitalists and proletariat. Like Kaiser Wilhelm, society tolerates no Jeremiahs. They'll call you "tactless," as the Mennonite jazz musician called him "arrogant." They'll call you aloof, but "he who integrates is lost": in a horrifying— and unconvincing—parallel, he compares integration to the concentration-camp technique of turning prisoners into murderers. One might as well not attempt to reach these barbarians, for as the writer expresses himself more "precisely, consciously, appropriately," he is perceived as "obscure" and "inconsiderate." Hannah Arendt courted unpopularity for the advantage of entering the political arena. Adorno's aspiration is more modest: "to be still able to perceive anything at all."

As always, lurking behind the esoteric gesture is the child. Well as Adorno evokes the émigré's economic plight and his crisis in intellectual identity, *Minima Moralia* expresses a terror that resides deeper and appeared earlier. For Adorno, the worst fears of childhood have been realized. He compares the bourgeois father, accusing his children of disobeying his orders in order to enjoy themselves, with a guard at Auschwitz; he notes the progression from the child's sibling rivalry to Fascism, and finds the war's origins in British public schools and German military academies. In an odd burst of "homophobia," he sees the homosexual as totalitarian in his rejection of anything unlike himself; these homosexuals are "tough guys." At Oxford, where Adorno spent some years, aesthetes are "almost automatically equated with the effeminate." The assault can be read, then, as a refined intellectual's revenge on the schoolboy bullies of his youth: "You're the real sissies."

Childhood is not all misery. From a children's song about rabbits he first derived an "unrestricted openness to experience, amounting to self-abandonment." Here, uncharacteristically, he drops the dialectical apparatus with which he usually evaluates

experience. The child stands open before the world. The behavior of children and animals provides a vision of post-Enlightenment society. Yet, finally, Adorno was too smart to idealize childhood innocence. In his later essays he argued that the id was both defenseless and inauthentic—what seemed to be primordial lusts and stirrings were, in fact, programmed from without; only the ego was strong enough to resist the cultural juggernaut.

Minima Moralia's one autobiographical passage, "The Bad Comrade," makes plain the connections between an unhappy adolescence and an adulthood of emigration. Adorno remembers his German classmates, and sees in their bullying behavior a forecast of Nazi violence: "In Fascism, the nightmare of childhood has come true." Almost sheepishly, he confesses that "it often seemed to my foolish terror as if the total state had been invented expressly against me." Adorno is too supple and inventive for us to go back and find the origins of his despair entirely in his childhood. But how much this passage does tell us: "I felt with such exquisite clarity the force of the horror towards which they were straining, that all subsequent happiness seems revocable, borrowed." The Third Reich fulfilled his "unconscious fear."

Adorno escaped to the rewards and accomplishments of an adult career, as have countless bright children who were outcasts in school. For most such people, childhood enemies return perhaps in nightmares, as a limit on absolute happiness. For Adorno, they represent every force that "dispossessed me of my past life and language." The bullies who beat the outsider grew into Nazi torturers. The ones who laughed raucously when "the top boy" made a mistake later laughed at a Jewish detainee's botched attempt at suicide. "They who could not put together a correct sentence . . . found all mine too long"; the critics of the future refugee's language would become the Nazis who destroyed German literature. (His famous pronouncement, "To write poetry after Auschwitz is barbaric," has the extravagance of an improbable revenge.) The working-class boys who majored in crafts became the Third Reich's technicians, in a ridicu-

9

Not a "Nice Guy": Bertolt Brecht

"Even his thinking is sensual." Since Bertolt Brecht played so cunningly with the identification between himself and Galileo, we can use his characterization of the scientist to situate the playwright. So much is made of Brecht the theoretician, or Brecht the Party man, that we need such reminders. He examines the role of the refugee with all the intellectual rigor of an Eisler, Adorno, or Benjamin, but he tests and elaborates upon that role with a playfulness absent in their work. This makes him appear at times something less than serious. Benjamin said that Brecht imagined some tribunal questioning him about his political aesthetic, "Did you mean that seriously?" and his replying, "Not quite seriously," but then adding that his conduct was *"legitimate."* He eluded precise definition in order to oscillate between the categories. This was, in part, because the dialectical swing amused him. In his *Refugee Dialogues* he discovered wit in Hegel's ideas, marching in wedded pairs with their polar opposites in a ravishing symbiosis.

"Long live dialectics!" Brecht concluded, as if this were the only satisfaction left him. The tone here is, as often, both melan-

choly and ironic. Brecht recognized that his need for ideological confirmation was itself sensuous: "My love for light flows from my rather obscure thinking. I have become a little doctrinaire because I have urgent need of direction. My thoughts get easily confused. I acknowledge this calmly; confusion calms me." And with an intellectual disposition that resembles a physical instinct, "If I think something through, I immediately oppose it."

This is a man who could be mean—during the 1920s, he dismissed his former collaborator Kurt Weill's music as "culinary"—and coarse—in New York, in 1935, he encapsulated American theater as "shit"—and hysterical—in the forties he compared a Broadway producer with Hitler—and whose very person could be repellent, because of the rankest cigar smoke and body odor (he suffered from a chronic foot condition). But even as a physical presence, Brecht played both a role and its own commentary. His swagger and his infatuation with boxers had the pugnacity of a boy who had lacked a certain kind of early social success. In California he criticized American education's obsession with "popularity." Like Adorno, he had not been popular; unlike Adorno, he insisted he did not wish to be. If adolescence helped make Adorno apprehensive, it made Brecht costive, as intellectually contentious within the sphere of his own imagination as he could be physically offensive.

Just as Brecht analyzed brilliantly the social implications of gesture, his own appearance registered more meaning than he realized. Max Frisch, meeting him after the war, noted that Brecht looked from the distance like a working man, until, up close, Frisch could see he was too "unrobust, too slender, too alert." Brecht's slovenliness embarrassed bourgeois intellectuals; but Frisch beheld "a refugee, slinking, watchful, who has already left countless rail depots, too shy for a man of the world, too hardened for a man of learning." This was not a man liberated by the dialectic but a physically frail refugee, "knowing too much not to be apprehensive, a stateless person, a man of limited sojourns, a passer-by in our times." The mold had been set; Brecht still resembled a man on the run.

———

The six years Brecht spent in America were not very pleasant or productive. There was almost no public support for Berlin's most famous playwright. "Wherever I go, they ask me 'Spell your name!' . . . and oh, that name was once accounted great." Yet considering what he represented, it is not surprising that he failed to find a public here. Out of the rigor of his theory came a body of work that provided none of the conventional consolations. Not the religious ones: his "parable of the pound" in the *Threepenny Novel* made Jesus a liar and all forms of benevolence hypocritical; while in the United States, Brecht profoundly offended W. H. Auden and Christopher Isherwood by dismissing their spiritual beliefs as evidence of despair and cooptation, signs that they had been "bought." Nor would Brecht's aesthetic allow for smugness among his fellow Marxists; as he would later tell the critics after his return to East Germany, his concave mirror distorted even positive characters. Perhaps what most set him apart from the humanist tradition in Anglo-American literature was his attempt to "smash the introspective psychology of the bourgeois." His Epic Theater treats individuals as the instruments of objective social conditions.

This is not the world of Jane Austen or E. M. Forster or James Joyce or Virginia Woolf. Brecht's aesthetic is so special that it has the intended effect of making the most disparate approaches appear alike in their concern with the individual. Brecht even removed the confidence of spontaneous physical life: his concept of the *gestus*, as realized in performance by his friend Peter Lorre, comprehended "bodily posture, accent, facial expression" and treated them all as exemplifying a "social relationship, like exploitation or cooperation." So philosophy, psychology, physical life are all demoted in Brecht's theater. He takes perverse pleasure in denying room to intellectuals who seek depth of any sort. As he tells Benjamin in one of his most acid remarks, "Depth is a dimension of its own, just depth which is why nothing comes to light in it." The last thing Brecht wanted to become, after escaping to Hollywood, was what Americans called a "nice guy."

Yet of all the refugee writers, Brecht had shown the most extensive interest in America before he saw it. Up to his conver-

sion to Marxism, he had celebrated America for its technology
and popular arts as the most vital spot on earth. And even later,
America remained the focus of his attention, but as an example
of the ultimate horrors of capitalism, to be caricatured in *St.
Joan of the Stockyards, Happy End*, or *Mahagonny*. Brecht en-
joyed popular culture, hymn tunes, movies, murder mysteries.
He was also capable of moving gracefully between cultural
realms, and as always, of creating out of the clash of two objects
a third figure. For example, Hans Mayer describes a survey
conducted by *Die Dame*, a women's magazine edited by the ref-
ugees-to-be Vicki Baum and Anita Daniel, of "the strongest im-
pression." Brecht replied in one sentence, "You're going to
laugh—the Bible." ("You're going to laugh" was a slang expres-
sion in the cabarets. It usually announced an absurdity, and its
very usage implied a demotic irreverence.) This kind of city talk
skirts obscenity and blasphemy but radiates too much confi-
dence and optimism to become either. Such fluent negotiations
of tone and idiom suggest how easily Brecht could speak to a
popular audience. A similar manner allowed other refugees,
such as Kurt Weill and Billy Wilder, to master American cul-
ture. But Brecht did not utilize his capacity in America, though
some of his unfulfilled movie projects might have allowed him
opportunity—e.g., a modern-dress version of *Macbeth* involving
Slavic immigrants in the Chicago stockyards.

When Brecht's exile began in 1933, he is reported to have told
a fellow émigré, "Don't go far away. In five years, we will be
back." He stopped in Prague, Vienna, and Zurich, where he en-
countered Walter Benjamin and Heinrich Mann. 1935 found
him in Russia, briefly reunited with Erwin Piscator, the great
director of the Brecht-Weill collaborations. Neither man did
well in the Soviet Union, though both were luckier in Russia
than some other members of the German theatrical colony, who
were exterminated. The same year Brecht joined Hanns Eisler
on a tour of the United States, where the two proceeded to dis-
miss the naïve native attempts at Brechtian theater.

Benjamin, of course, did not make it to America. But the two
writers met in Svendborg, Denmark, where Brecht lived for
some years. Benjamin kept a diary of their conversations. In

them, we see the émigré Brecht at his most despairing and mercurial; at this time he hoped history would regard him as a middling sort of maniac. Benjamin wrote of Brecht's "curious indecision" and his attempt to distinguish himself from other "less advantaged" refugees. This does not suggest much perceptiveness by Brecht about his own lot, and was contradicted anyhow a few days later when he exclaimed: "They have proletarianized me as well. They have not only taken away my house, my fishpond and my car; they have also stolen my theater and my public," as well as the living models for his characters. This is typical Brecht, immediately, acutely aware of specifics; not merely the house is gone but the fishpond and the car. Emigration proletarianizes him and reminds him of a fundamental rottenness: the Germans are terrible, Hitler is indeed their spokesman, and "in me, too, whatever is German is bad." He recalls his hometown, Augsburg, calls it a "dung city," and makes a shrewd distinction between the Free Reich cities and the city states of the Renaissance: again his characteristic impulse is to locate the German "narrow-minded self-sufficiency" in political history, even as a gesture must always express a social relation. In America, Brecht was to exhibit a much more tolerant attitude toward his fellow Germans. So this linkage of philistinism and bigotry with the forces that have deracinated Brecht is clearly a *cri de coeur*, though not without premeditation.

By 1934 Brecht had affirmed "artifice" as a necessary means for the émigré to convey the truth. His writing had always been compact, Aesopian, ironic, his messages embedded in layers of street sarcasm that qualified the strictest party line. (He was unbeatable at put-downs because his dialectical wit afforded his opponents no room to maneuver; any straightforward defense would expose them as being hopelessly philistine or tone-deaf.) Yet Brecht was a Marxist playwright from the late twenties on, and political and economic realities informed every element of his art.

The question of Brecht's Stalinism has perplexed many crit-

ics; it led Hannah Arendt to the implausible conclusion that he
paid for his bad politics with the loss of his talent. Yet an ortho-
dox Communist like Wieland Herzfelde still recalls Brecht as a
not-quite Marxist who always retained a tinge of anarchism.
Not that he didn't try to leave another impression. Klaus Mann
had met him in Denmark in the thirties and was repelled by
"the strange, arid hyperenthusiasm." Mann detected an "icily
intellectual ecstasy" about Brecht's Marxism, as he might also
have in his plays. Brecht was so vocal a convert that George
Grosz used to call him "schoolmaster Brecht." Brecht's own
views of Stalinism were problematical. He wrote poems about
the leader of the Russian Army who succeeded, at a cost of
twenty million lives, in defeating Fascism in Europe; he referred
to Stalin variously as a "classic" and "the useful one." But he
knew the reality of Stalin was less simple. To begin with, his
own Marxist allegiances were extra-Stalinist. Hans Mayer re-
ported that until his death Brecht continued to plan a play about
Rosa Luxemburg. Perhaps he merely found the dramatic possi-
bilities unworkable, but he also knew that any play about Lux-
emburg would have to confront issues that would discomfit the
Stalinists; he feared that "in a sort of way, I would have to argue
against the Party." In Svendborg, he told Walter Benjamin that
he disagreed with Stalin's concept of "socialism in one country,"
implicitly siding with Leon Trotsky, who argued that the encir-
cled country would have to compromise with its capitalist
neighbors in an exchange that would always work to its disad-
vantage. To Benjamin, and also to his friend Karl Korsch,
Brecht admitted his reservations about the Stalinist cult of per-
sonality and the brutalities of forced industrialization. Well into
the 1950s, he used the material of this debate in an incomplete
work titled, appropriately enough, *The Book of Changes.* The
Moscow trials engaged everyone's attention while Brecht was in
Svendborg, and he admitted here too that there were excesses,
though he believed there was some validity to the charges. More
telling was the despair he voiced in 1943 after reading a biogra-
phy of Stalin. Sounding like a Trotskyist, he deplored the
"transformation of a professional revolutionary into a bureau-

crat" and of "an entire revolutionary party into a bureaucratic body."

Yet Brecht did not air these reservations publicly. In part this was in keeping with his lack of interest in heroes and leaders. He insisted that he was defending the Soviet Union, not Stalin. As he wrote Karl Korsch, the Soviet Union "is not only a workers' *state*, but also a *workers'* state"—i.e., the leader will depart, the workers will remain, the class character of the state will produce reform from within. Henry Pachter remembered from his talks with Brecht the playwright's need for political confirmation. The Soviet Union was "his last and only rock to stand on . . . Stalinism was an ephemeral transitory phenomenon." Pachter reported Brecht's belief that Stalin would be forgotten in fifty years; Brecht added, however, "But I want to be sure they still play Brecht. Therefore, I cannot separate myself from the Party." This is in part a self-serving statement: imagine its analogue from an American writer defending his silence during the McCarthy era. But Brecht was well acquainted with self-valuation, as shown by his declaration in an autobiographical work of fiction that he lacked backbone, or his poetic comment, after a fruitless expedition for hack screen assignments, "And I . . . I am ashamed." He could even make Berlin comedy out of it. In one of his last works, someone asks a Herr Keuner what he is doing, and this Brechtian figure replies, "I'm having a lot of trouble; I'm preparing my next mistake."

On July 21, 1941, after a two-month trip that began in Finland and diverted him to Moscow, Brecht arrived aboard a Swedish boat, the S.S. *Annie Johnson*—the very name is Brechtian— with his wife, the actress Helene Weigel; their two children; and his assistant and mistress, Ruth Berlau, in San Pedro, California. During the trip, he threw his copy of Lenin overboard; after years of dodging European government authorities, Brecht had no desire to provoke American officials. In an incident no less fortuitous than all those of the preceding eight years, the archfoe of Hitler had received a certificate of good behavior from the

German government that made possible a passport application. Brecht's failure to remain in the Soviet Union has been explained by Communist friends as resulting from (a) conflicts with the literary line set down by George Lukács, (b) the end of *Das Wort*, a German-language journal he edited, and (c) the lure represented by the many friends exiled in Hollywood. The actor Fritz Kortner and Dorothy Thompson sponsored his entrance; affidavits were also signed by Luise Rainer and the poet H. R. Hays. The Hollywood colony included some old friends: Peter Lorre, Lion Feuchtwanger, Berthold and Salka Viertel, Hanns Eisler, Oskar Homolka. As members of the European Film Fund, Fritz Lang and William Dieterle had helped subsidize his last years in Europe, and they proved generous again during the initial difficulties in America.

On his earlier visit with Eisler to this country, Brecht had been contemptuous of American cultural life. Clearly, his move here was prompted by necessity alone. During his stay, he always insisted that he was not an "emigrant" in the throes of resettlement but an "exile" on the verge of returning to Germany. He remained a needy case: almost from the start, his American life was regulated by an obsession with money. He stayed in California only because Feuchtwanger had assured him that it was a better place for refugees, cheaper, with more opportunities for employment. The Brechts lived during the first years on $120 a month: this would be the equivalent of $500 today, still a poverty-level income for a family of four. Elsa Lanchester remembers the Santa Monica house the Brechts moved to in 1942 as "rather untidy," with a toilet that didn't work, but with a "wonderful apricot tree"; not perhaps a replacement for the house and pond in Svendborg, but at least a source of *aprikosen*, that fruit beloved of Germans—no small consolation for Brecht, who commented on the bad quality of American food. (In 1941 he described the California markets as filled with giant fruits that possess "neither taste nor smell.")

Brecht had no American audience, and his plays were virtually unperformed. So he joined his fellow émigrés in the movie industry. There seems to have been no affection for the

medium or imaginative energy that determined this decision. Rather, he agreed with his friend Eisler that no serious artist would work in Hollywood for any reason but money.

> Every day to earn my daily bread,
> I go to the market, where lies are bought,
> Hopefully
> I take up my place among the sellers.

The implicit irony of that "hopefully" suggests that he may become both the salesman and the commodity itself; this was an undreamed-of extension of the "hope" he had once advanced as the exclusive requirement of emigration. The Hollywood situation provoked Marxist analyses akin to those of Eisler or Adorno. By October 1941 Brecht had conceived a metaphorical history of capitalism that began in the Elizabethan theater and ended in Hollywood. Always alert to resemblances to earlier playwrights, he now compared the hack writers of Elizabethan England and southern California, both groups writing quickly on demand. This was, once again, both shrewd analysis and a magnifying of his own situation. By December 1941 he was defining Hollywood as a network of "buyer and seller, master and servant," surrounded by hierarchies of "experts and agents." Art becomes merchandise, "crippled and raped." He had a crazy vision of Hollywood executives screaming "Deliver the goods"—"show [us] what we want to have shown"—discern our wants—"Divine our secret desires"— fulfill our needs: "Show us the way out, / Make yourself useful!"

Yet he tried to deliver. Almost none of his film projects came close to being realized, but many were worthy enough. He revived an idea that he had entertained in the 1920s, to be titled *Joe Fleischhacker in Chicago*, about an entrepreneur's attempt to take over a "Mom and Pop" bakery. This leads to an adulteration of quality. Fleischhacker finally learns that good bread can be baked only with goodwill, a good social spirit, and "a good appetite"—Brecht never neglected the last part. Here was a theme that spoke to his heart, and more than his heart: he wrote in his journal that "there is no real bread in America," a com-

mon enough cry among émigrés. As late as 1944 Brecht hoped to make the film *The King's Bread* with his new friend Charles Laughton.

He dreamed of other projects involving his friends. Some were conventional: for William Dieterle, whose films had expressed enough social consciousness to disturb Congressman Martin Dies, he offered a revision of a script on jazz, *Syncopation*. Brecht knew little about jazz, but he appreciated the irony that the film's sponsors wished Dieterle to downplay the Afro-American element in favor of the love interest. But for Peter Lorre he contemplated a film version of Gogol's *The Overcoat*. The combination might have produced a classic film in which the paranoia of Gogol's hero was rendered even more intense by the émigré situation of Brecht and Lorre. (Brecht's friendship with Jean Renoir might have introduced another émigré element to the project.) Less promising but still daring was the American version of *Macbeth* that involved Lorre in its early stages.

Brecht finally made money in Hollywood, from an unlikely source. In January 1942 he spoke sarcastically of the "Metro-Goldwyn-Mayer Gospel for the little man," but in 1944 it was Samuel Goldwyn himself who paid a fifty-thousand-dollar advance to Brecht and Feuchtwanger for *Simone Machard*. Not surprisingly, Goldwyn had been confused by the play, and it was Feuchtwanger's more conventional novel on the same topic that had prompted Goldwyn's purchase. The film was bought for Teresa Wright, who was then pregnant. By the time Wright was ready, the topic of French Resistance was no longer topical. Perhaps as well, given Brecht's own doubts about the project.

The one Hollywood project that materialized, *Hangmen Also Die*, provided yet another disappointment. The assassination of Reinhard Heydrich, sent by Hitler to "protect" Czechoslovakia, was an appealing subject for Brecht, though he didn't know that the Czech assassins were also British agents. The film featured the talents of several illustrious émigrés: Fritz Lang directed, Eisler composed the score, and the cast included the Berlin actor Alexander Granach. Yet from the word go, bickering disrupted the very political and cultural loyalties the film was supposed to dramatize. Brecht managed to wangle a salary equal to that of his Ameri-

can cowriter John Wexley from the European producer, Arnold Pressburger, who saw his finagling as "blackmail." Brecht didn't know that Wexley was a member of the Communist Party, and tried to instruct him in Marxist ideology. Fritz Lang was not as sympathetic as Brecht had expected; he turned down two of his agitprop titles, *Never Surrender* and *Trust the People,* and excised scenes that dramatized the need for a multiclass Popular Front (although Brecht was able to sneak in Hanns Eisler's "Comintern Song"). Brecht also abhorred Lang's box-office mentality—"the public will accept this"—and claimed that the director showed so little sympathy for the Czech Jews' plight that he refused to show them wearing the obligatory yellow star. The final insult was that Wexley received sole credit for the screenplay, though Brecht was to have been listed as coauthor of the story with Lang. The infuriated Brecht brought his case to the Screen Writers Guild. Lang and Eisler testified for him; Pressburger had his revenge and stayed home. The absurd guild decision favored Wexley. The guild reasoned that Wexley was an American writer who needed screen credits while Brecht was, as Max Frisch might say, on "a limited sojourn" and would return to Germany anyhow. Here was simple unfairness compounded by chauvinism and casuistry. After leaving the hearing, Brecht wrote, "The look of intellectual mutilation makes me physically ill."

Frustrated in his work and discontented with his physical surroundings, Brecht nevertheless retained his good humor, according to Elsa Lanchester, who remembers him as "always funny about institutions and authority," simply a "professional 'anti-.' " Brecht's sense of play renders his private criticisms more convincing perhaps than those of Adorno, which are so untouched by anything like fun. Still, his pleasures were always short-lived. If he granted that "the houses in Hell . . . are not all ugly," Los Angeles was still Hell, and the danger of winding up on its streets dispossessed preoccupied the inhabitants of its villas and shacks. It hit him that "these pretty villas are built

from the same material as the ruins over there"; again the refugee fear that the very stuff of houses and furniture mocked his existence. So "we live in a time without dignity."

Brecht stressed the absence of dignity with all the alarm of a scholar robbed of his privacy. In March 1942 he described how "a universally demoralizing cheap prettiness stops one from leading anything like a cultivated, i.e., dignified life." A month earlier he despaired that "utensils . . . , dwellings, furniture, even the landscape itself are mean, infamous and undignified." Likewise "eating, looking at a landscape, talking, writing a book, reading a book, business—all that has an ulterior purpose, . . . and is not quite dignified and satisfying in itself." He joined Adorno in looking back to the Old World intellectuals "who work for something finer than their pay." At such moments Brecht came closest to the refugees he otherwise mocked for playing those same old games.

He shared Adorno's contempt for the émigrés' clownish attempts at assimilation; however, he found Adorno's crew the most despicable of all. True to form, Brecht's gloss on the Frankfurters combined a historical insight with a political animus; his disdain for Adorno's hauteur constituted a rather typical tale of émigré backbiting, involving two atypically gifted and eccentric writers. During the war years Brecht parroted the Stalinist line and regarded the Frankfurters as fallen Communists. Their resident economist Friedrich Pollock diagnosed Soviet economy as "state capitalism," which was anathema to a Communist, whether Stalinist or Trotskyist. Pollock also believed that public works would pull capitalism out of its cyclical depressions: the raising up of highways had overturned Marx's theories. Brecht found all this disgusting. Almost anything would be better: in a 1941 diary note, he commended Hitler's "excellent . . . criticism of the Social-Democrats and of the Frankfurt School."

As mentioned earlier, before coming to America, Brecht had been planning a novel about "Tuis." After lunch at Horkheimer's one day, Hanns Eisler suggested the Frankfurt institute to him as the very model of a Tui group; here were the sons of millionaires shedding tears over laborers, speculating about

the sources of the working class's troubles. Yet Brecht and Eisler kept turning up at institute evenings. Perhaps it was better to argue in German than to socialize with ignorant Americans. In his early turn to Marxism, Brecht had been influenced by Fritz Sternberg, a historian who had written a study of imperialism for the Frankfurt institute in Germany. Eisler, a facile dialectician himself, had worked in Germany with Ernst Bloch and later, as we have seen, collaborated with Adorno on a study of film music.

Brecht and Eisler, precisely because they could play the Frankfurters' intellectual game, saw through some of its sillier manifestations. One time Horkheimer spoke with alarm about Vice President Henry Wallace's promise that after the war each child in the world would receive a daily pint of milk, as if capitalism would seduce the masses with an outpouring of real milk, and "not just [the] milk of human kindness." Brecht was delighted by the image of well-fed scholars, enamored of *Würstchen und Rauchfleisch,* begrudging children a pint of milk. Two months later he reported that the same Horkheimer was worried that cultural demands would decrease when the "needs of the body were too well-satisfied." Brecht developed this argument: "Suffering created culture, apparently barbarism will follow if suffering is abolished."

Brecht also bemoaned the miserable times he spent with Herbert Marcuse and Leonhard Frank: "The intellectual isolation here is monstrous. In comparison with Hollywood, Svendborg was a world-center." Frank had gone from writing *Der Mensch Ist Gut* to "a Boy-Meets-Girl romance," exchanging one cliché for another.

Brecht was not, however, a total misanthrope. He maintained his friendships with the refugees Peter Lorre and Oskar Homolka, and proved surprisingly sympathetic to Alfred Döblin, who at a birthday party in 1943 confessed that his "lack of God" had compromised his anti-Fascism (a matter apparently rectified by his family's secret conversion to Catholicism). Brecht was also generous to Heinrich Mann, perhaps as a means of showing up his enemy Thomas.

In much the same way that Brecht had always loved Ameri-

can films and detective novels, he showed a deep curiosity about regional idioms and folk tunes, especially since folk music was largely an obsession of the American Left at the time: in an amusing adaptation of Huddie "Leadbelly" Ledbetter's "Gray Goose," he had this symbol of oppressed black America fly to the east. He also studied the history of the American labor movement, and planned to write a play about Joe Hill.

Brecht was not unmoved by his American neighbors—"small people." He admired their grace and generosity, their refusal to snoop. Quick to derive a *gestus* from a gesture, he saw in their agility a freedom from "the pinched, neurotic disposition of German petty bourgeoisie . . . their servility and arrogance." Yet they too were without dignity. Their newspapers broadcast working-class violence; the cost of sickness would wipe out their savings; they shared "stinking prejudices" against Negroes, Jews and Mexicans. While emigrating, he had avoided the ownership of property. But now he offered a condensed Marxist explanation for his neighbors' loss of that dignity provided by a fixed residence: "people change their place of work and even their trade" so often that "they have neither a fatherhouse nor a home." School grades were given for "popularity," a status he himself had never sought, even as a child. When the popular child grew up, he was expected to remain a "regular guy," trapped in the inertia of routine. Brecht made a career of exploding the bourgeois obsession with the individual, but even he commented that "all this leaves little room for individuality."

A sign of his distance from American life was his failure to translate certain American expressions in his journals, as if the experience were as uniquely American as the vocabulary. "Here if anywhere it would be necessary to keep one's distance." He described the gambling atmosphere of Hollywood as *"das Roulettespiel mit den* Stories," as if movie fictions were too flimsy to be called *"Geschichten." "Spielen ist hier* Acting *und* Gambling"—in fact, the German word can refer to both activities. Brecht's point was that here they were coincident, as mammon turned art into activity that was random, contingent, immoral. Brecht dismissed the Hollywood intellectuals with their own language. Clifford Odets, the soi-disant radical, discussed film-

ing Brecht's play *The Private Life of the Master Race:* the journal notes "Odets *sucht* [seeks] something uplifting." The German of Brecht's past had no equivalents for the American "easy-going, cheerful and mentally balanced," at least not in such casual combinations.

By 1943 Brecht had spent enough time in New York that he could identify Louis B. Mayer and the Theatre Guild as the enemies of serious dramatic art. "In the States," he wrote, "there is as much and as little theater as in ancient Rome." The theater provided no alternatives; if there was "escapism," it was merely up the elevator. Living in a Hollywood of pinup queens, he complained that the aphrodisiac stopped at the tease. Though all this didn't inspire him to feats of prodigious screenwriting, he remained as committed as ever to the principles of Epic Theater. Elsa Lanchester witnessed demonstrations of this zeal. She remembers that the translation of *Galileo* took two or three years (curiously, her politically cautious husband Charles Laughton insisted on "sharper formulations"). Brecht's constant presence ruined her comfort; she remembers that the "sourest, bitterest smell" from his cigars required her to change the upholstery, a complaint that reads like a line of Brechtian dialogue.

His Broadway excursions were unsuccessful, though his stay in America produced one masterpiece, *The Caucasian Chalk Circle*, as well as the brilliant new version of *Galileo*, with its transparent allegorical references to the recent activities of American scientists. Disappointment and frustration did not bring out the best in him, as a review of his Broadway period shows. He shared his first Christmas in Santa Monica with the actress Elisabeth Bergner, a fellow pupil of Max Reinhardt. Bergner found his *Good Woman of Setzuan* boring. She was unimpressed by the prospect of politically didactic theater. Not surprisingly, her acting displeased Brecht some years later when she performed in the title role of his adaptation for Broadway of *The Duchess of Malfi*, but he hardly needed to allude to her "lack of intelligence and stature" in the play's published notes. After his many unkind pronouncements about Kurt Weill,

Brecht resumed discussions with the Weills in 1943. They centered around a musical version of *Good Soldier Schweyk*. Weill was tough enough himself, insisting that an American playwright like Ben Hecht "render the humor of your script in American terms." With a loan from Peter Lorre, Brecht commissioned an American poet, Alfred Kreymborg, to do a translation. Erwin Piscator had been planning to use the same translator for the dramatic production of Brecht's 1928 play that he was contemplating. The ensuing bitterness involved precisely the "same old games" Brecht expected refugees to stop playing: Piscator saw it all as another "swinish Brechtian trick."

Unpleasant as were the insults to his friends Weill and Bergner and the undercutting of his old mentor Piscator, there was meaner, more indefensible behavior. Luise Rainer, the actress, and H. R. Hays, the poet, did not even know Brecht when they signed his affidavits. Rainer suggested that Brecht use the legend of the Caucasian chalk circle for a play. Brecht confessed that he had considered the same idea for years. Rainer went to the trouble of finding a backer, but when after some time she asked Brecht about the play's progress, he responded with extreme rudeness. He finally sent her a script while she was recovering from malaria that had been contracted on an army tour. This apparent callousness was in keeping with a characteristic that Max Frisch noted: "Brecht, perhaps like all other people who live independently, is not at all interested in approval." Or perhaps Brecht might echo Jay Gatsby's observation that someone's dislike was "only personal."

Brecht requested that H. R. Hays turn his storyline for *The Duchess of Malfi* into dialogue. Meanwhile, he courted W. H. Auden for the same play—"I have told Miss Bergner that no one could do it better than you"—which prompted Hays to quit. The final Broadway production relied mainly on the original John Webster. Auden received sole credit, in a farcical replay of the *Hangmen* situation.

It is often observed that Brecht, despite his obsession with American matters in Europe, wrote no plays about America while living here. His responses to American life were as negative as his estimate of American entertainment. It is therefore

noteworthy that Brecht spoke more positively about the American theater. In the text for *The Caucasian Chalk Circle*, he claims that "its structure is partly conditioned by a revulsion against the commercialized dramaturgy of Broadway," yet the contrary Brecht admits that the play also "makes use of certain elements of that older American theater whose forte lay in burlesques and 'shows.' " He links this tradition with the films of "that splendid man Chaplin." What he liked about burlesque shows and Chaplin movies was their concern with style—"how" rather than "what."

He was even more full-throated in his praise of Broadway in his notes for *The Duchess of Malfi*. "The model to be followed is the Broadway musical which, thanks to certain fiercely competing groups composed of speculators, popular stars, good scene designers, bad composers, witty if second-rate song writers, inspired costumers, and truly modern dance directors, has become the authentic expression of all that is American." This is quintessential Brecht, from the sneaky knocks at "bad composers"—did Weill read this?—to the Marxist enumeration of "competing groups," all conjoined in the poetic leap that makes Broadway the "authentic" expression of American life. Perhaps because of his early training with Max Reinhardt, Brecht was prepared to see parallels between Broadway musicals and his Epic Theater. The folkloric devices of Broadway ballets, doubtless those of Agnes de Mille, produce "alienation effects"; the choreography dramatizes social relations; its mime is composed of "gestic elements." Elisabeth Bergner and company did not share Brecht's notions about performing *Malfi*. In a last shot at them, Brecht admitted that the American musical is "entirely phony, . . . empty entertainment in greedy obedience to the fashions of the day," but that its "primitive epic methods" would have allowed for a more contemporary rendering. The show was a flop, but the spectacle of Brecht scolding the company for not being sufficiently true to Broadway—after all, Bergner was German and Auden was English—provides considerable amusement.

A survey of Brecht's American career shows the greatest of refugee playwrights disdaining the counsel of the greatest émigré

directors, Piscator and Lang, while making his other colleagues feel like a bunch of talentless schoolchildren. Brecht's gutter tactics have no human justification, yet he was within his rights as an artist to object to the vulgarization and sentimentalization of his work. He conceived a theater that would at once be elegant, entertaining, and emancipatory, all three qualities resulting from a rigorously maintained aesthetic. He discovered that nobody understood his theatrical practice, not even Piscator and Weill. As he told the American director Harold Clurman, he didn't want "atmosphere," he didn't want "mood." He may have sounded mean-spirited, but he was correct in his judgment. Too many subsequent American productions of his plays have offered little beyond "atmosphere" and "mood," thus making the works appear ill-conceived and sententious, as well as making Epic Theater seem like dated political kitsch.

The Caucasian Chalk Circle obliquely expresses something of Brecht's life as an émigré. In order to define his heroine Grusha, he used the American word "sucker"; though his revisions of the play toughened Grusha until she became political enough not to wish great riches on her adopted child ("Let him be afraid of hunger, not the hungry man's scorn"), she is also sentimental enough to tell her soldier lover that she took the nobleman's child because of their previous betrothal ("So it's a child of love"). The child is called Michael, the name later given Brecht's illegitimate son by Ruth Berlau who died at birth.

It is easy to identify Brecht with the character of the whimsical judge Azdak. The Pope observed that Galileo, as a sensualist in body and mind, could be physically threatened. Azdak admits as much himself: "I won't do anybody the favor of behaving like a great man. . . . I'm drooling at the mouth. I'm afraid of death." Now, Brecht had always spoken against heroes, "unhappy the land that needs them." But his own measures of self-protection occurred in an era of such widespread heroism that Azdak's statements may constitute the playwright's apology.

The play contains other elements that apply more generally to the émigré's lot. Someone says, "Why does a man love his

home country? Because the bread tastes better, the sky is higher, the air is spicier, voices ring out more clearly, the ground is softer to walk on." This is a Proustian tribute to the senses, albeit set to Brecht's *misuc*, as is Azdak's advice to a hungry officer not to ogle so ravenously a piece of cheese, "because it's already vanishing, like all beauty." When Azdak releases his servant from domestic service so that he can follow his natural bent, "which teaches you to plant your heavy boot in human faces," he recalls their time together: "I've led you by the iron bit of reason till you bled at the mouth, spurred you on with syllogisms and abused you with logic." This again is thought converted into sensuous life, the exhausted cry of a peripatetic intellectual, who is not much better than he should be, but who still prefers the life of reason to the riotous confusion of fleshly emotions.

Although the war years were the era of "Uncle Joe" Stalin and a time of visible activity by the U.S. Communist Party, Brecht was politically unhappy in America. He collaborated on a play about the French Resistance with Feuchtwanger, and found his old friend uninterested in social, as opposed to "biological," explanations of character. (Marta Feuchtwanger remembers Brecht's many attempts to get her husband to read Marx.) Brecht worked with a screenwriter who would wind up in the Hollywood 10, and considered him politically immature.

Worst of all, Marxist analysis that appeared shocking in Germany had no impact in a country where the bourgeoisie had no illusions to lose about its humanist tradition. However, Brecht's political behavior in America could also be conventional: he shared the affection of many refugees for Roosevelt and the American war effort, as evidenced by his "Hollywood Elegies" (1942), a text set to music by Hanns Eisler, with its salute to "fighter planes" soaring high above "the stink of greed and poverty." But he was thwarted here too. During 1941 and 1942, he broadcast anti-Fascist propaganda, until, as John Houseman remembers, the British and American intelligence agencies decided that intellectual émigrés "beaming back to Europe . . . would have a negative effect."

Brecht fell into the trap of Stalinist aesthetics. His wartime plays, *Simone Machard* and *Good Soldier Schweyk,* tended to romanticize the Resistance; even Eisler recognized that such unsubtle heroics contradicted Brecht's cynical theory of character. Brecht had the grotesque idea of translating *The Communist Manifesto* into dactylic hexameter verse. The classical humanist side of his socialist humanist comrades resurfaced; they ridiculed his metrics and questioned his ideological motives. And all the while—as Brecht argued with the Frankfurt institute members about their concepts of "state capitalism," met affectionate disagreement from his friend Feuchtwanger, was bemused by Hollywood Stalinists, who in turn found him arrogant and his plays obscure, and was criticized by Eisler for being a vulgar Marxist himself—another political reality intruded. The curfew kept him in at night; both as an enemy alien and as a notorious, if currently discreet, radical, he was subject to investigation: "The police . . . inquire about us," he reported.

As we now know, the FBI was trailing him constantly. James K. Lyon has ascertained that for over thirteen years the organization maintained a file on Brecht. In 1943 the Bureau moved his file from "enemy alien control" purview to "internal security," in recognition of his radical affiliations; in an informed bit of literary criticism, the writers of the file entries noted thematic parallels between *Hangmen Also Die* and one of his most ideologically extreme dramas, *The Measures Taken.* Between 1943 and 1945, federal investigators tapped his telephone; judging by the size of its file, the FBI must have continued to spy on him after his return to Europe. It seems that most of the informants were other émigrés, since the reports describe meetings held in German. The thousand-page file yielded no names of American Communists—the surveillance was a bust, and Hoover ordered it concealed. But the subject had caught on early. As soon as they learned about the police inquiries, the Brechts prepared themselves for phone taps. On one occasion, Lyon reports, Mrs. Brecht read Polish recipes over the telephone, no doubt baffling the FBI eavesdroppers. In such surprising ways, Brecht benefited from the cosmopolitan cunning and linguistic virtuosity that emigration had demanded.

10

Advise and Affirm

Brecht might have been unhappy anywhere outside Berlin. His presence had helped set the city's tone—he had become its symbol. He was also typical of those émigré radicals who assumed that their American period was a stopover. Such people made a political principle of not associating with the barbarous bourgeois natives. And, sequestered in their impotent and impoverished little cliques, they appeared to other émigrés—in one refugee's harsh, very American term—to be "losers." The others reckoned that they would not be returning, and that they might as well accept their move as permanent, fortunate, a *"Gelegenheit"* (opportunity). The elderly widow of Arthur Schnitzler, the chronicler of fin de siècle Vienna, consoled younger refugees by saying, "Yes, we have lost a homeland but we have gained a world." Those who agreed responded with gratitude and affection to the country that had taken them in.

Those optimists may have shared some of Brecht's and Adorno's distaste for an American life that devalued independence and privacy, yet the ones who triumphed here recognized, with Frau Schnitzler, that they had inherited a new world, came to terms with this knowledge, and proceeded to put down roots. They might insist that the country would always confound

them with its devious grammar and impenetrable customs, but by the late forties some of them had become guides for the natives to the rights—exemplary—and the wrongs—remediable—of postwar America. In the academy they were lords of new disciplines as well as inheritors of old ones. They found themselves to be role models, the classiest academics on the campus.

Once the refugees had established themselves, it seemed as though America couldn't make a step, public or private, without their guidance. From excavations of the deepest reaches of the self by psychoanalysts to the intimate exchanges between parent and child, they gave private life a new self-consciousness that would separate regions and generations. Refugees colonized public life as well, initially through analyses of American politics and business, a generation later through participation. "I have no love whatsoever for Henry Kissinger (né Fürth) and Henry Kaufman (né Wennings), those provincial reactionaries," an ex-Berliner said a few years ago. "But isn't it amazing how Americans can't seem to do without us poor German Jews?"

The impact on American life began to manifest itself during World War II, when the note of affirmation rang loudest and purest. Love of country was accompanied by a love of its leader. Roosevelt-worship prevailed on all levels. One woman remembers, "If you looked at the little people, they all had their pictures of Papa Roosevelt, just like the little Germans had their photos of Papa Hitler frowning down on their *Würstchen* and *Kartoffelsalat.*" Even the grandest genuflected before FDR, radical and conservative alike. Brecht followed the 1944 elections with the obsessive curiosity of an American baseball fan during the World Series; Heinrich Mann wept when Roosevelt died. For Peter Drucker, the advocate of big business, Roosevelt was the incarnation of community during the Depression, the leader who shot down with rhetoric the possibility of economic revolution. As if assenting to this view of FDR's fundamentally conservative role, Thomas Mann hailed the president as a "patrician friend of the people . . . a match for the dictators of Europe," in part, perhaps, because of the aristocratic distance he kept from the masses.

Optimism was the companion of assimilation; one curtsied to the other. After the war, as some refugees began to regain, if not surpass, their former good fortunes, many of them acquired a public attitude that resembled Eleanor Roosevelt's "I never look back." In the early fifties Donald Kent published a survey of 1,509 refugee intellectuals. Though none were identified, it is likely that the attitudes they expressed provided the bases for their more affirmative writings. Some familiar complaints remained. The refugees interviewed still could not understand the public nature of American life. Walk down a city block, they said; no window shades are drawn, everything is displayed before you, as if privacy didn't exist. (This observation arose in a less paranoid age than ours.) They described their permanent difficulties with the American language. Curiously, these refugees from the most involute of tongues objected to the indirectness of American speech. The circumlocution and ceremony—"It seems to me," "Don't call us, we'll call you"— struck refugees as hypocritical. (Rudolf Flesch, addressing himself to this failing, wrote a postwar best-seller, *The Art of Plain Talk;* the paradox implied by the title was only compounded by the irony that the author had originally been a lawyer in Austria.) Nevertheless, the refugees could live with these changes. Indeed, adjustment and consensus are the signal values that are stressed in Kent's study. Newcomers are advised to "burn all bridges" and "never complain, it's futile." Can one combine the perspectives of two cultures? "Don't mix the mother tongue and English." You are here, and must root yourself "wholeheartedly ... without the least mental reservation." The admonitions would satisfy any chamber of commerce: join groups, don't criticize, "be under all conditions an active member of a religious group."

The bourgeois smugness of some refugee intellectuals had been evident years earlier; Heinrich Zimmer would tell his wife after an evening with friends that the questions were always the same: "Where do you live?" "How much rent do you pay?" "Where do your children go to school?" But a decade later, as adjustment swamped all other considerations, only one midwestern political scientist in Kent's sampling objected to the hypoc-

risy of his professional peers, their political spinelessness in the face of American foreign policy, their newly acquired racism, and their "reactionary . . . ridiculous, religious zeal."

The rest assumed that being a good American meant participating in the central institutions of native conservatives—religion, politics, and capitalism. Yet matters were often askew, the diverse confessions of loyalty strained or unconvincing, the suturing of traditions about to tear apart. Paul Tillich, the most influential theologian of his time, called his autobiography *On the Boundary*, presenting his borderline position as resulting from both psychological disposition and cultural deracination. After years of working for American business and universities, Peter Drucker called his autobiography *Adventures of a Bystander*, defining the bystander as one who is neither an actor nor a member of the audience; in this he tacitly agreed with Franz Schoenberner that, as such, the bystander had a privileged perspective on both.

These outsiders developed cunning rhetorical strategies for insinuating themselves into the mainstream. Tillich, for instance, admitted that as a "transcendent Christian" he could have no homeland—once he could have made the same statement as a radical committed to working-class struggle—while allowing that his every response was stamped with Germanness. But despite his numerous attacks on American empiricism, nationalism, and conformity, Tillich, almost as much as Drucker or Hans Kohn, affirmed American society as the "ideal most consistent with the image of one mankind. . . ." This slant made patriotism and internationalism complementary principles.

Another line—promulgated by Kohn, Drucker, and Hannah Arendt and seconded by conservatives—rejected the social and economic focus of European writers. Reviewing Arendt's *On Revolution*, Kohn noted that for the author, class conflict had been replaced by a political battle between freedom and authoritarianism. Drucker insisted that the American genius was "political." He noted that America was the only democratic country which "believes in a correct social philosophy," as evidenced by the fact that here schoolchildren take courses in "Civics." He observed that a term like "un-American" makes sense in no

other language, not even British English (although he neglected to mention that Hitler had used the similar formulation *"un-deutsch"*).

Emigrés like Drucker and Arendt were actively disowning the French Revolution. Since for two centuries European radicals had claimed two homelands—their own and France—it appeared that a move in space had compelled a shift in ideology. That an American political identity seemed to require an intellectual sea change was nicely summed up by Heinrich Blücher: surveying his European mentors, he declared, "Kant was a servant, Nietzsche a master, Marx a despot, and Kierkegaard a slave. And I am a prospective citizen."

But even the émigrés who applauded the American political system could not ignore the lessons of history. They admired the system, perhaps excessively, loving it as much as other refugees loved Roosevelt. But they knew too much to trust in it completely or to abandon their commitment to intellectual nonconformity. Thus, while émigrés objected to the American invasion of privacy, they also tried to goad Americans into leading a more responsible public life, encouraging them to act upon political principles that the natives might have forgotten but that émigrés had learned as background for their citizenship examinations.

During the postwar euphoria that enraptured many intellectuals, several émigré historians attempted to enlighten Americans about their past. In the course of their sanguine analyses of American politics, these scholars usually deplored the European tradition that had culminated in their exile; such studies by academic historians dealt with refugee themes, but sometimes very quietly. Even Felix Gilbert's benign and objective analysis of the farewell address delivered by George Washington—but written by Alexander Hamilton—asserted, "The world of Law began when the world of Power had ended." This, of course, has been the traditional dream of all émigrés driven out of countries by the abuse of power: to arrive at the shores of a nation built on law. There is a peculiar poignance to Gilbert's cool description

of Hamilton's attempt to "avoid connections with the politics of other nations." Gilbert is discovering the origins of an isolationalism that would eventually exclude German Jews, much as Leo Lowenthal, a few years earlier, had analyzed the habits of twentieth-century American prejudice—many derived from a legacy of isolationism—that projected onto the Jewish refugee everything the bigot hated in himself.

Hans Kohn's studies of American history were fired by personal involvement; his scholarship never disguised a fervent enthusiasm for the countries he admired most, Great Britain and the United States. Kohn began his magisterial studies of nationalism in his native Prague and continued them in Jerusalem, to which he moved during the 1920s. He left Palestine when he found the early Zionists succumbing to chauvinism and class prejudice. By the time he arrived in America to lecture at the New School in 1933, he was a distinguished scholar of forty-two. (Other champions of the American system—Drucker, Arendt, and Gilbert—were younger when they arrived and without reputations.) Kohn called his autobiography *Living in a World Revolution.* The subtitle, *My Encounter with History,* declares both his vitality and his distance from the principles of a revolution he lives in but not for. Despite his definitive studies of the origins of revolution, he had little affection for its contemporary forms. Since 1848, he says, it has degenerated into the ethnic and linguistic xenophobia that drove him out of Palestine. Instead, he finds his model in the Anglo-American tradition, often selecting his citations from American literature; the refugee Jew had an easy and affectionate command of the anti-Semitic American writers Henry Adams and Henry James.

In his study *American Nationalism: An Interpretive Essay* (which *The Economist* said "did more to clarify what it is to be an American than any other of recent years"), Kohn repeated Oliver Wendell Holmes's assertion that the Americans are the Romans of modern times, "the great assimilating people," and offered his own reformulation. It is frankly Anglophilic. While living in England, he first discovered the virtues of the British "economic and social revolution"; now, in a curious tribute to

cultural imperialism, he applauds American society as the ulti-mate refinement of that system. This means discarding the myth of the melting pot. If America is the great assimilating country, it is only because it reduces other forms of political organiza-tion—whether by class or ethnic group—to a dominant Anglo-phone. This country represents "not a new cosmopolitanism but the universalization of the English tradition of liberty, which the settlers brought with them." In the confrontation between "cul-tural pluralism" and the "unifying character" of American na-tionalism, Kohn sided with the latter. It took a cosmopolitan European to expose the myths of cultural pluralism . . . and then applaud the ethnocentric reality.

Kohn was a good liberal who shared the conservative distaste for Marxism. He viewed the United Nations as the preferred setting in which "American leadership" could thwart "the Com-munist strategy for organizing the whole non-Western world against the West." By 1949 he had joined the consensus chorus, writing that Americans had achieved "a consensus in their thinking which was ready for the world of the 1950s." He ab-sorbed the fifties ideology so well that he could write in the early sixties, "It is *unthinkable* that the foremost democratic na-tion would invade smaller neighboring countries . . . or unleash preventive wars," despite the earlier episodes in Guatemala and the Bay of Pigs—or Nicaragua and the Philippines, for that matter. Brecht's apologies for the Soviet Union were no more strained. (Kohn's widow, however, reported his deep unhappi-ness during the Vietnam war; his sister-in-law remembered him actually commending the draft resisters.)

Living in a world revolution, Kohn was required to begin ex-ploring the world again. At the age of seventy he was forced to retire from CCNY on one-sixth of his salary. He and his wife gave away most of their books and furniture, and he took a series of semestral teaching jobs at various colleges. Kohn didn't mind. When a moving company stole some of their possessions, he told his wife, "People have lost much, much more." The study of American history kept him as young as both Yeats's "passionate old man" and Goethe, renewed in his seventies by the prospect of America. (Kohn's countryman Johannes Urzidil titled his

study of this late episode in Goethe's career *The Happiness of the Present Time*.) Kohn's happiest vision of America, his most original, may have been that the land of institutionalized adolescence could also be the setting for a great man's old age.

American conservatives have often revered this country's principles while decrying their betrayal by modern politicians and social scientists. A distinctive variation of this approach was offered by Leo Strauss. Perhaps the foremost conservative émigré scholar, Strauss embodied a commitment to historical tradition combined with a wariness of innovation. He was trained in Jewish and Greek philosophy, and after leaving Germany, he extended his interests to include the seventeenth-century political philosopher Thomas Hobbes. From the works of medievalist writers, Strauss acquired a concern with natural law and natural rights that informed all of his later writing. A bit like Arendt, with whom he had almost nothing else in common, Strauss felt that the noblest American principles—set down for him in the Declaration of Independence, with its "self-evident" truths— had been severely eroded, not least by the positivist tendency of contemporary political science. His application of philosophical categories to political matters introduced an alternative mode, one far more moralistic than the ostensibly "value free" social science assayed by such émigrés as Paul Lazarsfeld.

Although Strauss was a hero to American conservatives, he was always aggressively European in his method. In particular, Strauss delighted in discovering the hidden meanings of esoteric texts. He believed that the true, invariably ethical message could be extracted only by a subtle process of interpretation. (In this approach to writing, he was a bit like another Berliner, Walter Benjamin.) The texts he chose to examine inevitably were foreign ones; appropriately, his disciples have become expert readers of world thinkers, from the Greeks to Nietzsche. Strauss posited a correlation between reading well and leading the good life. Although he seemed to argue that America was the best place for one to make such strenuous connections, he brought a classically European sensibility to his praise of the country.

While other émigrés respected America for being unlike the Continent, Strauss's affirmations suggested that this country, at its best, was directly in a European tradition. He combined the familiar American conservative's distaste for novelty with a European's conservation of his culture's classic texts; his conservatism can be thus be read as another academic product of emigration.

Refugees also became experts in practical politics. The members of the Frankfurt institute often contended that adopting American methods required a willful blindness to the forces of social control. For them, an uncritical social scientist was no more than an administrator of the public order—by their lights, an "oppressor." There is no doubt that émigrés provided the means for ordering society—witness the extraordinary success of the systems developed by John von Neumann and Oskar Morganstern that were distilled into the evocatively dubbed "games theory"—and the ideology for doing so. From such people it was pointless to accept any questioning of popular assumptions, much less a list of alternatives. Instead, they employed European terminology to affirm American values, as in the attempts to merge mental health and consensus: in one of the Institute of Social Research's studies, *Dynamics in Prejudice*, Bruno Bettelheim contended that an antidote to the mental aberration of prejudice was an acceptance of authority. Quite unlike Adorno and company, he linked tolerance with social conformity!

The overlapping needs of politics and commerce were addressed by a new kind of professional, the manager. The virtual founder of management science was an Austrian, Peter Drucker. Like Hans Kohn's, Drucker's arrival in America was delayed by a long stopover—in his case, in London, where he worked for a brokerage firm. Also like Kohn, Drucker was hounded by Stalinists, in both England and America, for pessimistic predictions during the period of the Molotov–Von Ribbentrop pact; these analyses would withstand close inspection much longer than his more popular encomiums of American business.

During the postwar period, Drucker let Americans know that

their country's political system was uniquely diverse. In 1948 he wrote of the concept of "pluralism," which was usually identified with the pre–Civil War advocate of states' rights John Calhoun. (Drucker noted, parenthetically, that Calhoun saw the problem of slavery as merely one of "interests.") Drucker believed that Europeans were always confused by the bloc interests that crossed party lines in America and produced a condition of "sectional and interest pluralism"; they were equally baffled by the procedures followed by congressional committees. Drucker explained that a congressman is a statesman and a business agent. This sounds like a combination of high rhetoric and low scruples worthy of a Balzac or a Dickens.

Having escaped from the nightmare of prewar feuding, the anti-Marxist Drucker welcomed a politics without ideology. This did not prevent him from articulating an ideological apology for American capitalism. As early as 1941, in *The Future of Industrial Man,* he argued that the business enterprise had become deeply rooted in the social community. Recently he has reasserted that business incorporates all the best qualities of American life. He has nothing but praise for industrialists: Samuel Johnson was right, Drucker says, when he characterized the man making money as innocuous, concerned with neither power nor property. This altruistic capitalist resembles a "good artist or scientist" in his adherence to the near-at-hand, his old-fashioned trust in the specific details that must accumulate before the imaginative leap into generalization. (Drucker's fellow Viennese Paul Lazarsfeld compared himself with "an artist or a criminal," the last a whimsical step beyond Drucker's self-assessment.) So Drucker finds models of integrity in "those much-maligned 'tycoons' John D. Rockefeller, Sr., and Andrew Carnegie"—men remembered in other circles as murderers for their part in the massacres that occurred in Ludlow, Colorado, and Homestead, Pennsylvania.

Drucker has a bystander's perspective on the first executives he encountered. They represent for him the last generation of businessmen to escape academic training. The émigré finds these rugged anti-intellectuals exemplary Americans. He dram-

atizes Henry Ford as the practical little guy who disproved the smug platitudes of Marxism. The elegant Drucker likes the mixture of craft and gaucherie: he speaks admiringly of that "ugly duckling" Harry S. Truman. He also accepts, without irony, former General Motors president Charles E. Wilson's self-identification as a Eugene V. Debs socialist. (A reader can imagine Wilson confronting some union workers on a Labor Day of Judgment, protesting, "But I was a socialist too.") He presents other General Motors executives as models of tolerance—for example, the executive who flooded the market with Cadillacs during the Depression after cultivating Negro buyers, and later provided assembly-line jobs for black Detroit prostitutes during World War II. Rather disingenuously, Drucker blames the male unions for "racism" and "sexism" when they demanded these jobs for returning veterans.

In 1946, following his own tenure at GM, Drucker published *The Concept of the Corporation*—a book that he claims "set off the 'management boom' of the last thirty years"—and in it examined the roles and functions of management both inside and outside the business setting. He still believed that management was "the specific organ of all institutions of modern society" and as such must employ intellectuals: an invitation to his friends to quit holding their noses and join him in the marketplace. In the same book, after celebrating the corporation's scope, he proceeded to argue for "decentralization" in business, which was something of a contradiction in terms—a formula for Mom-and-Pop stores, not for international finance. Similarly, while at GM, he had envisioned a workers-managers paradise in which responsibility would be shared by employees and management alike, liberated from petty fears by the prospect of guaranteed income. These ideas may have been partially realized in the German Federal Republic, but they still seem too European a vision for American management and labor. (The "self-governing plant community" proposed by Drucker recalls the notions of "rural sociology" current in the Vienna of Drucker's youth and first popularized by Mousie Polyani, the sister of the famous social scientist Karl Polyani.)

Drucker was finally disappointed. The great industrialists,

because they declined to assume "responsibility for the common weal," failed "in terms of public esteem and political acceptance." They lacked a vision that resembles old-fashioned humanism; i.e., they were not conservative enough! Looking elsewhere, Drucker attacked his old friends Buckminster Fuller and Marshall McLuhan for the inadequacy of their technological visions, the misplaced emphasis on "how things are made" rather than on "how man makes things"—a criticism that Marxists would not take issue with. Hardly a doctrinaire conservative in the area of international politics, Drucker even gives lessons in American civics to Henry Kissinger and his mentor Fritz Kraemer. Drucker locates Kissinger via Kraemer in a tradition that descends from the Prussian leader Bismarck. The two Ks share Bismarck's belief in the primacy of foreign policy, his obsession with military and political power, and his self-serving concept of the all-powerful foreign minister, who is not dependent on informed counsel from inferior sources (or nations: Drucker laments Kissinger's exclusion of "middle-powers," such as Western Europe). The last idea is undemocratic, clearly "un-American," to employ a concept Drucker believes untranslatable. So Drucker finds the "American creed" subverted by businessmen, intellectuals, and his fellow émigrés. If "politics is the only genuinely native art form," he does not approve of the post-modernist phase.

Drucker is such an engaging advocate of American capitalism because he sees it as an artist's line of work. An admiring colleague at New York University says, "We were all grateful for the Continental charm Drucker brought to business. But when you get past all the elegant dicta, it's still a case of buy low and sell high."

On a more prosaic level, the practical impact made by émigré businessmen was considerable. The French financier André Meyer pioneered the conglomerate movement—from the perspective of older companies, the gobbling up of American enterprises by his conglomerates may have appeared a particularly insidious refugee's revenge! Meyer's protégé Felix Rohatyn was to play a leading administrative role in the émigrés' favorite American city, New York. Rohatyn's vision of business com-

prises "three realities—the reality of economics, which deals with people's greed; the reality of the power structure, which deals with people's ego; and the public presentation of the finished product." In its precision, dry wit, and particular attention to public imagery, this is a classic émigré formulation.

In 1980 Drucker bounced back from the pessimism of his recent *The Unseen Revolution: How Pension Fund Socialism Came to America* with a book of financial counsel that appeared briefly on the best-seller list alongside numerous similar works. Refugees were still directing American investors, in an amusing supplement to the history of émigré artists and intellectuals. Most of them were children of the bourgeoisie, and, frequently, they were disappointments to their parents unless they entered the family business. The émigré financiers can be seen as the more conventionally successful brothers of bourgeois intellectuals, with whom they shared an affection for high culture. The old family conflicts persisted in exile.

There was one unanimous complaint in Donald Kent's survey of émigré intellectuals; the émigrés were all bothered by the "child-centered" nature of the American family. They all objected to the "impudence" of children who talked back, read comics, and listened to trashy radio programs. It was bad enough to teach in institutions where students were elevated to star position, but to see the child installed as head of the house was intolerable. Emigré writers pondered ways of improving despots they found variously illiterate, vapid, or insane. Among the advisers on Bringing Up Baby, the refugees assumed dominance. Between 1945 and 1949, the ego psychologists Heinz Hartmann, Ernst Kris, and R. Lowenstein published the four-part *Psychoanalytic Study of the Child*. On a more popular level, Rudolf Flesch, following the success of *The Art of Plain Talk*, wondered *Why Johnny Can't Read* and suggested a phonic method of instruction. ("God knows these American children need something," says one retired professor of sociology. "You take for granted that they should be able to write their own language, especially when we went to all that trouble to learn it.

And yet, there I was, correcting their grammar in graduate school!") Frederic Wertham blamed Johnny's inability to read on long hours before the television, and warned that mindless violence would be the result of a lack of traditional culture.*

The émigrés' distrust of American children was confirmed by their own unhappy memories. Many of them had experienced anti-Semitic assaults, verbal and physical, from schoolchildren. Others knew from history that children more often repeat their parents' sins than redeem them. In Germany, the film director Douglas Sirk had planned a movie about the Children's Crusade that would show the movement sabotaged from within by the "bad . . . older . . . domineering ones." Sirk did not sentimentalize children's crusades; his would have been "a pessimistic mirror of the adult world." The Sirk movie *All That Heaven Allows* presents the heroine's children as spoiled brats who obstruct their mother's chance for happiness.

Such a historical perspective sees children as symbols of social disorder. This is often true in the work of Hannah Arendt, whose first husband's father, Wilhelm Stern, had been an important child psychologist. Arendt always insisted on the separation of public and private worlds: for her, politics was a privilege best reserved for the intellectually mature. Thus, since she believed that certain stages of development require privacy, she waged a peculiarly conservative argument that children should be insulated from a political arena that is baffling enough for their elders. Arendt's attitude toward young people was neither loving nor respectful, but rather old-fashionedly didactic. As unimaginative little conformists—she noted that no peer group was as inflexible as one composed of adolescents—they needed "the security of concealment to mature undisturbed." Children should not have the public pressure of modern life thrust upon them. For Arendt, it was no wonder that the off-

* As a piece of trivia, it might be noted that Henry Winkler, who personifies 1950s greasers in his role as the "Fonz" on the television show "Happy Days," is the son of refugees, and that another 1950s adolescent stereotype, Gidget, was created by the émigré screenwriter Frederick Kohner.

spring of famous people so often go mad. Yet Arendt's pastoral vision of childhood was not perfectly suited to American life. It prompted one of her least convincing pieces, a 1959 essay on desegregation in which she argued for states' rights. Viewing a picture of Arkansas schoolchildren taunting a little black girl, Arendt observed that adult politics had produced juvenile delinquents. In her view, racism was a political problem (not an economic one, she insisted, finding the NAACP misguided on this issue, nor a psychological one: questions of taste or personal prejudice were private matters and irrelevant to politics as long as they did not impinge on public gatherings—as if the work of education were undertaken in a closet), and she wondered whether Americans wanted their children to solve, at the cost of their innocence, the problems of grown-ups. The real civil rights issue, she decided, was miscegenation, a question fundamentally constitutional—underwritten by "the pursuit of happiness"—and adult.

Arendt's colleague Bruno Bettelheim often writes as if, for young people, political conformity and mental health were synonymous; curing their delusions means correcting their politics. His analyses of American adolescents are charged with references to European history, specifically the Holocaust. This is an inversion of his procedure for examining life in the concentration camps. Bettelheim was interned in Dachau and Buchenwald for a year, and from his observations there, he concluded that camp life reduced inmates to "infantile regression," a loss of adult sobriety and wisdom evident in the frantic scrambling for food. This signified for Bettelheim the absence of an "adult frame of reference" and the inability to "plan for the future": like infants, the prisoners were mired in the moment's needs. A reader may ask if any others held precedence in a death camp.

This interpretation is clearly biased: other former inmates view the dedication to physical survival as a testament to their spirit. But if Bettelheim's analyses of camp life are of questionable value, his rhetoric becomes far more provocative when he applies it to the experiences of American childhood. The camp inmates regress from adulthood; the autistic child cannot reach it, held back by his own prison guards. Bettelheim sides with

disturbed children to the point of identifying their oppressive parents with Nazis, as when he compares "the Nazi Holocaust" with the patient's "private hell," and the Nazi government's agents with "parents who, more often than not, are themselves deeply unhappy people." Such language defends the defenseless infant by convicting the parents; Clara Claiborne Park, the mother of an autistic child, has written that Bettelheim's work tends to make the troubled parents of mentally ill children feel even more guilty about matters whose origins have not yet been determined.

Like all the émigré parents confounded by adolescents' freedom, Bettelheim concludes that in America adolescence is a "culturally imposed age." The first adolescent, he says, was Wagner's Siegfried. Given the Nazi infatuation with Wagnerian themes, this citation is politically loaded. Like Arendt, he despairs of youthful conformists. He remembers when a cultural hero was an individual; the emphasis on "other-directed" group identity he finds meretricious. There were, of course, many radical émigrés who did not share his exalted view of the individual. But they, in a reflection of Bettelheim's own paradoxes, did not share his respect for political conformity either.

Within his own clinical domain, Bettelheim demands a fixed and sacrosanct order. A colleague has described Bettelheim's Orthogenic Institute for autistic children in Chicago as "a Viennese young man's idea of heaven," consecrated to bourgeois values and filled with "toys, a strong father image, and all you can eat." He requires conventional appearance; men are not bearded, women do not wear slacks. (His 1962 study *Growing Up Female* takes "marriage and motherhood" for granted.)

In his study of the Israeli kibbutzim, *Children of the Dream*, he lauds the community's cohesion and the "high degree of consensus on all essential issues." The Kent study tells us how many émigrés wanted to form a consensus in the 1950s, as if such a thing could be declared by fiat at the cost of all more ancient claims. Like his fellow Viennese Peter Drucker, Bettelheim affirms traditional American values as a spectacular improvement over the follies of European romantics and Marxists.

Yet, again like Drucker, he retains some homesickness for the old country. Recently Bettelheim has recommended European folk tales as a way of directing the child, and giving him a grounding in imaginative thought. Some readers have found his Freudian approach reductive and his stress on the didactic unimaginative. But Bettelheim dismisses their criticism as being irrelevant to the psychic needs of children. When a group of Californians objected to the unrealistic happy endings of fairy tales, he exploded, "Leave me at peace with your reality. It comes out of my ears. Your children are so thick they will never learn that death is permanent. What's the hurry?" Intimidating parents and infuriating young adults with the twists and turns of his speech, he has never ceased regarding himself as the defenseless child's advocate.

It now appears that Bettelheim has other interests to defend. He has recently sought to rescue his mentor Freud from the abuse he has suffered at the hands of translators. Bettelheim finds the culprit in the language of Anglo-American psychoanalysis. He celebrates Freud's prose for both its specificity of reference and its provisional nature, two attributes inseparable from German vocabulary, grammar, and syntax. But the English translators have transformed Freud's "it" to "id" and "I" to "ego," thus turning a wonderfully open-ended vocabulary into a series of abstract phrases. Similarly, the American establishment, with its requirement that all psychiatrists earn a medical degree, has transformed a discipline suited to artists and poets into a normative pseudoscience. Despite his paeans to this country's political system, Bettelheim now reveals himself as yet another émigré humanist horrified by an American invasion of his territory.

Bettelheim has become the most celebrated example of the émigré expert bullying his audience into submission. A counterattack against such figures was waged years before they acquired their full force, and by one of their compatriots. In 1941 Leo Kanner, an Austrian-born child psychologist, wrote a book titled *In Defense of Mothers*, subtitled *How to Bring Up Children in Spite of the More Zealous Psychologists*. Kanner, too, used the language of warfare and politics: "There is no raid shel-

ter from the verbal bombs that rain on contemporary parents."
He called the culprits "would-be omniscient totalitarians," and
described their psychoanalytic jargon—"weird words and
phrases which are apt to confuse and scare one no end"—as
"blah-blah, blah-blah and more blah-blah." In an amusing coda
to the Americanization of psychoanalysis, Kanner attempted to
disarm the European discourse of his fellow émigrés by appeal-
ing to American habits of "common sense."

As another—and politically neutral—contribution to the
heightened American consciousness of childhood, there is *The
Psychological Birth of the Human Infant,* a recent study
directed by the émigré psychoanalyst Margaret S. Mahler. Em-
ploying precise clinical data acquired during years of observa-
tion, Mahler vividly captures the first stages of infancy. Her
work shows how haphazard a healthy development is, each one
sidetracked by false starts and mixed signals. She introduces
several new concepts, such as "separation-individuation," which
provides a measurement of the subtle change from infancy
(when the child's experience is totally defined by the mother)
to a time of initial autonomy. Mahler is alert to undertones; she
sees that each subdivision that development occasions is an im-
mense stage in itself. In describing her observations, she rejects
the word "ambivalence"; babies are more mercurial than that.
They are, rather, "ambitendentious": instead of balancing two
feelings, they move instantaneously from one to the other, as
anyone who has held a laughing-crying infant knows. Such an
ambitendency allows for each emotion to impose its own au-
thority and receive its own expression. This latest émigré con-
tribution reflects and refracts the refugee experience itself:
before the variousness of American life, the honest refugee did
not always know whether to flee or to embrace, to laugh or to
cry.

11

Entrepreneurs of Images

"I can't explain what kind of feeling I had," Jacques Lipchitz has said, remembering his first sight of the New York harbor. "It was like I came from death to life." Hoping to recapture that moment, he would often take the ferry trip from Staten Island to New York, "but the feeling never returned." There are many reasons for the émigrés' preternatural attention, as artists or critics, to American imagery, but surely the dominant one was invoked by Lipchitz: the capacity to invest a visceral impression with "indescribable" feelings compact of memory, hope, and fear.

The émigrés' production of new images could tease an observer, subliminally, into thought. Among the refugees, there were several kinds of artists registering visual impressions. On the one hand, there were fine artists whose work was usually avant-garde, nonrepresentational, and limited to an elite audience. Although many of them acknowledged the influence of America on the works they produced here, they nonetheless operated as individuals, insulated from commercial requirements. On the other hand, cinematic artists had an exponentially greater audience, but their subservience to studio bosses and the simple need to delegate or share responsibility con-

stricted their freedom. Somewhere between the two was the émigré photographer. He worked alone much of the time, but he still had to produce images that would satisfy American editors and audiences. He was thus in the paradoxical position of producing personal images for commercial purposes.

Photography is the mate of both art and journalism. In its journalistic role, it became for some the incarnation of empiricism and pragmatism, depicting reality exactly and without distortion. Certain Hegelian émigrés knew better than to overvalue straight reporting—and consequently were alert to the psychological influences that can shape even the most casual snapshot. But for a prominent European journalist like Arthur Koestler, the absence of simple data-gathering was a sign of irresponsible reporting. He writes that "German journalism [was] unlike American and British. . . . Its starting point was the correspondent's *Weltanschauung* and the paper's political philosophy. His job was not to report news facts, but to use facts as pretexts for venting his opinions and passing oracular judgments. Fed on this kind of diet, Germans never developed an empirical approach." Koestler believes that such an approach to the news is politically crucial. But pictures can lie, facts can deceive, documentaries can be a special kind of fiction.

Walter Benjamin was less certain about the objectivity of the photographed image. Though John Heartfield's photomontages for the Communist magazine *A-I-Z* revealed a radical perspective, Benjamin felt the more typical use of photography was "to renew from within—that is, fashionably—the world as it is." Quite expectedly, in Benjamin's mythology the photograph has more in common with the mindless chatter of the newspaper than with the "anarchic stillness" of a book. The problem is that newspaper photographs, as the virtual neighbors of advertisements, cannot escape linkage to a commercial ethos. And worse, by rendering events aesthetic and "fashionable"—in a word, photogenic—they can make violence and poverty alluring. An unwitting echo of Benjamin's position comes from Alexander Liberman, the editorial director of Condé Nast Publications and an émigré. He describes his metallic sculptures as being deliberately difficult, in contrast to the ads and photographs he displays

in his magazines: "All serious art is against convention. It works to stimulate a deeper yearning; one that would upset society. I probably rebel more in my art because I work for a magazine [*Vogue*] that concerns itself with good taste and conventions . . . surface and appearances." The magazines' frivolous obsession with "appeal" is precisely the "renewal from within" that Benjamin warned against.

Yet fashion photography during the thirties and forties was often the work of Europeans: the Hungarian Martin Munkacsi, for one, was known for photographing models outdoors, although his fantasies became no more real away from the studio. That refugees, the most transient of contemporary men, should also be the recorders of the most ephemeral of forms, fashion, was an oddly appropriate fitting of vocation to condition. The popular photo magazines depended largely on the work of European photographers: Robert Capa, Alfred Eisenstaedt, André Kertész, Philippe Halsman. The glamour of their work was a kind of commercial for American culture. In fact, it was precisely their contributions that distinguished *Life* and *Look* from the more typically American magazines, such as *The Saturday Evening Post*. After the photographs of Andreas Feininger, Norman Rockwell's illustrations seemed to be the artifacts of an earlier age, one not necessarily falser but certainly less brilliant.

A few émigrés championed nonrepresentational photography. In 1937, when László Moholy-Nagy inaugurated the New Bauhaus in Chicago (later the Institute of Design of the Illinois Institute of Technology), he introduced a course in photography "to free the student from cultural preconditioning and 'visual indoctrination.' " He intended to achieve uniquely photographic effects by exploiting the medium's elements—film, angles, lighting—rather than relying on the conventional reproduction of realistic images. The language he used and the Bauhaus tradition he built on made this attempt implicitly political: avant-garde photography, by rejecting the seductive appeals of "cultural preconditioning," would liberate both artist and viewer. Conversely, other émigrés became prominent exponents of "visual indoctrination." However, their new perspective made all the

difference. Americans were trained to look at objects by foreigners, through foreign eyes.

These objects included themselves. As the new champions of the world—in war and peace—Americans needed a new self-image. Emigré photographers captured all the traditional American characteristics—physical strength, forthright emotion, youthful energy—imbued with an iconic force that frequently filled the photographic frame. This obtained whether the subject was a movie star photographed by Eisenstaedt or a bag lady photographed by Lisette Model. It was particularly evident in Eisenstaedt's famous photograph "The Kiss," which showed a triumphant sailor embracing a stranger on V-E Day; the photograph celebrates his indiscretion. Eisenstaedt shares his jubilation, and makes it universal: his photograph declared to American viewers that they had earned the right to similar abandon. Forget what old fogies might say! Take it from Eisenstaedt, the world's your oyster: you've won the war.

Philippe Halsman's first American picture showed a young model reclining on an American flag, made of paper because Halsman could not afford cloth. Another photographer, Lotte Jacobi, proved almost too American for the Americans in her acceptance of casual dress. In 1937 she photographed Albert Einstein in a leather jacket—a picture *Life* wouldn't print.

Later, of course, an American president could declare in his wardrobe—and his name—his populist preference for the informal and relaxed. Jacobi photographed Einstein in the manner he preferred, which also happened to reflect the way Americans lived, so the *Life* editors' rejection seems doubly misguided. During the twenties, Jacobi's photos had registered the taut energy and androgynous frenzies of Berlin and its cabaret denizens. Her American photographs are as different in nature, if not composition, as their subjects are unlike Peter Lorre and Lotte Lenya. Her photo of Paul Robeson shows a combination of intellectual assurance and athletic grace in repose that provides the image of a uniquely American dignity. In 1944 she shot Eleanor Roosevelt from a peculiar angle: the seated woman is turned toward the camera. Mrs. Roosevelt is relaxed and ani-

mated, talking with her hands and smiling: in fact, the picture cannot contain the tips of her fingers. From this angle, the homely woman assumes a lanky beauty, again an American athleticism, characterized by intelligence and goodwill.

The work of such photographers is the single most loving contribution by refugees to American culture. Surely the affection invited the welcome—in that fine old Southern expression, "What leaves the heart reaches the heart." Andreas Feininger's photos of New York have become the definitive renderings of America's greatest city. Their emphasis on New York as a port town, abutting the water, may recall the Berlin movies of the twenties. Feininger provides visions and angles not usually available to the unaided eye. He understands New York as a fantasy image, both in his famous shots of skyscrapers at night, during the wartime dim-out, and in his numerous shots of the city taken from New Jersey or Staten Island, or a Brooklyn graveyard, locations from which Manhattan seems to be a new kind of life form dropped from nowhere onto nowhere. Feininger captures the 1890s elegance of Central Park, diamond horseshoes, and grand hotels, as well as the 1940s working people in their business uniforms of suits and hats. His New York is a city of bridges and markets, of business districts and ethnic neighborhoods.

Refugees often complained that the American landscape either dwarfed or obscured any sense of the person. Perhaps because he is photographing a city, Feininger manages in his massive views to see all the city's astonishments in human terms. In this context, the unpopulated shots seem at once horrific and forlorn, as incomplete as the uninhabited expanses of the West. Feininger mythologized a New York that is both a technological marvel and a humanist capital. Because so much of that city is gone, the émigré's photographs have become the native's mementos. As a paean to past glories, they achieve an ideological value that Benjamin might not have foreseen: even today, during a hard period for New Yorkers, their images "renew from within" the dedication of a committed urbanite.

Perhaps the purest émigré entrepreneur of images was Otto Bettmann, director of the Bettmann Archive, a famous collec-

tion of historical photographs. Even within the hermetic domain of his archival kingdom, Bettmann maintained a familiar émigré distrust of images. "I deplore the cult of nostalgia, even though I have made a hell of a living from it, because it blinds us to progress. Nostalgia is papier-mâché history, sterilized of all pain. . . ."

The émigré artists were chaperoned in their efforts by the entrepreneurs among them—publishers, editors, and art dealers. These people had their own dilemmas. To whom did they owe their loyalty—the American consumer or the émigré artist? In order not to shortchange either, these established figures were forced to become teachers, instructing a rearguard audience in the appreciation of avant-garde images. New York's Fifty-seventh Street became a center of galleries; it was here in 1942 that Pierre Matisse saluted émigré surrealists in the exhibition "Artists in Exile." This important event gave notice of their arrival and of their intention to cultivate an American public.

Among the other émigré art dealers were Karl Nierendorf, who specialized in German expressionists but also gave Louise Nevelson her first entry into the art world; Samuel M. Kootz, who introduced many of the works of his fellow émigré Hans Hofmann as well as those of Picasso; Curt Valentin, who specialized in sculptors, including Europeans like Jacques Lipchitz and Max Beckmann and Englishmen like Henry Moore and Graham Sutherland; and Hugo Perls, whose gallery represented émigrés like Marc Chagall together with such American artists as Alexander Calder. Pierre Loeb, a famous French art dealer, spent the war years in Cuba. In one of the more curious instances of the émigré's infatuation with American images, Otto Kallir, who dealt in expressionist painters such as Egon Schiele, Gustav Klimt, Oskar Kokoschka, and Paula Modersohn-Becker in his Galerie St. Etienne, became the representative of Grandma Moses and even edited her autobiography. A career that encompasses clients as diverse as Paula Modersohn-Becker (the subject of Rilke's great requiem) and Grandma Moses is unusually catholic, even for an émigré!

Like the art dealers, the émigré publishers who prospered did so by providing novelty entertainment, albeit of high quality. Foremost among these were Kurt and Helen Wolff. Thirty years earlier, in Munich, Wolff had modernized book distribution and advertising. His European roster included Kafka, Karl Kraus, and several writers who had fled Germany: Richard Huelsenbeck (an early Dadaist and for many years a New York psychoanalyst), Huelsenbeck's fellow Dadaist George Grosz, Heinrich Mann, Walter Mehring, Erwin Panofsky, Ernst Toller, and Franz Werfel. In New York, the Wolffs published English-language editions of books by Robert Musil, Erich Kahler, Paul Claudel, and Hermann Broch. Their Pantheon Books imprint achieved its greatest commercial success with Anne Morrow Lindbergh's *Gift from the Sea*—yet another refugee irony in light of the Lindbergh family's reactionary politics.

The Wolffs came to New York from Nice in 1941. They moved into a small apartment on Washington Square Park where they lived and conducted their business. At the time, "Thinking itself was a luxury," Helen Wolff later told Laura Fermi. Wolff and his colleague Jacques Schiffrin did not begin their enterprise with grand visions: "No American publishing house offered them an opportunity to use their experience. They had no choice but to start their own." The two men shared the belief that a publishing house should have a certain "physiognomy" and not publish indiscriminately whatever would sell.

Helen Wolff adapted more easily than her husband, who, like many male refugees of his generation, continued to have trouble with the English language. At first, Wolff moaned about the emigration to America, *"Es war nicht ein Geschenk des Himmels, es war ein Tritt des Himmels"* (This was not a gift from heaven, but a kick), although he would remark in later years that after New York, Europe seemed provincial.

Born in Turkish Macedonia, Helen Wolff had been "used to running all my life." When times were bad in Germany, during the years of the Weimar Republic, she had thought nothing of pawning her goods, "something no self-respecting bourgeois

would do," and she retained this ability to focus on the moment's requirements. Her perceptions were always acute: she describes her original feeling upon reaching this country as being a total sense of doom, and in reviewing her distinguished career as an editor, she sees herself "mainly as a midwife, as a middlewoman." In 1943, in the first Pantheon catalog, she wrote a brief description of her intellectual model, the Swiss historian Jacob Burckhardt; a century earlier, he had anticipated the "terrible simplifiers" who would overrun Europe. "Here was a man who had thought deeply about the past and who assumed that for anybody but a fool the past does define the future."

The Wolffs benefited from their association with Paul and Mary Mellon. The Mellons were wealthy Americans who had been patients of Jung's, and Mary Mellon founded Bollingen Press—whose books were distributed by the Wolffs—to introduce Jungian ideas to Americans. Not all Bollingen Press books were precisely Jungian, however. There was an English edition of Hugo von Hofmannsthal's poetry with a stirring introduction by Hermann Broch, who was the recipient of a Mellon grant. The book did have an indirect connection with Jung, though: Hofmannsthal's daughter was the widow of Heinrich Zimmer, the author of the seminal studies on Oriental mythology that were published posthumously by Bollingen. But perhaps the most popular Bolligen book was the *I Ching*, adapted from a German translation by Richard Wilhelm.

What a dizzying sequence of events! No matter how one reads Jung's politics, his celebration of the mythic complemented the political programs of the refugees' worst enemies. Yet émigrés now made available to Americans materials that could only reinforce a Jungian tolerance for the occult and the irrational. Postwar piety reduced the scholarly books of the Bollingen Press (translations such as the *I Ching* and monographs such as *Oriental Mythology* or Alan Watts' *Zen Buddhism*) to coequal elements in an ethnocentric mix that included books on astrology and speaking in tongues. Heinrich Zimmer would not have been pleased. His meeting with Jung in the late thirties convinced him of the need for thematic analysis of Indian mythology, an undertaking that the German academy had found

insufficiently philological. But Zimmer's study of the Orient employed that familiar component of intellectual credibility: he wrote of the rich Hegelian implications inherent in the dialectic of a devouring-and-creating Mother Goddess. His wife insists that he always believed "It was not for Western people to imitate the East. Heinrich would have told the hippies not to run to gurus." But once the books were available, scholarly interest degenerated rapidly into an exotic fad, not unlike a high-toned craze for chinoiserie.

A happier use of Bollingen Press materials occurred when the Wolffs' son, Christian, took a copy of the recently published *I Ching* to John Cage, who found in it the seeds of his musical aesthetic. Cage's notions inform much of today's avant-garde music, so that, at least indirectly, this new music, with its explicit rejection of European musicology, is another émigré contribution.

The Wolff publications did not represent the full range of refugee positions. This becomes clear when one thinks of other publishing houses started by émigrés, such as Schocken Books, which was established in 1946 by the war veteran Theodore Schocken, publisher of Kafka and Agnon and, more recently, distributor of English editions of Adorno's writings, or New American Library, the massive paperback house cofounded in 1947 by Kurt Enoch, which runs the gamut from Shakespeare to Mickey Spillane. Another émigré, Fritz Landshoff, had helped publish books—first in Germany with Kiepenheuer, then in Sweden and Batavia with Querido Verlag—by almost all the major refugee writers, including the popular Vicki Baum and the arcane Alfred Döblin; the pacifist Zweig and the Catholic Annette Kolb; all the Manns, with their range of political disagreements; the Communist Anna Seghers and the democrat Emil Ludwig; the veteran of Munich 1919, Ernst Toller; and the Hitler biographer Konrad Heiden. Since 1951 he has worked with Harry N. Abrams, a New York art-book publisher, for which, in a pleasant turnaround, he is responsible for bringing American art books to Europe.

———

The most promising attempt at a group effort among émigré writers was the short-lived Aurora Verlag, started during the war years by Wieland Herzfelde. A native Swiss, Herzfelde was both an early Communist ("Rosa Luxemburg signed my Party card") and a Dadaist. His brother, John Heartfield (he Anglicized his name many years before his actual emigration to England), was the inventor of photomontage (see chapter 1). For many years Herzfelde was a director of the left-wing Malik Verlag; the press's last title was Brecht's Svendborg poems.

After his arrival in New York, Herzfelde opened a stamp shop, proudly displaying the sign I DON'T SELL THE STAMPS OF FASCISTS. With some small savings and assistance from other refugees, he founded Aurora Verlag; the name, dreamed up by Brecht, was whimsically ambiguous, denoting either a dawn or the boat that fired over the Czars' palace. All Aurora titles were printed in German, intended for prisoners of war. They all enunciated a progressive social vision, and most of the writers— Brecht, Anna Seghers, Ernst Bloch, F. C. Weiskopf, Herzfelde—were Communists who would soon return to the Russian Zone. Other authors were the fellow-traveler Oskar Maria Graf and the politically peripatetic Alfred Döblin (already a Catholic convert, though one more acceptable to the Left than Franz Werfel). The Aurora catalog also advertised works by Hermann Broch and George Grosz. Though the Grosz book was not published, Herzfelde believes that the very title *Under the Same Sun* indicates not that Grosz had disowned his radical past but that he had found the same Fascistic situation under an American sun. The catalog's first entry was *Morgenroete* (Dawn),* a reader designed for German captives, complete with an introduction by Heinrich Mann. It was astonishing that a new publishing house was able to present such a range of artists and styles; this was only possible because emigration had brought together so many disparate writers who happened to share a similar political position. The catalog even included a

* The word *Morgenroete* also alludes both to a "red" morning and to the German translation of Homer's rosy-fingered dawn. Like the name "Aurora," this was a pun to amuse German socialist humanists.

picture book, John Heartfield's *Faschistenspiegel* (Mirror), the title a portmanteau word to bestride a collection of photomontages.

All for naught. *Morgenroete* was published in 1947, too late to have any impact on prisoners of war. Herzfelde believes that the German officers had veto power over the literature distributed in prison camps, and so Aurora never reached its desired audience. In a 1948 book published by Harvard University Press, Hanns Eisler's sister, Ruth Fischer, identified Herzfelde and company as "a German Communist front in New York." Herzfelde, who still regrets that foreigners could not join the American Communist Party, moved to East Germany. No matter what the political allegiances of its authors—and Hermann Broch, for one, was hardly a Communist—the very existence of Aurora Verlag expressed a touching, rather old-fashioned, and very German faith in the power of literature to reform the opinions of readers. As such, its failure was yet another sign that the émigré writers' battleground was to be strewn with loss and disappointment.

In 1920s Berlin, there were two contending theatrical strategies, represented by Max Reinhardt and Erwin Piscator. Both were supremely innovative, but while Reinhardt was committed to spectacle for its own sake, Piscator's political aims informed all his productions. Though unalike, both men proved to be too European for American audiences. Yet they presented their new public with striking images that would eventually become the theatrical realm's common coinage—too late, however, to change these directors' sense of having failed in America.

A certain kind of movie-musical kitsch flourished in the thirties, a weird amalgam of melodrama and a music-appreciation course. Its apotheosis was the cinematic wedding of Deanna Durbin and Leopold Stokowski in *A Hundred Men and a Girl*—a Schnabelian "trashuoso" episode to remember. The émigrés Henry Koster and Joe Pasternak served respectively as director and producer; both were journeyman professionals who followed public taste. The real master of the musical spectacle,

Max Reinhardt, fared much less well. In Germany, several of his productions had sometimes run simultaneously, packing in the bourgeoisie and the intelligentsia: Bert Brecht had even served him as dramaturge, and both Brecht and Fritz Lang were influenced by the effects he achieved with his *clair-obscur* technique.

Reinhardt staged some unsuccessful Broadway productions and directed one American film, *A Midsummer Night's Dream.* The film was dismissed by, among others, the émigré critic Siegfried Kracauer as an arty failure. But a contemporary viewer is struck by numerous happy examples of the director's talent. The characteristic lighting makes everything appear dizzying and visionary. The American actors were directed in ways that resulted in their best work, performances that are also unabashedly American: James Cagney as a prole Bottom is uproarious, and Mickey Rooney as Puck manages to giggle over four octaves, the most wizened babe in movie history. Some of Reinhardt's devices anticipated Off- and Off-off Broadway. His call for a permanent repertory and his delirious mixing of forms—film, ballet, pantomime, drama—have not dated.

Yet after the commercial failure of his movie and plays, Reinhardt was reduced to opening a school of acting in Los Angeles. He recruited other Germans, such as William Wyler and William Dieterle to teach directing and Erich Korngold to do the same for film scoring. Reinhardt continued to live well, and detailed enthusiastically for guests the virtues of California—its contemporaneity, its freedom from political pressures: "I don't believe art and politics ought really to have anything fundamental to do with each other." But friends like Salka Viertel, remembering his commanding status on the German stage, were horrified when talentless young actors would casually call the maestro "Max." Her response was not elitist; she detected the implicit putdown, the leveling of a great artist.

Meanwhile, Piscator was having his own problems in New York, although he managed to realize far more projects than the ill-starred Reinhardt. Piscator had been the foremost experimental director of the Berlin twenties, as much a symbol of that city as Brecht was. After Wieland Herzfelde converted him to

Marxism during World War I, he became an advocate of the political uses of theater, beginning in 1920 with his Proletarian Theater, which performed in the meeting halls of Berlin labor unions. Piscator is often described as the creator of terms like "agitprop" and "Epic Theater." His uses of technology, his experiments with mime and gesture, and his development of the documentary and propaganda as theatrical tools became part of much of avant-garde theater in the mid-twentieth century. "For Piscator," Brecht said, "theater was a parliament and the audience a legislative body." Max Reinhardt provided entertainments; Piscator drew his spectators into an active participation that was not meant to end with the theatrical experience. Walter Gropius collaborated with him in developing the notion of "total theater," which would involve three stages, interchangeable stage mechanisms, and the use of spotlights and film to achieve an atmosphere of perpetual surprise.

Piscator's plain-style politics were presented with great visual boldness and beauty, but the politics nonetheless dominated. His hit plays in Berlin included *Hoppla, We Are Alive* by Ernst Toller, Brecht's *Good Soldier Schweyk*, and Leo Lania's *Economic Competition*, with satirical cartoons by George Grosz and incidental music by Kurt Weill and Hanns Eisler. It was not incidental that all these political artists—Herzfelde, Piscator, Grosz, Toller, Brecht, Lania, Weill, Eisler—were exiled and wound up in New York. After leaving Germany in 1931, Piscator spent five years in Russia, where he directed his one movie, *The Revolt of the Fisherman*, based on a novel by Anna Seghers. During this period, several of his theatrical colleagues were killed in Russia, and after his departure, *Pravda* attacked his "left-wing libertinism and formalism." He was deeply upset by the assassination of Trotsky. Yet, according to his wife, he never turned against the Soviet Union.

After his arrival on January 1, 1939, Piscator directed the Dramatic Workshop of the New School. The work was strenuous—eighteen-hour days were the norm—and there were no commercial hits. First his President Theater was closed by creditors, then his Rooftop Theater, and finally the Dramatic Workshop itself. Yet Piscator's influence was real. For many

New Yorkers he represented the only interesting development in the theater of the forties, and his writing students included Tennessee Williams and Arthur Miller. His acting students included many people usually identified with the Actors Studio—Marlon Brando, Tony Curtis, Harry Belafonte, Rod Steiger, Shelley Winters, Ben Gazzara. The Brecht-Piscator aesthetic of "epic distancing" is diametrically opposed to the claustrophic self-projections of Strasberg and Stanislavsky, so it provides at least an interesting theatrical footnote to point out that the luminaries of forties theater were exposed to both approaches. (Piscator's students also included Herbert Berghof, founder of his own studio, and Judith Malina, whose Living Theater shares some of the political aims of Piscator's European work as well as the pacifism of his final years.) Piscator instructed actors in conventional forms of analysis and dramaturgy, but also emphasized social and political experiments, the *Lehrstück* (learning play), dialectical theater, and dramatized history, an assortment of European concepts.

Similarly, Piscator's American productions reflect his continual interest in the drama and political issues of his European past. His 1940 production of *King Lear* was performed without curtains on an open platform and succession of ramps leading to a revolving stage. Characteristically, the experimentation accompanied a political slant: Lear was a little Hitler, dividing nations while spouting slogans. The reviews were poor, but the seventy-eight-year-old Belgian refugee Maurice Maeterlinck wrote Piscator that he had "dared to wrest [the play] from the silence of the book . . . with mechanical means which were practically nil." The same year, Piscator produced a new staging of Lessing's *Nathan the Wise*, the traditional German drama of religious tolerance, and Shaw's *Saint Joan*, which was a precursor of Brecht's and Lion Feuchtwanger's modern Joan in occupied France.

Despite his displeasure with Brecht over *Schweyk*, in 1945 Piscator put on a performance of *The Private Life of the Master Race* with music by Hanns Eisler. In 1947 he introduced Sartre's existential drama *The Flies*, and in 1948 *All the King's Men*, reportedly after instructing Robert Penn Warren in the

political implications of his drama. In 1950 there was an adaptation of Kafka's *The Trial;* in 1951, his last American production, *Macbeth*, employed gauze curtains that doubled as movie screens. Photographs of the angles and shadows of these later productions evoke the visual tensions of expressionist films.

Walter Matthau, a former Piscator pupil, recalls the director saying that "he wished he could put on plays with just turntables, screens, projection machines, light effects . . . actors got in his way." This may suggest that the aesthetic vision honed with the aid of Gropius proved to be a more durable source of inspiration in America than politics. But since Piscator remained committed to something more than abstract design, his exasperation may also have had to do with American actors: a scenic designer might have been able to execute his plans more efficiently than an actor whose affiliations were with either the Group Theater or the Actors Studio.

Piscator's widow believes that the extraordinary influx of people with theatrical talent had no effect. Language problems prevented the transmission of ideas. Madame Piscator recalls that Max Reinhardt could only stand silent and take notes. Her husband, Maria Ley-Piscator says, tended to find everything "fantastic," and people invariably laughed at his effusions instead of learning from him. Yet surely she is wrong. The mere existence of a Piscator theater in New York must have contributed to a Berlinization of sensibility.

Piscator's first production after his return to Germany was *Danton's Death*, in which both Danton and Robespierre came off badly. A youthful Kenneth Tynan saw the production as a "gauntlet thrown down to Brecht." Perhaps. Piscator is remembered by Rolf Hochhuth as the "last surviving champion of the truly clean, sermon-on-the-mount type of socialism of the twenties." To the end, he loved and defended America. Yet it was the specter of the House Un-American Activities Committee that drove him from the country: he left in 1951 after being subpoenaed to appear. In 1961, back in Germany, he directed Hochhuth's *The Deputy*, "the epic-scientific, epic-documentary play I have been waiting for, for thirty-nine years," with its outspoken assault on the Roman Catholic Church. Three years

later came *The Case of J. Robert Oppenheimer*, an ambivalent valedictory to life in America.

In 1978 Goethe House in New York honored Piscator with a posthumous eighty-fifth birthday party. The guests, mostly refugees, mostly old, admired slides of his productions. Some former American students testified to his influence; one critic hailed him as the forerunner of every interesting movement in the theater, though the failure of any celebrities other than Lotte Lenya and the former soubrette Dolly Haas to appear suggested that he was not a theatrical legend in this country. The most eloquent analysis of his methods came from a well-dressed matron who volunteered a set of memories so fluent and engaging that they appeared rehearsed. As the widow Piscator announced the woman's name and she began to move forward, the audience murmured, "Who is she?" With that characteristic refugee combination of arrogance and aplomb, she announced, "Never mind. You don't know my name. I'm someone who didn't make it here."

12

A Club for
Discontented Europeans

Movies, the only aesthetic form in which Americans were the acknowledged experts, also happened to be the one in which refugees made the most public impression. Along the way they helped shape the world audience's vision of American life by providing images of a culture that could be blithely hyperactive or painfully adrift, a model or an omen. While refugee social scientists deciphered American fantasies, the filmmakers moved beyond them and, with their creations, gained entrance into those dreams and nightmares. And if there was everywhere an Americanization of perception induced by exposure to Hollywood movies, émigrés could consider themselves largely responsible for it.

Whether it was Billy Wilder's conception of the wise guy, Fritz Lang's of the vigilante, or Douglas Sirk's of the housewife, what the world audience assumed to be quintessentially American types were really the creations of émigrés far from home. The paradox of their American achievement was that, more often than not, it repudiated the larger, less parochial vision of their youth. Frequently their physical resources expanded as

their artistic vision was either constricted or driven below the surface, signaling oblique messages.

So many Americans—actors, writers, technicians—are involved in movie production that it is not always easy to extract from it a European sensibility. Yet every great émigré director was the product of principles and procedures acquired in Europe. It is good fun for some movie lovers to see how the ominous lighting of Fritz Lang's German films or the extended tracking shots of Douglas Sirk or Max Ophuls are recalled in their American work. But the European legacy is more than visual, and larger than cinematic—and not merely because many of the émigrés in Hollywood were former writers, journalists, or art historians. The important fact of their careers was that Hitler had kicked them halfway across the world, from Unter den Linden to Hollywood Boulevard. Their move had been political, and the deepest message of their careers was likewise political. For these men, with their highly cultivated historical sense, knew that their work involved a brand-new nexus of art and commerce, just as the aesthetic means at their disposal made possible brand-new forms of artistic production or political manipulation.

More than any other director, Fritz Lang remained a guide to the moral ambiguities that came to dominate the century. His most famous German movie, *Dr. Mabuse* (1922), anticipated Heydrich, Himmler, and Hitler. Mabuse did not spring out of nowhere; his type had been marching through the streets of Munich since 1920, though the critic Siegfried Kracauer, in a classic instance of confusing the messenger with the message, argued that Lang's films contributed to the Nazis' takeover. Either this was not so or it was the fault of movies in that they can be misperceived; it was certainly not the fault of Fritz Lang. But on a subtler level Lang did traffic with shifts in moral definition. While the child murderer in *M* is a monster, by the film's end Lang forces us to identify with his terror: his final rescue by the law, represented by a monolithic and slightly totalitarian Shadow, almost makes us cheer. Twenty-five years later, in his last American film, *Beyond a Reasonable Doubt*, Lang presented rather cautiously a man who almost gets away with murder,

until his fiancée, while attempting to save him, discovers his guilt. The film makes her disloyalty appear worse than his crime. Lang's departing message to America remained one of moral ambivalence, the distillation of both his political history and his professional career.

The less severe Otto Preminger is often credited with a cost accountant's mentality—no insignificant asset in Hollywood —but a political sensibility is easily detected in his work. Preminger has always been a man of divided sensibilities and loyalties. His father was a leading Austrian lawyer who experienced considerable hostility as a Jew; the father instructed his son that a public performer must bear public criticism. Preminger has minded his father's lesson, though he has forgotten neither the anti-Semitism of his youth nor the "provincial" atmosphere of his hometown; this is one émigré who does not sing "Vienna, City of My Dreams." The sense of public responsibility was manifest in Preminger's later political actions, particularly his breaking of the Hollywood blacklist in 1959. It was also reflected in the sobriety of his first American films, particularly the earlier ones; his medium shots are the visual correlative of an ethos of fairness and a balancing of psychological claims. Although he began his career in the theater as a colleague of Max Reinhardt's, he assumed some distance from the Reinhardt spectacle, and is similarly detached from another apparent mentor, Ernst Lubitsch, because he has found that the older man's humor sprang from plot contrivance rather than from character. A bit like Hannah Arendt, whose parent also instructed her in the ways of public life, Preminger has a political alertness to individual actions. This is reflected in his role as a public performer, the director as star. Preminger has frequently been outspoken on social and moral issues, confident that his personal presence contributed its own authority.

For émigrés, even the most purely aesthetic principles contained political resonance. Douglas Sirk had studied in Germany with Erwin Panofsky. And though he hardly needed Panofsky's confirmation, his theories on filmmaking resemble the art historian's in the distinction they made between theater and movies—the one activated by language, the other by image—

and in their concern with space and form: "Long before Witt-genstein, I and some of my contemporaries learned to distrust language as a true medium and interpreter of reality. So I learned to trust in my eyes rather more than the windiness of words." Sirk is not alluding to an academic debate: what politicians did to the German language helped turn his attention from the ear to the eye. He was eighteen at the time of the Bavarian Social Republic; its collapse convinced him that a gap existed between revolutionary aesthetes and the conservative masses. Sirk worked for years as a theater director. Unlike his later movies, his plays were "very literary" and outspoken in their politics: his productions included an "extremely harsh" *Three-penny Opera* and *Silverlake*, an attack on hunger and poverty by Kurt Weill and Ernst Kaiser, "ten times tougher" than the Weill-Brecht collaborations.

Sirk's subsequent career in German films provided a better training for the constrictions of Hollywood. Political criticism was obviously impossible in Nazi Germany. Sirk's German movies, especially *Zu Neuen Ufern* and *La Habanera*, fore-shadowed his Hollywood work. Both contained flimsy story lines; they were intended as star vehicles for the *diseuse* Zarah Leander. Sirk managed to smuggle messages past the German censors, diverting them with technical flash while his drama condemned a corrupt legal system and various forms of sexual oppression. Sirk learned, out of political necessity, to balance schmaltz and social observation. In Hollywood he would apply the lessons in an arena where, once again, more overt criticism was a ticket to unemployment. Sirk defended one of his Holly-wood movies, *Magnificent Obsession*, by finding a "dialectic" that operated between the "kitsch" and the "craziness."

Like Sirk, many of the directors who began in the theater came into the orbit of two theatrical geniuses defeated by Holly-wood: Max Reinhardt, who trained many of them, and Bertolt Brecht (Lang considered Brecht the supreme genius of modern Germany, and acknowledged the impact of Epic Theater and *Lehrstück* on his early American films). Brecht's rigorous method was defiantly political—although, in his typically per-verse way, he always paid homage to Reinhardt's aesthetic. Of

all the émigré directors, Max Ophuls's cinematic achievement would appear most immune to Brecht's programmatic demands. Yet consider Ophuls's appreciation of realism: "It upsets and slows down the dramatic flow. You have to concentrate your forces to touch the heart. . . . It's like in a symphony, when you separate emotional truth from the truth of life." This is, if you will, Ophulsian *Verfremdung* (distancing), structurally not dissimilar to Brecht's.

Ophuls's understanding was perhaps the richest and most sophisticated and, although he is a god to many cinéastes, the most literary: in his essays he liked to assimilate cinematic details to theories about Goethe, Balzac, and Stendhal. In the same way that Proust was the great novelist of time's passage, Ophuls was its foremost cinematic exponent. His sense of tempo and pacing drew from music and history, the idiosyncratic needs of character, the generalized demands of narrative. He was playful in two senses of the word—full of play and full of the theater—as his last European film, *Lola Montes*, with its proscenium frames makes clear. His films are exercises in melancholy. Yet he did not talk or write like an unhappy man. He shared with many other refugees the satisfactions of one who enjoys his own company. Hannah Arendt described the philosopher as seldom so fully occupied as when he is with himself; similarly, Ophuls said, "In Hollywood, I spent years without work, but I never felt myself abandoned, for I believe in a certain current . . . it is the current of the imagination." In his temporal kingdom of the imagination, history deepens our sense of change while allowing us access to the real pleasures of youth, the gifts we have been too naïve to grasp. In his later life he would scold the vanguard of cinéastes: they will grow old quickly "because they want to stay young forever." "Honoring masterpieces" can be "preserved living," leading us to the paradisiacal ideal of a mature youth.

This might appear a charming literary conceit, were it not expressed by a man who had wandered all over Europe during the thirties, even spending a few months in Moscow, where he encountered bureaucrats whose likes he would not rediscover till he met the "time is money" crowd in Hollywood. Ophuls's ad-

vocacy of aesthetic patience, along with his preservation of past masterpieces through cinematic revision, was an implicitly political stance. Like Walter Benjamin addressing the angel of history, Ophuls refused to give up the past to anyone—he held fast against Nazi censors (who deleted his name from his most famous German film, *Liebelei*), Soviet Stakhanovites, and Hollywood executives.

Among refugee directors, in order of their first American directorial assignments, Fritz Lang (1936), Otto Preminger (1936—although his career did not begin in earnest until 1943), Billy Wilder (1942), Douglas Sirk (1943), and Max Ophuls (1947) are generally the most highly regarded. All came infatuated with American film techniques; they lacked either the condescension or hopelessness that characterized other émigré artists. This does not mean that they all achieved success with equal speed. Lang, the most famous, arrived in the country hailed in some newspapers as "the world's greatest director," and quickly proved why he was preeminent in the profession. The others proceeded more slowly, Americanizing themselves to the extent that two of them changed their names: Detlef Sierck was Anglicized into Douglas Sirk, and Max Ophüls (né Oppenheimer) dropped both "h" and umlaut to become Opuls, briefly. Once Billy Wilder and Otto Preminger (both of whose names were Anglicized with regard to pronunciation) achieved their momentum, they became leaders of the Hollywood establishment, more publicized than many native-born directors, thanks to their histrionic talents: journalists found that both were "quotable" and both were "types." But Sirk spent years mastering the studio route, settling for poor-man's versions of Hollywood glamour before becoming the leading figure at his studio, Universal, and Max Ophuls languished in Hollywood for six years without any assignment at all.

As products of the Berlin cafés, the émigré directors saw popular culture as the repository of those elements of American life that they needed to master. So Lang would read comic strips in order to understand the American character and slang, while

Wilder learned English by listening to broadcasts of baseball games and soap operas—a sensible introduction to the rhythms of dramatic excitement in this country. Wilder also loved American popular music, having first worked in Berlin as a publicist for the Paul Whiteman band. American popular music would eventually be exploited in the films of Wilder, Robert Siodmak, Preminger, Sirk, and Edgar Ulmer: Lang later boasted that his *Rancho Notorious* was the first Western with its own theme song.

Another asset was an attraction to landscape and myth that could be traced back to their schooldays. In his first years here Sirk was forced to support himself by operating farms on which he raised chickens, alfalfa, and avocados. He thus must have realized fantasies he had cultivated since childhood as a result of his reading. In fact, Sirk believes that he was one of the few Hollywood émigrés who had read about the country before coming here. And later: "I was about the only one who got around and about. I used to travel whenever I could, whereas most of the others sat in Hollywood talking about the good old days and never saw the country." Sirk says he would have directed more Westerns had he been an American: "I am not an American, indeed I came to this folklore of American melodrama from a world crazily removed from it." Lang also gravitated to the Western. For him, it was the American counterpart of the *Nibelungenlied*. During his early days in this country he lived for several weeks with the Navajo in Arizona. He claimed he was the first to photograph their sand paintings, as later he was the first to film war-painted American Indians in color. In contrast, Billy Wilder got most of his inspiration from cities. In the thirties he teamed up with an American, Charles Brackett, initially on screenplays, but later, when Wilder began directing films, Brackett became his codirector as well. Brackett had been the first drama reviewer of *The New Yorker*, so that their partnership coupled New York City humor with a Berlin/Vienna version.

While they reached out to Americans, these émigrés remained in contact with each other, especially during the thirties, when they rallied to the defense of those still trapped in Europe. What

Jean Renoir called "a club for discontented Europeans" was also a community of loving friends. Though film critics would later use one émigré's oeuvre to dismiss another's, among themselves there existed a camaraderie. Max Ophuls was sustained, during his long period of unemployment, by contact with "European friends who were more or less absorbed in their own work" but who "made sure I never lacked funds." His first job came through the auspices of his fellow émigré Robert Siodmak—"a great gesture of friendship." Similarly, Edgar Ulmer got Douglas Sirk his first American assignment, and Billy Wilder made his Hollywood debut writing for the director Joe May, formerly of Berlin, in 1934. When Wilder graduated to directing eight years later, his mentor Ernst Lubitsch arrived at the studio unannounced, joined by several other directors, to salute the newest of their company. That the storyline was thoroughly American was incidental; the good wishes were in German. Likewise, when Otto Preminger overheard a group of émigrés conversing in Hungarian, he admonished them, "Don't you guys know you're in Hollywood? Speak German."

Refugees often found themselves isolated from a Hollywood that regarded them as alien and unpredictable. Even the most assimilated experienced the wrath of the Hollywood bourgeoisie. Wilder and Lang spoke casually of the common complaint that they were "goddamned foreigners." Infuriated with one Lang film, a studio executive blasted, "You son-of-a-bitch—you're not at UFA any more," a fact that hadn't quite eluded Lang.

Lang's Hollywood career was a peculiarly appropriate culmination of his earlier work in Europe. On his first visit to this country, after viewing the skyline of New York he conceived *Metropolis* (1926), his terrifying vision of the city of the future. He later apologized for the film's naïveté: "I was not so politically minded in those days as I am now." Its thesis that the intermediary between the hand (labor) and the brain (capital) is the heart (woman) later struck him as, at best, reactionary. That *Metropolis*'s vision was prophetic did not console him: "Should I say now that I like *Metropolis* because something I have seen in my imagination comes true?" Lang liked to think that his crit-

ical judgments had matured as a result of his experience with the Nazis, and the one place where he felt those judgments could be tested and elaborated was America. So one could say that years of work in America enabled him to disown—in the form of a new oeuvre—a vision inspired by this country.

In adapting to the American scene, Lang's work may have improved (although he did not seem to have much affection for his Hollywood films). Klaus Mann suspected the change was more than geographic. Some of Lang's films, he wrote, had suffered from a "hollow monumentality," spectacle at the expense of thought. Mann blamed this on Lang's connection with "that mistress of kitsch," Thea von Harbou, who was Lang's first wife. Von Harbou stayed in Germany to make Nazi films, unlike Lang, who quit the country as soon as Goebbels offered him control of its film industry. Without Von Harbou in America, Lang's works became, for Mann, more stark and lucid. Abandoning an expressionist aesthetic, he could dramatize "the inward pressures of character": the move was an aesthetic renewal.

It also required a modification of method. Lang discovered that Americans don't like symbols, and later admitted that his films benefited from a tighter approach without them. He realized that if he wanted to continue treating his favorite themes of revenge and failure, they must be recast in American terms. A self-professed "superman" like the German Mabuse would be succeeded by an Al Capone, and Capone was John Doe, the audience's twin, if not its surrogate. Lang was not the only émigré to see that if fascism appeared in America, it would assume a new guise, but he was special in that he had the aesthetic means to depict this insight. And in ironic confirmation of his new knowledge, Lang's films implied a politics that resembled nothing so much as anarchism: a streak of vigilante justice already apparent in *M* flowed through his American films, alongside the attacks on mob justice in films like *Fury*. Another director's strategy derived from a similar perception of American character. Douglas Sirk found American naïveté alluring to work with ("Your characters should remain innocent of what your picture is after"), but when the naïveté was shared by the audience, he

was afraid that his effects might be subverted. If Americans were pleasingly "simple" and "naïve in the best sense of the term," this innocence made them "want a cut and dried stance, for or against," and shut them off from "the nuances which handle both at the same time": a lovely depiction of the dialectic! Even when those nuances were clarified in simple words by second-rate actors—part of the working conditions of most of Sirk's career—the cinematic atmosphere most congenial to him was still "completely foreign to Americans." His love for America was no simple passion.

As political and economic pressures had led them into this aesthetic muddle, professional craft led them out. Some émigrés had news to deliver; Fritz Lang despised the Hollywood wisecrack "If you've got a message, use Western Union." Others had less precise intentions. But they all realized that content in movie terms emphasized almost everything visual—lighting, montage, sets, costumes—over anything verbal. This recognition was a formidable asset for refugees: it called upon their training as European artists, while allowing for their less than sure grasp of the English language.

Ophuls tells a nice story about Jean Renoir informing some friends that his movies often lacked a text. Once the actors were "properly put" and confident in their roles, Renoir let them improvise. "Poor actors," said someone. But rich Renoir, Ophuls thought to himself. Another tale similarly shows how the language takes care of itself once the direction is right. After his first American film, *Fury*, Lang was harassed by a studio executive who thought he had amended the script. Lang insisted his English would not have been good enough, and indeed line for line the American found no changes. But Lang was, of course, being disingenuous. In the same way that a good stage actor can give contradictory readings of the same line, a film director can make words almost irrelevant: Lang himself said that audiences tended to remember only the images. Ophuls added that "the words, the technology and the technique and the logic of the visible must be secondary to the image, subordinate to the vision containing untold wonders within it." Sirk provided a simpler gloss: "Stories are not all that important," though he found dia-

lectical pleasures everywhere else—his concern was "the *how* instead of the *what* . . . structure instead of plot."

All these directors shared a sense of their own importance. They might not agree on anything else but they all knew where authority resided. "A director should know everything," said Lang. He alone is finally responsible for the whole: "a script has to be completely filtered through my brain," says Preminger. But the script is only the beginning—content is conveyed otherwise: "The angles are the director's thoughts," says Sirk, "the lighting is his philosophy."

Such beliefs prepare one to be either an artist or a dictator. Several German directors—Lang, Lubitsch, Wilder, Preminger ("They call me Otto the Monster"), Von Sternberg—acknowledged that others found them Prussian martinets. Since the same criticism fell on a Lubitsch, who tended to order everything in advance, and an Ophuls, who cherished the unexpected possibilities that opened up while shooting and felt a worker's solidarity with "the ordinary people" (the set technicians who manufacture objects for temporary cinematic use), the problem might have had less to do with aesthetics than with national style. Egomania may be involved in assuming control of an audience's dreams, but Ophuls defended his calling: "One believes that one has a heart that beats for them, feelings that see for them, in brief, after all, a nose."

Yet after all their demonstrations of aesthetic mastery, the émigrés continued to find themselves treated as mere employees. Though every émigré artist, even Thomas Mann, complained of financial woes, no other group was so continually enmeshed in the conflict between art and commerce. And these were professionals who were willing to compromise, to adjust to studio pressures, as they had been forced to do on a lesser scale in Germany. On a high level, the box office requirements inhibited the treatment of ambitious material. On a more mundane level, the directors were dependent on studio arrangements and B-movie finances; while film scholars might applaud their capacity to make much out of little, the directors would gladly have settled for an increased production budget. It was probably because they viewed the studio set itself as both their castle and their

prison that the émigrés turned to the *film noir*, with its ambience of entrapment. The furtive quality of life in these films mirrors the directors' procedure. How much could they bring to a film? That is, how much could they get away with?

Artists have always broadcast multiple messages, some invisible to themselves because they are blinded by more prosaic concerns. But this kind of sneaking around both one's sponsors and one's public was something new, especially when that public was the largest popular audience ever available to an artist. There was something morally shabby about such work: the directors would have understood Brecht's poetic comment about job-hunting in Hollywood, "And I . . . I am ashamed." Their unanimous sense was that they could have done better. The unasked question was, Where?

Moral disequilibrium, observed in their colleagues and themselves, allowed these directors to discover the insidious and problematic elements in the most conventional situations. It is far too glib to see them as outlaws, but they all shared a sense of living on the periphery of normal life. Billy Wilder, in his early days in Berlin, wrote a series of articles on the gigolo, a figure any free-lancer must acknowledge unhappily as his half-brother. Indeed, Sirk likes to think that if he met Shakespeare, the playwright would offer the free-lancer's benediction: "My dear boy, I know what it was like in Hollywood. I had to make money too, and a lot of my stories were lousy."

Studios, censors, agents, language itself—everything conspired against aesthetic control. Both more privileged and less independent than other émigré artists, the film directors surpassed them all in the number of American masterpieces they created. Not that refugee directors didn't contribute their share of kitsch and schlock: the professional calling required one to be, at least part time, a hack. And so Max Nosseck was responsible for *Dillinger*, Steve Sekely for *Revenge of the Zombies*. Douglas Sirk insisted that his melodramas packed a subversive cargo, but others found them high-quality soap opera. Refugee films

comprise a group that contain titles as disparate as *Harvey, Death of a Salesman, Hell's Kitchen, Porgy and Bess, A Man Called Peter, The Wild Ones, House of the Seven Gables, The Death of Frank James, The Singing Nun* and *Miss Sadie Thompson.* No form of American life was shut off; given the flexibility that studios demanded of their employees, émigrés had to be ready for anything. As Fritz Lang said, when asked whether he liked a particular story, "*Like?* Look—you sign a contract."

On occasion, Hollywood executives required them to transform their own pasts to fit American expectations. The Vienna of Max Ophuls's *Letter from an Unknown Woman* is like the Warsaw of Ernst Lubitsch's *To Be or Not to Be:* a fantasy city filmed on Hollywood studio sets populated by Austrians and Poles with Indiana twangs and California drones. Instead of local color, these cities exhibit the qualities of an Americanized Europe.

But in such films something else was conveyed that was more faithful to émigré history. Refugee directors could call on refugee writers, photographers, set designers, and actors when the opportunity arose. There was a special political curiosity—one could almost discern a cabal of conscience in the occasional reunions. Karl Freund, who had photographed *Metropolis,* worked as cinematographer on the 1944 film of Anna Seghers's *The Seventh Cross,* directed by Fred Zinnemann, who was another product of the Berlin studios; the second film offered an implicit repudiation of *Metropolis*'s aesthetic and political visions. Rudolph Maté's American work seldom matched the audacious experimentation of his earlier photography in Carl Dreyer's *The Passion of Joan of Arc* and *Vampyr,* or in Lang's French film, *Liliom.* One of his few projects with a fellow ex-Berliner was Ernst Lubitsch's wartime comedy *To Be or Not to Be,* a film that, according to Lubitsch, exposed the absence of any serious German resistance to Hitler. Franz Planer, a veteran of UFA films, worked in the same year, 1948, for two émigrés: for Robert Siodmak's *Criss Cross* he photographed evocative sequences of southern California life; for Ophuls's *Letter from an*

Unknown Woman, his mood was as wistfully fin de siècle Austrian as it had been in their film of a quarter-century earlier, *Liebelei*.

In the craziest of career shifts, émigré actors were often hired to play Nazis. Similar exigencies allowed émigré directors to examine European politics. In 1942 Fritz Lang conceived a cinematic depiction of Heydrich's assassination ten days after the actual event. Though the actors were such unlikely German impersonators as Walter Brennan and Dennis O'Keefe, the film united Lang with Brecht, Hanns Eisler, and the émigré actor Alexander Granach. It also enabled him to depict one Nazi as a pervert, more preoccupied with his pimples than with human lives, and another as a reincarnation of a bullying teacher from Lang's youth. The same year Lang planned a modern version of *The Golem*, adapted by Paul Falkenberg and Henrik Galeen, to be set in France during the Nazi Occupation. This would have been his homage to Jewish tradition, and it remains one of the great unrealized émigré projects, along with Ophuls's *Magic Mountain*, Jean Renoir's *Dead Souls*, and Billy Wilder's black *Camille*.

Wilder had the happy chance to master his American craft while treating themes of central interest to émigrés. The second Hollywood film he directed, *Five Graves to Cairo* (1943), is a study of British espionage in Egypt. The hero winds up in a small hotel that has been commandeered by the German forces under Field Marshal Rommel, played by Wilder's old idol, Erich von Stroheim. Wilder sneaks in some German humor, including a lot of German dialogue, most of which goes untranslated except for the passages that Von Stroheim repeats in English in order to spare Allied interceptors any extra work. This Rommel is witty and cosmopolitan; he calls for the excision of *Aida*'s second act because it is too long and not much good —in short, an amiable sadist, a role naturally suited to Von Stroheim. In an astonishing extension of sympathy—there is nothing like it in Lang's work—Wilder shows Germans who understand and are discomfited by their unpopularity, who tell Billy Wilder jokes ("the working bathroom goes to the German

High Command, the other bathroom goes to the Italian"), and who stand in awe before American expertise ("You can afford to improvise, we relied on preparation").

Wilder followed *Cairo* with movies about Los Angeles and New York. But circumstances returned him to Berlin. In 1945 he spent six months with the Psychological Warfare Division of the U.S. Army working on the reconstruction of the German film industry. He had a chance to portray the war-ravaged Berlin. His second film upon his return to Hollywood, *A Foreign Affair* (1948), involves a priggish congresswoman, Miss Frost (Jean Arthur)—as émigré puns go, this is not the worst—who arrives in Berlin on a fact-finding mission and falls for an American soldier (John Lund), who is courting a former Nazi nightclub singer (Marlene Dietrich); the last was a casting selection that would titillate all the émigrés who remembered Hitler's unsuccessful wooing of the actress. Wilder's Berlin is full of a "moral malaria" that infects the cynical congressmen and the black-marketing GIs. The Berliners themselves are almost somnambulant ("For fifteen years, we haven't slept in Germany") and are awakened most vividly by the sight of a chocolate cake (*"Eine Schokoladentorte!"* they cry, reminding any former Berliner of the pastries sold up and down the Ku'damm).

Wilder has a director's revenge, bombarding the Nazis with *Berlinerisch* wisecracks (the suicides of Hitler and Eva Braun made for "a perfect honeymoon"; "The thousand-year reign: that's the one that broke the bookies' hearts") and slapstick (as a bullying father demeans himself before the American police, his schoolboy son draws a swastika on his back). Marlene Dietrich turns out to have most unsavory connections, but she is so charmingly transparent (the film tells us "a woman changes her politics with her fashions") that, next to the frigid Miss Frost, she conveys maturity and a kind of urban wisdom.

Politicians and critics alike were appalled by this display of European amorality. A critic found the depiction of Dietrich in "rotten taste." The Department of Defense issued a statement denying any resemblance between the film's GIs and American

soldiers. On the floor of the House of Representatives, Wilder was denounced for his equally irreverent treatment of Germans and Americans, as if they were equivalent.

By contrast, the fin de siècle Vienna of Max Ophuls's *Letter from an Unknown Woman* (1948) was politically neutral. Its sentiments and historical period removed the film from any possible controversy. Based on a Stefan Zweig novella, the film's plot makes for superlative kitsch: a young girl (Joan Fontaine) devotes her life to a concert pianist (Louis Jourdan). Though they meet on several occasions, during one of which he impregnates her, he does not connect these encounters—she remains nameless, an "unknown woman." He receives her letter only after she has died, while nursing their son through a fatal bout of typhoid. The film ends with Jourdan smiling, en route to a duel, trailed by her ghost and perversely thrilled by the rapprochement of Eros and Thanatos.

This is kitsch *mit schlag*, yet the film avoids bathos far more scrupulously than had the earlier, similarly sentimental *Liebelei*. It is, after all, an American film produced for an American audience. Ophuls is a brilliant director of actors—the story may be maudlin, but the actors are not. He has an exact sense of details accompanied by a riotous sense of humor. In one sequence, Jourdan and Fontaine dance at a Viennese café to the music of a female orchestra (the sexual designation was Ophuls's idea), and these ladies with the thick accent—most likely, Hollywood émigrés who were never going to make it there—observe the lovers with a displeasure compounded of cynicism and tight girdles. They prefer married couples who have given up these starry-eyed marathons on the dance floor. Here, as so often in the film, Hollywood allows Ophuls to tweak slyly the conventions of European pathos.

Of all his American films, *Letter* most fully realizes what Ophuls called "a new kind of tension which . . . has never existed before in any of the other forms of dramatic expression, the tension of pictorial atmosphere and of shifting images." In the initial scenes the girl's passion is rendered both lyrical and hallucinatory by diaphanous shadows and sweeping camera movements; a subsequent shot of a thick rug being noisily pummeled

and rolled through a crowded courtyard achieves an exhilarating contrast. Arches, columns, window bars, wheel spokes variously represent Fontaine's fantasies, confinement, and approaching death. Movement itself assumes the force of a visual metaphor. When at last Jourdan comes to Fontaine declaring his love, his stride is so invested with her desires and strategies, her endless, monomaniacal calculations that the viewer almost swoons with her. *Caught* and *The Reckless Moment*, Ophuls's next two films before his return to Europe in 1950, had contemporary settings; they also exhibited a more relaxed, almost documentary quality, as if *Letter* were his valedictory to the lovely and fated forms of European artifice.

In the 1960s the rapid-fire shifting of imagery employed by Russian directors for dialectical purposes was unfavorably compared by film critics with the lingering frames and psychological probings of the great German directors. It is proper to emphasize that the Germans' procedure was also consciously dialectical, albeit cadenced more subtly. They could achieve their effects not through montage but through focusing on sets, angles, frames, windows—in short, every visual component of a scene outside the characters themselves. In an indirect fashion, they frequently depicted the contradictions inherent in the world of power and glamour, which was consecrated to capitalism, and was symbolized by the very name Hollywood. Without rhetorical devices they managed, in Brecht's ironic phrase, to "deliver the goods."

They often attempted to do so, simply by their choice of characters. During a time when, according to Ronald Reagan, former president of the Screen Actors Guild, the nation didn't even know it had a race problem, refugees almost monopolized the cinematic interest in blacks (excluding the low-budget films slated exclusively for black audiences). True, there had been King Vidor's *Hallelujah* in the twenties, as there would be Vincente Minnelli's *Cabin in the Sky* and Elia Kazan's *Pinky* in the forties, but the involvement of refugees in black films was disproportionately great. In 1939 Edgar Ulmer directed an all-

black movie, *Moon Over Harlem*. As usual for Ulmer efforts, there was no budget to speak of—the extras were paid twenty-five cents a day. Ulmer believes the film was the first American anticipation of Rossellini's postwar method, largely because professionals could not be hired.

Sirk employed black performers in *Meet Me at the Fair*, and feels that the "black is beautiful" theme is the only interesting element in *Imitation of Life* (in which a black girl passes for white—and is, incidentally, played by an émigré's daughter, Susan Kohner). In the early fifties Billy Wilder planned a black *Camille*, with Lena Horne as the courtesan, Paul Robeson as the father, and—an amusing choice—Tyrone Power as the mulatto son. Typically, Fritz Lang had the most provocative schemes. His hero in *Fury* (1936) is almost lynched over a phony crime. Lang had hoped to present the issues of lynching without compromise: he wanted the lynching victim to be the black rapist of a white woman. This was material too touchy for the studios; also excised from the film as potentially offensive to Southern audiences was a sequence in which a black girl sang a freedom song. Many years later Lang directed *House by the River* (1950), a somber film in which the scion of a Southern family murders a servant girl. This time, Lang wanted the girl to be black and was again overruled. Perhaps Otto Preminger alone got what he wanted, but he now admits that his musicals *Carmen Jones* and *Porgy and Bess* were fantasies, not reflective of black life—although they had the rare virtue of giving employment to many black performers.

The best émigré directors gave the measurement of American life, recording its habits and routines with an exactitude that predicted neorealism. The pawnbroker's shop in Wilder's *Lost Weekend*, as well as the insurance office in his *Double Indemnity*, and the bungalow dressing rooms in his *Sunset Boulevard*; the seedy finance company in Ophuls's *Reckless Moment*; the fish cannery line in Lang's *Clash by Night:* the various workplaces of America were registered with definitive clarity. (Jerry Wald, the executive producer of *Clash by Night*, wondered if Lang "as a European" could capture so American a workplace.

Lang answered simply, "Look, Jerry, either one is a director or one is not a director.")

Lang gave the best justification for this attention to detail: "Every serious picture that depicts people today should be a document of its time." With that in mind, we can locate Lang's view of contemporary America in his masterly films of the genre known as *film noir*. These films, made in the forties and early fifties, combine a realism of subject matter with a technique so distinctive that in retrospect they seem almost surreal, the startling contrasts in light and shadow coloring both images and characters. The first of the *films noirs* was Wilder's *Double Indemnity* (1944), with its evocation of a world most bluntly rendered in German as *unfreundlich*, a term that conveys the condition of climate as well as of people.

In the first scene an insurance investigator (Fred MacMurray) collapses into a chair and dictates his confessions to his boss (Edward G. Robinson). MacMurray thus immediately loses our sympathy, even as his low-keyed charm makes us identify with him: Wilder was demanding from American audiences an unprecedented degree of ambivalence. MacMurray is seduced by a spoiled suburban wife (Barbara Stanwyck) into murdering her husband. By the end he is as demoralized as she, and in a literal dance of death, they shoot each other. Without strain, the film's images achieve an allegorical power: the split-level office with its suggestions of busywork on one floor and shenanigans on the other; the fruit market where Stanwyck and MacMurray rendezvous surreptitiously, parched spirits amid the abundant fruit.

Also during the mid-forties, Fritz Lang directed two remarkable *films noirs: The Woman in the Window* (1944) and *Scarlet Street* (1945), both starring Edward G. Robinson and Joan Bennett. As in his own *M* or Wilder's *Double Indemnity*, Lang obliges the audience to identify with criminals and to share their fear of capture. *Scarlet Street* is an adaptation of Renoir's *La Chienne*, with the original Montmartre setting transferred to Greenwich Village. The film is dense with compact vignettes: Salvation Army revivalists bugle-blowing on the street corner,

signifying the hero's withdrawal from conventional morality; his whistling of "Melancholy Baby" gradually undermined by an atonal orchestration; witnesses at a trial, photographed in expressionist style, their torsos foreshortened or distended. The play of light catches in the same confining nimbus Robinson and Dan Duryea, a pimp he frames for the murder of their mutual mistress (Bennett). Geometric patterns of light and shadow surround Duryea as he walks to the electric chair. A door slams as the invisible man pleads, "Won't somebody give me a break?" Similarly stark forms surround a distraught Robinson with an extralegal proclamation of doom (and fall ten years later on the psychotic murderer in Lang's *While the City Sleeps*).

These are great films, but their American setting is arguably incidental. In the early fifties Lang was blacklisted for over a year, although he denied ever having been a member of the Communist Party. His second film after his career resumed, *The Big Heat*, may be his masterpiece. It is also thoroughly American in its tone and ambience while managing to be one of the darkest films in Hollywood history. When a young cop (Glenn Ford) investigates political corruption in his town, the mob places a bomb in his car. His wife is killed instead of him. He is thwarted in his investigations by his crooked superiors, and is eventually fired from the force. At last, assisted by a gangland moll (Gloria Grahame), he exposes the crooked lawyers and captures whatever gangsters have not already suffered violent deaths.

Lang always believed that the camera should move with the leading character's perception of events. Glenn Ford "becomes the audience," and the camera discovers the "results of violence" along with him, drawing us into his horror. So we are in the house with him when his car explodes—a terrific rocking of the screen. We accompany him as he discovers that nobody—not the police commissioner, not the city council members—can be trusted. Only a bookkeeper has any integrity, and she is crippled, unlike the glamorous gangsters and white-collar criminals with their dearly purchased good health. Even Grahame must be scarred—a hoodlum (Lee Marvin) throws hot coffee at her—in order to be numbered with the good folk.

Everywhere we are enclosed by defined angles, as if space has squeezed in on itself. The curtains in the middle of walls and rooms frame sets as various as a nightclub, a seedy hotel suite, a lower-middle-class kitchen, an upper-middle-class salon. After her scarring, Grahame persists in holding herself at an angle, thus calling more attention to her disfigurement. Toward the film's end she kills the proper but corrupt widow of a city official, declaring, "We're sisters under the mink." After she scalds Marvin, he shoots her. Dying, she begs Ford to describe his late wife. As he does, her face remains in semiprofile, only turning completely toward him to say, "I like her, I like her a lot," the malformed once again identified as the sign of wholeness.

Does justice triumph? When, upon the mob's orders, the cops withdraw protection from Ford, they are replaced by his brother-in-law and other neighbors, some of them former soldiers. This is either a moving display of populism or vigilante justice. Ford is reinstated on the force, but in the film's last scene he leaves his office on assignment, calling out to an assistant a most uncomfortable command, "Keep the coffee hot!"

The *film noir* renders a nightmare in forms so stylized that its verisimilitude can be questioned. Perhaps more interesting is the émigré handling of something else, the American dream, the ideology implicit in all Hollywood films. For while alternately celebrating and subverting glamour, the émigrés found themselves entangled in the same bind. Since the days of Berlin cafés, when Karl Kraus had reminded them of their moral failures, the intellectual masters of popular culture had contemplated the same problem: in making the meretricious beautiful, was one somehow contributing to its triumph? Like other émigré artists, the directors found a solution in an irreverent questioning—circuitous, dialectical, but not invisible—of the values conventionally associated with Hollywood. It was in their more sober films, rather than in the mannered *noirs*, that they achieved their most subversive effects.

Otto Preminger would later become identified with middlebrow spectacles, but his best early films transformed conven-

tional melodrama into something far more astringent, decorous, even documentary. In *Laura* (1944), the obvious gap between the hero's daydreams of a murdered society girl and the reality represented by a pretty but uncompelling heroine expresses Preminger's understanding of desire, his reiteration of the Proustian theme that we construct a loved object who often bears no resemblance to the person in our arms. At the same time Preminger gives us the social details and interior designs of café society. (The film also includes a sympathetic maid as a contrast to the dissolute socialites.) A year later, in *Fallen Angel* he again downplays a melodrama of absurd coincidences while ringing in changes on the traditional American conflict between a blond angel (Alice Faye) and a dark-haired vamp (Linda Darnell), rendered now in class terms: Faye is a rich virgin, Darnell a promiscuous waitress. Similarly, in other films, he takes a variety of hyperbolic types—a fashion designer (*Daisy Kenyon*, 1947), an astrologer (*Whirlpool*, 1949), a sadistic cop (*Where the Sidewalk Ends*, 1950), and an incestuous psychopath (*Angel Face*, 1952)—and by precisely locating them in their class and social setting, grants them a dignity extrinsic to the melodramatic story lines. For example, *Daisy Kenyon*, the study of a postwar triangle, could have been a glossy "woman's picture." But where Douglas Sirk would later relish every excess, Preminger's choices are always on the side of decorum. The heroine (Joan Crawford) is a career woman, and he celebrates her occupational rewards—a spacious brownstone apartment, an interesting job—while slyly satirizing the more chic milieu of her lover.

In his later pictures Preminger graduated to the so-called Big Themes of postwar America. Along the way, he demonstrated considerable political courage. He broke the blacklist in 1959, when he hired Dalton Trumbo to write *Exodus*. Preminger felt this was a gesture in keeping with American principles of fair play; likewise, he defended the film's muting of the novel's xenophobia. His version rallied to neither side, Arab or Zionist: "It's an American picture, after all, that tries to tell the story, giving both sides a chance to plead their case." Here is the by-now-familiar case of a refugee lecturing Americans on how best

to fulfill their country's principles. When Edward R. Murrow objected to the cynical depiction of politics in *Advise and Consent*—a curious response from the fifties symbol of journalistic rectitude—Preminger replied, "I feel that our weapon is truth. I feel that showing America as it is . . . will make it clear to foreign countries . . . that we have freedom of expression." Preminger ultimately vanquished the Hollywood censors with his inclusion of the words "virgin" in the dialogue of *The Moon Is Blue* and "abortion" in *Anatomy of a Murder*, a happy instance of a refugee contributing to the freeing of American public speech. He broke similar barriers with the drug addiction of *The Man with the Golden Arm* and the gay-bar scene in *Advise and Consent*.

When Max Ophuls was finally assigned American subjects, he too de-emphasized the allure of materialist success. While the romantic haze of his European characters' dreams seemed to require a hallucinatory momentum, his strategy for conveying the mental states of his American characters was taut and sober; we expect him to transcend melodrama, but we may not be prepared for such understatement. Both *Caught* and *The Reckless Moment* bespeak a less studio-made effect and a consequently wider range of physical settings. In *Caught*, produced by Max Reinhardt's son, Wolfgang Reinhardt, a model marries a wealthy psychopath and eventually leaves him for a doctor who runs a clinic in a working-class neighborhood. Ophuls shows us her various settings—a railroad flat, her husband's home, the doctor's office—with precise attention to each, as well as a characteristic swirling of the camera that replicates her own confused sense of location. (The refugee actor Curt Bois played the millionaire's panderer—a charged role, one imagines, for actor and director alike: Bois's autobiography bears the knowing title *Too True to Be Good*.)

The Reckless Moment is the most soap operatic of all; indeed, one of its writers later wrote two television serials, *The Guiding Light* and *As the World Turns*. While her husband is away on business, a rigid, unimaginative housewife (Joan Bennett) becomes involved with blackmailers—one of whom (James Mason) falls in love with her—in an attempt to protect her

daughter from a murder charge. Some years before Sirk did the same, Ophuls shows us lush interior spaces that swallow up their occupants. We are always aware of the stairway, the long hall with its several regular rooms from which Bennett's relatives pop out like figures in a cuckoo clock. Bennett can find no shelter at home, no secret closet where she can attempt to think or plan or, after Mason's death, mourn. At the end she is finally allowed a release, which only definitively establishes her imprisonment. As she breaks down on the telephone while talking to her still-absent husband, we see her framed between two stairposts, cut off from her family and home, as if for life.

There was barely a couple of years between Ophuls's first American movie, appropriately named *The Exile* and situated in the seventeenth century, and his last two, with their contemporary settings. Of course, during his years of unemployment he had prepared himself for his eventual breakthrough. Ophuls exhibited a tourist's curiosity about the country and its movies: he was, he said, "a fan."

Douglas Sirk would eventually portray many versions of American reality, but his apprenticeship took longer. His first American film, *Hitler's Madman* (1942), dramatized Heydrich's assassination, with American actors and a largely European crew, including Eugen Shuftan, whom Sirk hired on the sly—Shuftan was not a member of the guild—to do the photography. Subsequent films were both "literary" and dominated by European influences: for example, *Lured* (1947) involved a fin de siècle London Bluebeard who quoted Baudelaire. By trial and error, Sirk eventually acquired a method more suitable to American material.

When Sirk hit his stride, it was with characters that, given his temperament, he ought to have found most unsympathetic: bigoted, superstitious, materialistic men and women. But by then Sirk had learned that their lack of culture was no hindrance to the exercise of his craft. He came to prefer two kinds of cinematic characters; a central "immovable one," around whom the more mercurial could move, and a more complicated figure who "turns around himself." His most famous subjects are women, some as dimwitted and inert as Lana Turner in *Imitation of*

Life, others as alert and independent as Jane Wyman in *All That Heaven Allows.* Sirk's heroines are often suburban housewives who abandon their interior-decorated rituals for an emotional anarchy, which is expressed in their attraction to younger, poorer men. (As a veteran of making do with second best, Sirk appreciated their plight: he was forced to make matinee idols out of unknown actors like Rock Hudson because his budgets at first were too small to allow him to hire big stars.)

Sirk insists that the women's liberation shown in his films expresses a profoundly antagonistic view of the American family. In *All I Desire* (1953), adapted for the screen by the émigré Gina Kaus, "a woman comes back with all her dreams, with her love—and she finds nothing but this rotten, decrepit middle-class American family." The producer insisted that this woman remain with her husband and children rather than return to her lover, but the "happy ending" resembles a kind of doom.

For a director of women's films, Sirk is most unsentimental about children. "The point is: are children really pure? I don't think so. The innocence they have will be destroyed. They are symbols of melancholy, not of purity." So Sirk's mothers must break away from their families. His glossy soap operas are really, he contends, subtle examinations of the themes of American romanticism, discoveries of the real American dream beneath the contemporary dream of success. Thus, when in *All That Heaven Allows* (1955) a matron ignores her snooty offspring to elope with the gardener, her liberation is "ultimately" an homage to *Walden,* a copy of which is shown in close-up.

Sirk's later successes spell out more boldly the decline of bourgeois propriety and self-confidence. In *Written on the Wind* (1956) "a condition of life is being portrayed and in many respects anticipated": Sirk questions the trappings of success even as his camera makes them luminous. Still, none of the good guys go off impoverished—the critique of materialist ambitions is only implicit.

The Tarnished Angels (1957), based on William Faulkner's *Pylon,* invokes the bewitched qualities of ordinary American life. A study of itinerant pilots, the film captures the seedy

charms of bars, carnivals, Mardi Gras parades. There are glorious shots of planes silhouetted against a beach, skirting the ground, and as if to demolish the myth, a horrifying climax in which a plane comes close to crashing into the carnival crowd: in a cunning use of wide-screen photography, Sirk packs the frame with carnival customers—the audience's surrogates—running in all directions, as confined for the moment as is the camera's image within the screen's borders.

Sirk had to camouflage his more serious criticism. If one wanted an aggressive exposé of American fictions, one had to turn to Billy Wilder, who appeared to be the most Americanized of émigrés. Although Wilder enjoys presenting himself as a vulgarian, he too had been a bright, middle-class Jewish boy who read Karl Kraus and attended parties with Bertolt Brecht. In Berlin he participated in several avant-garde movements during a time when interests in popular culture, high living, and radical politics were not perceived as contradictory. In learning the art of film, he had had excellent teachers: Ernst Lubitsch, Erich von Stroheim, and the scenarist Carl Meyer. Among them, these men represent a range that encompasses brittle comedy, psychological melodrama, and self-conscious aestheticism.

Wilder's treatments of American life are either cynical or realistic, depending on one's angle of vision. His *Ace in the Hole* (1961) savaged American journalists with a scorn worthy of Karl Kraus himself; his *Kiss Me Stupid* (1964) suggested that small-town hicks were ripe for a sexual revolution and prompted an editorialist to demand that Wilder be deported as a corrupter of morals; and, as we saw, *A Foreign Affair* assigned no moral superiority to American GIs. Wilder was dunned by critics and executives alike for such films. But the loudest criticism from Hollywood came with *Sunset Boulevard* (1950). After the premiere, Louis B. Mayer reportedly said, "You should be tarred and feathered and run out of Hollywood." Wilder says the moviemakers' displeasure revived old anti-refugee prejudices: "They thought, 'The son of a bitch with the accent, Wilder, is biting the hand that helped him out of the water and is feeding him now' ": like a Nabokov formulation, this is an embroi-

dering of American idiom that could only come from a foreigner.

As perhaps only *Sunset Boulevard* could. Surely this was an émigré's most dramatic deconstruction of the American dream in its contemporary incarnation, which was Hollywood itself. The film was an émigré's triumph, exhibiting a total mastery of the American reality and also a defiance of his American bosses. By exposing the system to outsiders, Wilder achieved one great émigré ambition: to know American culture thoroughly and yet remain not quite part of it. As so often happened, the Berlin tone allowed for a salutary detachment from the kitsch at the center.

Even today, *Sunset Boulevard* astonishes with the scope of its attention. The same Wilder who filmed the southern California markets and offices of *Double Indemnity* here shows us the work settings of Hollywood. Many viewers have been fascinated by the garish mausoleum where Norma Desmond (Gloria Swanson) lived with her servant and former husband (Erich von Stroheim), but Wilder also shows us the cramped quarters of an unemployed writer (William Holden), which are as seedy as any set in an Edgar Ulmer film, and the studio bungalows, all squat and low-ceilinged, as are the offices reached by flimsy outdoor stairs—these work spaces are primed for collapse.

Hollywood resented most the dissection of Swanson's glamour. Even Charles Brackett disliked the filming of her treatment at the hands of cosmeticians: why inform the boobs that their dreams were composed, literally, of makeup? Swanson, in the film, is both the embodiment and caricature of old Hollywood, queening it over her cronies, played by the former movie stars Von Stroheim, H. B. Warner, Buster Keaton, and Anna May Wong, or prancing about as a mock Charlie Chaplin, a pose of a pose of a pose. When the young lovers William Holden and Nancy Olson commence their flirtation, their dialogue is a rapid-fire sequence of old movie lines and clichés ending with the soap-opera title "Life Can Be Beautiful." This is a very early instance of film characters behaving like archivists. The hothouse irony of these two aspiring writers leads them to talk, reflexively, in double quotes. But they remain, to use a good

American word that Wilder utilizes throughout the film—there is no German equivalent; Brecht and Ophuls had to lapse into English to use it—"fans."

Sunset Boulevard is also one of the first films to fuse the fan's idolatry and the lover's devotion. In the same way that Von Stroheim once gave Swanson to the fans, in his final masquerade he becomes their stand-in, a single man writing hundreds of fan letters a week. During this time, émigré students of popular culture were announcing what was apparent to anyone who cared to glance at the best-seller lists: in late capitalism, popular art works are transient, ephemeral, manufactured. Wilder's perception is more intimate. The whole world has abandoned Swanson, except for Von Stroheim, for whom she is all the world that matters, as well as his supreme creation, a Trilby to worship and a maniac to protect. That such awareness is inseparable from material conditions, from box office receipts and shooting schedules, is Wilder's triumphantly American expression of a European literary insight. A literary sensibility sabotaging the myth of Hollywood dreams with memorable visual images: here was the rare instance of an émigré taking it all.

Despite their manifest contributions, the refugees' lot in Hollywood allowed for few happy endings. If they missed at the box office, they weren't given many new chances; if they succeeded, public taste would eventually define their efforts as dated. Hollywood has seldom been a happy place for growing old. The late careers of many Hollywood Germans degenerated into a futile scrounging for funds or assignments, a miserable replay of the first years after emigration.

Fritz Lang had the fewest early difficulties, but his dissatisfactions with Hollywood were several. In Berlin there had been no studio bureaucracy to wrest control from the director. The pressure to finish films here was greater. Lang must have had problems with his crews, even though he claimed they learned to love him. He tyrannized his actors; managing to alienate not only Americans but also Europeans, he offended alike Marlene Dietrich ("Marlene resented going gracefully into a little, tiny

bit older category; she became younger and younger . . .") and Lilli Palmer ("She has no heart").

But the worst problem was the inability to realize his ideas completely. Following orders from the studio, a dark film had to have a happy end, betraying any serious analysis; typically, the final kiss in *Fury* trivialized the whole treatment of lynching. Lang felt himself reduced to the status of a child. Since his youth had been dominated by sadistic, protofascist professors, his perpetual defeat by the censors ("You try to do something good, but you sit out there like a schoolboy who's done something wrong, waiting for the schoolteacher to come and say, 'Now comes the punishment for what you did'") must have condensed the nightmares of a lifetime, both the European student's and the American director's.

The teacher and the censor are implicitly political figures. Lang experienced more explicit political difficulties. Perhaps as a result of his blacklisting, his films after 1953 are bitter indictments of American society—the physical disgust is palpable. Yet the prophet of violence, its most talented cinematic exploiter, eventually became terrified by its ubiquitous presence in modern life. This development is evident in Lang's appearance as himself in Jean-Luc Godard's *Contempt.* After a movie producer jokes, "When I hear the word 'culture,' I reach for my checkbook," Lang recalls that "some years ago, some terrible years ago," the Nazis used a similar formulation, replacing checkbook with gun. The man who spent years illuminating social disorder had become the low-keyed representative of historical consciousness, proposing a connection between politics and capitalism that had both forced his exile from Germany and straitjacketed his Hollywood career.

It was a surprisingly mellow old character named Fritz Lang, not the autocrat of countless anecdotes, who remarked after the climactic deaths in *Contempt* that "murder . . . killing . . . is no solution." But by this stage of his life, the real Lang believed that the "philosophy of love" had become a laughing matter. He cared for America "very, very much," but the American Dream had become either the pursuit of wealth or "to be very crude— how to commit the perfect crime and not get caught."

America also disappointed Sirk. Although *Imitation of Life*, with its sentimental depiction of cultural identity, was his biggest success, he had grown tired of the devices necessary to hide any serious analysis. *Imitation* was his last film. He left the country, disillusioned by the Cold War and McCarthyism and bored by films that meant only to please. He had made artful attempts to conform to the tastes of an American audience. He explains, "The criticism has to start in the audience. I am merely trying to awaken the audience to a consciousness of conditions. It is more a piece of social awareness: it remains in the realms of sign and symbol; it is pointing to things." But the public remained "too simple and naive in the best sense to be sensitive to irony."

In 1979, when asked whether American sociologists had inspired his social criticism, Sirk laughed and replied, "I got it from my eyes." But more advances than CinemaScope were needed to cultivate an audience that looked as carefully as he did. Sirk was fated by his aesthetic as much as his times to make nuance central to his work in a country where he found nuance to be "completely foreign."

Preminger and Wilder managed to last in Hollywood; like the very socially conscious Fred Zinnemann, another émigré survivor, they turned to newsworthy subjects, not always successfully. Wilder, the enfant terrible of Hollywood past, became its valedictorian. Since he continued to present himself as brightly up-to-date, a connoisseur of the latest trends and idioms ("I roll my own," he told an interviewer not long ago), one might not have expected him to celebrate the past or, after all the hugely popular American comedies, to find him still indulging in a gallows humor that smacked of Berlin and Vienna. (When considering the problematic future of a 1978 film financed in Germany, he said, "I can't lose, because if this picture is a big hit, it's my revenge on Hollywood. If it's a total disaster, it's my revenge for Auschwitz.")

Wilder has won six Oscars, more than any other refugee. But recently he has fallen on hard times. With a refugee's resilience, he jokes about dropping from the Ten Best films to the Hundred Neediest Cases, as if to say, "Norma Desmond—*c'est moi.*" For

a time he was dismissed as a crass opportunist who trafficked in easy cynicism and vulgar sensationalism. Now when he returns to Germany, he finds that "the mantle of Murnau, and of Fritz Lang, and of Erich Pommer, and of Lubitsch falls on my shoulder." He could say, as Fritz Lang did, that he has become "the last dinosaur." Likewise, the American critics who resented him in his salad days have now begun to discover his genius. As an old Hollywood hand, not to mention a refugee, Wilder is familiar with such paradoxical turns, and is not gratified: "They just don't feel like kicking an elderly man in the ass anymore." A good Berliner, Wilder will not exploit his old age for the condescension of pathos.

The directors had problems aplenty in Hollywood. But they did not blame their troubles exclusively on the executives who ran the studios. Instead, they expressed a peculiar sympathy for those men, perhaps because many of them had also stumbled along equipped with only an immigrant's English. Ophuls liked the merchants who founded Hollywood very much. He saw them as "pioneers" and instinctively visualized them in cowboy boots. Preminger compliments Darryl Zanuck, Louis B. Mayer, even the egregious Harry Cohn—"a showman, not a businessman"—because they didn't interfere with production. Wilder also speaks fondly of the "olden marvelous days . . . of illiterate moguls." Lang agreed. He didn't mind his audiences' naïveté: "I love audiences." But the "go-betweens," the new-style producers, were his nemesis. At least, Harry Cohn cared whether his backside itched; he understood Lang's use of violence to "make the audience a collaborator, to make them feel." But the new crew was only interested in making money with pictures; compared with these conglomerate types, the old crowd had been Mom-and-Pop store operators.

In retrospect, the directors realized that the problems lay both in the Hollywood system and in the gap between the American audience and an ideal one that capitalism had almost wiped out. Hollywood was merely the symptom of the decline. At the end, Ophuls complained that the public everywhere had become a mass of "consumers." They flit from sensation to sensation, lacking "aesthetic patience" or the simple courtesy to wait for a

13

Er Gibt den Ton An

Exaggerating only slightly, Thomas Mann wrote in 1941 that "all of German literature had settled in America." The arrival went largely unnoticed, with the single exception of Mann himself. For while Americans were welcoming foreign musicians and filmmakers, the writers saw that far from shaping and cultivating a popular audience, they were losing even their émigré readers. This made them the unhappiest of refugee artists: the ultimate vindication of their talents, evident in the numerous scholarly studies of *Exilliteratur,* occurred long after it could have made any difference. But the truth is that the writers' influence on this country was real. As much as any group that was more visible, they set the tone for other émigrés.

They did so initially with a special confidence. As Thomas Mann's son Klaus put it after surveying his fellow refugees, "There is only one homogeneous group and representative minority, the writers." They alone had sensed, almost at once, the danger represented by Hitler, not least because they had perceived his rape of the German language. The exodus united members of disparate religious and political groups, as well as experimental and traditional stylists. What linked them, as Klaus Mann saw, was "the political mission to warn an unaware

and drowsing world." The veterans of Berlin, Prague, Vienna, and Paris were thus forced to combine the barely compatible roles of artist and Cassandra. It was a hard job with meager rewards. As if Hitler were exacting his revenge, the boldest political witnesses would also suffer the greatest professional losses. Their political observations had been rooted in the German language, and the network of linguistic associations proved almost impossible to transport. Yet, while they embodied failure, they were temperamentally disinclined, at least for a period, to indulge in self-pity.

The writers defended themselves by holding to the cocky, impious tone that had once been a generational style. The German idiom *"Er gibt den Ton an"* (He sets the tone) applies particularly to those writers who continued to assert the skepticism and irreverence of their youth. Not that sentimental novels didn't sell well to some émigrés, or that a roll call of the names of Holocaust victims at the annual *Jahrzeit* services of a German Jewish congregation would not evoke massive outbursts of weeping. But along with the predictable notes sounded in their exile— elegiac, melancholy, baffled—the characteristic assertiveness of their emigration remained to guarantee that all was not lost. Hitler had not conquered a group that could still say no to everything. Appropriately, the best writers provided few consolations and employed a narrative voice that was bracing rather than embracing.

The irreverence was salutary: Walter Mehring reported that his *Berliner Schnauze* saw him through the worst days of emigration. It was not only the Berliners who agreed that the best way of approaching a monstrous history was through satire and parody. Even the magisterial Thomas Mann delighted in such play: he once said that another writer wrote exactly the way he did but meant it *seriously*. There were other signs of disrespect for traditional material. As émigrés became literary athletes engaged in prodigious feats of quotation, the writers rummaged everywhere in search of an appropriate slant or image. This eclecticism invited accusations of plagiarism and blasphemy. Brecht admitted that emigration had made them scoundrels, but he defended his friend Hanns Eisler's pastiches of classical

music: "Well, it may be that as an exile, he is not in a position to lug so much stuff around with him."

Few refugee writers in America suffered as harshly as the impoverished émigré poet Else Lasker-Schüler, who spent her first days in Switzerland, sleeping on park benches and begging for food (admittedly the slightly demented Lasker-Schüler enjoyed such occasions). A parallel case was Robert Musil, also in Switzerland. Mrs. Musil had American relatives, but they could not provide the affidavit necessary for emigration. The consummate master of irony and distance now grew desperate for public recognition. A friend says he was obsessed with the trivia of social ritual. When a local literary society refused to admit him, he fought for membership "as though his life depended on it." He spoke wistfully of best-sellers and book promotions. At least two guests remember his railing about the impossibility of emigration: "If I go to North America, Thomas Mann is there. If I go to South America, I will meet Stefan Zweig." In 1943 Musil died while performing gymnastics, as if limbering up for the flight.

In America the lack of funds diminished everyone. Artists found themselves dependent on the whim of sponsors. Brecht's poems were copied and privately circulated, a sort of Stalinist samizdat; the venerated Richard Beer-Hofmann's last publication was subsidized by a wealthy émigré. Hermann Broch's novel depended on prepublication subscriptions solicited by Helen and Kurt Wolff. Commercial assignments and/or academic fellowships at least sustained writers like Brecht and Broch. The editor of a leading Dresden newspaper ended his days as a New York watchmaker. Johannes Urzidil, a lion of Czech literary circles, supported his family in the forties with leatherwork.

While there was a spirit of camaraderie among most of the film directors, the writers' community was riddled with feuds and hostility. Not surprisingly, the most famous were also the most attacked. Franz Werfel's colleagues frequently condemned him for supporting the Austrian clericofascist Schuschnigg, who

had helped destroy the anti-Fascist Austrian labor movement. (Schuschnigg arrived in this country in 1947, and taught at St. Louis University for many years.) Werfel's flirtations with Catholicism climaxed in the lugubrious *Song of Bernadette.* Werfel's friend Thomas Mann ridiculed his "snobbish Catholicism and unpalatable belief in miracles." In the end, however, Mann could not stay angry with Werfel, whom he saw as "basically a figure out of opera." Though Werfel never officially converted from Judaism, some readers found traces of anti-Semitism in his last works. Another famous writer, Erich Maria Remarque, was condemned both for his aloofness from the émigré colony and for his silence during the war years that he spent in Switzerland. Franz Schoenberner joked that Remarque must know nothing about émigré life or he wouldn't have a character spend enough money on liquor and cabarets in a day to support other refugees for a fortnight.

Throughout the thirties, whether living in France or attending the international conferences of anti-Fascist writers, Lion Feuchtwanger was a symbol of literary resistance: together with the ill-fated Ernst Toller, he headed the German-speaking branch of PEN. As we have seen, his camp behavior was not universally well regarded. Other émigrés attacked his style or his salon Stalinism. In the United States he continued to socialize with left-wingers while residing in impeccable comfort: "The political climate here is terrible, but the climate is good, and I remain optimistic that man will advance toward reason." This spirit won him many American fans, including Richard Milhous Nixon, but not all refugees were persuaded.

Thomas Mann was excoriated on all sides. His supplicants became his enemies. Some refugees recalled his initial attempts to retain a German audience; conversely, others accused him of being too unforgiving toward the Germans. Still others simply disliked his style; missing the spirit of parody, they found him egregiously middlebrow. The émigré novelist Alfred Döblin's contempt for Mann seems to have kept him happily enraged for years. In 1928 he referred snidely to Mann as his "colleague" for "stylistic beauties"; in another letter, he called him an "opportunist." Döblin once received a fellowship recommendation

from Mann, and accepted his congratulations on his sixty-fifth birthday. But he was soon back on the prowl, insisting that Mann symbolized the moribund in literature. Mann himself wrote of Döblin, "He would like to kill me, for that is really the sense behind his claim that I *am* dead."

Success was everyone's aim, and it came occasionally, but usually in forms that were not satisfying. During the thirties and early forties many émigrés had supported themselves by turning out historical novels. Some were potboilers; others, like Stefan Zweig's historical fictions, *gemütlich* middlebrow entertainments, good for a few tears and a little education. Yet others, such as Heinrich Mann's two novels about King Henry IV of France, could be read as coded references to the present. The witty Berlin writer Kurt Hiller accused such writers of retreating into the past, and offered a set of outlandish historical subjects: "Pippin the In-Between, Rameses IV, and Melanie the Unusual of Paphlagonia." But historical vagaries transport better than local color, and though it was hardly planned that way, such novels provided a useful preparation for the Hollywood that homogenized all historical periods.

During the war years, movies were made from the novels of Vicki Baum, Lion Feuchtwanger, Franz Werfel, Bruno Frank, Martin Gumpert, Alfred Neumann, Erich Maria Remarque, Hans Habe, Stefan Heym, and Ernst Toller. There were also best-sellers written by émigrés, and Thomas Mann, Franz Werfel, and Stefan Zweig maintained their audiences. On a less exalted level, popular writers stayed popular. Emil Ludwig's middlebrow biographies satisfied a readership that later welcomed James Michener and John Gunther, while a large audience still hankered for the urbane kitsch of Vicki (*Grand Hotel*) Baum, who lived in the California hills, supported less successful refugees, and admonished all newcomers, "Don't be afraid." A more unusual popular success was Curt Riess. As New York correspondent for *Paris-Soir*, he had developed a colloquial, quasi-fictional approach. In the manner of later participant journalists, he wrote such series as *I Was a G-Man* and *I Was a Racketeer*. Riess was a cynic and hustler, but the chameleon air of his journalism was peculiarly appropriate to the refu-

gee. He made a career out of the mobility and flux that were the normal conditions of émigré lives. How different from Riess were the refugee lawyers, engineers, and sociologists who could have written books entitled "I Was a Frenchman," "I Was a Butler," "I Was a Janitor," "I Was a Cook"?

There was a writers' community of sorts, and not all of it was German-speaking. English writers like W. H. Auden, Stephen Spender, and Christopher Isherwood were close to émigré circles. After all, Auden was Thomas Mann's son-in-law (he had married Erika Mann in order to provide her with a passport), while in England Isherwood was to write *Prater Violet*, a novel about an émigré filmmaker, a character inspired by Berthold Viertel. Once in California, Isherwood joined the circle of bohemians, radicals, and homosexuals that convened at the home of Viertel's wife. In New York, American writers like Upton Sinclair (whose works had helped inspire the youthful radicals) and Theodore Dreiser socialized with other émigrés; Dorothy Thompson and the English novelist Bryher provided many introductions. New German-American literary careers opened up. Hans Sahl and Walter Mehring translated several American plays into German for émigré little theaters, while Hermann Kesten translated American novels for the Foreign Council on Books under the Office of War Information.

Yet there was about all this something desperate and even disreputable. Gifted artists, preoccupied with petty tribal squabbles, counted themselves lucky to find hack assignments. Serious work did not find a public. One émigré, Klaus Mann, speculated that the real problem was the absence of a language sufficiently flexible to render unprecedented events: "The refugee writers will have to find a new vocabulary, a new set of rhythms and devices, a new medium to articulate his sorrows and emotions, his protests and his progress." The refugee writer needed the liberating perspective of a new language as much for himself as for a world "drowsing and unaware." Klaus Mann thought that an American journal would be the appropriate literary hybrid. It wasn't, it failed after twelve issues, but what other forum would have been better, or truer to the refugee writers as a community?

That Klaus Mann should conceive of such a magazine bespoke his prominent position in literary circles, as well as his particular affection for American life. If the action was quixotic, Klaus was the right man to perform it. Klaus, Thomas Mann's oldest son, lived the life of a Mann character, frequently to his father's annoyance. In the late twenties he and his sister Erika had become the very types of spoiled bohemian socialites, engaging in all forms of the avant-garde, from surrealism to expressionism. Klaus liked to move between the domains of "world literature" and "the underworld." He shared his uncle Heinrich's Francophilia, and a concomitant irreverence for German pomp. As a homosexual, he could go beyond Heinrich in exploring the night world of large cities.

From the start of his travels, Klaus was the sort of tourist who approaches the foreign with an erotic curiosity. At first this limited his attention to "sexual-psychological issues." But political considerations began to fuse with his sexual and literary concerns; he ultimately saw the three to be inseparable. Throughout the thirties, Klaus and Erika toured in *The Pepper Mill,* a radical cabaret sketch that poked fun at the philistines and the Fascists; it was the rage of émigré circles throughout Europe and a resounding flop in America—an augury of future failures to import the distinctive émigré tone. Though Klaus attended anti-Fascist congresses, sponsored by Communists as the early ones usually were, he was a highly querulous fellow-traveler. After he saw Brecht in Denmark, he spoke of the playwright's "icily . . . intellectual ecstasy"; Marxism failed for Klaus because he thought it denied metaphysics. The mystery that Marxism betrayed was no orthodox faith. Klaus's metaphysics was clearly of the flesh: his Jesus was "dynamic," "revolutionary," the master of a "bold and colorful wit" and "incredibly handsome"; Klaus swooned before him, tracking spiritual ecstasy to an erotic source. This was the preferred route to wisdom: Klauschen, forever torn between philosophical speculations and scandalous activity, ransacked literature for models. His Olympus excluded Luther and Wagner—Teutonic heroes—and Aristotle, while

welcoming Milton, Plato, Socrates, and Walt Whitman; the American poet became a curator of erotic epiphanies, and his homeland a mecca of sexual and political freedom.

The Fascist threat took this excessively whimsical spirit and rocked him into the sturdiness of a firmly held position. "I am proud to state that the name of my family appeared on each of the four initial 'black lists' issued by Dr. Goebbels," he wrote in 1942. Klaus advanced such commitment as an alternative to quietism; better than most, he understood the lures of apathy. During the war, he argued on the radio with his brother-in-law, Auden, who, already en route to his final years as a Christian, advocated a retreat from politics. Artists, he said, were neither informed enough nor disposed to understand political power; they had best leave it to the big shots. Klaus responded with simple good sense: "We run the danger of a paralyzing skepticism in which everything is equally relative."

His old friend Jean Cocteau had behaved less well; like many Frenchmen, he had collaborated with the Germans. A distraught Klaus consoled himself with the following fantasy, a surrealist refugee's revenge on the widepread *trahison des clercs*. Cocteau is a drug addict, as is Hermann Goering. Klaus imagines Cocteau serving the cause by detaining Goering from attendance at a mass execution. The Nazi sits immobilized by laughter and cocaine, as a smashed Cocteau trips around the room, variously imitating Adolf Hitler, a parrot, and Marlene Dietrich.

In his first months in America, Klaus lectured to audiences of all kinds and persuasions about the Fascist danger. He downplayed the fact that his mother was a Jew. At this time he stressed that focusing primarily on Hitler's anti-Semitic actions distorted the full scope of his crimes; there may have been in his attitude a sense of detachment from the more bourgeois Jewish émigrés. Unlike most other refugee writers, Klaus fitted comfortably into the reigning bohemian sets, landing in the midst of people like Carson McCullers and Paul Bowles while also presiding with Erika over the literary émigré circle.

An illustrious list of editorial advisers graced the journal he inaugurated in 1941. He first thought of calling it *Cross-Roads*

but rejected the title as ambivalent, and chose the more straight-forward *Decision*. Exile literature needed rejuvenation; exile writers needed an audience; the aims of literature and propaganda would be met in *Decision*. In the first issue, Mann wrote, "The most distinguished representatives of European literature in America are doomed to perish unless they have contact with the vigor and youth of American literature."

Decision will be a "mouthpiece for European refugees," he said. As such, it will be irreverent and opinionated. Also in the initial issue, Mann waged a typical refugee attack on the American infatuation with "facts, just facts." But he went other critics like Adorno or Lowenthal one better, in both wit and perspicacity. In an analysis of the popular radio program "Information Please," he noted that "knowledge for its own sake" was a nineteenth-century monster, peculiarly European, dolled up in New York fashions. In another article, Aldous Huxley sounded a similar note: there is "a general over-estimation of facts and under-estimation of concepts and ideas." Along with his call for a new language for the refugee, Klaus Mann demanded a new epistemology, larger than the mere acquisition of facts but not abstract to the point of political quietism.

In different issues, *Decision* saluted several refugee groups. German writers were represented most often, but special issues were devoted to English, French, and Italian literature. Through his relationship to Auden, Mann recruited such distinguished English writers as Christopher Isherwood, who provided an obituary of Virginia Woolf, and E. M. Forster. But the magazine was always manifestly an American journal; it printed Sherwood Anderson's last work, stories by Eudora Welty, and Carson McCullers's comparison of Southern fiction and Russian realism.

Because the refugees had a new subject and audience, *Decision* was interested particularly in refugee responses to American culture. In its first issue, Franz Werfel paid homage to Poe and Whitman: Werfel loved Whitman for showing him that there was no subject too "commonplace" for poetry; in a reformulation of the Wordsworth-Coleridge split, he lauded Poe for discovering the exotic in the familiar. Werfel sounded like a

French structuralist when he celebrated in Poe "the cabala of the consonants and the demons that dwell in the vowels." Klaus Mann wrote paeans of praise to Whitman as an American match for Socrates himself in his uniting of the erotic and the metaphysical. Mann also paid rigorous attention to current best-sellers. Anne Morrow Lindbergh had begun publishing her diaphanous musings. Mann was not charmed; he found them insidious pieces of Nazi propaganda, for they advocated a passive withdrawal to nature. He spoke as an insulted European when he criticized her glorification of an "American October" unique to this continent: Is your October the same in Detroit, Seattle, and Florida? he questioned sarcastically. He was much more sympathetic to the American women Gertrude Stein and Carson McCullers, and imagined an amusing conversation between the "well-preserved aunt" and her "delicate niece," with Stein perhaps scoring the nicer critical points.

Turning to unknown writers, Klaus Mann juxtaposed the attempts of American surrealists—he had long since broken with his French surrealist comrades—and a new young writer, Paul Goodman. He recognized in Goodman the "revolutionary conservative" temperament of a Goethe. Goodman, for some reason, was not pleased with Mann's approval. But Mann's judgment of Goodman's polymath achievements and his perpetual debts to romanticism seem to have been strikingly prophetic.

With refugees so well launched in Hollywood, *Decision* paid movies the tribute of taking them seriously.* Erich von Stroheim, in an article for the journal, wrote that he had been the first to present a realistic cinematic depiction of sexual desire; he also wrote that he was dismayed by the new film *Citizen Kane*. Richard Plant observed that, on the whole, American films were quite as good as European: we merely saw Europe's best and least representative works. Klaus himself analyzed anti-Nazi films in Hollywood. Once, he said, in a German film directed by Richard Oswald, militarism had been properly indicted, but Hollywood reduced the plight of anti-Fascists to something "too

* Klaus worked on several screenplays in postwar Europe, among them the premier example of Italian neorealism, Robert Rossellini's *Open City*.

idyllic, too private, too sentimental, too conventional." (Virtually at the same time, Lowenthal and Arnheim were noting the same flaws in magazine biographies and radio dramas.) In a devastating attack on Fritz Lang's *Man Hunt*, he accused the director of "venturing on the most appalling topic of human history with the shabby tricks of Wild West and gangster thrillers." Here was justification for a true refugee complaint: American culture could diminish the most talented émigré artists.

A few of *Decision*'s political essays remain timely. Klaus's younger brother Golo used a review of Emil Lederer's economics as a pivot for an attack on Marxism and dismissed such terms as "capitalist," "socialist," and "revolutionary" as obsolete, while paying patriotic homage to the "permanent revolution" of America. This argument would be echoed by many conservative émigrés after the war. (Recently, Golo Mann was a supporter of Franz Josef Strauss, the conservative West German candidate for chancellor—a stand one cannot imagine shared by his father, uncle, or brother.) In the final issue of *Decision*, a Trinidadian analyzed the potential for black fascism, and pointed out that the separatist Marcus Garvey had negotiated with the Ku Klux Klan. A Harvard historian alluded to the debate between Rosa Luxemburg and Lenin that had split the German Left in World War I, and echoed Lenin's argument that it was possible to fight a socialist war on the imperialists' side— an academic restatement of the debate between Stalinists and Trotskyists.

Klaus's sophisticated sense of politics was reflected in the work he printed. In an early issue was a poem by a new Warner Brothers screenwriter, "Bert Brecht." This is the famous "Yes I Live in a Dark Age," an acknowledgment of his generation's moral failures and an implicit plea for mercy: "We wanted to make our soil ready for kindness . . . think of us kindly." On one occasion, *Decision* demonstrated by focusing on Ernst Toller, the hero of Munich 1919, that among the victims of emigration were the writers themselves. Toller was not happy in America. His low estimation of the culture had been evident in his play *Mary Baker Eddy*, written even before he reached the country, in which Eddy is sexually obsessed and a secret ally of the town

bosses against the workers. For a while in New York he received flattering publicity, and kept busy raising funds for orphans of the Spanish Civil War. But the public interest in Toller and his cause dwindled. After his suicide, *Decision* printed an obituary by Hermann Kesten, a young writer who had helped organize the rescue of the writers stranded in Marseilles, in which he wrote, "What grotesque adventures lie behind us German émigré writers. We have lost our people and our market, our publishers, newspapers, theaters, homes, bank accounts, passports, papers, our manuscripts and our friends. . . . One and all, we were prophets, for we knew about Hitler and Germany, we foresaw the future, predicted the war. . . . No-one listened to us, no-one believed us." And then, to arrive, "see the same processes at work" and not dare to speak "because one is an alien"; no wonder Toller killed himself. Kesten's lament was a synopsis of many lives. World War II had not yet begun, and already their story could be told, as if they were all dead men.

The man of letters, Klaus Mann said, had became a "political": whatever his subject matter, the change in his fortunes had specific political implications. It was no longer a question of finding an adequate prose style in German or English when language itself, the writer's privileged sphere of interest, had been subverted. In a manner that resembled the analyses of Orwell or Adorno (or of the New School authors of *Nazi Deutsch*), Klaus Mann wrote in *Decision* that the "function of the word is no longer to inform, to clarify, to reveal, but to confuse." He asked: What is left when language has become the instrument of a "disquieting state of schizophrenic confusion"? Unlike other writers like Adorno or the New School authors who also recorded the social damages of Nazi *Deutsch*, Mann extended his analysis of "the word" into a political editorial in which he attacked the English (for their devotion to Bank of England economics rather than to political morality) and the Russians (the Kremlin needed to recover the integrity of Dimitroff, the Communist who stood up to Nazi prosecutors after the Reichstag fire). Prophetic again, he anticipated the postwar confrontations: the Allies' coalitions must not conceal a plot to usher in world revolution, or an encirclement of the Soviet Union. Mann wrote as if

he knew that the distortions of language are coterminous with the confusions of politics—and that both are "schizophrenic."

Klaus loved America. After the failure of *Decision*, he served in the American Army. But transcending the parochial prejudices and moral restrictions of all national groups, he remained an internationalist. In his autobiography he defied the philistines: "My moral consciousness is not affected by the sex taboos of bourgeois or proletarian society . . . or by the hateful slogans of nationalism." Some years later Hannah Arendt would draw a similar connection between political and sexual outsiders, and recently neoconservatives and fundamentalist Christians have waged a right-wing attack on the homosexual's lack of commitment to family and country. Klaus Mann would have been the perfect man to answer Norman Podhoretz and Jerry Falwell. But in 1950 he committed suicide. He had made many earlier attempts, though for a brief period during the war he had come to realize that suicide was "pompous and obsolete."

Klaus had in his favor youth, a facile social manner, and a command of American language and culture. Still he left no mark on this country's literature. So it should hardly be surprising that much older men fared no better, particularly the crew that toiled—or, more likely, didn't toil—in the Hollywood studios. They may once have seen themselves as modernists and radicals, members of an international vanguard; exile revealed them as custodians of a humanist legacy, eccentric but all too European.

The political commitment was indisputable. Heinrich Mann arrived in 1940 at age sixty-nine, after having been for decades the symbol of socialist humanism. During World War I, his scathing depictions of German philistines and the Gallic lucidity of his prose had distinguished him from his brother Thomas with his orotund verbal flourishes and muddleheaded nationalism. Thomas mistook their political disagreements for sibling rivalry. When he detected unflattering personal references in an essay of Heinrich's, his brother responded, "There is no 'I' in my public utterances, and for that reason also no brother." In

bouts of miffed feelings as in political argument, Heinrich's dignity did not fail him.

The two brothers had achieved a personal and political rapprochement during the twenties. But it was Heinrich who presided over conferences of anti-Fascist writers during the thirties, just as he had served on a "soviet of brain workers" during the 1918–19 Munich revolution. In 1933, rising above the self-destructive quarrels of the German Left, he joined Kaethe Kollwitz in pleading for a reconciliation of the Social Democrats and Communists. Shortly after the election of Hitler, he published a series of dialogues, *Scenes from Nazi Life*, that anticipated Brecht's later plays, as well as a devastating essay in his nephew Klaus's magazine *Die Sammlung*, which asserted that Hitler's gangsterism was evident in his assault on the German language. "Future generations" would have to be "cleansed in their vocabulary from the words peace, justice, and truth." By erasing the words and the values they represented, Hitler might succeed in snatching the Germans' children from them. This was too bold a literary analysis for other German writers; brother Thomas, Alfred Döblin, and Stefan Zweig all disavowed the article, though they got the message soon enough. As the noblest and most prophetic of anti-Fascist writers, Heinrich Mann became, in Ludwig Marcuse's words, "the Hindenburg of the emigration."

After his arrival in America, Heinrich wrote for *Decision* an essay in which he recalled the cultural issues that had dominated his thinking for over thirty years. "The pattern is always the same: the worthwhile goes down in France—the great King, or the Republic, his distant successor [Mann's late work *Henry, King of France*, presents the French king as "laying the foundation for the first democracy"]—and at once the Germans get the elbow room needed to commit excesses, as is their custom, and exercise their calling which is destruction." Mann had noted all this in a novel: "*Der Untertan* was devoured and did not change a thing." Yet once again he found himself laughing at his destructive countrymen—"They have become a horror; and yet in my eyes, they remain the grotesque figures they were when I met them."

This last observation is one of the recurrent notes of émigré literature; it is repeated by the Mann brothers, Brecht, and even Hannah Arendt in her later dissections of Adolf Eichmann's prose. The Germans are horrible, horrifying—and also terribly funny, as ridiculous as they are grotesque. Such gallows humor, smacking of the cabarets or the Berlin streets, also characterized the left-wing politics of writers like Leonhard Frank and Alfred Döblin, other Hollywood émigrés. Frank too was a socialist humanist: the title of his autobiography *Links ist wo das Herz ist* (literally, "Left is where the heart is") sounds like oom-pah-pah Marxism. He enjoyed big-city life: friends remember him in Paris during the thirties, snarling like a Berlin cabdriver, making fun of everything.

The more dour Döblin was also the most spiritually peripatetic of émigrés, a man for whom exile was an enduring condition. The son of a working-class family, he practiced medicine for many years while turning out fiction, essays, and articles. The constant attitude in his work was an identification with suffering humanity, prompted either by political principles or by an almost masochistic delight in his capacity to withstand hardship. This was accompanied by so many shifts in philosophy and politics that in the thirties some fellow exiles dubbed him *Konfusionsrat* (counsel of confusion). Always sympathetic to the Left (in exile he wrote a three-volume study of Rosa Luxemburg) though often anti-Marxist, Döblin was briefly a Zionist and eventually converted to Catholicism, arguing that he had become what evangelists call "a completed Jew."

Döblin was assertively contemporary in his manner. He championed a "Berlin program" for writers, one that stressed kinetic movement, a cinematic sensibility, and vernacular discourse; Walter Benjamin said that "he speaks with the city's voice." His most famous novel, *Alexanderplatz Berlin* (1929), is the story of a one-armed Berlin laborer, Franz Biberkoph, and his prostitute lover, Mieze. The book is crammed with statistics, road signs, headlines, advertising slogans, popular song lyrics. The language is always resolutely simple and colloquial, often with the singsong rhythms and rhymed phrases of an agitprop anthem.

There was a similarly advanced urban sensibility expressed in Leonhard Frank's work. While Döblin at times resembles a Berlin James Joyce (although he derived his stream-of-consciousness passages from Dadaism and expressionism), Frank's *Carl and Anna* reads like a Berlin version of D. H. Lawrence's romantic mysticism. An army veteran assumes his buddy's identity and succeeds in convincing the man's wife that he is really her husband. Their love affair is described as a "nature film," compact of blood knowledge and nonverbal understandings; the two find themselves in an "unfathomable" but eminently erotic mystical state. The novel's American edition appeared with the kind of apology that once graced Lawrence's novels: "clean . . . informed by an almost religious purity."

With their gift for the vernacular and the erotic, Frank and Döblin seemed well equipped to write in the American popular style. Heinrich Mann's craft appeared to be more forbidding. Yet early in the century he had exhibited a similar mastery, first in *Professor Unrat*, the source of the Josef von Sternberg–Marlene Dietrich film *The Blue Angel*, and even more in *Der Untertan* (*The Subject*). The latter novel's hero, Diederich, is an arriviste, something of a Teutonic Flem Snopes. By ignoring all humanist values and carrying nationalist pieties to absurd extremes, he manages to become rich, marry well, and defeat the grand old man of his town. Diederich is at once terrifying and pathetic. Anticipating writers as varied as Hermann Broch or Erik Erikson, Mann depicted his protofascist villain initially as a lonely and fearful child.

Der Untertan, published in 1912, foreshadowed some of the major cultural issues of the emigration: one character becomes an actor, insisting that "the representative man of this era is the actor," but gives up the stage after moving to tears a police officer who had earlier fired on striking workers (compare the perpetual amazement that admirers of Beethoven or Brahms could also run concentration camps). Someone observes that capitalists like Diederich buy off their employees with just enough goods to prevent a real class war—an observation central to the essays of Herbert Marcuse.

These were not literary snobs. Granting their great ages—Mann arrived at sixty-nine, Döblin at sixty-three—they would still seem to have had the equipment for the movie studios. Döblin had constructed his fiction cinematically, having edited a movie, *Das Kinobuch*, as early as 1913. Scholars have found cinematic techniques in Heinrich Mann's late writings. Döblin enjoyed popular art; unlike some of his fellow California exiles he felt that "entertainment music" liberated people's lives.

At least at first, Döblin attempted to hustle himself a position in the literary marketplace. He placed his hopes on a trilogy, *November 1918, a German Revolution*, which would only be published in 1949 after his return to Europe. This book about the weeks in which the Berlin revolution sputtered and died includes a huge cast, real and fictional, in a text crowded with images and animated symbols. Only Döblin could conceive a Rosa Luxemburg lucid enough to see through political *quatsch* and delirious enough to marry a dream lover, Satan in disguise. (Another devil appears in Thomas Mann's *Doctor Faustus*, also composed in California!) Döblin blends essayistic asides with laconic putdowns of God and the world: his visionary hero undergoes a conversion from alienated intellectual to holy fool, and dies a bum. Could any work seem less suited to American readers than this one?

Yet how such men must have hated their periods of Hollywood underemployment, what Alfred Neumann called "$100-a-week charity." Döblin loathed his Hollywood assignments; he contributed to such war films as *Mrs. Miniver* and *Random Harvest*, but complained in a letter that "One does nothing, absolutely nothing." In 1942 Heinrich Mann wrote his nephew, "Here one drags one's life along without particular necessity. No one asks you to give evidence of your presence . . . One must not be discouraged. We are more or less buried with the debris of a decrepit humanity which is nevertheless in world rebellion." As for his work: "I see a film and say something. Actually I could say something without having seen it." Bad as the jobs were, losing them was worse. Heinrich Mann was poor; he wrote his sister-in-law, "Don't open the door, unless creditors aren't behind me." After his death, there appeared reports of his

haunting the offices of Hollywood studios. Döblin wrote a friend, "It is simply *fatal* for an author to have no money and to live on subsidies, as I and others are doing."

Döblin and Frank, at least, managed to escape after the war's end. Döblin returned to work with propaganda forces in Germany. He left America, having accomplished little besides the composition of his journal of European exile, *Fateful Journey* (*Schicksalsreise*), but without recriminations. Like Brecht, he admired the natives' friendliness and physical grace. He noted their "robust business sense and the curiously easy and superficial religiosity that belongs to this society." En route to Europe, Döblin composed a short poem bidding farewell to America, with the assurance that he loved her even though she did not want him. (By the end of his life, Döblin's audience had so shrunk that he was forced to publish his last novel in East Germany. In 1951 he wrote Ludwig Marcuse that his manuscripts were being ignored, "just as in Hollywood," and within two years, he had "emigrated a second time," this time to France.)

Leonhard Frank also returned, publishing in Germany a novel, *Mathilde*, that he had started in Hollywood. This is an unsettling combination of intellectual humanism and Frank's patented sexual mysticism, the first represented by a historian who becomes a RAF pilot, the second by his farm-girl wife; while her husband participates in the political present, Mathilde remains an almost prehistorical figure, drawing him back to the period when they were "wedded by nature." Nothing in the novel smacks of Hollywood.

For all his mystical high jinks, Frank retained his Berlin humor. In his autobiography he joined émigrés of such disparate personality as Albert Ehrenstein and Max Horkheimer in condemning a consumer culture responsible for *"Gefühlsarmut"* (poverty of feeling). So, indeed, the Left was where the heart was: a political decision needed to be heartfelt. After all, how else could one prove, as one of his titles naïvely proclaimed, that *Der Mensch Ist Gut?*

Heinrich Mann did not live to return to Europe. His last years were terrible ones. He had married a Berlin bargirl, Nellie

Kroeger. Shades of *The Blue Angel*, she publicly humiliated her old husband, smashed up cars, and eventually committed suicide. Despite everything, the old man kept writing. In 1946, in honor of his seventy-fifth birthday, Thomas described his brother's punctilious work habits, citing the clear Roman script and steel pen as anachronisms. Thomas went on to praise the prophetic language of Heinrich's autobiography: "the prose's condensed and intellectually resilient plainness makes it appear to me as the language of the future, the idiom of the new world." This gracious tribute, with its implicit condemnation of his own style, must have warmed his brother, but it could not make up for a lost public. In 1949 Heinrich wrote a friend, "In fifty years, I have not been so completely disregarded as now."

By 1948 some German Communists had revived interest in *Der Untertan*, but Mann objected that "it's the wrong kind of discovery. . . . I don't want to survive as the author of an editorial in novel form." Heinrich Mann's autobiography revealed enough of his old Stalinist sympathies to endear him to the East German literary bureaucrats—despite the book's praise of Roosevelt, Churchill, and de Gaulle—and they invited him to return. Eventually funds were raised for the trip, but he died in March of 1950, a month before his planned departure. In one of his last letters, he surveyed a decade that had been reduced for him to a ceaseless pursuit of funds and added, "If we had no need of dollars, we would laugh. At least let me smile."

After Heinrich's death, Thomas paid a final tribute to his brother's mastery of a New World idiom: "It was so moving to see in his fiction and essays how a highly cultivated, austere and brilliant mind sought plainness, strove to reach social community and the common people, without the slightest surrendering of his aristocratic quality." All émigré writers would applaud this ambition, and see in Heinrich's case a ringing example of its failure; Heinrich's New World idiom ended along with Klaus's wish for a new refugee prose. A decade earlier in *Decision*, Heinrich wrote that he had derived from French literature the notion that "life ought to be a novel." The balances of his own life were already clear and he could acknowledge the fiction be-

cause "the ending satisfies if and when the truth was fought for." The coda to that "novel," the final years in Hollywood, would render the estimable ending anticlimactic.

Despite the abysmal conditions of literary exile, at least one writer as poverty-stricken and fatalistic as the rest was able to produce a masterpiece. This was Hermann Broch, who may have had the curious advantage of not living in Hollywood, where the general malaise seemed to demoralize everyone. Broch comprehended the extremes of Middle European intellectual temperament. He was so prodigiously devoted to humanist culture that he could spend years composing his masterpiece, *The Death of Virgil* (*Der Tod des Vergil*). But Broch was also a political witness; part of the *Virgil* was written in a Nazi prison cell, and the book was completed in America, where the exigencies of health, money, and language made his work seem a quixotic comment on the general hopelessness of exile. Before Broch turned to ancient Rome, he had already portrayed the decline of German society; his first novel, *The Sleepwalkers* (*Die Schlafwandler;* 1931, published in English a year later), looked forward to Nazi terror as the culmination of an era of unreason: Hannah Arendt asserted that Broch was the first author to figure out the "radical atomization" of modern life.

The scholarly Broch was enough a product of his generation to imagine a more coherent future elsewhere. There are times when Esch, the doomed anarchist of *The Sleepwalkers*, feels "that there is a region in his head that is America, a region that is none other than the site of the future in his head, and yet that cannot exist so long as the past keeps breaking in so boundlessly into the future . . ." Broch's tragedy was that America, "the site of the future," produced neither the breakthrough to a transcendent vision nor a sympathetic public. Here was a man with a scholarly command of the modern sciences, from physics to psychoanalysis, and with a literary reach from the abstract to the sensual that was always tinged with melancholy. Yet everything—in the times, in his intellectual tradition, in his own

complicated self—conspired against him; as he had forecast, "the wrecked and annihilated overwhelm[ed] the new."

Broch was the son of a wealthy Austrian textile manufacturer, and he worked in the family business throughout his youth. In his forties he resumed his education with studies in mathematics, philosophy, and psychology. He studied with the Vienna Circle positivists, and immersed himself in science, although the spiritual undercurrents in his fiction have been identified by Hannah Arendt, his most loving reader, as "essentially Christian." Broch prepared a script for a movie on Einstein's relativity theory; he also planned six movies on scientists to combat the 1930s anti-intellectualism (a ridiculous mathematics teacher in Broch's *The Guiltless* [*Die Schuldlosen*] attacks Einstein's theories). Einstein helped facilitate Broch's entrance into the country, and the two later became friends.

Broch was also a modern city man, deeply affected by Freud's work. In a devastating analysis of Viennese kitsch worthy of Karl Kraus, Broch reiterated his belief that culture and politics were indivisible. He observed a world in which adult concerns were imperfect suppressions of childhood terrors. He valued Kafka and Hugo von Hofmannsthal for discovering, by stylistically discrete routes, the center of modern consciousness in "that symbolization of helplessness itself . . . the child."

The Sleepwalkers drew upon all his preoccupations as well as the novels of Mann and Joyce (who, for Broch, had brought "all aesthetic elements under the dominion of the ethical"). Broch is a profounder thinker than either Joyce or Mann. He may also be a less talented novelist, but his works of fiction are so fused with historical and philosophical speculations that the term "novel" as applied to any of his fictional writings may not be adequate. Hannah Arendt noted after the 1945 publication of Broch's *Death of Virgil* that Broch resembled Proust in his "fondness for the world" and also Kafka in his recognition that the hero as individual had been replaced by "man as such." Thus the real life of Virgil was no more than the occasion for a treatise on art and humanity.

The Sleepwalkers is not so formidable a work as the novel on

Virgil. Of its three main figures, only the last, Hugenau, seems without individual traits, and this lack is a deliberate comment on the dehumanizing times in which he lives. The novel covers the period from 1888 to 1918. Far more than Mann's *Der Untertan*, it sees politics as the surrogate for unconscious desires. Broch's characters are consumed by homosexual panic and an almost lustful need for a powerful parent. Each is more mindless than the last; the least conscious of all, Hugenau, is a murderer without guilt, because he is without memory.

Broch collapses Hugenau's pathology into the general mindlessness: "War is war, *l'art pour l'art*, in politics there is not room for compunction, business is business,—all these signify the same thing . . . that uncanny, I might almost say that metaphysical lack of consideration for consequences, that ruthless logic directed on the object and on the object alone, which looks neither to the right nor to the left; and this, all this, is the style of thinking that characterizes our age." In Broch's difficult but coherent vision, nationalism, capitalism, academic art, and kitsch all exemplify the same failure to investigate consequences.

Broch stayed in Vienna until the late thirties. During a very brief imprisonment by the Gestapo, he began to work on his *Virgil.* After his arrival in America he depended on grants and university fellowships; even his novel's publication was partially subsidized. More than any other émigré writer he is remembered for his unceasing generosity and kindness. Arendt recalls that in a circle in which distress was "ubiquitous," it was always Broch who "took care of everything." One of his translators, Jean Starr Untermeyer, says that in his last years Broch would go about on swollen feet collecting money for poorer friends. He himself was then living in shabby students' digs.

With perhaps undue optimism, he placed his confidence for American success in the *Virgil.* Stefan Zweig, after reading the manuscript, had warned him that the work was untranslatable, but Broch was sufficiently impressed by Jean Starr Untermeyer's translations of Rilke's *Duino Elegies* to contact her. Though Untermeyer still recalls him as the signal influence on her life, Broch at first exhibited that combination of haughtiness and desperation that could make émigrés appear monstrous. In

an early meeting he despaired over the universal atmosphere of death. She replied in a note, rather platitudinously, that "death-in-life" was the real danger. Broch had no time for such "kitsch." He informed her that if she lacked his "poetic strengths," she would endanger his "whole American future." And when she objected to his arrogance, he answered, "You act like a spoiled child who says I'm not appreciated." Once again, the curiously European directness offended an American; conversely, of course, émigrés complained that the natives were not straightforward enough—no wonder a blunt assertion struck them as tactless. Only later did Untermeyer recognize that the harsh tone confirmed Broch's trust in her: since *she* was a mature artist, she could take criticism.

Although he continued to serve his fellow refugees, Broch was also concerned with American problems. During the war years, he worked on a study of mass psychology in addition to *Virgil*. Distressed by the race riots in Detroit, not to mention the anti-Semitism that had driven him from Europe, he submitted to the United Nations a "bill of duties." He told one correspondent that he expected his next "work of a politico-psychological nature" to be of "definitely greater importance" than the *Virgil*.

The *Virgil* is an extraordinarily long and difficult telling of the Roman poet's last days. There are vivid passages depicting the carnival excesses of Roman street life as well as Virgil's memories of the courtesans and shepherds he has loved. But there are endless declamations—one sentence runs for twelve pages—on art and responsibility. Virgil wishes to disown his art for many reasons, and each is subjected to Talmudic or Jesuitical exegesis. Broch, at his most despairing, felt himself completely alienated from the humanity he meant to serve and removed from the human being he was when he began to write. He wrote the Germanist Hermann J. Weigand that "The three years spent in polishing up the *Virgil* have in large measure blurred for me the experience of the cognition of death such as I had divined it." He credited his American supporters with pushing him to finish the exhausting work. "I came over to America with the unfinished *Virgil* and I have experienced the

confidence and helpfulness of so many people and institutions that I had to keep my promise. . . ."

European readers immediately recognized the importance of the *Virgil*, that here was a novel that evoked their recent lives as much as the chaos of Virgil's last days. Appropriately, the book received a front-page review in *The New York Times*. It was Broch's bad luck—"my perpetual fate"—that the review was published during a truckers' strike. Perhaps no mass market existed for Broch's work, but the strike augured a lack of attention that confirmed his sense of isolation. Writing in *The Nation*, a still-unknown Hannah Arendt stressed the book's immediate relevance: "When the night arrived, Broch woke up. He awoke to a reality which so overwhelmed him that he translated it immediately into a dream, as is fitting for a man roused at night"; Arendt's own prose rhythms pay homage to Broch and Kafka. In a plaintive note, she observed that those "greedy with self-idolatry" were "excluded from all true community, which is based on helpfulness." Arendt's own work leaves little doubt that "helpfulness" in the "community" refers to the circuit of refugee assistance, to which she and Broch donated so much time.

Alvin Johnson recognized Broch's integrity. "Mann gave us a stone," he wrote Broch, "but you gave us bread." Einstein read the *Virgil* and found himself "steadfastly resisting" the book's implications: "The book shows me clearly what I fled from when I sold myself body and soul to Science—the flight from the I and WE to the IT" (although, as we shall see, Einstein was no slave to abstractions). With all this affirmation, Broch must have known he was loved and honored. Yet he saw himself, almost like Virgil, betrayed by physical desires and neuroses. He wrote Edith Jonas Levy after receiving an analysis of his handwriting: "In my feeling, I wasted my life, and doubtless my neurotic compulsions have a large part in causing this failure. However there are other reasons, and I am wondering whether and why the analyst didn't mention them; it is the whole field of drives and instincts (the field of the 'it') which was a real battleground for me." Perhaps no tribute could assuage his self-doubts.

Broch's last years were cursed by illness, financial worries, and public indifference. In 1950 the Austrian PEN Club almost nominated him for a Nobel Prize, but Broch proved to be equally unattractive to the Stalinist and clericofascist (Catholic) members. His deepening depression alarmed his American friends. Edith Jonas Levy suggested that Alvin Johnson reopen Broch's Nobel candidacy, but Levy and Johnson then learned that Broch's backers would have to be former prizewinners in literature. Broch, who had once feared for "his whole American future," now trembled at the elusive prospect of world recognition. Once more reduced to scuffling about, he would sit with Mrs. Levy and compose lists of writers to solicit for recommendations.

Broch exhibited a Kafkaesque embarrassment before his American friends. When Hermann Hesse replied to Johnson that he was too ill to write a word, Broch despaired over *Johnson*'s humiliation. Johnson, "this wonderful old man," was not disturbed. He wrote Thomas Mann, pleading for a commitment to Broch, a message that was a bit insulting to Mann, as well as patronizing to Broch, with its implication that only a Nobel Prize could revive his drooping spirits. Mann replied, "I regret that his condition leads him to believe 'I never will consider him worth my backing.' What hypochondria! Good heavens, I am sure I need his 'backing' more than he does mine." Mann noted that the committee had also bypassed Joyce and Kafka, that Broch's works were considered "abstruse and sophistical" in many quarters, that even he felt that Broch's achievement was not "fully ripened." Withal, he allowed the use of his name. Broch didn't win. His status as a world-class novelist would be secured only after his death in 1951 in a New Haven lodging house. Broch was a cardiac patient, yet he lugged an empty foot-locker up three flights of stairs. Some friends suspect it was a form of suicide.

Perhaps the most poignant valedictory to émigré culture came from an unexpected source, Walter Mehring. Unlike the other writers, he was an *echter* Berliner, born there and the son of a

newspaper editor, Franz Mehring, who had championed Rosa Luxemburg. He made his cultural debut at the age of twenty-two, when he staged with his friend George Grosz a Dada matinee, highlighted by a race between a sewing machine and a typewriter. Two years later, he produced the *Dada Almanac of 1920*, illustrated by Grosz and published by Wieland Herzfelde. Mehring's poems resembled pop lyrics ("Berlin, your dancer is death— / Foxtrot and jazz—"), and their appropriate setting was a cabaret. As Berlin's leading cabaret poet, Mehring moved in the circles of Brecht, Grosz, and Reinhardt. Long before the 1960s' overevaluation of puerile pop poetry, Mehring composed something really new, a compilation of sounds and images that mirrored the rhythms of his city as it fox-trotted on the edge of a precipice.

Mehring's talent was animated by surprisingly literary sources, besides those disclosed by George Grosz when he compared Mehring with François Villon and Heine. The French outlaw-poet and the Francophile German Jew were fitting antecedents. Mehring spent part of the twenties in Paris; Kurt Tucholsky hailed him as "the first to see Berlin just as the world had always seen Paris." In the early thirties the Nazis set out to arrest him. They found him as usual in a café but Mehring escaped his captors by pretending not to be himself, and returned to Paris, living out the thirties amid his fellow exiles, still entertaining them with a gallows humor that kept alive the old Berlin cabaret spirit. During this period he became increasingly alienated from his Marxist friends as they executed the ideological changes dictated by Moscow. (The loyal Communist Wieland Herzfelde never forgave Mehring for turning against the Soviet Union, and accused him of simply misunderstanding the 1939 war with Finland. Herzfelde wrote Mehring a letter on his fiftieth birthday calling him a "bastard.")

After his escape via Marseilles, Mehring arrived in America in 1941. He spent the usual unrewarding time in Hollywood, then moved to New York, where his old friend Hertha Pauli and former Dadaist colleagues like von Huelsenbeck, Grosz, and Herzfelde also lived. In 1944 a collection of his poems appeared, illustrated by Grosz and translated by an American leftist friend

of Erwin Piscator. Mehring also worked for the Office of Strategic Service's section for foreign propaganda, and later supported himself by working in a Long Island factory.

In 1951 he published *The Lost Library: Autobiography of a Culture*, composed partially on the farm of a New England tobacco farmer, who was a pacifist and jazz musician. Who would have expected such a book from Mehring? In celebrating his father's Berlin library, Mehring comments on a scholarly humanist tradition that antedates and would have disapproved of his own popular style. But somehow the American setting allows a rapprochement between father and son, high culture and the cabaret. Mehring recalls the tradition with the true Berlin tone, flippant, condensed, and very smart; when he wishes to, he can attend to literary mimesis as carefully as Erich Auerbach. More often, he exhibits an earthy irreverence: Marx is an unreadable old bore, and Nietzsche and Schopenhauer were simply crazed by syphilis. There is the typical émigré disdain for melancholy: as an antidote to the sorrow over the lost library, Mehring suggests good humor and good sex, not a better book but a better orgasm.

Despite the smart-alecky tone, this is not a happy work. At its saddest, Mehring celebrates literary resources while recognizing their absolute futility in the present era. As a composer of cabaret poems, Mehring understands verbal rhythms. He sees that, if nothing else, grammar can register a change in reality even before its subjects experience it. Language cannot accomplish very much, but it can prepare readers for what lies ahead. This belief underlies Mehring's defense of Proust against Gide, who objected to the younger novelist's arbitrary use of the tenses and his extensive abuse of subjunctives: Gide doesn't see that Proust followed "the grammar and syntax of prediction and prophetic dreams" and that his subjunctive was the "subjunctive of doubt." This last splendid phrase is true to the events of Proust's novel and émigré life alike, in which the knowledge of past betrayals, "the corruption of all ties," makes the fulfillment of any wish dubious. The "subjunctive of doubt" reproves desire, and allows a protective distance from the conviction that our hopes are either banal or doomed.

The library is lost; the wisdom it contained is buried in time and space, impossibly far from a New England farm in 1950. "All these things still exist only in the pluperfect tense, or in a *passé defini*": the grammatical form settles the matter, they are done for. After invoking the act of educated reading as the émigré's supreme talent, Mehring admits that the "remembrance of things past is a vain enterprise," although his book demonstrates that only that remembrance allowed émigrés to get by. What's left? Not, for Mehring, any social politics. At best, one can aim for "self-correction": a withdrawal as parochialized as the move from Berlin to a farm. Next best is the capacity to entertain. The final Berlin prank is to retire into comedy after betraying one's serious side. They won't bring the gallows humorist to the gallows: emigration has taught him that it pays to be elusive.

Women often had an easier time than these unhappy men. In the late thirties, observing the facility with which women writers entered the marketplace, Klaus and Erika Mann wrote, "Women and Jewish writers can adapt themselves to international taste." The women were "more natural," "greater realists," experts in the domestic events that knew no national boundary; above all, "the greater interest in *things* neutralizes spiritual differences and tensions," while the men "possessed by ideas, obstinately talk at cross-purposes." Such distinctions made on the basis of intellect were not meant to disparage women. Abstractions had ushered in Fascism and Stalinism; an attention to things cleared the air.

The successful women writers Vicki Baum and Martha Albrand produced novels packed with glamorous settings and melodramatic climaxes, albeit with more intelligence and sophistication than the "women's fiction" turned out by similarly successful American matrons. Closer to the depressing reality experienced by Heinrich Mann or Döblin was the history of Gertrude Urzidil. She was the daughter of wealthy Prague Jews; her brother had tutored Kafka in Hebrew. Late in her life, she boasted, "I am the last person in America whom Kafka called

'*Du.*' " Her husband, Johannes, was a baptized Catholic of Jewish origin. His book on Kafka, with its almost naïve title, *Da Geht Franz Kafka* (*There Goes Franz Kafka*), is one of the few studies to locate the writer in his beloved Prague. The two Urzidils in exile saw themselves as custodians of Czech culture, and they made little attempt to adjust to American conditions.

While Gertrude ventured forth with short poems and women's-page essays, Johannes wrote novels (*Das Grosse Hallelujah*) and literary biographies (*Goethe in Böhmen*). His wife was his greatest supporter: "My husband's range . . . I do not exaggerate . . . my husband was like Shakespeare." In 1941, after two years in London, the Urzidils arrived in New York City. They settled in the poorer refugee enclaves in the Queens suburbs, first Jackson Heights and then the outskirts of Kew Gardens. Mrs. Urzidil acknowledged that the times were always hard, and yet "not having to report to the office . . . that was our freedom." Her husband acquired a new career as a leatherworker, while she baby-sat. Among their friends the Urzidils' desperate condition became legendary. Only in the fifties, during a brief stint with the Voice of America, did Johannes earn a steady income.

Yet they were happy. Mrs. Urzidil often played hostess to their friends, Carl Zuckmayer, Hermann Broch, Erich Kahler, Hans Sahl. Food was always a refugee obsession. When reminded of Carl Zuckmayer's boast that his wife's cooking recaptured the past for their friends, Mrs. Urzidil snorted, "She was a good cook. *I* was a better cook." The Kew Gardens apartment was small and not elegant, though Urzidil had the discernment to pick off the street some well-made objects that masqueraded as Biedermeiers. One intricately carved chest impressed everyone—"even the most primitive workmen," Mrs. Urzidil remembered (it is a common error among foreigners to use "primitive" for "uneducated"). The apartment did not seem small to his devoted wife while Urzidil lived. "I told Heinrich Böll: when my husband was alive, the apartment seemed so big. Now it seems so small, because my husband gave *dimension* to everything."

After Johannes's death, she managed on almost nothing, earn-

ing a few royalties from her husband's paperbacks, selling an occasional poem to a Swiss paper or a short essay to *Aufbau*. For the well-dressed elderly of a local German Jewish congregation she might lecture on "Nobel Prize winners I have known." Gertrude Urzidil was, in her way, rather imperious. She was unamused by attempts to make her friend Kafka into a political figure or a Zionist, and furious over Philip Roth's story about Kafka in New Jersey: "Kafka would never have become a Hebrew teacher!" Anyway, Johannes had written a better story about Kafka working on a tomato farm in a misguided attempt to simplify his complicated nature. She surrounded herself with amateur émigré poets, a couple of housewives, and the owner of an antiques shop. Their daily phone calls reassured one another that they were alive; through one such call, her death in 1978 was discovered. Though she was extremely feeble and nearly blind, Gertrude Urzidil maintained her independence: "I don't know about hiding. I hide my bad things but not my money." Once, when a friend offered to walk her to the bathroom, she snapped, "I am not a dog." In her late eighties, she still saw herself as the foe of philistines: "I don't know if it's the right thing to adjust. Better to maintain a critical attitude—even if you're only critical about your lunch."

Gertrude Urzidil spoke of another émigré journalist, Anita Daniel, as her "golden girl." Miss Daniel, a wealthy and handsome woman, wrote sweet-spirited little travelogues with titles like *I Go to Mexico City* and *You'll Love New York* and a successful children's biography of Albert Schweitzer. (Other émigré women, such as Hertha Pauli, also wrote children's books.) Yet she had met and charmed imposing intellectuals from Einstein to Walter Benjamin. She won Einstein over by telling him an American anecdote: a Jew boards a subway and sees a Negro reading a Yiddish newspaper. "Are you Jewish?" he asks, and the Negro replies in Yiddish, "Not that! That's all I'd need!"

By the time Anita Daniel died she had become a doyenne of émigré circles. But the rabbi who officiated at the funeral did not seem acquainted with her history—the many moves, the loss of her child. Instead he cited (as a memento) the title of one of her

books, *Ein Bischen Liebe* (the others clearly would not have been appropriate): a little bit of love, a little bit of vaporous sentiment to commemorate an era.

After the changes they had lived through, the funerals of émigré writers would perforce appear incongruous, as if death itself had become anticlimactic. Funerals became community occasions when, as one writer said, "we always find out how many of us are left." Attempts at a lofty tone would often seem gratuitous: "Ach," said one cynic as she seated herself amid the mourners at a distinguished professor's funeral, "it's time for another recording of *Death and Transfiguration*."

Alma Mahler-Werfel, the Helen of Troy of her generation, could not be bothered by funerals, not even that of her husband Franz Werfel. "I never go to those things," she remarked. Her words echoing in his ears, Thomas Mann stood before Werfel's coffin, unsure "whether the heaving of my chest came from laughter or sobbing."

In the late forties George Grosz would get together with his old friends Mehring and Hertha Pauli. By then Grosz appeared to be an assimilated American; Pauli remembers his spending hours before the television, watching Westerns. He distinguished himself from his friends: "You've never arrived here. You are still in Marseilles"—waiting for a visa. Pauli admitted that "We got out of the trap like foxes who nevertheless leave a piece of leg behind."* But Grosz's adaptation wasn't all he supposed it to be either. In the late fifties he sold his Long Island home and returned to Berlin, dying shortly after in a drunken fall.

* Pauli's American career as a children's book author allowed her to treat the themes of emigration. She wrote a biography of Sojourner Truth—yet another instance of émigrés celebrating Afro-Americans—and a history of the Statue of Liberty. There were also biographies of Bertha von Suttner, the pacifist, and of Alfred Nobel, the inventor of gunpowder who established his peace prize after reading Suttner's *Lay Down Your Arms*. (Alfred Neumann also prepared an unproduced screenplay about Von Suttner and Nobel.)

Most of the émigré writers went back to Europe. America hadn't accepted them, and their own responses had been ambivalent despite the obligatory pronouncements about American hospitality: the American memoirs of Communist writers were particularly bitter. In 1946 almost all the German Communists residing in Mexico sailed to the Soviet Sector of Germany; in 1947 they were joined by Brecht, Ernst Bloch, and Wieland Herzfelde. By 1952 Leonhard Frank, Döblin, Mehring, Thomas Mann, Erich Maria Remarque, Alfred Neumann, Carl Zuckmayer, and several others were back in Europe. A few acquired new audiences: Friedrich Torberg, for one, consolidated his reputation as one of Austria's most important writers. Others faded with the years, overshadowed by younger, more experimental writers like Günter Grass and Heinrich Böll.

Many émigrés resettled in Switzerland, where the language was the same but the history was not so bad. The country had long been the watering hole of "all the very best Jews." Well into the 1970s older refugees would spend their vacations in St. Moritz and Sils Maria: "Our restitution money comes from Germany and goes to Switzerland." As they lived, so they died, and the Frankfurters Adorno and Horkheimer would end their lives in Switzerland, as had Rilke, Stefan George, Robert Musil, Hermann Hesse, Alfred Neumann, Erich Maria Remarque, Thomas Mann, and Carl Zuckmayer. (One writer's widow said, "It's better to die in the chocolate prison than in the camps.")

The history of the exiled writers in America is a disheartening one. Perhaps they could have exhibited a deeper curiosity about American life; why weren't there more émigré novels about New York or Los Angeles, two cities they knew well? Yet something new came out of the émigré experience, a style that tested, confirmed, and moved beyond the assumptions of earlier modernists.

Immediately new was the subject. The great "I" that inhabited the heart of Western literature had disappeared. In part, this absence was a legacy of modernism; as Adorno noted, even

Proust, the most subjective of writers, "decomposed the subjective mind." It was also a political reaction to the capitalist excesses of individualism: Walter Benjamin once said, "I write well because I seldom use 'I.' " Most profoundly, the sense of individual identity was blurred by the common experiences of exile, and some, such as Arendt, applauded this change. Alfred Döblin remembered a similar loss, though he was less happy about it: "I was never less 'I' " than during the flight from the Nazis. The move from the "I" to the "we" was purchased at the cost of a consoling warmth, but the chilly tone of the plural pronoun helped avoid the bathos that threatened the most heartfelt personal testimony.

As the traditional subject evaporated, the very conception of past and present began to blur. In 1945, reviewing Broch's *Virgil,* Hannah Arendt revealed a Berliner's impatience with the mind-set that "puts before us the alternative between going ahead and going backward, an alternative which appears so devoid of sense precisely because it still presupposes an unbroken chain of continuity." For writers like Arendt, history was a fraud, not merely in the phony objectivity of its method (historians were no more pleased with her cavalier use of data), but in its assumption that events moved in linear sequence. Arendt often cited William Faulkner's statement that the past was not over, it was not even past. She believed with her mentor Walter Benjamin that the past was a vast wasteland populated by victims still calling for redemption. The past had to be lived through, its issues fully confronted and finally settled before one could start living in some hypothetical present.

To render the new sense of self and time, the writers needed a new style. Various literary pronouncements were offered. Some were specifically grammatical, such as Mehring's analysis of Proust's "subjunctive of doubt" or Broch's assertion that the sentence suspends time by placing "subject and object in a relationship of simultaneity"—yet another reduction of the subject's autonomy, as well as a statement that was implicitly dialectical. While not many others investigated the conventions of grammar, the émigré writers as a whole were irritated with discrete literary forms.

The obvious exponent of such a cavalier attitude toward prose styles was the traditional man of letters. He could write about anything, leaping between forms, although his favored one was the essay. Yet the essayistic style developed by émigré writers is qualitatively different, both in the variety of forms they employed and in the urgency of their procedure. Above all, in keeping with the skeptical tone, this style demanded a resolute questioning of everything—the discipline, the form, the boundary, the sequence, the observers themselves.

At a particularly dramatic point in *Joseph in Egypt*, Thomas Mann apologizes for his discursive speculations: "When does a commentator set himself up in competition with his text?" The irony is deliberate. Mann presumes that literature today is possible only when the writer competes with his material and its reflection in himself. The result is fiction that resembles the essay, the literary manifestation of what Robert Musil called "decisive thought" rising above the lunacy of modern life and, for writers like Mann, helping to impose order on the chaos of emigration. For, finally, history and politics constitute the text that émigré writers must contend with. What they achieve with words is no simple aesthetic transcendence; theirs is not a French structuralist's linguistic legerdemain. Rather, with Teutonic solemnity, they aim for an intellectual advance that will enable them to organize data in a way that reflects the simultaneous changes in politics and the psyche. This approach keeps them in touch with the historical moment; it allows a style as manifold and diffuse as modern life while granting, virtually in its procedure alone, a control that almost no person alive could achieve, much less a deracinated writer in competition with his text.

Political events had undercut the old literary certainties and rendered literary decorum almost obscene. Regarding the traditional boundaries of genre as unsupportable, Arendt praised Broch for diminishing the status of the "made-up" in his fiction. Broch had no patience with *l'art pour l'art*, although his own seductive rhythms have been viewed as self-indulgent.

The Anglo-American academy, however, decreed that liter-

ary manners called for a faithfulness to genre and a modesty of tone, not the essayistic, heavily didactic style of émigré literature. In America the essayistic fiction of Musil and Broch went without readers, and Thomas Mann's most discursive and innovative work of fiction, *Doctor Faustus*, elicited an equivocal response (see the next chapter). These writers' audiences and imitators would not be found for years, and then only in Europe.

Some of their émigré interpreters fared better in this country. Perhaps because they addressed American issues, the works of writers like Arendt and Adorno ultimately succeeded in becoming models of academic prose. Yet one might say that they did so by standing the form of essayistic fiction—hybrid to begin with—on its head. Even as they assimilated the fictional sensibilities of writers like Kafka and Broch, Arendt and Adorno employed devices confounding enough in the fiction they admired—elliptical speculation, a surreal fragmentation of focus—in discursive essays that they prepared for stolid scholarly journals. Often, as a flickering code signaling to the initiated, these highly abstruse thinkers leavened their work with the familiar irreverence of the émigré skeptic.

In Arendt's work, an anecdote can yield a perception that will, almost magically, expand into an elaborate diagnosis that skips over disciplinary borders, and makes no apologies to the frontier guards she declines to recognize. Adorno—like Arendt, so confirmed in his manner that he approached self-caricature—continued to punctuate detailed, metaphysical arguments with whimsical conceits, as if a droning pedant were to leap an octave and imitate a wise-cracking adolescent. Thus, in the midst of a philosophical attack on George Lukács, Adorno suddenly compared the Hungarian's most recent work to an ice cream sundae shimmering in a state between thaw and refreeze.

On a less abstruse level, émigré writers were pitiless in examining all kinds of social and political rhetoric. One could forgive Bruno Bettelheim many sins for the power with which he demolished certain clichés: from the description of Helen Keller's nurse as a "miracle-worker" although no "miracle" was possible

for Keller (one of the happiest instances of a refugee squeezing all the untruth out of an American idiom), to his attack on a movie in which a Nazi guard gives a gun to a concentration camp inmate and orders him to shoot his friend (as Bettelheim notes, any sane inmate would have turned the gun on his captor). Adorno was similarly horrified when thoughtless artists used the Holocaust as an occasion for slapstick. He condemned Charlie Chaplin's *The Great Dictator* for presenting the unlikely situation of a Jewish girl satirizing the Nazi authorities, when in reality such behavior would have ensured her death. At their best, Brecht and Arendt are full of such moments. These writers can sweep away a mess of idiocies with the broom of good sense. In the presence of the émigrés' common wisdom, arguments about methodology become insignificant.

A generation of young American academics has acquired the Adorno method and now produces essays that read like botched translations from the German. Hannah Arendt's ferreting out of the moral and political origins of social commonplaces preceded many similar investigations by cultural critics like Susan Sontag and Renata Adler, while political scientists have benefited from her distinctive vocabulary. Today, German novelists like Günter Grass acknowledge Döblin and Thomas Mann as their literary ancestors.

Although the writers who suffered through years in Hollywood did not share the spectacular successes of émigré directors, in retrospect it is clear how much the two groups had in common. Above all, there is that icy, rigorous tone. Outside perhaps of Ophuls, none of the great émigré directors offered the invigorating consolations associated with the most admired American ones. And even Ophuls's spectacles, like those of Sirk or Lang, Wilder or Preminger, cast a shadow over the reality they depict by embedding it in doubt, despair, and the fatal passage of time. In the use of aesthetic means to explode conventional film values and epistemologies can be found mirror images of the writers' procedure. *"Er gibt den Ton an"*: was it Brecht who set the tone? Or the directors? Or Musil or Broch or the later, liberated

Thomas Mann? No matter. The characteristic tone of emigration distinguished them all. Only on the page, however, could it be expressed so directly, without charm or kitsch, and without the involvement of American performers or settings to temper its foreignness.

14

The Loneliness of Thomas Mann

While America paid little attention to most other émigré writers, it conferred numerous blessings on Thomas Mann. Other writers couldn't get their work published; his novels were best-sellers. Broch and Brecht might be asked to spell their last names; Mann arrived in America in 1938 hailed as "the world's greatest novelist," and remained long enough to be accepted by some critics as "America's greatest writer," although, as the other émigrés were quick to observe, he didn't write in English. Most major European artists became isolated figures, but soon after his arrival, Mann received an honorary degree from Harvard, together with Albert Einstein, and dined at the White House. There were even rumors that Roosevelt had selected him to head a German government-in-exile, thus making him a literary de Gaulle.

Mann became the spokesman not merely of émigré writers but of informed anti-Fascist opinion. He recognized his responsibilities and made himself endlessly available to committees. By 1941 it had become customary for him to place his imprimatur on the new works of émigré writers. In his journals he wondered

"Why everyone who wants to immigrate or is looking for a job appeals to me," then appended, "a question to destroy." He continued to sign petitions and grant applications. He informed the PEN Club of the perilous situation of the émigrés stranded in Marseilles, as he later complained to Attorney General Francis Biddle about the wartime restrictions placed on "enemy aliens." Perhaps most significantly, it was Mann who in November 1941 broadcast over the BBC news of the crimes committed against the Jews, and in September 1942 was one of the first prominent figures to give credence to reports that European Jewry was on the verge of extinction.

The war years were Mann's easiest time in America. Even as he agonized over the European situation, he became a citizen of a country whose leader he admired to the point of idolatry. His ambivalence about American culture was tempered by a commitment to America's military role: as he wrote later, it was a morally good period. Above all, the wartime spirit accommodated Mann's internationalist perspective. Unlike other Germans, who viewed their emigration as a temporary switch in national identity, Mann believed that it signified the transcendence of all nationalist postures; there no longer existed any real or metaphorical "homeland" for him to regain. In 1942 he observed, "Our emigration . . . assumes an entirely different significance from that of any former emigration, the significance of the coalescence of the hemispheres, of the unification of the earth. . . ." Europe had not come to America; America and Europe now composed one entity. Hence, the émigré's cultural sacrifice would be no greater than the American's, since both would be involved in founding a postwar world. (Similarly, he regarded the verbal style of his *Joseph* novels as "speech in the absolute . . . which . . . pays little attention to idiom and local linguistic divinities. . . .") This was not a unique vision in 1942, though by the war's close, Mann saw that it was unlikely it would be realized. He had subsumed American citizenship into world citizenship; after 1945, the identification would remain more local.

Mann, appointed to the thankless roles of spokesman and prophet, was not equipped for the attendant pressures. Some

writers are invigorated by public life; they invest their public selves with the ambiguity and momentum of their fiction. Mann was not a graceful public performer; he appeared cold and distant. His friends described him as shy; outsiders found him remote. Mann himself saw "public activity" as "prone to take on a character of fantasy, dream and buffoonery." Typically, the literary insight was not extended into a public style; this was not Charles Dickens reducing his audiences to shrieking frenzies, or Norman Mailer making his audience the gift of a singular self. Yet Mann—awkward, displeased with himself, and quintessentially German—became a fixture of the American lecture circuit.

Almost from the start, Mann's time in America was marked by criticism of him by a series of enemies. His fellow émigrés comprised the first group. Like the generous American critics, they took him seriously, not as the king of fiction, but as a middlebrow aesthete who was hogging the attention withheld from more deserving writers. Bertolt Brecht and Erik Erikson, among others, condemned his politics along with his fiction; they called him a traitor to the German people. Even a friend like Alma Mahler-Werfel provoked Arnold Schoenberg, the musical prototype of *Doctor Faustus*, to rage against him. These various "attacks, falsifications, and stupidities tire me like hard work." But as if to defy his enemies, his rate of production did not decline.

There were other miseries besides the verbal assaults of his companions in exile. Mann, his wife, Katja, and their children, Erika, Golo, Klaus, Monika, Elizabeth, and Michael, all arrived safely in America, along with Mann's brother Heinrich and Heinrich's wife, Nellie. But en route to America, Monika's boat had been attacked and her husband drowned before her eyes. Klaus and Erika ruled the New York and West Coast colonies of émigré bohemians. However, Klaus especially was ill at ease with the obligations and competition inherent in his role as Thomas Mann's son. After one of several suicide attempts by Klaus, Mann complained to a friend that the problem was that Klaus was "spoiled." He lived as publicly as his father, though as a former actor he may have enjoyed the spotlight more. His

self-doubts, his mental illnesses, his defiant homosexuality—
Klaus kept no secrets from his readers. His ultimately successful
attempt at suicide was a final embarrassment added to the many
others he had brought his family, and only Michael attended the
funeral. Regarding his brother Heinrich's luck in Hollywood,
Thomas observed that anyone gambling on a career in movies
was dependent on "Satan's mercies." Nellie Mann committed
suicide in 1944. Heinrich died a few years later, in 1950, as did
Klaus and another Mann brother (two sisters had committed
suicide in Europe).

All this happened while Thomas was still extolling the ad-
vantages of life in America! Yet Mann's life at this time, over-
burdened with disappointments and unhappiness, may have
been his richest creative period, when he produced the work he
considered most important. And this country played a paradox-
ical but definitive role in its creation. In 1939, Mann had ob-
served that "Here in America, writers are short-lived," burned
out after a few early successes. Older writers, such as the Mann
brothers, did not exist: "Life in the Goethean sense belongs to
our tradition alone; it is less a matter of vitality than of intelli-
gence and will." But in his old age, Goethe had delighted in the
prospects of an "alleviation of humanity" ushered in by the
American Revolution; the idea of the New World revived him.
So, too, did Mann find in America the setting for an atypical old
age.

Prompted almost certainly by the increase in his political
awareness, Mann sought a literary rebirth. One resource was
myth, but myth "fabulously neutralized," no longer a vehicle of
Fascist campaigns. In 1942, addressing the Library of Congress,
Mann spoke of his *Joseph in Egypt* as exemplifying another kind
of myth, not unlike that of the American pioneer spirit, "in-
spired by an interest in humanity transcending the individual."
He implied that the latest product of this tradition was the im-
proved prose style of Mann himself. The American manner was
a compound of "tradition and revolution . . . [an] infinitely at-
tractive mixture." Finally, in this country, Mann could combine
his conservative and revolutionary tendencies; here they were
the same, merged in "the *good* will." The American example

had allowed him to make free with the German literary tradition. And so he had recently engaged in "playful boldness" with the literature of the past, by using Goethe's *Faust* as the source of allusions in his *Joseph* novels—and by newly embodying an old myth in the then-forthcoming *Doctor Faustus*.

This 1942 speech revealed Mann at his most confident about the nature both of American politics and of the kind of writing possible here. Mann's political view later darkened; the rescuer of humanity began to resemble its scourge. But his spirit of playful boldness grew tougher and more embracing, until in America he achieved a true literature of old age.

For a man who felt uncomfortable in public, Mann entrusted his readers with an astonishingly complete presentation of himself. The most perceptive observer may grow myopic in self-examination, but the dispassionate irony of Mann's fiction convinces us that he recognized the not altogether flattering light in which he cast himself in his letters and journal. Mann told a New York editor that the epithets applied to him by his homeland were ill-chosen: he was not "pompous," "pretentious," "Olympian." He despised solemnity and affectation (although Brecht might see him as their personification). No, his ideal was clarity, a surface light and sparkling even if it exposed a juggernaut beneath. He had been reared in a language that inclined to verbal density, but he cited a sentence in *Joseph*, almost two pages long, as something not "pompous" or "ponderous," but funny, a send-up of Teutonic prolixity. Mann wished to convince Americans that he only aimed to please.

In 1944 he disdained any "Olympian arrogance. Basically all I want is to make people laugh, and for the rest I am the soul of laborious modesty." This is mildly disingenuous, for Mann was more shy than modest, though he was Olympian only if the gods are seen as comedians. Some years later Mann contradicted the public estimation of him as a "virtually universal mind." He had been "almost inconceivably ill-educated." True, he had acquired an expert's knowledge of several scientific and historical subjects. But he had done this only for his fiction, and such facts

were always to be discarded as useless once the novel was completed.

At his least appealing he came across to readers as priggish, self-involved, hypochondriachal. For years before, he had been haunted by the affinities between illness and art. His personal writings made less exalted claims for disease: Mann recorded the development of his own sicknesses with an obsessive interest few outsiders would share. But, in fact, he was critically ill during the 1940s. His hospital journals convey his familiar interest in medical discoveries and even record an almost invisible flirtation with an attractive male orderly. Mann awoke from an operation and informed his wife, "I suffered too much"—in English. He wondered what his statement revealed about unconscious physical memory. A reader might wonder why suffering would be registered in an uncharacteristic use of English!

There is an answer to Mann's critics. Not in his insistence that he is, *au fond*, a humorist. All his books contain funny passages, but few readers repair to a Mann novel for light reading. When Mann's fiction becomes most serious, it is either saved or threatened—for not every reader wants a let-up from serious analysis—by Mann's consuming sensuality. Even when critically ill, he made a point about the physical charms of his orderly, and delighted in the quickening of his taste buds as he drank his first glass of orange juice after the operation. He officiously acknowledged a young American reader's praise, and then admitted that he was equally attracted by her comeliness. Although unlike the playwright in so many ways, Mann joined Brecht in his admiration of American physical grace: he noted the "perfected naturalness" of American acting, something so artless that Europeans could never reproduce it.

Throughout his work there is a positive lusting for the mindless physical beauties who dance in worlds where Mann and his narrators stumble. Thomas Mann was not an outspoken homosexual like Klaus, though his interest in homosexuality endured, as did his preoccupation with incest. In his great story "Mario and the Magician," the protofascist magician is both vile and poignant as he hypnotizes the handsome Mario into a physical response he could never evoke through normal means. In his

journals, Mann examined elements of homoeroticism in Sten-
dhal, and claimed to incorporate them in the affair of Leverkühn
and Rudi in *Doctor Faustus*. This is, again, disingenuous. Mann
admitted that he was completely in love with Leverkühn. The
recent evidence of Mann's bisexuality merely confirms what is
evident in his work from "Tonio Kröger" to *Faustus*. The im-
portant thing about Mann's lusts, whether for aphysical genius
or mindless beauty, is that they engaged him in a productive am-
bivalence by reminding him of what he could not possess.

After all, there is something ludicrous about Mann's narrators
clumsily pursuing their unattainable loves. And with Mann
himself, there was more than a little self-mockery. During the
war years, he undertook several lecture tours. He noted the large
turnout in Boston, wondered whether he satisfied the audience,
and rather vainly concluded that he did. But then he went off to
the provinces. In one town, the audience couldn't hurry out fast
enough, and the embarrassed sponsor attempted to soothe
Mann's feelings with a quart of fresh milk. He relished such
American behavior: for him, the light and dark sides of Ameri-
can life were exemplified by a front-page announcement that a
man's canary would sing at his funeral. Mann's bemusement at
these incredible American responses became another source of
comedy for his journals.

Increasingly involved in political action during his years in
America, this ironic, conflicted, self-obsessed man, for whom a
step into the political arena represented an act of self-delusion
and buffoonery, became a figure of American public life.

The first political steps in Europe had been tentative, as he
was nudged and guided by his children Klaus and Erika. His
brother Heinrich's prophetic essays and Klaus's spirited journal
Die Sammlung appeared immediately after the Nazis' rise to
power. But for three years, there was public silence from
Thomas Mann, perhaps to preserve his German readership (he
was a best-selling author); perhaps out of a reluctance to face
facts; perhaps out of fear. Whatever the reasons were, in 1936
came his outspoken letter to the dean of the philosophical fac-

ulty of the University of Bonn: "Should . . . a German author accustomed to the responsibility of the Word . . . be silent . . . in the face of . . . inexplicable evil. . . . To what a pass, in less than four years, have [the Nazis] brought Germany." After that, there could be no question about his position. Mann's political analyses owe more to Freud than to Marx. In his novels and stories he presents Fascist rituals as *Walpurgisnacht,* finding them more comprehensible as riotous orgies than as the tailspins of late capitalism. This perspective had peculiar ramifications in America. In the 1929 "Mario and the Magician," the magician is a spellbinder, manipulating his German audience with the finesse of an American evangelist. Indeed, at one point, a woman in the audience begins to dance in the aisles, like an American pentecostal suddenly stricken by the urgings of the Holy Ghost.

A year later, Mann described Nazi rallies in terms that fit evangelistic services: "political scenes in the grotesque style, with Salvation Army methods, hallelujahs and bell-ringing and dervishlike repetition of monotonous catchwords, until everybody foams at the mouth"—a Nazi glossolalia. Klaus Mann observed a similar parallel between revivalist and Fascist methods. He found that Hitler's microphone technique had only one antecedent, that of the American faith healer Aimee Semple McPherson. The Manns' insight still obtains, especially today, when right-wing politics and Charismatic Christianity are political bedmates. Emigrés were frequently struck by the evangelistic hysteria; it seemed to them quintessentially American, a deafening worship in a noisy culture. For Mann, with his dry, sotto voce manner, this American style—also evident in types of huckstering other than the holy kind—summoned bad memories.

After Mann left Germany, he looked back at a "reign of failures, of misfits . . . they burned books they were incapable of writing," employing a personally wounded tone that resembled that of Theodor Adorno when Adorno recognized the childhood bullies who mocked his overlong sentences as being the Nazis who were destroying the German language. Mann sought to find a new homeland in the traditions and literature of the German language, as other émigrés had done. In his diary, he wrote,

"What is homelessness? In the works which I take with me is my home. . . . They are language, German language and style of thought, the individually developed traditional treasures of my country and people. Where I am, is Germany." This statement is often adduced as an example of Mann's arrogance. But it could be echoed by countless other refugees, particularly those in concentration camps who kept themselves sane with quotations.

Perhaps the real anguish for Mann lay in his battles with other Germans, but his political experiences in America also provided a constant source of melancholy. The dissatisfaction was all the greater for the initial optimism: when he received his citizenship papers and the judge asked his witness, Max Horkheimer, whether Mann would prove to be a devoted citizen, Horkheimer had replied, "You bet." One reason for Mann's loyalty to the United States was its leader. He credited Roosevelt with winning the war. By the late forties, however, he had become more circumspect in his devotion to Roosevelt: "I am glad to think—but had best be brief in uttering this thought—that I became [a citizen] under Roosevelt, in *his* America." Roosevelt is Mann's one egregious blind spot. Like many others, he did not choose to grapple with the mystery of Roosevelt's refusal to admit European émigrés after 1941.

In Mann's first major speech to the American people, "The Coming Victory of Democracy" (1938), he declared himself the advocate of a "socialist morality." Mann despised the excesses of Stalinism, but he continued to differentiate Stalin's crimes from Marxist principles, a simple enough distinction but one incomprehensible to many Americans. Mann's wartime hope was that America would participate in a postwar union of "one world" guided by socialist principles.

While it lasted, his admiration for the American landscape and character was constant and full-throated. His change in attitude began during the war. By 1943 he had already recognized that the war effort was not all it seemed. He mentioned a coal miners' strike, and the attempts to hire scabs. He noted a readiness among Americans to prepare for a forthcoming war with Russia. In 1944 he discerned a widespread hatred of Russians, Englishmen, and Jews—of everyone, it seemed, but Germans.

In November 1945 he wrote Einstein about the growing xeno-
phobia and anti-Semitism. Mann was not paranoid. Shortly
after, a Georgia congressman attacked him and his fellow mem-
bers of the National Committee to Combat Anti-Semitism for
their attempts to "control the thoughts of American citizens."

Though 1945 marked the war's end, the year brought Mann
little joy. Instead, it was marred by Roosevelt's death and his
enemies' ill-disguised glee. The Hiroshima bomb was, for
Mann, a gratuitous horror, deployed merely to "prevent Rus-
sia's participation in this victory." He recalled Goethe's phrase
"the innards of nature": they had been exploded for purely po-
litical purposes. At the year's end, Mann recognized that noth-
ing had been learned, that the war was an "elevating interlude"
by comparison. This insight didn't prevent him from speaking
at a dinner for Helen Gahagan Douglas, "who courageously
lashed out against the misuse of our troops in China where they
had no business to be," the sort of contention pounced on by
Douglas's fellow Californian Richard Nixon.

The year 1946 found Mann more gloomy. Postwar America
was an admixture of "raw avarice, political reaction, racial ha-
tred." His German experiences made him profoundly pessimis-
tic, although "there would be no further exile—for where would
I go?" He attempted to cheer up his correspondent, the ubiqui-
tous Mrs. Agnes E. Meyer, by assuring her that the conditions
here were quite different from postwar Germany's. But he could
not resist some gallows humor: "If fascism comes, I can point
out that I was once Senator Taft's guest. That perhaps may save
me from the concentration camp."

In 1947 Mann beheld Churchill, Roosevelt's ally, itching to
rearm Germany for combat with Russia. The Roosevelt vision
had been repudiated by Americans. He wrote to Mrs. Meyer of
the new "inquisition" that was forcing his friend Hanns Eisler
out of the country. The general fear had gotten to Mann: the
unimpeachably right-wing Stravinsky might be organizing a
demonstration for Eisler, "But I have wife and children and am
not inquiring further into the matter." (Interestingly, Mann did
join a committee to defend Eisler's indisputably Communist
brother, Gerhardt.) Two days later, he wrote another American

in defense of Lion Feuchtwanger, who had reportedly described America as being without culture. Mann considered himself "still . . . an American patriot," although he had been disillusioned by America's decision not to lead the world but to buy it (once he referred scathingly to the "Marshallization" of Europe). America's rightward turn grieved him, but he insisted that the government, and not the people who elected it, was responsible.

As the Red-baiting increased, Mann addressed the Committee for the First Amendment. At another meeting, he reiterated his hatred of dictatorships, but expressed sympathy for "the starving and oppressed" who preferred food and shelter to a nebulous political freedom. Mann could not continue making such public statements without incurring attacks. In 1949 he endorsed the basic tenets of the Arts, Science and Professions Conference at their dinner, which was held at the Waldorf-Astoria. (Such liberals as Norman Cousins and Norman Mailer joined radicals, fellow-travelers, and Stalinists at the conference, which was later regarded as one of the last gasps of the Old Left.) As a result of Mann's show of support, former Attorney General Francis Biddle sent him an angry letter. Mann replied that he was not a fellow-traveler; Stalinist Russia was "quite malicious." But he refused to back down; he might have, he wrote, "if I were alone with my doubts regarding the wisdom of our foreign policy," but he could point to numerous Americans who felt the same way. He persisted in distinguishing between Communism's "idea of humanity" and the "absolute vileness of Fascism." In an article he wrote for *The New York Times*, he confessed to being a "non-Communist rather than an anti-Communist." For him, the jury was still out on Communism; for American zealots, the verdict was now in on Mann. By the end of 1949 he was writing cynically that what "gnaws at our American hearts" is that "instead of beating Russia with Germany, [we] were beating Germany with Russia . . . we'll never forgive Roosevelt for it." The use of the personal pronoun is unconvincing: each year removed from the Roosevelt who accorded him his citizenship diminished Mann's identification with an American "we."

In 1950 Mann wrote to Theodor Adorno, who was by then ensconced in Germany. Mann was not happy about the political spirit in the United States and, like most Americans, hated paying taxes. The real trouble, once again, was ambivalence. "Basically we in this foreign land that has become so homelike are living in the wrong place, which confers a certain air of immorality upon our existence." And yet, as always, there was a catch: "I rather enjoy it." One feels that this was the real Mann tone. The master detector of the morally dubious in himself, as well as in others, had discovered again that no response was pure. America was frightful and terrific, and he rather enjoyed having it both ways so that he could continue to feel a bit disreputable, no matter what position he assumed.

In the same letter, he told Adorno that the political air had become "unbreathable." The metaphor is loaded: on March 12, 1933, a telephone warning about "bad weather" from his children in Munich had persuaded Mann, then vacationing in Switzerland, not to return to Germany. For some, Mann was now a public enemy: the Beverly-Wilshire Hotel refused to rent its facilities to a political group because of his participation; the Library of Congress canceled his scheduled lecture. As Mann joined protests against the jailing of the Hollywood 10 and the firing of schoolteachers suspected of being Communists, he found "the media had been closed to him. . . ."

They could curtail his audience, but they couldn't shut the old man up. Only three major intellectuals might be counted on to defend political heretics by 1950, Linus Pauling and two émigrés, Mann and Einstein. Not that Mann wasn't frightened as well as angry. In March he wrote a friend that "the 'cold war' is bringing physical and moral ruin upon America; that is why I am against it—and not 'against America.' " The joke about Senator Taft had yielded to real panic: "If the Mundt-Nixon Bill [the Internal Security Act] should be passed, I shall flee—head over heels, together with my seven honorary doctorates." The shame is that he might have been forced to. A second emigration had become a likelihood.

By 1951 Mann regarded his situation as desperate. He wrote his old friend Erich Kahler that a move now seemed inevitable:

Europe was bad, but worse was the "barbarous infantilism" of American life. A month later he was attacked in the House of Representatives by an American congressman for his birthday greetings to the East German poet Johannes R. Becher: Congressman Donald Jackson warned Mann that ingrates were seldom welcomed back to dine. Mann was now a symbol of the resistance. He attended a birthday dinner for the black Communist scholar W. E. B. DuBois, and later joined in an appeal on behalf of the Rosenbergs.

In his last year in America, Mann continued to defend himself wherever he could. To *Aufbau*, the German Jewish weekly that had published his occasional pieces through the years, he wrote a letter that deserved wider circulation. For almost the last time—and, ironically, in German—he argued that he had "felt it an honor and a joy to become a citizen of this country. But hysterical, irrational, and blind hatred of communism represents a danger to America far more terrible than native communism." That same year, he wrote Walter Ulbricht in defense of East German political prisoners. With admirable consistency, Mann reminded Ulbricht that war guilt was universal in Germany, and he made his familiar distinction between Fascist and Communist totalitarianism in order to strengthen his plea for the prisoners' release.

Some critics have contended that Mann's departure was due largely to the American rejection of *Doctor Faustus*, which appeared in 1948. But he cited other reasons for refusing to publish the journal of that novel's composition in English. In part, no doubt, because "confidences are unbecoming in the lonely." But also, as he wrote another émigré writer, Alexander M. Frey, in 1952, "because of its only too correct predictions about the evolution of post-Rooseveltian America." The journal was published posthumously in English in 1961. It is a book steeped in bitterness. Under Truman, "in contrast to the rest of the world, America stood far to the right."

Mann left the country in 1952. "I have no desire to rest my bones in this soulless soil which I owe nothing, and which knows nothing of me," he had written a friend, Hans Carossa, a year earlier. In 1953 he casually dismissed his beloved California

as an "artificial paradise." Mann was now neither American nor German, but European. He told a European journalist that the Continent should remain "not neutral but free." America and Russia were similarly alike, similarly alien. As far as patriotism was concerned, Mann's spirit had been broken.

Recently, commentators have attacked his political arguments, specifically his assertion that some Americans would have joined Germany in its war against the Soviet Union, for being paranoid lapses. Yet Mann did not exaggerate greatly. Many Americans did talk that way—aggressively during the thirties, more quietly during the war. If he magnified the danger, he also addressed the issues. If he signed too many petitions, other American writers refused to sign any. If he diverted attention from Soviet guilt, he was surrounded by writers who produced highbrow apologies for the American inquisitors. Mann was culturally and temperamentally isolated; one can imagine his extreme discomfort at a public meeting for the Hollywood 10! Yet instead of applauding the courage that led him to honor American principles of dissent, critics still demanded the superhuman of him, an omniscience that he never claimed to have.

Because political controversy denied Mann a Goethean old age of wisdom in tranquillity, he lived another, newer myth: that of the author released by old age into an interrogation of his past. As he had said in 1942, his literature burst all the boundaries of the aesthetic, philosophical and political. It encompassed everything: ancient Egypt, modern Germany. Science became a central source of imagery and metaphors; he was prepared to see Hiroshima as a Faustian experiment. Mann might have absorbed and incorporated these influences into his work anywhere, but it makes sense to see his late activity as a response to the newness of America.

For example, the self-conscious Mann had begun to feel old-fashioned, not merely because his German naysayers said he was, but because literary critics were drawn to more experimental novelists. It took an American critic to make him feel at ease. Mann read Harry Levin's study of James Joyce, largely

because his English was too poor for him to read the original. From Levin's book he acquired a sense of identification, recognizing in Joyce "my own question whether in the field of the novel nowadays the only thing that counted was what was no longer a novel." (Compare Hannah Arendt's comment that Hermann Broch rescued the novel from fiction.) Somewhat playfully, Mann let critics like the Hungarian Lukács or the American Levin make sense of him to himself. This was but some more data to incorporate in "my work."

Life in America reminded him, too, of his distance from his fellow émigrés. In the mid-forties he read the latest effort of his friend Bruno Frank. It was splendid, Mann allowed, although in fact he found it tired. Frank used "the [traditional] humanistic narrative style . . . with complete seriousness. . . . In matters of style, I really no longer admit anything but *parody*. In this, I am close to Joyce. . . ." (Italics mine.) Obviously, other old men could improve in exile: witness Mann's tribute to his brother Heinrich's "idiom of the new world." But the master of "playful boldness" now maintained an ironic distance from his earlier prose style. History, politics, the state of the art itself had all made that form ready for retirement.

The language of Thomas Mann's American novels was increasingly marked by the use of the "impersonal"—quotations or parody—as assertions of a newly achieved vision. His fellow émigrés Döblin or Brecht might single him out as a facile belles-lettrist, but it was obvious that pretty prose and refined sensibility were no longer Mann's preoccupations. The times demanded another prose style: this was a *moral* requirement. Mann's late writings show the intimate connection between politics and literary style. In the early thirties Robert Musil, who cared little for Mann's work, wrote that its supreme animating force was "conscience"; the more sympathetic Arthur Schnitzler located that force in "humor." Mann linked the two in parody, for his parody, though playful, was never amoral. Late in his life, he wrote a horrified note about Aldous Huxley's *Doors of Perception;* Mann found the celebration of drugs "immoral" and "irresponsible." Mann responded as an enraged writer upholding the writer's duties to his public. The influence of Huxley's work on

the American drug culture supports Mann's conviction that an author is morally accountable to his readers. Mann was not being priggish: he tested himself by the same standards.

The masterpiece of Mann's late period, *Doctor Faustus: The Life of the German Composer Adrian Leverkühn as Told by a Friend* (1948), is a dramatization of the obsessions of his exile, composed in the style developed in that exile. Yet his other American novels also reflect a looser, more essayistic quality. The last *Joseph* novels (1938, 1944) were "composed under the serene Egyptian-like sky of California." Mann mingles the past with the present. *Joseph the Provider* is filled with contemporary allusions—to his friends, to Roosevelt, to the hardships of Jewish exile. *The Beloved Returns* (1940) is a work of fiction about the old Goethe, Mann's model. The work celebrates *Zitate* (quotations). Mann was not unique in his dependence on quotations, the only portable reminders that "where I am, is Germany." But he surpassed his fellow exiles by merging the quotations and allusions with his own parodistic skills in what some thought was a new, late work of Goethe. Mann was delighted when during the Nuremberg Trials the British prosecutor, Sir Hartley Shawcross, quoted his manufactured Goethe as the real thing.

Doctor Faustus is Mann's most ambitious novel both in style and in theme, an absolute confirmation of the triumph of old age. The work incorporates the perceptions of a lifetime, conveyed with the amplitude and irreverence characteristic of Mann's late writings. It draws upon his own history (the novel and the composition of the novel share the same time span; the hero's first major work and Mann's first novel were begun in the same place), his relatives and friends, and his biases and schemes (material for later novels is scattered throughout the book). Even the difficulties of translation are alluded to: Mann knew that this might be his least accessible work.

Doctor Faustus may be the supreme literary distillation of the themes of exile. America hardly figures in the book's content, but this country shares in its achievement. It simply could not have been written anywhere else, not then, and like hot news, it is uniquely a product of its moment. Nevertheless, the Ameri-

can critics who had applauded his novels of Egypt or Weimar considered *Faustus* parochial; in this instance, they found too many "idioms and local linguistic divinities." They blasted the novel's "G-E-R-M-A-N allegory," treating Mann as though he were a cross between a chameleon and an elephant. True, the novel contains few overtly American episodes. Yet it was written during the time of Mann's increasing disillusionment with this country, and his demoralization heightens the work's pathos, defining more sharply his own isolation. The book ends in 1945, and thus the narrator's prophecy that the leaders of Western democracy will create postwar "conditions more justified of life" is one that Mann must have written uneasily, having lost both Roosevelt and his confidence.

Yet, in one of the novel's rare attempts at a happy vision, Mann evoked a certain period in this country's history. In early-nineteenth-century America, there was a community of Seventh Day Baptists who sang a form of twelve-tone choral music. The singing was in wordless falsetto and returned to music all the "bovine warmth" previously removed through the "pedantic cooling off" of compositional theory. The practice resulted in an epidemic of composition: the procedure yielded a true community of artists. Since Mann can leap over time and space, the fact that this occurred in nineteenth-century Pennsylvania doesn't diminish its validity for the 1940s or the present. It might also be noted that one of Mann's political aims in writing *Doctor Faustus* was to learn why Germany had not become a democratic country. The very posing of this question reveals an Americanization of sensibility and an assumption of values that were still foreign to Mann's literary subject. The novel can be read as the work of a German asking American questions about Germany.

Doctor Faustus is the life of the German composer Adrian Leverkühn (born 1885), as told by his oldest friend, Serenus Zeitblom, Ph.D. (born 1883). (This is how Zeitblom pedantically identifies himself.) More than an alphabet separates Adrian and Zeitblom, although between them they manage to embody most of the salient aspects of the German temperament. Leverkühn is a brilliant, nihilistic artist, reared in the violent

traditions of Lutheran theology; Zeitblom is a Catholic human-
ist, modest to the point of self-parody. Leverkühn is a bachelor
who destroys his lovers of both sexes; Zeitblom is a devoted
family man abandoned by his Nazi sons. The novel is concerned
with Leverkühn's development—intellectual, artistic, and spir-
itual. It includes a Faustian bargain with the devil, dramatized
in an encounter between the composer and the most fluent and
engaging Lucifer since Milton's Satan. After a visit to a brothel,
Leverkühn contracts syphilis, the ultimate physical agent of his
degeneration as well as the emblem of diabolical vengeance. The
novel incorporates Leverkühn's mythological attributes into its
own, more comprehensive myth. Through the years, he encoun-
ters a variety of people—musicians, journalists, amateurs, fans.
Most of the artists are talentless, the intellectuals sophistic.
They are also richly amusing and pathetic.

While Mann might have wished to compose a summation of
German history, his novel is nothing like conventional German
scholarship, if for no other reason than that his treatment of
source material was so cavalier. Almost like Brecht, Mann ap-
propriates ideas and concepts with an abandon that could pass
for plagiarism. Theodor Adorno gave him informed counsel
about the book's musical passages; Mann acknowledged him in
his journals, then playfully added that Adorno's analyses might
have been colored by his own earlier writing, that in raiding
Adorno, he was in effect robbing himself. Anyway, "the thing
that matters is the way [an idea] functions within the frame-
work of [an artist's] creation." To compound Adorno's griev-
ances, when the devil makes his entrance, he talks like Adorno,
who, in recognition of this, signed a letter to Mann "your faith-
ful devil." Lucifer calls art a "highbrow swindle," indulges in
dialectical witticisms, and makes Adorno-like assertions. Could
the Frankfurters have anticipated that even their hermetic criti-
cal language might become the material of fictional play?

Other émigrés were not charmed by Mann's plundering; to
them, the higher cause of art—or the need to understand Ger-
many's breakdown—did not excuse the theft of their property
and the revision of their lives. Thus Mann was unprepared for
Schoenberg's irritation with the way *Faustus* dramatized his

musical theories. Mann believed that he had given the twelve-
tone technique a brand-new "coloration," making it in fact
"really my property, or rather the property of the book."
Schoenberg—despairing of public recognition, his resentment
abetted by Alma Mahler-Werfel—thought otherwise. Yet surely
Mann is right: Without creating a literary equivalent of program
music, he makes a metaphor that encompasses his novel's social
and political events.

The novel is loaded with digressions and circumlocutions.
They are often instructive, sometimes parodistic, but also a psy-
chological defense: the narrator confesses that they divert atten-
tion from the future. Like Laurence Sterne (one of Mann's
heroes) or a 1960s concrete poet, Zeitblom occasionally retires
from his fiction to contemplate its physical form; after a terrify-
ing essay about the Nazis' "gangsterism," he introduces aster-
isks as a "refreshment for the eye and mind of the reader."

Mann employed all his narrative resources in order to make
sense of something unparalleled in history. Similarly, he at-
tempted to devise a new form of characterization, joining the
other émigré writers who sought to depict human life in a differ-
ent way once the traditional evaluation of the individual no
longer made sense. Brecht once contended that the "type of this
century can no longer be shown in the old form, from the old
standpoint." Brecht's solution—a political program in itself—
was to reduce the individual to his gestures and social functions.
Mann's, in *Faustus*, was to replace physical life—although other
characters are vividly described, we don't know how Leverkühn
or Zeitblom look because such details would "undermine
[their] symbolic dignity" and "render banal [their] representa-
tiveness"—with an elliptical combination of the sensuous and
the intellectual. It was not surprising that Mann should repre-
sent abstractions as erotic. He confessed in his journals that he
was, like Zeitblom, "painfully in love" with the figure of Le-
verkühn from boyhood, "infatuated" with his apparent inhu-
manity, his pessimism, his "conviction that he was damned."
Now, this was an un-American response! Had Leverkühn been
a less cerebral sort, American critics might have appreciated

Zeitblom's crush, but the erotic power of symbols and ideas was Mann's contribution.

Implicit throughout, explicit in the novel's last words—"God be merciful on thy soul, my friend, my fatherland"—is the conflation of Leverkühn's destiny with Germany's. Some émigré readers felt that for a political parable, *Faustus* was insufficiently detailed. The novel lacks a specific economic or political analysis, though there are numerous allusions to an unnamed Hitler-like character. Such readers also found the stress on art's pre-eminence dubious; they allowed that Mann's vision illuminated German culture but questioned the application of that vision to political history. Of course, Mann would answer that the two cannot be separated in a country that for generations filled a political vacuum with a surplus of mythology.

At the same time, American readers found the novel's concerns too narrowly German and the final reciprocal identifications excessive. But, as the book passes through the various periods of German history, the critique of German culture is lively, dramatic, even funny. Leverkühn's hometown of Kaiseraschern (something of a pun, meaning either the king's ashes or his buttocks) is steeped in medieval customs; its museum exhibits instruments of torture. From the medieval Children's Crusade to the child warriors who compose a gang called the Werewolves, the last defenders of the Third Reich, the novel surveys a history in which "grim deposits of saga" drive the German people mad.

Of particular interest is Mann's treatment of the two Jewish characters, Dr. Chaim Breisacher and Saul Fitelberg. Encountered in postwar Munich, the doctor is a Jewish reactionary; his "dialectic readiness" provides the most insulting parody yet of the Frankfurt school. Whereas Disraeli managed to combine protofascism and philo-Semitism, Breisacher goes him one better by categorizing the Jews as the decadent descendants of Jahweh-worshipers; this is, at once, the most abstruse and the most absurd form of anti-Semitism. Predictably, Breisacher's paeans to atavistic origins are followed by calls for "social hygiene" and "a renunciation of all the softness of the bourgeois epoch" in

order to achieve a "deliberate barbarization." This is an awful representation of the modern intellectual, Jewish or not.

In 1923 Breisacher's opposite number turns up. He is Saul Fitelberg, an artists' representative, notably Semitic in appearance, with almond-shaped eyes and the fleshiness of an immobile voluptuary. He is gushy and volatile, to the point of caricature; but the caricature is deliberate, self-conscious, a game played to ingratiate himself. While Breisacher is a tribal shaman, Fitelberg is an internationalist, speaking several languages imperfectly. He makes a fine refugee witticism: Only Jews know how to be good Germans. After all, a French writer may call himself Anatole France, but the closest German pseudonym would be Deutsch, and "this is a Jewish name, ooh la la." Fitelberg begs to be Leverkühn's Jewish mediator between Germany and the world. He is uniquely equipped to serve both, since as a Jew he is both "international" and "pro-German." Indeed, even to the eyes of Leverkühn's peasant cook he is a "man of the world."

He wishes to promote the composer so that concert audiences everywhere can applaud Germany's greatest artist, but also, and not incidentally, so that its greatest artist will acquire the non-German traits of tolerance and good humor. Otherwise, he warns, the self-contained Germans will find themselves in "real Jewish trouble." And the novel ends with the image of an ostracized Germany shut off from other countries "like ghetto Jews." Once the "inward need of world-wideness," shared by Leverkühn and his homeland, might have been satisfied by the peripatetic Fitelberg; his wit might have leavened the Germans' lugubrious dispositions. Instead, the Jew was slated to be Germany's victim, since he couldn't be her agent or friend. In such passages, *Faustus* is more subtly and concretely political than its critics recognize. And Fitelberg can be seen as Mann's tribute to the Jewish refugee—as well as his salute to all the middle-class middlebrow Jews who at home and in exile composed his most loyal audience.

Fitelberg is also the extension in fiction of an idea that had tantalized Mann throughout his exile. In a 1934 diary note, Mann had anticipated that the most worthy Germans would

have to leave their homeland, sustained largely by the saving grace of Jewish irony: "Perhaps history has in fact intended for [the Germans] the role of the Jews, one which even Goethe thought befitted them, to be one day scattered throughout the world and to view their existence with an intellectually proud self-irony." Fitelberg's cosmopolitan advice comes, as it were, with Goethe's benediction.

While his fellow Germans blunder through the 1930s, Leverkühn lives out the decade as a senile invalid. In his final humiliation, he enters a second infancy and is nursed by his mother, who silently watches over her prodigal. The fate of his survivors is no happier. As the novel ends, Zeitblom remains, like all Germans, "a lonely man." He sees his country "clung round by demons, a hand over one eye, with the other staring into horrors." In this visual echo of medieval legend and classical sculpture, a nation consecrated to myth is reduced to a final grotesque image.

Since the reception of *Doctor Faustus* was so unfriendly, Mann vowed to give the American public some fun next: "I want the dummies too." *The Holy Sinner* (1951) is a tale of incest (not every American's idea of entertainment) set in the Middle Ages: the hero, Gregory, weds his mother, who is also his aunt, before settling down in sanctity as the Pope. There is an Irish monk, Clemens, who writes an international prose (shades of James Joyce!): "French, German, or Anglo-Saxon . . . all run together in my writing and become one—in other words, language." As a priest in his historical era might do, Clemens wittily links monotheism and an "absolute" language that transcends "idioms and national linguistic gods"—virtually the same formulation Mann had employed in the *Joseph* preface. Although the book works best in German—Mann was as much a votary of linguistic household gods as any other writer—the homemade German-English—words like "flimsig," "Kauert," "bosten," and "swaggern"—constitute pleasant addenda to the italicized English words that constantly appear in refugees' letters, like noisy intrusions from the Americans next door.

The Confessions of Felix Krull, Confidence Man (1955) was written, as Mann told Erika, to prove that he was more than "a

ponderous philosopher"; begun in America, this novel of the eighteenth century was three-fourths completed by the time he left the country in June 1952. Felix Krull ambles blithely about, the very model of Mann's artist as crook. Mann was both alarmed and titillated by the artist's disreputable aspect: witness his remark to Adorno that he rather liked being in the wrong place. Krull's criminal talents verge on the artistic and even the philosophical. The draft dodger who fakes epilepsy to avoid induction and proceeds to flirt shamelessly on whatever level his conquest prefers, low lust or high seriousness: Felix is the chameleon trickster whose genius it is to expose his peers as knaves and fools. Mann's composition of the novel was darkened by political events. In February 1951 he wrote despairingly to Erich Kahler, "Human wickedness deserves a visitation—and this civilization of grabbers, fools, and gangsters deserves to perish." The note was triggered by Kahler's article on the political misuse of atomic energy; Mann had already registered his horror at the American bombing of Hiroshima.

In his earlier work, science often appears as a Mann-made mythic force, a storehouse of hopes for the race's improvement. No more. Now its representatives are damaged by the general corruption; the humanists long for a nonhuman world. A brilliant scientist—the last of several such figures in Mann—is cuckolded by Krull. This good man, appropriately named Kuckuck, guides Krull through his laboratory and proffers a vision of universal destruction: "Being did not always exist and will not always exist." There is something beautiful in the prospect of a nonhuman world: "This interdependent whirling and circling, this convolution of gases into heavenly bodies, this burning, flaming, freezing, exploding, pulverizing, this plunging and speeding, bred out of nothingness and awakening nothingness . . ." This passage, like the prophecy of universal destruction in Horkheimer and Adorno's *Dialectic of Enlightenment*, may recall Birkin's vision at the end of *Women in Love*. Mourning a dead friend, Birkin dreams of increasing cycles of wonder, a natural world renewing itself long after the departure of mankind. Mann's articulation of the same theme is both more bitter and scientific, in keeping with his own interests and style,

but it is also a response to a new historical situation. A humanity that produced the atomic bomb deserves to be excluded from the natural miracles of biology and chemistry. In such ways, even the European confidence man's cynicism is a plangent echo of Mann's American experience.

The two greatest disappointments of Mann's last American years—the rejection of *Faustus* and the inception of the Cold War—were, to the old man, more than coincidental. Had Mann's perspective been the prevailing one after World War II, his masterpiece would have been received as something more than an exile's aberration. But the prospects of an internationalist posture in literature and in politics were both cut short. Mann thought this condition was permanent: the philistines were back in the White House and in the academy. So he quit America, thoroughly embittered. Even today some critics remark glibly that "Thomas Mann was never really in this country." (What American gesture did they expect from him—a guest shot on Ed Sullivan?) More likely, they hate to admit that "America's greatest writer" left, not without justification, in despair. Shortly before his departure, Mann admitted to A. M. Frey that even his isolation, compelled by American ill wishes, only confirmed his Germanness: "We poor Germans! We are fundamentally lonely, even when we are 'famous'! No one really likes us."

PART THREE
The Return of the Enemy Aliens

15

The Victims Start Judging

As the news from Germany grew more horrendous, one émigré remembers that "It became a good thing, the best thing, I tell you it was the *only* thing, to be an American." And when many refugees recited the oath of citizenship, it was with an almost ingenuous enthusiasm, reflected in Thomas Mann's assertion that these years constituted a morally good period.

But even then, with the enemy clear and the military procedure direct, émigrés could not retire their sense of political complexity. It was a morally good period if morality was limited to defeating the indefensible Hitler, but the moral atmosphere grew murkier if one considered the war profiteering or outlawing of strikes in America, as well as the crazy-quilt political alliance of groups that ranged from clerico-fascists and imperialists to Stalinists—three groups that émigrés had ample cause to distrust. There was another matter that continued to split the émigré community: the degree of German guilt. Perhaps this remained an internecine dilemma because émigrés knew that should it become public, it would immediately confirm the suspicions of all those, friendly or not, who believed that the refugees' hearts and minds were still in Berlin.

Because Thomas Mann was the most public émigré spokes-

man, his positions on German guilt were vehemently condemned by those who didn't want him as their representative. He was relentless in making his pronouncements, not terribly concerned with whether or not he was speaking for others. As early as 1941 Mann had begun announcing over the BBC that Hitler was murdering European Jews. Mann spoke out long before the reports of a Final Solution were generally accepted. His war broadcasts and lectures reiterated the message: the entire German nation was implicated in these horrors. He wrote an American friend that despite the "patriotic fashion" of "German left-wing socialists," he believed Germany's "fall and atonement cannot be deep enough."

Bertolt Brecht, one of those German socialists, disagreed. He contended that there were a huge number of dissenting socialists and anti-Fascists busily engaged in subversion and sabotage and that three hundred thousand underground fighters had already perished. His solution for dealing with the other Germans was not punishment but social revolution: "to deNazify the Germans, one will have to de-bourgeoisify them." Brecht considered Mann a "reptile," salivating over the prospect of a half million German corpses. Erik Erikson, writing in German, called Mann's pronouncements a "foul-tasting paper soup of German mediocrity," as pungently medieval an image as any envisioned by the devil in *Doctor Faustus.* (In English, Erikson had earlier expressed scorn for Mann's rabid nationalism during World War I, comparing it with the excesses of Nazi philosophers.) All the while, Mann was the soul of reason. He wrote Brecht that he, Mann, could not lead a movement of "Free Germans," since such a group might appear to absolve the Germans of their guilt. He anticipated worse horrors to come, rendering premature Brecht's confidence that a nation of committed anti-Fascists would hail their own defeat. When Brecht and Mann finally confronted each other at a Free Germany meeting in New York, the playwright stared at the novelist with a "mockingly bitter" scowl, convincing Mann that, come the revolution, Brecht would do him "all the harm possible."

Emigrés who, like Einstein, in 1945 supported the harsh recommendations of the Morgenthau Plan—which would have

converted Germany from an industrial to an agricultural econ-
omy—resembled Mann in their belief that they knew the Ger-
man capacity for mischief too well to expect any self-control
from the vanquished. Toward the war's end, Einstein wrote that
after defeat, "we must not let ourselves be deceived."

And yet, and yet. Mann himself couldn't disentangle the
"Nazis" from the "German people." In the thirties he had writ-
ten that Hitler, with his frantic hustling for approval, was his
brother, that everything horrible and German lived in him
too: "the sense of guilt, the anger at everything, the revolu-
tionary instinct, the unconscious storing up of compensatory
wishes . . ." By the end of the war, Mann felt compelled to cor-
rect the more sentimental refugees, who observed that there
were two Germanys and that one of them had remained immune
to evil. But he did so by presenting himself as his own witness to
the ubiquitous guilt: "I have it also in me. I have experienced it
in my own body."

Brecht was not all wrong; there had been some instances of
working-class resistance, especially during the thirties, and
many humane Germans had hidden Jews from the authorities.
Also, certain cities never accepted Hitler. The citizens of the
refugees' beloved Berlin had remained particularly unpersuaded
by Hitler's Bavarian rantings. Indeed, when Berlin Jews had to
be rounded up for deportation, the local police proved so indo-
lent that some zealous Viennese had to be imported. So the
questions of who were the truly guilty and how they were to
suffer remained. (Of course, Brecht knew that he had oversim-
plified matters. Why else, in his 1945 poem "Song of a German
Mother," does he have the German mother regard her son's
deeds and lament, "If I'd known then what I know now / I'd
have hanged myself from a tree." Or why else, in another poem,
"Germany 1945," does he invert the awful image into "The sow
has shat in my bed / The sow's my mum. I said: / O mother
mine, O mother mine / What have you done to me?")

About those questions, as about many others, Theodor
Adorno worried in private. In his California journal, later pub-
lished as *Minima Moralia*, he wrote that not for anything would
he countenance executions, yet he "would not want to stay the

hand" of the executioner. He admitted his position was "contra-
dictory" but "perhaps the fault lies in the question and not in
me." If the press could describe the extermination of millions of
Jews as a mere prelude to wartime catastrophe, then surely he
was allowed his own problems of moral definition. The cautious
Adorno was not unwise. But, as would become increasingly
clear, intramural debates could not be kept secret from the
émigrés' American hosts.

The disposition of Germany after the war was another issue,
one that was clearly tied in to the refugees' previous arguments
about German guilt. Yet their position toward Germany became
interlocked with their mixed feelings about an American gov-
ernment that was now superintending German policies, often in
collaboration with the same bureaucrats that had administered
Hitler's system. If you were an émigré who had dreamed of jus-
tice, the 1951 General Act of Clemency, implemented by the
U.S. High Commissioner for Germany, John J. McCloy, was a
sickening assault. "It appeared," one ex-Berliner recalls, "that
our former friends had ganged up with murderers."

For some émigrés, the obvious suffering of the German people
after the war and the prison sentences, no matter how brief, al-
lotted to tens of thousands of Nazis were atonement enough.
Such people hailed the Act of Clemency; they also tended to
applaud German rearmament and to accept the necessity of
using former Nazis to fight Communism. They found Ade-
nauer's extreme conservatism tolerable, arguing that only a con-
servative could reform the Germans; anyone more liberal would
have been impossible for ex-Nazis to accept (although right
across the border millions of Germans were adjusting to some-
thing far more radical). Others regarded the newly constituted
German Army as the first true civilian army in the country's
history, and thus potentially immune to the notorious Prussian
tendency toward militarism.

But some refugees could not forget the murder of six million
Jews. Albert Einstein received many invitations to return to
Germany—extended by impeccable anti-Fascists—but he was un-
moved. In 1948 he wrote the former Nobel Prize winner Professor
Otto Hahn that "The crime of the Germans is truly the most

abominable ever to be recorded in the history of the so-called civilized nations. The conduct of the German intellectuals—seen as a group—was no better than that of the mob." In America, Einstein had become a leading advocate of academic freedom, so his criticism of the German *trahison des clercs* had a special resonance. Three years later, he wrote President Theodor Heuss of the Federal Republic that as "a self-respecting Jew" he could "not possibly wish to be associated in any way with any official German institution." Einstein realized that Germany had to resume normal diplomatic relations, but he vehemently opposed German rearmament: one of his last public messages was a final reminder of the devastating effects of German militarism.

Other, usually left-wing émigrés shared Einstein's distrust of the Federal Republic and, like him, refused to go back. When Salka Viertel's husband, Berthold, invited her back to share in the pleasures of a renascent Berlin culture, she said no: the knowledge that non-Nazis had acquiesced in the disappearances—and, inevitably, the exterminations—"made it impossible for me to return." In the late forties the eminent Wagnerian Thomas Mann declined the offer of a directorial position at Bayreuth. He saw this ostensibly disinterested homage to art as an attempt to "restore" a thoroughly factitious "purity."

There were other responses that were as true to the political history and psychology involved as Mann's ambivalence, Brecht's confidence, and Einstein's rejection. Bruno Bettelheim, for example, advised against the International Military Tribunal for the prosecution of war crimes, since "to try men following orders could only destroy the legitimate role of government, even if that role is abused." This idea is in keeping with Bettelheim's respect for authority, his cynical remark that a half-good government is better than none.

Typically, Hannah Arendt offered an original approach to the question of German guilt, in which she considered all the participants, not excluding the refugees themselves. (She hadn't always been so objective: Henry Pachter remembers her announcing during the late forties, "Of course, returning to Germany is impossible. Why, I'd be sitting on the subway right

next to a murderer.") Arendt's 1945 essay "Organized Guilt and Universal Responsibility" puts a plague on all houses. She harks back to the cultural Zionist Lazarre, who had observed that considering the racist behavior of the English, French, Russians, and Germans toward their subject peoples, no nation was in a position to cast the first stone. Arendt attributes the failure of the German people to oppose Hitler to their singular ignorance of the "classic virtues of civic behavior"; lacking a sense of community, they could not comprehend the idea of totalitarian society. Arendt adheres to internationalist perspective: when asked if she feels shame as a German, Arendt replies, "I am ashamed of being human." Among Hitler's crimes was that he imposed guilt on an entire nation, implicating each citizen; for us to respond by killing off eighty million Germans would be to follow his lead rather than to repudiate it. Arendt exudes scorn for the glittering socialites who were as much war criminals as any goose-stepping Junker, but she is especially illuminating about the hypocrisy of refugees: "Only a few Jewish or Socialist refugees" have shown themselves "prepared to bear the odium of unpopularity involved in telling the truth."

Let us be plain, Arendt insists. We all know that we were saved not by good works but by "good fortune." Yet we indulge in "that insufferable tone of self-righteousness, which frequently and particularly among Jews can turn into the vulgar obverse of Nazi doctrines." Arendt alone has the courage—or the nerve—to criticize her fellow refugees for letting their "insufferable" smugness interfere with the development of good judgment. Then, as always, Arendt's sympathy with the displaced persons wandering through Europe is paramount. But this sympathy doesn't inhibit her severe indictment of almost everyone else.

And all the time, while Brecht, Mann, Arendt, and Erikson attempted to define German guilt, there remained other refugees whose views were closer to those of the former Berlin rabbi who remarked, "None of them saw that this was not necessarily their question to settle." But, in truth, what other group outside of Europe had a greater claim on the matter?

While a few followed Einstein's lead and refused to return to Germany and some rejoined German-speaking society in round-about fashion by settling in Switzerland, yet other émigrés were among the first to arrive in the occupied country. Most of these were involved with American propaganda forces. The opinions they expressed were usually several leagues to the right of a Brecht or even an Einstein. During the first six months of the American occupation, the Psychological Warfare Division of the U.S. Army, later renamed Information Control, employed émigré journalists to write for ten short-lived German-language newspapers. Hans Habe, a veteran anti-Communist, was placed in charge of the publications; his assistant was Stefan Heym, a young novelist with a different political perspective who would eventually move to East Germany and a career that would be frequently disturbed by government interference.

With their conflicting allegiances, Heym and Habe composed the odd couple of German reconstruction. But once again the onslaught of events made a blur of political labels. One episode reflected the general confusion. Klaus Mann, as a correspondent for the U.S. Army newspaper, *Stars and Stripes*, interviewed the English-born Winifred Wagner, a devout Nazi as well as the director during the war years of the Wagner Bayreuth Festival. Mann delighted in the irony that "there is only one self-confessed Nazi in Germany, and she is an Englishwoman": a verbal echo of the thirties tribute to the Communist Dimitroff, "There is only one man left in Germany, and he is a Bulgarian." The interview was an occasion for other ironies. Winifred Wagner later recalled that Mann addressed her in English but that his accent and grammar were so grotesque that she replied in German, the native speaker deliberately tripping up poor Mann as if to draw attention to his émigré pretensions.

No position was fully explained by a political label. Alfred Andersch, an opponent of Hitler, had been reluctantly drafted into the German Army and served time as a prisoner of war in America. He too worked as a journalist for the American mili-

tary government in addition to cofounding a German literary journal, but his magazine was later banned by the American forces during the McCarthy period. Willi Schlamm, a former Trotskyist who became the shrillest of the Time-Life Cold Warriors, returned to Germany to edit *Zeitbühne*, an extreme right-wing journal in which he consciously emulated the cultural criticism of Karl Kraus's *Die Fackel*. Schlamm's journal never acquired an audience, but how surprising it was that Kraus's work, the model for émigrés from Adorno to Billy Wilder, should eventuate in this obscure publication (although Schlamm believed he was simply claiming Kraus's legacy as a cultural conservative).

Some émigrés applauded the Americanizing of Germany. Hans Speier, a polymath social scientist and literary historian who had acted during the war as an adviser to the overseas branch of the Office of War Information, returned to Germany on behalf of the Department of State and "witnessed the transition of U.S. postwar policy from its early punitive stance— disarming, de-Nazifying, deindustrializing Germany—to its achievement phase involving Germany's imposed democratization and rearmament and her reindustrialization with Marshall Plan Aid." As someone who believed that Europe should be the fulcrum of American anti-Soviet foreign policy, Speier welcomed many of the developments that distressed refugees like Einstein. (Not all opposition to the the Communists was from the Right. Several members of Karl Frank's New Beginnings returned to Germany, and, according to Henry Pachter, prevented a "Russian takeover" by opposing the merger of the Social Democrats with the Berlin Communists. Similarly, Pachter believed that Herbert Marcuse and Franz Neumann at the OSS promoted the activities of independent socialist groups in the American Zone.)

Max Horkheimer and Theodor Adorno returned in the late forties and became the new leaders of German higher education, exerting much more influence than they could have in the prewar academy, with its tradition of anti-Semitism and its opposition to their eclectic methods. By the sixties they had become the leaders of the Establishment, considered by some rebellious

students the very symbols of academic elitism. Horkheimer himself wrote Leo Lowenthal that "We stand for the good things: for individual independence, the idea of the Enlightenment, science freed from blinders," sounding more like a missionary for American positivism than a nay-sayer.

Other émigrés were less happy when they returned to Germany, East or West. Among those who went to the German Democratic Republic, Alfred Kantorowicz—once assimilated enough to have worked for CBS—left in 1957, while Ernst Bloch, the philosopher of hope, lost his in 1961 and fled back to the West. Brecht's return to Germany was accompanied by trepidations: in 1947 he wrote in his journal that the prospects of a Russian-style revolution in his homeland left him "shuddering." Although the East German government granted him his own theater in Berlin, the censors would not leave him in peace. Fritz Lang recalls that "plays [Brecht] had either written, adapted or directed, were taken off after the first, second, or third performance." In private, Brecht agonized over the workers' rebellion of 1953, but lacked the courage to come up with anything more contentious than a bit of Berlin whimsy, in which he noted that the secretary of the Writers' Union had accused the people of forfeiting their government's confidence: "Would it not be easier / In that case for the government / To dissolve the people / And elect another?" The subtext here appeared to be yet another *trahison des clercs*, rather than the collapse of government authority.

Alfred Döblin's despair over a new generation of Germans was echoed in the observation of the physicist Max Born that "the unteachables are in the ascendancy again." Thomas Mann, on a brief visit to the Federal Republic in the late forties, detected re-Nazification everywhere and found it most clearly demonstrated by "the shamelessness of the press"—specifically, in its attacks on the Mann family.

By that time, Mann had already become the butt of vicious assaults by German writers, who questioned his abandonment of the fatherland in its hour of greatest need and identified themselves with the heroes of the "inner emigration." In the blunt, medieval manner of *Doctor Faustus*, Mann dismissed

their self-serving arguments as so much "devil's shit." The most devastating attack appeared in 1947, when a German writer claimed to have seen a note written by Mann during the mid-thirties to the Nazis, in which he begged obsequiously to return. This rumor would not be stilled, although when the letter finally turned up, it bore out Mann's assertion that his contempt for Fascism was "innate, necessary" and had been clearly communicated. German rage at Mann extended to his children. In the late forties a Munich newspaper accused Klaus and Erika of being Stalinist agents. In the postwar atmosphere, the charge found a receptive American audience. To Mann's dismay, he saw in the hysterical anti-Communism of the period a link between Americans and former Nazis. The newspapers in both countries provided, for the old man, more evidence that his brother Heinrich's 1933 insight that the abuse of language foreshadowed the emergence of Fascism had been correct.

There was no denying that the Adenauer regime had inherited the entire civil service apparatus of the Nazis. The most famous culprits may have been apprehended, but the same authoritarian teachers and bureaucrats remained, ready to corrupt a new generation. Hans Globke, who had written a legal commentary on the Nuremberg race laws, assumed a high position in Adenauer's 1959–60 government, along with another prominent ex-Nazi, Heinrich Luebke. Postwar German justice was equipped to deal with conventional crimes—a concentration camp guard might be punished, for example—but the unfamiliar crimes—such as the ordering of mass murders—fell outside the legal vocabulary. Perhaps no punishment could fit such crimes, but the German authorities meted out such skimpy sentences to the real criminals that one might wonder what ratio was being applied: so many months in jail for so many thousands of victims? By the early fifties, Herbert Strauss observed, a returning émigré could walk down the streets and bump into his father's murderer. Many émigrés who remigrated to Europe found life in Germany impossible. Hermann Kesten was able to fill a book with their testimonies: *I Don't Live in the Bundesrepublik.*

So, despite the experiences of Speier, Adorno, and Hork-

heimer, the situation facing returning émigrés was seldom a happy one. In a classic summation, Ludwig Marcuse wrote that "the rupture between the Fatherland and the émigrés from Hitler will heal only in the day that last refugee who not only escaped but fought back is dead." Each year, that day comes closer.

The spectacle of Germany in ruins was still a spectacle. It is therefore not surprising that the impressions of émigré filmmakers briefly returned to their homeland were especially intense. Since these men were also the products of a European cultural education, they knew how to make sense of what they saw. Such directors came as visitors, retrained by Hollywood, and went back to America more deeply informed about the political nature of all imagery; no doubt, their new European knowledge affected their American films, however indirectly.

First to arrive, in May 1945, was Billy Wilder, who, in the employ of the Psychological Warfare Division, was to assist in the reconstruction of the German film industry. The trip was not a happy one: Wilder learned that both his mother and grandmother had died at Auschwitz. But he conducted his work as a professional, and noted, with a film director's eye, that "the amazing thing is the German neatness, how the rubble had been built up on both sides of the hastily repaired streets, like snow . . . coming up more than fifteen or twenty feet . . . so that the traffic moves." Three years later, Wilder's *A Foreign Affair* conveyed some of the moral and physical ruin he perceived on that trip.

Douglas Sirk returned in the late forties and left soon after, deeply distressed. He discovered "no profound break" with the past, a total failure to confront recent history. Criticism was reserved for those who had left the fatherland. He felt the movie industry had been destroyed, first by the Nazis, then by the American occupying forces (a slap, perhaps, at Wilder?). He found German life and thought sapless, without spirit. But his old friend and fellow émigré Carl Zuckmayer was more optimistic. Hadn't *The Devil's General*, his play about a late-

blooming anti-Nazi, become the greatest hit of postwar German theater? Weren't ecstatic audiences carrying the leading man triumphantly through the streets? Sirk, the master of all the elements—lighting, costume, and sets—that compose an image, interpreted the enthusiasm otherwise. "I think the play was such a huge success because it allowed the Germans to see a Nazi (because this general was wearing a Nazi uniform), and to be able to express their feelings towards Nazism, which were sympathetic, in a context where they did not have to be explicit." The naïve Zuckmayer believed his anti-Nazi drama was applauded as such, but Sirk, who would later make supremely sophisticated movies from the most banal of scripts, knew that visual impressions made all the difference.*

Otto Preminger returned to Vienna to discover that some old colleagues were stars once again, after having surpassed the Nazis themselves in the fervor of their anti-Semitism. What did he feel? "Hatred? No. Contempt? Perhaps." Preminger, like other émigrés returning to Germany to visit or to live, found no Nazi leanings in Berlin and northern Germany. But Vienna, Austria, and southern Germany were another matter. Preminger believes that former Nazis thwarted his efforts to film *The Cardinal*. When a minister of education announced that Austrians should not be reminded of the Nazis' invasion, Preminger wondered why the man had not done something about the actual event in 1938.

Fritz Lang's episode in postwar Germany was the saddest of all. The man to whom Goebbels had offered control of the entire German film industry returned to hack assignments. Sirk believes that "Lang . . . had apparently to go right back to the past. When he returned he was unable to find any new elements in postwar Germany. . . ." Upon Lang's arrival in 1956, he was confronted—"the first thing—bang! when I re-entered Germany"—with newspaper headlines announcing the death of

* In recent years, Sirk has spent much time in Germany working with young film students. He was acknowledged as having been the mentor of the late Rainer Werner Fassbinder. Accordingly, says Sirk, "my problems with Germany have lessened considerably."

Brecht. The playwright had broken off relations with the director years earlier in Hollywood, disgusted by what he took to be Lang's pandering to the movie studio bosses. The memory of that rupture must have made the news of Brecht's death particularly painful for Lang. Brecht had fled the country in 1947 after his appearance before a congressional committee. Lang had spent the year of 1952 jobless, blacklisted for his associations with people like Brecht. Neither America nor Germany had proved a happy place for the two men.

Lang found himself unusually irritable, perhaps in remembrance of the devious routes that had intertwined his fate with Brecht's. So when an airport cop bullied him, "I couldn't help it—I started a hell of a fight. I said, 'Are we back in Nazi times?' . . . You know I made a hell of a stink. The people apologized afterwards, this man was taken off duty, but these were my impressions the first time I went back to Germany." First impressions: the death of a writer blacklisted in Hollywood and the revival of Nazi behavior.

No wonder the German audience wouldn't allow "a refugee to give any kind of an interpretation of what life was like in Germany during the war." In all of these men, there was embedded an anger that could be set ablaze by the merest shift of tone or image. Theirs was the hypersensitivity of a film director who is also a refugee, a formidable capacity for separating the spiritual reality of an underdeveloped German consciousness from the materialistic image of an economic miracle.

A more complete consideration of German reconstruction was attempted by Hannah Arendt in 1950. After visiting Germany to press the claims to property of refugee Jews, she wrote an article, "The Aftermath of Nazi Rule," which was printed in *Commentary*. Like Sirk, Arendt observed a willful and general refusal to consider the enormity of Nazi crimes. Every German had a sad story to tell: "true enough, of course, but beside the point," she said in her patented manner of dismissing irrelevancies, even if, as in this instance, they may comprehend the most massive events. The essay includes the dominant themes and metaphors of Arendt's fifties prose. She regrets the loss of respect for landmark buildings—which, incidentally, is not the

case in East Berlin, where more such buildings remained unde-stroyed—the visual talismans of history. Similarly, she misses the traditionally excellent German workmanship. The values of craft have been replaced by "feverish busyness"; to employ Arendt's own categories, work has regressed to the order of labor, as she defines it, a mindless, almost biological impulse. She condemns the German press for its *Schadenfreude*, a glee in universal suffering that perforce undercut the Germans' miser-able state at the time, without examining the reasons for it. Worse yet is the failure of the press to distinguish between fact and opinion: in a misapprehension of democracy, feelings are assigned equal value with facts, at the expense of both historical and psychological truth. Upset by all the frantic words and deeds, Arendt explodes, "But this is not real—real are the ruins, real are the past horrors, real are the dead which you have for-gotten."

Only among the Berliners is Arendt at home. They retain their humor and frankness, and even more, they apparently share her politics: they hate Stalin but are not anti-Russian, de-spite the excesses of Soviet troops or the memory of the recent Berlin blockade. The rest of Germany seems buried beneath a sea of forgetfulness. The moral confusion is only heightened by the Allied posters of Buchenwald, with their pointed fingers seeking out the passerby and informing him, "You are guilty." Arendt shares the Germans' bafflement—how could they be guilty of what they didn't know?—but she overestimates the ig-norance of the German population.

De-Nazification is a compromised policy for which Arendt can find no alternative. Contrary to the hopes of writers like Brecht and Erikson, the German people have not risen up in an "outbreak of . . . spontaneous wrath." No protection is needed for the former Nazi leaders: anti-Nazis have a harder time re-entering German society. Arendt's view is generally pessimistic. There is a lack of initiative, of the drive to institute something new. The German unions have never been weaker. German de-mocracy lacks pride and spunk. Germany is "not likely to play a great role in Europe." This is hardly the political scientist at her most prophetic!

The same issue of *Commentary* contains an article by another émigré, Karl August Wittfogel, titled "How to Checkmate Stalin in Asia." And Arendt's article too is suffused with Cold War attitudes that compromise her intellectual rigor. To explain why so many of the best people chose to remain in the Eastern Zone, she devised an elaborate existential structure of grace under pressure and the happiness of shared miseries; she does not explore political allegiance. She contrasts the low status of German labor with the American system of free enterprise in which labor and management counterbalance each other, an image of equal trade-offs that seems a period myth today and actually more relevant to subsequent German history.

In the same way that the Cold War colored Arendt's arguments, other questions of international morality complicated the refugees' responses to postwar German reconstruction. Only a few émigré radicals had pointed out in 1945 that among the occupying forces were the two leading colonial empires, England and France; that the Vichy government's record made a travesty of France's role as victor, both militarily and morally; that by the end of the year, French troops had killed ten thousand Algerians. Or that Great Britain's treatment of refugees had been contradictory at best (recent scholarship has disclosed the British Foreign Office's hostility toward Jewish emigrants). Or that resistance groups in many countries had been crushed after the reactionary, prewar governments returned to office. Or that the United States, after Hiroshima, may have forfeited its tone of moral superiority.

By the late forties and early fifties many other émigrés became alarmed as the Cold Warriors began recruiting former Nazis to fight Communism. Alfried Krupp, fresh from jail for his exploitation of concentration camp inmates, appeared in *Life*, framed in a photograph by his baronial estate, offering avuncular advice on the Marxist menace.* Among the many Americans who criticized the 1951 General Act of Clemency was Eleanor Roosevelt, who descried an attempt to strengthen militarist

* A similar reinstatement of the capitalist leadership was occurring in Japan.

forces, in order to once again fight Communists with Nazis. (As Benjamin Ferencz's recent study, *Less Than Slaves*, shows, the directors of major German industries like IG Farben were loath to acknowledge their mistreatment of camp inmates and tended to pay meager compensation only when forced.) Meanwhile released war criminals zoomed back to the top: for example, Fritz ter Meer, the only executive convicted of mass murder, slavery, plunder, and spoliation, was elected chairman of Bayer in 1956.

If, by November 1949, Thomas Mann could write a friend that Washington was "swarming with sinister Germanophiles," the 1951 clemency decision made by U.S. High Commissioner John J. McCloy (who was to resurface in 1979 as an advocate of the Shah of Iran, together with Henry Kissinger and David Rockefeller) appeared, to some émigrés, to be definitive proof of collusion between this country and former Nazis. Increasingly, any criticism of German rearmament became an implicit indictment of this country, as the Federal Republic became the cynosure of Western interests.

Perhaps the final bewilderment attended a product of the economic miracle. This was the issue of restitution: the Adenauer government decided to grant to Jewish victims of Nazism either a single large sum for prior holdings or a monthly stipend that indemnified the government against lawsuits over loss of health or of professional earnings. This policy maintained the old class divisions: the poorer émigrés benefited only slightly, since their losses, including friends and relatives, could not be measured in financial terms. Adenauer's largesse alleviated the old age worries of many émigrés—it enabled them to retire gracefully in New York, California, Miami, St. Moritz, Jerusalem, a few even in Germany. Restitution also bound together Israel and the Federal Republic; this was one of several devastating observations that critics of Israeli *realpolitik* would subsequently make. But it also separated the Jews from the political refugees, who found it much harder to plead their cases or justify their flight. Restitution meant that almost every surviving refugee of a certain class—particularly artists and intellectuals—could spend the latter part of his life in almost as agreeable a manner as if there

had been no Hitler and no decades of emigration. It was either a gift that served to whitewash history, or a humble gesture that compelled gratitude, or an arrogant bureaucratic bid for mercy. On every surviving refugee who receives a monthly check—whether he returns to Germany or not—that country continues to inflict, to paraphrase Arendt, an imposed ambivalence.

Many years later, in 1961, Billy Wilder's film *One, Two, Three!* was to offer a cynical and hilarious summing up of the postwar alliance of West Germany and the United States. Never before had Wilder's mastery of American popular culture been so clearly paired with his sense of that culture's antecedents in Berlin. Here, the confusion of idioms, inherent in Wilder's work, provides the source of a unique émigré reading of the economic miracle and German guilt. The film opens up on an East Berlin rife with Marxist propaganda—NIKITA ÜBER ALLES—juxtaposed at once with a Western sector, where all the advertisements are commercial: progress is defined by TRINK COCA-COLA signs. The film recounts the marriage of a devout East German Marxist (Horst Buchholz) to the daughter of an American capitalist, as engineered by an executive (James Cagney) of her father's company. Wilder caricatures both sides, the humorless East (Cagney to Buchholz as his trousers slip: "Pull your pants up, Spartacus") and the amoral West (Buchholz to Cagney: "Coca-Cola colonialist!"). In a cultural stand-off, the two hurl at each other the equivalent horrors of "Khrushchev" and "Frank Sinatra" after the Communists have tortured Buchholz with hours of nonstop American pop music.

Wilder exposes the amorality of both Russian apparatchniks and German accountants—a supposedly incorruptible West Berlin journalist is revealed to be a former S.S. officer. And the German malaise is catching: Cagney's wife keeps calling him *"mein Führer."* The movie includes many sequences that would probably appeal most to those who had once patronized the cafés of Wilder's youth, such as the scene that introduces a former count who now cleans the men's room at the rebuilt Kempinski's. The most unsettling moment for émigrés may be

the frantic car chase through bombed-out East Berlin; the physical evidence of their history has become the material of slapstick. And perhaps the most sublime cinematic expression of émigré humor—its irony, irreverence, and range of cultural associations—occurs when Cagney follows the Russians to their East Berlin hang-out, the Grand Hot l (the neon "e" on the marquee fails to light up) Potemkin. Here, surrounded by walls draped with tattered rugs, the commissars sway to "some rock 'n' roll," performed by a band of ancient musicians in formal outfits who bounce syncopatedly through a rendition, in German, of "Yes, We Have No Bananas."

One, Two, Three! is one of the fastest-paced American film comedies. It is also an émigré's pronouncement on postwar politics and a final legacy of café Berlin, proof of its wily rapprochement with commerce and kitsch.

The question of what to do about a defeated Germany seemed almost trivial when compared with the problems faced by displaced persons, the former inmates of mass extermination camps. The refugee needed superhuman reserves of strength and compassion to be able to spare some sympathy for the perpetrators, unwitting or not, while their victims remained homeless and unprotected. All Jewish or political refugees knew that they could have been among that number. The displaced person might well be their relative, or a witness to their relative's murder. Of course, there was a brief outburst of universal horror once the camps were opened and their carnage exposed. But the world had other matters to attend to. As in the thirties, the fate of wandering Jews became the preoccupation of overtaxed administrators and beleaguered émigrés. Emigrés who recalled the lack of sympathy for refugees exhibited by such influential figures as Rabbi Stephen Wise, Bernard Baruch, and Walter Lippmann were not inclined to trust American Jews. This memory, together with numerous disagreements with right-wing American Zionists, trisected the émigré view of resettlement into something involving their relatives, themselves, and a dubious American ally.

In the postwar period, there was a consensus that Palestine was the appropriate home for Jewish DPs. This belief was even held by those Western intellectuals, often of radical bent, who had objected to the nationalistic tendencies of right-wing Zionism. There simply appeared to be no other solution. The world had abandoned the camp victims, either passively, for example, by not bombing the routes to Auschwitz or by declining to barter Jewish lives for the tanks demanded in exchange by the Nazis, or actively, as when Great Britain refused to admit Russian and Hungarian Jews into Palestine, although negotiations might have saved thousands of lives. There had been no Allied pressure on the Nazi satellite countries to save their Jewish citizens, and the Vatican had not threatened Catholic Fascists with excommunication. Despite the pleas of émigré organizations (American Jewish groups were much more circumspect), bureaucrats in America and Great Britain during the war years had tended to regard the refugees' fears as hysterical and hyperbolic while further implying that, even if it was a reality, the slaughter of Jews was of minimal importance.

After the war, even with emergency visas, Jewish DPs had the familiar hard time with U.S. bureaucrats, and eventually only 137,450 came here. In a sense, the Jews still existed only through the sufferance of others. As Einstein observed, they could be the subjects of caricatures and generalizations, "treated as though they were a nation," but that was all, for they had no national platform or credentials. Hannah Arendt, covering the 1945 United Nations sessions for *Aufbau*, was infuriated that Jews were denied representation. Hitler had attempted to remove them from the world, and now their lack of a political base seemed to confirm their worldlessness.

In 1945 Einstein demanded that Palestine be opened to Jewish immigrants. That same year, Arendt, while actively opposing much of the American Zionist movement, insisted that emigration to Palestine was "the only irreducible minimum in Jewish politics." As always, Jewish politics involved exchanges with the Gentiles. Einstein's 1949 statement that the British mandate had disguised a policy of divide and conquer, setting off Jews against Arabs, is a reminder that Zionism was once an anti-colonial, if

not anti-Western, ideology. Invoking that tradition, Arendt would argue that the domination of Zionism by American Jewry destroyed Zionism's original intent and effectively turned Israel's allegiances away from its Third World neighbors. She had been devastated by the 1942 Biltmore Hotel conference in New York when David Ben-Gurion's Palestine-centered Zionism had prevailed over the protests of those who either didn't want a further ghettoizing of the Jews or regarded militant defense of European Jewry as a more urgent task than the settling of Palestine. For them, Zionist revisionists were turning something practical—a safe harbor for Jewish refugees—into something mystical and philistine—a cultural and religious homeland. (The pragmatists were also the ones who joked about Palestinian settlers, "Did they come out of conviction or out of Germany?") Like the rearming of postwar Germany, the future political alignment of the Jewish state evoked bitter, if silent, disagreements between refugees and Americans.

Einstein and Arendt make an interesting team here—he as the most famous of Jews and supporters of emigration to Palestine and she as the most eloquent reporter of shifts in Jewish politics. They shared an ideological mentor in the German Zionist Kurt Blumenfeld. They also shared a mordant wit on the subject of world Jewry.

In the thirties Einstein spoke as a refugee who did not welcome the extension of European forms of nationalism. He honored the Jewish traditions of social justice and tolerance, and feared that a political Zionism, as opposed to the cultural brand proposed by Ahad Ha'am or Judah Magnes, would rob Judaism of its moral advantage. In a charming note, he saluted the Jewish "weekly day of rest" as "a profound blessing to all mankind" and as evidence of a tradition that appeared more socialist humanist than theological. But by 1945 Einstein had assumed the tone of a Zionist activist, perhaps because at that moment there seemed to be no other way of defending the interests of displaced persons. The British foreign minister had just advised Jews to remain in Europe, where their "genius" was still required, but he also warned them not to act pushy, "not to try to get at the head of the queue lest they . . . incur new hatred. . . ."

As Einstein detected, even while attempting to restrain emigra-
tion with compliments, the Englishman couldn't tamp down
his anti-Semitism. "It is sheer irony," Einstein said, that the
Jews should be at once encouraged and discouraged: "Well,
I am afraid they cannot help it; with their six million dead
they have been pushed at the head of the queue, of the queue of
Nazi victims, much against their will." With an émigré's dis-
dain for jargon, Einstein demolished both the idiom and the
subtext.

For some émigrés, the new forms of Zionist nationalism had
distressing Teutonic echoes. They frequently saw Bismarck
being used as the model—the wrong one—for postwar politics.
In 1947 Einstein observed in the American military mentality's
gains at the expense of "the human being, his desires and
thoughts" a revival of certain aspects of the era of Kaiser Wil-
helm II—yet more evidence of an unfortunate similarity be
tween the German and American temperaments. In her attacks
on right-wing Zionism, Hannah Arendt noted an "uncritical ac-
ceptance of German-inspired nationalism, explaining peoples,
not in terms of political organizations, but in terms of biological
and superhuman personalities." Arendt's comparisons of Ger-
man and Zionist racial policies may be questionable, but there is
no denying that members of the Stern Gang, like Yitzhak Shamir,
had in 1940 sought an alliance with Hitler, while advocating a
national and totalitarian Jewish state, or that in attempts at
rescue other Jewish leaders in the forties would barter lives for
trucks. Arendt acknowledged that "in fairness, [we must] con-
sider the Jews had no territory." But she foresaw the compro-
mised politics of the stateless Jewish people degenerating into
policies that mirrored those of the imperialist nations. She
wasn't the only refugee to fear the debasement of Zionist ideal-
ism. In the late 1920s Hans Kohn and his wife quit Palestine
after they detected the growth of anti-Arab racism. In 1950 an-
other émigré couple in Israel decided to return to Europe after
their daughter arrived home from school complaining about
"those filthy Arabs."

Arendt had admired the socialist Zionists of the thirties, but
found them "too pure for politics." Because Arabs were their

economic foes, they failed to woo them as potential allies. Yet Arendt loved the implicit political nature of Palestine. This grungy, dilapidated land offered no economic lure. It was thus the realization of her dream of politics emancipated from economic necessity, a place of pure human fabrication, a totally "artificial experiment." In *Paradise Lost*, Milton writes of the golden apples of Eden that they are true only there; all later myths are lies. Palestine was Arendt's golden apple, real as a model only in that Eden.

What Arendt considered the proper political development of Zionism was elucidated in 1943, when Judah Magnes, director of Hebrew University, proposed a regional federation. Magnes's disciples, who included such émigrés as Arendt, Hans Kohn, and Erich Fromm, were in basic agreement with Count Bernadotte's plan for a confederation of Arabs and Jews. Magnes's plan failed, Arendt noted acidly, because it had "no economic necessity" and would have meant a loss of charitable support—by which was really meant, simply, the loss of American money. Once again setting herself up for caricature as a Jewish anti-Semite, Arendt declared war on the doyens of American Jewish charity. Charity constituted a "curious sort of body politic," dictating terms in a limbo of bureaucratized needs. Arendt loved America for its openness to ethnic diversity, but American Zionists, she said, had linked up with the Palestine maximalists, who demanded Jewish domination of Arab lands; likewise, the early Zionist vision of socialist brotherhood was bound to mean little to the plutocrats who subsidized the American Jewish groups. Charity required emergencies, and so the American organizations would always see militarist actions as occasions for further fund-raising, an activity that Arendt and other émigrés, including Hans Morgenthau, condemned as "schnorring." Arendt was not alone in believing that Americans were in league with right-wing Zionists working to destroy the prospects of Jewish-Arab reconciliation. One refugee woman, who had lived briefly in Palestine between residence in Berlin and then New York, says, "I was part of Youth Aliyah, I was there at the early kibbutzim. And this is not what we wanted. I cannot tell you how angry I am. For years, I've said those damn Americans with

their charitable organizations destroyed Israel. Since 1948, I always say, Israel has been an American colony."

There may, of course, be a cultural animus here: rage at the Americanization of a European cultural vision. More likely, it is simply a restating of the classic revolutionary disappointment that when the revolution comes, it's for the wrong reasons in the wrong place with the wrong actors. Yet it suggests how widespread the émigrés' alarm at the turn of Zionist history was. In 1948 Arendt lamented that everyone in New York "from the Bronx to Park Avenue down to Greenwich Village and over to Brooklyn" supported the right-wing Irgun Zvei Leumi and its terrorist splinter group, the Stern gang. In the same year, Menachem Begin, a former member of both groups, arrived in America as a representative of the "Freedom Party." Arendt and Einstein were among the signers of a public letter—printed in *The New York Times*—that revealed the left-wing Zionist opposition to Begin. (Along the same lines, in 1946 Rabbi Joachim Prinz, formerly of Berlin, now of New Jersey, had arranged for the publication of ninety-two pictures of British soldiers who had been killed during Begin's attack on a Jerusalem hotel.) The letter expressed regrets about Begin's connections with the "conservative Zionist elements" in the United States, and enumerated affinities between Begin's party and the methods and policies of Nazism, including similarities regarding antilabor policies, strike-breaking, "religious mysticism," and "racial superiority." The letter was primarily an attack on Begin, but its final references to his allies among "the top leadership of American Zionism" and not just the conservative branches imply that the American Jewish establishment had replaced the right-wing forces that had troubled émigrés throughout their exile.

Though most Jews felt that the immediate needs of displaced persons were more urgent than any "good liberal" concern with the Arab enemy, for some there was an abiding sadness and truth in Judah Magnes's observation that Zionism had produced a brand-new group of displaced persons. Einstein remained firm in his support of Israel, but he turned down an offer to become its first president. He quelled his evident doubts about Israeli

politics, so great was his concern for the rescue of his fellow Jews. Yet many American Jews viewed him with distrust. He had to resign from his advisory position at the newly formed Brandeis University—whose namesake had once looked forward to a total identification of Zionist and American interests. Einstein's perspective was both political and economic. In the mid-thirties he had described anti-Semitism as the tool of those who control the means of production, and in 1945 he attacked the American Council for Judaism for its "pitiable attempt to obtain favor and toleration from our enemies by betraying Jewish ideals and by mimicking those who claim to stand for 100 percent Americanism." Like the complaints of Arendt and the former Youth Aliyah member, his attack exhibited a refugee's anger at seeing Jewish values distorted by right-wing American politics. It acquired an added potency when he compared the American Council for Judaism with the Zentralverein Deutscher Staatsbürger Jüdischen Glaubens—the Central Organization of German Citizens of the Jewish faith.

The real issue for many émigré Jews, no matter how devoted they were to the welfare of displaced persons, was the change in character that nationalistic politics was bound to impose. Many of the assimilated, people who understood nothing about the uses of yarmulkes and matzoh, still prided themselves on having a certain Jewish legacy. This is the posture of the "non-Jewish Jew," Isaac Deutscher's term (from his essay of the same title) for all those who subscribe to "speaking and acting on behalf of universal human emancipation." Too often, as Arendt noted, this has meant sympathy for every group but one's own. Yet, as the Jewish identity changed from that of the international to the national freedom-fighter, there seemed a constriction that was moral as well as geographic. Max Horkheimer had regarded the Jews as perpetual, peripatetic reminders of the "negative principle." In the 1970s he lamented that the Jews, as Israeli nationalists, had become "positive themselves." Henry Pachter often said that the role of a "rootless, cosmopolitan Jew" suited him better than that of a land-locked xenophobe.

Freud's famous assertion that Jewish identity was discovered not in religious ritual or folkloric custom but in sustained critical

resistence dovetailed with the attitude of many émigrés. They had no desire to return to the faith of their grandfathers, but they would rather have died than leave the community of intellectuals ranging from Heine to Marx to Freud and Luxemburg and Einstein, especially after their own families had perished for simply being Jewish. And, not surprisingly, the more assimilated, having donned the uniform of American patriotism, had little problem with Zionism.

But for those émigrés who had kept faith in a larger international vision, whether socialist or humanist, the postwar transformation of the Wandering Jew into the rooted Israeli was profoundly disturbing. They discovered themselves despised by other Jews for confiding their suspicions of Jewish nationalism in public. After the Europeans and the Americans, they would now find their own people regarding them as "enemy aliens." Henry Pachter used to remark that as a result of his numerous criticisms of the Israeli government, his American Jewish coeditors of the liberal magazine *Dissent* referred to him as "the German."

16

The Scientists and the Bomb

With nineteen Nobel Prize winners numbered among them, émigré scientists have scarcely lacked for recognition. Indeed, the American media so often used émigrés as the model when they wished to dramatize the intersection of science and politics that the ultimate movie image would be Dr. Strangelove—accented, tic-ridden, monomaniacal, a blunderbuss of the laboratory. This caricature, for all the points that it scored against its model Henry Kissinger, is unfair. Emigrés were the most morally scrupulous of scientists, perhaps the first ones to consider fully the potential horrors they had loosed on the world with the atomic bomb.

The ostensible justification for dropping the bomb at Hiroshima, which was that it would save the lives of American soldiers, was questioned almost at once, particularly by those who saw the explosion merely as a warning to the Soviet Union. Such people not only noted that Japan was on the verge of surrender but would later cite Secretary of War Henry L. Stimson's remark that the United States' delay "in stating its position" on unconditional surrender, which the Japanese found unacceptable and did not in fact finally have to accept, may have "prolonged the war." As much as the investigation of political

nonconformists or the military rearmament of Germany did, Hiroshima contributed to the disillusionment of émigrés who had once been fervent patriots. For some scientists, the moral reckoning took a while. Not until 1948 did J. Robert Oppenheimer make his famous remark that "in a very real way, scientists have known sin" in the heedless pleasure they derived from their experimentation. But émigrés understood the problem more quickly. Having earlier been at the forefront of the atomic research program, during the postwar period some émigrés were thus among the most knowledgeable and articulate protesters. Often the debate became an internal confrontation pitting one refugee against another. (The first literary attempt to examine, albeit obliquely, the responsibility of scientists in the atomic era was also made by an émigré. Bertolt Brecht intended his American version of *Galileo* [1947] to trace an occupational culpability that linked the Italian physicist to the researchers working on the Manhattan Project. His theme also was that, under the sway of institutional powers, scientists had known evil.)

These men dissented from official policy, supported in their actions by devotion to the American principles of petition and redress. They acted with the confidence of recent citizens and with a sweetness of spirit that is scarcely the most pronounced émigré quality. While other academics impressed Americans as disdainful and aloof, men like Einstein, Leo Szilard, and Hans Bethe were known for their modesty and accessibility. Similarly, although many refugees offended the natives with their perpetual comparison *"Bei uns"* (We did it better), refugee scientists hailed American working conditions. They believed the democratization of physics had immeasurably strengthened the war effort: doing good had led to doing well. Later no other group of refugee professionals would match their political commitment, but then of course no other group had so much to answer for. (Only one refugee, Wolfgang Pauli, had refused to work on the atomic project; this helped solidify his image as "the conscience of physics.")

Albert Einstein's position in A-bomb history is perplexing. As the most celebrated living scientist, Einstein was recruited by Leo Szilard in 1939 to sign the famous letter to President

Roosevelt that called for an expansion of atomic research in order to thwart Nazi efforts in that area. Szilard astonished him, on their first meeting, with the prospect of an atomic chain reaction, and he always distanced himself from the results: "I do not consider myself the father of the release of atomic energy." In fact, during the war years Einstein was denied entry to the research laboratories; as we shall see, his political history made him appear to be a security risk! Even before Hiroshima, Einstein had commenced his pleas for restraint in the use of atomic energy. In March 1945 he cosigned a letter to Roosevelt with Leo Szilard, this time advising against a future arms race. Roosevelt was dead within a month, and if Einstein's alarm reached Truman, it did not inhibit his decision to drop the bombs at Hiroshima and Nagasaki. Within two months of the bombing, Einstein was a cosigner with Thomas Mann and several notable Americans of a public letter that opened by asserting that the bomb had "exploded our inherited, outdated political ideas" and quoted Roosevelt's call in his final address for a "science of human relationships" to advance peace between nations.

In May 1945 Einstein became the chairman of the Emergency Committee of Atomic Scientists. His fellow members included the émigrés Szilard and Hans Bethe, as well as Linus Pauling. For the rest of his life, he continued to insist on the need for supranational solutions to military problems. He advocated one-world government. Today, with at least three different international conflicts, this notion seems cockeyed, but during the postwar period it was immensely popular; even the physicists Eugene Paul Wigner and Edward Teller zealously supported the concept, at least for a time. Einstein and other adherents considered political and ideological arguments between East and West adolescent diversions compared with the urgent need to outlaw atomic war.

Right-wingers and anti-Russians disagreed: a New York *Herald Tribune* editorial said the scientists spoke out of turn. At the same time, the Soviet Union adamantly opposed any scientific entente with the West; it rejected the chance for joint participation offered in the Baruch Plan, describing the proposal as an imperialist fraud. Although Einstein was dismissed as a Red by

some Americans, Soviet scientists also mounted attacks on his politics: to them, one-world government would, by definition, undo the unique identity of a Communist system. The Russian scientists condemned any method that did not reflect their government's ideology—followers of the "Marxist" scientist Trofim Denisovich Lysenko sneered at the undialectical nature of "bourgeois Einsteinism." As Einstein's postwar experiences made clear, science and politics had become indivisible.

Leo Szilard learned very early that his brand of physics would require a mastery of fund-raising and publicity techniques more suitable to an entrepreneur. A native of Hungary, he moved to Berlin in 1922, and later demonstrated the matter-of-fact, no-nonsense sensibility that also characterized that city. Where others saw fortitude, he saw chance; where others applauded genius, he credited common sense. Thus his summary of his escape from Germany in 1933: he managed to leave Berlin one April morning on an empty train; when the same train left the next day, it was so jammed with fleeing Jews that Nazis stopped it at the border and interrogated the passengers. Szilard's escape was, to him, an example of sheer luck. He applied its lessons widely: "This just goes to show that if you want to succeed in this world, you don't have to be much cleverer than other people, you just have to be one day earlier."

He lived for a time in London, without either recognition or anxiety. He would spend three hours a morning soaking in his hotel's floor bath, which created an atmosphere abstractly sensuous enough for the sensuous abstractions of his physics. By 1934 barely two years after the discovery of the neutron made it possible for scientists to analyze an atomic nucleus, Szilard had thought out the potential behavior of atoms so thoroughly that he applied for a patent on the laws governing a chain reaction. After moving to the United States in 1937, Szilard found himself "loafing" until the Munich agreement galvanized him into action. In 1939, together with Walter Zinn of the Columbia faculty, he performed an experiment that demonstrated, as the report's title indicates, the "Instantaneous Emission of Fast

Neutrons in the Interaction of Slow Neutrons with Uranium"—in other words, the construction of a nuclear weapon was possible.

Scientists in Europe were involved in similar research. When the Frenchman Frédéric Joliot-Curie decided to publish the results of his work, Szilard begged him to reconsider and keep matters within the family of English, French, and American physicists. He feared that the Nazis would use such information—with dreadful results. (David Jorovsky suggests that Szilard's plea was also an "unwitting effort to revive the hermetic tradition of high-minded scholars like Isaac Newton." If so, Szilard learned quickly that this was not the seventeenth century.) When Joliot-Curie went ahead with the planned publication of his article, a desperate Szilard drafted the aforementioned letter, cosigned by Einstein, that beseeched Roosevelt to provide funds for atomic research.

American support was not immediately forthcoming. Nuclear research remained for the moment largely an obsession of émigré scientists. As newcomers, they didn't want to presume on their employers' hospitality by suggesting policy. Szilard later wrote that since neither he nor his colleague Enrico Fermi was yet an American citizen, and their colleague Eugene Paul Wigner had only recently been naturalized, uranium research was halted for six months. To advance the effort, Szilard was willing to join the Columbia faculty at the low salary of four thousand dollars a year. In 1942 the Manhattan Project with Szilard was transferred to the University of Chicago. Here Szilard enjoyed the friendship of Robert M. Hutchins, the university president, and was stirred by the example of Hutchins's move from an originally isolationist stance to full-throated support of one-world government.

Szilard had advocated nuclear research as a means of combating the Nazis; the knowledge that the United States had nuclear capability could have a deterrent effect on Germany. But as their defeat became apparent, Szilard began to wonder "what we were working for." Although many of his émigré colleagues shared his horror at the actual use of atomic weapons, he considered it pointless to discuss the matter with the American leaders

involved: Vannevar Bush, director of the Office of Scientific Research and Development; James B. Conant, chairman of the National Defense Research Committee; and—most particularly—Major General Leslie R. Groves, director of all army activities associated with the Manhattan Project. And so in March 1945 he decided again to go right to Roosevelt himself, in the letter, cosigned with Einstein, that may never have reached the dying president.

Like so many other émigrés, Szilard had a possibly exaggerated sense of Roosevelt's moral stature. But with Roosevelt gone, he was convinced that the actions of the military leaders would go unchecked. Terrified by the prospect of a nuclear holocaust, he sought out James F. Byrnes, then an influential private citizen and later secretary of state in the Truman administration. Szilard argued against the use of nuclear weapons for purposes of show; once again he argued for secrecy. But Byrnes felt strongly that the Russians needed a lesson. Weren't they right now plundering their way through Rumania and Hungary? Perhaps Szilard spoke as an internationalist convinced that a nuclear confrontation must be avoided at any cost; perhaps he responded as a Jew who knew that the Rumanians and Hungarians were eager participants in the execution of the Final Solution. Either way, the native of Budapest told Byrnes that at this juncture "I was *not* disposed . . . to worry about what would happen to Hungary." Anticipating future horrors for America, he tried to appeal to Byrnes's patriotism. Byrnes was adamant; the Russians had a lesson coming to them.

Leaving Byrnes's house, Szilard found himself caught in a depression that encompassed all the vagaries of his career. "I thought to myself how much better off the world might be had I been born in America and become influential in American politics, and had Byrnes been born in Hungary and studied physics. In all probability there would have been no atomic bomb, and no danger of an arms race between America and Russia." In a merciless display of self-criticism, he condemned both Byrnes and himself for the excesses unleashed by their individual obsessions.

Szilard rallied. He did not accept Byrnes's arguments for

dropping a bomb, but neither did he hold to his old position of keeping it secret. It finally hit him that a public test of the bomb was the only way to confirm its existence. In June 1945 the German-born physicist James Franck, a Nobel Prize winner and Szilard's colleague at Chicago, issued a report that called for an open demonstration of the bomb before any military deployment. Franck recognized, with Szilard and Einstein, the dreadful potential of a postwar arms race, and he pleaded for reciprocal restraints on America and the Soviet Union. But his report was largely ignored.

Szilard felt strengthened by the support of his fellow émigrés and, even more, by his own reading of the American Constitution. In an attempt to correct his past errors, he drafted a petition to the president that because of its public nature would in itself end the secrecy surrounding the bomb. Although army authorities were "violently opposed" to his action, Szilard was resolute: "The right to petition is anchored in the Constitution, and when you are a naturalized citizen you are supposed to learn the Constitution prior to obtaining your citizenship."

Although Szilard's petition was signed by all the leading physicists in the Chicago A-bomb project and many of the leading biologists, he was opposed by project chemists, who argued that more lives might be saved by ending the war, once and for all with a bomb. Szilard heard in their attempts at a reasonable weighing of figures an unpleasant echo of the "utilitarian arguments" that he remembered from Germany. The chemists remained immune to other considerations.

Szilard began to see other parallels between this country and its enemies. His July 3 petition noted that "our Air Forces, striking at the Japanese cities, are using the same methods of warfare which were condemned by American public opinion only a few years ago when applied by the Germans to the cities of England." A day later, in a letter to the group leaders at Chicago, Szilard made an analogy between the moral issues confronting them and the guilt of individual Germans who had remained silent during the Hitler regime. He condemned the efforts of the Germans at self-exculpation: that "their protest would have been of no avail hardly seems acceptable" as an ex-

cuse. And we, Szilard continued, who risk only the displeasure of some military bosses, cannot avoid our "responsibility" to the American people. Indeed, our actions will vindicate democracy since in this land of free choice we alone can make an intelligent one.

After the war ended, Szilard learned that the army was rushing an atomic energy bill through Congress without informing the public of its nature. Once again, Americans were being denied the facts. "I got mad at this time," he wrote. Robert Hutchins helped him to contact the Chicago press, and at last the quondam advocate of scientific secrecy became a fully public spokesman, stating his position first in the press, then in two appearances before Congress. His efforts prevailed: "the bill never reached the floor of the House." Like a redeemed Faust, for the rest of his life Szilard remained an outspoken foe of the weapons that resulted largely from his own research.

Hans Bethe had left Germany in the early thirties, first to work in England, then in America. It was still a time when one could return to Germany on vacations. But though he had been away only a short time, upon his return in 1935 he found Germany a "weird" place, so rapidly had he assimilated the relaxed, informal manners of the other countries. Bethe's long and happy career in America—as a Nobel Prize–winning physicist and perhaps the most influential physics teacher of his generation—is largely the result of a genial disposition that allowed him to feel at home here quickly. Much like other émigré scholars—one thinks, in other fields, of the sociologist Paul Lazarsfeld and the psychologist Kurt Lewin—who command twin skills as scholars and administrators, Bethe was the opposite of the public image of the isolated, disgruntled émigré.

As a model, Bethe likes to cite Enrico Fermi, whom he first met in Italy. Fermi "did not have the word formality in his vocabulary"; from him, Bethe derived a "lightness of approach" that suited him better than the oppressive rituals of the German academy. The English physicist Freeman Dyson was amazed upon his first trip to Cornell to hear students refer to Bethe as

"Hans"; one didn't talk like that at Cambridge or Heidelberg. But Bethe would argue that his openness to younger colleagues, demonstrated by the casual use of his first name, enabled him to lead a more innovative team of physicists during the war than had been possible in a Germany, where the man in charge, no matter how misguided, would have been beyond critical challenge.

If Bethe is the universal "good physicist," his opposite number in popularity is surely Edward Teller. The two men had met in Munich, and were reunited in this country. Relations between them have shifted through the years. At times, Bethe's relationship with Teller was what Paul Lazarsfeld's had once been with Theodor Adorno: that of an expansive, Americanized spirit in conflict with a defiantly critical European. As was the case with Lazarsfeld and Adorno, where Bethe expressed a democratic optimism, Teller might show elitist, if not hermetic, tendencies and find the American elements dangerous and banal. Yet, at other times Bethe and Teller could be as chummy as Adorno and Horkheimer, with enough in common to neutralize any political disagreements.

At first, Bethe and Teller were close friends in the United States, as if they were still in Europe: they shared a lab on weekdays and went mountain climbing together with their wives on weekends. Their conflicts commenced at Los Alamos. Bethe was named the head of the theoretical division (he was thirty-seven at the time), although Teller (then thirty-five) believed he had seniority. Teller has since objected that Bethe "overorganized" the division. This could mean either that he was too German (compulsively meticulous) or too American (sloppily overextended). Conversely, Bethe modestly asserts that his "plodding but steadier approach" was preferable to Teller's "over-fertile" explosions. From that angle, Teller might have appeared too American (a pestering adolescent) or too German (a precocious virtuoso).

Fearing a Soviet threat after the war, Teller began his work on developing a superweapon to contain the Communists. At this time Bethe's concerns were much less belligerent. He became a member of the Federation of American Scientists, an or-

ganization dedicated to the establishment of international controls on scientific research and development. In agreement with Leo Szilard and James Franck, Bethe considered secrecy foolhardy. In a pamphlet entitled "One World or None," he and his coauthor, Frederick Seitz, contradicted Vannevar Bush and General Groves on this issue, maintaining that the Soviet Union would probably catch up within three years, secrecy or no. And, as it turned out, the first Soviet bomb was exploded in 1949. (Noting the obstinacy of American authorities when confronted with the forecasts of "all younger men" that Russia would shortly develop its own A-bomb, Szilard commented dryly that "This is a case of 'youth did not prevail.' ")

Teller remained sure that the Russians had become our mortal enemies. Like many other émigrés, Teller in his adulthood was haunted by memories of childhood bullies, in his case specifically the soldiers of Béla Kun's short-lived Communist regime who had been billeted in his family's Budapest apartment. Teller has often spoken and acted as if America were the last outpost of freedom and the Pentagon the only force preventing a Gulagizing of the West. Childhood fears have rarely been so potent.*

Bethe may have doubted Teller, but the Hungarian could be quite seductive in his appeals for continued nuclear research. His spell was countered for a while by Mrs. Bethe's arguments. As early as 1939 she asked her husband to refuse an assignment on the A-bomb project. Now, ten years later, Teller was impatient to start work on an even more terrible weapon—his beloved "super," the hydrogen bomb. Mrs. Bethe spoke up again: "You don't want to do this." It would be too "irresponsible"; she shared Szilard's perception of a scientist's duties. Bethe was persuaded to decline Teller's offer by three refugees—his wife and two physicists from the Los Alamos team, Victor F. Weisskopf and George Placzek, who was also Bethe's colleague at

* A similarly vehement anti-Communism was expressed by another Hungarian refugee, John von Neumann. Neumann, the mathematician who had worked on the Los Alamos project, is reported to have advocated in later years a preventive nuclear war against the Soviet Union.

Cornell. (In 1980 Weisskopf was still publicly insisting that "everything must be subordinated" to the "reduction and eventual abolition of nuclear weapons." Two years later, acting as an emissary for the Pope, he met with President Reagan and pleaded again for nuclear disarmament. Asked by reporters whether he had converted the Pope, Weisskopf made a typical émigré response: "The Pope gets his inspiration from God, not from a Viennese Jew.")

Opposition to the H-bomb had thus become a refugee matter, to be advanced, debated, and settled in German-speaking circles. But Teller discerned an American hand; he was convinced that J. Robert Oppenheimer had influenced Bethe. This only fueled Teller's animosity against the American whose spare, bony presence seemed the visual and temperamental opposite of his own stocky, impassioned self. Bethe briefly yielded to his wife and friends; he initially supported a ban on H-bomb research. But when Teller as the director of Los Alamos, together with the Polish émigré Stanislaw Ulam, finally developed the bomb between 1949 and 1951, Bethe returned to work at Los Alamos from February to December 1951, convinced that history was irreversible. But now he says, "In retrospect, I am doubtful that it really was necessary to develop the H-bomb, even after we recognized that it was technically feasible." Once again, the Soviet scientists caught up within three years; Bethe believes that we could have closed up the gap just as quickly, had we abstained and they persisted.

But with or without second thoughts, Bethe was no longer opposing Teller from the side of the Szilards, Einsteins, and Francks. A new conflict arose, however, once again over J. Robert Oppenheimer, the cipher in their debate over H-bomb research. In 1952 Teller got a place of his own, the Lawrence Livermore National Laboratory in California. He had become the most famous advocate of nuclear weapons, "the father of the H-bomb" (actually, in Bethe's symbolism, Ulam was the father and Teller the mother, "because he carried the baby for quite a while." If his metaphor holds, Teller's maternal instincts were of another kind than Mrs. Bethe's!) Teller and his zealotry

were enlisted by government officials in the trial of Oppen-
heimer, the Bethes' good friend.

In December 1953 Oppenheimer had been formally charged
with two offenses: disloyalty, as manifested by his opposition to
A-bomb research (a charge that was later dismissed and had in
fact been contradicted by his 1948 confession that he had, if any-
thing, enjoyed the research too much), and attempting to shield
a left-wing friend. Leo Szilard quipped that the attempt to ban-
ish the author from his creation would be seen abroad as "a sign
of insanity, which it probably is." Bethe was frightened by the
tide of anti-Communism in which his friend was drowning:
"Having seen what had happened in Germany, I was not at all
sure how far McCarthyism would go. It might well have led to
the persecution of liberals in general, with no Communist asso-
ciation needed." Before the congressional hearings, Bethe and
his wife visited Teller's home and pleaded with him to testify in
Oppenheimer's favor "or, at least, not against him. . . . But
Teller was immovable." His testimony was reminiscent of Marc
Antony's praise of honorable men. "I have always assumed, and
I now assume, that [Oppenheimer] is loyal to the United States.
I believe this, and I shall believe it until I see very conclusive
proof of the opposite." Teller admitted that he saw no reason "to
deny clearance" on political grounds, but "if it is a question of
wisdom and judgment as demonstrated by actions since 1948,
then I would say one would be wiser not to grant clearance."
Bethe reports that after testifying, Teller shook Oppenheimer's
hand and said, "I'm sorry." In popular imagery, "the father of
the H-bomb" had vanquished "the father of the A-bomb." In
1954, Bethe wrote an angry essay about the Oppenheimer trial.
It was immediately classified by the government and withheld
from the public until 1982. In this essay, Bethe declared that the
snags in the Los Alamos H-bomb project resulted not from Op-
penheimer's political opposition but from Teller's miscalcula-
tions.

The Bethe-Teller friendship broke over Oppenheimer. Teller
would be permanently identified as the vehicle of Oppen-
heimer's disgrace, while years later Bethe would give an impas-

sioned eulogy at the American's funeral. (Teller is one to keep feuds alive even after his opponents have died. He recently repeated the story that Einstein, after the dropping of the A-bomb, lamented that he would "rather have been a plumber." Einstein's executor, Otto Nathan, denied this was true and added, "I have reason to believe that this was brought to Dr. Teller's attention before.")

Through the rest of the fifties Teller and Bethe found themselves once again divided. Bethe supported a ban on bomb tests, a position shared by the State Department (under John Foster Dulles) and Bethe's former colleagues at Los Alamos. Teller and the members of his Livermore laboratory were strongly opposed to the ban, a position they shared with the Department of Defense. In 1959 the two scientists confronted each other in a hearing before the Joint Congressional Committee on Atomic Energy. Bethe remembers, "Teller appeared and came on terribly strong. I had a very unpleasant hearing." Finally, the two men appeared as rival spokesmen in the *Headline Series*, a publication circulated in American high schools, as if the two émigrés between them encompassed the range of American scientific debate.

Well into the sixties Bethe managed to be acceptable to the Establishment while questioning its military assumptions. As a member of the president's Science Advisory Committee, he argued for years that an antiballistic missile system was a pointless waste of money; any such system could be out-missiled "at a cost less than that of the ABM system itself." Meanwhile, Teller, still adamantly anti-Soviet, remained the popular image of a militarist scientist.

But years often dissolve the grievances and disagreements of people who came up together, especially in difficult and momentous times. Many émigrés have commented on the capacity of right- and left-wingers to rally together, conjoined by their mutual plight. Lately, Bethe says that the conflicts of the fifties and sixties have "lost their urgency, and other issues have taken their place." In May 1979, following the public outcry over the Three Mile Island nuclear accident, Edward Teller returned to Congress to defend the safety record of nuclear reactors and

point out the superior qualities of nuclear energy. The seventy-one-year-old Teller was supported by others, including the seventy-seven-year-old Eugene Paul Wigner and the seventy-three-year-old Hans Bethe. The émigrés had become the grand old men of American science, insisting on a vision of nuclear energy that appeared misguided and dated to many but retained for them the glory and freshness of a dream.

17

From Undeutsch to Un-American

The refugees had come out of the war, as Hannah Arendt noted, a new kind of creature: their enemies placed them in concentration camps and their friends interned them. It was a popular World War II myth that after Hitler's defeat the refugees' lives would return to normal. Only the more naïve believed that this was possible; the others knew that numerous enemies remained, particularly in the United States, all of them waiting to punish the refugees for their unorthodox politics. The war ended, and radical émigrés were left scarcely less vulnerable than before.

For example, László Moholy-Nagy, who had come to the United States in 1937 and since that year had been president of the Institute of Design (originally called the New Bauhaus) of the Illinois Institute of Technology, applied for citizenship in 1945. On July 28, barely two weeks before V-J Day, he was ordered by the Immigration and Naturalization Service to forward his correspondence with the leader of a Hungarian anti-Fascist group. By November he was denying any participation in the Hungarian revolution of 1919: there were "wild stories" about his "throwing bombs at non-Communist Hungarians." In February 1946, he wrote William Benton, the assistant secretary of

state, "Though I am now almost nine years in this country, my own and my wife's applications for citizenship are being handled . . . with a baffling slowness." He surmised that his involvement with the Democratic Hungarian-American Council was the problem, so he insisted that as "an artist I never had political affiliations" and that his work for the council had ended with the war. The authorities deigned to accept his apologies for supporting the war against Hitler: he was finally granted citizenship seven months before his death from leukemia.

Suddenly émigrés found that long periods of their lives were regarded with suspicion. In the postwar period, "premature anti-Fascism" became a euphemism for Communism; but when had anti-Fascism been premature for an émigré? The term "un-American" seemed to have specific application to the non-American; naturalization did not change this. And as if to confirm the correctness of this notion, refugees assumed special prominence in the postwar obsession with traitors. "The newspapers screamed about conspiracies," a scenarist recalled, and as the émigré experience during the 1930s had earlier demonstrated, "every conspiracy naturally implies aliens." In 1950 the first postwar spy was uncovered. He was Klaus Fuchs, a German-born British scientist who had worked on the Manhattan Project and transmitted atomic secrets to the Soviet Union. (Recent data has indicated that Fuchs's spy control in Great Britain was another émigré, "Sonya," actually Ruth Kaczynska, the daughter of a Berlin economist.) When the House Committee on Un-American Activities made its reappearance three years earlier, the first witnesses it had called were Gerhardt Eisler and his sister Ruth Fischer. Since émigré radicals were everywhere in the news, other refugees feared that they would be widely perceived as spies and traitors. For many, it looked like time to start packing again.

Some years before, in 1941, Vannevar Bush, director of the Office of Scientific Research and Development, had written that the proposal to involve Albert Einstein in the Manhattan Project was considered "utterly impossible in view of the attitude here in Washington of those who are familiar with his whole history." The phrase "his whole history" is a clue to the émigrés'

sense of alarm; such statements made it seem as if one's whole history were up for reinterpretation. The events of ten, twenty years ago were recalled, reanimated by a new group of enemies that sounded increasingly like the old gang. When Bertolt Brecht testified before HUAC, he recalled that the Nazis had first targeted him when he was a twenty-year-old balladeer. It took them fifteen years to punish him with exile. Now he and his collaborator Hanns Eisler were being condemned by Americans for writing songs that had been composed twenty years earlier: nothing was ever done with or forgotten. In Germany, the positions of Brecht and his friends—a group including a wide range of comrades, both socialist and Christian—had been dismissed as being un-German: *"undeutsch;* a word which I hardly can think of without Hitler's wolfish intonation." The echoes of *"undeutsch"* in "un-American" took the breath away.

Epithets that had trailed radicals in Germany were revived. Once again, "intellectual" and "cosmopolitan" became code words for "traitor." When Congressman Conde McGinley, a New Jersey conservative, attacked the "Red Rabbi," Joachim Prinz, he linked Prinz with Einstein and noted that they had both fled from Germany because the government disliked their radicalism (no attempt to identify the nature of that government was made); McGinley also appended a reference to Prinz's "high-falutin" professorial diction. McGinley was a spokesman for an extremist contingent of "native white Christians." It might have seemed to be a long route from his know-nothing rage to the *Congressional Record,* but that record itself included Red-baiting attacks on the likes of Thomas Mann and Albert Einstein. Refugees had become expert readers of images, not merely the film directors who composed the images of mass culture or the cultural critics who decoded them. Any intelligent refugee could pick up those shifts in tone that had always signaled the need for flight. How could they not worry?

During the so-called McCarthy era (which actually predated by some years the eminence of the junior senator from Wisconsin), émigrés also found their American friends under scrutiny as a result of their association. Some of their closest allies were now implicated in un-American activities. Dorothy Thompson,

the émigrés' champion in the press, had acquired a German-born assistant, Hermann Budzislawski. As a Communist, he had edited *Die Neue Weltbühne* (his predecessor at the newspaper was Willi Schlamm, who later became a Time-Life staff writer and a presiding genius of *National Review*). Budzislawski's views did not change: after the war, he returned to Europe and settled in the German Democratic Republic. Thompson felt betrayed, and joined the bandwagon of journalists calling for public exposure of those devious Reds.

Charlie Chaplin had become the refugees' proxy. His silent-screen image seemed to reflect something of their helplessness and cunning. In Hollywood, he surrounded himself with such radicals as Brecht, Hanns Eisler, Lion Feuchtwanger, and Thomas Mann; he had even met Einstein. While the rumpled informality of the two might have rendered them more appealing to the masses, to those who saw humanism as a Communist plot, the evocations of a common humanity made them appear all the more sinister.

The émigrés' best friend in public life was Eleanor Roosevelt. She took a personal interest in their welfare, attended their conferences, answered their letters. In 1941, when Einstein wished to protest the restrictions on immigration—"a wall of bureaucratic measures alleged to be necessary to protect America against subversive, dangerous elements"—he wrote to her, recognizing that she stood apart from the unsympathetic political establishment. Similarly, ten years later Einstein appeared on Mrs. Roosevelt's television program to attack Senator McCarthy and his allies.

With Mrs. Roosevelt so outspoken in her support of "foreign radicals," it was not surprising that their mutual enemies would use the one to get at the other. Thus, after Mrs. Roosevelt had attacked Congressman John Rankin's racist politics in the press, the archsegregationist—the very same who had once advised the American people to "get wise to this fellow Einstein"—made pointed references to her friendship with Hanns Eisler, the current subject of a HUAC investigation. In the image-obsessed world of the American Right, the refugees and Mrs. Roosevelt were one another's creatures. By the late forties Thomas Mann

was worrying in private that public advocacy of FDR's policies could brand one a Communist. And, along the same lines, loyalty to Mrs. Roosevelt became grounds for suspicion.*

The postwar period was characterized by many equally confusing shifts in mood. For a few years, it had not seemed a crime for refugees to socialize with Communists—no noncitizen could be a member of the Party—since the Communists had declared themselves to be patriots. During the war they stood behind Roosevelt, even to the extent of encouraging the Smith Act harassment of radicals, as long as those involved were the Trotskyist members of the Socialist Workers Party or the Minneapolis Teamsters Union (at that time, a progressive organization!). Yet the nation's anti-Soviet bias was only briefly suppressed. By 1945, Thomas Mann was citing rumors that World War II was simply a rehearsal for the battle with Russia. The wartime alliance collapsed quickly, as if the common opposition to Fascism had been a mere passing fancy. The American demand for reparation of Soviet debts and the hoarding of A-bomb secrets offended the Russians, who felt they were entitled to more after sacrificing twenty million people. (On the other hand, conservatives felt that the Soviets had gotten too much out of the war: as a shield against a West they continued to regard as a monolithic threat to their social system, they established domination of all the countries they had occupied.) The postwar political epithets of "Iron Curtain" and "slave states" resembled the familiar language that always accompanied military preparations.

After years of making themselves indispensable to Americans, émigrés didn't want to assume again the unpopular mantle of Cassandra. Yet how could they avoid sensing something ominous when the recently defeated enemy was treated with more consideration than the former ally? The head of the State Department's visa office announced in 1948 that he had no problem admitting former Nazis, as opposed to Communists, since they did not support the overthrow of *our* government. For a

* Another émigré supporter, Frank Kingdon, the educator and journalist who helped sponsor the emergency rescue effort, was blacklisted in the 1950s and lost both his newspaper column and his radio program.

long time, opposition to Communism ensured entry even though everyone knew that in Central and Eastern Europe the most zealous anti-Communists had invariably been Fascists. The image of Nazi war criminals living comfortably in this country could be juxtaposed with the equally disturbing possibility of concentration camps for radicals, set up under a provision of the Emergency Detention Act. The exponents of the *Berliner Schnauze* did not miss this new opportunity for gallows humor; they joked that the government was in the market for experienced camp guards.

The political discourse of American conservatives became increasingly hysterical. In 1946 there was a rash of strikes by American workers; even the timorous Communist Party could no longer restrain its followers. Radicals were powerful in many unions. Incredibly, for some conservatives these workers represented a fifth column of the Russian Army. Among the politicians who exploited the revitalized antagonism toward radicals were such liberals as Hubert Horatio Humphrey, fresh from his demolition of the Minneapolis Trotskyists, and President Harry Truman, who in 1947 instituted the loyalty oath. For the refugees, the problem was not disloyal actions—the bureaucrats had effectively screened out almost all the revolutionaries among them—but, rather, the revelation that they lived in a place where they would never be done proving themselves. Words and images were garbled: to oppose congressional witchhunters was to be un-American, to attack loyalty oaths was to be disloyal, to defend the Constitution was to be treasonous.

The House Committee on Un-American Activities (HUAC) had not been active since 1938. For its 1947 comeback, it reopened with an investigation of Hollywood radicals—a focus that may seem stunningly peripheral. "Poolside revolutionaries indeed," snorts one old Marxist. "Can you imagine what those cells and study groups must have been like?" The émigré screenwriter Vladimir Pozner observed, "This was probably the first time that anyone mentioned ideas in connection with American movies." Yet even its enemies must now grant that HUAC was not only successful theater but something more than that: an attempt at ritual purgation by means of public em-

barrassment and personal ruin. The HUAC members shared with Hitler and Stalin the conviction that art must be politically correct. More up-to-date, or at least less concerned with traditional forms of culture, they took after filmmakers instead of writers and artists. But it was once again the scrutiny of images, with which refugees were so familiar. And the investigation of the image industry began—in one of the deepest ironies of the émigrés' perpetually ironic history—with a refugee family.

The Eisler siblings—Elfrieda (aka Ruth Fischer), Gerhardt, and Hanns—could not have seemed less American. Despite their American jobs—Ruth had been a social worker, Hanns a successful composer of film scores—they were still totally enmeshed in the politics of another time and place. Gerhardt Eisler was a Communist Party veteran. His sister, forever contentious, had once been known as *die rote Ruth* (Red Ruth), but had since developed into the sternest anti-Communist. During the early forties she picketed meetings of émigré radicals, distributing mimeographed pamphlets on the Communist threat. By 1947 she had graduated to the lofty position of granting interviews in the New York *Journal-American;* a year later, Harvard University Press published her study of German Communism.

Here was a family romance performed in public before an audience that could scarcely have comprehended the cultural and historical setting. Ruth hadn't spoken to Gerhardt for many years; more recently, she had severed connections with Hanns. On February 6 she informed the members of HUAC that events had forced her to testify against Gerhardt. If loyalty was at issue, Ruth Fischer had abandoned any to her family in favor of anti-Stalinist principles. She asserted that the Russian secret police were hovering everywhere, and at their center was her brother Gerhardt, "the perfect terrorist type," a man who would without remorse turn over to Stalin "his child, his sister, his closest friend." But Ruth was too smart for Gerhardt: since learning of his arrival in the country, she had devoted herself to his exposure. She wrote Hanns in 1944 that if he and Gerhardt had plans to kill her, they ought to know that three doctors had examined her (so that any sudden demise would be viewed with

suspicion) and that copies of this letter were being mailed to "other German immigrants."

In her testimony, Ruth rattled off a series of accusations, some clearly wrong, a few simply restatements of conflicts that had split émigré groups for years. She held Gerhardt responsible for the death of Nikolai Bukharin, as if his testimony would have made any difference after Stalin had ordered Bukharin's purge. She acknowledged that Gerhardt had been an inmate of the French concentration camp at Gurs, but, she insisted, he had been interned as a "Communist Comintern representative," not as an "anti-Fascist"; given the times, this was a distinction without a difference. Still, Ruth had the grace not to accuse her brother of "premature anti-Fascism." And in accusing him of participating in the transfer of German Communist women from Russian labor camps to the prison at Lublin before being rerouted to the infamous women's camp at Ravensbrück, Ruth recalled one of the most shameful products of the Molotov–Von Ribbentrop pact. This abandonment of refugee Communists was one of the blackest marks against Stalin—a complete denial of Communism's spirit of international fraternity and solidarity. Since Gerhardt personified the Comintern for Ruth, she now held him personally responsible for Stalin's crimes.

The subject of Ruth's testimony, Gerhardt, had already appeared that day before the committee; he proved to be as garrulous as his sister but in defense of his own principles. With a fine display of obstinacy, he refused first to take the stand, then to take the oath. Robert Stripling, the chief investigator, complained to J. Parnell Thomas, the chairman. But Gerhardt was adamant: "I have the floor now." The chairman asked him to sit down and remember that he was a guest of the nation. "I am not treated as a guest," Eisler replied. "I am a political prisoner in the United States" (he had not been allowed to leave the country), adding, "You will not swear me in before you hear a few remarks." Congressman Karl Mundt proceeded to cite him for contempt, and the motion was seconded by Congressman John Rankin. Eisler's chutzpah would seldom be duplicated by HUAC witnesses.

The committee was not finished with the Eisler family. On September 29, 1947, they summoned Hanns. He appeared as an embodiment of Hollywood radicalism, and he pleaded not to be separated from his co-workers in the film industry. During an examination that focused on his art and politics, Hanns assumed the offensive. He began by accusing the committee of having "smeared" him and requested the right to question witnesses, a privilege recently granted to Hollywood's own Howard Hughes. When his request was denied, he proceeded to assert his credentials: he was a composer, might he add, "of international reputation." In a touching homage to his teacher, he described himself as "the pupil of the famous composer, Arnold Schoenberg"; one wonders what Schoenberg's response to this political use of his name was. Hanns Eisler would not identify himself as a Communist, although he had once applied for membership. It was not that he disowned the party, as Ruth had, but that he admired it too much. He felt he had no right to share in the glory of the members of the underground, who had actively opposed Hitler for so many difficult years: "I am not a hero, I am a composer." He disclaimed any of the attacks on Stalin he was reported to have made, so determined was he not to be a "coward," so uninterested was he in winning his inquisitors' approval.

The committee next began to examine imagery and gesture. Here was a thirties photograph of Eisler—giving a Communist salute! Eisler was asked to demonstrate the salute. He did, and then added a mite disingenuously that it was an anti-Fascist gesture. Next he was questioned about a hammer and sickle with a violin clef that was affixed as a logo to a Workers Music League announcement, which forced him to give the congressmen a lesson in the political uses of music: "Songs cannot destroy Fascism, but they are necessary." When Stripling argued that Eisler had become the "Karl Marx of Communism [sic] in the music field," Hanns demurred: "I would be flattered."

His tone grew more sneering and disrespectful, as when he referred to "a book printed by a subversive organization, Oxford University Press." In one of the more ludicrous exchanges he

was accused of plotting "the destruction of art," the title of one of his essays, to which he replied, "No, I didn't destroy art. You can't criticize me there. I spoke on—I guess you can find it—how Fascism has destroyed art." Eisler regretted that the committee did not like his compositions. And, with evident contempt for American popular culture, he offered the congressmen an alternative in the current hit tune "Open the Door, Richard."

Having interrogated him about his American past, the congressmen then disinterred his German history. Hadn't he and Bertolt Brecht composed songs opposing racism and upholding a woman's right to abortion? Congressman John McDowell was beside himself: such sentiments were worse than obscene—they were outside the boundaries of civilized discourse. Eisler objected: "They are considered as great poetry." Once again, positions on politics, art, and morality had converged; the Americans' indictment could have been formulated by Nazis. When the same McDowell questioned whether the committee had indeed smeared Eisler, Hanns retorted that their "fantastic press campaign" would have infuriated "every red-blooded artist." Rankin simultaneously leaped to the committee's defense and launched an attack on Eisler's songs—"this filth here." With gorgeous equanimity, Eisler observed, "I don't know, Mr. Rankin, how you are familiar with American poetry." The syntactical ambiguity might not have been deliberate, but Rankin was caught short. "American what?" "Poetry," Eisler replied. "Poetry," Rankin repeated. "And American writing," Eisler continued, insisting that his work was not American poetry or writing. "This was written in German. . . . I say, again, it is great poetry." Cultural exchange now turned to farce, as Rankin, the most rabid segregationist in Congress, insisted on his familiarity with American and English poetry "generally." And, Rankin informed Eisler, "anybody that tries to tell me that this filth is poetry certainly reads himself out of the class of any American poet that has ever been recognized by the American people." Later that afternoon Rankin proceeded to associate Eleanor Roosevelt, author of a recent attack on Southern reactionaries, with such masters of "Communist infiltration" as Hanns Eisler.

The statement that Eisler was not allowed to read appeared

later that year as "Fantasia in G-Men," in an Austrian radical newspaper. In the article, he alluded to the Conradian problems of fidelity posed by his sister's embarrassing disclosures. He stood behind his brother: "Does the committee believe that brotherly love is un-American?" Eisler knew that the Neanderthal attack on progressive art would damage the art more than the politics. Like Leo Szilard, he invoked the American Constitution to support his arguments. Rankin and McDowell, he wrote, were the harbingers of an "unconstitutional and hysterical political censorship. It is horrible to think what will become of American art, if the Committee is to judge what art is American and what is un-American." (Unfortunately, he did not raise similar objections after his return to East Germany.)

During one exchange with Stripling about his brief stay in the Soviet Union, Eisler declared, "We were refugees. We all stick together, regardless of our political beliefs—details of our political beliefs. We stick together." The use of the present tense was appropriate. Eisler, for all his Hollywood successes, had not advanced beyond the insecure status of a refugee. The final irony was that Hanns wished to stay and was threatened with deportation, while Gerhardt, who wished only to leave, was sentenced to prison; he was released on bail, however. After such internationally influential figures as Charlie Chaplin, Heinrich and Thomas Mann, and Einstein petitioned the attorney general to drop deportation proceedings and following a big farewell concert in New York City, Hanns Eisler and his wife were able to make a less humiliating exit via Czechoslovakia by choosing a "voluntary deportation"—doubletalk for purchasing one's own ticket. The more cunning Gerhardt simply jumped bail and stowed away on a Polish ship, the *Batory.* A New York paper's headline may serve as the final comment on the Eislers' unhappy dealings with American popular culture: RED SAILS IN THE SUNSET.

Five weeks after the committee interrogated Hanns Eisler, they called to the stand his former collaborator Bertolt Brecht. Brecht, whose time in Hollywood was wasted in the pursuit of

hack assignments, now became a shadowy accomplice to the more illustrious screenwriters, the eleventh man to Hollywood's "Unfriendly Ten" (Billy Wilder commented that only two of these were talented, the rest were merely unfriendly). Since his American career was too meager even for HUAC's microscopic inspection, they focused instead on his activities in Europe. Again American conservatives were about to inflict the punishment that the Nazis had been cheated of.

The Hollywood émigrés all knew where Brecht stood, so they shared Salka Viertel's surprise when he denied he was a Communist. In point of fact, he wasn't a Party member, although he showed much less courage in acknowledging his radical inclinations than had Hanns Eisler. Brecht had decided to appear as a friendly witness, thus breaking ranks with the Hollywood 10, who had agreed not to answer any questions that would require their tattling on other radicals. It is now clear that his appearance was well rehearsed in gestures and props—he was advised to smoke a cigar as a signal of camaraderie toward the cigar-smoking chairman J. Parnell Thomas—as much as in content. Hermann Budzislawski, Dorothy Thompson's assistant, prepared Brecht for the inquiry. The two men suspected that Brecht's European work would, like Eisler's, be brought up. So they decided to argue that more than poetry was lost in translation. The message itself, Brecht would say, was changed in the Englishing. This was a wonderfully rich joke, considered in the history of emigration. For when before had a linguistic gap actually worked in the *favor* of a refugee writer?

Elsa Lanchester remembers that Brecht was accompanied by an interpreter whose accent was thicker than Brecht's own Augsburg version. The two men found themselves correcting a translation of *Die Massnahme*, Brecht's adaptation of an old Japanese Noh drama. Brecht's anti-Fascist play had been written in 1930. This confused the congressmen, who had to be instructed that the struggle against Fascism had commenced in 1923. The play's theme is confusing enough: it tells of a young cadre member who commits suicide after recognizing that his independent behavior is detrimental to his party's cause; his comrades "tenderly" accompany him to his death. (The play can be read as

yet another exposition of the dangers to group solidarity posed by individualism. Rather than justify such strident Stalinism, Brecht simply switched plays and described another, more placid work, *The Yea-Sayer*. To further complicate the understanding of a difficult play, Brecht noted errors in the translation: "That is not correct, no. That is not the meaning. It is not very beautiful, but I am not speaking about that." When he was asked about the revolutionary intent of the line "You must be ready to take over," he replied that the correct translation was "You must take the lead." He was forced to educate the congressmen in the makeup of anti-Fascist protest: he had written for workers of all sorts, "even Catholic" (this last remark was of course unclear to the congressmen, since no such tradition of powerful Christian unions existed in this country).

Brecht managed to answer questions truthfully but not completely. He was not a Communist, although he didn't mention that he had been an ardent fellow-traveler. He described his homage to Marxism in strictly intellectual terms. By telling so much and no more, he avoided a closer inspection of his career. Although Chairman Thomas refused Brecht time to read his prepared statement—"It is a very interesting story of German life, but it is not at all pertinent to this inquiry"—the playwright's cooperation so disarmed the congressman that he stopped investigator Stripling from examining Brecht's past: "We are not interested in any works that he might have written advancing the overthrow of Germany or the government there." When Brecht stepped down, Thomas praised him as an exemplary witness.

Brecht declared that "as a guest of the United States, I refrained from political activities concerning this country even in a literary form." But his unread statement directly attacked the American witch hunts. The recapitulation of his past battles served to remind him that in Germany "assaults upon the physical life of the people" invariably followed "reactionary restrictions in the field of culture." And so, while weaseling out of a clear identification with the Party, Brecht exhibited enough courage to finally speak about "American matters." He also warned in his unread statement that "The great American peo-

ple would lose much and risk much if they allowed anybody to restrict free competition of ideas in cultural fields"—an unwitting prophecy of his forthcoming problems with the German Democratic Republic's cultural censors.

Brecht left this country on the evening of his appearance. Wieland Herzfelde remembers the playwright was so nervous that Herzfelde and Ruth Berlau had to pack his bags for him. In 1950, back in Germany, Brecht wrote a short memoir of his investigation, "We 19," a reference to the actors, directors, and writers who had been called up for investigation. It exhibited his characteristic wit as well as his typically cavalier treatment of facts. He noted that the real threat of the investigations was not prison but unemployment, the ultimate punishment in "the land of the dollar." Brecht made dialectical sport of his situation: he was "saved by not being an American." Since he lacked the Constitutional protections of native-born Americans, he was forced to answer the committee's questions. The natives had both more freedom and less. Brecht noted that while his colleagues enjoyed enough Constitutional protection to guarantee their jail sentences, "it was the Constitution that was not protected." In an image both mythical and ribald—and very German—he recalled that the Constitution had been written "at a time when the goddess of freedom had oil in her lamp, not in her face." Brecht was wrong about his lack of Constitutional protections as an émigré: he was also wrong when he declared that most of the Hollywood 10 had not been Communists. His last view of American life was at once astute and imbalanced.

Eisler and Brecht were HUAC's prize refugees, but they were not the only émigrés who had settled in Hollywood who suffered the consequences of McCarthyism. The actress Mady Christians, fresh from a role in Max Ophuls's *Letter from an Unknown Woman,* died shortly after being hounded by blacklisters; her friends had no trouble affixing blame. Douglas Sirk, the director of quintessentially American films, was a friend of Brecht, Eisler, Feuchtwanger, and Heinrich Mann, and although he was personally unthreatened, he shared their sense of

doom. Fritz Lang found himself blacklisted for a year, largely because of his membership in the Anti-Nazi League (Lang did not apologize for this. But the Molotov–Von Ribbentrop pact had made him feel like an "idiot.") Lang believed he had been photographed leaving a Henry Wallace meeting in 1948; by 1952, this was tantamount to treason in some quarters. He may also have suffered from one of the postwar about-faces: his 1946 film, *Cloak and Dagger*, was an early paean to the OSS that happened to have been written by two scenarists who later were members of the Hollywood 10. They had worked on the screenplay during a time when CP sympathizers zealously supported the American war effort without suspecting that the OSS, and its successor, the CIA, would eventually turn against Communists and their fellow-travelers. In a similar instance, the ineffable Ayn Rand slammed László Benedek before a congressional committee, for his work on *Song of Russia*, a rather giddy 1942 homage to this country's major wartime ally.

Another émigré who was living and working in Hollywood, Salka Viertel of the Maberry Road salon, had supported many left-wing organizations and had a Trotskyist son. By 1953 she found the atmosphere subverting all the American traits she had come to value. Her normally generous neighbors refused to donate old clothes to the orphaned children of German underground fighters—"Communists will get them," they complained. The new image of anti-Fascists as Communists had prevailed. Viertel decided to return to Europe, but she was briefly denied a passport, following allegations of Party membership. She replied in typically outspoken fashion: No, she was not a Communist; yes, she had sided with them in their fight against Fascism. In yet another émigré homage to American principles, she insisted that "the independence of thought and expression of it are essential in a democracy." Eventually she acquired a passport through the intercession of another German refugee who was married to an American under secretary. Viertel returned to Europe, spending her last years in Switzerland. Later, when someone asked why she hadn't joined the party, she replied simply, "Because I am not able to accept or to follow any party discipline." Other radical émigrés—Brecht among

them—might concur, but such willful evasion of political labels, although "essential in a democracy," as Viertel had insisted, was not acceptable at the time. Years later the refugees who were victims of blacklisting were vindicated when Otto Preminger broke the list. But given their ages and histories, that event offered slight consolation. Viertel's was a perspective attuned to historical and political subtleties—the one sure legacy of emigration. To Americans, it revealed merely a treasonous disposition.

Without meaning to, the congressional investigators demonstrated how small and closely knit the world of émigré radicalism was. Their two other major witnesses had both been part of the Brecht-Eisler circle. Hede Massing, who testified in 1951, was an Alma Mahler of the German Left, having been married first to Gerhardt Eisler and then to Paul Massing, a member of the Frankfurt school. (True to both the émigré interest in imagery and the obsessions of her right-wing audience, Massing titled her autobiography *This Deception.*) Five days after Massing, Karl August Wittfogel testified before Senator Pat McCarran's Internal Security Sub-Committee of the Senate Judiciary Committee. He too had been a member of the Frankfurt institute, and, in addition, in his earlier incarnation as a poet-playwright he had been part of the Berlin avant-garde group that included Erwin Piscator, Brecht, Hanns Eisler, and the Herzfelde brothers.

However, by 1951 Wittfogel was a Sinologist, celebrated for a theory of society that drew upon Marx's studies of Oriental despotism to characterize systems in which the bureaucracy assumes social control without having acquired the means of production "and without class struggle." His committee appearance was ostensibly motivated by political dangers confronting the Institute of Pacific Relations, with which he was associated. Wittfogel was later condemned for informing on his colleagues—a charge he has denied—although by stressing the collusion or naïveté of his IPR colleague Owen Lattimore in hiring Communists like Wittfogel himself, he contributed to the

atmosphere of censure that eventually drove him from this country. According to Martin Jay, the historian of the Frankfurt school, Wittfogel's testimony also hastened the flights of other scholars.

But the historical import of his appearance was much greater than anything that could result from common academic in-fighting. As the appearances of the Eisler family and Brecht had also been, Wittfogel's testimony before Congress was in a sense a culmination of political events that had originated decades earlier in Germany. Like Ruth Fischer, he had been an early member of the German Communist Party, having joined in the fall of 1920. He was briefly interned in Germany in 1933. After his release, he fled to Great Britain, where he wrote a novel about his experiences that was published in 1934 by Wieland Herzfelde's Malik Press. For a while he remained part of the circuit of literary Stalinists; in America, a play of his was translated by Michael Gold, one of the U.S. Party's resident literary commissars.

But Wittfogel rapidly became alienated from his comrades. He was furious when the German Party missed its chance to confront the Nazis while wasting its energies on battles with the "Social Fascists" of the SPD. Stalin's "crazy German politics," he has observed, led to the extinction of "90 per cent of the old comrades, including many friends." The Molotov–Von Ribbentrop pact was the last straw, despite the "shabby" apologies of men like Brecht, who argued that the agreement purchased time to restore Soviet defenses. After meeting Wittfogel in New York in 1943, Brecht described him as the well-married keeper of "a kind of salon." This was still a time when émigrés' analyses of German Communism remained in the family. Referring to Wittfogel's attack on Stalin and perhaps to his literary career, Brecht said he had "the heart and the trauma of a disillusioned troubador."

Wittfogel perpetually found himself in the midst of American politics. In the late thirties he had been cochairman of a German-American Popular Front group, affiliated with the pro-Communist contingent. But within a decade he was advising Americans on "How to Checkmate Stalin in Asia" (the title of a

1950 article in *Commentary*). At home, he became alarmed by his "pro-Communist" colleagues at the Institute of Pacific Relations. (As history would demonstrate, with the counsel of such scholars the government might have avoided many of its subsequent mistakes in Asia.) Convinced that political dissension had "paralyzed our work," Wittfogel testified before the McCarran committee.

The repercussions of his appearance would trail him for years. Even at eighty-three, he felt obliged to justify his behavior to a young German reporter. He insisted that he had "abhorred the McCarthy witch hunt," but that by the standards of "independent liberals and socialist observers" Senator McCarran had been "conscientious." (Indeed, McCarran had been supported by such liberal anti-Communists as Herbert Lehman and Hubert Humphrey.) Wittfogel had felt that by testifying he could at last punish the Stalinists for their many betrayals of the German working class while exposing naïve Americans to "the dimension of Communist infiltration." Not everyone applauded his motives.

He now feels that the congressional interviews marked "the end of our project [IPR]." But he considers it "astonishing" and a sign of "the positive forces of American democracy" that he retained the support of "understanding colleagues, liberals and anti-totalitarian socialists." Given the mood of that era, this is one of the lesser astonishments of émigré life. In a curious addendum to this history, Wittfogel finally returned to Germany in 1979 and was received with great warmth. His congressional testimony seemed insignificant to German students, who hailed him as the prophet of a Marxist anti-Communism. (Similarly, Wittfogel's stress on the permanence of Asiatic despotisms, as opposed to the evanescence of Fascist dictatorships, was also affirmed in the recent neoconservative distinction between authoritarian and totalitarian governments.)

Wittfogel still cites Communist sources; he alludes to what Marx called "the general slavery" and laments that Trotsky had merely observed the "Asiatic" nature of Russian cities, without analyzing them in detail. This is the kind of loving revision that became a familiar aspect of émigré writings—Hannah Arendt

indulged in it. Emigrés still insist that their heroes really concur with them; they were simply sidetracked by grubby details or intellectual sloppiness from seeing the logical development of their own system. In keeping with this mode of salvaging one's intellectual ancestors from their present defilers, another old émigré, a former employee of the CIA, recently observed in defense of his boyhood hero, "But Marx . . . Marx was not a Communist."

By the early fifties most of the émigrés still living in the country had become citizens. But the restrictive policies of the Immigration and Naturalization Service, which had greatly hindered the rescue of many Europeans, continued to frighten émigrés. In the past, those restrictions had often been blatantly racist: this country's 1882 Chinese Exclusion Act had been the model for the Austrian protofascist Georg von Schönerer's ideas for restricting Jewish mobility. During the late forties several hundred foreigners were deported for being subversives or anarchists, while many more were denied entry. The McCarran-Nixon Act (also known as the Internal Security Act of 1950) excluded "totalitarians," but a year later twelve congressmen informed the attorney general that the word "totalitarian" did not refer to former Nazis or Fascists and was simply a code word for "Communist." In 1951 Ernst Chain, a native of Berlin who was then residing in Great Britain and a Nobel Prize winner for his work with penicillin, was denied entry into this country—apparently because he had supervised a United Nations medical team in Czechoslovakia after the Communist coup of 1948. More ominous to citizens was an event that occurred a year earlier. In 1950 the actor and former OWI employee George Voskovec was detained at Ellis Island for ten months before the government cleared him of ties to the Czech Communist Party. In 1952 the Immigration and Nationality Act (the McCarran-Walter Act) became law, despite President Truman's veto. Under the term "inadmissible aliens," the act listed potential saboteurs and terrorists. But the catchall clause, paragraph twenty-eight, applied to the advocates of anarchism and Communism. Particularly

alarming was the reference to "aliens who write or publish (or circulate) any written or printed matter, advocating or teaching" what amounted to radical principles.

So the way was smoothed for Nazis, while a Hanns Eisler might be deported and a Salka Viertel denied a passport. Early in 1953 the attorney general announced that investigations had been initiated for the purpose of discovering grounds for the denaturalization of ten thousand citizens and for the deportation as subversives of twelve thousand aliens. Between 1953 and 1958 the Immigration and Naturalization Service completed 60,371 investigations of "subversives." A citizen might be immune from deportation, but how was a refugee to be sure? The fact was that many had prevaricated upon entering this country. Of course, they had known Communists; in some cases, they had been Party members during their youth, but these were not facts they had volunteered. Now their white lies gleamed like neutral matter turned radioactive. No wonder many people felt insecure even in their citizenship, and regarded the course of their emigration as a transit from affidavit to subpoena.

The phenomenon became more generalized with the advent of McCarthyism. This development spelled danger not only for émigré radicals but for liberals and conservatives as well. Descendants of the pacifist Bertha von Suttner found themselves as vulnerable as those of the revolutionary Rosa Luxemburg. They too might have dallied with leftist alliances; many of them had on occasion socialized with Communists and fellow-travelers. After all, as Hanns Eisler had said, "Refugees . . . stick together," and as Vladimir Nabokov had dramatized in *Pnin*, émigrés upon their arrival lived most vividly among themselves. Now the ideological disputes of countless *Kaffeeklatsche* had been simplified and caricatured for the American public. The way in which the less radical émigrés responded to McCarthyism revealed the wide range of revisions and accommodations compelled by their experiences in this country.

Conventional liberals recognized, as Hans Bethe had during

the persecution of Oppenheimer, that they might be the next to suffer. The institutional home for nonradical émigrés was surely the New School for Social Research. Anyone familiar with émigré quarrels knew that radicals had condemned its faculty for being "insufficiently prematurely anti-Fascist," while the members of the Frankfurt school had dismissed them as pompous philistines. The school had instituted an early loyalty oath affirming allegiance to democratic institutions (the codes of anti-Communism!), and a former employee recalls that murals painted by the radical José Clemente Orozco were kept hidden behind a curtain during the McCarthy days. In a 1953 statement: "The New School stoutly affirms that a member of any political party or group which asserts the right to dictate in matters of science or scientific opinion is not free to teach the truth and therefore is disqualified as a teacher." But right-wing Americans considered the New School a locus of subversion in part because of Hanns Eisler's affiliation with it. After Eisler's appearance before HUAC, Congressman Rankin wondered out loud whether the New School was a "Communist school of instruction." By the early fifties picketers routinely assembled on New York's Thirteenth Street, home of the New School, to condemn the foreign-born Reds.

Alvin Johnson, the school's head, never disowned Eisler: he even addressed a press conference while holding a copy of Eisler's book *Composing for the Films.* He was less alarmed by McCarthy than were other faculty members. When a group of New School and Princeton scholars were plotting ways to combat the inquisitors in the early fifties, he advised them not to waste their energy: according to Hans Staudinger, Johnson said, "This is a political, not an academic, fight. This man McCarthy finishes himself in a year." (Mary McCarthy similarly poohpoohed Hannah Arendt's fears.) Staudinger was less certain. Like Johnson, he offered to testify before congressional committees, but no New Schooler was ever summoned. Shortly before his death, Staudinger claimed that the committee had feared them: "They knew we were ready to hit back." Then the old scholar became adamant. "Either this country has freedom of speech or it is Hitler!"

The conservative Peter Drucker found McCarthyism an amusingly circuitous attack on the Left, destroying them with their own tactics. He pointed out that the blacklist had been initiated in America by Stalinists, recalling his own ostracism in the late thirties after he had predicted a future Hitler-Stalin pact. Drucker lauds his former boss for being "the first prominent American to speak out against McCarthy." Henry Luce did so in a June 1953 editorial, and the date only serves to underline the courage of Mann and Einstein—they too were prominent American citizens—who began to speak out much earlier, as did numerous less celebrated editorialists.

In July 1953 Hannah Arendt wrote for *Aufbau* "Yesterday They Were Still Communists: Former Communists versus Ex-Communists," a German version of an essay she had published four months earlier in *Commonweal*. The essay—a bit tendentious and self-serving, since Arendt's husband, Heinrich Blücher, had been a Trotskyist in Europe—demonstrates her tendency to define by comparison. She characterizes ex-Communists and former Communists in terms of their public roles: former Communists merge and disappear into "the general public and private life"; but ex-Communists are so loath to relinquish their previous renown that they make careers out of their past Party affiliations. For them, it is easier to withstand public humiliation than the private embarrassments that attend a change of profession: "It is a greater decision to disappear from the limelight and become a private person than to change the roles in world history." As militant anti-Communists, they remained zealots, acolytes of a new faith with the old confidence that history had reserved all the prizes for their side. But to believe in any side's final victory is to assume a totalitarian moral stance. "History has many beginnings," Arendt says, "but no ending." She also insists that any rigid ideology is un-American—"America cannot be . . . categorized"—and un-Arendtian —"it cannot be fabricated." Like several other émigrés, she relies on constitutional protections: "The limitations on dissent are the Constitution and the bill of rights, and no one [*sic*] else."

Arendt's essay is subtle, observant, and a little beside the point. The point at that time was moral lassitude and generalized terror. Only two émigré figures confronted this terror and all its implications: these were Albert Einstein and Thomas Mann. Mann, as we have already noted, saw the danger fast and proclaimed it loudly. In 1948, after the HUAC investigations began, he spoke on the radio. Addressing the congressional inquisitors, he declared, "I have the honor to expose myself as a hostile witness." He proceeded to ridicule notions of Communist subversion of the film industry; he said he was embarrassed over American know-nothingism. The persecution of ideas was "very harmful to the cultural reputation of the country." As a writer, he could not ignore the triumph of doubletalk; the use of the word "peace" stamped you as a subversive, and earned you a position on the attorney general's blacklist. At last, Mann stated in public the fears that had animated his private letters and journals. "As an American citizen of German birth, I finally testify that I am painfully familiar with certain political trends. Spiritual intolerance, political inquisition, and declining legal security, and all this in the name of an alleged 'state of emergency' . . . this is how it started in Germany."

The tone of defiance was so much the same in Thomas Mann's "I have the honor to expose myself as a hostile witness" and his son Klaus's "I am proud to state that the name of my own family appeared in each of the four initial 'black lists' issued by Dr. Goebbels" that the echoes may have been deliberate, as if history, in repeating itself, demanded similar responses and language from the vigilant Manns.

If Einstein is to be taken at his word—and his later campaigns for peace constituted the central achievements of his life—then his time in America, especially during the Cold War, was his richest, if most frustrating, period. His was an old age marked by the political crises of an era, causing public matters to be submitted to the judgment of a man who preferred solitude and retirement.

For over forty years the self-described "incorrigible Non-Conformist" suffered the attacks of those who condemned his politics. In 1922, following the assassination of his friend

Walther Rathenau, Einstein embarked on a trip around the world, in part because he had been warned that he was next on the reactionaries' hit list. He became acquainted with flight and adept at subterfuge: a protégé remembers that years later Einstein signed his letters from Princeton to Germany "Elsa Alberti" (after his wife) so that his friend would not suffer from guilt by association. In 1945 the egregious John Rankin, infuriated by Einstein's opposition to Franco's Spain, spoke out in Congress about "this foreign-born agitator. . . . I call upon the Department of Justice to put a stop to this man Einstein." Despite the vulgarity of Rankin's diction, was his message any more disgusting than Vannevar Bush's refusal to grant Einstein the right to participate in atomic research because of the negative implications of "his whole history"?

Over the years, an insidious line about Einstein's life in America has been developed. Because his commitment to a unified-field theory seemed to contradict the conclusions of most eminent physicists, he is pictured as having been something between a superannuated genius and a deluded old man. The implication is that his scientific misconceptions reflected his political errors and that he was duped into supporting subversive organizations. Einstein's refusal to accept the implications of Heisenberg's uncertainty principle continues to set him at odds with most physicists. However, recent Nobel Prize–winning theories have posited an interrelationship between two familiar forces, gravitation and electromagnetism, and two forces discovered after the study of the atom began, the strong force and the weak interaction. If confirmed, this interrelationship would validate the scientific direction of Einstein's late career. Similarly, events since his death only serve to confirm the acuity of his response to politics in an era of mass confusion.

Einstein settled permanently in this country in 1933, although he had made earlier trips here. From the start, he found himself in the company of American radicals. During a 1931 visit to California, he met both Charlie Chaplin and Upton Sinclair. One of his more radical colleagues at Princeton was the mathematician Oswald Veblen, a champion of émigré scientists who would later come close to being denied a passport during the McCarthy

era. Veblen was the nephew of Thorstein Veblen, whose analyses of "the criminal policies of the German ruling class" in 1917 had struck Einstein as being singularly prophetic. Another American acquaintance was Jane Addams, a fellow supporter of the Women's International League for Peace and Freedom. In 1935 Einstein suggested that Addams nominate Carl von Ossietzky, a pacifist newspaper editor who had been arrested by the Nazis, for the Nobel Peace Prize. (Ossietzky was awarded the prize a year later and died in prison in 1938.)

From his earliest days in this country, Einstein aligned himself with the fight for civil liberties and academic freedom. He saw threats to both as the products of an obsolete economic structure. In 1936 he publicly objected to a teachers' oath. Just as McCarthy-era émigrés would, he stressed constitutional law: freedom of speech was guaranteed by the Constitution, although it was at the time inhibited by the machinations of an "econominally dominant minority." Einstein supported an Organization of Intellectual Workers in 1944, exhibiting an astonishing democratic spirit: how many other people of his rank would see themselves as part of so scattered and demotic a work force? But then Einstein modestly said his scientific accomplishments were possible because he had come late to his discipline, after a most unpromising youth.

His concern with the quality of American life was central to his 1946 essay "The Negro Question." Einstein knew that his attacks on segregation would not be well received. By then, he had been told often enough to mind his own business. He anticipates his critics in the essay and contends that as an outsider, "one who has come to this country as a *mature* person" (my italics), he can see what the native-born miss. Yes, the émigré should "speak out freely on what he sees and feels," Einstein adds, gently, "for by so doing, he may perhaps prove himself useful."

"He may perhaps prove himself useful." If there is a characteristic Einstein tone, it is to be found in such tactful, self-effacing statements. Einstein's writings during the postwar period demonstrate a consummate understanding of subtle dis-

criminations—moral, political, and psychological. (Originally unsympathetic to psychoanalysis, Einstein eventually responded more favorably to Freud's analyses of psychological responses.) There are even moments of wit—Einstein always treasured a playful disposition as one means of confounding his enemies. Read together, these essays reveal a spectacularly erudite intelligence that always seeks to render events in human terms, but not to simplify them, for it was Einstein's pleasure to make the complicated accessible while reminding his audience of the human implications of abstruse policies and governmental decisions.

Einstein's humanism shines through his 1949 essay "Why Socialism?" Unlike more melancholy émigrés—Adorno, Arendt, among others—Einstein affirms the Enlightenment's vision of progress in history. He is thrilled by the prospect that human beings are "not condemned because of their biological constitution." His defense of socialism draws upon anthropology, psychoanalysis, and ethics, but it is rooted in economics, because up to now, "economic anarchy . . . the oligarchy of private capital" has thwarted any coherent social planning. He is outraged by the power of American corporations, unchecked by "commensurable responsibility." Yet he fears that such a concentration of power in a Socialist government might make that country even more obsessively militarist than the United States.

Einstein always saw himself as a free spirit. The sensitivity he showed to possible violations of freedom, from Left or Right, was typical. He had been damaged during his youth by the bullying, overregulated nature of German schools. Having barely escaped with a breakdown, he could never countenance the sustained withdrawal of civil liberties—although, as he later told Sidney Hook, he understood the need for a temporary halt during the early days of the Russian Revolution, while condemning as "harmful and even ridiculous" the later Soviet intervention into the arts and sciences.

As an opponent of the United States' exclusive possession of atomic secrets in the 1940s, Einstein found himself forced to comment on the growing hostilities of the two major powers

that eventually resulted in the Cold War. In 1948, during a time of extensive aid packages that culminated in the Marshall Plan and were seen in some quarters as America's purchasing of the Western world, he made the discouraging observation that no action is politically neutral: "Is it not true ... that we have stumbled into a state of international affairs which tends to make every invention of our minds and every material good into a weapon and, consequently, into a danger for mankind?"

On the subject of the Soviet Union, Einstein was remarkably outspoken during a time when sympathy for it was viewed as tantamount to treason. He understood the Soviet uproar in 1946 over U.S. advocacy of UN membership for fascist Argentina, explaining the Russian suspicions by reminding his audience that Western governments supported Hitler during the thirties. Yet the Soviet opposition to a world government struck him as "fanatical intolerance." He did not understand how political anarchy could be tolerated in the homeland of economic planning.

Einstein wittily dismissed some of the Soviet fears of American exploitation. The free enterprise system was too anarchic and muddleheaded to provide a serious, systematic threat; he cited as an example the United States' hoarding of gold in Fort Knox. When the World Congress of Intellectuals convened in Poland in 1948, "those in charge of the congress" would not let his emissary Otto Nathan read his "supernational government" message without deletions that Nathan found unacceptable, although the congress permitted numerous anti-American remarks. Nathan and Einstein were both infuriated, and Einstein later concluded that "our colleagues on the other side of the fence are completely unable to express their real opinions." A year later Einstein and Mann were two of the five hundred sponsors of the Cultural and Scientific Conference for World Peace, held at the Waldorf-Astoria. Right-wingers thought the conference was Communist-dominated; Shostakovich's journals, recently published, indicate that the composer's appearance was largely hypocritical, since he despised Stalin. The image the Soviets projected of a peace-loving nation glossed over twenty years of unspeakable crimes. Einstein would scarcely have been surprised by revelations of Soviet duplicity; anyway, for him

the issue of disarmament always superseded that of a country's internal policies.

Yet Einstein recognized that political stability required both a calmness of spirit and a reduction of the hysterical suspicions with which the two major powers regarded each other. A concern with psychological conditions had already begun to inform his pronouncements. Thus in "Why Socialism?" he mentions that a friend had asked him why he was so deeply opposed to universal destruction. Einstein thought such questions—and many people, fed up with the human race, asked them—were something new in history, "the expression of a painful solitude and isolation." This longing for death obviously pre-empted politics. Einstein became particularly alert to any unconscious obstacles to social change, as in "The Negro Question," when he described the negative influence of tradition on our conscious thought. He was equally sensitive to the historical origins of psychological attitudes in the Soviet Union. He called for tact, not the "clumsy Truman style," in winning the Russians over to disarmament. When a refugee psychoanalyst, Dr. Marseille, wrote him about enforced aerial inspection of the Soviet Union, Einstein replied that the Soviets' "psychological situation" was more complicated than a simple opposition to world government. They hadn't forgotten their twenty million war dead, and neither had he.

As Einstein worked tirelessly for disarmament, he unavoidably became drawn into the outcry over congressional investigations of radicals. On February 1, 1950, he and Thomas Mann joined several Americans, including Carey McWilliams, I. F. Stone, and Linus Pauling, in signing a public statement that condemned the harassment of lawyers who had served as counsel to the defendants during the first postwar Smith Act trials.* Twelve days later, Einstein appeared on Eleanor Roosevelt's television program, together with J. Robert Oppenheimer, who was by then unalterably opposed to Edward Teller's hydrogen

* In the 1951 Smith Act trials, one of the indicted defendants was Abner Green, a native-born Communist and member of the American Council for Protection of the Foreign Born.

bomb. Once again, Einstein deplored the arms race and called for "mutual trust" among nations. Both positions revealed him to the American Right as a traitor.

Yet he was too imposing a figure to confront directly: Rankin's 1945 congressional attack was not repeated. Instead, attempts were made to discomfit Einstein through his friends and colleagues. Rabbi Joachim Prinz had joined Einstein on many podiums since Berlin days; "Einstein," Prinz remembers, "always said all rabbis are terrible but Prinz is a little less terrible." When Conde McGinley attacked Prinz in his *Common Sense*, he compared the rabbi with that other New Jerseyan: "The Red Rabbi, not unlike Albert Einstein, was expelled from Germany for his radical politics."

The most extensive attack on an Einstein colleague was directed against his friend Otto Nathan. Some refugees considered Nathan to be Einstein's political adviser, the man responsible for his outspoken identification with left-wing causes. Accepting this condescending view of Einstein's intellectual independence, American inquisitors must have felt that they could punish Othello by breaking Iago. Nathan himself is a longtime veteran of left-wing and pacifist causes. His own political inspiration came from the pacifist Bertha von Suttner, and he prides himself on being the only man ever to have served on the board of the Women's International League for Peace and Freedom. In the 1950s he was denied a passport on the grounds that he had joined the Communist Party in Germany. Nathan says that this is untrue, and also claims that some of the government's information was obtained from opened mail. Despite his political radicalism, he never joined a socialist party in this country: "They were too inconsequential, and I didn't want to jeopardize my citizenship"—yet another reminder of the inhibitions restraining émigrés. Ultimately he became the first radical to sue for a passport. In July 1955, three months after Einstein's death, an appeals court ruled that Secretary of State John Foster Dulles could not deny Nathan a passport without identifying his accusers. Dulles granted the passport rather than reveal his sources. Subsequently the ACLU initiated several similar lawsuits; they were all successful. A foreign-born radical had helped

reclaim the Constitutional rights of free travel. Likewise, Hannah Arendt's literary demonstration that statelessness was a crime against humanity was cited by Supreme Court Justice Earl Warren when he recommended the outlawing of denaturalization.

Einstein's boldest public stand against McCarthyism occurred in May 1953. While in a month or two Henry Luce might gently scold McCarthy, Einstein wrote to William Frauenglass, a Brooklyn teacher, in a letter he expected to be published, that reactionary politicians were seeking to demoralize teachers—the very subjects of his address twenty years earlier on academic freedom—by getting rid of "all those who do not prove submissive." In a characteristic addendum, Einstein explained that to suppress freedom means "to starve them out." He saw that the Cold Warriors' political attacks proceeded through the pocketbook, because in what Brecht called "the society of the dollar" the loss of money and status usually spells an end to political activity.

In perhaps the most daring public statement of the whole McCarthy period, Einstein said, "Every intellectual who is called before one of the committees ought to refuse to testify, i.e., he must be prepared for jail and economic ruin, in short, for the sacrifice of his personal welfare in the interest of the cultural welfare of his country." Einstein knew that the Fifth Amendment had lost its evocative power through disingenuous rote citations, and that congressmen and journalists had caricatured it as a Communist device. So he counseled not "the well-known subterfuge of invoking the Fifth Amendment . . . , but . . . the assertion that it is shameful for a blameless citizen to submit to such an inquisition and that this kind of inquisition violates the spirit of the Constitution." In the same way that Leo Szilard confronted the United States military armed with his citizen's rights as defined in the Constitution, so did Einstein look to that document to support offensive actions against the United States Congress.

The consequences were predictable. Virtually all the American newspapers, particularly *The New York Times*, were outraged; Einstein, with typical émigré good humor, credited this

to their dependence on advertisements. He wondered out loud to a friend (Otto Nathan?) whether he might have to go to jail himself. The remark was only "half in earnest"; Einstein was that much less frightened than Thomas Mann had been when he had contemplated flight from America three years earlier. Einstein's response may have been the more reasoned one, though even half a chance at prison was too much. Still, the fear must not have been too great: months later he advised Oppenheimer on the eve of his trial to resist by refusing to cooperate with the investigators. (Oppenheimer either didn't hear or didn't listen; his testimony was forthright, detailed, and filled with *mea culpas.*)

The most famous of the refugees, Einstein exemplified the best kind of émigré critic. Instead of wasting time on laments that New York wasn't Berlin or Frankfurt or Paris—i.e., that Americans weren't European enough—he asserted that the problem was that Americans weren't American enough. The victims of so many false images, émigrés now served to remind Americans of *their* proper and original image; it was the cowards and demagogues among them who were truly un-American. The risk of jail or deportation meant less to such émigrés than the privileges and obligations of citizenship.*

* Einstein's belief that the only way to arouse people's opposition to nuclear weapons would be to "bring the news to the village square" is a similar instance of his faith in American democracy at its purest level.

18

"I Somehow Don't Fit": Hannah Arendt

Though Hannah Arendt described herself professionally as a political scientist and was frequently regarded as a metaphysician, she seemed most content and persuasive as a storyteller. She once observed that "the memory of a committed act is revealed only when the action itself has come to an end and become a story susceptible to narration." Her life, which ended in 1975, comprises a special story of emigration, primarily because of its public resonance. Arendt, who had little use for introspection and saw thinking itself as "a kind of practice between men," would not have committed her own story to the page. Her range of interests defied disciplinary barriers, which she considered artificial and anachronistic. She pursued the political implications of all actions, and could be equally impassioned about an intellectual error and a physical assault: thus she could discover in the banality of Eichmann's language the evidence of his thoughtlessness and the matrix of his actions. Yet the range of her interests did not strike her as peculiarly versatile. She saw it as having been prompted by the experiences of emigration; it was the sign not of a holistic disposition—she found something

unseemly in other refugees' pursuit of a "well-rounded personality"—but of a tradition whose pieces were fragmented, intertwined, and, like her, displaced.

Arendt was to become perhaps the most celebrated of émigré academics, although she always distanced herself from the academic Establishment she had entered very late: she received her first university appointment when she was forty-nine. It was her extra-academic experiences in transit and in America that led her to develop a set of terms—"political action," "public realm," "public space"—that served to define a public life that had always been there, though invisible, awaiting her discovery. Arendt's favorite intellectual ploy was the rhetorical device of disclosing something rare in the familiar; she would do what Walter Benjamin called "pearl-fishing," not underwater but in the town square.

Arendt's intellectual independence often isolated her from the surrounding community, whatever its nature; thus when she characterized her heroine Rosa Luxemburg as standing "completely alone" on some issues, she was also describing herself. Yet, paradoxically, her loneliness was accompanied by a large popular audience, and to make this paradox even more surprising, she acquired an American public with two works—*The Origins of Totalitarianism* and *Eichmann in Jerusalem*—that sprang directly from her experiences in emigration. Few other refugee writers made as successful a transition from European to American subject matter. In fact, her ultimate authority as a commentator on American politics was derived from the response to her earlier work on Europe. For a while during the fifties a sizable group of Americans saluted her as the intellectual of the hour; she had already acquired a reputation as the "first lady of Jewish letters." But in later years, although she did not really change her slant or confidence, Arendt found herself regarded as a scourge of the American right wing and as a traitor by the Jewish Establishment. Once the lines of her distinctive émigré vision were clear, she became the subject of bitter public controversy—never more alone than when she was famous.

When she looked at exemplary lives, Arendt insisted that

character was the least subjective of elements, that it was "beyond the control of the subject" precisely because it was fed by historical and political events. Yet when acknowledging her own capacity to infuriate readers, she admitted that "the tone is really the person." Arendt's tone is a characteristic legacy of her tradition and her experience: in fact, the tone as a product of tradition may have enabled her to live through the emigration.

Above all, Arendt was unsentimental. In a short, charming review in 1946 of a friend's book of Berlin street songs, she defined the Berlin sensibility as "extreme skepticism and keenness of mind together with simple kindness and a great fear of sentimentality." Arendt shared these attributes. If this meant, as Gershom Scholem complained, that she lacked *"Herzenstakt"* (heart's tact), in writing about her fellow Jews, she would accept the analysis: *Herzenstakt* was for her too perilously close to an abandonment of intellectual rigor. And this would not be good for Jewish history either, as can be inferred from Arendt's contempt for the postwar trend in Germany and America that could, as in the canonizing of Anne Frank, "reduce horror to sentimentality." Arendt preserved her own heroes from sentimentality. She could dismiss Rosa Luxemburg's poignant letters from prison as irrelevant; insisting on their charms would demote Luxemburg into a figure of pathos. And in her assessment of Bertolt Brecht, whose talent she worshiped but whose politics she abhorred, she took for granted that he was without self-pity, unlike his fellow émigrés, and thus uniquely equipped to sing the saga of emigration.

Arendt's own tone, as she told a young German interviewer, was "largely ironic." That's how it was. If people misrepresented her work, she was furious, but if she hurt their feelings, well—there was nothing she could do about that. She would rather laugh than cry; in fact, she expected to be laughing three minutes before her death. She would leave it to later writers to discern whether the ironic, unsentimental manner of the Berlin streets was suitable to apprehending the history of German Jewish emigration.

Arendt was trained as a philosopher under such eminent professors as Karl Jaspers and Martin Heidegger. As she told Scho-

lem, "the tradition of German philosophy" and not politics of any description had been her starting place. But political events turned her from philosophy. Among these, surely, was her mentor Heidegger's flirtation with the Nazi movement. Years later Arendt observed the special lure of tyrants for philosophers, from Plato to Heidegger, excepting only her favorite, Kant (and, by extension, her other mentor, Karl Jaspers, whom she saw as Kant's heir). Also, as she acknowledged in her last book, she did not share the traditional Teutonic displeasure with the world as it was constituted at present, or the associated inclination, shared even by a Theodor Adorno, for "homesickness." Arendt was not homesick for heaven, or for the ivory tower, or for nineteenth-century Europe, nor was she inclined to find a promise of bliss in some upcoming utopia. As one of her titles indicated, she found herself living precisely "between past and future," unable to derive solace from the prospect of either.

She offered as an intellectual apology the facts of her emigration. Hitler's accession to power turned her into a displaced person, and instructed her that the categories of political thought and moral judgment had evaporated. Arendt saw her peculiar task as salvaging the best of the past. She would read her predecessors "as though nobody had ever read them before," often finding meanings that contradicted history and common sense. Benjamin's "pearl-fishing," she said, would perforce uncover a Shakespearean sea change. An old friend says, "I used to call her, with affection, chutzpah Hannah, because she would take on anyone and remake him in her image."

Arendt found the real "moments of truth" in anecdotes, not in philosophical discourse. Similarly it was language, "what we live by," that sustained her rather than any philosophical or metaphysical assurance. As she told a German reporter, "What's left? The mother-tongue is left." Her own historical experiences always provided the resonance, and there remained, if not a mother tongue, at least a mother's tone.

She was the daughter of wealthy Jews in the East Prussian city of Königsberg; her grandfather had been the president of both the liberal Jewish congregation and the city council. This was a very special family. Its lineaments can be guessed from

her description of Rosa Luxemburg's clan. Luxemburg represented the smallest minority of assimilated Jews, but by Arendt's lights the best, the very models of Nietzsche's ideal Europeans, liberated from the bondage of nationalist goals and identities. Families like the Luxemburgs and Arendts provided "peer group protection," an awkward term for a quality of humane acceptance that allowed for political experimentation and became "the source of revolutionary spirit." What Luxemburg's family instilled was "moral taste," an elusive attribute but one that Arendt would discover in all her later heroes. Equipped with moral taste and the peer group's protection, these Jews developed a self-confidence that could be "perceived as arrogance and conceit," quite as the self-assurance of Arendt and her fellow émigrés would later be described. But such responses, while not surprising, were unsubtle. For, in truth, the peer groups shared a "genuine almost naïve contempt for social and ethnic distinction." Emigrés like Arendt may have been snobs, but they appealed to standards of intellectual accomplishment that had nothing to do with wealth or social status.

Arendt was both a loyal daughter and an intellectual rebel. Her mother, Martha Cohn, was a devotee of Rosa Luxemburg and a socialist—which Hannah clearly, publicly, repeatedly asserted she was not, although her first husband, Günther Anders, was also sympathetic to Marx. She was even more alienated from her mother's interest in Freudian psychoanalysis, and to extend her discomfort, Anders's father was the child psychologist William Stern. Her equanimity was possible because Arendt knew better than to confuse personal loyalty and intellectual positions. Thus it was in keeping that many years later in America, Arendt's first husband bequeathed his New School lectureship to her second husband, Heinrich Blücher.

Arendt's distrust of inwardness was also a personal reaction to the bouts of melancholy that had marked her youth from the time her father died of syphilis. As her biographer Elisabeth Young-Bruehl has revealed, Arendt was masochistically self-demeaning when Heidegger rejected her and briefly suicidal during her internment in France. She was thus no stranger to the depressions that had vanquished other refugees. In addition,

her friends knew her as ferociously opinionated when aroused—the very model of a snappish émigré. Hence she might have been expected to exhibit more compassion toward émigrés' weaknesses, but instead, with a quite Prussian vehemence, she became determined *not* to be sidetracked by merely personal considerations. Brecht often noted that self-reflection inhibited productivity; Arendt would have added that it also got in the way of politics.

Her distaste for *Schmus* (sweet talk) was a political resource. It was exemplified in Germany during the early thirties when her Gentile friends insisted that she was beyond category—a European, a human being—and she replied to such "silliness" that all she was, was a Jew. Any attempt to enlarge her social identity would obscure her immediate danger. Similarly, when Arendt spoke about language her focus was again political. Her critics may have been right on many counts, but they were dead wrong in seeing her attacks on the banality of language as merely aesthetic. In 1933 Günther Anders exhibited singular courage by conducting a seminar in Berlin on *Mein Kampf.* One friend remembers that "he had great difficulty recruiting participants." Intellectuals were either naïve or frightened about what a close reading of Hitler's book would reveal. So Arendt had an early lesson that German Jews were quite as ready to avoid unpleasant truths as anyone else. She was also prepared for a history of positions that would leave her at times virtually isolated, and that would always be informed by her characteristic way of drawing meanings from the text she read, whether it was *Mein Kampf* or the testimony of Adolf Eichmann.

In fact, the study of language was an immediate cause of her emigration. She was chosen by her friend the Zionist Kurt Blumenfeld to analyze the use of anti-Semitic expressions—so-called *Greuelpropaganda* (horror propaganda)—among the working classes. Typically, Arendt, the "Pallas Athene" of her Zionist crowd, recorded her notes on vulgar slang in Greek. The Nazis arrested her for this scholarly research—they agreed that linguistic analysis was a radical political action—as well as for harboring Communists in her apartment. She spent only eight days in jail, during which she was befriended by a jailer who

provided her with cigarettes (her chain-smoking was a lifelong habit). But she fled the country illegally while the investigation was still in progress. When Arendt writes that Augustine, mired in intellectual dilemmas, was rescued by the language itself, which provided grammatical solutions, she seems to be indulging in rarefied academic chitchat. But from her arrest for linguistic analysis to her later conviction that only the mother tongue remained of past history, the study of language was for her no academic matter.

After leaving Germany, Arendt lived in several cities, including Prague, Geneva, and Paris. She became an early Zionist largely because Palestine offered a sanctuary to refugee Jews. While in Paris she worked for the Zionist group Youth Aliyah, facilitating the rescue of Jewish children. She also acquired a deep suspicion of the Jewish Establishment. From her observations of her acquaintances the Rothschilds, she became convinced that such philanthropists would always patronize the poor and court the rich—in other words, they refused to defend the interests of Jews in other countries. While in Paris, Arendt and Günther Anders were divorced, and she subsequently married Heinrich Blücher, a Trotskyist workman who later taught philosophy at American colleges. She spent some time in the French internment camp for enemy aliens at Gurs before arriving in New York with her mother and husband in 1941. Mother and daughter found jobs rapidly enough. The mother worked, as many refugee women did, as a seamstress, and before long, she participated in a strike by her sister laborers—a nice instance of class consciousness amid the daily toils of emigration. Her daughter found employment as the research director of the Conference on Jewish Relations. She also found time to write. By November 1941 Hannah had published in *Aufbau* "Die Jüdische Armee—der Beginn einer Jüdischer Politik," a call for the Jewish people to assume their own defense. It was a quixotic essay, no doubt, but one that raised questions that would reappear two decades later in the Eichmann book.

For several months, Arendt contributed to *Aufbau* a column entitled "This Means You," a recruiter's slogan. She continued to assert that there was a need for a new kind of Jewish poli-

tics, and her position was once again anomalous. Admittedly radical but in no way Marxist, militantly agitating for a Jewish army but wary of a Jewish state, she was a European Zionist rapidly disabused of her Zionism through her experience of American life. By 1943 she was adducing the United States as a model of federation for the Jews and Arabs in Palestine. She also presaged her analysis of Eichmann in an essay that described Heinrich Himmler as a *Spiessbürger*, a Babbitt or philistine. (Her friend Henry Pachter objected that the issue was not Himmler's lack of intellectual "quality" but his abundance of political power.)

Along with these pointedly political articles, she begun turning out a series of essays on refugee life for *Aufbau* and other Jewish journals. More than almost anything else Arendt wrote, these essays demonstrate a literary voice, one that evokes émigré conversation of the highest order—studded with literary allusions, political references, and condensed poetic images. Already her stance was offensive: "I speak of unpopular facts," she wrote, courting ostracism then as later in her determination to speak the truth. The tone she deems appropriate for truth telling is witty and acerbic, a journalistic extension of the *Berliner Schnauze*. It is also combative: she places herself at some distance from the more famous émigré writers.

Arendt had decided that the failure of other émigré writers was as much social and political as literary; her main example was the miserable Stefan Zweig, whose suicide was widely regarded in the émigré community as a betrayal. (It is interesting to note that although Arendt did not acknowledge this, Zweig had briefly employed her as his secretary in Paris.) Arendt dismisses his suicide as the predictable culmination of a lifetime spent denying reality. Because Zweig had no political sense whatsoever—and was proud of this lack!—his nostalgic memoir, *The World of Yesterday*, misrepresented the era before World War I as a "Golden Age of Security." In Vienna, the school of fame was the theater, the image of fame the actor, the hierarchy of fame merely a dress rehearsal for the star system. As a logical consequence, Zweig's generation of cultural chameleons confused reputation with power. They constructed *kitschig* fanta-

sies while withholding from their people the practical information necessary for survival in a Gentile world.

In castigating the publicity machine, Arendt was promoting a better way of becoming public and visible. Unlike those émigré writers who ignored certain realities, her intention was to speak Jewish truth to Gentile power—although for the moment "we refugees" constituted her only audience. She shared the group's sense of humor, but when she alluded to refugee jokes—for example, the story of the émigré dachshund bemoaning his prior life as a St. Bernard, or the tale of her archetypal refugee, "Hans Cohen of Berlin"—it was in order to bring émigrés back to their senses. Enough of fiction, enough of theater, enough of fame.

She began her essay "We Refugees" with a characteristic analysis of the word's meaning followed by a refutation of the popular usage. Her ironic tone discriminated between the "refugees," of which she was obviously one, and a "we" to which she'd rather not belong. To begin with, "we" don't like the word that describes us. Call us immigrants or, better yet, newcomers. We "committed no act" (an unsatisfying demurral for Arendt, who values action). Everyone knows that refugees are all radicals—although we had "no radical opinion"—or Jews. So please don't link us to "the so-called Jewish problem," the double quotes tossed off with the disdain of some traveler delayed between flights from Gstaad to St. Moritz. (Arendt was enraged by the refusal of émigrés to own up to their Jewishness. Although she had left Germany after sheltering Communists in her Berlin apartment and although both her husbands were political radicals, she insisted that the source of the refugees' victimization was no more and no less than their Jewish identity. She discerned a ridiculous insularity in the failure to acknowledge a mutual plight: to her it was predictable that the Jews of each European nation believed themselves safe from Hitler's executioners, unlike the vulgar "yids" in surrounding countries. The awful joke was that precisely because these Jews had lacked an international perspective on their condition, Hitler was able to apply one of his own. These conclusions informed Arendt's postwar assertion, previously cited, that only a few refugees had been courageous enough to tell the truth.)

She understands the general confusion. We lost our homes, our jobs, our language. But instead of recalling our losses and their historical implications, we have been instructed to forget them. We were not Europeans before, but persons sealed off in a kind of "unconscious exile"—what on another occasion Max Ascoli described as Americans waiting to be born. "Among ourselves, we don't speak about the past." The past we deny is really the present: the concentration camps where other Jews are dying. We choose to regard the future. We do not refer to "contemporary history" because it tells us we are Jewish and homeless. But having disowned the past, we reject history and politics. Instead, our guides to the future are the stars and penmanship, astrology and graphology. The result is an "insane optimism," which is not buoyed by confidence in a political cause but instead disguises a profound desire for death, the proper terminus for such life-denying games.

So we commit suicide and leave cheerful notes, as if to divert attention from our action. In a personal aside, Arendt recalls her detainment at Gurs. Suicide was not even an option there, for one would have been "abnormally asocial and unconcerned about general events if one were still to interpret the whole accident as personal and individual bad luck." Since the monolithic apparatus is not aimed exclusively at oneself, since one is merely one among ten million other European Jews, suicide is more than senseless—it is an affront to the group. She sees émigré suicides as having been defeated by a loss in status, a phony identification with the very powers that oppressed them: "They die of a kind of selfishness." (Similarly, Thomas Mann exhibited no sympathy for the suicide Zweig: "Did he regard his life as a purely private affair? Could he concede the archenemy such a triumph?")

Much as she regarded such acts of desperation as selfish, she had little tolerance for any displays of self-obsession. Her essays of the forties are filled with snide comments about individual biography. She had no tolerance for psychoanalysis or popular biography, dismissing the one as a kind of witchcraft, the other as commercial gossip. Instead, she merged social and psychological perception, subsumed the individual in the group, as if anyone

larger than life is aberrant: "Men's lives must be nominal, not exceptional."

Jews required alternatives to the passivity of self-regard. In a 1944 essay Arendt invoked the contrast between the pariah as outsider and the parvenu. For her, the finest Jewish qualities— "humanity, humor, disinterested intelligence"—were pariah qualities; the major Jewish shortcomings—tactlessness, political stupidity, inferiority complexes, money grubbing—were parvenu attributes.

She did not advocate that émigrés remain pariahs—they had been that long enough—or that they aspire to the vapid rewards of the parvenu. Rather, she wanted them to transcend their pariah-hood by engaging in a group effort: only "within the framework of a people" can men's lives be nominal, the plural prepares the way for the singular. While insulting nearly everyone in the émigré community, Arendt had an almost ingenuous confidence. "Those few refugees who insist on the truth" will be unpopular, but they will acquire access to history and politics, "no longer the privilege of the gentiles." Quit acting, she encouraged her readers. Admit who we are, and we can become the "vanguard" of all nations.

So, all at once, Arendt was challenging the members of her common world—whether the "You" in "This Means You" or the "We" in "We Refugees." Her tone also conveyed an implicit literary manifesto. Arendt had little sympathy for other refugee writers; as she commented in her Brecht essay, most of them "remembered everything and forgot what mattered." In their self-obsession, they neglected the world, the only ground of meaning left them. Emigré writers should have been, as Brecht had recognized and named them, "messengers of ill tidings." But they had forgotten the message in transit.

She was particularly removed from her fellow émigrés of the Frankfurt school. The alienation was personal, political, and philosophical. She never forgave Adorno and Horkheimer for keeping Walter Benjamin uncertain about whether they would sponsor his visa. She admitted that they eventually came through, though she believed they sat on some of Benjamin's best work, not publishing it until 1945. She also disliked the

Frankfurters' Hegelianism. Toward the end of her life she told an audience that she thought "critically," and then regretted the use of the word because of its Frankfurt school associations. She dismissed the "Hegelian trick in which one concept, all of its own, begins to develop into its own *negative. No it doesn't.* And *good* doesn't develop into *bad,* and *bad* doesn't develop into good."

Her remark leaves little doubt of Arendt's disdain, although she too has been accused of transcending factual reality. Another émigré, the Anglo-Austrian Marxist E. H. Hobsbawm, sees her work as a "cross between literary psychology . . . and social prophecy," and feels it "as unfair to judge her intellectual drama by factual standards as Schiller's *Don Carlos.*" As he observes, it would be "another order of discourse" that objected to Arendt's imaginings for being riddled with historical errors.

Arendt's first American years were a time when "we were all poor." She began working as an editor at Schocken Books, actively promoting the new American success of Franz Kafka. Despite a career of opposition to the excesses of publicity, she is remembered by her friend Hans Jonas as "a very good publicist" herself. Finally, she began appearing in American journals, having been encouraged by American literary friends. Randall Jarrell, for one, edited a series of essays she contributed to *The Nation.* In a 1946 review of John Dewey, she began to apply the characteristic Arendt style to American issues. She questioned the philosopher's naïve optimism about progress in history—years later, she remembered that a *Partisan Review* editor had grumbled, "She doesn't even believe in progress"—and noted the situation of concentration camp inmates who had lost even the barest semblance of human usefulness. Not that she saw history as a drama of decline, either. She refused to traffic in the "delightful playground of mythology," no matter what the myth. With epigrammatic flippancy, she consigned Dewey to an "Ivory Tower of Common Sense."

She was happier writing about the works of her friends Hermann Broch (*The Death of Virgil*) and Robert Gilbert (*Meine Reime Deine Reime*), stressing in these two most disparate writers a similar contempt for kitsch. During this time she was

introducing existential and death philosophy to the readers of *Partisan Review*. But she preferred Broch's treatment of death and his understanding that we all " 'stand on the bridge that is spanned between invisibility and invisibility and nevertheless . . . are caught in the stream' ": a gentle way of asserting that the awareness of mortality is useful only insofar as it illuminates the life before death.

While remaining loyal to her émigré friends, she cultivated a new group of American and English writers, including Jarrell, Dwight Macdonald, Mary McCarthy, and W. H. Auden. Her affection for this country and its political institutions was very strong; for someone who had to flee Germany after analyzing the Nazification of the German language, American freedom of speech was a matter of pride (though during the Cold War she was hardly its boldest exponent). By the late forties, she was introducing young Americans like Irving Howe to the virtues of the Federalist papers. Yet during this period, her main concern was the recent events in Europe. With enormous ambition, she attempted to make sense of the apparently senseless slaughter of eleven million people—Poles, Gypsies, homosexuals, and, above all, her fellow Jews. Arendt's first major study, *The Origins of Totalitarianism* (1951), with its almost obsessive inspection and interpretation of data and its dense, occasionally claustrophobic prose, suggests someone employing every intellectual strategy at her command—not to mention every piece of information—to release herself from a nightmare.

Arendt admitted that the title of the book was inadequate. The very word "origins" assumed a methodology, but, as she acknowledged, she made little use of the "officially recognized instruments." Instead, the book is a highly idiosyncratic attempt to understand something "radically new" through eclectic means and with none of the assurance vouchsafed by intellectual tenure in any discipline. As always when Arendt is fully engaged, hers is a writer's book, written by someone whose experiences of emigration provide the basis of all perceptions. The most poignant image in the book is that of a new twentieth-century creature, the displaced, or stateless, person, the *apatride*. Inasmuch as the displaced person is beyond political protection

or conventional recourse, Arendt feels justified in sketching the disparate and contradictory factors that produced his condition.

The *apatride* had been deprived of his place in the world and, consequently, of all attendant rights. Paradoxically, he is better off committing a crime; at least when he breaks a law, the law will recognize him: better by far a jail than a concentration camp. In her most convincing argument that introspection and personal emotions—sentimentality, if you will, or domestic concerns—are irrelevant, Arendt shows the displaced person forced to rely on the "unpredictable hazards of friendship and sympathy," which simply are not strong enough. Human rights became a kitsch slogan during a time when there was "nothing sacred in the abstract nakedness of being human." Not that she doesn't respect each person's "absolutely unique individuality," but she contends that without a worldly place to express itself such individuality loses all significance. The displaced person is the real hero of Arendt's book. He is never named, but his very namelessness and lack of visibility provide a negative image of all the famous public figures who have driven him to his doom.

As usual, Arendt is at her best when telling a story with which she is familiar. Hence the section on anti-Semitism, because it draws extensively on her earlier essays for Jewish magazines, is the most satisfying. Though she disdains fiction or anything smacking of the made-up, the work resembles a twentieth-century extension of Balzac or Stendhal, for whom, she says, human passions and fate were social and political phenomena.

She offers a family romance of assimilated bourgeois Jews; despite her attacks on Marxism, she shares its distaste for the bourgeoisie. These Jews sacrificed "character" for convenience, solidarity for social success—thus their swift route to the Establishment and their own anti-Semitism, directed against the poorer *Ostjuden*. She cites, approvingly, the attacks of Heine, Marx, and Karl Kraus on Jewish businessmen and journalists. Her hatred of the bourgeoisie is evident in her contention that the modern era is, pace Marx, "not the last stage of capitalism but the first stage in the political role of the bourgeoisie." Hobbes was right, she says, about the burgher's character:

bourgeois man is without what Rosa Luxemburg would recognize as moral taste. Arendt is equally tough on Jewish chauvinism, though more sympathetic. She abhors the contemporary leap from Judaism as a religion to Jewishness as a cultural style—a common response among émigrés—and notes that by introducing the idea of a Chosen People, admittedly without political claims, the Jews made themselves the logical enemies of the pan-nationalist movements that swept nineteenth-century Europe.

She attacks the bourgeois fathers' obsession with historical progress, citing—perhaps for the first time in English—Walter Benjamin's image of the angel of history looking back on his slaughtered victims. With their eye on the main chance the fathers settled for a small view of political action.

Their sons didn't do much better. In lieu of their proper role, which would have been public and political, they cultivated an "artificially complicated inner life." Arendt echoed Proust's observation that the emotive, self-dramatizing Jew was to become an exotic figure in fin de siècle society, along with criminals and homosexuals. (A roughly similar mix of Jews, radicals, and homosexuals constituted the salons of many émigrés, among them Salka Viertel—and Arendt herself.) The price for entering society this way was exorbitant, as Jews became confused with gangsters and traitors.

Arendt finds that other bourgeois sons declined the rewards of money and status by becoming socialists and artists. And the best of these rejected even the traditional names of intellectual power: "My son the genius" refused to be one, for he saw that the genius, particularly the Jewish genius, had become "a kind of monster." Thus the attempt in the 1920s by Brecht and the Bauhaus artists to demote genius to a mere mastery of logic and craft was an implicit assault on the bourgeois exaltation of the individual.

Bohemian sons, as much as their philistine fathers, would contribute to the spreading of anti-Semitism by exploring every imaginable field of interest but the appropriate one, politics. Arendt suggests a fictional saga in which the descendants of Balzac's burghers and Proust's neurasthenics wind up at Ausch-

witz. And she was to be caught up in a variation of the fiction years later, as we shall see, when the Jewish burghers finally recognized her as their enemy.

Clearly drawing on decades of anger and thought, Arendt's analysis of anti-Semitism proceeds with the urgency of great literature. This indeed is the reality that "We Refugees" had denied. Her later inquiries are less resonant and a good deal more questionable, perhaps because they present a less coherent fiction. The section titled "Imperialism" affords interesting character sketches, somewhat in the manner of early Conrad; Arendt is admirable in relating the massacres of Africans to a generalized European racism. She particularly emphasizes the German slaughter in southeast Africa and Kaiser Wilhelm's verbal attacks on the "yellow peril." But she commits a colossal error—not racist in intent though clearly so in implication, prompted by her curious political categories—when she comes close to exculpating the massacres of African natives because these benighted people had not fabricated a social world. They were merely "natural human beings," unlike the Chinese and Indians with their complex organizations. So, "in a curious sense," the real crimes began only in China and India. One hardly needs a Lévi-Strauss to point out the naïveté of this view of African life. (Like other émigré intellectuals, Arendt was never very shrewd about culture in its more demotic forms.)

Arendt writes contemptuously of the puffed-up titans who set out to colonize the world. Because she sees their imperialist ideology as a forerunner of Fascist terror, she saves her sympathy for their ultimate victim. Unlike the celebrated bankers and kaisers, this person is nameless. She describes him as lower in status than a common criminal and distinguished only by whatever idiosyncrasies the local social oppression has induced.

The subsequent section, "Totalitarianism," is a hodgepodge of straightforward reporting, shrewd analysis, and tendentious argument. Arendt offers an unhappy analysis of the masses, mired in their "essential homelessness," condemned to choose an atomized existence that constitutes a "verdict against the world." Juxtaposed with the masses' anomie is the relentless frenzy of the mob. Arendt describes only two groups as being

largely immune to such infection: Americans, who know least about mob violence (so much for a century of lynching), and Marxists, who were as unprepared for an alliance of mob and capital as they were for the extreme nationalism of the proletariat. She believes the gravest Marxist error was to ignore the power of racism: it wasn't the profit motive that led to the worldlessness inflicted on millions of Jews, Gypsies, and Poles.

She acknowledges the contradictions and paradoxes that attend her interpretations. Americans may be naïve about mobs but Nazi propaganda was inspired by Madison Avenue, and its infrastructure derived from the organization of American gangs (although she rejects Franz Neumann's description of Germany as less a state than a gang and Konrad Heiden's theory of government by clique: she sees all authority as emanating from Hitler or Stalin—which, of course, means that after Stalin's death, the Soviet Union ceased to fit her categorizations). She knows that racism is not limited to Germany, that the Jew is threatened almost everywhere. And, even as she once allowed neo-Catholic journalists the solace of a "fighting faith," she concedes that the masses derive a sense of dignity and protection from the water-tight assurances of their ideology.

The Origins of Totalitarianism is most vulnerable in its embittered analysis of the Soviet Union. Admittedly, Stalin was alive when Arendt wrote it, and the link between Marxism and Stalinism was the standard party line; though as the wife of a former Trotskyist, Arendt knew that not all Marxists were Stalinists. Yet when she asserts that "practically speaking it will make little difference whether totalitarian movements adopt patterns of Nazism or of Bolshevism . . . or organize in the name of race or class," she provides the most blatant justification for hard-line Cold War politics: National Socialist and Communist societies were both insane, committed to their own mad "supersense" of history with its implicit license to murder anyone who fell outside the historical design. It is important to note a neo-Trotskyist tendency in Arendt's work that allowed her to distinguish between Lenin as the author of the revolution and Stalin as its betrayer. Her condemnation of Stalin was thus not necessarily a condemnation of October 1917, although she

didn't offer much hope that the original vision could be salvaged after Stalin's death. There is a big difference between attacking Stalin's form of totalitarianism and attacking Soviet Marxism, but since Arendt didn't make this clear, her work was frequently regarded as a Cold Warrior's bible.

In fact, she muted the parallels between Nazism and Bolshevism in a postscript she published some years later. Perhaps because economic matters seldom claimed her attention, she now contended that economic differences between the East and West constituted a "relatively harmless conflict." Class warfare was pretty much irrelevant. The real battle was between "the totalitarian fiction and the everyday world of factuality in which we live." Earlier, like many other émigrés, she had chosen categories that were virtually post-political: the conflict was not between classes or power groups, but between decent people and thugs. (In private, Arendt was wont to consider the battle of capitalism vs. socialism "intellectual *Quatsch.*")

It is a sign of the book's careless organization that its most moving passage is almost buried toward the end. Here Arendt, speculating about the effects of contemplating the horrors of the death camps, confesses that "the psyche can be destroyed" in the process. What quickens the inanimate and resurrects the mentally dead is thought, and, because this is Hannah Arendt's interpretation, the thought must be of political matters. Such thoughts are "useful only for the perception of political contexts and the mobilization of political passions." She justifies her position as an outsider commenting on the Holocaust, maintaining that precisely because she didn't know the "bestial, desperate fear," she can think through these events. Arendt's is a very bold claim: out of her grief and sympathy for the victims, she comes close to appropriating knowledge of the experience from those who lived it. Perhaps, too, it is a personal declaration addressed to her husband. Blücher was deeply depressed by the revelations of concentration camp atrocities. He may be the hypothetical Lazarus she is raising from despair to more "political passions."

That Arendt's book received so much acclaim—despite the contradictions, despite the characteristic slighting of economic

or sociological analysis—evidenced the curious and probably unparalleled coalescing of a literary émigré's reading of history with the political demands of American Cold Warriors. As a case in point, consider the far less rapturous reception for Franz Neumann's equally massive study of Nazi Germany, *Behemoth* (1942). Of course, Neumann's Marxist analysis was less flattering to American readers than Arendt's conviction that totalitarian societies were something new under the sun, and quite unlike any elements in American life. Neumann's study had its flaws, particularly in its underestimation of the virulence of German anti-Semitism and in its programmatic appeals to the Allies to cultivate German resistance (Neumann was a member of the OSS when he wrote the book). Yet his study has proved to be more prophetic and, for many scholars, more helpful than Arendt's idiosyncratic work.

Unlike Arendt, Neumann had little use for the abstract model of "totalitarianism," recognizing that it blurred the continuities and resemblances between all capitalist societies. Instead, he proffered a concrete analysis of the Nazi system, dividing it into four components: the bureaucracy, which was amoral and self-perpetuating; the party elite, fragmented into ephemeral cliques; the army, made up of contrasting historical types, figures out of Wagner unhappily allied with technocrats; and industry (as a Marxist, Neumann stressed Germany's similarity to other capitalist nations, and predicted that, like the bureaucracy, the forces of production would come through the war unscathed). Arendt would later write about a guilt imposed by Hitler on the German people. Neumann discerned a much more plausible imposition: Hitler was driving the masses crazy for political and military purposes. Neumann's socialist confidence was that the working class could slough off this imposed insanity.

Neumann's method was utterly foreign to Arendt's way of thinking. Her contempt for the petit bourgeoisie—apparent in her theory that capitalism was simply the triumph of the philistines—led her to deny class distinctions; Fascism had simply abolished them. Her lack of interest in economics caused her to find insignificant what struck Neumann as a crucial point: "The

modern fascist leader canalizes the unrest in a manner that leaves untouched the material foundations of society."* The divergence of focuses may explain why Neumann remained obscure while Arendt sprang forth as America's new Delphic Oracle of politics.

Arendt's pleasure in acquiring a large American public with *The Origins of Totalitarianism* was mitigated by her despair over the political atmosphere. Heinrich Blücher wrote friends that "a simple denunciation" could set in motion the process of denaturalization. Mary McCarthy suggests that Arendt was more terrified of the potential for totalitarianism in America than she let on. She describes Arendt in 1952 as having been convinced that Senator McCarthy would "emasculate" the State Department. "Her trust [in American protection of émigrés] vanished on the spot."

As we have seen, Arendt was not the only émigré to have such fears. But by 1958 they had been sufficiently alleviated for her to write more boldly in the second edition of *Origins*. This time she refers to American plans to deprive native-born Communists of their citizenship, though she is still guarded: the attempt is "sinister because undertaken in all innocence." She underlines the "totalitarian tendencies in McCarthyism," especially its demand that citizens prove they were not Communists, which induced a police-state atmosphere of pervasive suspicion. Arendt also appends a reference to Israel's creation of a whole new category of refugees, almost a million stateless, rightless Arabs. Such comments are in keeping with her attacks on militant Zionism during the forties.

By the mid-fifties Arendt had become a doyenne of intellectual circles. Norman Podhoretz, who later would lead the chorus of anti-Arendt Jewish conservatives, admits in his autobiography that an invitation to Arendt's New Year's Eve party

* Of course, Hitler left Germany in ruins, but followers of Neumann would argue that the capitalist forces, as exemplified by the major industrial firms, would bounce back almost immediately and ultimately wind up with a tremendous share of the international market: this was once known as "losing the war and winning the peace."

was a guarantee of "making it." Her intellectual status was enhanced by her 1958 work, *The Human Condition*, a study admittedly prompted by her disagreements with Marx over the nature of human life and productivity. Arendt refused, however, to be enlisted in any campaign against Marx; she quipped that, though he had been accused of never working, "he's provided work for so many." Likewise, she agreed with him that ideas were valuable only to the extent that they functioned in social relations.

Arendt insists on distinguishing labor, an almost biological process involving total immersion in it, from work, the fabrication of something larger than the act itself, akin to her discovery "natality," the beginning of something new (itself, one would think, a biological process!). Vaguely echoing Marx's distinction between productivity for use and productivity for profit, she asserts that the products of labor exist to be consumed and forgotten, while work products are to be used and admired. One reason Marxists welcomed the Industrial Revolution is that it obviated such distinctions. Arendt is less sanguine about history. Since she does not believe in progress, she beholds workmanship diminished to the level of labor, and is unconcerned with the political implications of either labor or work, since they fall below her favored form of activity, public action.

The public world she celebrates had its origins in the Greek *polis* (city). Arendt admits that this world was closed to slaves and foreigners (and women), but with her enduring capacity to snatch what she needs and reject whatever is troublesome or contradictory, she continues to use the *polis* as her model of "power independent of material factors." In the modern world, neither the jobholder nor the businessman inhabits a public space. Her leftist critics fail to recognize that Arendt is even less accommodating to the bourgeoisie than to the proletarians.

For Arendt, at least the latter have an attractive history. She celebrates the early labor movement as the only nineteenth-century model of men acting for political as well as economic gains. In fact, she is sympathetic to workers as long as their considerations are extra-economic; elsewhere she argues that "economic necessities needed the role of masters to function well." In a

dizzying sequence of unproved assertions, she denies the economic nature of labor unions—they did not arise out of labor itself, which is a thoughtless activity, but out of considered opposition to injustice and hypocrisy—and then sees the demise of contemporary unions as class society is transformed into mass society and a guaranteed annual income is introduced.

And yet, despite an analysis that would not offend the members of the National Association of Manufacturers, Arendt was poising herself for the far bolder, more radical analyses she was to produce in her last years. By 1953, in a review of her friend Waldemar Gurian's *Bolshevism*, she appeared unconvinced that Marxism and Stalinism were the same. And her later points scored against Marx—e.g., that he misconceived a pattern, "class struggle," for a meaning—were abstract and abstruse in ways that could scarcely fuel any Cold Warrior's arsenal.

For several years, she continued to teach and lecture, and to publish in journals ranging from the right-wing *Review of Politics* to the liberal, anti-Communist *Partisan Review*. Her public audience expanded manifold when *The New Yorker* commissioned her to cover the Jerusalem trial of Adolf Eichmann, the Nazi official in charge of Jewish deportation whom Israel had abducted from the Argentine home to which he had fled after escaping from the Allied police in 1945. The ensuing book, *Eichmann in Jerusalem: A Report on the Banality of Evil* (1963), made her a figure of violent controversy. She found herself misrepresented by critics who, apparently unaware of the positions evident in her 1941 *Aufbau* essay on the need for a Jewish army and political program, treated her as a renegade. Yet the Eichmann book is one of Arendt's more stirring and least tendentious works. It springs from a refugee's attempt to understand the cluster of actions that culminated in the Holocaust. As a result, perhaps, it is much less abstract than *Origins*, with its vague notions of "supersense" and "radical evil," and far more attentive to the local differences that made it possible for some Jews in some places to survive. Paradoxically, a book geared to a popular audience may exhibit more rigorous think-

ing than Arendt's more scholarly work. The Eichmann book also elaborates on several of the themes that had obsessed her since the 1930s, above all the political consequences for the Jewish people of denying reality. And its reception by Europeans and Americans, Jews and Christians, and particularly by émigrés, makes for one of the most astonishing chapters in the history of the escape from Hitler.

Arendt does not masquerade as a disinterested observer. From the start, she is clearly and consciously implicated in the history being revealed in that Jerusalem courtroom. In fact, Arendt often writes as the representative of all the German Jewish refugees who have nourished terrible memories and worried about the same questions raised in the trial. A refugee would especially appreciate the good sense of the judge leading his colleagues to employ German, their mother tongue, in interrogating Eichmann. As she says, the courtroom was packed with "middle-aged and elderly people, immigrants from Europe, like myself, who knew by heart all there was to know, and who were in no mood to learn any lessons and certainly did not need the trial to draw their own conclusions." There is the characteristic Arendt tone, measured, tough, immune to kitsch.

Arendt had no illusion that Gideon Hausner was the most clear-sighted and disinterested of prosecutors. When he asked Jewish witnesses why they hadn't resisted, she commented that the question was sententious and rhetorical—"cruel and silly"—because, in fact, no group had resisted, and the very few unorganized Dutch Jews who had were tortured so mercilessly that Auschwitz would have been a better fate. Arendt makes the political point that the prosecutor's thesis has a political subtext: only right-wing Zionism and a militant Israel can prevent another holocaust. She doesn't agree, which immediately puts her at a disadvantage with many American and Israeli readers. She observes that Israelis are disingenuous when they oppose ethnic distinctions while outlawing mixed marriages. She constantly accuses the Israelis of sharing a German preoccupation with superior and inferior peoples. Thus in her second edition she notes that Hausner considered the extermination of the Gypsies to be of lesser significance. She points out that the anti-Hitler con-

spirator Carl Friedrich Goerdeler had been willing to indemnify German Jews in 1942, while ignoring the other nationalities that Hitler was persecuting. Late in the book, recalling that the Nazis introduced the category of "Prominent Jews" in 1942, she is disturbed by the fact that so many Jews and Gentiles alike assented to such hierarchies. Her point had always been that the victimization of the little man, Hans Cohen, was much more horrible than the harassment of an Einstein. For Arendt, the "dubious attempts . . . to tell only the Jewish side of the story distorted the truth, even the Jewish truth." She insists that this is a case much too narrowly defined as the persecution of one isolated religious group. She is extremely severe on the prosecution for so dramatically stacking the case against Eichmann—buttressed largely by the testimony of an American judge who would later blast Arendt on the front page of *The New York Times Book Review*—that the judiciary felt the need to come to his defense. The misrepresentation of Eichmann as the man responsible for the initiation of actions conceived by his superiors, she says, is in tune with the prosecution's generally misguided emphases.

If Arendt is hard on Hausner, she is clearly enraged by the West German government. Many refugees have noted a peculiar symbiotic relationship between Israel and West Germany; after all, Israel has been generously subsidized by German restitution money. And, as Arendt later observed, the Israelis' case for restitution depended largely on limiting the crimes to German nationals. She observes several times that the Adenauer administration has welcomed many former Nazis—while continuing to absolve the protofascist murderers of Rosa Luxemburg.

The leniency extended by the German courts disgusts her. She will not let the German people off so easily. Instead she notes the "ubiquitous complicity" that extended far beyond party membership, and, eighteen years after the war, discovers "mendacity" to have become a national characteristic of the Germans. Just as she will not traffic with Israeli propaganda, she is merciless in attacking the prized German myth of 1944 anti-Hitler conspirators. Their sole desire was to head off a civil war,

she claims, and quotes a concentration camp inmate: "A little late, gentlemen," to oppose the man you have supported for so long. Unlike a Brecht, Arendt is inured to sentimentality of the Left: she dismisses the conservatives' rebellion but also observes that there was no sustained socialist resistance. Regarding what Nazism has done to the German people, she tells a story worthy of Brecht about a deranged woman who, prepared to die for Hitler, complained that all the good gas had already been wasted on the Jews.

Arendt says that many, many people are like Eichmann, and that these many are "terrifyingly normal." This statement has been misread as a whitewash of Eichmann, rather than as what it is: a devastating vision of the kinds of citizens caught up in the "ubiquitous complicity" of German guilt.

Arendt's analysis of Eichmann emphasizes the banality of evil and its expression in a banality of language. It is a major misreading to see her objections as merely aesthetic ones: as she says, the many people who call the Nazis "barbarians" make it appear that their victims objected to their "unrefined" manners. She was not expecting a Goethe or a Heine in Eichmann. Rather her perceptions about his jargon derive from her profound respect for language as the clearest reflection of human thought. This is, after all, the woman who felt that if nothing else was left, the mother tongue remained. Perhaps the problem with Arendt's analysis is that she finds Eichmann so comical: "The horrible can be not only ludicrous but downright funny." For someone steeped as she was in the verbal traditions of the German language, it is funny to hear Eichmann cite *"geflügelte Worte"* (literally, "winged words"—but also the title of an anthology of well-known sayings) when he speaks in slogans and stock phrases; her émigré ears hear the equivalent of "I will now illuminate my crimes with a few of Bartlett's familiar quotations." Eichmann's inability to speak is for her irrefutable evidence of his inability to think. He admits that *"Amtssprache"* (officialese) is his only language. And Arendt, in one of her astonishing leaps of sympathy, explains that *Sprachregelung* (language rules) were employed by Germans in order to insulate themselves from the full horror of their actions. Sensitive to

rules of grammar and syntax, Arendt makes the subtle point that speech rules and official language enable the guilty parties to turn their "instincts around, as it were," so they can meditate not on "what I did but on what I had to bear." At such moments, the refugee Arendt can give the last word on an era in which words did not fulfill their proper function of describing reality.

Because Eichmann is for her a clown, she has fun at his expense. When he bargains in 1944 for Hungarian Jewish lives, his prices are the lowest in town, simply "because he was not used to thinking big." (A similar gallows humor surfaces when she notes the Rumanian about-face in switching from zealous anti-Semitic butchery to a willingness to sell Jewish lives for gold as proof that Rumania was "the most vicious and the most corrupt country in the Balkans.") Eichmann dies a clown. Arendt notes the "grotesque silliness of his last words": saluting Germany and Argentina, he declares, "I will not forget them." Then he addresses the crowd with some final *geflügelte Worte:* "We shall meet again." Like the final, most horrible apotheosis of Heinrich Mann's *Untertan,* Dieter, Eichmann was positively "elated" at his own execution.

The disentangling of words and sense could not be sharper, or, given the circumstances, funnier. Yet shortly before her description of the execution, Arendt notes that what enabled the Israelis to kidnap Eichmann in Argentina and bring him to trial was his statelessness; the very condition that had made his victims so vulnerable also proved to be his own undoing.

Arendt cites in the book many other instances of banal expression, always linked to political and moral failure. Arendt never forgave the Catholic Church for its inertia during World War II. When the Vatican finally extended asylum to a few Hungarian Jews, it did so, according to official announcement, "not from a false sense of compassion," a blood-curdling phrase that Arendt takes particular care to emphasize. But German banality is Arendt's prime target, and she tracks it with the sustained animus of one sitting in that courtroom who had indeed drawn her own conclusions after years of acquaintance with the facts.

She recalls the German Robert Ley, who suggested in 1945 that "conciliation committees" bring Jews and Germans together again. Like Eichmann, she says, the German people are protecting themselves with "self-fabricated . . . stock phrases." In their "veritable genius for understatement," they can refer to the Nazis as "ungut" (ungood); what the Nuremberg Charter called "inhuman acts" was translated into German as *Verbrechen gegen die Menschlichkeit* (crimes against humanity). Arendt has no sympathy for the middle-aged Germans who seem to have shed all traces of guilt. And she is exasperated with the sentimental younger Germans who assume a guilt for which they are not responsible. It's very pleasant to scourge oneself "if you haven't done a thing"; but it's all a diversionary tactic. Young Germans may indulge in orgies of self-recrimination, prompted by the Eichmann trial or "the *Diary of Anne Frank* hubbub." Really, all they are doing is retreating into "a cheap sentimentality." Facts are not examined, society is not changed, and kitsch continues to rule the day.

All this material is presented in a vivid, colloquial manner: this is surely Arendt's most accessible book. But what infuriated many readers was a short section on the leaders of the Jewish community who provided German authorities with all manner of assistance. Arendt is not bothered by the participation by Jewish *capos* in the Holocaust: this was "horrible [but] no moral problem," since as prisoners, they had little alternative. But the action before is something else: the "disastrous role" of the Jewish councils is "to a Jew"—and she later insisted that this was purely a Jewish complaint—"the darkest chapter of the whole dark story."

Everywhere—Amsterdam, Warsaw, Berlin, Budapest—it was the same. Jewish leaders compiled lists of persons and property, "secured money for the deportees to defray the expenses of their deportation and extermination," and organized the efficient evacuation of whole communities. On occasion the leaders even selected a few people to be saved—and these tended to be "prominent Jews" and functionaries. Arendt surveys the various Jewish leaders—scoundrels and scholars—and is unhappy with the lot: her description of the Berlin rabbi Leo Baeck as a "Jew-

ish *Führer*," expunged from further editions, is unnecessarily flippant. But this matter—legally irrelevant to the trial—had been raised by the Israeli prosecution.

Why, she wonders, did the Jewish leaders keep matters secret from their own people? In a word, why didn't they warn them? One rabbi testified that perhaps half of those who attempted to escape were captured and killed. She remarks that this is a considerable improvement over the 99 percent who perished in the camps. Such details inform Arendt's remarkable assertion that if the Jewish people had been "unorganized and leaderless," they would have suffered aplenty but would ultimately have been better off, since so many people, left to their own devices, would have escaped. (Of course, she knew and insisted that once they entered the camps, the Jews had to abandon all hope.)

Arendt may underestimate the amount of Jewish resistance, although she is deeply stirred by the quixotic courage of those who fought back. And, indeed, when numbers were so small, what point is gained by finding a few more? Her point is that Jewish resistance was not representative, for the same reason that "people volunteered for deportation from Theresienstadt to Auschwitz and denounced those who tried to tell them the truth as being 'not sane.'" Whether out of melancholy or chagrin, Arendt does not insist on the point that here was another refusal to face facts, as well as a terrible instance of misrepresenting reality for "humane" or "sentimental" considerations. (She notes that although Leo Baeck believed the *capos* would be gentler to their Jewish captives than the Nazis, in fact they were even more brutal, because they had everything to lose. The sentimental projection was simply unrealistic.)

The disinclination to face facts is linked for Arendt to the artificial categories accepted by many Jewish leaders, e.g., the privileged categories that arose after World War I and pitted German Jews against Polish Jews (an echo of the German prejudice against *Ostjuden* that she remembered from her childhood), or decorated army veterans against nondecorated, and so on. These categories marked "the beginning of the moral collapse of respectable Jewish society." Never very sympathetic to the bourgeoisie, Arendt at this juncture pointedly says their

snobbery was self-destructive. As she did in *The Origins of To-talitarianism*, she regrets that Jews were not belligerents; had they been so, they might have been eligible for the less exacting conditions of prisoner-of-war camps.

Despite the many dreadful facts she presents, Arendt does not yield to the sentimentality of hopelessness; as she had written in the John Dewey essay, she was equally ill-disposed to visions of progress or decline in history. And she discovers a few details to lift the spirit. If German Jewish war veterans exulted when awarded medals, French Jewish veterans renounced exceptional benefits. All the European countries seemed to have resisted deportation of their native Jews—a case of chauvinism that worked to the Jews' benefit. And in the ideal realization of her abstract schemes—the equivalent, if you will, of that 1930s Palestine that exemplified her vision of a society totally fabricated for non-economic motives—the Danish people demonstrated the connections between responsible citizenship and human decency. Led by a king who offered to wear the Yellow Star, the Danes succeeded in saving almost all their native Jews, thus exhibiting "the enormous power potential inherent in non-violent action." The Italians were similarly committed to saving their Jews, but their motive, she says, was simply humanitarian. The Danes saw the issue as "a political question": Arendt could offer no higher praise. (She might also have noted that there were very few Danish Jews, or stressed that the Danes, of all the Europeans, had offered no resistance to Hitler. As so often, Arendt was choosing what kind of political behavior she wanted to emphasize.) Even more astonishing than the Danish record is the Bulgarian one: not a single Bulgarian Jew was killed. Forgetting all her treatises against the "folly" and "error" of European Communists, Arendt recalls the Bulgarian Georgi Dimitrov, who stood up so brilliantly to Göring during the trial following the Reichstag fire that people began saying, "There is only one man left in Germany, and he is a Bulgarian." In all, these instances may not constitute a very full record, but for Arendt they are enough to make life still worth living on a planet that could produce a holocaust.

Conversely, except for the pathetic instance of one German

soldier, Arendt finds no notable examples of German opposition to the destruction of the Jews. One veteran claims that any action would have been useless, though in the doubletalk of German idealism he admits that it would not have been "morally meaningless." In an outburst that combines scorn and great sadness, Arendt contends that *nothing* could have been of more practical use to Germany's "sadly confused inner condition" than a few stories of "useless" heroism. But the Israeli prosecution, "so careful not to embarrass the Adenauer administration," did not demand such instances. Adenauer, blithely insisting that Hitler was an aberration that had nothing to do with the German people, had no need of them; it bespeaks a legacy of German patriotism that refugees like Mann and Arendt did.

Arendt's last chapter weighs the possible criticisms of Israel for condoning the trial of a noncitizen. She notes that the postwar International Military Tribunal was incorrectly named; it was not international but "simply the court of the victors," and it broke up too soon to mete out justice adequately. Justice was not done, and the Israelis have a right to exact it, because they represent in geographical space a Jewish state that was previously without territory but not, she contends, without existence. She does regret that the Eichmann trial was not treated as "a case against humanity," since the crimes involved affected so many people besides the Jews. She also has a final swipe at religious sentimentalists who would place themselves on the altar of the God of Mercy, when justice is the offended party: characteristically, she describes the mistake as more than "a slip of the tongue."

The response to Arendt's *New Yorker* articles was immediate and tremendous: her secretary remembers returning from a summer vacation to find two trunkloads of angry letters. On all sides, she was misrepresented as someone who had accused the Jews of going to their death like sheep—precisely what she had taken the prosecution to task for suggesting. There were a few positive reviews of the subsequent book, including those of colleagues at the University of Chicago, Bruno Bettelheim and Hans Morgenthau. But other refugees were deeply shaken. While covering the trial in Jerusalem, she spent some time with

an old friend, the Zionist Kurt Blumenfeld: a mutual acquaint-
ance remembers Blumenfeld yelling at one point that she was an
anti-Semite to ask such questions about Jewish behavior under
such extreme circumstances. Rabbi Joachim Prinz remembers
discussions with her over the issue of Jewish defense: "I told her
it's the old problem of the middle-class person and the gun."
The German Jewish scholars of the Leo Baeck Institute were so
upset over her tactless description of the man for whom the in-
stitute had been named that they expelled her from their board.
The Zionist leader Nahum Goldmann attacked her in public;
Hans Jonas severed ties with her for a year. Henry Pachter
condemned her "righteous" demands for heroism in the con-
centration camps; he must have remembered some private con-
versations, since nowhere in the book does she claim to have
looked for such heroism. Other refugees grew apoplectic at the
very sound of her name. They thought Arendt had blamed the
victims for their own slaughter, when she had simply tried to
ask political questions rather than succumb to thoughtless
grieving. "How that woman was hated," Gertrude Urzidil re-
membered. "I thought they would kill her."

American response was equally severe, though not as painful.
Judge Michael Musmanno, whom Arendt had criticized for
transforming Eichmann into his own superior, got his revenge in
a foolish but widely read front-page review in *The New York
Times Book Review.* The doyenne of New York intellectual so-
ciety found herself its pariah, the subject of a well-attended
public forum where, among numerous *ad feminem* remarks, one
American acquaintance described her as a "Rosa Luxemburg of
nothingness." Even her publisher, The Viking Press, was insuf-
ficiently supportive, Arendt thought; she could do something
about that—she switched publishing houses with her next book.
Meanwhile, American and Israeli writers began bombarding the
journals with replies to her book. Facts were produced that
would supposedly demolish her argument. As always, Arendt's
perspective was determined by more than mere facts, despite
her loud insistence on factuality. But most of the articles scored
only minor gains: Arendt may have underestimated Jewish re-
sistance; there were a few instances of rabbis accompanying

their congregations to the death camps;* the Zionist collaboration with the Nazi architects of immigration greatly diminished
after 1941. None of this detracted from her analysis of the intellectual and moral failure of the Germans, her criticism of the Israeli prosecution, or her questioning of the nature of pre-war
Jewish politics. Her ironic tone was misapprehended; some
readers accused her of exculpating Eichmann, and rendering
him a creature of pathos, more deserving of sympathy than the
millions of dead Jews. In a celebrated letter, the scholar Gershom Scholem accused her of lacking *Herzenstakt*—a love of
the Jewish people that he had long found missing in leftist intellectuals. In language as sober and meditative as Arendt's was
vivid and immediate, he criticized her "sneering and malicious
tone." Finally he joined the many others who simply felt that
nobody had a right to judge people in so hopeless and fatal a predicament.

The 1965 paperback edition of *Eichmann in Jerusalem* (also
published by Viking) contained over sixty textual changes and
additions; the most substantive may have been the removal of
the offensive description of Leo Baeck. In a new postscript,
Arendt answered her critics. No, she had not attacked the Jewish people; their behavior had been "magnificent . . . only the
leadership failed." She shunned any structural explanation, sociological or psychological, and specifically rejected Bruno Bettelheim's concept of a "ghetto mentality" as an explanation of the
Jewish lack of resistance, since non-Jewish groups had also failed
to resist. To those who objected to the "banality of evil" as
vague and precious, she replied that it was strictly factual. Eichmann was no Iago or Macbeth. But she insisted that his "sheer
thoughtlessness" was far from "stupidity" and that his "banality" did not make him commonplace. One suspects that Americans today, after the experience of having had several national
leaders who combined a banal style with great mischief, would
be less confused by Arendt's distinction.

In one of the most moving passages, she turns to her fellow

* She later wrote that the few actual resisters interested her more than
the "saints."

refugees as if she were now confronting the other spectators in the courtroom—the only audience that really counted for her. She rehearses the argument that one cannot judge what one did not observe. And she replies that this attitude renders history and justice impossible. In a moment so intimate that she seems to be speaking *in camera*, she invokes other refugees. Let's admit it, she argues; haven't any of us wondered how "many of [our] own group would have done just the same if only they had been allowed to?" (Emigrés had often joked among themselves that some of their group would have made model Nazis if Hitler had not been anti-Semitic.) But is our condemnation "any the less correct for that reason?" She stops there. In the long history of Arendt's troubled writings about her compatriots—from "We Refugees" in 1943 to the 1968 essay on Brecht—this is the one point where she must retire from complications and modestly offer her argument as a possible alternative.

Arendt was courteous but unyielding in response to her old friend Gershom Scholem's strictures: she began by addressing him by his birth name—"Dear Gerhard"—as if to say their friendship could withstand these disputes, and proceeded to admit that she did not have an amorphous "love of the Jewish people," she merely belonged to them. (Arendt must have found something dubious about Scholem's profoundly mournful tone—no doubt it struck her as a false pathos, especially since his letter contained the spectacular misstatement that she typified the German Left; as Scholem must have known,* Arendt was no more a Marxist than he was.) She was more fractious in her review of Jacob Robinson's book-length case against her. After revealing Robinson's work for the Israeli prosecution—"it was, in fact, his own case"—she accuses him of psychocal color-blindness; later she compares his moral obtuseness to tone-deafness, a lack attendant on his "sheer inability to read." She wonders why he presents the conditions of refugees during the thirties in rosy colors and then discloses that he is in league with the United Restitution Organization, "a group established

* Scholem, however, knew something about the German Left: his brother was a member of Ruth Fischer's Berlin party cell.

to press Jewish claims against Germany." It is thus politically expedient to deny that there was anti-Semitic oppression in other European countries and to claim instead that "all initiative came from Berlin." She repeats a rumor that the Israeli Establishment is linked to the European Jewish leadership of the war years; hence, in condemning her analyses, they are protecting their own reputations. The point may appear perfervid, but it is clear that with few exceptions—Rabbi Joachim Prinz is one—those who oppose her anti-Zionism oppose her interpretation of the Eichmann trial and, for that matter, her increasing opposition to American government policies.

Many years earlier, contemplating the Vienna of Stefan Zweig, Arendt imagined a world in which the pursuit of fame and publicity diverted attention from serious politics. Now it seemed that the same confusion of imagery and substance had returned to destroy her. And true to the terms of her own story, it appeared that the Jewish bourgeoisie were avenging themselves for her numerous attacks on their philistine values and impotent politics. The "former functionaries of German Jewish organizations," she says, had joined forces with "their countless channels of communication" to produce the image of a book that was never written, thus broadcasting exactly what they wanted to keep quiet. She was right about that: her book is largely remembered as having said that Jews went to their slaughter like sheep and that Eichmann was any old Babbitt. She didn't mind objections to her tone—"that's a reproach against me as a person." But she was infuriated by the "malicious propaganda" against her thesis. As for Eichmann's being like the rest of us, she later told some students and colleagues that such a statement was "really 'abstract'—meaning 'not thinking through experience.' " There might be many Eichmanns, but he is not in all of us: "this is much more abstract than the most abstract things I indulge in so frequently." Ironically, her most concrete attempt at thinking through experience had been rendered abstract; the nice addendum of self-derision points up the general bafflement. Karl Kraus could not have invented a clearer instance of publicity swamping truth. Arendt would be haunted by the Eichmann

book for the rest of her life; in such strange ways would fame have revenge on its arch-opponent.

In another book published in the sixties, *Men in Dark Times*, Arendt provided a kind of summary statement about emigration. The title, derived from a Brecht poem, describes a group among whom she could number herself: these people had traveled the same road, and the responses she salutes in them reflect her own understanding of the dark times they had all lived, and thought themselves, through. Since she disdained the self-absorption necessary for autobiography—"the personal element is beyond the control of the subject and is therefore the precise opposite of mere subjectivity"—the book must function as an intellectual autobiography. It also provided for her the rare occasion to tell stories about people. As always, however, her stories are freighted with her characteristic themes and concerns. The essays are a combination of literary analysis—for as she says of Brecht, language is "what we live by"—and a deep sympathy for character, the personal element, as it is displayed in public action; thus Arendt can turn a physical description into a form of political analysis, as body and gestures express her heroes' state of ease with the public world.

She opens with a speech about Lessing that she gave to a group of German students in 1959; it contains references to her own lot as a Jew in Germany, as if this alone is the salient biographical detail worth recounting. Her essay on Rosa Luxemburg contains an émigré subtext, for it was only in emigration that Arendt discovered the importance of Luxemburg. There is also a charming irony that Arendt, disposed to neither autobiography nor feminism, found in the other woman a reflection of her own qualities.

Beyond the vagaries of Arendt's reading of Luxemburg, particularly her stressing of "spontaneous revolution" at the expense of Luxemburg's subtle dissection of those economic and political conditions necessary for revolt, Arendt's admiration has in it an implicit affirmation of standards and positions that she

herself had come to exemplify. She tells a story about Luxemburg and another woman friend referring to themselves offhandedly as the last two men of German social democracy. And even as she rescues Luxemburg from a sentimental canonization, she finds in a 1914 speech of hers a " 'manliness' unparalleled in the history of German socialism." Similarly, Luxemburg's preference for a direct prose style, in her own words, "without coquetry or optical illusions," spoke to Arendt's determined avoidance of anything resembling *Schmus* or *Quatsch*.

Her essay on Walter Benjamin helped introduce her friend and mentor to American readers. His story is also a tale of refugee politics. By the sixties Benjamin's legacy had been claimed by two German groups, the Communists and left-wingers epitomized by Brecht, and the intellectual aesthetes led by Adorno and Gershom Scholem. Arendt mediates between both groups, and then removes Benjamin from either camp. No, he was neither a Jewish Communist nor a Jewish fascist (a 1930s, left-wing epithet for Zionists). The man, to his own grief, resisted categorization: he remained where history had placed him, outside all groups. Yet Arendt probably sides more with Brecht than with Adorno or Scholem. She was not a zealous advocate of Jewish traditions, certainly not as a final resting place for an intelligence as peripatetic as Benjamin's.

Benjamin may be the model of that favorite Arendt character, the rebellious bourgeois son. Just as Kafka rejected the overheated, soul-destroying climate of his parents' home and declared that reality could only be found in the peasant huts of poor Jews, so Benjamin needed to flee his background by assuming positions—either Zionist or Communist—that would have horrified his elders. Of course, he was finally immune to either ideology, since his life took place in language: Arendt observes that truth for him was an "acoustical phenomenon," that to quote was to name, as if the past could be made present in a quoted passage of "name-giving words." His ideal text would have been a series of quotations, without connectives or exegesis: proximity alone would provide gloss and context.

Another essay—her complicated study of Brecht—underwent

several revisions. She loved his poetry, his style, his way of living through emigration: the first sentence evokes the irony of a great writer living in Hollywood and being perpetually asked to spell his name. Arendt was upset that so many of her generation collapsed in self-pity and self-regard. But not Brecht: "There is not a shred of sentimentality left in Brecht's beautiful and beautifully precise definition of a refugee" as "a messenger of ill tidings." She adds, characteristically, that "a messenger's message . . . does not concern himself," since the merely personal is totally irrelevant to the larger reality of émigré life. Brecht was simply unable to accommodate himself to every new place—as he wrote, "the news that calls you home is written in familiar language"; he was unacquainted with self-pity, although skilled in self-serving. Thus he never forgot his message, and became the quintessential poet of exile.

In fact, Brecht's personal and public styles meet many of Arendt's standards. After a sectarian debate with Lukács, he observed that the Hungarian was uncomfortable with the unpredictable nature of productivity, the element of surprise whether in artistic composition or industrial planning—precisely what Brecht welcomed, and what Arendt would always insist spelled the end of any ideological certainties. She could tolerate Brecht's mistreatment of women—"in me you have a man on whom you can't rely"—because it expressed his contempt for sentimental romances. As she often said of Rosa Luxemburg, Brecht was "hardly interested in himself," so of course his lovers could have little expectation of winning any conventional devotion from such a person. In addition, Brecht's theatrical aesthetic, with its demand that the actor always signal his awareness of the artifice of his actions—"She doesn't imitate nature," Brecht explains, "she acts"—is an uncanny reflection of Arendt's philosophical categories. For the distancing of Epic Theater announces that this is a public performance in a public world, not to be confused with or corrupted by personal feelings.

Arendt analyzes Brecht's poetry with a passionate engagement that leaves literary criticism well behind, and becomes the final product of years of living with these poems and relying upon them as the "words we live by," the meager consolations

left in an exile in which nothing remains but the mother tongue. In a lovely aside, she compares him with other pariah poets: the street ballads he draws from are like Negro spirituals, the art songs of "people condemned to obscurity and oblivion."

Yet, despite Brecht's exemplary literary accomplishments, his absence of self-pity, his firm grounding in common sense, she is profoundly unhappy with him, for Brecht was an apologist for Stalin. Arendt believes that after his return to the German Democratic Republic, he was punished with the loss of his talent. This outrageous statement could only come from someone who treasures the making of language as a supreme human action. She could have the gods punishing the poet only because she believes that they had so richly blessed him. "It is the poet's task to coin the words we live by," and he failed in his task by writing in praise of Stalin. Ezra Pound also praised a dictator, she adds, but he was insane. Brecht was a model of good sense; he had no excuse.

These curious conclusions bothered even some of Arendt's conservative friends. The critic Erich Heller reminded her that she had cited one of Brecht's last poems; surely this meant he hadn't lost his talent. She replied that the poem was short and derivative (but so were many of the earlier lyrics). Others noted that, after all, the late Brecht was sick and dying. Arendt herself felt the poems tugging at her—she would continue to live with them, one would provide her book with its title— yet she was willing to expose herself and Brecht to public embarrassment. "I am not one of them . . . [who have] overcome their unease." And she insisted that Brecht would never have expected special treatment, implying that even her expressions of grief and horror were signs that she, at least, took him seriously.

As proof that *Men in Dark Times* is a covert history of émigré intellectuals and artists, Arendt swings almost full circle in another essay, from the left-wing Brecht to the right-wing Waldemar Gurian. Gurian was a devout Catholic convert from Judaism and the editor of a conservative scholarly journal, *Review of Politics*. Yet if she distrusted Gurian's politics, she revered the man. She depicts the clumsy, obese Gurian as

constantly prone to embarrassment, "a complete stranger in the world of things." In a description worthy of any great novelist, she notes that his smile remained that of a surprised adolescent, and that this estimable man was without "humor ... perhaps one of the most adult qualities," which was also, as Arendt's reading of the Berlin poets Brecht and Robert Gilbert suggested, one of the exigent qualities of emigration. Despite the immense political gap, Gurian joined his fellow émigrés Brecht and Benjamin in his loyalty to the dead, constituted now only in the names that he always uttered with particular care, as if to keep them among the living.

Arendt remained a public figure up to her death. Although she essayed new subjects and addressed contemporary events, the old images and worries of immigration continued to reappear. Her analysis of the American revolution drew upon familiar themes, such as her continual invocation of Rosa Luxemburg's call for workers' councils and her anger at Jewish leaders for their inattention to political forms and constitutions. Money didn't protect the Jews, only politics could; and somehow, private economic considerations, the cares of the household, were also tangential to the achievements of the American Founding Fathers when they waged a revolution she chose to regard as political rather than social in origin. It might appear that Arendt was never more the refugee than when writing about American history. (She was certainly not without compassion for the underprivileged. Witness the solution she offered Mary McCarthy during a New York school crisis: "Hot breakfasts for the children"—*echt Berlinerisch* counsel in its display of common sense.)

Late into the sixties, she could excoriate de Gaulle for his public rehabilitation of Pétain and his "incredibly blatantly lying statement" that the Communists were responsible for the fall of France in 1940, what he euphemized as *"les événements."* Though she rejoiced in young European activists and their discovery that public life was fun, she could not share the optimism of yet another member of the Frankfurt school, the philosopher

Ernst Bloch—he anticipated a revolution led by these students. Since she had never committed herself to any historical design, she reasoned that a counterrevolution was equally possible; alas, events have proved her right. But she continued to preach the gospel of spontaneous revolution, ignoring critics who argued that the forms and constituencies of various councils and soviets differed too greatly to allow for generalization, and that the "entirely spontaneous" event was virtually unheard of.

She continued to read other people's political language perhaps more scrupulously than she observed her own. Thus she could explode when some European students described Stalin's role as an "alienation," a term that "sweeps under the rug . . . the most hair-raising crimes," and she was disgusted when "our innocent children in the west" made sport of "what they call 'bourgeois freedom.' " On the other hand, when the political scientists Nathan Glazer and Zbigniew Brzezinski attacked the American student activists of the 1960s as Luddites, the last of the counterrevolutionaries, she was quick to spot the differences between the tools broken by Luddites and the weapons of the Pentagon. She wondered wryly about Glazer and Brzezinski, men with whom she had once had much in common, writing, "Isn't this fear in favor of marching forward at any price rather odd in two authors who are generally considered to be conservatives?"

Arendt's last years were filled with the same disappointments and disillusionments that blighted many other émigré lives. For her, the drop may have been even greater because she had invested so much hope in the American political experiment. By the end of her life it seemed to her that Western bureaucracies, and their huge political party machines, had virtually cut off the possibilities of public action. In a similar extension of her characteristic themes, she described the electronic eavesdropping on American radicals as a form of expropriation—a major indictment, since for her the ownership of property confirmed one's position in the public world. This spying on the citizenry was also a total denial of the great American promise—for her—of protection from government. Voting was the single political ac-

tion left, but the voting booth was private and built only for one. Earlier in *On Revolution,* she lamented that the Constitution itself, in succeeding the Articles of Confederation, had diluted the revolutionary spirit by replacing town meetings with centralized government. Her late preoccupation with civil disobedience, inspired by the example of Dr. Martin Luther King, may have been a final attempt to discover political possibilities for her fellow citizens.

In 1968 she wrote a tribute to one of her early editors, Dwight Macdonald. She surveyed a quarter-century of American political history, including especially events she had noticed but not remarked on. In 1951, she had written of the "innocence" of Americans vis-à-vis European reprobates. But now she summoned up Charles E. Wilson's 1944 proposal for a permanent war economy; President Truman's "outrageous jubilation" over the dropping of the atomic bomb; and a Cold War that had degenerated from a "horror" of Stalinism to Big-Power Politics. She provided an interesting addendum to *The Origins of Totalitarianism* when she recalled that the restoration of prewar governments in France, Greece, and Italy had been achieved at the expense of the radical underground resistance groups. The Allies had proved to be as inimical to the resisters' cause as the Fascists and Stalinists had been. Arendt gently scolded Macdonald for confusing Bolshevism with Stalinism, an unacknowledged error of her own past. She was more sympathetic to his 1945 statement that after Hiroshima he was ashamed to be an American. He had not been wrong then, but, as Vietnam had proved, his remark was merely premature.

For Arendt to speak so sympathetically of an American's sense of shame was a tremendous leap away from the glowing patriotism of her earlier work. Much like the last years of Mann or Einstein, hers included premonitions of flight. She talked to Mary McCarthy of emigrating back to Europe "while there was still time." Despite these fears, Arendt grew increasingly bold in her criticisms of U.S. policy. Her essays for *The New York Review of Books* described the phenomena of Vietnam and Watergate as national calamities. When collected, the essays were

appropriately titled *Crises of the Republic*, since Arendt felt that every presidential abuse of power reduced the unique political role of the American citizen.

Thus by the time of her death she had acquired an almost institutional status and was alternately perceived as the arbiter of America's moral decline and as an intemperate scold. She began to receive the familiar criticism that when it came to American matters, émigrés were not to be trusted.

Hannah Arendt insisted on her intellectual independence. If she lost the conservatives or the radicals along the way, well then, she had no fear of traveling by herself. A bewildered Nathan Glazer, puzzling over her later political analyses, recalled the halcyon days of *Totalitarianism* and *The Human Condition* when Professor Arendt had been "our teacher." Meanwhile, a new audience of young radicals asked her to define her special influence. But she shared her generation's perception: "the idolization of genius" was a degradation of the human person, a concept that smacked of what Marxists called reification, turning people into commodities. Influence, she told a young German, was not important: that was a male question. And she told a scholarly conference devoted to her work that it would be impossible to impose her positions on other people, since "these are adults." She was a grown-up woman, and these problems did not concern her.

She closed the conference with a final, implicit plea that she not be turned into some intellectual guru. "I would like to say that everything I did and everything I wrote—all that is tentative." A questioner asked her to locate herself in the political spectrum. She replied, "So you ask me where I am. I am nowhere. I am really not in the mainstream of present or any other political thought. But not because I want to be so original—it so happens that I somehow don't fit."

The "somehow" appears with the suddenness of an explanatory insight; perhaps the prophet of public life was unsuited to its present form: she herself had always claimed that she thought and wrote merely to understand, not to act upon a public world.

Yet this same public world had acted upon her, whether by forcing her into exile or later by freeing her to talk more openly with the years, and to a larger audience. "I somehow don't fit": these words spoke for a generation of émigrés who found themselves, like Arendt, no longer rooted in any academic discipline or national culture.

─19─

Heroes of the 1960s

"The point," Erik Erikson wrote in 1950, "is that it is almost impossible (except in the form of fiction) to write in America *about* America *for* Americans." Especially because you are an immigrant, he noted, your journal is a record of passage, of a process that qualifies and deforms your natural style. So "The only healthy American way to write about America for Americans is to vent a gripe and to overstate it. This, however, calls for a delicate gift and for a particular intellectual ancestry, neither of which is easily acquired." Erikson was not alone in seeing the virtues of that "delicate gift" of hyperbole. During his California exile, Adorno had written, "In psychoanalysis, only the exaggerations are true." And Arendt once informed Hans Jonas, "But, Hans, the more you exaggerate, the truer it gets."

By the 1960s and 1970s, three decades after their arrival, émigrés like Erikson had become the heroes of a largely new, largely young American audience. As if to confirm Erikson's prophecy, they found themselves the advocates of apparently extreme positions, seeming to their numerous critics to be the overstaters of trivial gripes. Yet because their "particular intellectual ancestry" disallowed a strident manner, they went about their extreme criticisms of American society with the sober mel-

ancholy of foreigners who had once been deeply in love with this country. In their own attempts to puzzle out the failure of the American dream, they managed to acquire an audience that did not share their ancestry, much less their commitment to scholarly rectitude. It was a final though not unfamiliar irony of the émigrés' contribution to American culture that their positions should be recast by others in a tone and idiom that vulgarized them. The real surprise was that eager Americans should turn in extremis to them as gurus, a phase that horrified a Marcuse or an Arendt.

Decades earlier, Freud had caricatured America as a "mistake," an "anti-Paradise," where psychoanalysts would be embraced and smothered. He was right that the fad of psychoanalysis would wax and wane. He couldn't see how his therapeutic method, once it entered the marketplace, would prompt the development of rival therapies. Particularly in America, the promises of psychoanalysis began to appear limited and without allure. Introspective Americans might look with favor upon Freud's concern with the individual psyche, but the theory didn't offer a speedy cure. After years of therapy, perhaps, if one was lucky—any advance often seemed a gratuitous leap, bewildering to patient and doctor alike—one might manage to live the life of a normal neurotic.

The hope that it offered was not enough at a time when advertisements promised rapid cosmetic changes, and, more important, when millions of Americans felt their lives weren't working at all. No wonder they couldn't appreciate Freud's solemn wit and looked to simpler, easier methods. This did not mean banishing émigré doctors. In fact, the two major therapeutic changes of the sixties and seventies were ushered in by émigrés, Fritz Perls of Esalen and Wilhelm Reich. Because their positions have become the roots of such American phenomena as "est" or sex therapy, it is useful to recognize how much both men were products of émigré culture. More than anything else, their American history involved the acquisition of a new tone to express theories they had cultivated earlier abroad.

Reich is often credited with unleashing the sexual revolution. This is surely among the more inflated claims made for an

émigré: the real sources of change are technological (the pill) and sociological (the decline of the family), not any doctor's textbooks. Yet of all Freud's disciples, Reich was the most obsessed with sexuality: Freud, in a letter, called it the younger man's "hobbyhorse." Up to 1934 Reich's contributions in Germany to psychoanalytic theory met with considerable favor. As his analysand Fritz Perls said, Reich gave Freud's "resistance theory a body." Reichian character analysis contained precise descriptions of how psychological disorder can be expressed in tone and gesture. In particular, Reich's notion of armoring provided an immediately convincing, visceral set of images. A man who could make the talking cure physical by pounding and pummeling analysands into sexual health could discover other intersections of psychoanalysis and the material world. Between 1930 and 1933, while living in Berlin, Reich attempted an early rapprochement of Marx and Freud. Under his supervision, the German Communist Party set up an association for proletarian sexual politics: its program was a model of enlightened attitudes toward marriage and divorce, birth control, abortion, homosexuality, and nurseries in factories. In 1933 his study of *Mass Psychology and Fascism* addressed an issue that many other intellectuals still chose to ignore (although his concentrated focus on only one group, the petite bourgeoisie, linked him with all the other émigrés from Arendt to Marcuse, who found this group totally unsympathetic). If Reich had died in 1934, his legacy would be unblemished. But his later trafficking in orgone therapy, and his invention of orgone accumulators that supposedly stored the sexual energy that powered the universe, made him appear to be a charlatan. Initially Reich thrived on such resistance: he called himself the eternal "Stehaufmännnchen," the master of the comeback.

Reich's eventual mental collapse had political causes. Even before he developed his "crackpot" notions, he found himself abandoned by his "less hysterical" colleagues. Freud indulged in shocking displays of red-baiting. In the 1932 *International Yearbook of Psychoanalysis*, he cautioned readers that Reich was "a member of the Bolshevist Party" and as such was as biased and unreliable as a Jesuit. In 1933 the German Psychoana-

lytic Society asked Reich to resign because of his reputation as an anti-Fascist. Considering the organization's largely Jewish makeup, one may wonder who was the real crackpot. Reich was not even able to maintain his left-wing support. The Soviet Union no longer seemed the site of a sexual Utopia after Stalin rescinded the liberal sex laws of the Bolshevik Revolution. More specifically, Reich, as an émigré, became virulently anti-Communist, following his mistreatment by the bureaucrats of Rote Hilfe, the Communist group in Denmark, to which he had fled in August 1933. His official expulsion from the party legalized the divorce. It was characteristic of Reich that he should object publicly to being mistreated as an émigré; the condescending behavior of rescue committees in England or the United States was often mentioned by émigrés in private, but the great majority were too frightened to speak up. After all, how could you report to the authorities the very people who were shielding you from them?

In 1939, after some years in Scandinavia, Reich entered this country on a nonquota professor's visa. He married a younger émigré, Ilse Ollendorff—his second wife—and set up an office and residence in Forest Hills. This New York suburb became the home of other, fairly well-off émigrés, yet it was not quite a German Jewish ghetto. In fact, Forest Hills was the locus of a kind of vapid, bourgeois striving: it would become the symbol of a strident, particularly American materialism (Reich lived a few blocks from the famous tennis courts). To complete his submergence in American life, he bought a summer house in Maine. Here his work led to the development of a "cloud-busting" machine, after which the émigré became, to his neighbors, a familiar mythic figure, the rain-maker.

His first American years were happy ones. He had students and patients, as well as a research project that was of paramount importance to him. Yet almost from the start, he was made to feel that he was the object of external criticism; initially, at least, "paranoia" was simple good sense. He acquired a black laboratory assistant, and the neighbors objected. Five days after Pearl Harbor, he was arrested as an enemy alien. He spent a night on Ellis Island, along with hundreds of members of the German-

American Bund. One can imagine what it must have been like for a Jew to be surrounded by people who spoke his language and dreamed of his extinction. While he was detained, the FBI examined his library; his wife says she lost her confidence in the bureau after an agent wondered why this eminent scholar marked up his books. Reich was shortly released as a "friendly alien" (he had been born in Austria), but his wife's "enemy alien" status remained. That a Jew should be an enemy alien in both Germany and America was grounds enough for the nature of all sanctuary to seem suspect.

Although Reich became known as the prophet of sexual liberation, he was no libertine. On the contrary, his wife's autobiography reveals him as rigid, humorless, miserly. (Paul Goodman wondered why her book didn't include any sexual revelations— though Reich would probably not have picked a wife prone to such *Quatsch*.) Like a caricature of German pedantry, he insisted on an academic formality, even in his labs; in public, he addressed his wife by her maiden name. He overestimated academic degrees to the point where he treated elementary-school teachers as if they were renowned scholars. For all his concern with female sexuality, he exhibited a conventional double standard: while his wife was away, he could play, but he expected absolute fidelity from her. Although Paul Goodman was one of his most loyal advocates, Reich abominated homosexuality. His theories have been called excuses for childhood license, but he was a strict and protective parent. The prospect of storms, fires, and car crashes filled him with alarm for his loved ones. All forms of safety were, for the émigré, provisional.

Where was there security? Reich found it in the United States government: he became a devout supporter of President Roosevelt. Despite his attacks on status, he prided himself on being noted in American almanacs. The concomitant of this patriotism was his series of attacks on "red fascism." His erstwhile colleagues, the Communists, now became his archenemies. In the early forties, after he attempted in vain to convince Einstein of the validity of orgone therapy, Reich credited Einstein's indifference to Communist intervention. When the Food and

Drug Administration began investigating his shipments of orgone accumulators as aids in cancer treatment, he concluded that the FDA was a nest of reds. Almost like the paranoid bigots analyzed by Adorno or Lowenthal, Reich eventually managed to scramble together all his enemies. He called Stalin the "father of both the Hitlers and the McCarthys," and by the time when it seemed the large medical concerns were also out to get him, he was imagining a conspiracy directed by "Moscow and the Rockefellers."

In Reich's late years he developed a mad language that summoned up all the themes of his exile. He added a new myth, flying saucers, to his array of personal threats. Yet even then, paranoia was not always unfounded. It was not unthinkable that friends could betray him. When the FDA took out an injunction against the shipment of orgone accumulators (the orgone energy accumulator was a six-sided box, the size of a telephone booth or confessional, with wood on the outside and metal within), the prosecuting attorney turned out to be his former lawyer, a man he later called the "twentieth-century Judas Iscariot" (by this time, Reich was convinced of parallels between his life and Christ's). During his trial for criminal contempt, Reich in his defense distinguished between what he "did" and what he "had to do"—yet another doomed émigré attempt to make the American language reflect his complicated thought.

Reich was convicted in May 1956 and jailed in March 1957. The image of an enemy alien was revived when he found himself again the victim of book burning: the FDA confiscated all his published works from his organization's stockroom, including those that had nothing to do with orgone therapy. In a legal brief Reich asserted that "The discoverer of the Cosmic Energy had fought . . . under the very eyes of the Air Force, the first Battle of the Universe." With his compulsive pedantic rigor, he insisted on distinguishing his jailers from his political leaders. He believed that President Eisenhower was personally protecting him; upon hearing an airplane overhead, he would look up and inform prison officials that his guardian angels were hovering near. In his last months he spent his time reading Emerson's

essays and Carl Sandburg's biography of Lincoln. The fifties in-
fatuation with God and country became his latest route to
safety. He attended the Protestant chapel, and this lifelong athe-
ist wrote letters exalting the nebulous power of faith. Like the
hero of a movie by Howard Hawks or Douglas Sirk, he advised
his son to learn the Cadet's Prayer.

Reich's death in prison on November 3, 1957, received little
attention in the press. It would be several years before his no-
tions were widely circulated. The sexual tolerance that became
identified with the application of his theories would surely not
have pleased the scourge of pornography and promiscuity. Not
even the right wing chose to claim Reich's zealotry as its own.
His paranoia was fulfilled: in death he remains an alien.

Frederick Perls, on the other hand, made a point of making
himself accessible. Reich's self-advertisements appeared pa-
thetic; Perls's may have seemed obnoxious and smug. The dias-
pora carried Perls to South Africa, where he spent the war
years. He arrived in America in 1946 and proved a quick study.
By the late sixties, as director of Esalen, Perls had become the
prophet of an American alternative to traditional psychoanaly-
sis. Between the icy precepts of the American Psychoanalytical
Institute and the hot tubs of Esalen lay more than a continental
divide. Equally removed from the academic decorum of analytic
prose were Perls's perfervid pronouncements; in his autobiogra-
phy, he flirts with, badgers, and hustles his audience. His claims
for his therapy are no less extravagant than Reich's. From
Perls's preoccupation with an integrated and monumentally
self-reflective character evolved the "human potential" move-
ments that swept the country in the late seventies with their
very American program for mobilizing previously blocked psy-
chic energies. This was not liberation as most émigrés imagined
it; Herbert Marcuse, for one, was repelled by Esalen's aim and
methods.

Yet Perls's life too was a special and not unappealing variant
of the émigré quest to master American culture with European
means. The very title of his autobiograhical *In and Out the
Garbage Pail* exhibits the familiar émigré infatuation with
idioms: what native American would make so much of so dreary

an image? Perls had an irrepressible itch to rhyme. His book is filled with verse, among the earliest this allusion to his psychology:

> Junk and chaos come to halt!
> 'Stead of wild confusion,
> Form a meaningful gestalt
> At my life's conclusion.

Not great verse, but the echoes of Goethe are obvious. The book contains homages to German poets: Goethe (whose "unity of language, rhythm and meaning" is, in itself, a *Gestalt*), Heine, and Schiller. The supreme moment of Perls's youth was reading Schiller; in the poet's evocation of two human needs—food and love—Perls discovers a reconciliation of Marx (sustenance) and Freud (libido). From Erikson to Marcuse to Perls, the citation of Schiller is an enduring feature of émigré prose.

Perls grew up in Berlin, and attended the literary cafés. At the gymnasium, his fellow Jews included the actor Joseph Schildkraut and Friedrich Hollaender, who composed Marlene Dietrich's theme song, "Falling in Love Again." Perls studied direction with Max Reinhardt. Obviously he saw himself as extra-academic. He boasted that, "unlike the other uptight M.D.s," he and his bohemian medical friends "hung out at the Café of the West and the Café Romanische." Perls's own development is more idiosyncratic than that of the writers and artists and filmmakers who drew from the atmosphere of popular culture that prevailed in the Berlin cabarets, but it allowed for a similar success with a popular audience. If most other doctors didn't want that kind of success, Perls would reply, with the American idiom of his old age, that they were "up tight."

Like other émigrés, Perls's pleasure is to decode the reactionary vocabulary of German and English. His drive to liberate the genitals stems in part from the German term *die Schamteile* (the parts of shame). Similarly, he makes suicide a crime by citing its German meaning, *Selbstmord* (self-murder). With this kind of attentiveness to the liberation of the mind, it is not surprising that Perls calls for "brain-washing": a mind as impacted with junk as a garbage pail needs cleansing. One might note that

only the more naïve American writers—evangelists, perhaps—
would make so free with so compromised an idiom.

When Perls outlines his own practice, he indulges in shame-
less self-promotion, redeemed in part by a sense of humor. Ges-
talt psychology is simply "the next step after Freud" and "this
spells efficiency." Few other émigrés would apply the language
of pragmatism to the psyche. But Perls does combat with his
European ancestors while luring American customers. Marx
was wrong, Hegel misguided, in their attempts to achieve a *Da-
sein* (literally, "being there")—ah, but "dasein manifests itself
in gestalt" (as if when the whole self coheres, it comprises its
own place). Conversely, when Perls scolds Americans by saying
that there is "more to life than the production and taking care of
things" or that "Happiness for happiness' sake will at best lead
to prefabricated fun à la Disneyland," he echoes an old line of
German romanticism; in a vulgarized form, this is Adorno's ar-
gument in *Dialectic of Enlightenment.*

Perls could convey these traditional concepts with such facil-
ity because he found his own disposition reflected in American
culture. He claimed to have broken with academic Gestalt psy-
chologists like Kurt Lewin when they became "logical positiv-
ists." He preferred uncertainties, the "unfinished situation . . .
incomplete gestalt." Yet if not a logical positivist, Perls can
sound like a positive thinker. He recalls his first visit to Esalen
when it was still a public inn. Since his tenure began, he says,
the business has developed greatly. Now "we are said to pro-
duce instant cures, instant joy, and instant sensory awareness."
American culture believes in instant change: the most popular
religious movement insists that one can be born again in the
twinkling of an eye. Salvation or sensory awareness: the break-
throughs are similarly speedy and gratuitous.

Few émigrés have written like Perls. No matter how
egomaniacal, not many would dare to announce, "I am the best
therapist for any type of neurosis in the U.S., maybe the world."
Of course, Perls's generally self-mocking tone suggests that his
outrageous claims are advanced in jest, though this doesn't mean
he'd turn away any customers. Perhaps he intuited that Ameri-
cans like their hucksters to be a mite transparent. His assertions

are also leavened by his *Berliner Schnauze:* "How is this for megalomania?" He requires that "uptight professionals" plunge themselves into the hot tubs. Once there, if they notice other people playing footsie, so what? Perls quotes a published description of his charms: "Nobody kisses like Fritz." Here is sexual looseness that would drive Reich to distraction. The frankness that Paul Goodman missed in Mrs. Reich's memoir is amply present in Perls's work. He tells us about his wife and lovers, exhibiting an honesty that may appear more vengeful than illuminating. At one point, he writes in a manner that appears typically American: "Freud, you have . . . a big mouth, so have I. And you are an asshole and so am I." But surely in the Berlin cabarets, many others showed a similar irreverence before Dr. Freud. Once again, the novelty is hearing that tone combined with this hodgepodge of therapeutic jargon.

And yet, there is an émigré subtext to all of Perls's pronouncements. Movements like est have made "human potential" appear a code for self-regard. But at his most honest and convincing, Perls provides a justification drawn from émigré experience. Like several other writers, particularly Bruno Bettelheim, Perls believes that "many Jews could have saved themselves" if they had "let go of possessions, relatives, and fear of the unknown" and had "mobilized their own resources." Only by discharging the cultural apparatus of a lifetime could they have escaped. With this in mind, he scolds a brother-in-law who stayed in Germany until the last minute and eventually wound up in Shanghai. Yet even he recognizes how much he is demanding, especially in his insistence that one let go of the "fear of the unknown." And as if to punish himself, he falls into a bad dream: "I woke up feeling guilty." But after arguing with himself—Perls presents such dialogues as occurring between "top dog" and "under-dog," another slightly askew émigré idiom—he concludes, "I am responsible only for myself."

The last remark may sound selfish, but at least it derived from an émigré's sense of imminent peril. Perls allows himself to appear unfeeling. When he recalls an older sister who died in the camps, he feels "not guilt" over her death but "resentment"; he has not forgotten how much he disliked her. He feels required to

justify such honesty—resentment is braver than guilt—as if his sister were still harassing him. Yet this is a cleansing honesty. For even as many émigrés in private might call their heroes "assholes," many people were caught between a survivor's guilt and a persistent hatred of others who died. How does one think about someone who troubled one's life and then happened to die horribly? Perls's argument that one can only look to oneself may not serve, but the context gives it a dignity absent from the evangelical excesses of his disciples.

Perls died in 1970, shortly after completing his journal. With typical honesty, he admitted his jealousy of Eric Berne, another émigré. Berne's *Games People Play* managed to find a catchy formulation for psychological behavior—a phrase so memorably glib that it became the title of a popular tune. Perls envied such verbal facility; after all, his playful spirit gravitated to games. A patriarch of pleasure inviting his offspring to have some fun, he smiled out from his last writings like a German Jewish Walt Whitman.

As a group, émigrés had not been enraptured with American youth. Some, such as Arendt and Bettelheim, spoke scathingly of their willful incursions into a public life better restricted to adults. Yet when young people acquired a new consciousness of themselves—as a distinct group, as a special sensibility, as a market, and, even loosely, to some, as a class—their intellectual champions turned out to be émigrés. The two most famous were Erik Erikson and Herbert Marcuse. Erikson's preeminence was not startling. He became the scholar of adolescence because, at least in part, he affirmed its values.

Born in Frankfurt, trained in Vienna, Erikson arrived in this country very early, in 1933. He appears to have become assimilated more easily than other émigré academics; his wife and "editor" is American, and his writings are crammed with citations of American social scientists. Like other California émigrés, e.g., Fritz Lang and Douglas Sirk, he was attracted to American Indian culture. He also enjoyed American folklore—he quotes folk tunes and legends, and, unlike Adorno, sees the

manifest contradictions between form and content as signs of resourcefulness and vigor. Similarly, he thinks "basic English" is wonderfully "precise when it comes to the definition of interpersonal patterns"—no longing here for German's dialectical sweep.

Some of Erikson's postwar work reads like a commercial for American culture: he quotes Freud's phrase *Lieben und Arbeiten* (love and work) as "the doctor's prescription for human dignity—and democratic living," and implies that only in America can Freud's ideal be realized. Thus some critics decided that he had acquiesced to this country's bourgeois smugness. His work is better read as the intellectual autobiography of an émigré who posited an American dream that was largely his own invention.

Much like Arendt or Bettelheim, Erikson's most impassioned work derives from the obsession of emigration. His single best study may be "The Legend of Hitler's Childhood," originally composed at the start of World War II, and later revised and included in his *Childhood and Society* (1950). The essay begins as a reading of Nazi propaganda and ends as an implicit homage to an American character that would appear thoroughly immune to Hitler's appeals. While conceding no sympathy for Hitler, Erikson demonstrates that the needs he satisfied expressed the profound immaturity of his followers.

Like other émigrés, Erikson is offended by the banality of *Mein Kampf*, but finds that it allows a transparent access to the national neurosis shared by Hitler and his fellow Germans. From the imagery of powerful fathers and seductive mothers, Erikson composes a Teutonic family romance. The cast includes a rigid, humorless father—a tyrant who lacks "true inner authority"—in perpetual conflict with a son who receives covert support from a mousy, dotty mother. For a brief moment in puberty the son has a chance to assert himself before his father. But puberty is "such a strange mixture of open rebellion and 'secret sin,' cynical delinquency and submissive obedience, romanticism and dependency," that it is "apt to break the boy's spirit, once and for all." As a result, adolescence becomes the occasion for a kind of repressive tolerance: Erikson feels that the

fathers allow their sons' rebellions as a means of maintaining their "patriarchal hold." Fortunately, Erikson adds, this is not the case in America, where the teenager is "the cultural arbiter," and where fathers never relinquish their adolescent habits.

Erikson now discovers a link between the Germans' desiccated home life and their underdeveloped political character. Simply, they lack a national identity. To them, the outside world becomes variously a site of some mystical voyage, a territory—or *Lebensraum*—to be settled, or a dangerous encirclement of enemy forces. Anything but a place where other people live.

Because the German is not secure in his own home, he resents the Jew, who retains his identity anywhere. Because his own style is dreary, he despises the securely flamboyant Jew. Because he recognizes himself as a philistine, he hates the Jew, who acts "the mediator in cultural change" and "the interpreter in the arts and sciences." Because he cannot make his mind up about anything, he fears the Jew, who, as "the healer of inner conflicts," knows his mind better than he does himself.

Thus from an inspection of Hitler's words, Erikson has charted Nazi mythology and achieved a plausible explanation for the German people's criminal actions: "the climactic accomplishment of the German mythological genius" was "to create a reality which seems impossible even to those who know it to have been a fact." Hitler's insight was that the psychologically immature required political confirmation. To those lacking a strong sense of self, "the question of national unity may become a matter of the *preservation of identity*, and thus a matter of (human) life and death, far surpassing the question of political systems."

The other essays in *Childhood and Society* celebrate American society precisely because there identity is firmly grounded where it seems most capricious. Other émigré commentators, such as Erich Fromm, also noted the same family pathology but refused to limit it to Germany's borders. Erikson was more sanguine in reference to America. To exemplify the differences, he introduces a new family romance. In America the roles have shifted. The fathers and sons are allies, not enemies: their aims

and idols are the same. The two share "the gestures of adolescence." Their real enemy is the wife-mother, the mom of American "momism." And she, unhappy soul, is really the representative of her father: momism is simply diluted paternalism. Father and son in America manage to become friends, a virtually unknown phenomenon in the Germany of Erikson's youth, while the mother, even as she incarnates social authority, loses her emotional power. American sons may blame their mothers for their public failures, but they are unacquainted with the Oedipal desires that cripple bourgeois Europeans.

Childhood and Society is famous for its encomiums to the American character. But when Erikson celebrates its tentative and playful nature, he has a familiar German precedent. He quotes Schiller's remark that "man is perfectly human only when he plays." When we play with gravity or time or love, we enact our freedom. In celebrating the apparently childish forms of play, Erikson joins the many émigrés from Adorno to Mann who prefer not to sacrifice their youthful exuberance to a spiritless adulthood.

Erikson observed that the "inability to settle on an occupational identity" disturbs many young people; and indeed after his codification of the stage, the "identity crisis" was to assume an incantatory power in the development of American students. They may have responded to a special tension they detected in the author. Erikson's declaration that ego identity requires a "deliberate tentativeness of autonomous choice" suggests a dialectical awareness of the ways the two apparent opposites merge and support each other. Just as Brecht praises "Those . . . whose transmutations / Leave their persons undeformed," Erikson celebrates an identity both anchored and resilient, rooted and mobile—that is, the best of European and American character traits. As for the "occupational" conundrum, something that could be called "role diffusion" (Erikson's negative phase of "identity") was the salvation of many émigrés: Peter Drucker claimed that his ability to teach a variety of courses clinched his academic success, at least in America. And Erikson's style, impressionistic and clinical at the same time, can be read as a vehicle of role diffusion itself.

In an autobiographical section of *Life History and the Historical Moment* (1975), he admits his own preference for "moving on," and for a career that seeks to avoid the necessity of "belonging anywhere quite irreversibly." He admires the American spirit of mobility: this is a country where one is "free to stay, free to move on." Americans are a traveling people; he considers the large number of war veterans who elected not to return to their former homes.

At least in 1950 Erikson was so smitten with this country that he had no trouble conflating a psychological and political ideal. *Childhood and Society* advances Cold War positions. In an essay on Maxim Gorky's youth, he calls the Russians "our cold, our dangerous adversaries." From pictures of swaddled Russian infants Erikson deduces that the Russian soul may be swaddled as a result of early experiences. (He might have noted that Wilhelmian Germans also bundled up their babies.) He describes the Russian people as perpetually plagued by bureaucrats, and interprets the Bolshevik revolution as a kind of Protestantism *manqué* that sought to replace "the wasteful superstitions of ancient agricultural moralities" with enlightenment values; unashamedly, he declares that our side does it better.

Erikson affirms all the conventional pieties, and roots them in mental health. The American family is compared with Congress in its balancing of "special interests." Everyone gets a chance at the speaker's podium; no one hogs the spotlight. Like other émigrés Erikson observes that a democratic home atmosphere prevents the translation of personal grievances into political ideologies and the consequent threat of "civil war," although he fears that as a result young people may lose a taste for real politics. While he condemns "bossism" and its representatives—the "self-made autocrats" who "hide behind the ambiguity of language"—he sees capitalism as the perfect economic mode of a healthy personality. These "freeborn sons," these "American adolescents believe deeply in truly free enterprise; they prefer one big chance in a hundred little ones to an average-sized certainty."

But with the years, Erikson became increasingly critical of the American establishment. Like Marcuse, he supported the war

resisters in the Vietnam era. By 1973 he was advocating "speciehood"—a contemporary version of the one-world dream that inspired many émigrés after World War II. The about-face was not surprising: Erikson had not so much changed his values as seen them overturned. The bosses who were peripheral in 1950 had assumed center stage. Congress was no longer like a household. Besides, he had never been totally convinced of the merits of perpetual adolescence. Even in *Childhood and Society* he denied that he was advocating a surrender to social roles: "This, of course, would mean a fixation on an adolescent solution." Beneath the paeans to what he later called an "expansively open . . . national character" was a familiar émigré criticism. Eccentricity in this country was merely an adherence to a series of conventions; psychic mobility was much more constricted than was geographic; the clones of popular culture wore a "mass-produced mask of individuality." Perhaps like those oppressive German fathers and ignorant Russian mothers, American parents had swaddled their offspring too snugly.

If this analysis is correct, there is a logical development in Erikson's recent work. He has moved from a concern with identity to his penultimate phase of development: generativity. He now believes that the suppression of parental tendencies will prove as psychically damaging as an earlier generation's repression of sexual desires. He refers not simply to bringing more children into the world, but to the kinds of experience—nurturing, training, educating, as once we were nurtured, educated, trained, or should have been, had we not had those abominable parents!—that will round out a life. This plea can be read either as a conservative yoking together of family and history or a progressive call to serve future generations.

The émigrés' interest in American youth assumed a whole new coloration during the Vietnam war. Thanks to the "teach-ins," émigré critics of the American government became public figures on college campuses, summoning those that Hannah Arendt always referred to as "the children" to recognize the full implications of the war. Their conventional academic bearing

lent to these occasionally riotous public occasions both dignity
and authority; their accents alone identified them as authentic
political witnesses. Never before had so many émigrés taken so
visible a stand on American policy. Not coincidentally, never
before had so many respected names descended from prestige to
notoriety. For a while émigré intellectuals had been sacrosanct
figures; now they regained the images of enemy aliens and cor-
rupters of youth that had caused them to flee from Europe.

Excepting Einstein and Thomas Mann, émigrés were notably
cautious during the McCarthy period. But the spread of nuclear
weapons, along with the Vietnam war, provoked many of them
to express an anger more typical of their history of dissent. Emi-
gré leftists spoke up first. Otto Nathan, for one, gave his first
anti-Vietnam speech in 1962. Even earlier, the nuclear disarma-
ment group SANE had derived its name from the title of Erich
Fromm's *The Sane Society.* In private, Vietnam's effect on
émigrés was devastating. Douglas Sirk had once been "deeply in
love" with this country, but Vietnam, on top of the McCarthy
investigations, clinched his disillusionment. Many émigrés had
nursed a kind of love-hate for the United States, and Vietnam
released their most negative feelings. The Jewish scholar Toni
Oelsner contended that "Vietnam and Cambodia were almost as
bad as Auschwitz."

But this was the Left speaking, and speaking out of a tradition
that had allowed Brecht in the twenties to dramatize America as
the capital of political and economic reaction. Much more sur-
prising was the vehement opposition to the Vietnam war from
émigrés who had once been among the most fervent supporters
of American institutions. Hans Morgenthau was one of the two
U.S. government officials to resign in protest over Johnson's war
policy. Morgenthau's original milieu had not been radical: "My
father would have turned in his grave if he had known what I
did on Vietnam. A Jew opposing the official point of view? You
don't do that if you know what's good for you." Morgenthau's
gesture evoked a response that émigrés critical of America had
grown accustomed to: "John Roche, . . . President Johnson's in-
tellectual-in-residence, [wrote] that I was one of those Europe-
ans who simply didn't understand what America was all about."

The wonderful thing about such facile dismissals is that they allowed one not to take Morgenthau—or Einstein or Thomas Mann—seriously, a foolhardy position in other circumstances, somehow justified here by a chauvinistic insistence on the native's privileged consciousness.

The apparent turnabouts of Hannah Arendt and Erik Erikson particularly incensed the neoconservatives of *Commentary*. How could they have found America so wonderful in the fifties, and so rotten in the sixties and seventies? Writers like Arendt and Erikson had in fact undergone no philosophical sea change. Their intellectual vocabulary remained the same, except that now the slots that had been reserved for other villains were filled by Americans. In 1950 Erikson had assumed that "bossism" was a remediable excess of the American character. By the seventies, he was attacking the "oppression . . . suppression . . . repression" unleashed by the "do-it-yourself" American, plundering and bullying the planet. Arendt had always proclaimed the need to speak truth to power. And as power achieved its American incarnation she objected, as she had earlier to similar actions by the Germans, British, and French. Hans Morgenthau, the champion of realpolitik, simply insisted that Vietnam was a dreadful waste of energy; it was pointless, impractical, *inefficient*, it didn't work.

The émigré intellectual most often identified with the war protesters was Herbert Marcuse. That Marcuse should become a media figure is perhaps the single most surprising incident in the whole history of émigré culture, for despite his valiant attempts to convey the idioms of American minorities, Marcuse was not a man who adjusted his tone to the marketplace. By Erikson's standards he should have been the last man to write in America about Americans for Americans. Yet for a time he seemed the antiwar movement's resident philosopher.

Since the early thirties Marcuse had been a member of the Frankfurt institute's inner sanctum. His special province was philosophy and, after his arrival in America, the relations between bourgeois culture and the rise of fascism. But he was also a devoted student of the arts, and his books are filled with references to literary figures. Marcuse's close reading was usually

directed toward a political purpose: in the third issue of the institute's journal, he devoted an entire review of a work of political science (Carl Schmitt's *Begriff des Politischen*) to enumerating the textual changes between the first and third editions.

Marcuse's first years in America were spent on institute activities: he remembered them as being without painful incident. During the war he and his institute colleague Franz Neumann served at the Office of Strategic Services. For some years after the war Marcuse continued to work for the government; he described this time as a period devoted to fighting a resurgence of fascist political groups. He continued his private scholarly studies, and in 1954 began a long and influential tenure as professor at Brandeis University. His 1958 study, *Soviet Marxism*, would have caused his former government colleagues little pain with its vehement indictment of the Soviet regime.

Shortly after joining the Brandeis faculty, Marcuse published *Eros and Civilization*, an attempt to assimilate Marx's theories into Freud's. Though Reich had tried the same thing years earlier, Marcuse's effort was singularly daring for an American academic in the fifties. His attempt to extend the terms of radical behavior was one product of the Frankfurt institute's disappointment in the working class. Whether bought out or sold in, Marcuse said, labor could no longer be relied on to provide a suitably revolutionary "agent of negation." The Frankfurters believed a failure of Marxist theory to be its ignorance of the psychological themes enunciated by Freud. In conjoining the two thinkers, Marcuse hoped to discover a new catalyst for social change: a liberated body not in lieu of, but incorporated in, a liberated social class. *Eros and Civilization* is as much a literary as a psychological or economic testament. Its presiding geniuses are not only Marx and Freud but Stendhal, Proust, Heine, and Schiller. The work also contains numerous citations of institute members; throughout his career, Marcuse would introduce writers like Adorno and Walter Benjamin to American students.

The book was written in memory of his first wife, Sophie Marcuse. Her death and the deaths of Hitler's victims contrib-

ute a fleeting melancholy to the book. More frequent is a note of release. Marcuse's manner is nothing like that of Fritz Perls, but in his sober way he too adumbrates prospects of real happiness.

The way out of the contemporary maze is eros. Marcuse finds Stendhal's *promesse de bonheur* not only in art, as his colleague Adorno would, but in perversion. He celebrates Narcissus for his aimless self-delight and the "homosexual" Orpheus* for his useless song. Happiness, in the form of sensual indulgence for its own sake, will disrupt the social order. In *Women in Love*, D. H. Lawrence distinguished between the activities of day and night, and insisted that any confusion of the two would produce authoritarian politics and sexual violence. Similarly, Marcuse separates dream (night world) from work (day world). And while orthodox Marxists would attend to the realities of production, Marcuse as a disciple of Freud celebrates the dream state.

Now one can hardly dream and live rationally at the same time. Marcuse's solution is to draw upon that familiar figure, Schiller; once again, as in Erikson or Perls, Schiller's "play impulse" is offered as a mediation between "sensuousness and reason, matter and form." This remains a rarefied solace: can one imagine a Halloween Ball at the Institute of Social Research? And yet, the abstruse Marcuse would, within a few years, command an immense audience of young Americans.

As he would have been the first to recognize, it was a series of historical events that made his gnomic, paradoxical style seem apt for the season. *Eros and Civilization* was, as its title indicated, a reflection of life in cities. It rested its practical hopes on the opening up of leisure time for the masses. Where else but in the rush of modern urban life could people disentangle themselves from the old sexual forms, with their exclusive focus on procreation? Marcuse's vision was convincing to young people who had enough free time to feel bored and experimental.

American readers were equally attuned to the audacities of Marcuse's next major work, *One-Dimensional Man* (1964). In

* Marcuse seems to have forgotten Eurydice.

the culture of monopoly capitalism, he declares, modern man is unidimensional, because all the areas of his life have merged: working, playing, thinking, he is always the same. There is an absolute identity of ideology and production: that this is also a Marxist ideal only exposes an inadequacy in Marxist theory. Man needs a place to live in and plot his resistance, but no area is really free. By then, Marcuse had lost his enthusiasm for sexual freedom. He concluded that the vaunted sexual liberation had become "repressive desublimation." With this concept, a paradox typical of the Frankfurt school, Marcuse suggested that sexual play had now become a trivial entertainment, granted to the masses in order to dull their sense of exploitation.

Within a year, Marcuse was to introduce perhaps his most provocative concept in his essay "Repressive Tolerance" (1965). Once again, for those already familiar with the Frankfurt school's love of dialectical gymnastics, the phrase was no surprise. More important, a large number of young American readers had been trained by Marcuse, if not by the sheer force of public events, to find his term appropriate. After examining the mass media, Marcuse concluded that any radical statement would sink beneath a mountain of positive observations. Like a latter-day Kraus or Benjamin, he considered a typical newspaper page on which gorgeous ads presented a pictorial denial of horrifying news items.

In a 1968 postscript, Marcuse spelled out his argument. No, he was not impressed by the newspapers' occasional airings of left-wing arguments. How could these "interludes" balance the pervasive "system publicity" that manifests itself in everything from production to entertainment? Newspapers had begun to print op-ed pages, the journalists' equivalents of Hyde Park soapboxes, but Marcuse understood that these isolated turns made the radical appear like a novelty act. He alarmed many Americans with his insistence that equal representation in the media was a fraud. Given the barrage of material that affirms the system, the naysayers required not equal but more, much more time and space merely to balance the scales.

While shocking Americans, Marcuse was simply stating one of the first perceptions of émigrés. For people who had first ap-

prehended the country as monolithic and foreign, it was no longer news that the American ideology manifested itself in more than speech. These émigrés might have argued that Marcuse's belief in the redemptive influence of radical journalism was literary and old-fashioned.

Marcuse's best-known works constitute some of the bitterest émigré indictments of American idioms and habits. While they spoke forcefully to young Americans who shared his anger, Marcuse's criticisms also reflect on his own situation as an émigré who has transported his European critical habits to a strange culture. When Marcuse celebrated the useless figures of Orpheus and Narcissus as frisky saboteurs of the capitalist system, he was invoking Adorno's portrayal of the intellectual Jews who, finding "happiness without work," become the living incarnation of resistance to the Gentile world's conformity. For Marcuse, the homosexual and all those freed from "genital tyranny" and enjoying an unrepressed sexuality were harbingers of Utopia. But any more concrete promises of happiness were met with severe censure as conformist, bourgeois, and—though he never said as much—hopelessly American.

Thus in *Eros and Civilization* he was totally dismissive of the neo-Freudian psychoanalysts. Among them was his old friend and former colleague Erich Fromm. Marcuse accused Fromm, Karen Horney, and Harry Stack Sullivan of oversimplifying Freud's theory and turning it into a series of therapeutic aims drawn from the "prevalent ideology." Back in the old days, Fromm had attacked all attempts to adopt conventional values. Now Marcuse found him advancing "inner strength," an ideal that sounded suspiciously like positive thinking. (Fromm considered this an unfair caricature.) When Marcuse discovered that Freud's ironic argument had degenerated into a social worker's sermonette, he was actually accusing émigré analysts of sacrificing their European rigor for the consolations of American positivism. He was blaming them for not sounding European enough, for drawing on Norman Vincent Peale instead of Schiller; as he wrote later, his own intelligence was motored by "the power of negative thinking."

In *One-Dimensional Man*, Marcuse the disenchanted aes-

thete and Marcuse the enraged activist converged in his analysis of contemporary political idioms. In a manner that extends back to John Milton, he showed how the corrupters of English were leaving the public "immune to everything and susceptible to everything." He observed that the very grammar was totalitarian. Certain terms contradicted good sense but demanded unthinking responses. Since the perfected political sentence resisted "demonstration, qualification, negation of its codified and declared meaning," those who paid attention to the hazy and illogical scrambling of concepts were almost committing an act of war. As examples, Marcuse showed how the phrase "science-military" "joins the efforts to reduce anxiety and suffering with the job of creating [them]," while a phrase like "clean bomb" wipes out logic and grammar, "attributing to destruction moral and physical integrity." Placing his own procedure in a European context, Marcuse cites Kraus's efforts to prove that syntax, grammar, and vocabulary are all political acts; he could also have recalled the words of Proust's Baron de Charlus: "I have always honored those who defend logic and grammar. Fifty years later, we recognize they warded off great perils." One of the happiest products of emigration was the brief time in the sixties when a political reading of language, cultivated in emigration, bound together émigré scholars and American students.

At one point, Marcuse puts into the mouths of some hypothetical detractors words that seem directed against all recalcitrant émigré intellectuals: "You talk a language which is suspect. You don't talk like the rest of us, the man in the street, but rather like a foreigner who does not belong here. We have to cut you down to size, expose your tricks, purge you. We shall teach you to say what you have in mind, . . . your language . . . must be translatable and it will be translated." No, says Marcuse, my intransigence is substantive. As if to counter George Orwell's famous argument that political language must be simple and direct, Marcuse asserts that a complex situation requires a complex commentary. Dialectical paradoxes apply also to prose; glib simplifications add to the general darkness, and only by remaining true to the principles of his very European style can he make plain sense out of the contradictions of American life.

Following his retirement from Brandeis, Marcuse assumed a new position at the University of California at La Jolla. While there he discovered in popular culture a relaxing of the ideological grip on society. In his 1969 book, *An Essay on Liberation*, he advanced an eloquent defense of minority culture. Marcuse found a linguistic breakthrough in the idioms of the Black Panthers. At times, the émigré overlistened, as when he made something uniquely liberating of the term "mother-fucker." But for an intellectual, especially one who was steeped in German culture, he was extraordinarily open to a cultural style that contradicted most of the romantic assumptions. Marcuse admitted that "soul" no longer resided in the works of Schubert and Beethoven. He recalled the remark in Mann's *Doctor Faustus* that after the contemporary horrors even the Ninth Symphony must be revoked. All right, Marcuse contends, the oppressed have revoked the Ninth Symphony, and replaced it with "soul music." With great acuity, he distinguished this black form of music from white commercial adaptations; just as he found hippie slang insufficiently subversive, he found white rock music lacking in soul's "raw immediacy."

At one other point, Marcuse makes an implicit connection between German Jews and blacks. To exemplify "the language of counter-sense," he reports the remarks of a certain judge named Christ Seraphim who objected to the noisy protests of black civil rights workers. Seraphim (of course, Marcuse can't resist a gloss on his diabolical intentions) condemns the blacks' lack of manners and wonders why they can't be like the Jews who "maintained their dignity," did "little marching," and, not incidentally, Marcuse wryly observes, were "baked in ovens." In his sublime "counter-sense," the judge regards attempts to prevent another holocaust as "criminal."

By 1969 the protests against the Vietnam war had become widespread, and Marcuse's contention that radicalized students constituted a new vanguard was a commonplace. But though the war dragged on, the student protesters never developed into a cohesive political force. Marcuse had already foreseen the possibility of defeat, while stressing the importance of civil disobedience. He would not seduce the young with promises of instant

cures of any sort. He exhibited little faith in the working class, although he always insisted that they alone would be the subjects and agents of revolution. And, once again disconcerting orthodox Marxists, he contended that the Soviet Union's abolition of private ownership and cultivation of a planned economy were insufficient achievements.

Marcuse's following began to turn elsewhere for guidance. Right-wingers dramatized him as a threat to the nation, the latest and worst of enemy aliens. After a series of death threats, in 1969 he moved briefly to the northern California home of his old colleague Leo Lowenthal. Orthodox Marxists had long despised him; now Maoists and Trotskyists, having placed confidence in working-class organizing, excoriated his lack of faith in their new comrades. In 1976, during a return visit to West Germany, Marcuse was verbally abused by some students. He also acquired a whole new band of critics in Great Britain. Whether as linguistic philosophers, political conservatives, or academic specialists, many British intellectuals were unsympathetic to the cross-disciplinary, radical ambitions of émigrés like Marcuse. Alasdair MacIntyre wrote a severe denunciation of him in book form.

Marcuse appeared on a BBC television introduction to philosophy in 1977. The interviewer gloated over the irrelevance of Marxist dogma (Marcuse replied that the analysis was in no way dated, since the gap in classes had not disappeared); made him apologize for the unreadability of Adorno (Marcuse granted that his friend was not always easy, but that the whole point was a resistant surface); and with special glee, asked him to agree that the *soi-disant* democratic new leftists were guilty of elitism. Marcuse objected to the tone of the last question; if such a feeling existed, it was "another expression of self-inflicted masochism on the new left": they had proved themselves a "catalyst group," they had no cause for apology. When the interviewer tactlessly commented that Marcuse's popular success must have been the surprise of his life, the old man agreed modestly and added, "I appear only as such a figure because others seem less deserving."

That same year a British journalist, Henry Brandon, credited Marcuse with inciting the violent actions of American Weathermen and the German Baader-Meinhof gang. A group of academic friends wrote a letter describing this assault as a "smear," redolent of the "terrorism . . . that so long ago drove him into exile from his native Germany." Brandon defended his argument by citing a 1966 conversation in which Marcuse had acknowledged his influence on the Weathermen; another supporter replied that the Weathermen did not come into existence until 1969. Marcuse withstood all these later attacks and disappointments with equanimity. Happily married for the third time, he devoted his energies to his last published book, *The Aesthetic Dimension: Toward a Critique of Marxist Aesthetics*. In this Adornoesque study, Marcuse felt no embarrassment in advocating an aesthetic elitism. Only an art achieved at great risk and distance from the people could provide a "rupture with the reality principle" (eros, it would seem, was still on sabbatical). Art for Marcuse must be difficult, a miming of "disintegration," since the easy, which would be "reproduction and integration," serves to affirm the status quo. And it is art's role to both draw from and deny the world of "Auschwitz and My Lai." While Adorno would see Auschwitz overshadowing all artistic achievement, Marcuse's émigré vocabulary had expanded to include the victims of both Germany and the United States.

In 1978 Marcuse joined some students at La Jolla protesting the ostensibly racist remarks of a visiting professor, who also happened to be a British linguistic philosopher. He told some student journalists that he realized *The Aesthetic Dimension* might banish him forever from some Marxist circles. He didn't mind, considering the kinds of people who traipsed around in the name of Marx. Anyway, he added in language that recalled Hannah Arendt's self-description, "I don't care what label is being given me; nothing could be of less interest to me." Marcuse continued his intellectual and political work until his death in 1979.

———

While some émigrés, Left and Right, opposed the American military policy in Vietnam, there was a conspicuous silence from Marcuse's old colleagues Max Horkheimer and Theodor Adorno. Since their return to Germany, the two had become symbols of the intellectual Establishment there. Now, as a large audience of students clamored for the old messages, the two chose to separate themselves from the intellectual campaigns of their youth. By the late sixties the bookstores of Berlin were packed with paperback editions of the earlier writings of Horkheimer, Adorno, Benjamin, Lukács. But Horkheimer advised caution in the reading of such dangerous material. During the fifties, according to his student Jürgen Habermas, he kept old issues of the institute's journal sequestered in the basement so that students would not be infected by the radical bug.

During the Vietnam period, Horkheimer wrote that Kaiser Wilhelm had been right (one of the rare occasions): the yellow races were a peril; Horkheimer occasionally derived his metaphors from commerce: "Like a businessman who must keep a cool head when times are bad, so must the national community." In a new preface to *Critical Theory* (1968), he refused to criticize the American involvement in Vietnam: such condemnation "contradicts the critical theory and is for Europeans a case of going along with the crowd." He applauded the students' ordinary aspirations—"desire for a better life and the right kind of society"—but advised them against outbursts of violence: once again the words of Rosa Luxemburg were cited as argument against the antidemocratic policies of Trotsky and Lenin, as if the debates of Horkheimer's youth had retained all their currency. Horkheimer preferred the protection of hard-won freedoms to radical political action—"Even a dubious democracy . . . is always better than the dictatorship which would inevitably result from a revolution today"—language that echoed Winston Churchill more than Red Rosa. Most German students, never noted for their subtlety, dismissed Horkheimer's reasoning as simple apologetics.

Horkheimer minded less than did Adorno, who had long pre-

sumed that Americans were intellectual barbarians, unequipped for his mediated negations. But Adorno was devastated when German students began to vulgarize his message and looked to him for the programmatic counsel he deplored. It was, indeed, as if they had been Americanized, turned into a yowling mob of positive thinkers. By 1960 he was lamenting that there were "no longer any hiding places." Once bohemians could live among their own, but the inhabitants of the Parisian Left Bank had all turned into Greenwich Village imitators and become "what Americans call 'phony' "—again Adorno was using American idioms to condemn American styles.

As versatile as ever, he continued to publish analyses of music, literature, and philosophy, culminating in the massive and daunting *Negative Dialectics*. He still sought in art the "antithesis of that . . . which is the case," and the means of acquiring a "negative knowledge of the real world." Such knowledge would never lend itself to summary or application. Any "message," no matter how radical, was an "accommodation" that denatured art. Yet Adorno always brought to his writings on art an awareness of social reality; he provided no message but much history. Thus he always believed that art, in the context of Auschwitz, was obliged to justify its essentially utopian nature, when the possibilities of hope have virtually disappeared. While considering the treatment of tempo by modern composers, he would pause to observe that people today "increasingly renounce memory"; what happened a few bars ago was as elusive as the guilt that Germans have renounced in a mass epidemic of amnesia. Despite such gloomy prose, Adorno remained an advocate of pleasure, though usually in aesthetic form. He still affirmed the avant-garde. Any other kind of music was "kitsch . . . infantile."

By the late sixties German students were tired of this familiar line. They expected something tougher. During a protest against the Shah of Iran a student was killed and afterward Adorno was asked to sign a petition. He abstained. Students responded by floating a red duck balloon in his classroom as he lectured on Goethe's *Iphigeneia*. A couple of girls bared their

breasts, as if to expose the radical's own "petty bourgeois" inhibitions. Adorno was heartbroken. He died a few months later, in Switzerland, and many people deduced that the students' hostile behavior had brought on his end. Seldom since Keats had such a public rejection been used to explain the demise of a man of letters.

Before his death, Adorno composed a brief essay, "Resignation," that demands to be read as his own apology and defense against the students. He describes most current political activity as "capitulation to the collective." These politics are not real, he says; rather they resemble "pseudo-activity." They speak to the same consumer impulses that allow for "do-it-yourself" enterprises even though, he observes, mass-produced goods happen to be better than the homemade variety.

Years ago in America, he had dismissed the mood of comfortable audacity that intoxicated the fans of popular music. Now in "Resignation" he argues that "the feeling of new security" allowed by American-style New Left politics "is purchased with the sacrifice of autonomous thinking." But there is a better route to winning the attentions of other people than mindless emoting. People can be reached through thought and memory. Since "what has been cogently thought once" cannot have occurred *in vacuo*, serious, rigorous "thinking has the momentum of the general" and unites the thinker with his proper comrades, dead and alive, in expectation of events that most likely will never take place. Adorno could be Shelley all over again, heralding the unsung legislators of mankind. The essay's dialectical twist is that what appears like an Ivory Tower perception of the abyss is actually a means of "happiness" and the "sublimation of anger," not passive but active, not resigned but transcendent. The political agitation outside the academy had inspired an émigré intellectual's purest argument, but a reader may wonder if anybody, including its author, was convinced.

In America, too, there were émigré voices raised against the antiwar movement. Bruno Bettelheim used his characteristic language with particular ferocity during the sixties: the student

protests were merely Oedipal rebellion and cultural conformity.* Like some other émigré scholars, who recalled the Nazi takeover of German universities, Bettelheim considered antiwar activities "a threat to the integrity and true calling of the university." In a typical critique, he raged against "Student Fascism of the left as combined with black Fascism such as that of the 'Panthers.' " Bettelheim had been associated for years with the University of Chicago. During the period he was publicly attacking black and student "Fascists," the Chicago police department was engaged in surreptitious activities that culminated in the massacre of a Panther leader, Fred Hampton. But such a detail was no more likely to be noted in Bettelheim's assault on students than was an indictment of the government leaders during the Vietnam war. Instead he counseled students to go along with any "half-way reasonable establishment" and added with Viennese whimsy, "any establishment is only half-way reasonable."

On a humbler level, many émigrés considered opposition to the American war policy a sign of ingratitude. One college professor, fulfilling his mother's dying request, wrote a letter to President Nixon conveying not only the old lady's assurances of her affection for the country that had showered so many advantages on her family but also her displeasure with those scandalous young people. "My country, right or wrong", was, for her, no mere slogan, and for others like her the combination of loyalty and caution made criticism of American politics unthinkable.

For all the more radical émigrés' despair over Vietnam, the intellectual symbol of support for the war was another émigré. Henry Kissinger's power overlapped Nixon's and lasted beyond the Nixon administration into Ford's. Kissinger says that he encountered some anti-émigré resistance at Harvard; McGeorge Bundy responded to him with the hauteur reserved for those with "exotic backgrounds and excessively intense personalities."

Kissinger became the most famous German Jew of his time.

* For another slant on American adolescence, the "acting out" of political dissent, see the work of Peter Blos, who helped train Erikson in Vienna.

To many observers, this was the triumph of the émigré intellectual. But to some émigrés, Kissinger's involvement in the vanquishing of Vietnam and Cambodia was deeply shameful. One woman says, "I hate him the most because he's one of us." For such people it was an unspeakable irony that the country they had loved so much should achieve what they regarded as its moral ruin largely under the auspices of a fellow émigré. As a result of postwar events that culminated in Vietnam, there would be a small, unhappy group of émigrés who spent their last years bitterly dissatisfied with America and, after a lifetime in the country, not quite at home.

Epilogue

By the time Erich Kahler amused Thomas Mann with the following story, it had already been circulated in émigré circles. Two refugees are sailing on the Atlantic, one toward Europe, the other toward America. As their boats pass each other, the two old friends burst out simultaneously, "Are you crazy?"

Thirty years later the surviving members of the generation of Hitler's émigrés, or at least those who thought like Mann, Einstein, Arendt, or Lang, could have revived the story. Take the hypothetical émigré who returns to Europe. Were he back in Germany, he could claim the benefits of restitution and enjoy the government's self-professed philo-Semitism. But if he were a certain émigré type, he would be alarmed by the *Berufsverbot*, the series of antiradical laws that exclude the politically unorthodox from the civil service. He might not fear an outbreak of anti-Semitism; after all, the average German under forty had never met a German Jew. But he would notice what Günther Anders called an "anti-Semitism without Jews," a new racial prejudice directed against *Gastarbeiter* (itinerant workers). He would not be pleased with the leaders of the small German Jewish community; shades of the Central Organization of German Jewish Believers, these men seem happier with the authorities, including former Nazis, than with radicals. As the ex-Nazi Karl

Carstens succeeds to the nominal position of West German president, as authoritarian attitudes reappear in a generation too young to remember Hitler, our émigré can be forgiven if he finds himself unable to shout hosannas over the economic miracle or bless the government that mails him his monthly restitution check.

Every alert émigré is the scholar of at least one discipline, emigration, and the master of at least one truth: the world had abandoned them, and the world has forgotten. This can lead to unbearable pessimism, the dissolution of all hope. But the émigrés are a sturdy lot. They still possess the acerbic tone, the *Berliner* humor. Emigrés back in Germany have recently had a new joke. A Jew enters a Munich train station, and joins the ticket line. He asks one neighbor if he had been a Nazi during the war. "No! Never! What do you take me for?" "Forgive me," cries the émigré, all meek apology. He asks another neighbor, and receives the same reply. Finally he turns to a third, and the man shrugs and says, "Of course I was." "Ah, wonderful!" cries the Jew. "I was looking for an honest man I could leave my bags with."

Emigrés have lived to see the behavior of German-speaking Jews, Establishment and otherwise, acquire an iconic force that resounded several times in the late seventies. For example, the well-publicized case of Jacobo Timerman, the Argentine dissident who accused his country's Jewish leaders of sidestepping the Fascist threat, had evident parallels to the émigrés' history. Timerman was ready to provide these: he invoked two letters written in 1933 by Berlin Jews, one calling for a massive boycott of Germany, the other counseling restraint and diplomacy. It was another replay of the interfamilial debates, dramatized recently in the arguments over the Israeli invasion of Lebanon. The division that the latter event caused within the Jewish community recalled the furor over Arendt's study of the Eichmann trial. In retrospect, that controversy assumed even greater significance when viewed in the context of the postwar history of American Jewry. It anticipated the recent polarization between neoconservatives, who supported Israel's invasion wholeheartedly, and liberals, who believed that something very terrible had

befallen the Zionist vision: the two groups were also diametrically opposed on social and military policy in the United States. Weren't these groups the successors of those who had objected to any Arendtian criticism of the Jewish leadership and those who had granted Arendt her case while perhaps questioning her tone? For all Jews in 1982, the use of words like "pogrom," "genocide," and "blitzkrieg" to describe Jewish actions was excruciating, regardless of whether the terms were violently rejected or bitterly accepted. But émigrés like Arendt and Einstein had foreseen such a development back in 1948, when they warned the American Jewish establishment not to embrace the "Fascist" Menachem Begin.

For émigré Jews or radicals, recent American history has been profoundly worrisome. The revival of Nazi and Ku Klux Klan activities might be played down by the national press, but the events—the acquittal of Nazis and Klansmen who had been televised shooting radicals; the high vote counts racked up by Nazis in North Carolina, Michigan, and California—were bound to remind émigrés of the past. Fifty years before, Klaus Mann, Sergei Eisenstein, and Salka Viertel had found the flamboyant evangelist Aimee Semple McPherson a joke or a scandal. In the late thirties, no émigré had failed to recognize the danger represented by right-wing religious figures, such as Father Charles Coughlin and Gerald L. K. Smith. And in the eighties emerged the Moral Majority, multitudes of anti-intellectuals answering to the call of television evangelists, people who combined McPherson's showmanship, Coughlin's fervor, and Smith's conservative politics. One of the great émigré perceptions of American life had been the centrality of a peculiar, uniquely American religion, but it did seem excessively ironic that the old-time religion should return with a Baptist leader declaring that God did not hear the prayers of a Jew, along with Pentecostals announcing that homosexuals and adulterers were headed for hell.

There were other events that held a special resonance for émigrés. In 1981, in an attempt to limit the illegal migration of Haitian workers, the Reagan administration declared that the majority were not political but merely economic émigrés—an

unhappy reminder of Switzerland's similar justification for returning Jewish refugees to Germany. Also in 1981 the eighty-seven-year-old John McCloy, who as high commissioner of the Allied Forces in Germany had supervised the 1951 General Act of Clemency, appeared before Congress to defend another controversial program, the wartime internment of Japanese-Americans. While a courtroom of angry Nisei hissed and hollered, McCloy insisted that their relocation had been fair and correct, describing it as a move to a "healthier and more advantageous climate." The echoes of Nazi commercials for the death camps were apparently unwitting. According to news accounts, McCloy later "cautioned [Congress] . . . not to advocate policies that might someday prevent the forcible relocation of other American citizens because of ethnic background." Such declarations were bound to alarm those émigrés who remained convinced, forty years after their arrival, that their stopover was temporary.

For years, critics have added a patronizing coda to their praise of émigré intellectuals. Yes, they grant, émigrés contributed magnificently to American culture, but they didn't really understand the kinds of energy abroad in the land. Mann and Einstein were overly paranoid about McCarthyism, the line goes; ignorant of political cycles, they didn't see that in American politics what goes around comes around, as if this country had acquired, together with all the other legacies of Great Britain, a good-humored way of muddling through. Such criticisms have begun to ring hollow. True, the émigrés were both attracted and bemused by American culture; they never got it all, though it is remarkable how they tried to get it whole. Yet if Einstein or Thomas and Klaus Mann were back and could observe the Ku Klux Klan in Connecticut or the Moral Majority in New Jersey, as well as a rebirth of Cold War sentiments in Congress and the academy, one doubts if they would feel inclined to apologize for their earlier misgivings.

Of course, some émigrés couldn't be bothered with these perpetual political agitations. A friend asked Otto Nathan recently why so many refugees had turned to the Right. "Not only refugees," the economist replied. It would be wrong to make heroes of all émigrés, as if each were a custodian of historical memory.

Many are too busy or, simply, too satisfied. Still, as was made clear during the sixties, a large number have not disowned their pasts. For better or worse, the survivors of the generation that congregated with the poets can still trouble themselves with most of the same issues that occupied their attention in the Berlin cafés.

Thus, as Thomas Mann, drawing upon Goethe, had dreamed, the new world has become a setting for splendid old ages. During the Watergate hearings, Arendt found herself smitten with Sam Ervin: "I am developing a crush on Senator Ervin. Long live old age. Old people, if they are halfway sensible, are almost impossible to intimidate." She could have been speaking for her own generation.

Well into the 1980s, émigrés were still politically engaged. Following the Israeli invasion of Lebanon, a newspaper article described conflicts within the Jewish community; prominent among the critics of Israel cited was Hans Jonas. The seventy-nine-year-old professor of philosophy was as forthright as his old friend Arendt: the invasion filled him with feelings of "disgust" and "shame." Practically the last public gesture of Nahum Goldmann—the architect of the German restitution plan and a major figure in American Zionism during the 1940s—before his death at eighty-seven was an attack on Israel's military policies.

Emigrés attended to other political matters. Among the scientists working most actively for a nuclear freeze were Hans Bethe, Konrad E. Bloch, and Victor Weisskopf. (Opposed to a freeze to an equal extent were émigrés like Edward Teller and Eugene Paul Wigner.) Bethe concluded an analysis of the outsized military budgets of the two superpowers this way: "These are the basic facts. Once they are recognized, the essential features of a sound national security policy become apparent." This is a quintessential émigré statement, both in its nononsense directness and in its confidence that American readers can still be swayed by rational argument. (Bespeaking their objectivity, Bethe and Weisskopf were also prominent critics of the Soviet mistreatment of political dissenters and peace advocates.)

Of course, people like Jonas or Bethe or Helen Wolff—at

seventy-seven, she was still making European literature available to American readers—would be exceptional in any group. But they are not strikingly different from the other gifted men and women who migrated with them. This is not a generation disposed to retirement—perhaps because it was astonished by its own survival. The publisher Fritz Landshoff was so surprised by his longevity that he referred to himself as "the late Mr. Landshoff." Richard Lindner, who died shortly after his last exhibition opened in New York, once declared, "When old people meet, they know each other's story." The single noun is telling; when old émigrés meet, they have one story in common, and so the final chapters written by Helen Wolff or Hans Bethe can be read as a completion of everybody's life.

Even after all their efforts to learn about America, the surviving émigrés could enter the eighties and still feel that their education was incomplete. What was left to be learned was not quite what they had expected. As a group émigré artists and intellectuals— aside from the psychoanalysts—had not been obsessed with individual behavior, perhaps out of the confidence derived from their own lusty personalities, or, ideologically, out of a commitment to a group, whether it was the working class or fellow Jews. Thus the 1970s' much publicized infatuation with the self was not to their taste. That radical politics should eventuate in narcissism was a bad joke.

Even the strict Freudians who had attended to the self were surprised by the changes in the American disposition. One psychoanalyst, Henry Lowenfeld, noted that it was all very confusing: Oedipus had been sent packing; today fathers wanted to be with their sons, and, like them, were themselves still in the throes of adolescence. Popular movies, as if to confirm Erik Erikson's 1950s perception of the new American family romance—with Dad and Junior allied against the egregious Mom—began presenting divorced fathers as figures of pathos and charm, more sentimentally attached to their offspring than their cold-blooded, careerist ex-wives. These were not, however, the films of émigré directors. Although they had depicted many

American types, none of them, not even that master of the quick change, Billy Wilder, had reckoned on the flourishing of delayed adolescence. (And it was probably unfair to expect émigrés who had been forced to learn so much else about American culture to now become scholars of immaturity.)

Emigrés had anticipated the many social and psychological changes of the sixties. But perhaps the guides had been not so much the psychoanalysts and sociologists, nor even those writers as percipient as Adorno or Marcuse, as these film directors. When Douglas Sirk made black pride the subtext of *Imitation of Life* in 1959, he forecast the subsequent obsession with roots. His juxtaposition in that movie's climactic scene of Lana Turner, an empress of secular consumption, and Mahalia Jackson, mourning the death of Turner's maid as she wails "Soon I Will Be Done with the Troubles of the World," managed to foreshadow enough questions of value that would be raised in later decades—sexual, spiritual, political—to fill a text. His capacity to move both black and white audiences—simultaneously, although not in the same way—was the kind of breakthrough, achieved by only a few émigré artists, that made possible an informed communication with the American public.

But hardly an émigré director now remains to woo that public whose fickle nature has rendered it increasingly unpredictable. Billy Wilder complains that audiences today "prefer mindless violence to solid plotting, four-letter words to intelligent dialogue." All the efforts to master American idioms in order to transform them are fruitless when "nobody listens any more." The problem for Wilder is that "the *mezzo*-educated, the *mezzo*-brow is falling away. It's the highbrow or it's the lowest. It's very difficult." Wilder's complaint reminds us that the most successful film directors, with rare exceptions like Sirk in his soap operas, focused right on that *mezzo*-brow. And much further back, it was the large public of middle-brow Jews who defined German culture in the twenties and thirties, who bought the books and attended the plays and filled the cafés. That was another audience, admittedly, but what Wilder laments is the American reflection of the decline.

While the artists and social scientists were trying to figure out a whole new audience, émigré academics were finding themselves similarly estranged. The quondam heroes of high culture, from Schoenberg to Marcuse to Gropius, have been dismissed as out-of-date, victims of the cyclical changes in public taste that émigrés were among the first to notice. All the academic generalists, the scholars who could teach history and political science and literature and psychology and philosophy and—and—and—appeared glib and unreliable in an era consecrated to specialization.

For a while there was an audience for Arendt's contention that scholarship as usual was absurdly irrelevant, but by the eighties, the traditional approach was again in place. An academic style that had once seemed forbidding now seemed to have taken a melodramatic turn. In this revenge *against* the refugees, some of their most famous scholars were reduced to the status of colorful characters. Einstein may have been the first to suffer such condescension. After all, it was much easier to see him as cute and eccentric than to acknowledge his criticisms.

The émigrés had arrived as enemy aliens, and often went out the same way, whether condemned by their fellow Jews for their anti-Zionism or by their fellow Americans for opposing the war in Vietnam. And those who returned to Europe in the late 1940s were just as ill-starred. Marxists were continually put to trial by fire. Stalin's war on "rootless cosmopolitans," among all his other political crimes, was particularly demoralizing for émigré radicals. They had fled Hitler after he had hurled the same epithet at them. Stalin's last campaign was directed against Jewish physicians—an event that made for a kind of gallows humor, the ultimate comeuppance for all the bright Jewish boys who had become "my son, the doctor." To find oneself turned once again into an "enemy alien" for being an intellectual was to discover that one remained an outsider; there appeared to be no home for these cosmopolitans.

And back in Europe the old battle with philistines, resurrected as commissars of culture, resumed. Late in his life, Brecht

traveled to Paris. The playwright delighted, as always, in the idea of good food. Ogling a sliver of cheese, he told a friend that he'd like to transport it to the lobby of his theater in Berlin—then he'd show those Germans what culture really was. Typically, the poet could make something as mundane as cheese represent history and style.

Surveying his generation's lifetime of disappointments, Brecht once again defined matters. In a very late poem, "Things Change," he recalled:

> And I was old, and I was young at times,
> Old in the morning, and young at night,
> And was a child recalling sad times,
> And a graybeard without memory.

Switching to the sing-song rhythms of a popular tune, he adds:

> Was sad, when I was young,
> Am sad, now that I'm old.
> So, when can I be happy?
> It had better be soon.

Ah, but in that third line's "So," with its *Berliner* shrug, there is the great achievement of émigré tone—the merging of melancholy and common sense, the gallows humor that turns all surprises, even death, into components of a comedy that is always too political for pathos.

There were heroes among the émigrés. Thomas Mann and Einstein were the most public and, surely, the most politically courageous. They were also prodigious in the counsel and assistance they rendered less fortunate émigrés. On a more parochial level, there were the heroes whose very presence served to calm the misapprehensions of their fellows: Arendt in the camp at Gurs, defending the ill and studying her Greek textbooks; the numerous émigrés who attempted to rout the barbarians with quotes from Goethe and Schiller; Hermann Broch, who was always there when his fellow émigrés needed him. And, finally, the scoundrel Brecht. After his death, Anna Seghers observed, "He was so completely us; he belonged to us so completely,"

and Wieland Herzfelde recalled that a troubled émigré had but to look at Brecht's sly, "unlachrymose" face to realize that sustained misery was beside the point.

The best of them—writers, artists, scientists, directors, scholars—were relentless in their devotion to the cause of humanity. Consider how many ended their lives still resisting. If they stood alone in conventional terms, they also understood that they were accompanied by millions, the victims of all history, particularly the friends and relatives Hitler had murdered. Leo Lowenthal likes to think that art is on the side of history's losers; Walter Benjamin felt that even the dead would not be protected from the enemy's grip; Einstein refused to return to the country that was responsible for six million Jewish deaths. All of them considered themselves the advocates of the dead, because they refused to accept as finished those many lives that had been so gratuitously cut short.

A few writers tried to cultivate a style that would express the historical breakdown and subsequent rearming of the defenseless individual. Whether it was Walter Mehring praising Proust's "subjunctive of doubt" or Broch positing a sentence in which subject and object were rendered equivalent or Marcuse trying to free American discourse from the slogans and catch phrases that inhibited serious thought—such writers were looking toward a style of liberation that would do justice to all the political and psychological lessons emigration had taught them.

They were too sensible to ignore the past, but they regarded it as *verrückt* (crazy) or *idiotisch* to overvalue it, or to attempt to deny the gap between then and now: in one of Brecht's last works, an émigré pales when he is told, "You haven't changed at all." They had no time for nostalgia. Instead of lamenting the past, some simply moved it into the present: Arendt engaged in her dialogues with dead thinkers; Brecht revised the dead as if they were living candidates for his satire. Their individual estimation of the artist determined the varying ways they read time. To a Marcuse or an Adorno, he conveyed the *promesse de bonheur*, somewhere in the future. But to Arendt or Brecht, he was simply a worker living in the present—as Arendt expected,

"telling us how we live," as Brecht hoped, "leaving the world a better place."

How did they see themselves? As alone, but not lonely. Arendt thought the thinker was never less solitary than when she was preoccupied in thought; Adorno, with whom she had few other agreements, would concur—his "happiness" resided in thought and memory. And on a more modest plane, the painter Richard Lindner said of himself, "I am a tourist everywhere, which means an 'observer.' " Once the émigré reconciled himself or herself to this position as observer, life became too interesting to waste in self-pity or to lament that if one was a tourist everywhere, one was at home nowhere.

Erich Kahler, who told Mann the story of the émigré voyagers, did not learn English until he was close to fifty, yet he wrote many works in that language. In 1954 Kahler received a note from his fellow Princetonian the matchlessly resilient Einstein about the persecution of J. Robert Oppenheimer. Einstein understood the American's predicament, but as an outsider. "Such a person rooted in the social community is incomparably more vulnerable," he told Kahler, "than a gypsy like you or me for whom the saying 'Go to hell' is not a mere figure of speech, but a natural attitude."

Notes

1. Berolina

Walter Benjamin's description of Proust's prose is from "The Image of Proust," Walter Benjamin, *Illuminations*, edited and with an introduction by Hannah Arendt, translated by Harry Zohn (New York, 1968). All other Benjamin references are from Walter Benjamin, *Reflections: Essays, Aphorisms, Autobiographical Writings*, edited and with an introduction by Peter Demetz, translated by Edmund Jephcott (New York, 1978). Ernst Bloch on Benjamin is quoted in Gershom Scholem, *Walter Benjamin: die Geschichte einer Freundschaft* (Frankfurt, 1975).

Also cited are Hannah Arendt, *The Origins of Totalitarianism* (New York, 1972); Johannes Urzidil, "The Literary Contribution of Jewish Prague to Modern German Literature," Leo Baeck Memorial Lecture, 1968; Cynthia Ozick, "Gershom Scholem: The Mystic Explorer," *The New York Times Book Review*, September 21, 1980; Walter Rathenau, *Schriften* (Berlin, 1965); Leon Trotsky, *My Life*; Elisabeth Young-Bruehl, *Hannah Arendt: For Love of the World* (New Haven, Conn., 1982); Jon Halliday, *Sirk on Sirk* (New York, 1972); Wieland Herzfelde, "On Bertolt Brecht," *Brecht as They Knew Him*, edited by Hubert Witt, translated by John Peet (New York, 1974); Alfred Döblin, *Alexanderplatz Berlin: The Story of Franz Biberkoph*, translated by Eugene Jolas (New York, 1929); Kurt Tucholsky and Walter Hasenclever, "Christopher Columbus," translated by Max Spalter and George E. Wellwarth, *German Drama Between the Wars*, edited by George E. Wellwarth (New York, 1974); Christopher Isherwood, *Christopher and His Kind* (New York, 1976). For discussion of *Neue Sachlichkeit* see John Willett, *Art and Politics in the Weimar Period: The New Sobriety, 1917–1933* (New York, 1978).

2. In Transit

Quotations from Bertolt Brecht's poetry are from Bertolt Brecht, *Poems 1913–1956*, edited by John Willett and Ralph Manheim (New York, 1979). Poems quoted in this chapter are "Ode to a High Dignitary" (translated by Michael Hamburger), and "Pipes," "Early On I Learned," "On the Suicide of the Refugee W. B.," "Hounded Out by Seven Nations," and "Finnish Landscape" (all translated by John Willett). Statistics from Maurice R. Davie, *Refugees in America* (New York, 1947); and Herbert A. Strauss, "Jewish Emigration from Germany—Nazi Politics and Jewish Response," II in *Yearbook XXVI* of The Leo Baeck Institute (London, 1981). Other sources include Günther Anders in Günther Hans Jurgen Schultz, editor, *Mein Judentum* (Stuttgart, 1978); Vladimir Nabokov quoted in Simon Karlinsky, editor, *The Nabokov-Wilson Letters* (New York, 1979); Herzfelde, "On Bertolt Brecht"; Lion Feuchtwanger, *The Oppermanns* (New York, 1934). The Joseph Roth and Walter Mehring quotations are from Hertha Pauli, *Break of Time* (New York, 1972).

Other sources include Halliday, *Sirk on Sirk;* "Conversations with Brecht," Benjamin, *Reflections;* Klaus Mann, *The Turning Point* (New York, 1944); Stefan Zweig, *The World of Yesterday: An Autobiography* (New York, 1943); Franz Schoenberner, *Inside Story of an Outsider* (New York, 1949); Lion Feuchtwanger, *The Devil in France*, translated by Elizabeth Abbott (New York, 1941); Adorno on poetry and Auschwitz in Theodor W. Adorno, "Cultural Criticism and Society," in *Prisms*, translated by Samuel and Shierry Weber (London, 1967); Benjamin, *Illuminations;* "Walter Benjamin: 1892–1940," translated by Harry Zohn; Hannah Arendt, *Men in Dark Times* (New York, 1968); David Wyman, *Paper Walls: American Refugee Policy 1938–1941* (Amherst, Mass., 1968); Varian Fry, *Surrender on Demand* (New York, 1945); Pauli, *Break of Time;* Thomas Mann, *The Story of a Novel: The Genesis of Doctor Faustus*, translated by Richard and Clara Winston (New York, 1961); Elias Canetti, *The Human Province*, translated by Joachim Neugroschel (New York, 1978); Hermann Kesten, *Der Geist der Unruhe* (Cologne, 1959); interviews conducted by the author with Henry Pachter; Robert Cazden, *German Exile Literature in America, 1933–1950* (Chicago, 1970).

3. Becoming American

The Brecht poems quoted are "California Autumn" (translated by John Willett), "Without Innocence" (translated by Derek Bowman), "Everything Changes" (translated by John Willett), "The Fishing Tackle" (translated by Lee Baxendall), and "1940" (translated by Sammy McLean), from Brecht, *Poems 1913–1956.*

Also cited are Thomas Mann, *Joseph in Egypt,* translated by H. T. Lowe-Porter (New York, 1938); Max Ascoli, "No. 38 Becomes a Citizen," *Atlantic Monthly,* February 1940; Halliday, *Sirk on Sirk;* Hanns Eisler, "A Musical Journey Through America," *Hanns Eisler: A Rebel in Music,* translated by Marjorie Meyer, edited and with an introduction by Manfred Grabs (Berlin, 1978); *The Aufbau Almanac: The Immigrant's Handbook* (New York, 1941); D. H. Lawrence, *Studies in Classic American Literature* (New York, 1923); Erik H. Erikson, "Conclusion: The Fears of Anxiety," in *Childhood and Society* (New York, 1980). The Arnold Schoenberg quotations are from Frederic V. Grunfeld, *Prophets Without Honor: A Background to Freud, Kafka, Einstein and Their World* (New York, 1979), and Dika Newlin, *Schoenberg Remembered: Diaries and Recollections 1938–1976* (New York, 1980). The Ernst Křenek quote is from Andrew Porter, "Not Without Honor," *The New Yorker,* April 30, 1979. Brecht's response to the situation of American blacks is found in James K. Lyon, *Bertolt Brecht in America* (Princeton, N.J., 1980). The review of "WHN's Refugees from Germany" is from *Variety,* February 1, 1939. The interview with Harry Rosovsky appeared in *The New Yorker,* December 4, 1978. Thomas Mann's description of California appears in *Letters of Thomas Mann, 1889–1955,* selected and translated by Richard and Clara Winston (New York, 1971), and his description of Max Reinhardt's funeral is from *The Story of a Novel.* Hannah Arendt's description of California is found in Elisabeth Young-Bruehl, *Hannah Arendt: For Love of the World.* The Helene Thimig quotation is from Erika and Klaus Mann, *Escape to Life* (Boston, 1939). Also cited are interviews conducted by the author with Henry Pachter, Marguerite Yourcenar, and Helen Wolff.

The following memoirs are cited or summarized: Ludwig Marcuse, *Mein Zwanzigstes Jahrhundert* (Munich, 1960); Alexander Granach, *There Goes an Actor,* translated by Willard Trask (New York, 1945); Albert Ehrenstein, "Rund um New York," *Das Goldene Tor,* October/November 1946; Martin Gumpert, *First Papers,* translated by Heinz and Ruth Norden (New York, 1941); Hans Heinsheimer, *Best Regards to Aida* (New York, 1968); Hans Natonek, *In Search of Myself,* translated by Berthold Fles (New York, 1943); Leo Lania, *Welt im Umbruch: Biographie einer Generation* (Frankfurt, 1954); Carl Zuckmayer, *A Part of Myself,* translated by Richard and Clara Winston (New York, 1970); Heinrich Zimmer, *Address to the Analytical Psychology Club of the City of New York* (privately printed); Salka Viertel, *The Kindness of Strangers* (New York, 1969); Erna Barschak, *My American Adventures* (New York, 1945).

4. The Academic Welcome

The hardships faced by émigré scholars are discussed in Toni Oelsner, "Dreams of a Better Life," *New German Critique*, Spring–Summer 1980. The Franz Neumann and Paul Tillich quotations are from Franz Neumann, Henri Peyre, Erwin Panofsky, Wolfgang Köhler, and Paul Tillich, with an introduction by W. Rexford Crawford, *The Cultural Migration: The European Scholar in America* (Philadelphia, 1953). Memoirs cited include Stephen Duggan and Betty Drury, *The Rescue of Science and Learning* (New York, 1948), and Alvin Johnson, *Pioneer's Progress* (New York, 1952).

Other sources were interviews conducted by the author with Hans Staudinger, Helen Wolff, and Henry Pachter.

Theodor W. Adorno passages cited are from "Sociology and Empirical Research," translated by Graham Bertram, in *Critical Sociology*, edited by Paul Connerton (London, 1976); "The Actuality of Philosophy," translated by Wes Blomster, *Telos*, Spring 1977; "The Sociology of Knowledge and Its Consciousness," "Aldous Huxley and Utopia," and "Arnold Schoenberg," *Prisms*; "Scientific Experiences of a European Scholar in America," translated by Donald Fleming, *The Intellectual Migration: Europe and America, 1930–1960*, edited by Donald Fleming and Bernard Bailyn (Cambridge, Mass., 1969). The Siegfried Kracauer quotation is from Martin Jay, "Adorno and Kracauer: Notes on a Troubled Friendship," *Salmagundi*, Winter 1978. The debate between Adorno and Walter Benjamin is found in Ernst Bloch, George Lukács, Bertolt Brecht, Walter Benjamin, and Theodor Adorno, *Aesthetics and Politics* (London, 1977).

The Max Horkheimer quotations are from Martin Jay, *The Dialectical Imagination: A History of the Frankfurt School and the Institute of Social Research, 1923–1950* (New York, 1973). Horkheimer's financial prowess is mentioned by Oelsner; and by Herbert Marcuse in Bryan Magee, "Marcuse and the Frankfurt School," *Men of Ideas* (New York, 1979). The Leo Lowenthal quotations are from Helmut Dubiel, "Interview with Leo Lowenthal," *Telos*, Fall 1980, and Leo Lowenthal and Norbert Guterman, *Prophets of Deceit* (New York, 1949). Bertolt Brecht's arguments with the members of the Frankfurt school are included in Lyon, *Bertolt Brecht in America*. Also cited is Ernst Bloch, "Disrupted Language, Disrupted Culture," *Direction*, December 1939. Karl A. Wittfogel quotations are from Felix J. Raddatz, "Vom Versagen der Linken," *Die Zeit*, March 9, 1979.

Paul F. Lazarsfeld's letter to Theodor W. Adorno is quoted in Jay, *The Dialectical Imagination*. Quotations from Lazarsfeld are found in "An Episode in the History of Social Research: A Memoir," *The Intellectual Migration*; Arthur Kornhauser and Paul F. Lazarsfeld, "The Analysis of Consumer Actions," *Institute of Management*, number 16, 1935; and Paul F. Lazarsfeld, "Sociological Reflections on Business: Consumer and Man-

ager," *Social Science Research on Business: Product and Potential* (New York, 1954). The Vladimir Nabokov passage is from *Vladimir Nabokov, Lectures on Literature: British, French, and German Writers* (New York, 1980).

5. Left and Right

Passages cited are from Hans Kohn, *Living in a World Revolution: My Encounter with History* (New York, 1964); Mann, *Escape to Life;* Otto Preminger, *Preminger* (New York, 1977); Viertel, *The Kindness of Strangers;* Dr. Rudolf Brandl, *That Good Old Fool, Uncle Sam: A Refugee Sounds a Warning* (privately printed, May 1940); *Letters of Thomas Mann, 1889–1955;* and Henry Seidel Canby, "Literary Transplants," *The Saturday Review of Literature,* October 19, 1940.

The Hannes Schmidt quotation, intensive analysis of émigré political feuds, and Klaus Mann's statement are found in Cazden, *German Exile Literature in America, 1933–1950.* Ruth Berlau's experiences at the OWI and Brecht's opinion of radicals working for the American government are found in Lyon, *Bertolt Brecht in America.* H. Stuart Hughes's passage is from his lecture, "Social Theory in a New Context," given as part of "The Muses Flee Hitler," colloquium held in 1980 at the Smithsonian Institution. For the Allied governments' responses to news of the death camps, see Walter Laqueur, *The Terrible Secret: Suppression of the Truth About Hitler's "Final Solution"* (New York, 1982). Also cited are interviews conducted by the author with Henry Pachter.

6. New Opiates of the People

Passages cited are from Bertolt Brecht, *Flüchtlingsgespräche* (Berlin, 1962); Paul F. Lazarsfeld, "An Episode in the History of Social Research: A Memoir," *The Intellectual Migration;* Friedrich Pollock, "Empirical Research into Public Opinion," translated by Thomas Hall, *Critical Sociology;* Schoenberner, *Inside Story of an Outsider;* Herta Herzog, "Why Did People Believe in the 'Invasion from Mars'?" (privately printed); Rudolf Arnheim, "The World of the Daytime Serial," *Radio Research 1942–1943,* edited by Paul F. Lazarsfeld and Frank Stanton (New York, 1944); Theodor W. Adorno, "The Radio Symphony," *Radio Research 1941* (New York, 1942); Theodor W. Adorno and Max Horkheimer, *Dialectic of Enlightenment,* translated by John Cumming (New York, 1972); Adorno, "Perennial Fashion—Jazz," *Prisms;* Leo Lowenthal, *Literature, Popular Culture and Society* (Englewood Cliffs, N.J., 1961); Ernst Cassirer, *Myth of the State* (New Haven, Conn., 1946); Ernst Kris and Hans Speier, editors, *German Radio Propaganda* (New York, 1944); Theodor W. Adorno, "Television and the Patterns of Mass Cul-

ture," *Mass Culture*, edited by Bernard Rosenberg and David Manning (Glencoe, Ill., 1957); and Günther Anders, *Besuch im Hades* (Munich, 1979).

7. The Line of Most Resistance

Josef Albers at Black Mountain College is discussed in Martin Duberman, *Black Mountain: An Experiment in Community* (New York, 1972). George Grosz's memoir is *A Little Yes and a Big No* (New York, 1946); his public tirade is discussed by Hilton Kramer in *The New York Times*, June 30, 1980. Hofmann quotations are from William C. Seitz, *Hans Hofmann* (New York, 1968). The Lindner quotes are from Wolfgang Georg Fischer, "Interview with Richard Lindner," *Art International*, April 20, 1974. The Richter passages are from Cleve Gray, *Hans Richter on Hans Richter* (New York, 1971), and an interview with Mrs. Richter by Cynthia Jaffee McCabe, published in pamphlet form. Erwin Panofsky passages are from Neumann et al. *The Cultural Migration*. The description of Victor Gruen is from his obituary in *The New York Times*, February 16, 1980. Philip Johnson's comments on the Bauhaus School are from "Rebuilding," *The New York Times*, December 28, 1978.

The passages about musicians and composers are from Artur Schnabel, *Music and the Line of Most Resistance* (Princeton, N.J., 1942); Erich Leinsdorf, in *The New York Times*, January 13, 1980; Ernst Křenek, in Porter, "Not Without Honor," *The New Yorker*; Viertel, *The Kindness of Strangers*; Adorno, "Arnold Schönberg," *Prisms*; and David Drew, "Kurt Weill and His Critics," *Times Literary Supplement*, October 3, 1975. The Lotte Lenya quote is from *The New York Times*, October 26, 1979. Other quotes are from Eisler, "On Schönberg," "A Musical Journey Through America," "Problems of Working Class Music," "Hollywood Seen from the Left," "Basic Social Questions of Modern Music," "Bertolt Brecht and Music," "On Stupidity in Music," in *Hanns Eisler: A Rebel in Music*; Hanns Eisler, *Composing for the Films*, Film Music Project of the New School (New York, 1947). Kurt Weill's letter to Brecht is quoted in Bertolt Brecht, *Brecht Collected Plays, Volume 7*, edited by John Willett and Ralph Manheim (New York, 1975); also cited is the Kurt Weill interview in *Time*, July 25, 1949. Thomas Mann's discussion of Adorno and Schoenberg is from Mann, *The Story of a Novel*.

8. The State of Having Escaped: Theodor W. Adorno

The Adorno quotations are found in Adorno and Horkheimer, *Dialectic of Enlightenment*; "Cultural Criticism and Society," "Perennial Fashion—Jazz," "Arnold Schönberg," and "Notes on Kafka," *Prisms*; "Scientific Experiences of a European Scholar in America," *The Intellectual*

Migration; and Theodor W. Adorno, *Minima Moralia: Reflections from Damaged Life,* translated by E. F. N. Jephcott (London, 1974).

Adorno's use of American expressions is detailed in H. Stuart Hughes, *The Sea Change: The Migration of Social Thought, 1930–1965* (New York, 1977). Also cited is Jay, "Adorno and Kracauer: Notes on a Troubled Friendship."

9. "Not a Nice Guy": Bertolt Brecht

The Brecht poems quoted are "Sonnet in Emigration" (translated by Edith Roseveare), "In View of the Conditions in This Town" (translated by Humphrey Milnes), "Hollywood" (translated by Michael Hamburger), "Deliver the Goods" (translated by Humphrey Milnes), "On Thinking About Hell" (translated by Nicholas Jacobs), and "Hollywood Elegies" (translated by John Willett), from Brecht, *Poems 1913–1956.* Other passages cited are from Benjamin, "Conversations with Brecht," *Reflections;* Brecht, *Flüchtlingsgespräche;* Max Frisch, "Diary 1948," *Brecht as They Knew Him;* Hans Mayer, *Steppenwolf and Everyman,* translated and with an introduction by Jack D. Zipes (New York, 1971); Mann, *Escape to Life;* Bertolt Brecht, "Anecdote of Herr Keuner," in *Tales from the Calendar,* translated by Yvonne Kapp (London, 1961); Ernst Schumacher, "He Will Remain," *Brecht as They Knew Him;* Henry Pachter, "Brecht's Personal Politics," *Telos,* Summer 1980; James K. Lyon, "Brecht's Hollywood Years," *Oxford German Studies,* 1971–1972; and Fetscher, "Bertolt Brecht and America." Brecht's comments about *gestus* and about Herbert Marcuse and Leonhard Frank are quoted in Frederic Ewen, *Bertolt Brecht, His Life, His Art and His Times* (New York, 1967). Brecht, *Collected Plays, Volume 7,* contains the script of "The Caucasian Chalk Circle" (translated by Ralph Manheim); Brecht's comments on Broadway theater; and Kurt Weill's letter to Brecht. The John Houseman, Elsa Lanchester, and Marta Feuchtwanger quotes are from a radio program broadcast over KPFK.

Lyon, *Bertolt Brecht in America,* is the source for the information on Brecht's first American trip; Brecht's remarks on Isherwood's religion, his quarrels with Fritz Lang and with the Frankfurt school; his interest in American regionalisms and folk tunes; his quarrels with Erwin Piscator and Luise Rainer; his reservations about Stalin; his attempts at composing a verse *Communist Manifesto;* and—most important—the FBI surveillance of Brecht.

George Grosz's "schoolmaster Brecht" comment is from an interview conducted by the author with Wieland Herzfelde.

10. Advise and Affirm

Passages cited are from Donald Peterson Kent, *The Refugee Intellectuals: The Americanization of the Immigrants of 1933* (New York, 1953); Paul Tillich, *On the Boundary* (New York, 1966); Peter F. Drucker, *Men, Ideas and Politics* (New York, 1968); Heinrich Blücher is quoted in Young-Bruehl, *Hannah Arendt: For Love of the World;* Felix Gilbert, *To the Farewell Address: Ideas of Early American Foreign Policy* (Princeton, N.J., 1961); Kohn, *Living in a World Revolution;* Hans Kohn, *American Nationalism: An Interpretive Essay* (New York, 1961); Bruno Bettelheim and Morris Janowitz, *Dynamics in Prejudice: A Psychological and Sociological Study of Veterans* (New York, 1950); Peter F. Drucker, *Adventures of a Bystander* (New York, 1979). The Felix Rohatyn interview is from *The New York Times,* January 24, 1982.

The émigrés' analyses of American children are found in Halliday, *Sirk on Sirk;* Hannah Arendt, "The Crisis of Education," *Between Past and Future: Six Exercises in Political Thought* (New York, 1961); Hannah Arendt, "Reflections on Little Rock," *Dissent,* Winter 1959; Bruno Bettelheim, *Surviving and Other Essays* (New York, 1979); David Dempsey, "Bruno Bettelheim Is Dr. No," *The New York Times Magazine,* January 11, 1970; Constance Carey, "Bruno Bettelheim in Person," *The San Francisco Review of Books,* September 1977; Bruno Bettelheim, "Freud and the Soul," *The New Yorker,* March 1, 1982; Leo Kanner, *In Defense of Mothers: How to Bring Up Children in Spite of the More Zealous Psychologists* (New York, 1941); Margaret S. Mahler, Fred Pine, and Anni Bergson, *The Psychological Birth of the Human Infant* (New York, 1975).

11. Entrepreneurs of Images

Passages cited are from Cynthia Jaffee McCabe, "Jacques Lipchitz," *The Golden Door: Artist-Immigrants of America, 1876–1976* (Washington, D.C., 1976); Arthur Koestler, *Arrow in the Blue* (New York, 1952); Benjamin, *Reflections;* László Moholy-Nagy, *Moholy-Nagy,* edited by Richard Kostelanetz (New York, 1970); Marie Winn, "Alexander Liber- mann: Staying in Vogue," *The New York Times Magazine,* May 13, 1979; Helen Markel, "The Bettmann Behind the Archives," *The New York Times Magazine,* October 18, 1981; Laura Fermi, *Illustrious Immigrants: The Intellectual Migration from Europe, 1930–1941* (Chicago, 1971); and interviews conducted by the author with Helen Wolff, Fritz Landshoff, Christiane Zimmer, and Wieland Herzfelde.

The Max Reinhardt passages are from Mann, *Escape to Life,* and Viertel, *The Kindness of Strangers.* Sources of the Erwin Piscator material include Ley-Piscator, *The Piscator Experiment;* C. D. Innes, *Erwin Piscator's Political Theater: The Development of Modern German*

Drama (Cambridge, 1972); Carl Zuckmayer, *A Piece of Myself;* and an interview conducted by the author with Maria Ley-Piscator.

12. A Club for Discontented Europeans

Douglas Sirk passages are from Halliday, *Sirk on Sirk;* Fritz Lang passages are from Peter Bogdanovich, *Fritz Lang in America* (New York, 1969); Otto Preminger passages are from Preminger, *Preminger;* Max Ophuls quotations are from Paul Willemen, editor, *Ophuls* (London, 1978), and interview translated by Rose Kaplin in Andrew Sarris, editor, *Interviews with Film Directors* (New York, 1969); Edgar Ulmer quotations are from Peter Bogdanovich, "Edgar Ulmer," Todd McCarthy and Charles Flynn, editors, *Kings of the Bs: Working in the Hollywood System* (New York, 1975); Billy Wilder quotations are from Joseph McBride and Todd McCarthy, "Billy Wilder: Twilight Times," *Film Comment,* January–February 1979, and Aljean Harmetz, "At 73, Billy Wilder's Bark Still Has Plenty of Bite," *The New York Times,* June 29, 1979. Jean Renoir quotation is from Louis Marcourelles, "Interview with Jean Renoir," in Sarris, *Interviews with Film Directors.*

13. *Er Gibt den Ton An*

Thomas Mann passages are from *Decision: A Review of Free Culture,* July 1941; *Letters of Thomas Mann, 1889–1955;* Mann, *The Story of a Novel* (passages about Franz Werfel and funerals); Thomas Mann, introduction to *Joseph and His Brothers,* translated by H. T. Lowe-Porter (New York, 1978); Mann, *Joseph in Egypt.* Brecht's description of Eisler is from Bloch et al., *Aesthetics and Politics.*

Klaus Mann's descriptions of Bertolt Brecht and of women writers are from Mann, *Escape to Life.* All other Klaus Mann passages are from *The Turning Point,* unless it is indicated that a given quote is from *Decision.* Klaus Mann *Decision* references include "Issues at Stake: Decision" and a review of Anne Morrow Lindbergh, *The Wave of the Future: A Confession of Faith, Decision,* January 1941: "From Socrates to Baseball" (a review of *Information Please,* 1941 edition), February 1941; "The Vanguard—Yesterday and Tomorrow" (a review of *New Directions in Prose and Poetry,* 1940 edition), March 1941; "The Present Greatness of Walt Whitman," April 1941; "Two Generations" (a review of *Ida, A Novel* by Gertrude Stein and *Reflections in a Golden Eye* by Carson McCullers), May 1941; "Issues at Stake: The Word," July 1941; "What's Wrong with Anti-Nazi Films," August 1941. Other citations from *Decision* include Franz Werfel, "Thanks," January 1941; Golo Mann, "Obsolete Revolution," February 1941; Erich von Stroheim, "Movies and Morals," March 1941; Bertolt Brecht, "Yes, I Live in a Dark Age" (translated by John La-

touche); Hermann Kesten on Ernst Toller, and Heinrich Mann, "The German European," October 1941. Other Heinrich Mann passages are from *Man of Straw* (*Der Untertan*), translated by Ernest Boyd (London, 1947), and *Henry, King of France*, translated by Eric Sutton (New York, 1939). His letter to his nephew is quoted in Rolf Linn, *Heinrich Mann* (New York, 1967).

Other Heinrich Mann quotations are from Nigel Hamilton, *The Brothers Mann* (New Haven, 1979); Hamilton's book is also the source for information on the Döblin–Thomas Mann feud. The other Alfred Döblin quotations and the Kurt Hiller quotation are from Grunfeld, *Prophets Without Honor.* Mrs. Döblin's letter to Benjamin Huebsch is in the possession of The Viking Press. Leonhard Frank works cited are *Carl and Anna,* translated by Cyrus Brooks (New York, 1930); *Mathilde,* translated by Willard Trask (London, 1948); and *Links Ist Wo das Herz Ist* (Munich, 1952). Cazden, *German Literature in Exile,* is the source for Alfred Neumann quotation, list of Hollywood films based on books by refugee writers, and list of émigrés who returned to Europe.

Hermann Broch quotations are from *The Sleepwalkers,* translated by Willa and Edwin Muir (New York, 1964); Broch's introduction to Hugo von Hofmannsthal, *Selected Prose,* translated by Mary Hottinger and Tania and James Stern (New York, 1952); and letters to Hermann J. Weigand, published in *PMLA,* June 1947, and to Edith Jonas Levy published in Maire J. Kurrick, "Some Letters of Hermann Broch to Edith Jonas Levy," *Books Abroad,* Summer 1974. Other descriptions of Broch are from Jean Starr Untermeyer, "Midwife to a Masterpiece," *Private Collection* (New York, 1965); Hannah Arendt, "No Longer and Not Yet," *The Nation,* September 14, 1946; Arendt, "Hermann Broch: 1886–1951," translated by Richard Winston, *Men in Dark Times;* Banesh Hoffman, *Albert Einstein, Creator and Rebel* (New York, 1972). The George Grosz and Kurt Tucholsky descriptions of Walter Mehring are from *Prophets Without Honor.* Also cited is Walter Mehring, *The Lost Library: Autobiography of a Culture,* translated by Richard and Clara Winston (New York, 1951).

Also cited are Pauli, *Break of Time;* Adorno, "Reconciliation Under Duress," translated by Rodney Livingstone, and "Commitment," translated by Francis McDonagh, *Aesthetics and Politics;* Bettelheim, *Surviving and Other Essays;* Bruno Bettelheim, "Miracles," *The New Yorker,* August 4, 1980; and interviews conducted by the author with Wieland Herzfelde and Gertrude Urzidil.

14. The Loneliness of Thomas Mann

Mann works cited are "The Theme of the Joseph Novels," Library of Congress, November 17, 1942; *Doctor Faustus: The Life of the German Composer Adrian Leverkühn as Told by a Friend,* translated by H. T. Lowe-Porter (New York, 1948); *The Coming Victory of Democracy,*

translated by Agnes E. Meyer (New York, 1938); *Thomas Mann: Diaries 1918–1939*, selected and foreword by Hermann Kesten, translated by Richard and Clara Winston (New York, 1982); *The Holy Sinner*, trans-lated by H. T. Lowe-Porter (New York, 1951); *The Confessions of Felix Krull, Confidence Man (The Early Years)*, translated by Denver Lindley (New York, 1955). Mann's letters to the dean of the University of Bonn, Hans Carossa, and *Aufbau;* his interview in *The New York Times;* and his descriptions of Nazi rallies and book burnings are from Hamilton, *The Brothers Mann.* Mann's letter to Walter Ulbricht and comments by Musil and Schnitzler on Mann are found in Henry Hatfield, *From The Magic Mountain: Mann's Later Masterpieces* (Ithaca, 1979). Mann's statement about Communism's appeal is found in Cedric Belfrage, *The American Inquisition, 1945–1960* (Indianapolis, 1973). All other Mann passages are from either *The Story of a Novel,* or—if indicated as a letter—from *Letters of Thomas Mann, 1889–1955.*

Brecht's remark about the "type of this century" is found in Ernst Schumacher, "He Will Return," *Brecht as They Knew Him.*

15. The Victims Start Judging

Works cited are *Letters of Thomas Mann, 1889–1955;* Erik Erikson, *Thomas Mann Neueste Wandlung,* cited in Nigel Hamilton, *The Broth-ers Mann;* Erikson, "The Legend of Hitler's Childhood," *Childhood and Society;* Brecht on Mann, quoted in Hatfield, *From the Magic Mountain: Mann's Later Masterpieces;* Albert Einstein, "To the Heroes of the Battle of the Warsaw Ghetto," *Out of My Later Years* (Secaucus, N.J., 1977); *Einstein on Peace,* edited by Otto Nathan and Heinz Norden (New York, 1968); Thomas Mann, "My Brother," *Order of the Day,* translated by H. T. Lowe-Porter, Agnes E. Meyer, and Eric Sutton (New York, 1942); Brecht poems, "Song of a German Mother" and "Germany 1945" (both translated by John Willett) and "The Solution" (translated by Derek Bowman), *Poems 1913–1956;* Adorno, *Minima Moralia;* Viertel, *The Kindness of Strangers;* Dempsey, "Bruno Bettelheim Is Dr. No," *The New York Times Magazine;* Hannah Arendt, "Organized Guilt and Universal Responsibility," in *The Jew as Pariah,* edited and with an in-troduction by Ron H. Feldman (New York, 1978); Hans Speier, *Force and Folly* and *Essays on Foreign Affairs and the History of Ideas* (Cam-bridge, Mass., 1969); Henry Pachter, "On Being an Exile: An Old-Timer's Personal and Political Memoir," *The Legacy of the German Refugee Intellectuals;* Pachter, "Brecht's Personal Politics," *Telos;* Bog-danovich, *Fritz Lang in America.* The Horkheimer quotation is from Martin Jay, "The Frankfurt School in Exile," *Perspectives in American History,* vol. VI (Cambridge, 1972). Also cited are Ludwig Marcuse, *Mein Zwanzigstes Jahrhundert;* and interviews conducted by the author with Henry Pachter and Herbert A. Strauss.

Max Born quote is from Grunfeld, *Prophets Without Honor;* also cited

are Hermann Kesten, *Ich Lebe Nicht in der Bundesrepublik* (Munich, 1964); Maurice Zolotow, *Billy Wilder in Hollywood* (New York, 1977); Halliday, *Sirk on Sirk;* Preminger, *Preminger;* Hannah Arendt, "The Aftermath of Nazi Rule: Report from Germany," *Commentary,* October 1950; Benjamin Ferencz, *Less Than Slaves: Jewish Forced Labor and the Quest for Compensation* (Cambridge, Mass., 1979). Sirk's response to present-day Germany is mentioned in a letter to the author.

Works cited that deal with Israel and Jewish identity are Hannah Arendt, "Die Jüdischen Chancen," *Aufbau,* April 29, 1945; Arendt, "Zionism Reconsidered," "The Jewish State: Fifty Years After," and "To Save the Jewish Homeland," *The Jew as Pariah;* Albert Einstein, "Why Do They Hate the Jews?" "The War Is Won, But Peace Is Not," "The Jews of Israel," and "Military Intrusion in Science: The Military Mentality," *Out of My Later Years;* Isaac Deutscher, *The Non-Jewish Jew and Other Essays* (London, 1968); Max Horkheimer, *Dawn and Decline* (New York, 1978); and interviews conducted by the author with Rabbi Joachim Prinz and Henry Pachter.

The public letter attacking Menachem Begin appeared in *The New York Times* on December 4, 1948. For statistics on postwar emigration see Leonard Dinnerstein, *America and the Survivors of the Holocaust* (New York, 1982).

16. The Scientists and the Bomb

Leo Szilard is quoted from "Reminiscences," edited by Gertrude Weiss Szilard and Kathleen R. Winsor, *The Intellectual Migration;* David Jorovsky is quoted on Szilard in "Scientists and Servants," *The New York Review of Books,* June 28, 1979; Szilard on Oppenheimer is quoted in Cedric Belfrage, *The American Inquisition, 1945–1960.* The Hans A. Bethe quotations are from Jeremy Bernstein, "Master of the Trade," *The New Yorker,* December 3, 10, and 17, 1979. Also cited is Freeman Dyson, *Disturbing the Universe* (New York, 1979).

17. From *Undeutsch* to Un-American

Arendt's description is from "We Refugees," *The Jew as Pariah.* Moholy-Nagy quotations from *The Golden Door: Artist-Immigrants of America, 1876–1976;* Vladimir Pozner, "bb," *Brecht as They Knew Him.* All transcripts of the congressional investigations of Gerhardt Eisler, Hanns Eisler, Ruth Fischer, and Brecht are from Eric Bentley, editor, *Thirty Years of Treason* (New York, 1971). Hanns Eisler's "Fantasia in G-men" is from *Hanns Eisler: A Rebel in Music.* Brecht's rehearsal of his HUAC appearance is discussed in Lyon, *Bertolt Brecht in America.* Brecht's "We 19," translated by Hugo Schmidt, is from *Thirty Years of Treason.* Salka Viertel quotations are from Viertel, *The Kindness of*

Strangers. Karl August Wittfogel quotations and Brecht's description of Wittfogel are from Felix J. Raddatz, "Vom Versagen der Linken," *Die Zeit,* March 9, 1979.

Also cited are letter from Douglas Sirk to the author; Bogdanovich, *Fritz Lang in America;* Jay, *The Dialectical Imagination;* interview conducted by the author with Hans Staudinger; Drucker, *Adventures of a Bystander;* Hannah Arendt, "Gestern Waren Sie noch Kommunisten . . . ," *Aufbau,* July 31, 1953; Mann, *The Turning Point.* Thomas Mann's statement is cited in Stefan Kanfer, *A Journal of the Plague Years* (New York, 1973). There are Einstein quotations from "At a Gathering for Freedom of Opinion," "The Negro Question," "Why Socialism," "A Reply to the Soviet Scientists," Einstein, *Out of My Later Years;* those quotes having to do with resistance to congressional investigators are from *Einstein on Peace.* Other sources of information were interviews conducted by the author with Otto Nathan, Rabbi Joachim Prinz, and Wieland Herzfelde. Hannah Arendt's influence on Supreme Court justices is discussed in Young-Bruehl, *Hannah Arendt: For Love of the World.*

18. "I Somehow Don't Fit": Hannah Arendt

Hannah Arendt works cited are "We Refugees," "Portrait of a Period," "The Jew as Pariah: A Hidden Tradition," *The Jew as Pariah; The Origins of Totalitarianism* (first edition, New York, 1951; second edition, New York, 1958); *The Human Condition* (Chicago, 1958); *Eichmann in Jerusalem: A Report on the Banality of Evil* (New York, 1963, 1965); "Truth and Politics," *Between Past and Future: Eight Exercises in Political Thought* (New York, 1968); "Eichmann in Jerusalem: Exchange of Letters Between Gershom Scholem and Hannah Arendt," *The Jew as Pariah; Men in Dark Times; On Revolution* (New York, 1963); and *The Life of the Mind* (New York, 1978).

Articles by Arendt cited are "Die Jüdische Armee—der Beginn einer Jüdischen Politik?" in *Aufbau,* November 14, 1941; "The Ivory Tower of Common Sense," a review of John Dewey, *Problems of Men,* in *The Nation,* March 23, 1946; "The Streets of Berlin," a review of Robert Gilbert, *Meine Reime Deine Reime,* in *The Nation,* March 23, 1946; "Understanding Communism," *Partisan Review,* September–October 1953; "He's All Dwight: Dwight Macdonald's *Politics,* " *The New York Review of Books,* August 1, 1968; "Thoughts on Politics and Revolution," *The New York Review of Books,* April 22, 1971; "Home to Roost," *The New York Review of Books,* June 26, 1975.

Arendt autobiographical passages are from "On Hannah Arendt," in Melvyn A. Hill, editor, *Hannah Arendt, The Recovery of the Public World* (New York, 1979), and "Was Bleibt? Es Bleibt die Muttersprache," Günther Gaus, *Zur Person* (Munich, 1965).

Young-Bruehl, *Hannah Arendt: For Love of the World* is the source for information on Arendt's affair with Heidegger, Arendt's quarrel with

Adorno over his treatment of Benjamin, and Arendt's letter during the Eichmann trial about Hausner. Günther Anders's seminar on *Mein Kampf* is discussed in Oelsner, "Dreams of a Better Life." The Mary McCarthy and Hans Jonas reminiscences are from lectures delivered as part of a Hannah Arendt symposium in October 1981 at New York University. Also cited is Irving Howe, *A Margin of Hope: An Intellectual Autobiography* (New York, 1982). Thomas Mann's comments on Stefan Zweig's suicide are from *Letters of Thomas Mann, 1889–1955*. Also cited are Franz Neumann, *Behemoth: The Structure and Practice of National Socialism, 1933–1944*, revised edition (New York, 1944), Erich Heller, "Hannah Arendt as a Critic of Literature," *Social Research* (Spring 1977); Nathan Glazer, "Hannah Arendt's America," *Commentary* (September 1975); and interviews conducted by the author with Henry Pachter and Rabbi Joachim Prinz.

19. Heroes of the 1960s

The Erik Erikson quotation is from Erik Erikson, "Introduction to Part Four," *Childhood and Society* (New York, 1950); also cited are Adorno, *Minima Moralia*, and Hans Jonas lecture at the 1981 Hannah Arendt symposium. The Wilhelm Reich quotations are from Wilhelm Reich, *Reich Speaks of Freud*, edited by Mary Higgins and Chester M. Higgins (New York, 1967); Wilhelm Reich, *Character-Analysis* (New York, 1963); and Ilse Ollendorff Reich, *Wilhelm Reich: A Personal Biography*, introduction by Paul Goodman (New York, 1969). The Fritz Perls quotations are from Frederick S. Perls, *In and Out the Garbage Pail* (Lafayette, Calif., 1969). The Erik Erikson passages are from "Reflections on the American Identity," the citation of Schiller from "Toys and Reasons," the discussion of basic English from "The Theory of Infantile Sexuality," "The Legend of Hitler's Childhood," "The Legend of Maxim Gorky's Youth," and "Eight Stages of Man," in *Childhood and Society; Life History and the Historical Moment* (New York, 1975); *Dimensions of a New Identity* (New York, 1973); and *The 1973 Jefferson Lectures in the Humanities* (New York, 1974). Brecht's poem "Hounded Out by Seven Nations" is quoted from Brecht, *Poems 1913–1956*.

Reactions to the Vietnam war are quoted from Halliday, *Sirk on Sirk;* Toni Oelsner, "Dreams of a Better Life," and Hans Morgenthau, "The Tragedy of the German Jewish Intellectual" in Bernard Rosenberg and Ernest Goldstein, *Creators and Disturbers: Reminiscences by Jewish Intellectuals of New York* (New York, 1982).

Herbert Marcuse's work with the OSS is mentioned in a letter from Marcuse to the author. Other Marcuse quotations are from *Eros and Civilization: A Philosophical Inquiry into Freud* (Boston, 1955); *Negations: Essays in Critical Theory*, translated by Jeremy J. Shapiro (Boston, 1968); *One-Dimensional Man: Studies in the Ideology of Advanced Industrial Society* (Boston, 1964); Herbert Marcuse, Robert Paul Wolff, and

Barrington Moore, Jr., "Repressive Tolerance," *A Critique of Pure Tolerance (Boston, 1965; 1968 postscript); An Essay on Liberation* (Boston, 1969); *The Aesthetic Dimension: Toward a Critique of Marxist Aesthetics* (Boston, 1977). Interviews cited are Magee, "Marcuse and the Frankfurt School"; *The Los Angeles Times*, November 13, 1978; and *Roadwork*, the journal of the University of California at San Diego, Spring 1978.

Max Horkheimer's 1968 preface is included in *Critical Theory* (New York, 1972). Other Horkheimer quotations are from Max Horkheimer, "On the Concept of Freedom," *Diogenes*, 53 (Paris, 1961). Adorno citations are from "Reconciliation Under Duress," translated by Rodney Livingstone, *Aesthetics and Politics;* "Music and the New Music," translated by Wes Blomster, *Telos*, Spring 1980; and "Resignation," translated by Wes Blomster, *Telos*, Spring 1978. Also cited are Jürgen Habermas, "The Inimitable Zeitschrift für Sozialforschung: How Horkheimer Took Advantage of a Historically Oppressive Hour," translated by David J. Parent, *Telos*, Fall 1980; Bettelheim, *Surviving and Other Essays;* Henry A. Kissinger, *White House Years* (Boston, 1979).

Epilogue

Among the sources cited are *Letters of Thomas Mann, 1889–1955;* Anders, in *Mein Judentum;* Jacobo Timerman interview, *The New York Times*, May 22, 1981; John McCloy's testimony before the Congressional Commission on Wartime Relocation and Internment of Civilians, reported in *The New York Times*, November 4, 1981; Young-Bruehl, *Hannah Arendt: For Love of the World;* Hans Jonas on Israel cited in *The New York Times*, July 15, 1982; Hans A. Bethe, "The Inferiority Complex," *The New York Review of Books*, June 10, 1982; interviews conducted by the author with Otto Nathan and Fritz Landshoff; Henry Lowenfeld quoted in "Psychoanalysis Today," *Partisan Review 1* (1979); McBride and McCarthy, "Billy Wilder: Twilight Times," *Film Comment;* Vladimir Pozner, "bb," Anna Seghers, "Brecht," and Wieland Herzfelde, "On Bertolt Brecht," *Brecht as They Knew Him;* Bertolt Brecht, "Things Change," translated by the author; Dubiel, "Interview with Leo Lowenthal"; Fischer, "Interview with Richard Lindner"; Brecht, "Anecdotes of Herr Keuner"; Albert Einstein letter to Erich Kahler.

Index